Acclaim for *O'Keeffe & Stieglitz*

"No rendition is better than Benita Eisler's . . . Prodigious research, excellent writing, and an intuitive, psychologically rich analysis . . . Eisler animates not only the lives of her protagonists: she also suggests new and meaningful ways to understand their art. It is biography at its best." —*The Washington Post*

"Brisk and bracing." —*The Wall Street Journal*

"The way these artists forged volatile lives and stellar careers is presented in vibrant, enthralling detail."
 —*The New York Times*

"This book is quite an eye-opener. In taking an objective look at this mythical couple . . . Eisler has done something long in need of doing."
 —*Los Angeles Times*

"Fascinating." —*Newsweek*

"Fascinating, well-researched. . . . An excellent biography."
 —*Chattanooga Times*

"Eisler has done exhaustive research and uncovered new sources. . . . She has pieced the tale together with formidable intelligence and penetrating insight. A compelling and important book."
 —*Cosmopolitan*

"Packed with personal revelations, thick with sexual affairs, this intimate, enthralling dual portrait demythologizes the iconic couple of the American art world, exposing the troubled realities beneath the public personae each skillfully wore."
 —*Publishers Weekly*

"The author's clear-eyed . . . analysis allows the tale of ambition, genius, love and loss an engrossing reign. . . . By pulling some of the loose threads out of the old myths and then watching them unravel into something closer to the truth, Eisler has produced essential reading on the first couple of the American visual arts."
 —*Edmonton Journal*

"Carefully, comprehensively chronicled."
 —*People*

"This book on the first couple of 20th Century American Art . . . [is] a well-documented and briskly told portrait of the prickly relationship between two major artists." —*Atlanta Journal and Constitution*

PENGUIN BOOKS

O'KEEFFE AND STIEGLITZ

Benita Eisler is the author of *The Lowell Offering: Writings by New England Mill Women*; *Class Act*, a study of social mobility in America; and *Private Lives: Men and Women of the Fifties*. A native New Yorker with degrees from Smith and Harvard, she has taught at Princeton and lives in Manhattan.

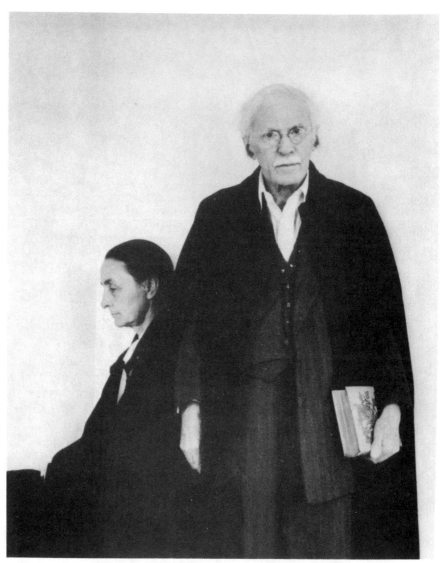

ARNOLD NEWMAN, *Alfred Stieglitz and Georgia O'Keeffe* (1942).
Copyright © by Arnold Newman

O'Keeffe and Stieglitz

ᴓ AN AMERICAN ROMANCE

BENITA EISLER

PENGUIN BOOKS

PENGUIN BOOKS
Published by the Penguin Group
Viking Penguin, a division of Penguin Books USA Inc.,
375 Hudson Street, New York, New York 10014, U.S.A.
Penguin Books Ltd, 27 Wrights Lane,
London W8 5TZ, England
Penguin Books Australia Ltd, Ringwood,
Victoria, Australia
Penguin Books Canada Ltd, 10 Alcorn Avenue, Suite 300,
Toronto, Ontario, Canada M4V 3B2
Penguin Books (N.Z.) Ltd, 182–190 Wairau Road,
Auckland 10, New Zealand

Penguin Books Ltd, Registered Offices:
Harmondsworth, Middlesex, England

First published in the United States of America by Doubleday,
a division of Bantam Doubleday Dell Publishing Group, Inc., 1991
Reprinted by arrangement with Doubleday
Published in Penguin Books 1992

10 9 8 7 6 5 4 3 2 1

THE LIBRARY OF CONGRESS HAS CATALOGUED THE HARDCOVER AS FOLLOWS:
Eisler, Benita.
 O'Keeffe and Stieglitz : an American romance / by Benita Eisler.—1st ed.
 p. cm.
 ISBN 0-385-26122-5 (hc.)
 ISBN 0 14 01.7094 4 (pbk.)
 Includes bibliographical references and index.
 1. O'Keeffe, Georgia, 1887–1986. 2. Artists—United States—Biography.
3. Stieglitz, Alfred, 1864–1946. 4. Photographers—United States—Biography.
 I. Title. N6537.039E38 1991
 759.13—dc20 90–46287

Printed in the United States of America
Designed by Marysarah Quinn

For Colin

CONTENTS

PROLOGUE

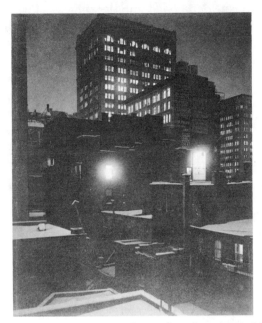

ALFRED STIEGLITZ, *From the Window of 291* (1915–16).

SATURDAY, JANUARY 1, 1916, was as dismal a New Year's Day as New Yorkers had seen in recent memory. Four days earlier, snow, sleet, and hail, driven by gale force winds, had buffeted the city, killing nine people, smashing thousands of windows, sinking barges in the harbor. To the inevitable post-Christmas doldrums was added the tedium of digging out: the dispiriting mounds of sooty snow, the endless delays of omnibuses, subways, and suburban railways. Now, in the dawn of the new year, straggling revelers emerged into streets cleansed by icy rain.

A few hours later, the figure of a slight young woman, bundled against the cold drizzle, could be seen leaving a brownstone just off Central Park West. She hurried toward the Amsterdam Avenue trolley car, emptied of its usual overflow crowd on the holiday morning. Leaving the car at 120th Street, she disappeared into the entrance of one of the gloomy neo-Gothic buildings that lined the block.

Shortly after 1:00 P.M., the same young woman rushed out, clutching a mailing tube under one arm. She fairly flew up the street toward Broadway, where she descended into the subway. Twenty minutes later she emerged from the Times Square station to join the flow of other theatergoers heading for the 2:15 matinee. Walking south on Broadway, past the Metropolitan Opera House, she crossed the wide thoroughfare at 40th Street.

Even unlit, on a murky winter afternoon, the marquee of the Empire Theater glittered with magic words: MAUDE ADAMS in PETER PAN. Swept through a drab corridor by a surge of other ticket holders, she was suddenly dazzled by the gilt and garnet velvet of the newly refurbished auditorium. She slid into her seat, still holding tight to the cylindrical package, addressed in black wavy letters TO: Miss Anita Pollitzer, c/o Teachers College Post Office, Columbia University; SENDER: Georgia O'Keeffe, College Station, Columbia, South Carolina.

Anita Pollitzer, twenty-two, had been dreading the New York winter with shivers of homesickness since October. It wasn't only the climate that gave her pangs of longing for home. Her furnished room was a place to sleep and change clothes, more cramped than any in the servants' quarters behind her family's gracious Federal-period house in Charleston. She missed the sender of the mailing roll she still clutched, her fellow student of last year and dearest friend, Georgia O'Keeffe.

As the other theatergoers took their seats and the excited treble of children in the audience was hushed by their elders, Anita reflected on the workings of chance.

If she had not acted on her resolve to start the new year right—spending the morning at work in one of the empty college studios instead of in bed—the package now in her lap would have waited in the student mailbox until after the holiday. Instead, passing the little college post office on her way upstairs, she had seized the parcel like an unexpected gift and pelted up the four flights to the silence of a top-floor studio.

Impatiently, she had slid the contents from the tube and, unrolling a sheaf of papers, spread the pages on the floor. They were covered with drawings in charcoal, without recognizable subject matter but consisting of lines, some jagged and saw-toothed, others delicate, swooping arabesques. Soft billowing shapes confronted angles, hard and unyielding. She had never seen anything "so pure," she wrote later of one composition of black and gray forms against dazzling white paper; another felt "so sensational and explosive"[1] that it filled the sheet to overflowing.

· · ·

"WORDS AND I are not friends," Georgia O'Keeffe liked to say, her spare, eloquent style belying this profession of enmity. The roll of drawings that she mailed to Anita Pollitzer late in December 1915 was in lieu of a letter, she said. But there were many letters too, penned in a forceful, sinuous script. During this holiday season, especially, exchanges flew back and forth from "Pat" O'Keeffe (her student nickname) to her "Little One."

Whereas Anita was homesick, Georgia O'Keeffe, at twenty-eight, was both homeless and exiled. In the past fifteen years, her family, prosperous Wisconsin dairy farmers in her childhood, had sunk into poverty and disease. Home had become a student boardinghouse in Charlottesville, Virginia, kept by her mother, who was dying of tuberculosis, and two sisters. Two other sisters had left; their father had taken to the road, supposedly looking for work; and both brothers had fled.

Following a year at the Art Students League in New York in 1907–1908, Georgia had been on her own, supporting herself, haphazardly alternating periods of work and study. By 1914, she had saved enough to spend the year at Teachers College, where she and the sheltered, adoring Anita, seven years her junior, had become friends. Then in June 1915, she returned to Charlottesville, teaching art for the third of four years in the summer school of the University of Virginia. But at the end of August, after helping out at home, she had no money and no better prospects than an offer to teach drawing at a two-year Methodist women's college in Columbia, South Carolina. The pay was a pittance and there was no one to talk to, but the hours of teaching were few and she had a studio of her own. The five months of exile seemed to peel away all excess from her art, eliminating color and realistic form.

"[I] have put everything I have ever done away. . . . I feel disgusted and am glad I'm disgusted," she wrote to Anita. "I am starting all over new."[2]

Seized with a manic energy, working day and night, she crossed an indefinable boundary. She was no longer a talented student. She had become an artist.

TWO MONTHS before she sent the roll of drawings, Georgia had confessed to Anita her conflict about letting others see her work. "I always have a curious sort of feeling about some of my things—I hate to show them," she wrote. "I am afraid people wont* understand and—and I hope they wont—and am afraid they will."[3]

* Throughout the book, O'Keeffe's idiosyncratic spelling and punctuation have been retained.

Georgia admitted to being "perfectly inconsistent." Yearning for approval and admiration, she would find herself seized by self-disgust. She tormented herself for "catering" to the imagined good opinion of others—"working for flattery" she called it—looking over her shoulder, wondering what Anita, their teachers, "or somebody—most anybody—[would] say if they saw it."

There was one name missing in this litany of wrongheaded dependence on others; Georgia confided: "I believe I would rather have Stieglitz like some thing—anything I had done—than anyone else I know of—I have always thought that—If I ever make any thing that satisfies me even ever so little—I am going to show it to him to find out if it's any good."[4]

Anita Pollitzer had read between the lines of Georgia's contradictory fears and yearnings. That New Year's morning, in the deserted studio of Teachers College, she made her decision. Now she settled back to enjoy the moment of anticipation that surged with the dimming of the great chandelier. As the footlights flared, her applause joined the tumultuous welcome of more than a thousand others in the audience, all echoing a reviewer's opening night greeting: "Peter Pan has come home for Christmas." After an absence of ten years, Maude Adams had returned to the Empire Theater as "the boy who wouldn't grow up in the play that will never grow old."

Celebrating eternal youth—the ultimate American virtue—*Peter Pan* was even more popular on this side of the Atlantic than in Sir James M. Barrie's Britain; its status as a classic was due to an actress from Utah, who invested the role with her "demure grace and charm." Maude Adams made it unthinkable that there might be anything less than enchanting about a boy who refuses to assume manhood.

If matinee-goers on this dreary New Year's Day 1916 waved white handkerchiefs with particular enthusiasm to signal their belief in fairies, they were also expressing gratitude for an afternoon's diversion. "There is trouble and sorrow aplenty abroad, but there is only joy at the Empire," caroled the *New York Times* reviewer, who went on to laud Peter's unique ability to "banish for a few hours the dingy spirit that broods over the world."

Christmas 1915 had demanded special efforts to offset cheerless news with any glad tidings to be found.

To avenge naval and ground losses at Gallipoli—one hundred thousand dead or wounded and six large ships destroyed before the port was evacuated—Britain proudly announced that five hundred aeroplanes were preparing to raid the Krupp works near German cities. "A new giant British plane would do the work," the *New York Times* reported,

"dropping bombs of greater destructive power than the 42.cc. shell."
By Christmas Day, the Krupp works were still intact, but British war
casualties totaled more than half a million.

At home, despite every precaution, a leak had revealed the design
of the last of Mrs. Edith Galt's many trousseau gowns two days before
her White House wedding to President Woodrow Wilson. The frock in
question, a "blue silk demi-toilet," ended speculation on another front:
such a summery confection, deduced the *New York Times* in a front-
page story, "was clearly intended for wear on a southern honeymoon."
While the President was preparing to be a bridegroom, his political
pledge of American neutrality was gaining powerful enemies, foremost
among them former President Theodore Roosevelt, who berated his
fellow citizens for their "lack of war spirit."

Among the virtues of war—although not one to be trumpeted to
suffering allies abroad—was a booming economy at home. Eastman Ko-
dak management (already reviled by Alfred Stieglitz for the shoddiness
of their products) distributed a million dollars in wage bonuses to em-
ployees who had worked more than a year for the company.

Not only the camera manufacturer but the entire country was en-
joying a trade boom; mills were running at full capacity, bank clearings
had increased dramatically, and department stores reported record hol-
iday sales, undampened by the recent blizzard.

War toys were a favorite with old and young. There were monoplanes
that really flew, propelled by compressed air. At the season's debutante
balls, where, after an absence of some years, the cotillion was revived,
gentlemen guests received party favors of flashlights in the shape of
guns.

Still, dispelling the dreariness of a sodden New Year's Day required
more effort for New Yorkers than once had been the case. The gracious
custom of paying New Year's calls or "receiving at home" had ended,
the casualty of a new century's lack of decorum and of new elements
in a society where the "right people" had once all known one another.
New Year's Day had become a "nothing-to-do holiday," one observer
mourned, "without fixed ceremony or ritual."

The long gray afternoon would have weighed with particular heav-
iness on those for whom a day at home promised only tedium or the
tension of family quarrels.

BY FIVE O'CLOCK, Peter Pan had taken his last bow and his en-
raptured fans, gathering together gloves and small companions, filed out
to face the real world of aging children and scarce taxicabs.

Anita Pollitzer threaded her way past the others down the red-carpeted stairs from the balcony. Normally, she would have walked to her destination, one and a half blocks east to Fifth Avenue and then south, but the lateness of the hour and the continuing rain decided her on an omnibus ride.

When she reached the old brownstone at 31st Street and Fifth Avenue, it was not yet dark. On earlier visits, she had ridden up to the attic floor in a tiny elevator, operated by a courtly West Indian who tugged deeply on a pull rope. But today the elevator was broken and she climbed the three flights to the top floor. Stepping into a small corridor, she turned left into a tiny room—no more than another hallway with a curtained partition—and into a larger one, measuring about fifteen feet square.

Together, the two small rooms had begun life a decade earlier as the Little Galleries of the Photo-Secession. In those ten years, hundreds of thousands of visitors had patiently waited their turn to squeeze, two at a time, into the tiny elevator: Whitneys and Vanderbilts, artists and housewives, students and tourists, philistines and those of the most advanced taste.

The proprietor, a slight man with bushy gray hair sprouting from his head, ears, nose, and mustache, was either a genius or a charlatan, a seer or a crank; his dark eyes, staring intently from behind steel-rimmed glasses, had the flash of the fanatic. The art he championed was insane or degenerate, or it represented, in originality and sophistication, the long-awaited spirit of the new century.

Only the fame of the Galleries was never in dispute. Forced by rising rent to move from their original quarters to the present adjoining brownstone, they would remain forever known by the old address, summoned by the magic numbers *291*.

"The loveliest place I ever saw"[5] was the way Georgia O'Keeffe remembered the square room and its atmosphere of transcendent peace. Suspended from the ceiling, a white screen covered the skylight, diffusing the harsh glare into a muted luminosity. In this calm, the outside world was forgotten; a mystic feeling of tranquility descended, allowing the visitor to fully experience the paintings and photographs displayed on the walls, painted a pale gray-green. Temple or sibylline cave, the little rooms became, for many, a place of conversion where suppliants received the oracles of a new religion.

Heightening the sense of mystery, of the hushed inwardness of a sacred place, there stood in the center of the room a kind of altar: on a square platform covered in burlap, a large brass bowl, polished to a glow, held an arrangement of bright leaves.

. . .

I N B E D that night in her furnished room, Anita Pollitzer swiftly pushed her pen over the pages, transcribing every moment of the fateful afternoon.

It was "twilight . . . & thoroughly exquisite," she recalled, when she entered the front room.

"He came in. We spoke." Suddenly intimidated by what she was about to do, she nevertheless took courage from a strange sense of "feeling alike . . . I said 'Mr. Stieglitz would you like to see what I have under my arm.' " He would like that, he said, leading her from the unheated gallery to a small back room warmed by an iron stove.

"I went," Anita's racing pen described, "with your feelings & your emotions tied up & showed them to a giant of a man who reacted— . . . He looked Pat—and thoroughly absorbed & got them—he looked again—the room was quiet—One small light. His hair was mussed— It was a long while before his lips opened.

" 'Finally a woman on paper,' he said."[6]

ALFRED STIEGLITZ's words on seeing the drawings of a twenty-eight-year-old art teacher from the provinces have passed into that nebulous realm between gospel and apocrypha. With Anita Pollitzer as apostle and scribe, the great photographer and art impresario's oracular phrase resonates with destiny more than discovery. At fifty-two, his wait had come to an end. He recognized his Eve through signs, decoding her self-portrait from black marks on white paper.

Any encounter so powerfully determined becomes suspect. Skeptical scrutiny has all but erased Stieglitz's words. No man could have uttered an exclamation so freighted with expectation and fulfillment. Someone—perhaps Anita herself—must have added the phrase later; scrawling it in pencil between the inked lines of her letter to Georgia, written that night.

In fact, Alfred Stieglitz wrote those exact words about O'Keeffe's drawings, and there is every reason to believe he was quoting himself— his favorite source. Buried in a letter to the photographer Anne Brigman, an old friend and companion-of-arms, Stieglitz described the last days of 291, closed in the spring of 1917. One event had, miraculously, redeemed his feelings of loss and bitterness. As he wrote of the Galleries' final weeks, his downcast tone suddenly rose to an ecstatic crescendo:

"The little room was never more glorious than during its last ex-

hibition—the work of Miss O'Keeffe—a Woman on Paper. Fearless. Pure self expression."[7]

A WEEK AFTER Stieglitz first saw her work on New Year's Day 1916, Georgia, in Columbia, South Carolina, wrote him asking "why you liked my charcoals . . . and what they said to you."[8] Stieglitz replied: "It is impossible for me to put into words what I saw and felt in your drawings." Only if they "were to meet and talk about life" could he make her feel what her art had given him. But he repeated what he had told Anita about the charcoals: "If at all possible I would like to show them."[9] Yet when he did just that, Georgia was enraged.

Three months later, in March, O'Keeffe precipitately left Columbia and the Methodists to return to Teachers College in New York; she had been offered a job in Canyon, Texas, for the fall and she needed Arthur Wesley Dow's course in methods to qualify for her new post. Strangely enough, when Georgia arrived in New York in March, she did not let Stieglitz know she was there.

Then, at lunch one day in the college cafeteria, Georgia was told by a fellow student that the work of a "Virginia O'Keeffe" was exhibited at 291. Furious, she is supposed to have rushed downtown, only to find that the perpetrator of this act—hanging her work without permission— was on jury duty. She returned to berate the offender. Unrepentant, he told her, "You don't know what you have done in those pictures."[10] He knew. Her work was about sex: "The male and the female principle on paper," he said. He was the first, but certainly not the last, to insist on this interpretation.

Stieglitz was quickly pardoned. In the hours that followed at 291 and continued over lunch in a small restaurant nearby, they talked about life and art—the conversation he said he needed before he could tell O'Keeffe what her work meant to him.

When Georgia took up her position in Canyon, their intimacy deepened in letters: sometimes as many as five a day from Stieglitz arrived for Georgia at the post office at West Texas State Normal College. Because she was still teaching, she missed her first one-woman show at 291 the following spring. Ending on May 14, the exhibition was the last to be held at the Galleries. But as soon as the semester was over, Georgia came to New York on the spur of the moment for a ten-day visit.

"It was Stieglitz I had to see," she told Anita. While she was there, he rehung the show for her alone.

In Flight from Eden

Georgia O'Keeffe in 1915, while she was living at home
in Charlottesville and teaching at the University of
Virginia summer session, a year before she would meet
Alfred Stieglitz.

NEVER TRUST ANYONE who has had a happy childhood, the saying
goes.

Georgia O'Keeffe claimed to be one of the few people she knew who
had no complaints about their early life. Indeed, the picture she painted
of her first twelve years growing up on a farm in Sun Prairie, Wisconsin,
in the last decade of the nineteenth century is part Winslow Homer,
part Currier & Ives, with a dash of McGuffey's *Reader*.

Born on November 15, 1887, Georgia Totto O'Keeffe was the oldest
daughter and second of seven children of Francis Calixtus O'Keeffe and
the former Ida Wyckoff Totto. The sunny childhood that the artist
would recall was the seasonal cycle of life on a large, prosperous dairy
and livestock farm. From her upstairs bedroom in the farmhouse built
by her father, the small dark child surveyed the red barns and secure
expanse of her family's six hundred acres of wheat and alfalfa. At the
end of their driveway stood the one-room schoolhouse in the Town Hall

where Georgia, remembered as a tomboy of exceptional curiosity and self-confidence, had the jump—physically and intellectually—on her classmates.

"The best farm in the neighborhood" was the way O'Keeffe proudly described her childhood home. Like unions between farm families from the beginning of time, her parents' marriage in 1884 was, most visibly, a consolidation of adjoining acreage.

Ida Wyckoff Totto O'Keeffe boasted descent from Dutch settlers who arrived in the New World in the seventeenth century. A hotel keeper in New York City, the artist's great-grandfather Wyckoff suffered, within a few years, the death of his first wife and the failure of his business. He remarried and set out for Wisconsin in 1854, only to succumb to cholera shortly after his arrival on the frontier. He left the two daughters of his first wife: Isabel, Georgia O'Keeffe's grandmother, and the artist's great-aunt Jane Eliza.

At the age of twenty-five, the orphaned Isabel Wyckoff accepted the suit of a Hungarian political emigré fifteen years her senior. George Victor Totto had arrived in Wisconsin via New York in 1854, the same year that Charles Wyckoff died. Family legend suggests that he had met Isabel Wyckoff while staying in her father's hotel on Warren Street in New York.

Totto had come west with his countryman Count Haraszthy. Like his companion, he claimed both a royal title and a heroic past: he is supposed to have participated in the 1848 Hungarian revolution against Austrian rule and to have arrived in New York as aide-de-camp to Louis (Lajos) Kossuth, who was offered asylum by the United States government following his exile by the Hapsburgs. Neither claim can be documented. Haraszthy gave his name, briefly, to the small, mostly German settlement in Wisconsin where both adventurers alighted. The hard-to-pronounce town of Haraszthy shortly became the less lyrical Sauk City.

With his marriage to Isabel Wyckoff in 1855, O'Keeffe's grandfather Totto availed himself of the opportunity to purchase several hundred acres of farmland in Sun Prairie, Dane County, for seventy-five cents an acre. Becoming a landowner, however, did not make him a farmer. After fathering six children, George Totto returned to Hungary, ostensibly to reclaim his patrimony. He never came back to Wisconsin to live. Nor, it appears, did he ever provide for his large family; a pair of emerald and gold earrings were his only legacy. A widow of circumstance, in the late 1870s Isabel Totto left the Sun Prairie farm in the hands of the neighboring O'Keeffe family and moved with her children to Madison, the university town twelve miles to the north.

Ida Wyckoff Totto, born in 1864, was the fourth child and third daughter of Isabel and George Totto. A handsome, dark young woman, she found that the move from farm to university center encouraged her cultural aspirations; some said she had wanted to be a doctor. But finding herself twenty and unmarried, she yielded to her family's urging and accepted the proposal of Francis O'Keeffe, who had been working the Totto family's Sun Prairie farm in their absence.

Francis's parents, Pierce and Catherine Mary O'Keeffe, had come to Wisconsin to homestead following the failure of the family wool business in County Cork, Ireland. In 1848, ten years before the arrival of the newlywed Tottos, they had taken advantage of the bargain price of land offered by the federal government along the Koshkonong Creek to turn the forest into farmland.

The O'Keeffe family's trip from Milwaukee to Sun Prairie in an ox cart pointed to the social gulf that separated Francis O'Keeffe from his bride; since her childhood on a farm, Ida Totto had become a city girl, brought up to revere a lost patrimony of castles and culture. During his stay in America, George Totto had shed his Catholicism, listing himself as a "free thinker"; his children were raised as Episcopalians.

As a suitor, Francis O'Keeffe, the third in a family of four boys, had other strikes against him besides being Irish and Roman Catholic. The thirty-year-old farmer's schooling had been rudimentary: he could just read and write. More alarming was the evidence of disease that stalked the O'Keeffe household. Tuberculosis—the "white death" that ravaged entire families throughout the last century—had already claimed the father and one brother, Peter, in 1883; Boniface, who was next to die, in 1888, may have already showed symptoms of illness.

But weighing his virtues against his liabilities, Isabel Totto would have reminded her dutiful daughter Ida that Francis was a "good son" to his widowed mother; steady, hard-working, and mature, he was a man respected by the community. Most important to a mother who might well be suspicious of masculine assets more seductive to a young girl, Frank O'Keeffe brought to the marriage the visible substance of rootedness: a prosperous farm adjoining the Totto property in Sun Prairie, whose land was now worth more than ten times the seventy-five cents an acre paid a quarter-century earlier by the repatriated Hungarian Count Totto.

Francis O'Keeffe accepted his bride's social superiority, symbolized by their marriage in the Episcopal church in Madison. Ida's brothers, not the O'Keeffe boys, served as witnesses. Following the wedding on February 19, 1884, the newlyweds returned to Sun Prairie and the

harsh farm life Ida had left in adolescence. Their first child, Francis Calixtus, was born in 1885, followed two and a half years later by Georgia Totto, on November 15, 1887. The two were joined by five other children: Ida Ten Eyck in 1889, Anita Natalie in 1891, Alexius Wyckoff in 1892, Catherine Blanche in 1895, and Claudia Ruth in 1899.

GEORGIA O'KEEFFE would often recall her father's industry. Like any farmer who expected to survive the cruel caprices of nature, banks, and railroad rates, he worked alongside his hired men from before dawn until after dark. To the discipline of hard physical labor he added the virtues of a forward-looking entrepreneurship, journeying to the Dakotas to trade cattle and pooling with neighbors to hire one of the new threshing machines.

White with dark trim, the farmhouse Frank O'Keeffe built for his bride was a lopsided box. A strange onion-dome turret on one end lost in the attempt to balance a steeply pitched roof on the other. Frank's lack of architectural ability, however, was offset by his enthusiasm for the latest amenities. According to Georgia, their house was the first in Sun Prairie to boast a telephone. She recalled waiting in the buggy as Francis O'Keeffe made the rounds of the neighboring farms to explain that if holes were dug for poles, wires for the marvelous new invention could be run past their door. Half a century later, the child who sat proudly in the buggy would rejoice that the telephone nearest her house was two miles away.

Her father's role in linking their farmhouse to others in their "island community"[1]—as one historian described farm hamlets like Sun Prairie—is emblematic of the decades surrounding Georgia O'Keeffe's birth. By the early 1880s, three more railroads had joined the first transcontinental route, symbolized by the Golden Spike driven into the ground on May 10, 1869, at the point where the Southern Pacific and Union Pacific rail lines met. Six years before Georgia's birth, the second of the new routes, the lyrically named and geographically prophetic Atchison Topeka and Santa Fe, boarded its first passengers.

With the taming of vast reaches of wilderness and the controlled dispersal of the native Indian well under way, Americans eagerly embraced other solutions to expansion and communication. The Brooklyn Bridge was the longest suspension bridge in the nation when it opened in 1883. Marconi's invention of wireless telegraphy in 1901 leaped oceans. As to the most troubling social and economic problems of the

day, immigration and labor unrest, these still seemed safely remote in big cities far away.

M O R E T H A N for his industry or energetic welcome of the new, Francis O'Keeffe was remembered by his children as a fiddle-playing man with a repertoire of Irish melodies and a pocketful of sweets. From an early age, Georgia recalled, she had been impressed by her father's "laughter at the things that others took so gravely, of his making light of any little mishaps."[2] Not always a virtue, some might say, wondering whether Frank O'Keeffe's levity in the face of trouble proved a misreading of events, his laughter an inappropriate response—in the phrase of our own day—to worrisome news, his "making light" a denial of danger or a fatalistic insistence on his own powerlessness. "He was like a chip, floating on the water, that takes the waves," Georgia O'Keeffe said of her favorite parent.[3]

The imagination of young children is rife with disaster, and fantasies of floods are a well-documented fear of early childhood. One of Georgia's teachers later recalled an outlandish question from her wiry, dark pupil: "If Lake Monona rose up, way up and spilled all over, how many people would be drowned?"[4] Still, Georgia's query into the statistical probability of drowning does not suggest a little girl's trust in an all-powerful male figure. Her later image of Frank O'Keeffe's buoyancy also points to his failure as a husband, father, and provider. Riding the waves himself, he could not save others from going under.

From the beginning, the O'Keeffes were a mismated, unhappy couple. Ida Totto seems to have been as rigid, retentive, and authoritarian as her husband was permissive, easygoing, and insouciant.

Biology played a part in this tense emotional polarity. For the eight years following her wedding, the slender young woman was carrying, delivering, or nursing a child. This quasi-permanent condition of nineteenth-century wives was reason enough for never-ending anxiety; in rural Wisconsin in the 1880s, Ida O'Keeffe had ample cause for terror: "In return for being a woman and bearing children," one historian of the region noted, "the country offered fatal epidemic diseases."[5] Local newspapers featured bleak chronicles of families in which all six children were carried off in as many days by "black diphtheria," typhoid, smallpox, or croup. The unsparing accounts of these young deaths and the lengthy public rituals of mourning, including the distribution of photographs of small bodies laid out for burial, may have created a greater than ordinary sense of doom among those families whose young survived.

After the birth of Ida's first child, her aunt Jane Eliza Wyckoff Varney—Jennie or Auntie to the children—came to live with the young family. Widowed when her husband was killed on the overland trek to California, the childless Jane fulfilled the traditional nineteenth-century role of resident maiden aunt, helping with the household in exchange for a home. Besides caring for the young, Jennie Varney would have been a comfort to her niece in the inevitability of pregnancies, births, and infant illnesses.

Ida's children were all spared. Inexorably, however, tuberculosis had claimed the lives of all the males in Francis O'Keeffe's family. His father had died in Frank's adolescence, followed by brothers Peter and Boniface. Then, in 1897, the only surviving brother, Bernard, was stricken. A bachelor, he moved in with Frank and Ida O'Keeffe to be nursed by his sister-in-law until his death a few months later.

Because its presence lurked everywhere—in each day's newspaper and in the room next door—death seems to have been banished from speech in the O'Keeffe household. Under fear of punishment, Georgia recalled, the children were warned never to mention the dead in their widowed Auntie's presence.

Besides the land inherited from Catherine O'Keeffe, their mother, which Bernard deeded to his brother's family, the dead man left a legacy of fear most, particularly to Francis. The once happy-go-lucky Frank O'Keeffe, it was said, became a man obsessed with the dread of death. No one in the household, watching Bernard die, could have escaped.

ALONG WITH Ida O'Keeffe's fears of mortality—for herself, her husband, and her vulnerable young family—she suffered the status anxiety of women who have married beneath them. For such wives and mothers, life becomes a prideful holding action, a vigilant scrutiny of children for signs of sinking downward coupled with a fierce determination to provide them with "all the advantages." In such a family, music, art, and books become a fortress, with the piano its most visible bulwark against the cultural poverty of the father and the barbarians at the door. The mothering of such women concentrates on training emissaries of maternal superiority. Exalted by Ida, the Wyckoff-Totto heritage was one of European culture and Victorian gentility. Her mother, Isabel, had painted charming still lifes; Ida herself was musical, with a dazzling ability to sight-read. She played the piano and sang for the children; she belonged to a reading and social club of Sun Prairie women who called themselves the King's Daughters. The local schoolteacher often

boarded at the O'Keeffes'. (With seven children, a little extra income would have been as welcome as another educated presence at table.) Evenings and Sundays, Ida read to the children from the classics— Cooper's *Leatherstocking Tales* and stories of the Old West, books chosen to interest Francis Jr., the firstborn and the favorite, whose eyesight was too poor to read on his own. For the girls, there were drawing and piano lessons at home, followed by painting classes taught by a Mrs. Mann in town and requiring a seven-mile drive in horse and buggy each Saturday.

Socializing was strictly monitored. Ida's children might invite play-mates to their house; but they were not allowed to return the visits. Whether she feared contamination by germs or the influence of crude country manners or what her children might learn from other families— or reveal to them—is unclear. In any case, Ida's best defense lay in control, in establishing and reinforcing a sense of superiority and high expectations, unrewarded by praise.

"As a little girl," Georgia O'Keeffe was to recall, "I think I craved a certain kind of affection that Mama did not give. . . . She counted on us and we were to do our best as a matter of course because we were her children."[6]

"BEAUTY," Jean-Paul Sartre wrote, "is reassuring."

Perceived as a homely, uningratiating child, Georgia did not provide the reassurance that might have allayed Ida's anxieties or elicited the special indulgence of other adults. One of her earliest memories was of being shut in a back room when company called; her mother judged her too ugly to be seen by visitors.[7]

Georgia recalled vividly her first revenge on rejection. Barely more than an infant, she crawled onto the grass from a black-and-red patch-work quilt, away from her mother and a visitor, a woman with a won-derful twist of golden hair. The two ladies were lost in admiration of her handsome brother Francis, two years older—until they spied the small figure moving toward the carriage road. They rushed to rescue her, carrying the baby back to the safety of the blanket.[8] In the extreme of danger, her homeliness had been forgotten.

O'Keeffe later claimed to profit from the freedom of the unfavored child who caused no trouble. Self-reliant from an early age, Georgia was easily forgotten in the large family. Left to her solitary pleasures, she created a miniature family who lived in a corner of the yard. Her dolls, dressed in clothes Georgia sewed for them, picnicked on the lawn

or sailed boats made of shingles on a dishpan lake—all under the rule of their sovereign maker.[9]

Auntie would often take the children's side against the rigid, rule-bound Ida, but she showed no sympathy for the ugly duckling. Georgia's only ally in this household of dark, disappointed women was the German hired girl: blond, buxom Annie seems to have provided the free-flowing warmth and approval withheld by her mother and great-aunt.

"Annie was important to me," Georgia O'Keeffe recalled fifty years later. "I longed to go wherever she was working in the house."[10]

If she could not win the love and approval of her elders, she enjoyed the respect—and sometimes fear—of the younger children. She did not need to bully; she had a natural authority whose force she recognized. "I had a sense of power," she said, "I always had it."[11]

IN 1893, when Georgia was six years old, the American economy suffered the worst financial crash and depression the nation had experienced since its founding. To a degree unknown in earlier economic panics when banking, commerce, and industry were less interdependent, the hard times of the nineties created vast numbers of unemployed and widespread misery.

In Chicago, 1893 was the year of the World's Columbian Exposition, celebrating the four-hundredth anniversary of the discovery of America along with the host city's rebirth from the Great Fire of 1871. Designed by Chicago's leading architects, the fair's pristine pavilions rose in Jackson Park and the adjoining Midway to welcome millions of visitors. But in the shadow of the White City, as boosters christened the Exposition, Hoxey's army of hungry, bedraggled men prepared to march on Washington, while newspapers complained about the thousands of destitute homeless camped in the corridors of City Hall.

Farmers in the Plains States suffered as much as the immigrant proletariat in the crowded cities. In small communities, business failures followed on one another in a domino pattern of collapse: the newspaper of Jackson County, Wisconsin, not far from Sun Prairie, noted that the crash had affected the owner of the town's flour mill and logging operation as well as its starch factory and electric light plant. This capitalist's ruin also closed the local grocery store, whose customers had been his now jobless employees.[12]

The poet William Vaughn Moody called the farmlands of the Midwest during this period "debtor's country,"[13] in which a "general asphyxiation was the fate of the farmers . . . who had to borrow from the banks to outfit their farms. [They] had no means whatsoever and, bor-

rowing at usurious rates, they were always in debt, exploited by the wholesalers, the packers, the railroads and the bankers."[14]

Bankruptcy, unemployment, the isolation of families in the long, freezing winters, the fear of disease and death all fed into another tragedy of rural life: alcoholism. Much of the business of these midwestern towns was conducted in or next door to the local saloon. "No matter where you went or what you did you just couldn't get away from those barrels of whiskey and jugs of rum,"[15] noted an observer. On the one occasion that a younger O'Keeffe daughter could recall her mother's open anger directed toward her father, it was to accuse Frank O'Keeffe of drinking too much Christmas eggnog.[16]

In 1899, Francis O'Keeffe pledged to sell his large farm, for which he would receive twelve thousand five hundred dollars, the equivalent then of almost ninety thousand. The incidence of tuberculosis in his family, it was said, had already forced him out of the dairy business. By the mid-1890s, he was forced to borrow money to keep the rest of his farm afloat. The pledge a few years later may have been used as collateral on a loan: in January and then again in December 1896, court proceedings were brought against an F. O'Keefe by Peter Batz for unpaid debts in the amounts of $748.78 and $763.19, representing the two loans plus eight percent interest. There is no record that these debts were ever paid.[17]

When she spoke of her early years, O'Keeffe was evasive about the circumstances of her family's move from her childhood home. In vague terms, she explained the sale of the farm by her father's poor health and the severity of their last Wisconsin winter: "He had overworked," she said of Francis O'Keeffe's decision.[18]

Still, overwork was the lot of the farmer; it was the only life Francis O'Keeffe knew. Others noted that he seemed obsessed with escaping the consumption that had claimed his brothers. During the terrible winter following Bernard O'Keeffe's death, the thermometer fell to thirty-four degrees below zero five days after the birth of Francis and Ida's youngest child. With lack of snow cover compounded by icy winds, food and water froze; a man consumed with fear of dying might well see the rigid paralysis of death everywhere, hear it in the howling of the wind. Isolated by the weather, the family was thrown back on itself; the only adult company for Francis O'Keeffe was his disdainful wife and her stern aunt. He found no comfort there.

After fifteen years, the discontented Ida could only have welcomed an end to the drudgery of farm life, to debts and disease. She had

exhausted the cultural possibilities of Sun Prairie for herself and, more important, for her children.

IN THE FALL of 1901—two years after Frank O'Keeffe's pledge to sell the farm—the family's next move was still unclear. Meanwhile, Ida O'Keeffe enrolled her oldest daughter in the Sacred Heart Academy on the outskirts of Madison. Marrying an Irish Catholic farmer might be a step down in the world, but a convent boarding school represented an ideal of culture and refinement in a rural society that lacked both.

She was glad to leave home, Georgia O'Keeffe later told Anita Pollitzer—a curious assertion for one who claimed an idyllic childhood. She would also insist that she learned more from the Dominican sisters than from any form of later schooling. She did well in the basic courses required by the school's academic program (including the curiously named physiography). Determined that Georgia should not lose ground in drawing and painting, Ida O'Keeffe paid a twenty-dollar supplement for art classes, above the annual fee of eighty dollars for room, board, and tuition. At the hands of Sister Angelique, Georgia had early lessons on the virtues of filling a sheet of paper with pale, neat forms. Instructed to copy in charcoal the white plaster model of a baby's hand, Georgia was sharply criticized for her tiny, dark drawing. A much enlarged and lightened version reversed the judgment. At the end of the school year, she was awarded second prize in art, a gold pin given to the student who had shown the most "improvement in illustration and drawing."

The following fall, Georgia was not permitted to return to the Sacred Heart Academy with the seventy-seven other students. Ida O'Keeffe's butter-and-egg money had to provide advantages for all her daughters, and it was Ida and Anita's turn. Georgia and Francis Jr. were sent to board with their unmarried aunt Lola Totto, a schoolteacher in Madison, where they both attended the large public high school.

For their parents, it was a year of upheaval and displacement. Four children away from home would have seemed a mercy. Early in 1903, the farm was sold. Accompanied by Auntie, Alexius, Catherine and baby Claudia, Ida and Francis O'Keeffe, reversing the direction of their forebears in search of a better life, crossed back east over half a continent to settle in Williamsburg, Virginia, a small tidewater city they had never seen. They appear to have been persuaded by a land agent in Madison offering Virginia property at bargain prices. His alluring description (elaborated in a brochure) would have emphasized Williamsburg's salubrious climate, its balmy winters in particular, exalting the former

colonial capital as the "garden spot" of the Old Dominion. The O'Keeffes proved to be the only takers.

Four years had elapsed between Francis O'Keeffe's pledge to sell his farm and the family's journey East in the spring of 1903. Despite having ample time to plan for the move, they seem to have left Sun Prairie in haste, taking few possessions. The suddenness of the departure suggests a flight from creditors. As a new beginning, it was hardly auspicious.

IN JUNE 1903, at the end of the school year, Georgia O'Keeffe, fifteen and a half, her brother Francis, eighteen, and her sisters Ida and Anita boarded a train in Madison. Almost two days later, they descended from the dusty coach into the tropical humidity of coastal Virginia, the family's new home. Their mother was not the sort to write letters expressing disappointment. But to the older children, at least, the disparity between parental hopes and the reality of their surroundings was visible wherever they looked.

"Dead as Pompeii" was the way one traveler described turn-of-the-century Williamsburg. In the years following the Civil War, the once gracious capital, located on a peninsula between the James and York rivers, had sunk into economic decline. Signs of entropy were visible everywhere: in the eighteenth-century houses whose sagging ruins were "sans paint, sans shingles, sans everything." Decay could not be hidden, even by the tropical growth of wisteria and crape myrtle; it hung over the main thoroughfare, the grand Duke of Gloucester Street, now "a dismal track of dust or much deeper mud. On the grass track in the median, in which chickens and the occasional cow straggled, there was stuck a low row of telegraph poles. On each side were abominable frame shops with false fronts. Nobody cared."[19]

The only public building to survive and prosper from earlier times was the state insane asylum. Built in 1773, it was the first public hospital in America to be devoted solely to the care of the mentally ill. It was operating at maximum capacity when the O'Keeffes arrived, and its location in the center of town caused another visitor to "stumble . . . unawares, inside its large tree-planted grounds where patients wandered, staring at me strangely and sometimes sullenly."[20]

What the land agent had failed to mention was the unhealthfulness of the climate combined with the location: the low-lying marshy peninsula, humid and mosquito-infested, suffered chronic epidemics of malaria, smallpox, and typhoid.

For years there had been no direct rail link between Williamsburg

and the outside world. The train that brought the O'Keeffes to their new home—a trunk line of the Chesapeake and Ohio Railroad—had been in operation only a few years. It would have taken the sharp-eyed Georgia only a short while to wonder, along with one of the first passengers, why a railroad came to Williamsburg since "there was no earthly reason why anyone would want to go there and no one there had enough money to buy a ticket to get away."[21]

In April 1903, a few months before Georgia rejoined the family, Francis O'Keeffe had bought Wheatlands, an older farmhouse located in a newly developed area. The residents, somewhat better off than their neighbors in the center of town, grandly christened the area Peacock Hill. The house and nine and a half acres of land had cost thirty-five hundred dollars, leaving the family, in theory, nine thousand dollars from the sale of the Sun Prairie farm. As the new arrivals also appear to have left their debts behind, they would have been among the richer families in a town of five hundred mostly impoverished white and still-poorer black citizens.

Instead, visitors to Wheatlands were struck by evident disparities in the lives of their new neighbors: the sprawling white clapboard house was set amidst rolling lawns at the end of a long driveway lined with pine trees; the grounds boasted a tennis court and stables. Yet there was scarcely any furniture in the elegantly proportioned rooms. An intense subject of speculation was the contrast between the curious Yankee husband and wife; they seemed to live in different worlds.

With his new capital, Francis O'Keeffe started a grocery and feed store—the first in a series of business failures. As he waited on customers himself, his coarseness and low level of literacy did not go unnoticed. In the years preceding the move East, Frank O'Keeffe's character seems to have changed. Remembered in Sun Prairie as a gentle and joking man, he was found by his new neighbors to be odd, even "terrifying."[22] The sickness and deaths of his brothers, the nagging debts he couldn't repay, his wife's discontent—a decade of griefs and burdens had taken its toll.

Ida meanwhile cultivated the local ladies over tea, impressing them with the Totto emerald earrings. She continued to pursue her dreams of a superior education for the children. Her vision of Williamsburg, however, as a paradise regained of learning and culture yielded to rude reality.

Founded in 1693, the College of William and Mary had declared bankruptcy in 1869. Its buildings remained empty, "except for the bats and the echoes," for the next seven years. When Ida enrolled Francis Jr. in 1903 (and for three more years until the school was taken over

by the state), only five professors, including the president, held forth in the single building still standing. Stripped of accreditation, the college was nevertheless described as the "one trembling little spark of life amid the encircling gloom"[23] of the town. Primary schooling in Williamsburg must have been far more primitive than in Sun Prairie; Ida engaged tutors for the younger children; Alexius went to the Academy of the College, Anita and Ida to nearby Stuart Hall. That fall, Georgia was sent to the Chatham Episcopal Institute, two hundred miles away.

LIKE MANY CHILDREN of families characterized by instability and tension, Georgia thrived on the discipline, order, and authority of a church boarding school: here, rewards and punishments had the same comforting predictability as classes, games, and prayers. Prepared for the demerits that followed inevitably, Georgia broke every rule with exuberance: taking unauthorized walks alone or teaching classmates to play poker after 10:00 P.M. curfew, for instance. If she felt the guilt often suffered by the child who escapes an unhappy family, it did not show in the supremely confident, successful student. In her year at the Sacred Heart Academy Georgia had learned the first rule of the escape artist: never look back.

More austere than its fashionable successor, Chatham Hall, the Institute welcomed daughters of "nobler and needier" clergymen along with better-off students from patrician families of the South. And although she belonged to neither category, Georgia was to be as happy here as she had been at the Sacred Heart.

She arrived at Chatham several weeks after classes had begun—a sure sign of trouble at home. Dressed in a loose-fitting, severely cut tan suit, her hair pulled back in a single braid, Georgia O'Keeffe left an indelible impression on at least one classmate in her first appearance in a study hall filled with the flowers of southern womanhood—wasp-waisted and pompadoured, beribboned and beruffled. To Christine McRae, the allure of this oddly attired new girl revealed for the first time the attractiveness of women who were neither feminine nor conventionally pretty: "Her features were plain—not ugly, for each one was good, but large and unusual-looking," McRae recalled. "She would have made [a] strikingly handsome boy."[24]

Georgia's masculine appearance made her midwesterner's direct, assertive manner more palatable. In a time and place where femininity was equated with the demure and the deferential, and deviousness was the essential disguise of an overabundance of intelligence, Georgia imposed herself through a conscious and openly expressed will to power.

With the artless assertion of entitlement that would characterize her throughout her life, she asked Christine: "When so few people think at all, isn't it all right for me to think for them and get them to do what I want?"[25]

Chatham's enlightened headmistress, Elizabeth May Willis, was also the art teacher. Trained at Syracuse University and the Art Students League, she was swift to appreciate talent and ambition that went beyond painting flowers on china—the school's most popular offering in art. Singling out the sixteen-year-old as special, she gave Georgia both encouragement and the freedom to paint as she liked and to use the studio instead of study hall, indulging at the same time a certain caprice and even rebelliousness. Mrs. Willis's message—that talent enjoyed rights and privileges denied to less-endowed mortals—was thoroughly absorbed by her most gifted pupil. Nor was it lost on Georgia's fellow students; even singular dress and behavior might be admired as evidence of anointment by the Muse.

In June 1905, Georgia graduated with five other members of her class. She returned to Williamsburg and the big white house with its bare rooms. The question of what the seventeen-year-old should do next was debated through the humid Virginia summer, but Georgia had emotionally left home four years earlier. Her future would clearly be spent away from her family; it was only a question of where that would be.

EARLY IN THE fall of 1905, a slight girl with a big black ribbon in her hair emerged, dazed and weary, into the glass-domed vastness of Chicago's Union Station.

Francis O'Keeffe had visited the Columbian Exposition in 1893. He would have told his wide-eyed children of the dazzling buildings, like confectioners' sugar, that had prompted the fair—and by extension the brawling town of railroads and stockyards—to be renamed the White City. Whatever the disparity between the heavenly image and the sooty, smelly reality, Chicago was Oz to aspiring young people.

For Ida O'Keeffe, lurid tales of the metropolis that swallowed innocent farm girls and spewed them out as painted harlots were tempered by confidence in her daughter's sober character, her artistic ambition, and the sheltered life she would lead. Within hours of her arrival, Georgia was installed in a spare bedroom of the apartment rented by her Totto aunt and uncle, Ida's unmarried sister Ollie, a stenographer, and her brother Charles, manager of a small credit business.

A few days later, her head still ringing and eyes smarting from the

unaccustomed noise and smoke, Georgia O'Keeffe walked the several blocks from the Totto house on sober, respectable Indiana Avenue to the bronze lions guarding the Art Institute of Chicago and its school. Socially and educationally, art school for her talented daughter was, to Ida O'Keeffe, the logical choice.

At the turn of the century, training in art for young women was divided along class lines. Poor girls had to make their way in the world; they enrolled in free schools of applied arts, such as the Boston School of Design or Cooper Union's Free School for Women, where they were prepared to teach school or design wallpaper. Daughters of better-off families or those with aspiring mothers like Ida were sent to schools of fine arts, which charged tuition: the Art Institute or the Pennsylvania Academy of Fine Arts, where Thomas Eakins, the resident radical until his resignation in 1886, had insisted on equal treatment for men and women, including revolutionary classes in dissection and anatomy. The most privileged, like the Philadelphian Mary Cassatt and six hundred sixty other young women at the turn of the century, enjoyed study abroad, in private classes or the special section of the École des Beaux Arts in Paris that met only on Sundays.[26]

Nearly eighteen, Georgia O'Keeffe was much younger than her fellow students. Because of her age and the sheltered atmosphere of the small female seminaries she had attended, she felt out of place. Oppressed by the gloom of the Great Hall, where she was sent to draw a plaster cast of a male torso, she was "shocked" when, in the anatomy class, the plaster was replaced by a handsome young man, naked but for a loincloth. "It was a suffering," she recalled, her sense of shame reddening her face for all to see.[27] She felt imprisoned in the dismal basement classrooms painted olive drab, and nothing in the Art Institute's collection inspired her; she was equally bored by classical sculpture and by Dutch and Italian paintings.

Too young, too shy, or too depressed to enjoy the boisterous high jinks traditional to art students everywhere, Georgia had little contact with her classmates. She does not appear to have been interested in the diverse backgrounds of the young people who streamed into the Great Hall with her daily and who had come from Indiana, Ohio, Illinois, Nebraska, Texas, and even New Mexico—a swarm that entranced Vachel Lindsay, who had left the institute and the study of painting for New York and poetry only the year before. Living in boardinghouses, away from their families, the other students would have enjoyed a freedom not available to Georgia. Hardworking and childless, Georgia's Totto relations could not have lightened her spirits much, even though Georgia was her aunt Ollie's favorite.

In class she worked diligently, doggedly. Her large, light drawings, rewarded by second prize at the Sacred Heart, fared better in the competitive grading, she noted with sour pleasure, than did the dark, heavily outlined forms of an arrogant male student who had patronizingly suggested that Georgia change her style. She recalled only one teacher with any fondness: John Vanderpoel, a small hunchback who reached high to make the large drawings that illustrated his lectures on the human figure. Even his course helped her only to draw casts and to get through the hated life class. She bought Vanderpoel's book but soon abandoned figure drawing.

Nothing of the great city seemed to captivate her, neither that year nor when she returned two years later. Not even her first look across the lake—a view from South Michigan Avenue that only the Art Institute was allowed by the city fathers to obscure. Seventeen years later, O'Keeffe would wax ecstatic at the sight of the sea from the Maine coast; she was silent on the blue-green expanse of Lake Michigan, "majestic in its shoreless spread," as Willa Cather described it. Nor, looking back from the lake, did she ever seem to feel herself, like Cather's heroine Thea Kronborg, a singer newly arrived in Chicago, "to be carried along on a rushing river . . . constantly saluting beautiful things on the shore."[28]

Unconsciously, though, Georgia was storing images for later use. Accustomed to flatness, plains, and the low-lying coastal marshland of Virginia, she now found herself in a vertical city, looking up from the narrow streets. There, in the twenty-two years between the Great Fire and the Columbian Exposition, had been built the most remarkable array of buildings ever constructed in such a brief span of time. Galvanized by the destruction of the city, Chicago had created nothing less than a new skyline, defined by the first skyscrapers of the city's golden age of architecture. What Georgia saw, gazing upward, would reappear in her own work: the organic ornament of Louis Sullivan. Across South Michigan Avenue from the Art Institute stood Sullivan's masterpiece, the Auditorium Building, whose glorious Opera House reduced the British writer Frank Harris to "speechless wonder"[29] as he compared its shimmering arabesques to those of Santa Sophia. In those first O'Keeffe charcoals a decade later—the works that drew Stieglitz to recognize the woman he was waiting for—the same abstract forms, based on nature, that Sullivan designed to be carved in stone thrust their stalklike diagonals across the page.

Georgia left the Art Institute in 1906 with first prize in the life class of twenty-nine women, a triumph of discipline over distaste. The Chicago year had been all drabness and drudgery. Worse was to come.

Weeks after her return home in June, Georgia was delirious with the typhoid fever that annually marked the arrival of spring in Williamsburg. After the long days of fever, her straight black hair fell out; dark little curls grew in its place. Although it would be unnoticeable on black and white film, her skin, always sallow, would bear the pitted traces of her sickness. The endless enervating summer of tropical heat slowed her recovery. Following each subsequent illness in her life, she would need a long convalescence to regain her strength.

By September, she was still too weak to return to school. She would not miss Chicago, but she had picked a bleak year to remain at home.

While Georgia and her Chatham classmates had tried on their high-necked graduation gowns the previous year, Francis O'Keeffe's grocery and feed store had limped through its last weeks before failure nailed the door shut. Depressed by the deaths of his brothers, haunted by fears of his own mortality (fears intensified perhaps by having fallen away from his church), the middle-aged ex-farmer cannot have brought to his new business ventures the optimism that might have offset a lack of skill and the local suspicion of Yankees. Each of his new schemes seems to have been chosen with distracted randomness, suggesting a mind clouded by melancholy or perhaps alcohol, taken to deaden despair. He may have been exceptionally gullible or anxious to ingratiate himself with neighbors. In rapid succession, he tried and failed at selling real estate with a partner, starting a creamery, renting a pier on the James River (purpose unclear), and manufacturing hollow building blocks made of molded shell deposits.

Each of these forays into entrepreneurship further eroded the dwindling capital that remained from the sale of the farm. To earn some money, or perhaps to help pay off new debts, Ida O'Keeffe began taking "table boarders" into the grand white antebellum mansion. College friends of Francis Jr. who had earlier come to call on the girls were now invited to become paying guests. Francis himself was off that fall to New York, apprenticed to an architect. His departure left another spare room to rent for a welcome few dollars. At table, plentiful meals appeared on the dining room dumbwaiter, cooked by Ida, Auntie, and the girls in the basement kitchen. As family circumstances worsened, Georgia became skilled at putting a good face on misfortune. The boarders did not mean extra work; they provided replacements for her departed brother. Ida's humiliation can be readily imagined.

BY THE FOLLOWING September, boarders' dollars and Ida's scrimping managed another year of art school for Georgia. She decided not to

return to Chicago but, perhaps on the advice of Mrs. Willis, her Chatham mentor, to try New York and the Art Students League.

For Georgia, 1907 would be a year of liberation. She had narrowly escaped death the year before. And with every mile of the twelve-hour train trip between Williamsburg and New York, the slow dying of her family, the withdrawal of Ida and Francis O'Keeffe into depression, illness, and poverty, was left farther behind.

At twenty, Georgia O'Keeffe was no longer the withdrawn young girl who had set out for Chicago two years before, to be overwhelmed by the brutal dynamism of the city, the vast halls and human swarm of the Art Institute, and the shame of drawing a naked man. With her tentative curls grown out to a glossy waved bob and her loose, uncorseted clothes, she already looked the part of the emancipated "new woman," ready for life on her own.

From the first, the Art Students League, unlike the Art Institute, felt like home. Located on 57th Street, between 7th and 8th avenues, the league building, in the Beaux Arts style, had none of the oppressive monumentality of its midwestern counterpart. Georgia's spirits soared when she saw the top-floor studios, whose natural brightness was provided by immense skylights. The smaller number of students made for easy camaraderie, begun in the lounge and continuing in the boarding-houses on 57th Street where Georgia and most of the other young people had rooms.

Georgia's name had changed, too. Dismissing Georgie, her former nickname, her fellow students at the Art Students League decided to call her Patsy, then Pat, in tribute to a gaiety and wit held to be typically Irish—and perhaps to a suggestion of androgyny, made stylish by the Gibson Girl's athletic charm. At the league's leap year dance, a costume ball that specified cross-dressing, Pat O'Keeffe is shown in a dinner jacket, bow tie rakishly askew; she makes a convincingly dissolute "lounge lizard" as she gazes at the camera from under heavily lidded eyes. She was escorted to the dance by George Dannenberg, a handsome scholarship student from San Francisco. As it was leap year, Georgia may have invited him. But George needed no prodding. He was smitten. Unlike most of the other male students, he took Georgia's work as seriously as he did his own. Hardworking and ambitious, Dannenberg was no aesthete. He had the qualities of masculine competence that Georgia admired—and missed in her own father. He was an outdoorsman, physically large, brimming with health, energy, and high spirits. In her later letters to Anita Pollitzer, Georgia would describe him, romantically, as "the man from the Far West."[30] He was the first man who overcame her defenses; she let George become close to her. For

the first time, she allowed herself to expect something from a man.

Georgia's attraction to Dannenberg seems to have made her more physically aware of other men, including her teachers. From her year of painting at the league, she would recall largely the looks and style of her instructors.

A "handsome slim young man," F. Luis Mora drew hands and heads—always those of Mrs. Mora—on the margins of his students' work. From Kenyon Cox, famous as a teacher of life drawing and anatomy and infamous as archenemy of all things modern, O'Keeffe learned "nothing," she said flatly. But she remembered Cox's "relaxed kind of grace" and "fine gesture" of lifting his hand.[31]

The only one of Georgia's teachers at the league to whom she would feel indebted was William Merritt Chase. A shoemaker's son from Williamsburg, Indiana, Chase had made his career a glittering success story, showing that the artist, too, could be an entrepreneur.

As both teacher and painter, Chase was early recognized and rewarded for his talent and industry. During his student years abroad in the 1870s, he learned to imitate the flashy tonal style of the Dutch and Spanish seventeenth-century masters and their disciples, the German academics of the Munich school. When he returned to the United States, the "American Velázquez," as Chase was soon known, became the favorite portraitist of well-to-do families. His pleasing celebrations of bourgeois life made him a rich man.

Chase's vast 10th Street studio, decorated with suits of armor, Old Master paintings, Chinese porcelain, and tiger skin rugs, was a famous New York gathering place. Even millionaires were awestruck when they found themselves admitted by a black servant dressed as a Nubian slave.

At the league, the Pennsylvania Academy, and later his own art schools, Chase both dazzled and inspired students. After Georgia and her classmates had labored for a week to complete the famous Chase assignment—an oil painting every day—the master appeared, in silk top hat, pale suede spats, and gloves, sporting a monocle and a dewy boutonniere. He encouraged, praised, or criticized efforts to achieve something of the Chase *sprezzatura*, that seemingly effortless virtuosity with color and pigment. He was "fresh and energetic and fierce and exacting . . . and fun!" Georgia recalled.[32] By way of inspiration, he might favor the class with a famous Chase tour de force: with one stroke of a loaded brush, he produced a sparkling gold watch and chain! O'Keeffe paid somewhat grudging tribute to the famous Chase training in speed and productivity: "Making a painting every day for a year must do something for you," she noted.[33]

Beyond her own ability to finish a painting in one day, beyond the

love of color and paint that Chase gave his pupils, the most important lesson Georgia learned from her famous teacher was a subversive one: an example of the artist as self-made professional, proud to be rich and famous.

MONEY WAS running out at home, Georgia knew. She counted every penny, as she would do throughout her life. Instead of registering for the eight-month courses offered by Mora and Chase, costing fifty and sixty dollars each, she signed up for five months to save thirty dollars. Her bedroom in a nearby rooming house cost only a few dollars a week.

At the league, modeling paid a dollar for four hours; although Georgia had many offers throughout the fall, she refused, insisting on the greater value of her time. "I wanted to work myself," she said.[34] But in January she succumbed, perhaps feeling especially poor after Christmas. Staying in the city to save train fare, she could not escape the opulence of New York's glittering holiday displays. Jewelers and other purveyors to the rich nestled among the art galleries on lower Fifth Avenue.

In deciding to model, she may also have yielded to the pleas of an older student and "very handsome young man."[35] Eugene Speicher won his first case by bullying; he would refuse to let her pass on the stairway until she agreed to pose for him. When she kept refusing, he sneered: "It doesn't matter what you do. I'm going to be a great painter and you'll probably end up teaching in some girls' school."[36]

She relented and he let her keep his portrait of her (now owned by the league), entitled *Patsy*. In it, she appears thin, pale, and anonymous-looking; she could be any serious pretty young woman. She must have liked the image, since she agreed to sit for another painting to be kept by the artist. Alfred Stieglitz was on the jury that awarded Speicher the league's Kelly Prize for *Patsy*. He pronounced the portrait a "swell head."[37]

Georgia's second sitting, on an afternoon in January 1908, was never completed. When Speicher was halfway through, a group of students came by and persuaded the painter, his model, and a few others busy at their easels to come along to Stieglitz's gallery at 291 Fifth Avenue. Their teachers, to a man, had insisted that no one miss the Rodin drawings Stieglitz was showing. The great sculptor (believed to have set down the lines and blobs with his eyes closed) had managed to persuade the gullible—or wily—Stieglitz that the resulting scribbles were art! Any league student, the art teachers believed, would depart the exhibit inoculated against the disease of modernism.

"It was a day with snow on everything," Georgia remembered. Just

before she climbed the stoop to the brownstone housing the gallery, she recalled, she brushed a trim of newly fallen snow from a little tree near the iron railing.[38]

"The boys," as Georgia called them, had come to bait Stieglitz; the idea was to "get him going," they said, to have some fun with this excitable little man as he worked himself into one of his famous frenzied harangues about modern art. They didn't care about the Rodin drawings; they knew nothing of Matisse, whose sculpture would be shown for the first time in America at 291 a few months later, nor of Matisse's friend, a Spanish artist living in Paris who had just painted a frieze of whores with faces resembling African masks or popular caricatures and who had impudently entitled this travesty *Les Demoiselles d'Avignons*.

As she would be many times in her life, Georgia O'Keeffe was the only woman among men. She would never have been asked along, she knew, if she hadn't happened to be posing for Speicher.

Stieglitz emerged from the back room, carrying in his hand a dripping photographic plate, his dark eyes glaring from behind the steel-rimmed pince-nez. He did not disappoint his visitors. "Within minutes," O'Keeffe recalled, "the talk was heated and violent."[39]

Ideas and theories bored her. She wanted to flee whenever noisy debates began—at 291 or at the restaurants where Alfred took the "men"—about the relationship between painting and photography, poetry and art, art and society, Cézanne and cubism.

At 291, it was usually Stieglitz, not visitors to the gallery, who did the baiting. Typically, he would appear to invite discussion, beginning with the mildest question: Which picture did the visitor like best? What did the work mean to him or her? The unwary gallery-goer had no idea that the questioning was a setup. As soon as the "wrong" answer was given (the visitor preferred identifiable subject matter or didn't understand the work in question) Stieglitz was off, railing against amateur photographers and professional museum curators; against collectors and dealers, critics and journalists, art teachers and students; against stupidity, ignorance, blindness, philistinism—or the reverse: education, sophistication, and culture, all enemies of a spontaneous spiritual engagement with art.

Conducted by Alfred solo or in discussions with others, the talk that Georgia fled was the discourse of New York intellectuals. The subject was abstract, the tone polemical; Georgia could never understand how people could get so excited over ideas. The emotional intensity of the debate was as foreign to most Americans as it was to O'Keeffe. Brought to this country by Eastern European immigrants, most of them Jews, it had filtered uptown from the cafés of the Lower East Side, where

anarchists argued down socialists and communists. Alfred might see himself as completely assimilated, but his talk gave him away: to regionalist painter Thomas Hart Benton, Stieglitz would always be "that Hoboken Jew."

On that snowy day at 291, Georgia O'Keeffe did not even care to hear arguments about Rodin—let alone participate. And Stieglitz took no notice of those who were not there to listen and to learn. Unobserved, she left the main gallery, walking to the farthest end of the smallest room.

"There was nothing to sit on," she remembered, "nothing to do but stand and wait. Finally, after much loud talk, the others came for me and we went down to the street."[40]

I N T H E league studios, no one was doing work that she admired; her own painting interested her still less. Looking at the dull offerings in a composition class she visited, she began thinking the unthinkable: instead of trying to paint what had been painted better by Chase, "I would try to make a picture I would really like."[41]

One clear, starry night, she walked with several other students up Riverside Drive. What she saw became a painting, a vision that took on the forms and colors of a Van Gogh: two dark poplars dominate the canvas, the sky appearing in the space between them. The grass was bright in the moonlight, the river shone. Painting this memory the next morning, Georgia found herself pleased with the results; the trees and water, at least, came close to what she wanted to do. When she showed the work to a fellow student, he explained that the trees she liked should have been painted in the impressionist style; he proceeded to demonstrate, painting over their darkness with bright spots of color. Still, even spoiled, the small canvas became a sort of talisman: a first conscious effort to break away from what others expected.

The prize Georgia won that June in Chase's still life class was not awarded for originality; her winning composition was a painting of a dead rabbit with fox-colored fur lying next to a bright copper pot. For this dutiful Dutch still life, Georgia received a scholarship to the league's summer school at Lake George.

In July, nothing about the lake or its surrounding daylight scenery inspired her to paint. But one night, she and a young man, possibly Dannenberg, sailed across the dark water. It was an unhappy evening. He was angry that she had invited another boy to join them. He became still angrier when they returned from errands in town to find that their red sailboat had disappeared; they would have to walk home around the

end of the lake. Then she looked "out across the marshes, at the cattails, patches of water and birch trees shining white at the edge. In the darkness," Georgia O'Keeffe would remember, "it all looked just like I felt—wet and swampy and gloomy, very gloomy."[42] The next morning, she painted the best painting she had done all summer.

Other very gloomy pictures of Lake George were yet to come.

T W O

The Spell of the Camera

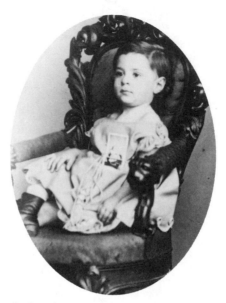

A career foreshadowed. As a toddler, Alfred refused to part with the
photograph of a favorite cousin. The image was tied around his waist
with a string.

GEORGIA O'KEEFFE's first impression of the famous photographer
and impresario of modern art was the clue to his most profound conflict.
Alfred Stieglitz's anger on being interrupted at a crucial moment in
developing a print was exceeded only by his constant need for an au-
dience. As O'Keeffe would have many occasions on which to reflect,
the inwardness of the artist had to accommodate the performing self of
the narcissist who does not exist without others. Alfred Stieglitz could
not bear to be alone.

The first son of adoring parents, he was born on January 1, 1864,
the year that would begin the end of the national agony of the Civil
War. Alfred's welcome appearance fulfilled other happy auguries. The
fortunes of his father, Edward Stieglitz, increased as his family
multiplied.

Both Edward (born Ephraim) and Hedwig Werner, his wife-to-be,

were part of the first wave of German immigration to America in the late 1840s. For Jews especially, the failure of the Hungarian revolution of 1848 to wrest constitutional rights from the Hapsburg rulers and the subsequent suppression of liberal elements in all the German states were warning signals. Thus, in 1849, at the age of sixteen, Edward Stieglitz left the rural hamlet of Gehaus, near Bach's birthplace of Eisenach, in Saxony, to join his two older brothers on New York's Lower East Side. A year later, the three Stieglitz brothers were securely enough established in the manufacture of surveying instruments to send for their parents and remaining brothers and sisters.[1]

Exchanging tools for textiles, the Stieglitz enterprise enjoyed still greater success in the manufacture of woolen shirts. In 1857, Edward left the family fold to strike out with a partner: "HAHLO & STIEGLITZ, Dry Goods, Merchandise, Commodities" sold to the carriage trade as well as supplying department stores in New York and Chicago. Business continued to expand, along with capital: by 1861, one thousand dollars inherited from his father had become worth almost twenty thousand in bonds, including two hundred fifty that the prosperous young businessman proudly invested in a municipal issue to finance the new Central Park. With his future secure, Edward Stieglitz could afford a patriotic—if token—leave of absence from the pursuit of profit: in April 1861, he volunteered in a German-speaking unit, Company F, of New York's 6th Regiment. After a noncombative four months at Fort Morgan, Maryland, he followed in the tradition of the rich, hiring a substitute to serve in his place.

In Edward's absence, Hahlo & Stieglitz did more than flourish. King Cotton—rotting in fields or blockaded in southern ports—was replaced by wool. Banks were delighted to lend the enterprising young merchants money for expansion.

Thus solidly established as citizen and capitalist, Edward Stieglitz lost no time in finding a suitable young wife. Born in Offenbach, Hedwig Werner had arrived in New York at the age of eight, with two sisters, a brother, and two stepsisters. She was eighteen when, in July 1862, she married the successful and dashing ex-Lieutenant Stieglitz, now a mature twenty-nine. Hedwig's family would have provided the intellectual leaven to the more provincial Stieglitz origins, buried so obscurely in a tiny farming hamlet that Edward's father's occupation was never recorded. The Werners boasted a tradition of talmudic scholarship that continued with Hedwig's cousin Alfred, professor of mathematics at the City College of New York and later adviser to his second cousin and namesake.

A few months after Alfred was born—"the happiest day of my life," Hedwig would recall[2]—the young family moved from their first rented home in Hoboken, New Jersey, to a grander brick house accommodating a live-in maid and Hedwig's sister Rosa.

Commuting on the ferry that plied between the slip at the bottom of their hill and the landing in Manhattan, Edward Stieglitz would have observed the early morning vision that his son later immortalized as *Gateway to New York*. The image reflected not the immigrant father's dream of conquest but the native-born son's ambivalence; the purity of nature, the path of sunlight on water, had become a churning thoroughfare, ferrying its lost souls to build bigger monuments to money and power.

For later immigrants, the distant towers of Manhattan, seen from Hoboken or Brooklyn or from the crowded streets of the Lower East Side, would wait for their children to claim. Like many of the first generation of German Jews, Edward Stieglitz made the momentous move himself in two decades. By 1871, at the age of thirty-eight, he installed his family, now joined by Flora, eighteen months Alfred's junior, the twins Leopold (Lee) and Julius, and two more girls, Agnes and Selma, into a grand brownstone mansion at 14 East 60th Street, just steps from Fifth Avenue. Within a very few years, this northern outpost of residential Manhattan would become what it remains to this day: the most expensive and fashionable address in New York.

IN LATER YEARS, conflating a sense of emotional and material privation, Alfred Stieglitz liked to allude vaguely to early poverty. Revising his family circumstances also allowed him to assert indignantly and often: "I am *not* a rich man, despite what people think." His own disclaimers, not the suspicions of his contemporaries, have been accepted by subsequent writers, who invariably describe his family of birth as "comfortable" or "well-to-do."

In reality and by any measure, Edward Stieglitz was a very rich man. If he was not in the league of an earlier Hoboken neighbor, John Jacob Astor, or landsmen like the Schiffs, Loebs, and Seligmanns, he would still qualify as enjoying great wealth at a time when the average American earned five hundred dollars a year and an annual income of three thousand dollars defined a family as well-off.

From the amply stocked wine cellar, where eight-year-old Alfred proudly learned to serve as sommelier for his father's convivial all-male gatherings, to the top-floor billiard room, where the small boy practiced

until he could beat his progenitor and friends, the house on 60th Street would have seemed luxurious compared with most residences in New York; the only houses to put the new Stieglitz home, quite literally, in the shade were Edward's nearest neighbors, the palazzi and châteaux in the style known as Robber Baron Renaissance, whose rusticated and turreted ranks had begun to line Fifth Avenue as far north as the Metropolitan Museum of Art at 82nd Street. Certainly, few brownstones of the era boasted some of the luxuries specified by Edward Stieglitz for his new house: steam heat and ice water in every room. Although the plan accommodated only one live-in maid, this was no measure of austerity: the autocratic and irascible paterfamilias was given to violent outbursts of temper at the sound of footsteps overhead or even of starched petticoats. (The one resident domestic wore slippers and unstarched undergarments.) Thus, the numerous servants required for the family's needs were employed as dailies: nurses and nannies, cook and coachman, along with Hedwig's personal maid, who doubled as waitress—all had to rise in the middle of the night to arrive in time to perform their first morning chores.

About noise, Edward Stieglitz was predictable in his rages. In other matters, he followed the first rule of tyrants everywhere: create confusion and uncertainty. What is acceptable today must be forbidden tomorrow. Money is the ideal weapon of household despots: now you see it, now you don't. In the first instance, there was the undeniable evidence of an opulent way of life. With the Victorian horror of vacuum, every square foot was filled with furniture, statuary, and lamps, every inch of floor and wall covered with carpets, hangings, and pictures, every shelf crammed with bric-a-brac and even books.

Then there were the numbers of servants in attendance, along with guests—both at table and in residence—including the beneficiaries of Edward's favorite charity: academic German artists who reciprocated his patronage by encouraging him in his own painterly pursuits. These soon required the addition of a studio to the house and an art teacher to the visiting staff.

There were trips to Europe, always first class, and gifts of furs and jewels for Hedwig, with a similarly expensive present for her sister Rosa. There were frequent evenings at the theater and opera, where only the best seats would do.

Yet underlying this lavish way of life was an obsessive parsimony. Terrifying explosions of wrath were occasioned by the homeliest expenditures in Hedwig's household accounts: the cost of washcloths—significantly, recalled by Alfred—was the cause of violent accusations

of extravagance, answered by Hedwig's sobs and pleas for forgiveness.*

Imprinted from birth with the attitudes of those born to wealth, Alfred Stieglitz would carry to his grave the expectations, assumptions, and prejudices conferred by privilege: notably the sense of entitlement and its corollary of noblesse oblige.

Alfred would always find despicable those who turned their talent into gold—as his onetime disciple Edward Steichen did. (He made only one exception to his revulsion toward success: Georgia O'Keeffe. No other artist dared aspire to more than the cost of materials and the barest essentials of life.)

Still, there was more to his asceticism, his often self-righteous espousal of "the simple life" than a style beloved of Americans born with too much. His family's purchase on ease and luxury was inseparable from his mother's humiliation and his own helplessness. Hedwig's tormentor, adroit in co-opting Alfred's loyalty, was a rich, self-made man. For Alfred, a vow of poverty promised escape from the conflicts and confusions of money, symbolized by an extravagance of washcloths that could drive a family to ruin.

Perplexity about the meaning of money was exacerbated by the isolation of the Stieglitz family from their peers among the German-Jewish bourgeoisie. In leaving the partnership of his brothers in 1857, Edward Stieglitz seems to have severed all ties with Judaism, however nominal they may have been. Whether through Hedwig's fear of her husband or her simple lack of interest, the talmudic tradition of the Werner family languished. Nor did it elide into that network of social, business, and philanthropic ties, cemented by marriage, on which institutions such as the reform congregation of Temple Emanu-El and the Harmonie Club† were founded.

Significantly, Edward's only formal affiliation was as far removed as possible from his own tribe or from those institutions composed of similar families: he claimed to be the only Jewish member of the all-male Jockey Club, an achievement still cited with a certain pride by his descendants.

Edward's children thus had no larger community to mediate between the family and the mysterious American society in which they found themselves; the substitute seems to have been an extended family, overwhelmingly German and consisting of artists, musicians, journalists,

* One need not be a rigid Freudian to connect Alfred's obsession with money as "unclean" to his recall of washcloths as the household expense with which his father tormented his mother while he, as a small boy, listened helplessly to their quarrels from his bed.

† Established in 1852 as the Harmoniegesellschaft, the club is now housed in a building, erected in 1905, on 60th Street a few doors west of the site of the former Stieglitz home.

and other bohemians whom Edward could exalt as intellectuals and patronize with his hospitality. In any case, with one exception—artist-in-residence Fedor Encke—they made little impression on the oldest son, as none is ever mentioned by name.[3]

The family's lack of connectedness or community, as it removed all grounds of comparison between "them" and "us," between "our family" and "our crowd," increased their difficulty of sorting out reality as understood by the rest of the world. Beyond questions of rich or poor, social isolation creates a moral vacuum. "The family was a law unto itself," recalls a great-grandniece of Edward's. "There was right and there was wrong and there was Stieglitz."[4]

A self-referring moral system reinforces the power of paternal authority. Conventional Victorian injunctions to children, both moral and social, embedded in such pieties as "Never tell a lie" or "Do not speak unless spoken to," became for the child Alfred absolute demands. The impossibility of living up to Edward's standards of perfection produced obsessional, self-punishing, or histrionic behavior aimed at alleviating guilt and placating the household god.

For his mutism when adults were present, Alfred was dubbed the Silent One. An adolescent act of plagiarism—at thirteen he had passed off as his own work an essay he had read and then paraphrased—poisoned months with silent guilt. When, finally, he confessed, begging his father's forgiveness, he swore it was the "<u>first</u> & <u>last</u>" lie of his life. No punishment would be too harsh if he broke his promise, Alfred assured Edward. Only this time, don't tell mother, he pleaded.[5] The infamous verbal outpourings of the adult Alfred Stieglitz, monologues that could last for five and six hours without a break, may also be explained in light of the guilt and fear associated with his childhood silence.

His father's demand for effort resulting in achievement was made more unnerving by the effortless success of Alfred's younger brothers, the twins Leopold and Julius. Three years his junior, they would be first in their studies everywhere and were squarely launched in their respective careers of medicine and chemistry while Alfred was still floundering. Caught between living up to paternal expectations of excellence and fighting off the fraternal competition, Alfred would always require a public arena, the better to "show them all."

To make matters harder, Alfred was small and slight in a culture where height and brawn were the measure of masculinity. Ritual displays of physical prowess and endurance were essential to offset another family role that he filled for life: the sickly child. Before adolescence, Alfred was the self-appointed star of a one-man twenty-five-mile marathon. While Alfred circled the basement for three and a half hours,

siblings and friends, armed with sponges, pails, and towels, mopped the brow of the lonely runner, streaming plentifully from the exertion as well as from the heat of the enormous furnace. Other bystanders counted laps or, holding stopwatches, timed his performance.[6]

Charity, too, became an arena of competition for Alfred. Did Edward Stieglitz require his children to help the less fortunate? While his father and the rest of the family tucked into their Saturday evening meal, Alfred, beginning at age thirteen, left the table for the street at the first strains of the organ-grinder's overture. In a weekly ritual that lasted five years, so he later claimed, Alfred brought coffee and a sandwich prepared by the cook, along with a dime from his allowance, to the hurdy-gurdy musician and his monkey.[7] (With a lifelong horror of pets, he fled the traditional pawshake of thanks.) Giving became and would remain for Alfred linked to performance—a theater of self, orchestrated by and starring Alfred Stieglitz, but produced and backed by others.

EVERY FAMILY has its fictions: disparities between what is said (especially in front of the children) and what is done. Indeed, a primary task of the transition from childhood to maturity requires that we understand—in order to forgive—parental fallibility, including the betrayals, compromises, and hypocrisies of adult life.

Inferring his father's infallibility from Edward's demanding perfectionism, Alfred found the truth hard to forgive. At the most sexually troubled period of puberty, the son became aware that sermons on absolute honesty and probity did not apply to the preacher. When he was not awakened by Edward's bullying tirades directed at Hedwig over the budget, Alfred could hear, with greater clarity still, the creaking of the back stairs that announced his father's late-night visits to the chambermaid. Later, Alfred aired suspicions that Aunt Rosa, too, had been Edward's mistress.[8] Whatever the truth of that particular rumor, Edward's infidelities were not, apparently, confined to his own house. In a poignant letter to Alfred, written forty years later, Lee Stieglitz advised his older brother to regularize his union with Georgia O'Keeffe. His own medical career had been blighted, he confessed, when the board of Mount Sinai Hospital rejected his application for a residency; the reason (as given to another colleague) was their father's notorious womanizing. Whether the trustees feared nature or nurture, they would not have been wrong in their apprehension about father and sons. For many years, Lee had an "official" mistress along with at least one known "unofficial" lover, while Alfred would freely indulge and just as indignantly deny his own infidelities.

Teased with the nickname Hamlet, Alfred at seventeen was a moody adolescent with a somber, unsmiling gaze and a dark mop of unruly hair. In emulation of Edward, he developed an early love of racing and horses, extending slightly later to a passion for women, whom he adored for the moment at a distance.

He became obsessed, first, with a friend of his mother's—a woman who always dressed, as Georgia O'Keeffe would later, in black. His yearning for the dark lady was succeeded by a mute and unrequited love, reminiscent of the passion of Proust's Swann, for a young girl seen in Central Park; like Albertine, the girl was accompanied by a governess, surrounded by friends, and completely oblivious to Alfred's worshipful presence on a bench nearby.

When he wasn't yearning for unattainable women, Alfred was obliged, with little enthusiasm, to attend school. He was first enrolled with his brothers in the Charlier Institute, a French-language private school, probably favored—like lycées outside of France today—by parents who preferred to emphasize their ties to Europe rather than to the Diaspora. Then, in one of Edward's fits of economy rationalized by democracy, Alfred was transferred to a public elementary school, followed by Townsend Harris High School, the feeder school for the City College of New York, where Alfred duly matriculated beginning in 1879. Finding neither challenge nor focus nor friendship in two years of college, he was ready for change.

Rescue came in the form of another of his father's quixotic decisions. In 1881, encouraged in the belief that he should devote the rest of his life to painting, Edward Stieglitz, then forty-eight, sold his share of his dry goods business for four hundred thousand dollars, having decided to spend the next five years abroad. While he would paint and travel, Hedwig and Rosa would be rejuvenated by luxurious hotels followed by curative spas; the children would be exposed, in their formative years, to the advantages of European culture.

Only weeks after the paternal decision was made, Alfred found himself boarding a steamer in Hoboken, accompanied by his parents, Aunt Rosa, his mother's personal maid, his two brothers, and his three sisters, along with mountains of baggage for each and all. A few days out, he had made two friends, the first to figure in his life by name.

Sons of prosperous German-Jewish families like the Stieglitzes, Joseph Obermeyer and Louis Schubart were being sent abroad on their own to pursue doctorates in chemistry in Berlin. Adopted by Hedwig (a motherly impulse she would always refer to with regret), the two young men formed an inseparable trio with Alfred. The fortuitous shipboard encounter would cast a long shadow on the lives of all three.

Leaving his new friends when the steamer docked in Bremen, Alfred spent the summer traveling with his family. In the fall, the three Stieglitz boys were enrolled in the Realgymnasium (classical high school) in Karlsruhe, boarding with cultured local families to ensure that their German would be up to university level. The girls were delivered to Weimar, where sixteen-year-old Flora was to study voice and music, while the younger ones finished their education in a pension for young ladies.

In the absence of vocational ideas of his own, Alfred's career had been decided for him. With a subway system, the Brooklyn Bridge, and new buildings under construction everywhere in New York City, engineering was clearly the profession of the future in America. An Old World degree from the Berlin Polytechnikum, where Alfred was enrolled in October 1882, could only enhance New World opportunities.

Edward Stieglitz was prepared to handsomely underwrite Alfred's years of foreign study. (His younger brother Lee asked Alfred, enviously, about his annual allowance of three thousand dollars—the equivalent of almost thirty thousand dollars today. In reply, Alfred "reduced" the sum, variously to twelve or thirteen hundred dollars.)[9] Besides his generous allowance, Alfred would enjoy almost complete independence while studying at the Polytechnikum. Except for the lenient weather eye of his landlord, Erdmann Encke, a society portrait photographer and brother of Fedor Encke, his parents' resident artist in New York, Alfred was on his own in Berlin.

Berlin in 1882 was a rich and sheltered young man's fantasy of liberation come true. The Prussian capital provided all the indulgences German culture traditionally offered students, with every pleasure at a bargain price: 37½-cent tickets to the Royal Opera House, with similar rebates for theater and bookstores. In Bismarck's Germany, sensual and sporting pleasures also were deemed essential for young men pursuing higher degrees: student discounts were offered at the "Roman baths" and even the racetrack.[10] All these diversions worked up a mighty hunger and thirst, satisfied by inexpensive restaurants and cafés that beckoned at every street corner. The middle-aged and thrifty Stieglitz would wistfully recall the days of cheap student gathering places: the smoky air redolent of beer, wurst, and talk late into the night.

In the heady flush of freedom, Alfred Stieglitz made two important discoveries: sex and the camera.

One dismal January afternoon, he was returning home from a lecture in mechanical engineering when he saw it. From a shop window in the Klosterstrasse, the large black box with a lens held his own gaze like a

human eye. He left the store with the camera, a ruby-shaded candle light, developing trays, chemicals, glass photographic plates, and a thick instruction manual—all for about seven and a half dollars.

He tore back to his room and, in a fever of excitement, set up an instant darkroom: in the triangular space created by hanging a sheet between the door and the nearest wall, he placed a chair and, underneath, the pans of chemical solution. It would be his smallest, but not his most primitive, laboratory.[11]

IN STIEGLITZ family mythology, Alfred's vocation—like that of the saints and martyrs—was foreshadowed in earliest childhood. Barely more than an infant, he is said to have refused to be parted from a photograph of a handsome boy cousin. In a later episode, which Alfred himself never tired of repeating, his first visit to the studio of the Lake George "village photographer" elicited from the boy a precocious lecture on the merits of "straight" photography, as opposed to retouched plates. Accompanying Edward on a summer holiday through New England and upper New York State, Alfred was installed with his father in the Prince William Henry Hotel. To display his collection of lead horses, the nine-year-old boy invented a game in which his tiny thoroughbred models "raced" by means of rolls of the dice, while spectators placed bets on the outcome. This diversion proved so popular with guests, young and old, it was decided that the local tintype maker must immortalize the players. While the horses were being arranged in the studio, Alfred infiltrated the darkroom, where he noticed the photographer applying rouge to the complexions of the portraits he was developing "to make 'em more lifelike." Horrified, the youthful purist objected; his sincerity and eloquence won the day. The rustic portraitist was converted to the cause of the unretouched image.[12]

His first photograph, Alfred Stieglitz later claimed, was a self-portrait. One of the earliest of his works to survive in any case, the likeness is not a self-portrait in the traditional sense of either art or photography: the painter depicting himself with the aid of a mirror or the photographer, after setting up his camera, rushing in front of the lens to click the shutter by means of a string (or, today, by automatic setting).

Stieglitz's auto-portrait is not one image, but an assemblage. The neophyte photographer pinned to a drawing board a number of prints of himself taken by Encke, his Berlin landlord. His self-portrait is a multiplicity of selves; the individual images of Alfred Stieglitz are re-

flections of how another sees him. (Forty years later, Stieglitz would say of the hundreds of photographs he made of Georgia O'Keeffe that she discovered her many selves through his serial portrait of her.)

Choosing among a larger collection of images taken by Encke, Alfred selected a series of selves in disguise, in which he is dressed variously as a turbaned sheik, a hooded monk, and a Romantic poet, bareheaded and open-collared.

With this composite of identities, the indifferent student of engineering found his vocation. He began a frenzy of picture taking, starting with the wall across the courtyard, photographed, he later recalled, "a thousand times,"[13] until he felt a mastery of the shutter and its sensitive registration of light. The challenge, he discovered, was in keeping the shutter open as long as possible without overexposure.

"PHOTOGRAPHY is my passion. Truth is my obsession," Stieglitz proclaimed. .

Photography, if not truth, in Alfred Stieglitz's life seems an inevitability. In its complex fusion of the technical and aesthetic, of process and practice, "seeing" and intuition, art and craft, the making of pictures with his new machine embraced both psychological need and expressive impulse.

Conferring the illusion of control (a piece of the world reduced, arranged, and contained in a little black box), photography leaves the power drive and fragile ego structure of the narcissist intact: the photographer is the metaphysical magician who, disappearing under his black hood (and, for Stieglitz, under his black loden cape as well), emerges to mystify and demystify at will.

Of equal importance, the process of the work legitimizes the demands of the obsessive-compulsive personality. In the trial and error method necessitated by primitive equipment, the photographer could reasonably shoot the same wall over and over; he could wash, rewash, and wash again the heavy glass plates, cleansing them of imperfections no one else could ever see. He could then "spot" the print, chemically removing, speck by speck, any trace of impurity that had remained hidden on the plate. What emerged, after the plate was dry, the print perfect—as Alfred occasionally announced one of his efforts to be— would seem nothing less than Truth, revealed and recorded for all time.

Along with his discovery of the camera, Alfred found a father figure in Berlin; at least, such is the role in which he later cast Hermann Wilhelm Vogel, professor of chemistry at the Polytechnikum.

By the 1870s, a decade before Alfred's arrival, Vogel had earned an

international reputation for his discoveries in photochemistry; in particular, his research had extended the range of light sensitivity of photographic plates. In Alfred's version, their mentor-disciple relationship began soon after his enrollment at the Polytechnikum when he abandoned engineering studies to audit Vogel's course in chemistry. Vogel, himself a talented amateur photographer, instantly recognized the young American's passion and genius, even showing Alfred's photographs to artist friends. Alfred was permitted to skip his professor's lectures and instead was encouraged to focus his entire efforts on darkroom experiments. When a new laboratory building was opened the following fall, Alfred arranged for the splendidly modern facilities to remain open around the clock. There, through the night, he could pursue his obsession with cleanness, bathing his photographic plates in chemicals over and over again. In Alfred's retelling of his apprenticeship, Vogel had to beg his best pupil to stop washing his plates; no further impurities could be removed. Similarly, in carrying out an assignment to reproduce tonal values, Alfred photographed compulsively a white plaster cast draped in black, trying repeatedly to capture the true intensity of contrast between the white plaster and the black velvet. His teacher again had to remind the driven perfectionist that in reproducing the black and white of fabric and plaster on glass and paper, there was no such thing as "exactitude."[14]

That Alfred Stieglitz discovered in Herman Vogel a scientist and teacher who also believed in photography as an art and a profession worth pursuing is undoubtedly true. Whether Alfred became, as he later claimed, Vogel's disciple, is at least open to question. In the collections of Stieglitz, the manic letter writer who corresponded copiously and faithfully with friends, lovers, colleagues, and the most casual acquaintances throughout his life (saving, it appears, every postcard, note, and telegram received in reply), there is no evidence that he ever exchanged a single word with his former teacher. Even more curious, in an academic culture that exalted the master-disciple relationship, Vogel never proudly claimed Alfred Stieglitz as his student.

Whether or not Hermann Vogel was father to Alfred's career, his own father endorsed and supported his decision to devote himself to photography. Given Edward's disdain of Mammon and its money-grubbing worshippers, along with his own decision to indulge the pleasures of amateurism, he could feel reassured: not only had Alfred found a métier, but he had discovered one practiced by well-off amateurs, gentlemen (and a few ladies) like himself. To seal his approval, Edward became his son's first patron. In the early summer of 1883, Alfred joined the family in Gutach, in the Swiss Engadine. With his father paying

for supplies, Alfred took snapshots of parents and siblings, posed in attitudes of serious tourism, against Alpine peaks and meadows.

In subsequent summers of what he called "foot tours" (translating literally from the German), Alfred, lugging more than thirty pounds of equipment, turned to "local color" as defined by the first camera-toting Edwardian travelers or, as Stieglitz himself described these efforts, imitations of Romantic genre painting. His early photographs celebrate handsome peasants in native dress going about their picturesque daily lives, Millet-like icons of noble laboring men and women, and the play of light and shadow on worn steps and medieval archways of Italian hill towns. Even in these literal clichés of tourism, however, the Stieglitz vision and technique transform the subject: a palpable feeling of space surrounds his figures, who emerge with an almost eerie clarity of focus. Using the new platinum paper from England, Stieglitz obtained a quality of surface texture never before seen, in which velvety blacks and the most subtle palette of grays play against dazzling white.

On his return to Berlin in mid-summer 1883, nineteen-year-old Alfred moved into rooms with Joe Obermeyer and Louis Schubart. From his lodgings with Encke, he brought the cherished possessions that would furnish his various subsequent Berlin quarters: an upright piano, "never without its scores of *Carmen*, of Wagner, of Gluck—my favorites." Later he would add a portrait of Hedwig, painted by Fedor Encke for Alfred's twenty-first birthday. "And over my mother's picture, there was draped an American flag, twelve feet long," hand-stitched by a German friend who knew of Alfred's fervid patriotism.[15]

Installed in newly spacious quarters, the three young bons vivants did not allow their pursuit of higher education, or even the potential of the new dry photographic plates, to interfere with the pleasures of theater and racetrack, the steins of beer and green-stemmed goblets filled with Moselle and Gewürztraminer. In Alfred's memory, his own preference for the grape held sway at their rooms in evenings, otherwise devoted, so he claimed, to improving activities such as reading American texts aloud to German friends (Mark Twain was his favorite).

But soon Alfred, more than the other two Americans, proved susceptible to another notable Berlin temptation: the availability of the city's large population of working-class young women, the chambermaids and barmaids, seamstresses and waitresses whose starvation wages made prostitution—even in exchange for a free meal—essential for survival.

At some point in the fall of 1886, following his family's return to America, Alfred Stieglitz moved into rooms at 23 Kaiserwilhelmstrasse with a young prostitute named Paula. The time they spent together, he later said, was the "happiest and freest" period of his life.

Friends asked him, he recalled, "how, feeling as he did about women, he could live with a prostitute." He could not have done it, he said, "had he not felt she was as clean as his mother."[16] To the shocked reaction that greeted this comparison, Stieglitz replied that he had given Hedwig the same explanation. His mother, he claimed, had understood perfectly. (One wonders whether Hedwig's portrait, festooned with Old Glory, accompanied him to Kaiserwilhelmstrasse.)

"Whenever I take a picture, I make love," Stieglitz said years later.[17] *Sun Rays, Paula* (1889), is the first of Alfred Stieglitz's haunting images of women with whom he was sexually obsessed. In this single surviving photograph of his companion, the young woman, seen almost from the back, is so intent on the letter she is writing that she has forgotten to remove her hat; its plumes merge with her massed golden hair, and her face is nearly invisible, but for the suggestion of a piquant profile. On the writing table, in an ornate frame, is another photograph of Paula, full face, hatted, and decorously dressed; a large pale bird sits on her shoulder. This same image is echoed with slight variations twice on the wall above her head (one print is identical to the photograph on the desk. The other appears to be from the same sitting, but the pose differs slightly).

Pinned to the bottom of one of the prints on the wall is another, more intimate view; her head nestled in a pillow, her hair loosed, Paula looks up at the photographer, whose camera points downward. Two other matching prints of a landscape with water flank the images of Paula. Three lacy and beribboned Valentines form a cross-shaped arrangement with pictures on the wall. Another print is partially covered by the heart on the right, which draws attention to its subject: a portrait of Stieglitz. The photographer twice inserts his presence in the scene: as the invisible object of Paula's languorous upward gaze and as the visible image on the wall. Also on the right, obscuring a much larger sheet on the wall, hangs a bird cage, in which we can make out one bird but two feeders.

The double-paned window on the left is the source of the sunlight whose rays cast diagonal bars across the wall, the table, and the writer. The foreground is circled in darkness; we observe Paula as through a keyhole or the peephole of a cell—images of imprisonment reinforced by the pattern of bars and the caged bird. Beyond the obvious allusions to Paula as a prisoner of sex, captured—in the language of the camera itself—by the photographer, the two references to birds reinforce the young woman's sexual function: the caged creature and the bird on her shoulder in the print refer to both her past profession and her present liberation.

In warm weather, open windows in the red-light districts of northern Europe were alive with the twitter of birds in cages, a promise of sweet excitements within. Paula's caged birds have been moved to the wall farthest from life on the outside. At the same time, paintings of the late nineteenth century illustrate another function of small, confined household pets: they provide diversion for leisured middle-class women who, freed from any kind of labor—honorable or shameful—have nothing else to do but watch goldfish swim around a bowl or canaries at play on their swing.[18]

Whether women are prostitutes or middle-class wives, some would argue, their role is the same: prisoners watching their fellow inmates. Alfred's remarks about Paula, however, suggest that the photographer felt that he had rescued, even as he sequestered, his mistress. If he is to be believed, his sense of responsibility for the young woman continued beyond this "happiest and freest" period of his life; for some time after his return to America, he sent Paula one hundred fifty dollars a year, so that "he could feel she was not on the streets."[19] It seems doubtful that Alfred's annual gift would have allowed her to remain in retirement; in any event, he learned (whether from Paula herself or secondhand we do not know) that another lover had set her up in a café. Alfred's "fallen woman" had been raised from leisured captivity to liberated capitalism.

Paula's vaunted "cleanness" and the grace and refinement apparent in the photograph were clearly part of her allure for Alfred. But her profession, with its promise of erotic escape from middle-class sexual taboos, was the compelling attraction. As Freud would reveal a decade later, the relations of his middle-class male patients, especially those still in thrall to their mothers, with women of their own class were fraught with guilt and anxiety.[20]

When Alfred referred to friends who, "knowing my feelings about women," were bewildered that he could live with a prostitute, he confirmed the stark sexual equation that initiated his relationships with women: the whore/Madonna dualism that defines one type of woman as completely eroticized, an instinctual animal whose predatory reflexes, by turning man into her passive victim, remove guilt by erasing volition. This male version of women's so-called rape fantasies is illustrated by one of Stieglitz's favorite paintings: *Sin*, by the German late Romantic painter Franz von Stück, depicts a vampirelike creature, her jaws dripping blood, who holds in her teeth a writhing male body. Indeed, Stieglitz later claimed that his first love was a "blonde and beautiful woman who raped him." Married, she posed no challenge to his passivity. Although both were living in Berlin, she wrote to him, he recalled, two and three

times a day. Their affair ended when she became pregnant, a condition, he confessed, he found "unaesthetic."[21]

A young woman absorbed in writing to her lover has been a favorite subject of profane art since its beginnings. Still, that Paula is shown in the act of writing a letter suggests its erotic importance for Stieglitz, who on a typical day might write between ten and twenty-five letters. In his portrait of Paula he seems also to have conflated his two Berlin lovers; of thousands of images he made of women, none is ever again shown pen in hand.

Untouchable in her purity and nobility, the Stieglitz Madonna was to remain forever frozen in her annunciate state—chosen but childless—an image he would attach to other women in his life, including O'Keeffe. Virginity, in these love objects, was both required and feared: needed for the adoration of feminine "innocence," dreaded as a challenge to the male who dared defile her, obliging him to become a husband, a father, and a man. To escape the anxiety created by the Madonna and her implicit demand that she be transformed into a woman by sexual passion, Alfred sought refuge in another favored Victorian escape from female sexuality. Instead of the Either/Or as defined by Kierkegaard, one of his favorite philosophers, the whore/Madonna became part of something larger called Woman (Alfred's uppercase spelling). This new creature was both: she was innocence and instinct, intelligence untainted by rationality; her pure polymorphous sexuality owed nothing to experience. Stieglitz's Woman no longer had fangs, she had baby teeth. She was nothing less than that most forbidden object of desire: the child.

In Alfred's redemption of the Magdalene, Paula, the "little prostitute," is forgiven and restored to her virgin state, reborn into the purity of both the child and his mother-as-Madonna, before she betrayed him with his father, only to be betrayed in turn.

WHILE ALFRED remained abroad for several summers, roaming Europe with friends and continuing to photograph, Edward had returned to New York and was searching for that symbolic possession of the securely rich: a summer place. Since his brief visits in the 1870s with his family, he had been drawn to Lake George, attracted by the unspoiled waterfront and its views of the Adirondack foothills. As a resort, the area met another requirement: it was too unfashionable to be restricted, but there were, nonetheless, no Jews to worry about as neighbors.

In 1886, Edward bought Oaklawn, a vast Victorian "cottage" on the western shore of Lake George. He had rented the property—which

included more than five acres of meadows sloping down to the water—for two summers, long enough to decide that it would be just right for his family and guests.

Oaklawn was a classic example of the summer retreats built by rich Americans from the end of the Civil War to just before World War I. Clustered in colonies in resorts such as Newport, Lenox, and Bar Harbor, these houses were cottages only by virtue of a rural or seaside situation or their rustic shingled or clapboard exteriors. In size, furnishings, and staff required to keep the household running smoothly, these grand establishments reproduced the overstuffed comforts of city or suburb.

Named for the ancient tree whose slow death Stieglitz would later dramatically compare to his own, Oaklawn consisted of a sprawling three stories of white clapboard and gingerbread gables, with a veranda and odd porches poking from the shapeless structure. Visitors arrived under the porte cochere, brought from the station in the carriage driven by Fred, the Stieglitz's summer coachman. Once inside, those guests who were also familiars of the house on 60th Street would feel right at home; downstairs, in rooms separated by sliding mahogany doors, they would recognize the identical profusion of art and bric-a-brac as on 60th Street. The only concessions to summer were the gaily striped awnings that unfurled from above the many windows along with the tennis and croquet courts, bathhouse, and dock added by the new owner.

The Newport or Bar Harbor cottage could claim, at least in its vistas of large reaches of water, a setting of rugged nature. Oaklawn's prospect—an end of Lake George so narrow as to resemble a river, banked by dark low hills—gave the setting an enclosed feeling. It was precisely this sense of enclosure, of protection from both wilder nature and the world outside of family that would bind Alfred Stieglitz to Lake George from his first summer there to the end of his life.

In July 1888, Alfred and the twins returned to America for their sister Flora's wedding, spending August and September with the family at Lake George. Even the crowded circumstances of this first visit—with overflow houseguests, Alfred had to share a room with Lee and Julius—could not diminish his instantaneous love for every meadow and tree on the property.

At twenty-four, Alfred might have seemed too old to establish the intense affection for a summer place that a child does when his growing up is measured by the holiday freedom of pleasures renewed and expanded. Yet at this time he forged the most enduring bond of his life: a mystical, pantheistic attachment to the lake and its surrounding country; a sense of place so transcendent that it would merge with the spirit

of other, more transient settings as they appeared in and disappeared from his life.

"Lake George is in my blood," Stieglitz would later write to John Marin, "the trees and lake and hills and sky, and here I am hardly back more than a few hours, and Lake George seems a dream and yet I know it is part of me and will live through 291."[22]

Happily, his allegiance to the house itself was not his primary attachment to the place. When Oaklawn was sold in 1922, he transferred his affection to the Hill, a farmhouse across the road, on land that climbed away from the lake. Edward had purchased that property in 1891 to dispose of its resident pigs, whose smell wafted through Oaklawn's paneled rooms.

For the rest of his life, the lake would minister to Alfred's most profound—and often contradictory—needs: permanence and change; rest and frenzied work; escape and retreat from family. Reverting to the swirling rivalries and exploding hostilities of children competing for parental affection, he could remain a brother and son long after he was a husband and father. At the lake he could also sustain his need for control: there his always problematic dealings with strangers were mediated by servants and family.

Most important, though, was the role of these surroundings in his photography. Whether part of nature or constructed by human hands, a miracle of rainbow or a crumbling barn, Lake George was, for Stieglitz, the "inscape" of Gerard Manley Hopkins—the natural world and inner spiritual state of the artist made one through his art.

With the exception only of Georgia O'Keeffe, the lake and the Hill were Stieglitz's most important and enduring source of inspiration.

IN OCTOBER 1888, Alfred returned with his brothers to Germany, where, from the date of the photograph, he would seem to have been living with Paula. In April of the new year, he succumbed to a mysterious illness. Like many of the sicknesses that afflicted him throughout his life, this one was of undetermined origin: it was unclear from his account the organic nature of the ailment or whether the source of his suffering was the soma or the psyche. Exhaustion, the result of a frenzy of photographing, may have been one cause; certainly, well before his visit home, Alfred had been astonishingly productive.

"Competing for critical approval almost as soon as he had first mastered photographic techniques,"[23] Stieglitz began to be mentioned in amateur photographic journals in 1887 as an extremely hardworking camera enthusiast.

In that same year—the year of Georgia O'Keeffe's birth in a Sun Prairie, Wisconsin, farmhouse—Alfred Stieglitz, then twenty-three, won his first official recognition. The seven prints he submitted to the Holiday Work Competition of the distinguished British publication *Amateur Photographer* won honorable mention, including the comment of a reviewer: "Alfred Stieglitz is certainly a master of photography."[24] Taken on a summer walking tour of Italy and Switzerland, one of the submissions, *A Good Joke*, was reproduced as the frontispiece of the special summer issue of the same publication. The scene of Italian peasants gathered around the village well now appears quaintly stagey, but to contemporaries it passed for casual realism and a fresh photographic spontaneity. The same journal awarded Alfred first and second prizes the following summer, along with three hundred dollars. These would be the first of more than one hundred fifty medals won by Alfred Stieglitz for his photography in the next eleven years. *A Good Joke* marked Stieglitz's official entrance into the competitive, politicized, and ambitious world of "artistic photography"—a world he would change forever.

T W O Y E A R S after Alfred's visit home for Flora's wedding, he learned by telegram of his sister's death in childbirth. Lonely and homesick in Los Angeles, where she had moved with her husband, a wine importer, the twenty-five-year-old woman succumbed to septicemia on February 17, 1890, following four days of labor and the birth of a stillborn thirteen-pound son. Hedwig was in a state of shock, probably compounded by guilt;[25] she and Edward had decided to defer a visit until after the baby was born.

Alfred did not return home for his sister's funeral. Trying to stave off the inevitable—the summons to face the question of his future—he spent the spring scrambling for work that would justify remaining abroad. In July, he won a traveling studentship from the *Amateur Photographer*; despite the stipend of only twenty-five pounds, he tried to convince himself that the assignment to photograph French sites beloved of English tourists—Arachon, Biarritz, St. Jean de Luz—represented independence. Not even the magazine's gold medal for his view of Biarritz, however, could change the reality.

Returning to New York in late summer of 1890, he was forced to confront the fact that the autonomy he had enjoyed for nine years was illusory: the freedom of the student who, as Alfred recalled, "felt like a millionaire" on a lavish allowance far from his family. He had come home to resume the role of the sheltered, dependent child, living on the top floor of his parents' house, expected to inform them of his

whereabouts, including his dinner plans if he was not going to occupy his accustomed place at table.[26]

Seeing his situation clearly, Alfred was yet too paralyzed to struggle. He could only advise his younger brother Julius, trying to decide, after a dazzling finish to his Berlin studies, between job offers in Worcester and Chicago, to head for the Midwest and the greatest possible distance from the family. Edward, meanwhile, had decided that Alfred's career must be settled for him. Before Alfred returned home—and seemingly without consulting him—the elder Stieglitz purchased from his friend and Lake George neighbor John Foord, an editor at Harper & Brothers, ten shares at one hundred dollars each in Foord's new photoengraving venture, the Heliochrome Company, along with the promise of a twenty-dollar-per-week assistant's job for the prodigal photographer. Arrangements made for Alfred in absentia also included the financial participation of his former roommates Louis Schubart and Joseph Obermeyer. Within a year, their families had bought out the other shareholders, making the three young men sole owners and partners in the rechristened Photochrome Engraving Company.

ON THE EVE of his return home, Alfred enacted a strange rehearsal of fatherhood. Either just before his visit in 1888 or his repatriation in 1890, he learned that a Munich servant girl was about to give birth to his child. Writing to the pregnant young woman, whom he addressed as Lenzel, he promised that he would send her money, urging her to write to him in care of his parents at Oaklawn.[27] If indeed he kept his word, the child, a son, would have been no secret to the family; as Alfred did not draw a salary from the Photochrome Company, he was still supported by an allowance, reduced since his return home. His own letters make no further mention of Lenzel, nor apparently did he ever make any effort to see the mother or son. The existence of the boy, however, surely helped decide the elder Stieglitz that Alfred, helpless on his own, must be provided with the part of provider. The next step was to find him a suitable wife.

THREE

Artist in Exile

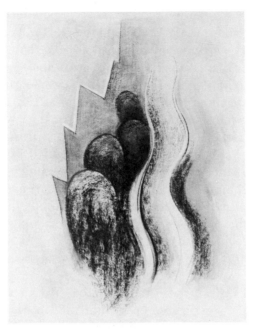

GEORGIA O'KEEFFE, *Drawing No. XIII* (1915).

IN LATE JULY 1908, the Art Students League summer school at Lake George ended. It was Georgia O'Keeffe's last month of student life. However gloomy she had found the lake, the weeks there would seem idyllic compared with what awaited her at home.

Fear and uncertainty hung over Wheatlands. Francis O'Keeffe had invested the remaining family savings in a final disastrous scheme, one all too symbolic of the family's sinking fortunes: the manufacture of hollow cement blocks to be used in the construction of cheap housing on his subdivided land. In his own wheelbarrow, he trundled the slabs, one by one, from the primitive equipment that molded them from surplus gravel to the site where the prototype house was to be built. As his finances deteriorated, he had been forced to sell parcels of the nine acres belonging to Wheatlands. This seems the only plausible explanation for his decision to build the model home close to the O'Keeffe house. Rising from raw foundation next to the graceful white clapboard

Wheatlands, the dun-colored cement structure was stark evidence of a family's decline: asymetrical gables and doors and windows punched randomly in the exterior wall suggested the blind despair of a man whose inner disorder found expression in the building of a prison.[1]

There were no buyers—either for the prototype house or any others. The rare neighbor with cash to spare preferred to shore up his rose-brick Georgian ruin than to relocate into this folly born of desperation. His capital gone, along with his hopes of an income, Francis O'Keeffe had no choice but to sell Wheatlands itself and move the family into his bunker.

On November 3, 1908, two weeks before her twenty-first birthday, Georgia, writing from home, told a league friend of her decision not to return to New York. Sounding the perfect flower of southern domesticity, she described having learned that very day to make biscuits. Every morning with mop and broom, "I make a dusty trip around the tower regions of the house," she added. Lulled as she was by the routine of household chores, "time," she declared languidly, "just slides over my head."

Her father would send her back to the league if he could, but he couldn't just now, she explained. "He is having hard luck these days, but never says much because he doesn't like to own up to it, even to himself."

His oldest daughter, who would so much resemble Francis O'Keeffe in this way, tried vainly to assuage the sense of failure and defeat that had turned her laughing, fiddle-playing father into a withdrawn melancholic. "I certainly like to please him," she wrote, the laconic phrase betraying her failure to penetrate such overwhelming sadness. At least she could put a good face on her own disappointment. Revising her memories of the league year, she became the fearful fluttery southern belle, grateful to be back home: "When I think of the fight to live up there," she wrote, "it seems this is the place for a girl. It doesn't seem like she ought to be bumping around New York alone."

Then, shaking herself from this somnambulistic state, she noted briskly that "the wisest thing for Pats . . . is to wake up and see what she can do."[2] Five days later and a week before her twenty-first birthday, Georgia left for Chicago, a city she hated, where she would take a job she would loathe.

Conflicted in tone as in content, her extraordinary letter to a fellow student speaks of both denial and admission of pain; the writer's voice shifts abruptly from the contentedly domestic, proper young girl disapproving of the "new woman" flapping about the big city to the grieved and frightened child worrying guiltily that her family is "too good" to

her, becoming finally the realistic young woman, purposeful and clear-eyed, who has roused herself from a creeping paralysis of will into action.

But there is a missing person in Georgia's rare chronicle of family troubles: Ida O'Keeffe, whose griefs and burdens in these years would prove mortal, was never mentioned.

ON THE OVERNIGHT TRAIN from Williamsburg to Chicago, Georgia could only reflect on the diminished life awaiting her. Once again, she would exchange the out-of-doors she loved almost as much as painting for the claustrophobic confinement of a city whose two million inhabitants increased by fifty thousand each year and whose smoky skies trapped the foul smells of railroads and stockyards.

Even in the family's straitened circumstances, Ida O'Keeffe's children would not have been permitted to take menial jobs over the long vacation. Georgia and her brothers and sisters had been free to enjoy the pleasures of a southern summer: walks perfumed by magnolia, crape myrtle, and wild roses, afternoons of swimming or sailing in the James River, evenings on the veranda of Wheatlands waiting for a breeze to stir the heavy tropical air.

Now once again, Georgia was enclosed by the Totto apartment, occupying one floor of a brick three-decker on Indiana Avenue; within a year these cramped quarters would shrink further when Uncle Charles and Aunt Ollie were joined by another unmarried sister, Leonore.

From her small room in the early mornings, through streets paved with blocks of granite that in winter, Edgar Lee Masters recalled, "oozed cold slime like grease, on which horses slipped and sometimes sprawled while drivers cursed or used the whip,"[3] Georgia walked to the El that took her to work. At one of the new advertising agencies near the Loop, in a large room with other young men and women hunched over desks, Georgia drew the machine-made lace and embroidered shirtwaists that appeared in ads in the local newspapers to tempt other working girls. For this was, indeed, what Georgia had become. In leaving home this time, she had left behind forever the genteel "accomplished" southern lady of Ida's aspirations.

Paid by the piece, she earned wages determined by her speed and endurance. The agencies were nothing more than sweatshops where workers' heads ached and their vision blurred over pen and paper rather than over sewing machines and fabric. Seventy years afterward, O'Keeffe was still putting a good face on suffering: her days of drawing lace at top speed, she said, enabled her later to complete paintings at the same pace.

There was no place in her life now for her own work; either she had resolved to give up art if she could not paint full time or she was too exhausted and demoralized to find even a few hours during the week to continue painting.

For the next two years in Chicago, as though willing herself a nonperson, O'Keeffe became a barely visible shadow, moving mechanically from the house on Indiana Avenue to her job and then back again. She does not appear on tax or census rolls; she did not join the Episcopal church a few blocks from the Totto apartment, whose youth group might have provided friends her own age. As far as Georgia was concerned, the activities that centered around Hull House or the Arts Club and that attracted the bright college-educated young midwesterners who flocked to the city could have been taking place in Bloomsbury or Montparnasse. For these were the heady years of the Chicago Renaissance, when young women in newly bobbed hair and loose-fitting smocks talked of socialism and free love and poetry, producing amateur plays and publishing little magazines like Harriet Monroe's *Poetry*, and when a young man named Sherwood Anderson, later to be a close friend of O'Keeffe's discovered that a suffocating past could be buried by a creative amnesia, setting free both a newly discovered sexual being and the artist within.

Her body rebelled against the punishing work; Georgia contracted measles. Her weakened vision forced her to give up the labor she had endured for nearly two years to earn a pittance. For the second time, she left Chicago and the crowded Totto apartment for the day-and-a-half train ride to Virginia.

Instead of returning to Wheatlands with its lofty-ceilinged rooms and cool sleeping porch, Georgia rejoined the family in the bleak barrack-like structure nearby. Dispiriting from the outside, Francis O'Keeffe's model home dripped moisture on the inside that varied only with the seasons: a freezing dampness in winter followed by suffocating humidity in the long summer.

After an absence of two years, Georgia's first sight of her mother would have been a profound shock. Haggard and hollow-eyed, Ida O'Keeffe languished in the first stages of tuberculosis. With all of Francis O'Keeffe's obsessive dread of the disease, his wife was the only member of his own family to succumb—the price, perhaps, of having nursed her brother-in-law Bernard through his final illness twelve years earlier. The forty-six-year-old woman was now too weak to walk downstairs. She spent most of each day lying on a sofa that had been moved to the porch adjoining her bedroom. From here, she was just able to see Wheatlands.

Then, a year later, buoyed by one of the febrile bursts of energy peculiar to consumptives, Ida packed up and moved to Charlottesville. The higher altitude and drier climate of the university town would, she hoped, arrest her disease; if the climate failed to help, there was the Blue Ridge Sanatorium.

Ill as she was, Ida was still the breadwinner. Francis O'Keeffe, remaining in Williamsburg, tried to find work as a truck driver—or so he told his family. If he was successful, he does not appear to have ever again contributed to their support. In Charlottesville, the large numbers of students offered Ida better opportunities for keeping a boardinghouse than impoverished William and Mary College had. Accompanied by her daughters, Ida rented a house on a residential street a few blocks from the commercial center of town. Unlike its tidy suburban neighbors, 1220 Wertland Street was one of those dejected sprawls of ugly red brick that seem built to house as many transients as cheaply as possible.* The cell-like rooms within spawned piecemeal additions that, like a cancer, gradually swallowed most of the backyard.

Shortly after her mother and sisters were settled, Georgia returned to Williamsburg to keep house for her father, leaving Ida and Anita to take care of their two younger sisters and to help run the boardinghouse. Both brothers, Francis Jr., now twenty-six, and Alexius, nineteen, had already made their escape from family miseries. It is not clear why Francis O'Keeffe, Sr., remained behind in the dank blockhouse; perhaps he was unwanted in Charlottesville. Never fond of her mother, Georgia may have welcomed the chance to minister to her troubled father without the reproach of Ida's deteriorating physical condition and despairing state of mind. The Oedipal fantasy realized at twenty-three, her destiny seemed that of every unmarried Victorian daughter: the substitute "angel in the house" in a motherless household. Her romantic prospects, moreover, could not have seemed bleaker. During the two years Georgia had spent drawing lace collars in Chicago, her friend from the "Far West," George Dannenberg, had been studying art in Paris. Pained by the prospect of separation, he had talked of sending for her. Then, when Georgia returned to Williamsburg in the spring of 1911, Dannenberg, on his way to the Riviera, wrote that he planned a trip home and would visit her in Virginia that summer. But in the fall, he returned to Paris to prepare for an exhibition of his work; both plans for a reunion with Georgia evaporated. Her disappointment in love and at proof of promises made and forgotten was more acute because she had invested her hopes

* The house is still used as a student boardinghouse.

of rescue in the expatriate. She would gladly have married him, Georgia later said, if he had asked her.[4]

Rescue came instead from another woman. That same spring of 1911, Georgia was summoned back to Chatham Episcopal Institute by her former art teacher and headmistress Elizabeth May Willis. Distressed to learn that her most talented pupil had given up painting under the necessity to earn a living, Mrs. Willis asked Georgia to take over her art classes during her leave of absence. Welcome as the offer was, Georgia, in accepting, had to recall her fellow league student Eugene Speicher's crude taunt: she had, indeed, ended up teaching art in a girls' school.

Still, she was back in a studio again, with the smell of turpentine, the new boxes of watercolors and their small square intensities of every hue, the feel of charcoal crayon, the grain of the paper as her fingers smudged the black into a spectrum of grays. Strange as it seemed at twenty-three to be addressed as if she were a middle-aged "Miss O'Keeffe" by giggling girls destined for early marriage and painting flowers on china, it was still exhilarating for Georgia to lead her students through the possible ways of filling the glare of white sheet. Even in the copying exercises of the drawing class, it was good to feel the familiar energy relayed from eye and mind to hand.

With the end of the school year, Georgia returned home, this time to Charlottesville and the boardinghouse on Wertland Street. Despite periodic remissions, Ida O'Keeffe's deteriorating condition could have allowed her older daughters—Georgia, Ida, and Anita—no grounds for optimism: after five years the fatal disease had attacked both lungs. Besides the exhaustion and weight loss apparent in Williamsburg, Ida was now subject to fevers and, very probably, hemorrhaging. Although most household chores were shared by the five girls and aged Aunt Jennie, the sick woman still had to expend her failing energies managing an establishment on which they depended for their entire income. Competition, moreover, was keen for the room and board of the transient population of young university men. On Wertland Street, other cash-poor families with gracious houses and black help in the kitchen discreetly took in student boarders.

Until the end of the first decade of this century, tuberculosis was the chief cause of death in the United States. As she neared the advanced stages of this most contagious of fatal diseases, Ida's condition, along with her occupation of boardinghouse keeper, made her a public health menace. Although there was no cure for the "white plague" until the discovery of antibiotics, its source in contaminated milk and its spread

through droplets of sputum were well known. In Charlottesville, the presence of the Blue Ridge Sanatorium attested to local awareness of the need to isolate sufferers from those not yet infected. Indeed, in 1908, the Commonwealth of Virginia had passed an act attempting to prevent the spread of tuberculosis. The code specified that "apartments occupied by any consumptive shall be deemed infected"; and anyone who "knowingly lets for hire or causes or permits anyone to occupy [such] apartments . . . shall be deemed guilty of a misdemeanor and on conviction thereof, shall be subject to a fine not to exceed $50.00 for each offense."[5] (More than a decade earlier, rumor suggests, Francis O'Keeffe had been forced to close his Sun Prairie creamery because of the high incidence of tuberculosis in his family.)

Had Ida O'Keeffe's condition been known in Charlottesville, it is unlikely that any young men from the university would have been found at her table. From the moment she opened her Wertland Street house to boarders, Ida and the adult members of her household were in violation of the laws of the commonwealth.

From this period on, friends remarked Georgia O'Keeffe's silence on the subject of family troubles. Stoicism, a distaste for washing dirty linen in public, a dread of becoming the object of pity—all these were variously offered to explain her refusal to mention the griefs of those years, worst among them, surely, watching her mother slowly die. Whatever hostility Georgia harbored toward Ida as a rejecting mother would become even more troubling, first by the child's anger at being abandoned by the parent through death and then by the child's own feelings of guilt.

The silence of children is one means of their conscription into adult life. For Ida O'Keeffe's daughters, silence was both a purchase on survival and a criminal offense, carrying in this case the potential for public opprobrium: they were knowingly allowing young men to be infected with a dreadful disease. Yet Ida's illness had to be kept secret, lest she be deprived of her only means of supporting her family. Indeed, the move from Williamsburg to Charlottesville may have been less the search for a salubrious climate than a flight from small-town gossip; word of the semi-invalid could well have erected a *cordon sanitaire* around the sweating slabs of the cement blockhouse, where Ida gasped for air on the porch outside her bedroom.

Whispers of disease and contagion did not, apparently, follow the family to the university town. Nor did any unguarded word betray the Wertland Street boardinghouse as a house of death. In the fall of 1912, Francis O'Keeffe joined the family. Shortly after his arrival, he opened a creamery, probably with the proceeds of the sale of the cement house.

None of his new neighbors appears to have objected to the creamery on the grounds of possible infection. The family was together again for the last time.

Meanwhile, Ida's faith in the cultural, if not the health benefits, of Charlottesville was vindicated. Charged with training teachers for the state school system, the university for the first time opened its classes to women for the summer session of 1912, and the older O'Keeffe girls enjoyed some relief from the drudgery of waiting tables, washing dishes, and making beds. Each afternoon, the sisters left the house on Wertland Street and trudged uphill past the gardens enclosed by red brick serpentine walks until they came in sight of the campus in the full glory of its setting. Circled by the Blue Ridge Mountains, deepening from palest lavender to deep violet, rose a "mass of buildings more beautiful than anything architectural in America," the historian George Ticknor said of Thomas Jefferson's neoclassical vision.[6]

Along both sides of the Great Lawn, ten porticoed pavilions, whose columns alternated the classical orders, descended from the domed Rotunda. To walk down the gentle slope past each pavilion was to experience Ruskin's definition of great architecture as frozen music.

Georgia and her sisters' destination was the arts building at the end of the lawn, where Design I was taught each summer by Alon Bement, regularly of Teachers College, Columbia University. "A funny little fellow" was the way Georgia would characterize her most important mentor.[7] For thirty years, she would use the same phrase to describe Alfred Stieglitz. Something of the same dynamic, didactic spirit animated these two small, commanding impresarios of art.

"Bementie," as his students—almost all of them women—called him behind his back, was a posturing, plump, performing flea of a man given to making his pedagogical points theatrically; in his textile design class, he would twirl a length of fabric around his rotund body, matador-style.

Ida and Anita giggled at their teacher's effete manner; Georgia was mesmerized by his lessons. Instinctively, she always knew when something or someone would be of use to her. As soon as she heard Bement hold forth on his central principle of design—"Filling space in a beautiful way"[8]—Georgia knew that she had found an aesthetic that affirmed her own groping efforts to unshackle herself from the constraints of earlier teachers. Bement's assignments consisted of exercises to make good design foolproof. Students practiced enclosing or dividing geometric shapes and then eliminating or shifting elements to create their own compositions. Later, they were taught to alternate dark and light forms, to contrast the play of soft biomorphic and hard geometric shapes. To Georgia, taught first in the gloom of the Great Hall in Chicago to copy

plaster casts and then rewarded at the Art Students League for imitating William Merritt Chase's razzle-dazzle illusionism, Bement's highly controlled exercises became, paradoxically, an alphabet of liberation. Forcing the artist back to basics, they could be used, Georgia realized, to make every aesthetic decision she needed. It was a moment of revelation. "Art," she discovered, "could be a thing of your own."[9]

Bement's radical exercises came, in turn, from Arthur Wesley Dow, the tutelary planet at Teachers College, where Bement, as Dow's protégé, was the rising star. Dow's teachings made the art faculty of that school a model for the country.

Unknown to his Virginia schoolteachers, Alon Bement was the third generation of an apostolic succession of New Englanders who became first converts and then prophets of Japanese art: Ernest Fenollosa, Arthur Wesley Dow, and Bement.

Collector, connoisseur, historian, and polymath, Ernest Francisco Fenollosa was the most brilliant of the three, born in Salem, Massachusetts, in 1853. Four years after his graduation from Harvard in 1874, Fenollosa left for Japan, where, after two years of study, he became in succession professor of aesthetics, political economy, and philosophy; manager of the Imperial Museum; and fine arts commissioner. On his return to Boston in 1890 to assume the curatorship of Oriental art (most of which he acquired) at the Museum of Fine Arts, he was decorated by the Mikado with the Order of the Rising Sun and the Sacred Mirror. Disdained as a "wild man" by Harvard and ignored by genteel Boston art circles, Fenollosa, through his writings on Japanese and Chinese art, made converts elsewhere; one avant-garde admirer, a young poet named Ezra Pound, edited Fenollosa's study of Noh, the classic theater of Japan, published in 1916, eight years after Fenollosa's death.

Arthur Wesley Dow, a painter from Ipswich, Massachusetts, had just returned to Boston in the late 1880s from Paris. After studying at Académie Julian and École des Beaux Arts, the promising young American had begun to exhibit regularly at the Salons; a photograph taken at Pont Aven shows him with a group of young painters that includes Gauguin. But French art along with his own work abroad left him dissatisfied. He returned home to study the Far Eastern collection at the Boston museum, and as soon as he met Fenollosa he recognized his destiny: to become the older scholar's lifelong disciple and publicist. "From 1891 on," his biographer notes, Dow was "teacher first, artist second. There was but one Fenollosa and Dow was his prophet."[10]

The Way—according to the Fenollosa-Dow aesthetic—was based on a large and simple principle: "The tentative effort of art expression in childhood and in primitive races has been in all ages and lands

artistically the same and its keynote is *Spacing*," the Master declared. "Dow's creative mind seized on this basic truth, sensed its import, amplified and explained it, carried it up and over to the fine arts and 'put it across' to the art student."[11] Generations of art teachers were trained by Dow in his classes at Teachers College; many more students assimilated his design principles through *Composition*, the most successful textbook on art ever written and a text that Georgia absorbed thoroughly and used in her own teaching.

In his introduction to the last of five editions to appear in his lifetime, Dow explained that he first wanted to use "Design" as the title for his series of lesson plans; he was dissuaded by the association of this word with "interior decoration" and other lower forms of art. Design and the decorative, however, were the basis of the Fenollosa-Dow-Bement aesthetic (Alon Bement would end his career teaching interior decoration, as director of the Traphagen School of Fashion).

Organic forms, stylized and flattened to fill shallow space, was the revelation of Japanese art, whose elegant sinuosities European artists had already translated into art nouveau. Central to Dow's method was what he described as the Japanese principle of notan, or dark and light in mystical balance. Chiaroscuro rendered in one dimension, notan, together with line and color, would lead the student to the goal that Dow unashamedly, even triumphantly, invoked: *Beauty*.

Music was the other crucial element in the American Orientalists' canon. Fenollosa had declared music to be the key to the other fine arts, "since its essence is pure beauty." Both Dow and Bement used recordings in class to stimulate students' visual imagination. On her own, Georgia began studying the violin. Sawing away in her small basement studio on Wertland Street, she achieved uninspiring results. But she learned how much music would always mean to her, not only as a source of intense pleasure but as the condition to which her own art aspired.

Moving abstract forms around on paper to the sound of a phonograph record, she felt in possession of "a new way to think about art" that owed nothing, she decided, to Chase's sleight of hand, producing dead rabbits from gleaming copper pots.

Still, the Chase *sprezzatura* and the serene Oriental aesthetic of beautifully filled space shared a bond that would hold Georgia O'Keeffe throughout her career. Both expressed an antimodernist definition of art in which the violent, the ugly, the dissonant, the displeasing had no place.

More than theory or even practice, Bement provided Georgia with practical help. A poor boy himself, he recognized that his gifted student's

most pressing need was to earn a living. At the end of the summer, he pulled strings to find her a teaching job in which she would also have time to paint. To be sure, his help was not entirely disinterested. He wanted to hire Georgia as his assistant the following summer, and university regulations required classroom or administrative experience in a public school. Through Bement's connections and with the possible help of a Texan classmate from Chatham, Georgia O'Keeffe, with only a few weeks of teaching experience in a finishing school and no credentials, was offered the job of supervisor of drawing for the six public schools of Amarillo, Texas.

FOUNDED IN 1887—the year of O'Keeffe's birth—Amarillo began as a construction camp for workers on the first railroad built across the Panhandle that same year. In 1912, Amarillo was a raw cow town just beginning to ship wheat along with cattle; its fifteen thousand inhabitants still trod wooden sidewalks past saloons and the Opera House to the end of town where the vast brown plains began.

The moment she saw Texas, in August 1912, Georgia fell in love. Ida had read her children stories of Kit Carson and Billy the Kid— adventures chosen to interest Francis, her favorite. But Georgia was the one who had always longed to see the real West.

Embedded in the simplest boys' stories, the myth of the frontier exalts a purchase on the future. The men and women who settled the West were celebrated by what they sought: gold, land, a life of larger opportunity. We now know them better by what they fled—a past and its troubles: debt, poverty, the claims of families left behind.

"This was my country," Georgia O'Keeffe would say of her first experience of Texas. "Terrible winds and a wonderful emptiness."[12] The emptiness was a land cleansed of people—the crowded Totto apartment, the cinderblock bunker in Williamsburg, the boarding house on Wertland Street—all oppressive with human need. Besides the noise of the wind sweeping through the town that was no more than a speck in the endless dirt-colored plateau, the sound that would haunt O'Keeffe from her Texas years on was the lowing of the cows for their calves day and night. The daughter abandoned by and now abandoning her mother, she would always hear the rhythmic sound, "loud and sad," of the cattle, separated from their young in pens near the station.[13]

Georgia stayed in the wooden Magnolia Hotel on Polk Street, playing dominoes at night with the other, more transient guests; she had not come this far to live in another boardinghouse, the preferred lodging of her fellow teachers.

Her new job gave Georgia her first chance to try the Dow-Bement method on young children.[14] By the beginning of 1913, she had effectively substituted Dow's exercises for the standard Prang workbook assignment: copying an orange. Most of her pupils were too poor to afford an orange anyway, she observed. Instead, Georgia started by asking her elementary schoolers to put a door into a larger square: "Anything to start them thinking about how to divide a space," she said.[15]

WHILE GEORGIA's subversive pedagogy was raising the hackles of her fellow educators in Amarillo, a more radical event rocked New Yorkers. On February 17, 1913, an exhibition of twelve hundred paintings and sculptures, most of them shipped from Europe, opened to the public in eighteen octagonal rooms improvised within the shell of the 69th Regiment Armory on Lexington Avenue. The most flagrantly "modern" of the works shown in the International Exhibition of Modern Art, known as the Armory Show, sent shock waves throughout America precisely because they proclaimed a truth that consigned the Dow-Bement aesthetic to history. Art and beauty had parted ways forever. To be modern was to embrace the ugly, the violent, the dissonant—as perceived by bourgeois vision. The human form suffered special outrage at the hands of the avant-garde Europeans: in Marcel Duchamp's *Nude Descending a Staircase*, the scandal of the show, a woman's body was reduced to slate-colored planar slices. Picasso's bronze *Bust*, lent by Alfred Stieglitz, defined the head as a pile of misplaced, misshapen features entirely composed of protuberances and gouged-out cavities.[16] Seen as a renegade who knew how to draw, Matisse was the target of particular venom from conservative critics for his hymns to color, exemplified by *The Red Studio*. The Armory Show's revelation of expressionist, fauvist, and cubist experiment was found more offensive as these provocative works hung side by side with masters of postimpressionism whose art had just recently been assimilated by American taste: only two years earlier, in 1911, Stieglitz had given Cézanne his first one-man show in America. It had not been long ago, moreover, when paintings by Americans well represented at the Armory Show—Robert Henri, Glackens, Sloan, Bellows, chroniclers of gritty urban reality who called themselves the Eight but were promptly dubbed the Ashcan School—had seemed revolutionary in their unseemly subject matter and careless handling of paint. Clearly, there was no limit to what the credulous would consider art.

Throngs surged through the exhibits—seventy thousand before the show went on to the Art Institute of Chicago. They gawked, mocked,

pondered, and sometimes even admired the sculpture and paintings displayed on burlap-covered partitions decorated with boughs of evergreen, echoing the show's symbol, the fir tree. Every man and woman, pundit and politician—all felt moved to pronounce on the outrageous new art. Former President Roosevelt obliged: the Navajo rug in his bathroom displayed more talent in its making, he said.

If Georgia read about the event in the Texas newspapers, it might have been taking place in another world. She didn't miss being there; she had never liked New York.

From her first visit to 291 five years before, when the Rodin drawings struck her as a bunch of "scribbles," Georgia had slowly come to admire the daring deliberateness of the Armory Show's more radical exhibitors. In the interval, she had studied reproductions of Picasso, Braque, and Matisse found in Stieglitz's *Camera Work*, and she would be still more fascinated by the work illustrated in another milestone publication, *Cubists and Post Impressionism*, by the Chicago lawyer and collector Arthur Jerome Eddy. In her own painting, however, O'Keeffe would rarely venture from the charmed confines of conventional beauty: the natural forms of flowers, the sublime of landscape, making exquisite the ordinary clamshell—even the cow skulls she painted would be bleached on her New Mexico patio until they attained the state of purest whiteness. "A study must be accurate," Dow declared. "A composition must be beautiful."[17] O'Keeffe seldom deviated from the lesson of the master.

WHETHER through overwork, lack of impulse, or time required for her ideas to gestate, O'Keeffe did little work during her two years in Amarillo. Perhaps she felt overwhelmed. Her impressions of Texas seemed to demand a period of assimilation related to the immensity of what she saw—the disjunctures of scale caused by the endless vaulted sky, the oceanic plains in which a herd of cattle or a train appear as the barest visibility, the canyons that seemed like "slits" in an infinity of brown flatness—and were painted later and largely from memory.

When she returned to Amarillo in the fall of 1913 for her second year of teaching, Georgia discovered that during her summer in Charlottesville the school board had ordered the Prang copybooks she had adamantly rejected. Being overruled in this area was tantamount to repudiation: her employers clearly wanted this year to be her last. She had few supporters and fewer friends in town. At best, her friendly manner had managed to neutralize gossip about her eccentric masculine

garb. "She dressed like a man," one of her students recalled. "I never saw her in anything except tailored suits. I mean men-tailored suits and oxfords that were square toed. . . . Her hair was cut just like a man's, short. . . . She wore a man's type felt hat."[18]

The following June, she left Amarillo for good. When she returned to Charlottesville for her second summer as Bement's assistant, he convinced her that it was time she studied with his mentor and Teachers College colleague Arthur Wesley Dow.

Life in the house on Wertland Street was more dismal than ever. The brief family reunion was over. Francis O'Keeffe had taken to the road, ostensibly in search of work. His visits home were sporadic. He was no longer listed on the tax rolls as head of household or even resident of Charlottesville. Indeed, there is no further official record of him until his death four years later.

Ida's student boarders had left; either her tuberculosis was now widely known or she was too weak to provide meals. A couple appear to have been the only other adults in residence. Before she could leave for New York Georgia had to persuade them to remain through the winter. Georgia's brothers were gone; Catherine and Anita were away, training to be nurses; sister Ida's whereabouts were problematic;[19] Claudia, still in high school, was too young to be responsible for a dying woman. Not least, rent money was badly needed.

Savings from her three-hundred-dollar salary in Amarillo and whatever she could hoard from the university summer session had to last Georgia an expensive nine months in New York. Anna Barringer, her friend and fellow art teacher in Virginia, daughter of the dean of the medical faculty in Charlottesville, had a full scholarship at Teachers College. Ida's notions of pride were passed on to her daughters: it seems never to have occurred to Georgia to apply for any subvention, either at the Art Students League or at Teachers College. Nor did any of Ida's adult children, apparently, feel any obligation to help the impoverished household on Wertland Street.

In New York, Georgia had to count every penny. She found a room around the corner from Teachers College costing four dollars a week. It was just large enough for a bed, a small dressing table, and a chair. The only decorative touch, according to Anita Pollitzer, was the pot of red geraniums on the fire escape.

"I went mad with color, that winter in New York," O'Keeffe recalled.[20] (Sadly, she seems to have destroyed most of this work the following spring.) Whatever else she had to do without, "her colors were always the brightest, her palette the cleanest, her brushes the best,"[21]

Anita Pollitzer remembered. In her person, too, she had the fastidious pride of poverty; making good use of the nuns' sewing lessons (as she would do throughout her life while her sight held), she could still "stand apart in the fineness of her dress";[22] underneath her beautifully cut suit of the best material, her white handmade shirtwaists were crisply starched.

Georgia's dignity made her seem haughty, Anita explained. She knew only too well the cost of everything—including missed opportunity and time lost. She was twenty-seven, after all. She spoke with "an air of authority and no words wasted. . . . She looked neither right nor left, unless it furthered the work she had come to New York to do. There was never an idle moment or gesture."[23]

Georgia had a devouring ambition that set her apart from her fellow students more than her poverty and elegance did. "There was something insatiable about her," Anita said.[24] Georgia, seven years Anita's senior and older than most of her fellow students, felt behind schedule. "I want everything and I want it now," she told her younger friend.[25]

What she needed, in that winter–spring of 1914–1915, was one last year in the dependent yet privileged role of "best student"—the compensation most often sought by the unfavored child. Under "Pa" Dow's sponsorship at the college, she could safely "regress" to join the beginners, doing charcoal abstractions to music of differing tempos with Bement's freshmen; at the same time, she could enjoy the special status of the advanced student. While the neophytes dutifully copied plaster casts, Georgia, Anita, and a young woman named Dorothy True were allowed to compose their own still lifes, set apart from the others by their talent, inventiveness, and, ultimately, the intensity of their friendship.

Six years younger than O'Keeffe, Dorothy True at twenty-one was a glamorous young woman from Mechanics Falls, Maine, with dark blond hair and a precocious history of stormy love affairs. Like Anita Pollitzer, she came from a family of wealth and social position; the Trues had been among the earliest settlers of Maine but, far from sinking into rural poverty like many old New England scions had done, Dorothy's father, Frank True, had sold his wholesale grocery business to become director and major stockholder of a successful Portland paper company.

From the beginning, the three-way relationship was fraught with undercurrents of jealousy and evasiveness. Anita and Dorothy had become close friends the year before Georgia arrived in New York. Yet it would seem that shortly after Anita introduced them, Georgia developed

a more intimate relationship with the sophisticated and seductive young woman from Maine.

Anita and Dorothy, later joined occasionally by Georgia, often took the long omnibus ride from Teachers College to Stieglitz's gallery 291. The alluring Miss True clearly captivated Alfred Stieglitz; he photographed her as the quintessential flapper—a composition that an accident of printing turned into a proto Man Ray surrealist montage; an icon of fetishism, True appears with bobbed hair and darkly lipsticked mouth superimposed on the profiled curve of her shapely leg, defined by a black lace stocking; her pump, with its aggressively pointed toe, immortalizes the woman as vamp, a classic femme fatale of her period.

Spellbound, perhaps, by Dorothy's powerful sexuality, Stieglitz did not appear to focus on O'Keeffe; she may also have chosen to stay out of the line of fire, as she did at the Rodin exhibition of 1908. But Georgia made at least three visits—and possibly more—to the gallery during the academic year 1914–1915. Sometime between December 9 and January 11, exactly a year before Anita would bring Georgia's charcoal drawings to Stieglitz, O'Keeffe visited 291 for an exhibition of Braque and Picasso charcoal drawings and oils, works owned by the French painter Francis Picabia and his wife, who were sitting out the war in New York. In February or March, she went to see an exhibit of forty-seven works by John Marin.

By now, O'Keeffe had gotten used to Stieglitz's aggressive style: she was no longer put off by the long harangues and hectoring challenges, laced with highly personal questions. Significantly, their first conversation was about money. Georgia's reserve melted with her interest in the SOLD label on one Marin drawing; was it really possible, she asked Stieglitz, for an artist to support himself by selling a work like that wonderful sketch pinned to the door of his office? Yes, Stieglitz told her, followed by a litany of complaints about Marin's extravagance: the artist had bought a Maine island with a recent one-thousand-dollar check from 291 sales.[26] (Earlier, the birth of Marin's son had occasioned similarly scolding remarks about the ruinous toll children exacted from art.)

Georgia was intrigued enough to return to the gallery—without the excuse of an exhibition. She went back to 291 at the end of the spring 1915 season; the walls were bare and the floor was dirty. She heard voices behind the curtain separating the gallery from Stieglitz's tiny office, but she did not venture farther. She wrote to Anita that she had gone back only to immerse herself in the spirit of 291 before returning to the South. The "spirit of 291" was Alfred Stieglitz's favorite phrase;

in letters to those who had been part of that magic circle, he signed with those words alone.

THAT SUMMER when she returned to Charlottesville, Georgia taught three classes in Bement's advanced design and fell in love.

At twenty-five, Arthur Whittier Macmahon was three years younger than O'Keeffe. An instructor of political science at Columbia University and Barnard College, he was teaching summer school with Georgia and his Columbia colleague Alon Bement, who may have introduced them.

Slight and serious, Arthur was handsome in the Arrow-collar style of the period, with a knife-sharp part in his hair. He came from a family of free-thinking clergy and academics, originally from Brooklyn, who had moved to suburban New Jersey. The Macmahons appear to have had independent means; they could afford to subsidize their daughter's studies in design at Pratt along with European travel for Arthur on his graduation from Columbia in 1912. His companion on the trip was his college roommate Randolph Bourne.

A precociously brilliant social critic, Bourne as an undergraduate wrote essays on education, published in the *Atlantic Monthly*, that made him a thorn in the side of the Columbia administration and a hero to his liberal contemporaries. Hunchbacked and crippled, with a large, misshapen head, Bourne took an uncompromising stance on every issue; in particular, his intransigent pacifism amidst the general war hysteria soon terrified more conventional—or opportunistic—Progressives like Walter Lippmann, his fellow contributor to *The New Republic*. On his death in the flue epidemic of 1918, Bourne was mourned as the conscience of his generation.

Macmahon seems to have shared Bourne's antiwar beliefs, along with the advanced views of those who have been since described as the "lyrical left,"[27] characterized by a concern with individual self-fulfillment through group movements such as feminism and trade unionism. (The unfrivolous grand tour of the two young men concentrated on visits to factories in Germany and Scandinavia.)

Aware of Bourne's fame among the enlightened, Georgia was proud of his close connection to Macmahon. Besides the deep feeling for nature, the "mania for tramping"[28] that she and Arthur shared, she clearly found another mentor in the young political scientist to replace Alon Bement, whom she had already outgrown.

After summer school ended, Arthur stayed four days longer; he and Georgia spent much of the time together, walking in the piney hill country near Charlottesville. "The Professor," as Georgia jokingly called

Macmahon in letters to Anita, "gave me so many new things to think about and we never fussed and never got slushy. I had a beautiful time and I guess he did too."[29] Arthur's high marks for "unslushy" behavior, however, pointed to a pattern that marked her other relationships with passive men. Georgia took the initiative.

When Macmahon returned to New York and his Columbia classes, he left a trunk of books for Georgia to forward. Using this errand as an excuse, she wrote to Arthur: "I just had to tell you about the box—and of course I wanted to say more—but to be perfectly honest—I started not to—then I thought no—that would be playing a game—and games don't interest me like they do most women. I wanted to write you so I will."[30] By laying bare her conflict—her desire for openness about her feelings against her fear of appearing too bold—she managed to get credit for both courage and maidenly modesty, along with the reminder to Arthur that she was superior to other games-playing women. His reply was reassuring. Now that Arthur, safely back in the parental villa, advanced, Georgia could retreat: "If you knew how very much afraid I am to say and do things some times you would think my nerve in doing them inexcusable,"[31] she wrote the week following her initial letter. Her third letter, in reply to a second warm note from him, confessed to still greater fear: "I will send you something when I want to . . . and I can—I'm always afraid."[32] (Was Macmahon too flattered to wonder why this intense young woman—clearly no free spirit—behaved in ways that caused her so much terror?)

Meanwhile, Georgia was still jobless. She would have liked to return to New York to be near Anita, her "Little One," she wrote Pollitzer, to see Arthur, and to take care of the tempestuous Dorothy True. Remembering the Chicago years, Georgia saw clearly that the "strain" of earning money in a big city absorbed all one's energies; she needed the condition of maximum freedom (Is there such a word as "freeest"? she asked Anita). She wanted room for "fun," for making the kind of art she wanted to make, giving form to the ideas that were still in her head.[33] Her sister Anita had just returned home ill from nurse's training at St. Luke's Hospital in New York; the dying Ida was distraught at the prospect of Georgia's health failing far from home. Her only job offer was not alluring: teacher of drawing at Columbia College, a two-year Methodist school for women in the South Carolina city of the same name.

Typically, she decided not to decide until the very last minute. Perhaps she was hoping for a summons from Arthur. In the meantime, the voracious pupil worked hard at catching up with the course of reading begun at Arthur's behest: because he was interested in feminism, she

tackled Floyd Dell, *Women as World Builders*; she read "war books," including an analysis of British and German attitudes leading to the present hostilities. She devoured Arthur's favorite Hardy novel, *Jude the Obscure*. He sent her a gift subscription to *The New Republic*, along with a copy of Randolph Bourne's essays *Life and Youth*. Recognizing Arthur's views in his famous friend's articles, Georgia proudly suggested to Anita that as intimates, their ideas were completely shared. The essays could have been written by her "professor."[34]

On her own, Georgia decided she must have a subscription to *The Masses*, the literary and political magazine of social protest whose covers featured the most powerful graphics in American political art; she begged Anita for the loan of her copies of Stieglitz's *Camera Work*, the sumptuous quarterly containing exquisite reproductions of photographs using the new photogravure technique, other illustrations of contemporary art exhibited at 291, and, in a recent issue, avant-garde writing by a Miss Gertrude Stein.

Georgia was "crazy about" a more lighthearted "son of *Camera Work*": the jaunty, satirical 291, with caricatures and drawings by its editors, the Young Turks of the Stieglitz circle—Marius de Zayas and Picabia—and with editorials featuring parodies of conservative critics.[35]

She continued with the violin, practicing in her basement studio on Wertland Street; however unsatisfactory the sound, she was listening for connections, correspondences to what she would paint. She tried the hollyhocks outside her window. Displeased with the results, she sent the picture to Anita anyway, promising to make a new, less realistic version. But it would have to be from memory. Summer was over; most of the flowers were dead.

FOUR

The Will to Art and the Will to Power

Alfred Stieglitz at 291 (about 1905). Alfred, in his early forties,
presiding over the first gallery in New York to show photography and
avant-garde art.

NO ALTERNATIVE to the Methodists materialized. Four days before
the semester began, Georgia wired Columbia College of her acceptance.

In the meantime, she had converted a miserably paid job that she
didn't want into a test of vocation: if she couldn't develop as an artist
in solitude, working on the ideas she was "crazy to try," stimulated by
letters from friends, by reading, and by her own "fun in living," she
wasn't worth much, she wrote to Anita.[1]

On the eve of her departure for South Carolina, the day before
classes began on September 4, Georgia's only regret concerned Dorothy
True. She longed to return to New York, she told Anita, because Dor-
othy needed her desperately. She seems to have felt accused by her
friend's unhappiness, and she rationalized her guilt at abandoning True
by deciding that True would be better off without her. Georgia then
elaborated a fantasy of protectiveness about the fragile Dorothy: reading
True's despairing letters made her feel she would "give most anything

in the world to just pick her up and lift her above and away from all the things that bother and worry her so. . . . I want to take her away from it all for always," she wrote to Anita.[2]

When she arrived in Columbia during the humid first week of September, Georgia's grandiose rhetoric of freedom in exile confronted the reality of her situation.

All but destroyed by fire three times since its founding in 1856, the college was barely solvent. In fall 1915, there were ten faculty members and one hundred fifty students, many of whose families were among the "cotton poor," unable to pay tuition because of the drop in cotton prices caused by the war.

The school, at the end of a two-mile trolley ride from town, still bore the scars of the last devastating fire of 1909 that had left every building a charred ruin. In 1914, the year before Georgia's arrival, the punishment of those students who had cut classes to hold a suffragist rally in town was to spend the remainder of the semester clearing rocks and brick from the still rubble-strewn campus! (The southern tradition of the chain gang was not, apparently, confined to prisons.) Bursts of political activism were rare, however; the typical student was there to qualify as a music teacher if, by graduation, she had failed to find a husband at nearby Clemson University. While waiting, she was more likely to join the Fudge Club or the Daughters of Do Nothing.[3]

Georgia's only gifted student was a private pupil. She waxed lyrical to Anita about Adelaide, the eleven-year-old daughter of the college music director. With yellow hair like Dorothy's, the child was an astonishing combination of innocent sprite and precocious sophisticate, incapable (so her teacher claimed) of work that wasn't original and interesting. By way of proof, Georgia sent Anita examples of the prodigy's talent, along with a sketch of the young artist by her teacher. (Anita did not share Georgia's exalted view of Adelaide's gifts; her work was just what one would expect of an eleven-year-old, she observed drily.)

The only other company Georgia found bearable was a young English professor and his family, crammed into quarters down the hall from her dormitory room. In fact, she had already met James Ariail, a Spenser and Swinburne specialist, in Chicago. Now, in gratitude for their hospitality, she painted a portrait of their young daughter Sally Cecelia.*

After Georgia left for the South, Anita dropped by 291 to report on her friend's new job and to mourn her absence from New York. Stieglitz commiserated with her, although it is doubtful whether he retained

* Cecelia perished, along with her portrait, in yet another fire that destroyed most of the college in the 1960s.

more than a fleeting memory of the silent, stern-looking young woman who had visited the gallery with the lively Anita and seductive Dorothy. Anita described O'Keeffe's heroic efforts to make something new in alien surroundings. " 'When she gets her money—she'll do Art with it,' " Anita reported Stieglitz's response. " 'If she'll get anywhere—its worth going to Hell to get there'—Perhaps that'll help you teach for a week!" Anita concluded triumphantly.[4]

Throughout the fall, Georgia and Arthur exchanged letters sporadically, and Georgia took care to sound positive and energetic. She exulted in the beauty of the countryside near Columbia, the pleasure of solitary walks (a reminder too of their tramps together). Knowing of Arthur's progressive faith in the power of education, she professed to feel happily challenged by the ignorance of her students and the smug philistinism of her colleagues.

To Anita, Georgia gave a very different account of her state of mind. At about the same time as her buoyant letters to Arthur, she wrote of feeling severely depressed, describing herself as feeling "all sick inside." She felt numb, overwhelmed by a sense of nothingness. She had the sensation of shriveling up, "as if I could . . . blow away right now," she wrote to Anita. She felt as empty as the white boards and canvases she had been compulsively priming in the hope that she would feel like working. The freedom she had eagerly anticipated in August mocked her now. A terrible blankness had replaced the ideas that she had been longing to try only a month before.[5]

Worst of all was the deadness of feeling—the loss of affect—that is the most frightening symptom of depression. Everyone around her seemed dead, automata going through the motions of living (a projection of her own depressed state); there was nothing, no one who inspired either love or hate.

Loss is made more painful by memories of happiness; Georgia grieved recalling what she had left behind: the intense affections, the devouring of experience that she, Anita, and Dorothy took for granted; the exchange of ideas that made talks with Arthur full of excitement. In this backwater, people lived in a state of entropy; their lives just evaporated, she told Anita. And she feared becoming one of them.[6]

Georgia's despairing words to Anita on the failure of feeling in the lives around her were followed by a stern lecture to her friend on the dangers of letting go.

At twenty-eight, O'Keeffe held to a theory of the emotions that explained much about her relations with friends and lovers for the rest of her life. Like the Victorian's view of sexual energy, Georgia's belief was that intense feelings were finite; they must be saved for the objects

in life that count. She warned the generous, impulsive Anita to keep "a string on yourself"; otherwise, she would exhaust all her resources now, leaving nothing for the future. Even self-control was not enough, she cautioned Pollitzer. "I think we must even keep ourselves from feeling to [sic] much . . . if we are going to keep sane and see with a clear unprejudiced vision."[7]

For O'Keeffe, the metaphor of seeing clearly was crucial to her as an artist, giving objective form to both feelings and ideas. The conflict between the woman and the artist, between art and life, was preparing itself.

Scarred by a childhood of scarcity and gradual impoverishment, Georgia could not afford emotional or sexual extravagance: Shakespeare's "expense of feeling in a waste of shame" came to describe love, not lust, in her accounting system. If she lost her head, there would be nothing left of her. Throughout this letter, among the most revealing O'Keeffe would ever write, she moved between the physical and emotional, the symbolic and concrete meanings of conservation and loss.

With the prevailing nineteenth-century view of consumption as a disease of the spirit, Ida's wasted form haunts Georgia's fearful calculations. Living through others, her mother had literally been consumed by bitterness and disappointment. Georgia's own emotional capital would be carefully invested.

She apologized to Anita for her "scolding" tone. Her friend would not have been fooled. Georgia's own fear of devastation glared through her cautionary words. It was herself she warned.

The cause of this double lecture had been a letter from Arthur Macmahon. With a curious mix of exhibitionism and evasion, Georgia was in the habit of sending Anita her lover's passionate outpourings while parrying her friend's queries about the course of the relationship. Behind her facade of the "new woman," Georgia railed against the hold that Arthur exerted over her; she was obsessed with him. Characteristically self-protective, she decided that it was disrespectful to fall in love with him simply because her life lacked other distractions. "Disgusting" is her judgment of passion by default, an "insult" to Arthur's honesty.[8]

Anita musn't start imagining things, Georgia warned disingenuously; she had shown her Arthur's letter only because of his unusually forthright words. She in no way reciprocated his feelings. Only occasionally, her terrible fatigue craved the calm he seemed to be able to give her. As Arthur appeared to be satisfied with her friendship, she felt under no obligation to dismiss him. But after this chilly and somewhat cynical acknowledgment that she was using Arthur, Georgia burst forth with

the plea that no one mention love to her again. If Anita valued her sanity, she too would flee passion. "It will eat you up and swallow you whole."[9]

Half-swallowed herself, Georgia struggled to break free. Attempting to rationalize her fall, she attributed her obsession with Arthur to the emotional and intellectual isolation of Columbia College. Confused, restless, isolated, unable to work, and with too much time on her hands, she was "nearer being in love with [Arthur] than I wanted to be" and "going on like a fool," she wrote Anita sternly.[10] Love, like nature, had merely rushed in to fill the vacuum of her present life.

Seizing the initiative with the passive young professor was one defense against loss of control. Another, still more familiar strategy adopted by Georgia was safety in numbers.

His name was Hansen and, like Macmahon, he was several years Georgia's junior. He was so "good to look at," Georgia wrote to Anita, that other women wondered how she had managed to enthrall this mysterious man who had so far resisted all romantic involvements. She had known him for a long time, she said. Right now, he was teaching poor children. Like them, he had suffered a "cramped and twisted" childhood, she explained, and he wanted to give something back before embarking on his lifework. He had visited Georgia in Charlottesville during the summer just past; the earlier months of his vacation he had spent "wandering" New York's Lower East Side.[11]

O'Keeffe's handsome and committed young teacher was very probably Marcus Lee Hansen, whose lifework as a sociologist studying welfare families and the immigrant poor secured him a posthumous Pulitzer Prize in 1941. Raised, like Georgia, in rural Wisconsin, Hansen never married and was still described as ruggedly good-looking in the years just before his premature death in 1938. More tellingly, his studies on immigration reflected a sympathy for the excluded that touched O'Keeffe.

With a barely literate, feckless father the cause of her family's decline, Georgia was attracted by the steadiness and security promised by highly focused young teacher/scholars like Macmahon and Hansen. Their youth and inexperience with women prompted her to take the lead emotionally and sexually, while the serious social engagement of the young reformers allowed her to defer to them as intellectual and moral guides.

Now that she had amortized the investment of her feelings, she could allow herself to respond to the ardent intimacies of both Hansen

and Macmahon on paper; in this mailing to Anita, she enclosed a letter
from Hansen along with a disclaimer that it was "only a human docu-
ment." But as she would often do, Georgia paired this offhand remark
with a contradictory one: when she had finished reading Hansen's words,
she told Anita, she felt as though her "soul had been peeled and sand
papered."[12]

Her tumultuous feelings about Hansen found expression in a series
of watercolors, which she sent Anita. The past summer, "when one of
his letters almost drove me crazy," she recalled, when she didn't dare
tell him what she wanted to say, she had made "that wild blue picture
with the yellow and red ball in the corner." Hansen himself Georgia
identified as the "little blue mountain with the green streak across it."[13]
In the same letter, she included a drawing that she explained as "Po-
litical Science [Arthur] and me—dabbling our feet in the water." On
their last outing, Arthur had urged her to plunge her feet in a deep,
swiftly running mountain stream to feel the rhythm of the water. Some-
thing about the proper young scholar suggested that he was not the free
spirit he seemed to be. Georgia had kept her stockings on.

Later, both O'Keeffe and Stieglitz would do portraits of lovers trans-
formed, like the Greek goddess, into trees. For the present, Georgia's
redemption of impotent words into powerful images suggests that she
experimented with color abstraction at an earlier date than has usually
been supposed on the basis of surviving work.

In their emotional and sexual transparency, her new "wild" and
"insane" works—in Georgia's words—"bothered" her. As soon as she
mailed the pictures to Dorothy True (the first recipient of her new work
in the complicated round-robin of communiqués among the three
friends), she had regrets.[14]

Why did Georgia feel so troubled about Dorothy seeing these wa-
tercolors? Did she fear that the images, as the expression of her erotic
feelings for two men, would be read as betrayal? Her particular worry
about Dorothy's reaction became generalized anxiety. Admitting that
she was "perfectly inconsistent" in hating to show her work, she ex-
plained: "I am afraid people wont understand and—and I hope they
wont—and am afraid they will. . . . they are at your mercy," she
announced to Anita histrionically. "Do as you please with them."[15]

Besides Anita, there was one other exception to Georgia's fear of
showing her work: "I believe I would rather have Stieglitz like some
thing—anything I had done—than anyone else I know of—I have always
thought that—If I ever make any thing that satisfies me even ever so
little—I am going to show it to him to find out if it's any good."[16]

But within a few weeks, she had decided that none of the work she

had done so far was "any good." In particular, she felt a sudden revulsion toward the color she had "gone mad over" less than a year earlier. "The things I've done that satisfy me most are charcoal landscapes—and—things—the colors I seem to want to use absolutely nauseate me. . . .

"Im floundering as usual," she added.[17]

Then, like color, landscape as subject matter was abandoned, releasing a freedom to experiment with expressive abstract forms: "I made a crazy thing last week," she wrote to Anita later in October, "charcoal—somewhat like myself—like I was feeling—keenly alive. . . . Something wonderful about it all—but it looks lost—I am lost you know."[18]

AT THE END of November, Georgia's elaborate defenses against Macmahon's advance-and-retreat behavior crumbled when Arthur wrote announcing his imminent visit. Before beginning a brief tour of southern universities, he planned to spend part of the Thanksgiving holiday with her in Columbia. Arthur's letter, giving Georgia his train and arrival time, made her so happy that "Im almost afraid Im going to die,"[19] she wrote to Anita. To the traveler, she confessed to being "the gladdest person in the world."[20]

The four days they were together exceeded Georgia's ecstatic anticipation of their reunion. They hiked in the mild southern autumn, took pictures of each other, talked, and made love: "I wondered if you had done what I wanted you to last night—and couldn't but laugh—I suppose you did but I can't remember when or where or how? Maybe I did it," she wrote to Arthur in a letter he would find on his return to New York.[21] She would regret her aggressive behavior, she told him, only if he should develop second thoughts about visiting her in the spring. For they had made plans to be together again—a measure of Georgia's passion, she who ferociously resisted planning ahead. Arthur was going to rent a cabin near Asheville with his mother and sister as official chaperones. He had even proposed inviting Anita. "Wasn't it nice for him to think of it?" Georgia wrote her friend.[22]

After he left, Georgia felt "stunned," she said. "I dont seem to be able to collect my wits—and the world looks all new to me."[23]

When her elation ebbed, she felt so desolate that she came close to taking all her savings and heading to New York for the Christmas holidays. In the absence of an invitation from Arthur, common sense prevailed. She stayed alone in Columbia and worked—always, for Georgia, the most reliable remedy for despair.

A few weeks earlier, her disgust with color and landscape had turned her toward "crazy" things in charcoal. In the agony of yearning to go

to New York, she had done no work at all. Now she was ready to begin again. She had been too immersed in the color theories of Kandinsky, the American art critic Willard Huntington Wright, and Dow himself; a genius like the Russian artist could transcend his own system, which found analogues in both the emotions and the musical tones for the color spectrum. For others, self-consciousness or even paralysis threatened as they pondered the palette's symbolic possibilities. (Anita's letters are rife with discussions of why she is planning to paint a female figure blue!) For O'Keeffe, abandoning the sensuous, expressive properties of color had a liberating effect that she herself explained as the freedom to go backward—"like learning to walk again."

"Did you ever have something to say and feel as if the whole side of the wall wouldn't be big enough to say it on and then sit down on the floor and try to get it on to a sheet of charcoal paper—and when you had put it down look at it and try to put into words what you have been trying to say with just marks," she wrote to Anita. [24]

Crawling around on the floor "till I have cramps in my feet" allowed O'Keeffe to forget her readings and to reach for the forms that could encompass memory and experience.

Where the vivid pastels and watercolors had been small in scale, her new work, using only charcoal, was done on large sheets of cheap drawing paper, whose size was now an element in her state of creative ferment. O'Keeffe's "action drawing"—with the importance of the gestural, the physical act of making the work—looks ahead to the abstract expressionists. Expansion of scale liberated both, releasing energy that, for Georgia, was the more intense as her palette was drastically restricted.

Dissatisfied with some of the results—"one creation looks to [sic] much like T.C. [Teachers College], the other is much like soft soap"— she knew what was in her head, but the shapes and forms whirling around still resisted translation in words or image: "I wonder if I am a raving lunatic for trying to make these things," she wrote.

In her frenzy to get them all down, she didn't even care. This was Georgia's last letter to Anita before the new year of 1916; shortly after Christmas, she would send the drawings themselves.

"I hope you love me a little tonight—I seem to want everybody in the world to," Georgia ended. [25]

MORE THAN anyone else, she wanted Arthur to love her, she told him. In letters written over the solitary Christmas in Columbia, Georgia confided her longing to see him, to kiss his hair and eyes. [26] The drawings

she was making on her knees on the studio floor late at night drew on desire. "I said something to you in charcoal," she wrote to him about the works she called *Specials*. [27]

Charged with erotic tension, the charcoal drawings Alfred Stieglitz saw on New Year's Day 1916 were freighted with the polarities that the impresario of 291 called "the linear graphing of the male and female principle."[28]

Jagged, saw-toothed forms or rigid diagonal bars slash through organic shapes: budlike, bulbous, or billowing; encircled by the lipped mouth of a cavernous opening, a jet cradling a dark, shiny ovoid spurts upward from a fountain of pale curved forms. Other drawings are built of ropey, tubular elements that hang like stalactites; surfaces are pocked by a pattern suggesting boiling liquid.

Complementary or conflicting, merged or isolated, the generative forms that were the basis of O'Keeffe's vocabulary would never receive more dynamic expression than in her charcoal drawings of 1915.

Learning to walk again, in black and white, also tripped the wires of visual memory. Material unused or forgotten in O'Keeffe's work in color was suddenly available; the unfolding bud motif in these early works is typical of arts and crafts movement pottery;[29] spills of dark forms on a light ground suggest that O'Keeffe had studied Tiffany vases whose pattern gave them the name "lava glass." Her veiled and folded forms reminiscent of draped fabric are reminders that Georgia sewed her own clothes. Even the painful Chicago years released a reserve of visual images. Stippled openwork patterns recall the texture of lace, magnified. Echoes of Sullivan's tendrils appear and reappear in O'Keeffe's favorite crook form—an element she would retain when she took up color again early in 1916.

As always, she knew what was best for her and her art. Locking the door of the studio, getting down on the floor with only the big sheets of paper and a stick of charcoal in her fingers, was more than a return to basics. Form and feeling, conscious and unconscious, past and present, male and female were forged into a visual language at once intimate and immediately accessible.

WHEN SHE TOOK the drawings from their roll that New Year's morning, Anita's discerning eye recognized what we would call a breakthrough. No longer the experiments of an art student, the charcoals showed a boldness and authority that marked another order of creation: the work of an artist.

"They've gotten there," she assured Georgia, "past the personal stage

into the big sort of emotions that are common to big people—but it's your version of it."[30] No one has ever better expressed the transformation of a private vision into the universality of art.

Georgia's outpouring of gratitude to Anita for acting as mediator, along with her rush of delight on hearing of Stieglitz's response to the work, leaves no doubt as to the artist's intentions: her stated instructions to her friend—that the drawings were for Anita's eyes only—were meant to be ignored.

"There seems to be nothing for me to say except thank you—very calmly and quietly," she began her letter to Anita on January 4, 1916. And by way of further reassurance that her friend had carried out her real wishes, she added: "I am glad you showed the things to Steiglitz [*sic*]—but how on earth am I ever going to thank you or get even with you," she wrote mischievously.[31]

O'Keeffe reacted uneasily to Stieglitz's ecstatic discovery of the Eternal Feminine in the drawings. He had acknowledged her to be an " 'unusual woman . . . broad minded . . . bigger than most women,' " and Georgia basked in "exceptionalism." On the other hand, she recognized that the package in which Stieglitz planned to wrap her could turn into a cage. He had locked her art into the box he would never open: " 'She's got the sensitive emotion,' " he had told Anita. " 'I'd know she was a woman—look at that line.' "[32]

Suddenly, she was dissatisfied with her work in progress: the "notions" that she was wasting all those sheets of paper to express were "rather effeminate,"[33] she told Anita, using a man's disparaging adjective for displaced femininity.

She wanted a different response from Stieglitz, not the scenario that she suspected had been prepared in advance, awaiting only its star.

This time, Georgia openly appointed Anita to act as go-between: could she please ask Stieglitz what he really found in her drawings. Then she changed her mind. A few days later, she wrote to Stieglitz herself. What did her drawings say to him? she wanted to know. "I make them just to express myself—Things I feel and want to say— haven't words for. You probably know without my saying it that I ask because I wonder if I got over to anyone what I wanted to say."[34]

Writing to Stieglitz, Georgia sounded the amateur and ingenue as never before. She knew she was to be reinvented; the form she was destined to take was in his hands. Her tone was meek, even self-effacing. Yet the message contained a reminder: she was something other than Woman, much more than the "Great Child" Stieglitz described to friends. She was twenty-eight.

"I know a few things,"[35] she would later slyly insist, countering

those who, like Alfred, had cast her in the role of innocent primitive.

Before a week had gone by, Stieglitz replied to Georgia's letter. But he didn't answer her question. The man who never stopped talking, who in as many as twenty-seven letters a day poured his intimate feelings, along with his thoughts on art and life, to friend and casual acquaintance alike, told O'Keeffe: "It is impossible for me to put into words what I saw and felt in your drawings. . . . I might give you what I received from them if you and I were to meet and talk about life. Possibly then through such a conversation I might make you feel what your drawings gave me."[36]

Stieglitz then weakened to the extent of telling O'Keeffe that the charcoals were a "real surprise" that gave him "much joy." And he concluded with a qualified promise: "If at all possible, I would like to show them, but . . . I do not quite know where I am just at present."[37]

For Alfred Stieglitz, the end of 1915 marked the twenty-fifth year since his return to America. During that time, he had tried and failed at the three bourgeois enterprises with which his parents had attempted to ensure his success and happiness: business, marriage, and fatherhood. With compensating symmetry, however, he had become the most famous American of his day in another trinity of roles: photographer, publisher, and promoter of avant-garde art.

Stieglitz's disaster as a businessman is particularly revealing for the light it casts on all of his troubled relationships, that with O'Keeffe included. His failure at commerce had little to do with the traditional conflict of the artistic temperament versus the money-grubbing values of the marketplace. Rather, in his role of employer, Stieglitz acted out a lifelong compulsion to feel isolated, misunderstood, and embattled while manifesting a total incapacity to comprehend or adjust to anyone else's values or needs or to communicate with others as equals.

One of the first photoengraving plants to use the new three-color printing process, the Heliochrome Company was owned principally by John Foord, Edward Stieglitz's friend and Lake George neighbor. A former *New York Times* editor, Foord had moved to Harper & Brothers by 1890, and he readily arranged a job for Alfred at Heliochrome. Pleased to end his absentee ownership, Foord sold one-third of the company to Edward, who in turn persuaded Louis Schubart and Joe Obermeyer, Alfred's Berlin roommates, to purchase the other shares, joining their friend as managing partners.

Although no runaway success, Heliochrome had good prospects and clients ranging from the saucy pink *Police Gazette* to the more respectable

G. P. Putnam's Sons and, by way of some mutual back scratching, the *American Amateur Photographer*, to which Alfred contributed editorials. Despite the partners' decision to change the name to the Photochrome Engraving Company, Alfred's brand of management doomed their enterprise from the start.

His last years in Germany had bred an impatience with the reactionary Old World attitude toward change: "The German," he cautioned his readers in an editorial, "is very conservative and slow in adopting anything new."[38] Now that he was back under the paternal thumb and miserable in America, Stieglitz embarked on what would become a lifelong exaltation of every Teutonic virtue, real or imagined, particularly as embodied in his favorite folk saint: the German worker. Thus, when he wasn't retailing accounts of the villainy, venality, double-dealing, and plain nastiness he encountered among his peers in the American business community, he was comparing the conscientious, competent, devoted German worker to his lazy, slipshod, and cynical American counterpart. Alfred's contempt, combined with a patronizing paternalism, especially outraged the traditionally proud, independent printers who were his employees.

More than his nostalgia for Germany, his antibusiness prejudice, or the romanticizing of craftsmanship over the "machine," it was Stieglitz's class blinkers that finally made it impossible for him to manage a small company: he was unable to communicate with, let alone enlist the best efforts of, those who worked to support themselves and their families.

Living at home with his hundred-dollar-a-month allowance from Edward, Alfred proposed to his employees that they accept reduced wages in slow periods in exchange for future profit sharing. His idea was met with outraged hostility and seems to have precipitated the end of his business career. When he left the firm in 1895, he did in fact give his hundred shares—purchased by Edward for one thousand dollars—to his employees. He could now play the double role he would juggle to the end of his life: the professional amateur and the father figure who remained a child.

Before the company was dissolved, the three partners forged longer-lived, if no more successful, alliances. In 1892, Louis Schubart married Alfred's sister Selma. And in a fashionable wedding at Sherry's the following November, Alfred celebrated his marriage to Emmeline Obermeyer, Joe's adored young sister.

WITH HER large dark eyes and heart-shaped face, spoiled by an excess of jaw, Emmy at twenty had the voluptuous, slightly sulky allure of the

girl on the cigar box lid. Alfred's own sour recollections of how he came to marry Emmy make no mention of any attraction or even affection on his part. He had been trapped, he said, into a loveless union by his parents and Joe Obermeyer. In one of Alfred's several versions of the event,* he had called on Emmy in the apartment the orphaned young woman shared with her older brother on the corner of Lexington Avenue and 73rd Street. Sitting in the parlor with him after dinner, Emmy had fallen asleep, her head on Alfred's shoulder. Reluctant to disturb her, Alfred had remained alone with Emmy in the parlor later than was seemly. When Joe came upon them, he announced that Alfred had compromised his sister and would be expected to "do the right thing."

As Alfred's oldest friend, Berlin drinking companion, and business partner, the sweet-tempered bon vivant bachelor Joe Obermeyer was an unlikely candidate to play the Victorian heavy, cynically trapping an innocent friend into marrying his sister. There is no reason to suppose, moreover, that Emmy, with her big brown eyes and bigger fortune, would not have had other suitors.

At the end of a lifetime spent proclaiming his disinterest in—indeed, his disdain for—money, Stieglitz confessed that he would never have married Emmy without her independent income:[39] the interest on capital of six hundred thousand dollars, representing her share in the Obermeyer and Liebmann brewery, combined with the mortgages on substantial real estate holdings. In any case, Alfred's attempt at equivocation—his suggestion of a five-year engagement, during which the other should feel free to disengage—was swiftly shot down by his father.

At thirty, his oldest son should be ready to marry. Edward promptly provided Alfred with an imposing diamond solitaire for Emmy. The size of the stone, Edward Stieglitz insisted, should be commensurate with the substantial fortune of the bride.

A picture of his fiancée taken by Alfred at Lake George shows the plump, sultry-looking young woman napping in the grass. The photographer's straw boater lies next to Emmy's body, abandoned to sleep. As in his serial portrait of O'Keeffe, Alfred's presence, in the form of a sexual claim to his subject, is an element of the composition.

Both the seductive promise of Emmeline as adoring young bride and her dreams of happiness with a famous and handsome older man were rapidly dissipated. The miseries of married life began on their honeymoon abroad. If Alfred's later account is to be believed, Emmy would

* His other version—still more unlikely—changes the setting of the compromising positions to a Lake George buggy ride.

not allow the marriage to be consummated until well after their return home. His reputation as a rake (gleaned from her brother) may have frightened her. With his experience confined to married women and prostitutes, he probably lacked any notion of what was required in the sexual initiation of a sheltered twenty-year-old girl. The most likely explanation is also the saddest: Alfred—never adept at disguising his feelings—could only have made it abundantly clear to Emmy that he cared nothing for her.

Their wedding trip lasted almost five months. Emmy's fear of heights—her refusal to stay above the fourth floor in hotels or to ride the funicular at Mürren—elicited no sympathy from Alfred. Her refusal to help carry his thirty pounds of equipment increased his irritability. He often went off alone at 4:00 A.M. to spend the day photographing. Terrified by his anger, Emmy became hysterical; in public, before the reserved Swiss-Germans, she accused him of trying to murder her. In her dreams, Alfred abandoned her in a burning hotel.[40]

Like other women of her class—including Alfred's mother and sisters—Emmeline had been brought up to regard travel as a stately progression from luxury liner to grand hotel, with days spent indulging in a little sightseeing, much shopping, and many rich meals. She found Alfred's passion for picturesque slumming—his peasants and fisherfolk—perverse. She begged to leave Venice; in the heat of midsummer, the smell of dead cats rising from the canal overwhelmed her.

Returning to New York in October, the newlyweds spent several months in a suite at the Savoy Plaza Hotel, among other places, while waiting for their apartment to be readied. Their new home, at 1111 Madison Avenue at 83rd Street, consisted of twelve rooms in the first luxury apartment building to be constructed east of Fifth Avenue.* From their sunny top floor, they had a splendid view of Central Park, which Alfred was soon to photograph for the first time in snow and in darkness, and of the Metropolitan Museum of Art, shortly to become the object of his most withering scorn.

To a startling degree, 1111 Madison replicated his parents' houses, both in town and at Lake George. A large staff of servants—cook, housekeeper, maid/waitress (soon to be joined by baby nurse and governess)—dusted and polished much ornate mahogany furniture and bric-a-brac. A reproduction of Alfred's favorite late Romantic German painting, von Stück's *Sin*, with its man-eating vampire, enjoyed the

* Gutted in the interests of efficient socialism, the handsome red brick building now houses the Mission of the People's Republic of Czechoslovakia.

place of honor in the salon, while a reproduction of a Rubens nude hung in the master bedroom. On the visual evidence alone, it was obvious that Alfred never left home; he took it with him. When those who associated Stieglitz with avant-garde art or with the austere "modern" simplicity of 291 visited him uptown, they were stunned. His insistence that 1111 Madison represented Emmy's overstuffed, overstaffed way of life persuaded some visitors. The more astute recognized his domestic setting as the real Stieglitz taste.

Dissociating himself from his bourgeois way of life was made both easier and more complicated by the fact that Emmeline paid all the bills. On Alfred's marriage, Edward had settled three thousand dollars a year on his son. It was far from the sixty thousand Alfred later claimed his father had promised him as his future yearly income when he was a student in Berlin,[41] but the allowance (the equivalent of twenty-seven thousand dollars in 1990) relieved Edward's firstborn of the stigma of living entirely on his wife's income and allowed him to pursue his photography and to sustain the illusion that he was self-supporting. Alfred's insistence that "he never touched Emmeline's money"[42] is, on one level, a classic instance of his lifelong obfuscation where finances were concerned. But in a deeper sense, his statement reveals a dissociation from reality at every level. As Stieglitz later explained the economics of his marriage, he only took his meals and used a "small room" for himself at 1111 Madison. The money he spent on helping "his" artists and on buying works of art was his own.

For, at about this time, Alfred had also begun collecting: he bought works by all the artists who would soon be shown at 291—Cézanne watercolors, Toulouse-Lautrec prints and posters, a Picasso sculpture. When Emmeline later went abroad without him, Alfred charged her to choose among two works by Brancusi. But like a child who believes that he lives on his allowance for movies and sodas, Alfred never considered the fact that his income was available to spend as he wished only because Emmy paid all of their living expenses. To be sure, this denial was made possible by the nineteenth-century convention that, socially if not legally, still allowed the wife's money to be controlled by her husband. Obermeyer and Liebmann checks, first endorsed by Emmy and then deposited by Alfred in his personal account,[43] subsidized the household, the annual trips abroad, and the education of their daughter, Kitty, born in 1898.

Emmeline's inclusion among the "Associates" of 291 also suggests that she contributed from her personal allowance to the gallery rent and the publication expenses of *Camera Work*, the sumptuous journal

of photography and the arts that would become another of Stieglitz's monuments. Bills for Alfred's daily lunches with the hungry artists who frequented 291 would be sent to Emmy at 1111 Madison.

Most important for Alfred among the benefits conferred by the Obermeyer fortune, he was no longer obliged to think of earning a living. He was free to take pictures and to promote his idea of what photography could and should become: a form of artistic expression that was neither a bastard child of painting nor a hobby for rich amateurs. These related pursuits—photographing, writing, publishing, organizing exhibitions, and establishing a political base in the camera clubs of the period—yoked what might otherwise have been conflicting drives: the will to art and the will to power.

WHILE SERVING TIME at Photochrome, Alfred had continued to take his own pictures. Then, in 1892, with great excitement, he bought one of the new 4 × 5 "snapshot" cameras. Small, light, and waterproof, it gave the photographer unprecedented mobility, which Alfred—as a measure also of his restless, unhappy state—began to exploit to the fullest. He became a wanderer in the city. Like many other lonely and talented young men of his time who, with notebook, sketch pad, or camera, set out to find their subjects in the streets, it was himself he sought.

In business, Alfred's insistence that his workers' interests were identical to his own helped destroy the Photochrome Company. In his photography, the projection of his sense of both the isolation and the oppression of urban life onto his subjects—New York's working poor—created unforgettable images of the powerless individual pitted against the modern city.

In *The Terminal*, taken in 1893, the year of his marriage, the driver watering his steaming horses in the cold slush of winter becomes, Stieglitz tells us, his double: a solitary worker struggling to endure and survive. Through the redemptive act of labor, he becomes one with suffering humanity.[44] Still, Alfred's pictures speak louder than his millions of words. He might claim to identify with those on the margins, but in his photographs they remain distant figures. Unlike the close-ups of New York's poor taken by his disciple Paul Strand, Stieglitz's photographs never show the faces of his "common people."

Far away and upside down in his lens, half-hidden by swirls of steam or snow, suffering humanity could engage Alfred's unequivocal empathy: he was always the organ-grinder waiting outside his father's house. Stieglitz's icons of the new industrial age—ocean liner, locomotive,

dirigible, and skyscraper—are all but literally deconstructed with irony and ambivalence. No structure summoned more of Alfred's love-hate relationship with the city—that "center of furious decay which was called growth and enterprise and greatness," in the words of his friend Lewis Mumford[45]—than the Flatiron Building.

The subject of one of his most famous photographs, the slender triangular structure had risen, under Alfred's watchful eye, through the winter of 1902–1903 at the junction of Fifth Avenue and Broadway on 23rd Street, near the Camera Club of New York. Then, on a day of heavy snow, he recalled, "I saw the building as I had never seen it before. It looked, from where I stood, as if it were moving toward me like the bow of a monster ocean steamer, a picture of the new America which was in the making." Yet when Edward Stieglitz asked his son why he lavished his time and talent on "that hideous building," Alfred told his father that the building "was to America what the Parthenon is to Greece,"[46] the embodiment of harmonious beauty.

The *Savoy Hotel, New York* (1898), a nocturne of Parisian elegance and glamor, was a first for Alfred: a night photograph taken in the rain. With the photographer-artist, we see the inviting luxury of the hotel from a distance; across a puddled pavement, carriages wait by the porte cochere whose globed lights shimmer in the mist. This image, too, mirrors Alfred's constructed self. He was part of this world; he and Emmy had spent seven months in the hotel's most luxurious suite. Yet he persistently portrayed himself as excluded, the outsider who would never belong.

In this respect, his own description of how he happened to take his most famous photograph is still more revealing of Alfred's fictive self. In a short text entitled "How *The Steerage* Happened" Stieglitz recalled that in the summer of 1907 he sailed for Europe, accompanied by Emmeline and nine-year-old Kitty: "My wife insisted upon going on the *Kaiser Wilhelm II*—the fashionable ship of the North German Lloyd at the time. . . . How I hated the atmosphere of the first class on the ship. One couldn't escape the 'nouveaux riches.' " By the third day out, Alfred ventured to the end of the deck where, looking down, he saw "men and women and children in the lower deck of the steerage." Along with this teeming life below stairs, he was fascinated by abstract shapes and contrasting tones: the round straw hat worn by a young man; the gangway bridge between the decks painted a fresh, dazzling white. "The whole scene fascinated me," he wrote.

> I longed to escape from my surroundings and join these people. . . . I saw shapes related to each other. I saw a picture of shapes and underlying that

of the feeling I had about life. And as I was deciding, should I try to put down this seemingly new vision that held me—people, the common people, the feeling of ship and ocean and sky and the feeling of release that I was away from the mob called the rich—Rembrandt came into my mind and I wondered would he have felt as I was feeling.[47]

With only one plate left in his camera, "heart thumping," Stieglitz took his picture; at the same time, one critic has noted, he "invented himself in Symbolist clichés," as a man suspended between two worlds: "a world that entraps and a world that liberates. The first world is populated by his wife and the nouveaux riches; the second by the 'common people.' "[48]

The ideological division Stieglitz proposes between these two worlds reflects the split between the clarity of the artist and the blindness of the man. From his first glance, Stieglitz was conscious of the abstract formal elements of his composition: the man's round straw boater, the diagonal of the gangplank. He would never see the crucial distinction between himself and his subjects: when he fled first class to become one of them, he always returned.

ALFRED'S PHOTOGRAPHY was soon to reach beyond the depiction of stoical suffering endured by artist and subject, beyond even the tension between Henry Adams's Virgin and Dynamo. Taking pictures became, for Stieglitz, who was small, frail, and prone to illness, an act of physical heroism.

On Washington's Birthday 1893, only five years after the "icy nightmare" of '88, New York was blanketed by another great blizzard. As Alfred recalled, he took his new "hand" camera, lightweight and waterproof, and, standing on the corner of Fifth Avenue and 34th Street, decided to photograph a horse-drawn coach as it lumbered northward through the wind-driven snow.

"Could what I was experiencing be put down with the slow plates and lenses available?" he wondered.

As soon as he had his shot, Alfred remembered, he rushed back to the New York Camera Club; even before the plate was dry, he was showing it to other members. "For God's sake, Stieglitz, throw that damned thing away. It is all blurred," one of them is supposed to have said. But the next day, the skeptic joined the spontaneous applause that greeted Alfred's projection of a lantern slide made from the same plate.[49]

An unspecified duration of time had become six hours spent battling the elements to get his picture: *Winter, Fifth Avenue.* In 1898, with *Icy Night*, he would add a high fever to his struggle against "gale force

winds, snow and sub-zero temperatures."[50] In describing this second triumph, Alfred recalled that, convalescing from pneumonia, he left his apartment in the dead of night. While a snowstorm raged through the empty streets, he climbed the wall separating Central Park from Fifth Avenue. On this occasion, the length of time he spent in the storm was unrecorded.[51] But he returned with the first photograph of snow at night, to join his series of pioneering images along with a new self-consciousness about photography as an art of male performance.

"This is the beginning of a new era," Alfred had informed his audience at the Camera Club in 1893. "Call it a new vision, if you wish."[52]

The new vision, of which Stieglitz proclaimed himself the seer, had already assumed form, a recognizable style, and a name: it awaited only a leader to become the cause or—to use Stieglitz's favorite embattled metaphor—the "struggle" he was seeking.

Pictorialism was the banner under which rallied a loosely affiliated group of photographers here and abroad: most notably, Clarence H. White, Gertrude Käsebier, and Anne W. Brigman in America; J. Craig Annan in Britain; and Robert Demachy in France. Serious and talented artists, they sought to rescue photography from its marginal status as an amusement of aesthetes and hobbyists, working toward its acceptance as an independent form of creative expression. Hobbling this goal from the very beginning, however, was the imitation of painting that dominated their work: from Whistler and impressionism, from the German Romantics and the French symbolists, pictorialists were haunted by pictures.

In their soft-focus, lyrical photographs, mothers gaze tenderly at exquisite children, picturesque cows enliven poetic landscapes, the moon rises through silvery tree trunks, and nude young women, tactfully veiled in mist, toss bubbles to one another. To achieve their painterly effects, photographers manipulated negatives, scratching the glass surface; and they printed on handmade or coated papers—Japan tissue, silvery platinum, or velvet-brown palladium, which they treated with gum bichromate before exposure. With the exception of scratching plates, Stieglitz occasionally used and passionately defended all these techniques. Pictorialism, as then defined by Alfred, was the battle for "individual expression." His own photographs, however, were already steering a course away from the artiness of art photography and the "manipulated" negative. Nonetheless, a leader needed followers; until "straight" photography offered an alternative struggle, pictorialism was the only war front, its troops the only Indians and Alfred their chief.

Although Stieglitz had been a failure as a conventional businessman,

he would prove a genius at takeover, acquisition, and merger. Made to order for his purposes, the camera clubs and societies of amateur photographers provided facilities, programs, networking activities, and publications.

Resigning as coeditor of the *American Amateur Photographer* in 1895, the same year he left the Photochrome Company, Alfred began working as unpaid volunteer for the Society of Amateur Photographers. Little more than a year later, he had brought about the merger of this group with the Camera Club to form the Camera Club of New York. With the instinct of the shrewd politician, he declined the more visible post of president in favor of the more powerful one: vice-president in charge of publications. As editor of *Camera Notes*, he transformed what had been an in-house newsletter into a vehicle to promote his ideas and his photographs as well as the exhibits and competitions he now began to organize and judge. This was his introduction to the importance of controlling media. He also brought into the club a group of disciple-assistants.

By the late 1890s, Stieglitz was secure in the acceptance of his own work, affirmed by the rewards, medals, prizes, and international renown that flowed from his well-publicized firsts and prolific writings. He had become the leader of an international movement whose rank and file included the most important photographers of the day. Only two elements—both crucial to politicians—were missing in his campaign for pictorialism: an organizational base and his own organ.

An occasional lawyer and photographer of misty pictorial persuasion, Joseph Turner Keiley was the first of the curious flock of remittance men and sometime journalists who became the original Stieglitz inner circle. The membership was characterized by independent incomes (essential, since Alfred never paid them a dime) combined with an infinite willingness to be exploited. Keiley, joined by John B. Kerfoot, Dallas Fuguet, and the more briefly tenured John B. Strauss, eventually relieved Alfred of the scut work of *Camera Notes* and supplied filler articles.

At the same time, "the men"—Alfred's macho designation for this distinctly unmacho crowd—were recognized by the majority of the Camera Club's members for the subversive element that they were; Alfred's personal staff soon became the most visible cause of demands for his ouster. The club's well-off amateur membership, sonorous with names of Knickerbocker New York, was incensed to learn from these nonentities that they now had to bargain with Stieglitz to include club news in their own journal, only to be informed by him that their work was unworthy of exhibition in their own headquarters.

Following a baroque series of charges and countercharges that lasted for years, Stieglitz was expelled from the club in 1907. After bringing suit against the trustees, he was reinstated. He then resigned. As a base of operations, the Camera Club had served its purpose; Alfred had already moved on.

FIVE

Gone to Look for America

PAUL STRAND, *Alfred Stieglitz at Lake George.*

ON A DULL March day in 1902, New York's first photo salon opened
at the National Arts Club on Madison Avenue at 30th Street. The title
of the exhibit—"American Pictorial Photography Arranged by the
'Photo-Secession' "—mystified everyone, including the photographers
invited to participate.

"What is this Photo-Secession? Am I a Photo-Secessionist?" Ger-
trude Käsebier asked Alfred Stieglitz, who had organized the show.

"Do you feel you are?" Alfred queried the veteran pictorialist. Käse-
bier thought she did. (She was, after all, one of the stars of the exhibit.)
"Well, that's all there is to it," Alfred replied.[1]

Asked to provide a title for the salon by the National Arts Club
exhibitions committee, he had seized on these fighting words as an
afterthought; he liked their echo of the Vienna Sezession, the self-
described group of young radical Austrian and German artists who had

joined forces to storm the Academy. The name was to be one of Alfred's most inspired flashes of promotional genius.

Pictorialism, as a movement, was aging and graying, becoming vague in concept and diffuse in membership; many of the misty images and heavy-handed genre subjects associated with the style were beginning to look old-fashioned to amateurs of advanced taste. Alfred's own photographs were increasingly characterized by a clarity and directness of both vision and technique; his mode of "seeing"—Alfred's favored word for a process of perception and intuition that went to the essence of art—had become less concerned with expressive statements of identity with suffering humanity and more consciously aware of abstract formal elements of composition. Ideologically, too, he needed a sharper focus and a more compelling cause.

Borrowing the battle cry of "secession," Stieglitz gave a revolutionary spin to his first entrepreneurial event, claiming for his exhibitors— mostly middle-aged amateurs of widely varying talents— the spirit of young rebels. Indeed, the question of just what Alfred's Photo-Secession was seceding from puzzled others besides "Granny" Käsebier. Still, the title was to prove more than a political slogan or an effort to infuse some youthful excitement into a movement whose genteel aestheticism was starting to look anemic. Stieglitz's new banner created, in the words of one critic, "an American identity"[2] for a group of photographers of widely disparate talents and interests. Although Photo-Secession, under Alfred's direction, would soon turn from photography to the promotion of European modernism, its New World identity—nominal at first— pointed in a direction that would join the destinies of its founder and a provincial Texas schoolteacher: the Americanization of Alfred Stieglitz.

To underline the message of revitalization, the largest number of prints—fourteen—exhibited in the Photo-Secession salon by one person were the work of the youngest exhibitor, Edward Steichen. Steichen was twenty-three years old, a painter and photographer living in Paris. Two years earlier, in April 1900, he had been on his way to Europe from his hometown of Milwaukee when he called on Stieglitz at the Camera Club of New York. His visit was unannounced, but Alfred already knew and admired the younger man's prints, exhibited in photographic salons in Philadelphia and Chicago a few years before. Although Steichen's work was the more "painterly" of the two, his photographs spoke to Stieglitz in a common symbolist language of mystery and melancholy: studies of moonlit trees and ponds, nudes half-hidden in velvety shadow, portraits of women whose beauty was emphasized by exotic flowers, and self-portraits of the photographer as

painter, cradling his palette with Romantic self-consciousness—all of these resonated for Alfred with reminders of his own youthful idealism along with his continuing quest for the spiritual essence of life, as captured by art.

Their meeting in 1900 came at a propitious moment: Stieglitz had a base of operations in the Camera Club, loyal helpers, and a firmly established international reputation. The master lacked only a disciple whose talent promised to enhance but not threaten his own position. Steichen seemed sent by the gods. To start with, the young midwesterner considered himself primarily a painter; he was headed for Paris to study at the Académie Julian.

Steichen's call on Stieglitz was certainly planned with the hope of finding in Alfred a mentor and, in particular, of eliciting practical help from the older man. His mother and sister's nest egg, combined with his own savings from work as a commercial photographer, would just cover his passage and a year of living in France. To augment his meager funds and enable him to stay abroad longer, he was hoping to obtain photographic portrait commissions in England and on the Continent. Introductions from Stieglitz would open all the right doors.

The visit ended in a happy exchange: after looking at Steichen's most recent prints, Alfred bought three for himself, paying the delighted young man five dollars apiece: "I got them for nothing, at that,"[3] Alfred recalled.

Along with his bargain, Stieglitz had acquired a disciple whose personal qualities attracted him as much as his talent did. Fifteen years younger than Alfred, tall and romantically handsome (with a startling resemblance to the youthful Gary Cooper), Steichen shared Stieglitz's northern European heritage of high seriousness, hard work, and ambition. Unlike his mentor, however, Steichen was the quintessential self-made American.

Brought to America from Luxembourg when he was three, he was descended on both sides from generations of peasants. In this country, his father had worked as a miner in central Michigan until an accident incapacitated him permanently and the photographer's mother moved the family to Milwaukee, where her hat shop supported them all. From the age of sixteen, Edward (having Americanized the spelling of his name from Eduard) painted cows and pigs for a printing and poster company, most of whose clients sold agricultural products. In his spare time, he studied art and took pictures: woodland nocturnes, portraits of friends and family, including his beautiful sister Lilian, soon to marry the poet Carl Sandburg.

Steichen was the first in a long succession of Stieglitz's fatherless

disciples: younger men and one woman—Georgia O'Keeffe—who had been abandoned, actually or symbolically, by a male parent. Besides the flattering attention this famous man beamed on talented young people, he communicated boundless energy combined with intellectual and moral authority. O'Keeffe's recollection of her first sight of Alfred, emerging from the makeshift darkroom at 291 with dripping glass plates in his hands, arguing with his visitors, was repeated, with variations, by others who came to stay. Interrogating, scolding, explaining, reminiscing, Alfred at the same time might be editing or dictating an article or letter, washing plates, packing prints, or wrapping his journals—all without a moment of silence.

Stieglitz represented a unique mix of qualities: the artist who exuded the combative, commanding style of the new breed of entrepreneur. In many ways, he had more in common with Henry Ford—born the same year as Alfred—than with the romantic archetype of the reclusive artist Albert Pinkham Ryder, living out his solitary last years a few blocks from the future 291.

For younger Americans like Steichen who, coming of age in an era obsessed with "getting on," had chosen a life in art, Stieglitz was a made-to-order father figure: an artist who engaged with the world. That the adoptive parent was himself a son who could never leave home, an absent father to his own family, a depressive who succumbed regularly to mysterious "breakdowns," was concealed by his dynamic public persona. The inner fragility of the narcissist is his best-kept secret.

From the moment Steichen appeared in Alfred's life, the beguiling young man became the son he would never have and a protégé who, initially, posed no threat. Indeed, Stieglitz's paternal pride in his new disciple has poignant elements of hero worship: the diminutive bespectacled Stieglitz seemed to see in the tall, handsome midwesterner an ideal self; Steichen was not only a photographer, but a painter—a "real artist," Alfred liked to point out, a remark that is also revealing of Stieglitz's "real" feelings about photography as an art form.

Like Georgia O'Keeffe, Steichen was a child of America's heartland; like her, he was acquainted early with privation and with the knowledge that he would have to make his own way in the world. Idealistic and ingenuous, tough and ambitious, natural aristocrats both, the two Wisconsin-raised artists exemplified that uniquely American brand of hard-nosed innocence that would always fascinate Alfred.

Steichen shared with O'Keeffe two other, related qualities: innate taste and style. He not only knew what he liked but was quick to sense the "coming thing"; and he had a flair for image. Once he left the darkroom, Stieglitz dealt in ideas. ("Why do you always speak in that

semi-abstract way?" Emmeline would ask him.) Even as fervent a fan of Alfred as Hutchins Hapgood, the reformer and journalist, noted that "the work of art was never of much interest to Stieglitz. . . . It is what the work of art symbolizes, what is behind it that counts."[4] But Alfred knew whom to listen to when it came to the concrete—on canvas or in matters of design. And in the young painter who took such astonishing pictures, he recognized his man.

IN 1902, Steichen was back from Europe, returning in time for the Photo-Secession show in March. Stieglitz opened the exhibition with an "informal address" before a glittering audience, which included Richard Watson Gilder, editor of *Century* magazine, along with distinguished British guests: the aged Pre-Raphaelite painter Sir Philip Burne-Jones and the Duke of Newcastle.

In his talk, Alfred inveighed against "the irreparable harm that had been done photography by the fact that it had proven a refuge for the incompetent in other crafts and professions, who had sought its shelter from the winds of adversity."[5]

As photography had proved to be the speaker's only "harbor and refuge" from a world in which he had displayed marked incompetence in "other crafts and professions," Stieglitz's accusing remarks go beyond hypocrisy, suggesting a self-indictment the more unforgiving for being unconscious. Of those in the audience familiar with Alfred's life circumstances, friends must have squirmed, enemies chortled.

The Photo-Secession salon was Stieglitz's first entrepreneurial success. Crowds thronged the Arts Club's brownstone; press coverage was extensive and—with a few dissenters—enthusiastic: the New York *Sun* reviewer hailed the show as "not only the best exhibition ever held by the Arts Club, but the best of its kind that has yet been seen in New York."[6]

One critic, however, noted pictorialism's parasitic relationship to painting—and bad painting at that: "The chief fault to be found with the photographers here is not that they fail to beat the painters on their own ground, but that most of them strive too modestly to imitate their inferiors, by tricks of style and manner."[7]

Among the triumphs of the salon for Stieglitz was the recognition of his new protégé: "Unquestionably the star exhibit in this collection is a group of prints by Edward Steichen, of Milwaukee, Wisconsin."[8]

Meanwhile, the charming expatriate was home for an extended visit, when he made an instant conquest of Alfred's entire family. Emmy adored him, as did Alfred's sisters and brother Lee; the elder Stieglitzes

pressed him to consider both Oaklawn and 60th Street as home when he was in America. The following fall, Steichen was married to Clara Smith, a student of voice whom he had met in France. Tactfully, the newlyweds divided their honeymoon between Lake George and Newark, Ohio, where Steichen presented his bride to Clarence H. White, Stieglitz's rival (with F. Holland Day of Boston) for the distinction of preeminent American artist of the camera.

When the gangly youth from Milwaukee returned from Paris in 1902, he was a successful and sophisticated worldling. In Paris he had become the portraitist and friend of his idol Rodin,* among other notables, and a regular of Gertrude and Leo Stein's famous evenings at the rue de Fleurus, where he met the dealer Ambrose Vollard along with Matisse and Picasso. Steichen had even established his own informal salon of young avant-garde artists, both French and expatriate like himself; the latter he organized as the Society of Younger American Painters, to whom he played host in convivial meals at his studio. No longer the talented provincial, on his return he was ready to assume the role of Alfred's collaborator in the two most important ventures of Stieglitz's second career: a new journal and a gallery.

Since Alfred's departure from the Camera Club and *Camera Notes*, he had been meditating his own publication, to be consecrated to the best of pictorial photography. Then in September 1902, during a visit to Lake George, Steichen gave form to Alfred's idea. A few months later, the first issue of *Camera Work*, dated January 1903, appeared.

On the cover Stieglitz proclaimed his new, powerful role: A PHO-TOGRAPHIC QUARTERLY EDITED AND PUBLISHED BY ALFRED STIEGLITZ NEW YORK. For the next fourteen years, he would enjoy a situation exceptional for any artist and rare enough for publishers: total control of the presentation of his own and others' work.

A work of art containing other works of art,[9] *Camera Work* owed its status as a precious object to Steichen's design. Borrowing from the German symbolist publication *Pan*, Steichen chose a subtle gray-green for the cover and discreet art nouveau lettering for the title and the typeface. The logo—a distinctive gold circle—became the symbol of the Photo-Secession.

Sumptuous is the word most often applied to the presentation of the contents; photographs were reproduced on Japan tissue; the mounting and reproduction by photogravure (many prints hand-tipped by Stieglitz himself) gave the illustrations—almost all in the painterly traditions of pictorialism—the appearance of original works of art.

* The Steichens named their first child Kate Rodina.

Steichen's elegantly simple design for *Camera Work* combined with Stieglitz's opulent presentation of the work of his chosen photographers emerged as a seamless collaboration between the two men. But the legendary literary "firsts" published by the journal were due to the expatriate.

While living in Paris, Steichen had become enamoured of the symbolist writings of the Belgian playwright Maurice Maeterlinck and by the vitalist theories of Henri Bergson. Maeterlinck's notion of correspondences among color, sound, and emotional state was soon to be of passionate interest to Georgia O'Keeffe.

The theories of Henri Bergson gained still wider currency among the young intelligentsia on both sides of the Atlantic. Exalting the intuitive over the rational, the spiritual over the cognitive (and, by implication, the sexual over the social), Bergson's *élan vital*, or life force, provided a liberationist ideology for an entire post-Victorian generation of intellectuals and artists; D. H. Lawrence found Bergson's source of generative energy uncorrupted in primitive peoples; for Marcel Duchamp, along with other proponents of dadaism and surrealism, the vital force restored the creative role of the irrational and unconscious. Americanizing her favorite concept as IT, Mabel Dodge translated the French philosopher's formulation as sexual power over others.

Then in 1912 and probably once again at Steichen's behest, *Camera Work* published a selection from Kandinsky's *On the Spiritual in Art*, the work Georgia O'Keeffe would so eagerly read when it was translated into English two years later. Also in 1912, Stieglitz accepted two articles, on Matisse and Picasso, from an expatriate friend of Steichen's precisely *because*, he later said, he did not understand them—thus becoming the first American publisher of Gertrude Stein.

Some visitors suspected that Stieglitz was also mystified by the avant-garde art he exhibited at Steichen's urging; showing these works filled other needs. Mabel Weeks, a friend of Gertrude Stein, wrote to the rue de Fleurus:

> To get my precious copy of your Matisse and Picasso, I had to have an interview with Stieglitz. . . . I suspect him of being something of a pose in his interest in the new things, because he is so pitifully eager to shock people with them. When he found that I knew the work of Matisse & of you, at least to the extent of not being in the least bit shocked, his face fell ludicrously and he lost all interest. What he dotes on is a chance to harangue some astounded soul.[10]

Steichen visited England and returned with photographic commissions along with contributions to *Camera Work*. His splendid portrait of George Bernard Shaw was followed by an essay on photography by the Irish playwright (himself a talented amateur) published in the magazine, along with an acute discussion of the drawings of Steichen's hero Rodin reprinted from the collected writings of British critic A. J. A. Symons.

The contrast between *Camera Work*'s domestic contributions and the texts scouted by Steichen abroad is embarrassing. Left to his own editorial judgment, Stieglitz favored the overripe fin de siècle prose of Sadakichi Hartmann (a.k.a. Sidney Allan), an all-purpose bohemian and literary hack who could be counted on for an ode to Stieglitz's photograph of the Flatiron Building. Alfred's boys in the back room were regularly represented by dialect humor and ponderous parodies: "Uncle Rastus on the Origins of Trouble" and "The Rubaiyat of Kodak McFilm" are a mercifully brief sample of titles. Contributions by female relatives were not disdained: Stieglitz's sister Selma was immortalized by a poem of epic length.

Most important, from the first issue in January 1903, *Camera Work* defined itself—albeit tongue-in-cheek—as the organ of Alfred's amorphous Photo-Secession. With a classic spritz of Stieglitz double-talk, the new journal announced: "*Camera Work* owes allegiance to no organization or clique, and though it is the mouthpiece of the Photo-Secession that fact will not be allowed to hamper its independence in the slightest degree."[11]

Now THAT Stieglitz had a house organ, he and the Photo-Secession needed a home. Since his return from Paris, Steichen had been arguing the advantages of a gallery for the exhibition of photography. Initially, Stieglitz was unenthusiastic. He wasn't persuaded that enough good work existed to warrant the investment. He was soon won over, however, by Steichen's enthusiasm, along with his novel idea of showing the newest in art along with photography, but most of all by the practical energy demonstrated by the younger man. In no time, Steichen found the perfect space: the studio he was about to vacate (plus two connecting rooms) at 291 Fifth Avenue. (He had found larger quarters for himself in the adjoining brownstone at 293.) He then proceeded to consider the decor, choosing elegant olive green and pale gray walls for the new exhibition area, which echoed the subtle harmonies of *Camera Work*. He decided on the lowered ceiling and diffuse light and found the

signature brass bowl. His wife, Clara, sewed the curtains that hid the shelving in the lower half of the large room.

With Stieglitz as unpaid director, who thanks to Emmy paid the rent, the Little Galleries of the Photo-Secession opened on November 24, 1905, with a large selection of photographic prints, including works by Steichen, Stieglitz, White, and Käsebier. The celebration after the inaugural exhibit took place at Mouquin's on 6th Avenue and 28th Street, a family-run restaurant also favored by Robert Henri and the painters of the Ashcan School. Its French staff, cuisine, and accordion music gave the neighborhood bistro a reputation as the closest thing to a trip to Paris.

Dinner at Mouquin's marked endings as well as beginnings. In a few months, Steichen would return to France, settling with his wife in Voulangis, a suburb of Paris. With his many connections in the world of postimpressionism, Steichen, from Europe, completed the process of reversing roles with Stieglitz; besides serving as *Camera Work*'s literary talent scout, he became Alfred's mentor and guide in the realm of avant-garde art. Fauvist and cubist painting, the first showing in America of le Douanier Rousseau and of Brancusi sculpture—the epoch-making succession of exhibits at 291, as the gallery soon came to be called, was due to Stieglitz's silent partner abroad. Overflowing with enthusiasm and eager to embrace the new, the former disciple prodded and pulled Stieglitz, still ambivalent, into the twentieth century. On Emmy and Alfred's annual summer travels abroad, Steichen "did" the galleries with his friend while Emmeline shopped. He steered Alfred through the Cézanne show at Bernheim Fils (by his own admission, Stieglitz took a while to get it), going on to explain cubist space, fauvist colors, Brancusi motion.

By 1907, Steichen's evangelistic efforts had succeeded; the partners agreed—or so Steichen understood—that the first nonphotographic show at the Little Galleries would also be the first exhibition in America of Rodin drawings: a few lines in pen or pencil that yet managed to convey the essence of the female body. Instead, Stieglitz—feeling his authority threatened or simply unable to see the brilliant daring of the Rodin works—launched the new era with paintings by Pamela Colman Smith, an Anglo-American raised in Jamaica and living in London. Smith specialized in embalmed-looking maidens raised from the dead by her late art nouveau style. Described by the *Camera Work* review as "visions evoked by music," these tepid symbolist offerings were said to be testimony of the artist's "inexhaustible resources of . . . imagination." Those who attended the show's opening, the review noted, were

further delighted by Smith's recital of West Indian nursery rhymes and chanting of Irish ballads.[12]

Undaunted, Steichen pressed on with his education of Alfred Stieglitz; Rodin followed in March 1908 with fifty-eight drawings, an exhibition predictably arousing the outrage and disdain of art critics and the incomprehension of one league student, Georgia O'Keeffe, who saw only "a lot of little scribbles" on her first visit to 291.[13]

In 1909, Steichen presented Alfred to Leo and Gertrude Stein at one of their legendary Saturday evenings. Alfred was invited back, where he continued his scrutiny of his hosts' great collection of paintings by Matisse, Picasso, and Braque. By now, he needed little persuasion. With Steichen as intermediary, he began negotiating for exhibitions of works by these artists at 291.

Steichen reported to Alfred on his pursuit of that difficult "galoot Picasso," along with two recent discoveries among his group of American artists living in Paris: a talented painter from New Jersey named John Marin, who was slowly moving away from the neo-Whistler etchings he knocked off for the tourist trade, and a New Yorker, Alfred Maurer, who, influenced by the Steins' collection, was beginning to experiment with fauvist color. Maurer and Marin were introduced to America in a joint exhibit at 291 in 1909.

The tiny elevator at the gallery was soon jammed with the sophisticated, the curious, and those New Yorkers whose life is dedicated to being seen wherever controversy turns into chic. 291 had arrived.

Meanwhile, three young European recruits to the Stieglitz inner circle replaced the expatriate prodigal son. One was Paul B. Haviland, a handsome and elegant amateur who was also heir to the French porcelain manufacture bearing his name. After graduating from Harvard, he gradually took over the business management of the gallery along with contributing articles and photographs to *Camera Work*. When the lease expired at 291 in 1908, Haviland guaranteed rent for the coming year in the rooms across the hall at 293 Fifth Avenue. As a tribute to the fame of the gallery and its presiding genie, 291—the name used by everyone with any claim to an interest in art—moved with it.

Another urbane emigré of talent and independent means, Mexican artist Marius de Zayas, joined the group, which was now growing younger and more cosmopolitan. With the exhibition of his caricatures—whose victims included members of New York's 400—more of the art-minded socialites appeared who had first visited the gallery for Pamela Colman Smith's one-woman happening.

Max Weber, the most gifted of this trinity of disciples, was a very

different refugee. Son of a rabbi, he had been brought to Brooklyn as a child with his family, in flight from the pogroms of the Pale. Despite terrible poverty, he had nonetheless managed to study in Paris, where he assimilated cubism along with an extensive knowledge of African tribal art. Later Stieglitz would acknowledge that he learned all he knew about these two related areas from this prickly, uncouth young painter. The penniless Weber, with nowhere to live, was given the back room of 291; he was regularly fed at Emmy's opulent table and was engaged to teach Kitty to draw.

FROM THE opening of 291 in 1905, the geography of Alfred Stieglitz's New York had mapped a double life: the uptown domestic existence in which he played a walk-on part as husband and father and his downtown role as producer, director, and star.

Twice a day, he moved between these two worlds. Each morning, Fräulein Bauer, Kitty's governess, handed the plump, solemn, beribboned little girl to her father. Together, they left the apartment on Madison and 83rd Street and, depending on the weather, made their way on foot or by omnibus down Fifth Avenue, where Alfred left Kitty at Miss Keller's Day School on 65th Street. Wending his way down to the gallery, Stieglitz, ever prone to bouts of nostalgia, might have had more than one Proustian reminder of a past gone forever.

In 1898, the year of Kitty's birth, his parents had sold the house on 60th Street, moving to an apartment hotel nearby. However ugly the New York of his youth, when brownstone houses "covered the city like a cold chocolate sauce," the modern metropolis, creeping steadily uptown with its arteries of underground subways and els, gave the inexorable thrust of his "monstrous" Flatiron Building the nature of prophecy. Already, new luxury hotels, smart shops, and art galleries were pressing toward 59th Street and the boundary of Central Park; soon 291 would be left behind, along with the rest of lower Fifth Avenue and Greenwich Village, their nineteenth-century stoops and brick row houses mercifully passed over by progress.

Housed in the style of the past, 291 itself was the kernel of the future, ready to burst forth from its brownstone shell. Once inside, Alfred was swept up by a frenzy of activity: prints of his own to be developed in the primitive bathroom/darkroom; material to be chosen for *Camera Work*; exhibits of photographs and paintings to be hung or taken down; endless letters, articles, and editorials to be dispatched to photographic outposts everywhere. Despite the storm of paper, he was, in the memory of everyone who stopped at 291, available to all comers:

telling stories, answering and asking questions—personal ones if the visitors happened to be attractive young women. "The men" had gradually been replaced by new recruits, who brought friends. Introduced to 291 by Max Weber, Abraham Walkowitz, also an Eastern European Jew, quickly became a Stieglitz intimate; he could be found almost daily at the gallery, huddled with the others around the pot-bellied stove. Obsessed with Isadora Duncan, he made thousands of wash drawings of his idol, poised in as many moments of her dancing as he could capture; Walkowitz was in the gallery on the momentous New Year's Day 1916 when Anita Pollitzer brought the roll of drawings from her friend in Columbia, South Carolina. Stieglitz must have recalled Walkowitz's worshipful record of Duncan when he came to make his serial portrait of O'Keeffe; for both artists, their subject was the icon of a private religion.

Other young people came to 291 and, finding what they needed to pursue their own vision, left, never to return. Emmanuel "Manny" Radnitsky crossed the bridge from Brooklyn to be warmed by Alfred's paternal interest and support. Stieglitz in turn was intrigued by the coarse jokes and prodigious talent of his new acolyte; barely five feet tall, Man Ray—as he soon called himself—was even smaller than Alfred. A painter and photographer like Steichen, Ray also chose photography and Paris, where he enjoyed commercial success with his surrealist portraits of the beautiful and famous.

A young doctor, William Carlos Williams, wrote poetry in whatever time he could spare from his busy practice. Usually on weekends, he left his patients and young family in Rutherford, New Jersey, to visit 291. He had always painted and he found in the artists' conversation and, especially, in the cubist works on the walls the equivalent of what he was trying to do with words. He soon found the rule of the autocratic Stieglitz stifling, however, and he shifted his allegiance to the glamorous dada salon of Walter and Louise Arensberg on West 67th Street, where creative free-for-alls lasted for days.

Teachers came to 291 with their pupils. In 1907, Lewis Hine brought his students from the camera club at the Ethical Culture High School to the gallery; among them was seventeen-year-old Paul Strand. On his first visit, Stieglitz validated Strand's passion for taking pictures and assured him a mentor whose genius was equal to his own.

By 1909, two other fatherless young painters of immense talent had attached themselves to 291. Arthur Garfield Dove, a burly, sandy-haired Upstate New Yorker, was trying to escape a successful career in magazine illustration to devote himself to visionary meditations on nature. Dove received from Alfred the support withheld by his own disapproving

father; he would remain a Stieglitz artist, his love and trust undiminished, until his death in 1946, four months after Alfred's. Marsden Hartley was the most troubled child in Alfred's downtown family: a dandy escaped from rural poverty in Maine, he replayed with Stieglitz the father-son relation, further complicated by the artist's homosexuality. Hartley's homeless wanderings and his hand-to-mouth existence, accompanied by rage, envy, and endless demands, ultimately exhausted even Alfred's need for his "children's" dependence.

In a daily ritual, Stieglitz's disciples, calling themselves the Round Table, would arrive fortuitously in time for lunch (for some the only meal of the day), assembling at Mouquin's or Holland House, an elegant art nouveau restaurant in the Prince George Hotel on 28th Street.* Alfred Kreymborg, a poet and the first literary recruit to 291, recalled his initiatory meal. After lunch, with Steichen and Walkowitz in advance, the group

> started down Fifth Avenue. People stopped and stared at the parade of men so dissimilar, chatting fooling and calling to one another; Steichen, lanky and boyish, Walkowitz, diminutive and dignified, . . . Weber, volatile and gesticulating, Marin, with his long lean face and roving dark eyes, Hartley with the aloofness of Hamlet, the stocky mercurial Strand, the stocky genial Dove, the grave silent Haviland, the quick-witted sharp-faced de Zayas and bringing up the rear, the nervous dynamo in grey.[14]

Possibly to prevent his downtown "children" from appearing en masse uptown, Emmy provided Alfred with a special Round Table allowance.

Alfred's all-male family finally acquired a mascot: Agnes Ernst, "the loveliest girl ever to appear at 291," in connoisseur Steichen's view, was also the first of the Stieglitz circle to have an official media role. A recent Barnard graduate and the first "girl reporter" on the New York *Sun*, she came to interview Stieglitz and was converted, like many others, on her first visit. The beautiful, clever, and ambitious Ernst, daughter of a Lutheran minister who had abandoned his family, had her eye on the big time. Spending a year in Europe to study and write about art, she recorded in her diaries the names of celebrities she conquered, largely through Steichen's introductions. While in Paris, she succumbed to the persistent suit of the immensely rich New York financier Eugene Meyer; following their marriage early in 1910, she became a patron of 291, its artists, and *Camera Work*.

* Now a welfare hotel housing New York's homeless families.

At first, Alfred and the newlyweds seemed to be engaged in a three-way honeymoon; Meyer considered 291 an extension of his Wall Street office, Stieglitz's secretary, Marie Rapp, recalled, often making deals on the gallery telephone. [15] The genial banker also became Alfred's broker and investment adviser; Alfred's letters to Meyer reveal that, Stieglitz's professed horror of money and its sources notwithstanding, he followed the stock market in knowledgeable detail and that he had more money of his own to invest than he ever admitted—discretionary funds (as he made clear to Meyer) that could be placed at higher risk than the capital he depended on for his income. [16] Meyer gave the same help to his friend Steichen. As the latter's grateful letters make clear, the brilliant financier turned Steichen's modest savings into a substantial nest egg; there is no reason to suppose he did less well by Alfred's patrimony.

PILES OF PAPERWORK, streams of visitors, Photo-Secession shows organized from Munich to Denver—this frenzy of activity kept Stieglitz away from home as much as possible. On his brief appearances during the family's waking hours, he was likely to be flanked by allies: "the men" who, after Emmy's well-set table was cleared by the servants, would cut and paste the next issue of *Camera Work*.

On the rare occasions when the small family was alone, quarrels between Alfred and Emmeline were so violent that the adolescent Kitty would telephone a nearby cousin to beg a last-minute dinner invitation.

The miseries of marriage that had begun on their honeymoon had intensified with the years. In the eyes of the Stieglitz family, if Alfred was unhappy, it could only be Emmy's fault. Having urged this union on their eldest and favorite, they turned against Emmeline with swiftness and savagery; she became, in the words of a niece, that classic victim, "the family scapegoat." [16]

Emmy's notions of the good life—smoothed by servants, made festive by outings to restaurants and theaters, marked by family holidays at the shore and travels abroad in style—were those of all young women of her class and education, including Alfred's sisters. In Emmeline, these expectations were now deemed outrageous frivolity and extravagance. That the money she spent was her own did not constitute a defense; a wife did not remind her husband—or his family—that her income supported them. As a scapegoat, moreover, Emmy had internalized the blame assigned her for the failed marriage. Her letters to Alfred acknowledge her dullness, stupidity, and lack of interests; still, if she were not so lonely and sad, she would make an effort. If only Alfred

would not always get so angry with her, she wrote to him at Lake George from the Jersey shore. She felt herself falling apart when he spoke to her in that savage way.

For her part, she promised to try to economize. They could move to a smaller apartment; she could make do with less help; she would start by buying her pillowslips untrimmed. More serious was the blame heaped on Emmy as the "bad" parent; her in-laws castigated her regularly for being a hysterical, overprotective, overpermissive mother to Kitty.

Emmy's cries for help—her frantic calls to Alfred's brother Lee, a doctor, over Kitty's every childhood ailment, her fear of being "alone with baby" in a houseful of servants—were derided by her Stieglitz in-laws as the infantile incompetence of a rich, spoiled young woman. In fact, Emmeline *was* alone; abandoned by Alfred in town, she was soon banished from his only real home.

In the summer of 1912, Kitty's appendix ruptured while at Lake George; an emergency operation was performed by a doctor neighbor on the kitchen table. At the end of this ordeal—makeshift surgery performed without anesthesia and with a high probability of peritonitis—Emmeline succumbed to a hysterical outburst. Berated by Lee for her lack of self-control, she pointed out that his tantrums—with no extenuating circumstances—were infamous.

"I am the son of the house, who are you?" he thundered.[17]

Nobody. Undefended by Alfred, Emmy stood accused by her own unhappiness. Now, with Prohibition already threatening the Obermeyer fortune, she was less significant than ever.

Unwelcome at the lake from that summer on, she wandered the ornate public rooms of New Jersey resort hotels or, accompanied by her devoted brother Joe, toured similar establishments in New England. In a sorrowing letter to Alfred from Elberon, New Jersey, the "Jewish Newport," she wondered why, unlike their friends the Meyers who invited her regularly, he could not take pride and pleasure in his family.

In August 1913, Emmeline traveled to Europe with a niece. Beginning that summer, Alfred spent Augusts at Lake George with Kitty.

Throughout Kitty's childhood, Alfred had been a virtual stranger to his daughter. His downtown life was so mysterious that Kitty had come home from school one day in distressed puzzlement; of all the girls in her class at the Veltrin School, she was the only one whose father never told her what he did all day away from home. Her art teacher had been astonished by Kitty's ignorance; didn't she know that her father was a famous photographer, a great artist? Was this true, Daddy? Kitty had asked. Still, Alfred equivocated; perhaps he was, but he was much more.

What he was could not be described, not even by the word *artist* or *photographer*.[18] (Stieglitz loved this story, telling and retelling it many times. He saw the anecdote as providing proof of genius too protean to be defined, not as revealing an estrangement from his daughter, her exclusion from his life, and the humiliation she felt in being exposed as singular in these ways.)

Now he discovered a Kitty who, at fifteen, was no longer a child. With her length of glossy chestnut hair and large dark eyes, she was a lovelier version of her mother twenty years earlier. Seeing Kitty in Paris in the summer of 1913, Steichen noted to Alfred that she had an "air of poise about her that one does not often find at that age—and she evidently observes *everything* and intelligently."[19]

No one failed to notice how intensely Kits—Alfred's special name for her—adored her father. Her aunt Agnes, Alfred's sister, who saw Kitty daily during those summers, recalled that her niece's moods mirrored Alfred's: when he was glum, Kitty was terribly upset; when he was happy, she was so overjoyed she went around telling everyone. Her watchful attachment to her father kept her apart from the group of young cousins who crowded the Stieglitz dock (the only one in the neighborhood) or performed amateur theatricals and charades for the benefit of their amused elders. "She behaved oddly, differently from the other girls," her cousin Hannah Small noticed.[20]

Alfred was unpredictable in his manner toward Kitty; he would be very sweet and affectionate with her at one minute and "go after her" in the next for something so slight as not doing well enough at her tennis lessons. Kitty was expected to excel at everything: tennis, swimming, studies. And his letters to her of this period (and about her to his friends) are full of scolding and complaints about her lack of application. The paternal promise was clear: Kitty would be loved to the degree that she did *not* resemble her indolent, ignorant, and frivolous mother, who excelled at nothing.

From her earliest years, Kitty had been aware of her parents' unhappy marriage, of the contempt in which her mother was held by her father and his family. During puberty, when the object of awakening sexuality is the parent of the opposite gender, Kitty was encouraged to exchange an Oedipal fantasy for a guilt-ridden and dangerous reality. Her mother had been banished; if the daughter succeeded in pleasing her father, she would take the mother's place.

For Alfred, if not Kitty, Freud's "family romance" was a summertime scenario. In his downtown life, Alfred had found another daughter. Four years older than Kitty, Marie Rapp was a student of voice. Another fatherless child of 291, she had to earn her own way immediately after

graduation from commercial high school. She lived with her widowed mother and managed carfare, lunches, and voice lessons on the six dollars a week she earned as Stieglitz's secretary. Quick, graceful, with the haunting inward gaze of a cat, Marie was utterly devoted to Alfred; they would remain lifelong friends. Seventy-five years later, her memory still as luminously clear as her eyes, she saw her role in his life as a "replacement" for Kitty, the real daughter Alfred had forfeited to her mother.[21]

Marie's warming presence in the gallery, beginning in the bleak January of 1911, would compensate Alfred for other losses; the original inner circle was shrinking. Max Weber was the first to defect. In 1910 he had hung more than four hundred prints chosen by Stieglitz for the largest and most comprehensive exhibition of pictorial photography ever to be mounted—at the Albright Gallery in Buffalo. Expecting to be first among equals, Weber felt he should be allowed to criticize Alfred as well as his fellow artists while remaining a star of 291. When only one painting was sold from his 1911 show—to Agnes Meyer—Weber blamed Stieglitz and took off in a rage.

In the wake of the Albright show came other defections, some unmourned by Alfred. The Buffalo triumph (in which the Albright Gallery became the first American institution to make a major purchase in photography) was, ironically, the swan song of pictorialism, with its once fervent promoter Alfred Stieglitz delivering the coup de grace.

Camera Work was turning away from photography toward modern art and its champions. Alfred now deemed Gertrude Käsebier and Clarence H. White, his former collaborators and fellow members of the Photo-Secession, hopelessly retrograde: for the gentle and tolerant White, especially, Stieglitz reserved the most savage contempt, tinged probably with envy. White's School of Photography (established in the sincere belief that the craft, if not the art, could be learned) was an enormous success, enhancing White's fame and multiplying his commissions. To Stieglitz, an artist who profited from his work or talent would always be a whore; when Stieglitz "allowed" the right owner to buy a photograph or painting, he was performing an educational service. It was a distinction many found hard to grasp.

Besides banishments and defections, there was, suddenly, competition. In 1912, Mabel Dodge, expatriate contributor to *Camera Work*, transferred her relentless energy and her hunger for ideas and people from Florence to 23 Fifth Avenue, a few blocks from 291. Although Mabel was a muse seeking out the (male) "movers and shakers" (the first title of her five-volume autobiography), her real talents lay as hostess and publicist; she quickly established a sphere of influence that would

compete with Stieglitz's one-man show. In her brownstone apartment, daringly decorated entirely in white, fragrant with flowers, and lit with the shimmer of Venetian globe lamps, the "head hunter" welcomed the leading exponents of new ideas: labor reform, women's rights, psycho-analysis, and art. Announcing the topic in advance of her Thursday or Saturday evenings, Mabel, her plump form hidden by flowing robes and her head wrapped in a gold brocade turban, would sit, sphinx-like, listening to argument ebb and flow. At midnight, depleted by debate, the throngs of talkers were refreshed by a lavish buffet. As an acolyte, Mabel was happy to play Mohammed to Stieglitz's mountain; visiting 291 often, she had only admiration for its presiding genius. Mabel's salon, with its give-and-take among eloquent equals, was not Stieglitz's scene. As Georgia O'Keeffe would note wryly a few years later: "Stieglitz was captain of the team, or he didn't play."[22]

Initially, Alfred himself had been one of the movers and shakers behind Mabel's first great cause on her return to America: the Armory Show of 1913. He attended a few preliminary meetings with the exhibition's organizers and was listed as an honorary sponsor. But while Mabel's efforts as publicist became ever more fervent, Stieglitz soon retreated into a patronizing—and threatened—ambivalence. The American passion for a Big Event, in Alfred's view, eclipsed any serious value the exhibition might have originally held. "A circus" was the way Stieglitz described the goings-on uptown. He bought for himself the one Kandinsky on exhibit, adding to his growing collection of avant-garde art; by way of reasserting the primacy of 291 and its founder, he then mounted the gallery's first and only one-man show of photographs by Alfred Stieglitz. Competitively, Alfred insisted that despite the "Bally-hoo at the Armory, 291 is still the stormcenter."[23] Whether the eye of the storm was located in the gallery or in Alfred's threatened ego was moot: the two were inseparable. More conflict—within and without—was to come.

Sixteen months later, the assassination in Sarajevo on June 28, 1914, of Archduke Ferdinand and his wife detonated the first salvos of war. By August 1914, every major European power, along with Great Britain, had declared war on Germany. The hostilities abroad made Alfred feel more beleaguered than ever. By education, sympathy, and now, at fifty, nostalgia for lost youth, Alfred was intensely pro-German. Heritage played a part: highly assimilated German Jews tended to be more Prussian than the kaiser (a superpatriotism that was the butt of many Jewish jokes). The Armory Show itself, with its display of the imperial French dominance of modern art, reinforced Alfred's aesthetic Francophobia. (When he came to champion the cause of American artists, it was in

no small part a reaction against "those damned French.") More soberly, he was revolted—as Georgia O'Keeffe would be three years later in Canyon, Texas—by an anti-German hysteria whose witch-hunting paranoia would be equalled only by two postwar "Red scares."

The divided loyalties of war signaled the beginning of the end of Alfred's relationship with Steichen. By heritage and by choice, Steichen felt part of France; its losses and devastation were his. Returning to America with his young family, he wanted only to get into uniform (which he soon did, his glamorous appearance arousing the admiration of all and the envy of Stieglitz) and fight alongside his adopted country. Beneath Alfred's pro-German sentiments lurked darker feelings. Soured by the smug philistinism and shoddiness—moral and material—of contemporary life, he welcomed the war as an apocalyptic purging. Emmeline was shocked by the callousness of his views, widening the rift between them. How could he speak of a cleansing process when so many young lives were snuffed out, so many others devastated? she wondered.

IF HE WAS unmoved by the slaughter in Europe, Alfred was grieved by losses close to home. The ranks of "the men" were thinning: Joe Keiley, his devoted helper from Camera Club days, died in 1914 of Bright's disease; the charming and capable Paul Haviland was called back to France and the family porcelain factory.

Probably the worst blow of all struck Alfred from within 291 itself. In response to the restiveness of the "youngsters," Stieglitz had agreed to a "son of 291," a commercial gallery whose avowed purpose—"the sale of works of art"—would, so the Young Turks argued, help Stieglitz's new American artists—Dove, Marin, and Hartley—secure steadier earnings than were possible at the "laboratory" of 291. Called the Modern Gallery, the new operation was funded by Agnes Meyer and managed in freewheeling style by the debonair Mexican artist Marius de Zayas with the help of his friend Francis Picabia, a Franco-Cuban artist recently arrived from Paris.

Located at 500 Fifth Avenue, across the street from the public library, the new operation began in 1915 with Alfred's blessing. Anita Pollitzer saw him there often, she reported to Georgia in South Carolina; "hopping on tables & chairs," he aimed his camera down from the gallery windows to take his first pictures of New York's skyscrapers under construction—photographs increasingly as abstract as the art on the walls.[24] Despite the inspiring views, Alfred's initial support of the new venture soon yielded to feelings of betrayal. The Modern Gallery's frank pursuit of the coin of commerce, combined with its managers' evident

desire to shake free of paternal control, had Stieglitz muttering of perfidy. His own children were trading on his name and reputation for profit. The first to be accused was the devoted de Zayas—"ruined by money and Dada," Stieglitz said venomously.[25]

ORIGINATING in the unlikely capital of Zurich around 1914, dada—in French, baby talk for "hobby horse"—was less a movement than a state of mind. Indeed, the "point" of dada, its proponents claimed, was that there was no point. Born of the war, it consisted of a nose-thumbing nihilism that took the exuberant form of send-ups and put-downs. Exalting absurdity, dada was a more intellectual precursor of the Pop aesthetic, bent on shattering the solemn status of the work of art as a precious object. Immortal among its creations was the urinal submitted to the Society of Independent Artists and attributed to R. Mutt. When dada converts, notably Francis Picabia and Marcel Duchamp, arrived in New York, they found among local artists, poets, and upper bohemians a fertile ground for their ideas and a welcoming atmosphere of jazz, sex, alcohol, and all-night parties.

Not wanting to appear an irredeemable old fogey, Stieglitz made a token contribution to dada's anarchic concept of art. His photograph of the famous urinal appeared in *291,* a handsomely designed two-color periodical produced and largely written by the Young Turks. But essentially, Alfred was right to distrust this particular revolution. His High German, High Serious view of Art—moralizing and idealistic, exalting Truth and Sincerity, respectful of the sanctity of the Artist and the Individual—was everything that dada, with its playful Gallic spirit, outrageous jokes, and disposable objects, hoped to destroy.

Dada's New York command post was the elegant apartment on West 67th Street, just off Central Park West, of Walter Conrad Arensberg. Amateur Shakespeare scholar and mathematician, poet and art collector, Arensberg had married a Pittsburgh heiress, a union that allowed him to devote his life to his aesthetic and scholarly interests. Following the Armory Show, Walter and Louise Arensberg amassed the most impressive collection of cubist paintings, Brancusi sculpture, and primitive art to be seen in America. Through their friendship and patronage of Marcel Duchamp, who soon moved in with them, Arensberg evenings became dazzling orchestrations of the unexpected, brilliant, and mysterious—in short, all one could wish of a dada salon.

An invitation to the Arensbergs' might well spoil an adventurous young artist for *291*'s predictably austere fare: Alfred Stieglitz talking. On West 67th Street, a visitor could find Wallace Stevens, a Harvard

classmate of Arensberg, reading from his latest poems; a less inhibited poet, Mina Loy, in bed with four men whose artistic talents went unrecorded; and, in another corner, Marcel Duchamp immersed in his usual chess game or parrying questions about his half-finished painting on glass that hung in the place of honor: *The Bride Stripped Bare by Her Bachelors, Even.* As further inducement to defectors from 291, the Arensbergs, William Carlos Williams recalled gratefully, "could afford to spread a really ample feed with drinks to match."²⁶ Alfred was a teetotaler.

D A D A ' S S I R E N C A L L was also *le dernier cri*, always the most potent lure for the young. But the siren herself, Alfred decided, was Agnes Meyer, the real villainness in his drama of corruption and betrayal. With the lure of her husband's fortune, the former "girl from the *Sun*" was the Pied Piper who had led Alfred's children from the purity of 291 to the depravity of selling art at the Modern Gallery. Through her friendship with Steichen (another strike against her), she had become infected by the French. Forgetting that he himself had just given Brancusi his first one-man show anywhere—in March 1914—Alfred pointed to the Meyers' purchases of work by the great sculptor as another symptom of Agnes's enslavement to European modernism. Nor, despite past help, was the generous Eugene Meyer spared; Stieglitz would later hiss that his wealth came from war profiteering, a calumny for which there was absolutely no basis in fact. For her part, the imperious Mrs. Meyer only fueled Alfred's anger, making plain her view that 291's day was done.

Only one of the "smart young people" associated with the Modern Gallery was spared Alfred's wrath. He had fallen in love with Agnes Meyer's friend, the equally beautiful Katharine Rhoades. Without this passion, Alfred later said—the first he had experienced for a woman who was not his social or intellectual inferior—he would never have been "ready" for O'Keeffe.²⁷

A poet and painter, Katharine Nash Rhoades came from a rich and socially prominent family whose roots in New York and New England reached back to the colonial period. The only daughter and the middle child of Lyman Rhoades, a banker and clubman, she grew up in the fashionable brownstone district of New York's West 70s, with summers in the still more patrician precincts of Stockbridge, Massachusetts.

Her parents encouraged Katharine's interest in painting. Along with studies at the Brearley School, she had taken private art lessons. Then, while vacationing with his wife and daughter in Camden, South Car-

olina, Katharine's father had died suddenly, at age fifty-eight. No cause of death was ever given, raising the possibility that Lyman Rhoades committed suicide. Katharine was twenty-two at the time of her father's death in 1907. In 1909, accompanied by two Brearley classmates, she spent the winter abroad, unchaperoned, absorbing the lessons of the Old Masters along with those of modernism. Of Katharine's traveling companions, Malvina Hoffman enjoyed a successful career as a sculptor of public monuments and Marion Beckett, also a painter, attracted Steichen's roving eye, to become the nominal cause of his divorce from the outraged Clara. In 1911, shortly after her return to New York, Katharine began to appear at 291 with her friends Beckett and Agnes Meyer. A year later, she was romantically involved with Stieglitz, then forty-eight.

Tall, willowy, and dressed in the height of current fashion—hobble skirts and large, elaborate hats—the glamorous trio of Rhoades, Beckett, and Meyer was known as the Three Graces. With her dark auburn hair, broad forehead, and generous jaw, Katharine Rhoades in particular was a beauty in the grand style of Sargent portraits. Her warmth and charm, moreover, captivated all who met her; suspecting nothing, Emmeline wrote to Alfred from Paris of her delight in the company of the "lovely Miss Rhoades" on a visit to the Steichens' at Voulangis.

Although there had been dalliances before Katharine, no other woman had caused Alfred to consider leaving his marriage. In the end, it was his sense of inadequacy, Alfred said, that explained his inability to act. Thirty years later, he recalled bitterly that "if he had been a real man, if he had been six feet tall, all strength and sinew, he would have carried Rhoades off to some mountaintop, built a little house for her, given her children and let her paint."[27]

Obscured by the regret of old age and nostalgia for past loves was another truth. When Stieglitz met Katharine, he was already looking for an artist who was a woman, an American, an original. Rhoades's art was an educated emulation of French modernism; her poems, published first in *Camera Work* and later in its dada-inspired spinoff *291*, are pallid versions of Apollinaire's cubist dislocations of words on the page.

The 1914–1915 season at 291 offered a glittering roster of exhibitions: Braque and Picasso; the first showing in America of "African Savage Art"; works by Francis Picabia and the recently repatriated John Marin. Stieglitz also gave a two-woman show to Beckett and Rhoades. We can only guess about Katharine's paintings; from brief descriptions, they seem to have been fauve-inspired portraits and landscapes. Shortly afterward, she destroyed nearly all of her work. The surviving exception,

apparently more advanced in style, is an illustration; a semi-abstract form, it seems to have been inspired by the cover article in the same issue of *291* (April 1915): "Motherhood a Crime." The short article reports the case of an unwed mother who ended her life with a bullet, unable to bear the shame of her condition. Read horizontally, Rhoades's drawing is a schematic rendering of a pistol.

Following her exhibition and the destruction of her paintings, Katharine Rhoades left New York and Stieglitz—"driven away," Alfred later said.[29] But he did not explain by what or whom she had been impelled to flee.

Looking back, he saw that he had failed Katharine: he could not be the man she needed. He did not see, then or later, that he had also moved beyond her.

Katharine Rhoades was Stieglitz's—and America's—nineteenth-century past. A cultivated, genteel aristocrat who looked toward Europe (and later the East), Katharine might have been the model for an Edith Wharton or Henry James heroine.[30]

Stieglitz was ready for the future, in the form of an independent, self-made young woman with the raw talent and unashamed ambition of a new America in the making.

SIX

"A Great Party and a Great Day"

ALFRED STIEGLITZ, installation photograph of O'Keeffe's first exhibition at 291 (1916). Two of Georgia's charcoal drawings are shown here along with the phallic sculpture she gave to Stieglitz. The latter went unmentioned by reviewers of the exhibit.

ONLY MONTHS AFTER Alfred's affair with Katharine Rhoades ended, Anita Pollitzer appeared at 291 on New Year's Day 1916, the roll of O'Keeffe's drawings under her arm.

For Georgia, the excitement of being discovered, along with the possibility of Stieglitz showing her work, quickened all her feelings. Her sexual challenge to Macmahon, always imperious, took on a histrionic note: "I want to love you," she wrote to Arthur early in February. Surely he could not "object to a woman daring—to feel—and say so without being urged in the least." She was determined "to hurry up and live fast,"[1] she told him. But the cautious Macmahon was not to be goaded into extravagant words or hasty action.

Then, by chance, she met an attractive blond young woman who knew Arthur. Her remarks suggested that Georgia was not his only romantic interest. "I seem to have just seen my bubble burst," she wrote to Anita despairingly, sending her another mailing of the charcoal draw-

ings inspired by her feelings about Arthur. She couldn't bear to have them around anymore, she explained.[2] Anita was appalled by Georgia's readiness to believe the gossip of a total stranger. Macmahon defended himself successfully against Georgia's accusations. But her suspicions—however unfounded—made it clear: she needed more than Arthur was giving her.

With perfect timing, fat envelopes bearing Stieglitz's flowing calligraphic script began to arrive at the little post office across the street from the college. From the first, Georgia seemed predisposed to see Alfred's letters as lifelines; his most innocuous remark—"The future is rather hazy—but the present is very positive and very delightful"—Georgia quoted to Anita, noting, "It just made me rediculously [sic] glad."[3]

Throughout February, she had other causes for gladness. In mid-January, she had applied for a job in Texas, and she was ready to pack her trunk, she wrote to Anita. If she got the offer, she'd have "a cat and a dog and a horse to ride . . . and the wind blows like mad—and there is nothing after the last house of town as far as you can see—there is something wonderful about the bigness and the lonelyness and the windyness of it all."

Just thinking about the Texas sunsets that turn the plains into an ocean made her more "disgusted" than ever with Columbia and the Methodists. During her exile, she had escaped by dreaming; now dreams disgusted her, too.

"I want real things," she wrote, "live people to take hold of—to see—and talk to—Music that makes holes in the sky—and Anita—I want to love as hard as I can and I cant let myself." Distance from Arthur made her doubt both of them—"so Im only feeling luke warm when I want to be hot."[4]

There was nothing lukewarm about her furious burst of energy for art; she was "working like mad . . . till my head all felt light in the top." No one ever had as much fun saying what she wanted to say as she did, she wrote. There was a manic quality to her laughter as she painted. When she showed her staid colleague Professor James Ariail a new drawing, he told her that he had never seen such wild excitement in anyone's eyes. And with reason: "I have a notion it's the best one I ever made," she told Anita triumphantly. She sensed the danger of this sudden rush of power: "I believe I'll have to stop—or risk going crazy."[5]

At the end of February, Georgia was offered the job at West Texas State Normal College in Canyon; the salary was one hundred fifty dollars a month for nine months' work, beginning in September. But the condition attached was even better news: before she could be hired to train

Edward and Hedwig Werner Stieglitz, Alfred's parents, his Aunt Rosa, and
the young Alfred on holiday in the Adirondacks in the mid-1870s. Rosa Werner,
Hedwig's sister who lived with the family, was rumored to be Edward's mistress.

Lake George from the back of Oaklawn, the first Stieglitz family summer house,
purchased by Edward in 1886.

ALFRED STIEGLITZ, *Paula, Sun Rays, Berlin* (1889). The model for one of Stieglitz's best-known photographs was probably the "little prostitute" with whom Alfred lived in his last year as a student in Berlin.

A student in Berlin, Alfred in his early twenties strikes a romantic pose while on summer holiday. THE COLLECTION OF AMERICAN LITERATURE, THE BEINECKE RARE BOOK & MANUSCRIPT LIBRARY, YALE UNIVERSITY

Anita O'Keeffe, the most conventionally pretty of the five sisters. Anita eloped in 1916 with a University of Virginia student of business, Robert Young. HOLSINGER STUDIO COLLECTION, SPECIAL COLLECTIONS DEPARTMENT, MANUSCRIPT DIVISION, UNIVERSITY OF VIRGINIA

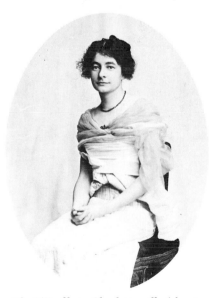

Ida O'Keeffe in Charlottesville (about 1915). Ida, the sister closest to Georgia in age, was a student nurse when the photograph was taken. HOLSINGER STUDIO COLLECTION, SPECIAL COLLECTIONS DEPARTMENT, MANUSCRIPT DIVISION, UNIVERSITY OF VIRGINIA

EDWARD STEICHEN, *Alfred Stieglitz and His Daughter Kitty* (1904–5). Steichen's camera seized the distance between father and daughter. THE METROPOLITAN MUSEUM OF ART, THE ALFRED STIEGLITZ COLLECTION, 1949

Emmeline Obermeyer Stieglitz, whom Alfred married in 1893, and their daughter, Katherine (Kitty), at about age eight. THE COLLECTION OF AMERICAN LITERATURE, THE BEINECKE RARE BOOK & MANUSCRIPT LIBRARY, YALE UNIVERSITY

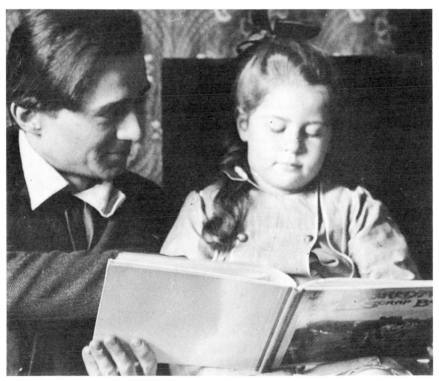

The handsome young painter and photographer Edward Steichen reading to Kitty (about 1905). Steichen, Stieglitz's first protégé, was adopted by the entire Stieglitz family. THE COLLECTION OF AMERICAN LITERATURE, THE BEINECKE RARE BOOK & MANUSCRIPT LIBRARY, YALE UNIVERSITY

Ornament drawing by Louis
Sullivan for one of the buildings
O'Keeffe would have seen dur-
ing her Chicago years (1905–6
and 1908–10). MICHIGAN HISTORI-
CAL COLLECTIONS, BENTLEY HISTOR-
ICAL LIBRARY, UNIVERSITY OF
MICHIGAN

GEORGIA O'KEEFFE, *Blue #2*
(1916). Sullivan's ornament re-
appears as a crook-shaped motif
in O'Keeffe's Blue series. THE
BROOKLYN MUSEUM, 58.74, BEQUEST
OF MARY T. COCKCROFT

GEORGIA O'KEEFFE, *Seated Nude,
No. 11* (about 1917). One of a series of
watercolor studies O'Keeffe made of
Leah Harris during the months they
lived and traveled together. During
Paul Strand's visit to Texas in the
spring of 1918, he spent an entire day
making sixty nude photographs of
Harris (now lost) at the same time
Georgia was painting her. THE METRO-
POLITAN MUSEUM OF ART, PURCHASE,
MR. AND MRS. MILTON PETRIE, GIFT, 1981

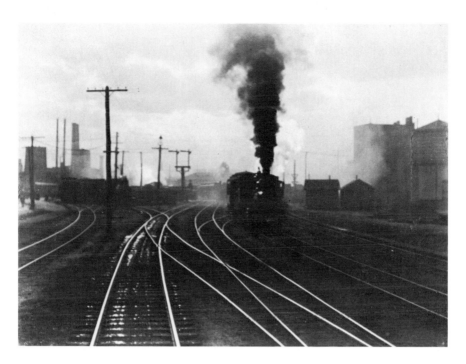

ALFRED STIEGLITZ, *The Hand of Man* (1905). THE COLLECTION OF AMERICAN LITERATURE, THE BEINECKE RARE BOOK & MANUSCRIPT LIBRARY, YALE UNIVERSITY

GEORGIA O'KEEFFE, *Train in the Desert* (1916). O'Keeffe's homage in charcoal to Stieglitz the photographer. PRIVATE COLLECTION

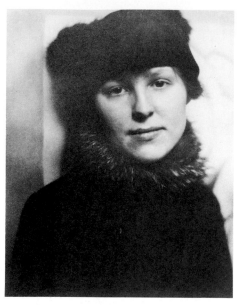

ALFRED STIEGLITZ, *Marie Rapp* (1916). Stieglitz's secretary and lifelong friend. From her first visit to 291, O'Keeffe resented the beautiful young student of voice who had become a surrogate daughter to Alfred. THE COLLECTION OF AMERICAN LITERATURE, THE BEINECKE RARE BOOK & MANUSCRIPT LIBRARY, YALE UNIVERSITY

Mabel Dodge. While Alfred lectured to all comers at 291, Mabel Dodge, Buddha-like and wearing a turban, received only "movers and shakers" at her white salon at 23 Fifth Avenue. THE COLLECTION OF AMERICAN LITERATURE, THE BEINECKE RARE BOOK & MANUSCRIPT LIBRARY, YALE UNIVERSITY

ALFRED STIEGLITZ, *Dorothy True* (1919). An accident in developing caused Stieglitz's portrait of O'Keeffe's alluring friend to become a proto Man Ray surrealist montage. THE METROPOLITAN MUSEUM OF ART, THE ALFRED STIEGLITZ COLLECTION, 1928

the future teachers of the state, she would have to return to Teachers College to pass "Pa" Dow's course in methods.

"Kick up your heels in the air!" she wrote to Anita. She was still two hundred dollars short of what she would need to see her through the spring in New York, but that wasn't going to stop her: "if I can't scratch around and chase it up from somewhere I'll go without it— because I'm going."[6]

Georgia's sudden notice to Columbia College, leaving the art department without a teacher for the rest of the term, was not accepted graciously; ugly things were said. She didn't even want to repeat them.

A few weeks later, a month and a half after classes had begun, Georgia arrived in New York for her third and last stay as a student. It took little persuasion from Anita to convince her not to spend money on another cell-like room near Teachers College. Her uncle, Dr. Sigmund Pollitzer, a dermatologist, lived with his wife and two daughters in a large rented house between Park and Lexington on 65th Street (a few blocks from their friends Dr. Lee Stieglitz, Alfred's brother, and his family). The Pollitzers' oldest daughter, Margaret, was at graduate school at Harvard, leaving seventeen-year-old Aline, a Barnard freshman, living at home.

Her parents found it altogether natural, Aline recalled, to help a poor and talented young woman. There were no strings attached to their offer of a large spare bedroom. Georgia did not take meals with the family; she came and went as she pleased. Perhaps because she was not expected to be another daughter or sister, she and Aline became close friends. Always barefoot, they would meet in the front parlor and talk late into the night.

Georgia O'Keeffe played an intensely important role in Aline Pollitzer's life. Sheltered and innocent, Aline had never met a young woman of powerful and outspoken sexuality. Georgia was the first in Aline's experience who talked about men in sexual terms. There was probably a reason for O'Keeffe's frankness. Aline was a student of Arthur Macmahon's at Barnard; Georgia may well have wanted to explore her feelings about Arthur with the acute and perceptive younger woman. Still, it was only a few years later, when Aline was working in a celluloid factory in Newark, New Jersey, and living with her boyfriend, that she realized Georgia and Arthur had been lovers.

At twenty-nine, Georgia was keenly aware of the passage of the years; her sexual involvement with Arthur was a reminder that she wanted to have a child and that time was running out.

Students in Dow's methods course were required to observe the youngest classes at the Horace Mann elementary school, Columbia's

laboratory school. On one of Georgia's visits, a small boy captivated her completely. She found herself imagining that the child was hers and Arthur's. Shamed by the nakedness of her yearning, she rushed from the classroom, her face burning.[7] Why did she feel so undone by the "normal" desire to bear the child of the man she loved? After all, she had boldly confessed to Arthur the intensity of her love for him. But of this longing, she could speak only when its possibility was all but extinguished. In the fall, when it was clear that passion on both sides was waning, she would tell him: "There had never been anyone else that I would want—or would have for the father of my child."[8]

Despite Georgia's romantic outpourings about Arthur, Aline was aware of a strong element of androgyny in her friend.[9] From Chatham days on, O'Keeffe had been described as masculine. In the conventional view of the day, this was a negative perception: Stieglitz's secretary Marie Rapp's first impression of the artist was of an "unfeminine" woman, an impression reinforced by the severity of her dress. With her hair slicked back, she looked, in the artless observation of a young faculty child in South Carolina, like "a little man."* Her skin, large-pored and marked by typhoid, was untouched by cosmetics.[10]

To Aline, Georgia's masculine attributes were those of liberation and autonomy. Georgia was the first "natural woman" she had ever met. Direct of speech, Georgia exuded an unself-conscious sense of "total freedom"—in her humor and sense of fun, the marvelous smile that dazzled, unexpectedly and complete with dimple, in the serious face. "She was so much herself," Aline Pollitzer recalled.[11] Few children born female in her time and place survived into adulthood with such an absence of social veneer.

ON MAY 2, 1916, Ida Totto O'Keeffe died in the house on Wertland Street in Charlottesville. She was fifty-two years old—thirteen days younger than Alfred Stieglitz. The cause of death was given as pulmonary tuberculosis and suffocation. A Charlottesville neighbor reported that the fatal hemorrhage took place when Ida, getting up from bed, painfully made her way downstairs to answer a knock at the door. The caller was the landlady demanding the rent payment, long in arrears. On the day of Ida's death, no food was to be found in the house.[12] The death certificate was signed by the daughter Ida, as next of kin,

* Portraits of notable lesbian women of the teens and twenties—Natalie Barney, Romaine Brooks, Ida Rubenstein—reveal that cross-dressing often signified male evening dress, characterized by black with touches of white.

who along with Claudia, seventeen and still in high school, were the only children known with certainty to have been living at home. Alexius was studying engineering in Chicago; Francis, an apprentice architect, was, like Georgia, living in New York; Catherine was a nurse in Wisconsin. Three days before her mother's death, Anita, twenty-five, had eloped. A few months earlier, she had left St. Luke's Hospital nursing school in New York for reasons of health. Shortly after her return home, she became pregnant. Following an abortion, she ran off with the unborn child's father, twenty-year-old Robert Young, a banker's son from Texas who had dropped out of the University of Virginia.

Many troubling questions still haunt the death, in Dostoyevskian circumstances, of Ida O'Keeffe. Why, for example, was her able-bodied twenty-seven-year-old daughter Ida incapable of materially contributing to the household or even, it appears, of seeking help from neighbors or friends? Why didn't she alert her brothers and sisters that their mother was dying and that there was no money for food, rent, or medical care? Ida O'Keeffe's doctor, who signed the death certificate, noted that he had not seen his patient for more than a month.

Whether in accordance with the dead woman's wishes or those of her daughter, Ida's body was shipped to Madison, Wisconsin, where she was buried on May 6. Georgia did not return to Virginia at the time of her mother's death[13] or to Wisconsin for the burial; rather, she remained in New York until June 13, shortly before her summer teaching duties began at the University of Virginia.

That spring in New York, Georgia does not seem to have visited 291. Possibly her work for Dow, her involvement with Arthur, and, finally, her mother's death claimed her time and energy. Pollitzer thought there was another reason she stayed away from the gallery; Georgia, she believed, was deliberately avoiding Stieglitz.[14]

He had not forgotten her. Nor had he returned the drawings that Anita had shown him in January. During the last week in May, Georgia was eating lunch at the Columbia University cafeteria when she was approached by a fellow student.

"Are you Virginia O'Keeffe?" he asked.

"No, I'm Georgia O'Keeffe. Why?" she replied. There was a notice on the bulletin board, he explained. An exhibition of work by Virginia O'Keeffe was on view at 291.

According to the golden legend surrounding this strange slip, Georgia, incensed, rushed downtown to demand that Stieglitz take her drawings—hung without her knowledge or permission—from the walls. The door stood open; the gallery was empty. Stieglitz was not there. He was on jury duty until the following week, Hodge Kirnon, the elevator op-

erator, told her. She walked slowly around the room, carefully inspecting her drawings on the walls. (Perhaps she also looked at the oils and watercolors by the two artists exhibited with her, Charles Duncan and René Lafferty.) Still angry, she left. But why was she so full of surprised wrath? A few months earlier, she had been ecstatic to learn from Anita that Stieglitz wanted, if possible, to show her drawings at 291.[15]

The next week, she made another trip down Fifth Avenue. Stieglitz was in the gallery, alone.

"I am Georgia O'Keeffe. I want you to take my drawings off the wall," she is supposed to have said. "You didn't tell me before you put them up."[16]

Accustomed to supplicants, he was shocked. She had immediately set herself apart—not only by her talent but in her rejection of his fame and power. According to Anita Pollitzer, Georgia was unaware of what Stieglitz's sponsorship could do for her career. As an art student, a subscriber to Camera Work, and a reader of other periodicals covering the small world of avant-garde art, Georgia is unlikely to have been so innocent. But to Stieglitz, Georgia's angry demand was proof of her purity: Georgia/Virginia, the virgin artist, was free to love him for himself.

"You don't know what you have done in those pictures," he told her.

Outraged, she retorted: "Certainly I know what I've done. Do you think I'm an idiot?"[17]

Not an idiot, but an idiot savant perhaps, unaware of what she had made. Before Stieglitz could create Georgia O'Keeffe, the first great American woman artist, he had to deconstruct her. She was not only pure, she was primitive—"The Great Child," he called her—innocent as he believed a child to be—of herself, of sex, of art.[18] The "woman on paper" he had seen five months earlier expressed, through instinct, what she had yet to experience.

When he met her, Stieglitz would later insist, O'Keeffe was "untouched," a virgin. He was forced to draw on science to explain the highly charged sexual imagery of her black and white drawings. Nuns, he had once read, were capable of powerful sexual feelings—the more powerful, perhaps, for remaining unexpressed. Indeed, he feared that in awakening Georgia's sexual consciousness, he would destroy the erotic impulse of her art.[19]

Stieglitz, apparently, had never read his greatest contemporary. But without Freud he managed a do-it-yourself theory of art as sublimation. In any case, he saw himself as God, weighing the creation of Woman against Artist: Virginia on paper or Georgia summoned to life.

When Georgia left the gallery, her drawings stayed on the walls. In that first meeting, she later claimed, Stieglitz's words had dispelled her anger. To keep her work from being seen, he said, would be like depriving the world of a child about to be born. The metaphor must have seemed all too apt. His words, his voice, his piercing gaze that seemed to see through her won from the wary and secretive young woman, protective of herself and her art, a condition of trust she had never before experienced.

"As soon as Stieglitz spoke to you, you felt freed of all your burdens and secrets; his understanding freed you," another woman explained.[20]

Georgia did not return to 291 before she went home to Charlottesville in June 1916. But Stieglitz began writing to her almost immediately on her arrival in Virginia, reporting on the reaction of gallery visitors to her drawings, on view until July 5. Through his own feelings about her art, he was able to tell the artist what she had already come to mean to him: "Your drawings on the walls of 291," he wrote to her in June, "would not be so living for me did I not see you in them. Really see."

But no sooner did he "see" Georgia than she disappeared—replaced by a mirror image of her creator: "Those drawings, how I understand them. They are as if I saw a part of myself."[21]

IT WAS six weeks after her mother's death that Georgia returned to Charlottesville. With both her father and older brother gone, she was now head of the family; it was her responsibility to dispose of Ida's belongings before the house on Wertland Street could be vacated.

"Is it hell?" Anita Pollitzer wrote anxiously to her friend, knowing what awaited her in the dismal rooms: remnants of boarders and relics of a dead woman's hopes—books, the piano, a few pieces of furniture salvaged from the white Sun Prairie farmhouse.

Memories, guilt, and an endless rain combined to make a melancholy task unendurable. As would often happen, Georgia's depression took the form of physical collapse. She spent most of the week following her return home in bed. "It seems absurd," she wrote to Anita, "but I get so tired that I almost feel crazy."[22] She was too exhausted to read or write. Her only respite was the "five wonderful Camera Works" that Stieglitz sent her. "The pictures excited me so that I felt like a human being for a couple of hours," she wrote. But she had only enough energy to look at the images; she was too weary, she added, to read any of the text.

Not even the unseasonable coolness lifted her spirits. Washed by the rain, "everything is wonderful heavy dark green—and the green is

all so very clean—but I hate it,"[23] she complained. So she would come to hate the somber, oppressive green of the Lake George landscape.

She was thankful for the convenient schedule of her classes. Teaching from 8:30 to 10:30 each morning, she could "do it and come home and go to sleep." One other "surprise" made her feel human for a little while. One night, just after dark, she had gone up the hill to the university. For the first time, she saw Jefferson's Rotunda, newly illuminated from the shrubbery below. The architecture and the people walking around gave "all sorts of fine effects from different views," she reported to Anita. "I think Im going to make some thing from it," she added, in the first reference to painting since her return. In her depressed state, she qualified even this modest leap into the future: "hope I am," she ended.[24]

Letters from 291 and Lake George, sustaining as food and drink, followed the exciting back issues of *Camera Work*. Alfred's own need to see Georgia as a child gave her permission to be frail, vulnerable, and irresponsible. Giving in to weakness had never been allowed during her mother's lifetime; with Ida's death, a failure of will on the part of her oldest daughter would have been the ultimate betrayal of maternal pride.

In sleep, too, the adult Georgia could return to the helplessness of the infant, of whom nothing may be reasonably expected. The sleeper is the consummate escape artist. As a chosen symptom of depression, sleep both narcotizes the pain of suffering and stifles its voice; but for nightmares, the sleeper's lips are sealed.

Few were ever allowed to hear of Georgia's darker feelings. Alfred was privileged with an openness that Georgia accorded no one else in her life: not the sheltered Anita, the troubled Dorothy True, or the young, idealistic Arthur Macmahon.

As Stieglitz had awaited her presence on paper, she was searching for the kind of sympathy—characterized by wisdom, encouragement, and forgiveness—that Stieglitz, in his role of "ideal father," lavished on his adopted children. "I think letters with so much humanness in them have never come to me before," she wrote to him that summer. "I have wondered with every one of them—what is it in them—how you put it in—or is it my imagination—seeing and feeling—finding what I want—they seem to give me a great big quietness.[25]

In the middle of July, after he took down the exhibit, Alfred had some of Georgia's drawings framed "to protect them—they have meant so much to me," he wrote, "that I can't bear the thought they may be soiled—rubbed—for they are not fixed." He had been reluctant to frame them earlier, he said, lest they "lose any of their freedom."[26] If, as these

remarks suggest, the drawings had been exhibited unprotected, then Stieglitz was strangely unconcerned about possible damage from crowds of casual visitors. His worries about "soiling and rubbing" emerged only when he was alone in the gallery with the pictures.

Recalling O'Keeffe's anger when he exhibited the drawings without her consent, Stieglitz now apologized for framing the works without asking her. In the few weeks that had elapsed since her visit to the gallery in late May, however, Georgia had experienced a change of heart: she was ready to entrust that most personal part of herself to Alfred. "Nothing you do with my drawings is 'nervy,' " she reassured him. "I seem to feel that they are as much yours as mine."[27]

At the end of July, Georgia went on a weekend camping trip with friends, climbing Mount Elliott near Staunton, Virginia. While her companions slept by the campfire, Georgia walked to the top alone in the moonlight. She reached the summit just as dawn was breaking, and her solitary communion with nature, "the wind—and the stars and the clouds below," seemed to lift her from the depths of depression and paralysis.[28]

Her energy restored, she had been "working some" the week before the Mount Elliott excursion; it was her experience of daybreak at the summit, however, that seemed to herald a rebirth. That same weekend, she began a remarkable series of watercolors, one based on her memories of sunrise above the clouds, another of Mount Elliott bathed in the blue light of dawn.

As though to celebrate her regeneration and reaffirm her as an artist, Georgia received, on her return to Charlottesville, a "surprise" from Alfred: a package containing nine photographs that he had made of her work during the exhibit at 291. Visible in the photographs, along with the drawings, is a plasticene sculpture by O'Keeffe, which she had apparently given him as a gift. Referred to by Anita as your "clay friend" or "the lady," the work, an unmistakably erect phallic form, seems to have been lost.[29]

In exchange for his surprise package, Stieglitz asked to keep one of the charcoals. The drawing he wanted for himself is "to the right of the *seething* one—the one I considered by far the finest—the most expressive."*[30]

Georgia's delighted response to the photographs was to send Alfred her most recent work. At the very end of July, she mailed a bundle of

* Stieglitz was surprisingly inarticulate about describing what he saw on canvas or paper. Later, when he wrote to friends telling them what Georgia was doing, he confined himself to observations that the work in progress was a "big red picture" or, more often, "a Wonder."

new drawings directly to Lake George. Marsden Hartley, whose observant painter's gaze was made keener by a lifelong envy of Georgia as the favorite child, noted that Alfred carried the drawings with him everywhere: Stieglitz's "celestial solitaire," he called the sheets of paper.

On August 1, Alfred wrote to Georgia "merely to tell you that the drawings are safely in my hands and that I am grateful—as I have ever been to you since I was first given the privilege to see your self expression."[31]

Georgia's self-expression—in Stieglitz's "progressive education" idiom—had already aroused critical reaction focusing on the sexual content of the charcoal drawings Stieglitz exhibited in the spring, followed inevitably by crowds of the curious. Eclipsing the timid postimpressionist efforts of her two fellow exhibitors, Charles Duncan and René Lafferty, O'Keeffe's meditations in charcoal were transparent in meaning to puritan and sensualist alike. Even the euphemistic prose of the *Christian Science Monitor*'s reviewer echoed Stieglitz's version of Georgia's subject matter: sexuality without sex. "Miss O'Keeffe looks within herself," the review noted, "and draws with unconscious naiveté what purports to be the innermost unfolding of a girl's being, like the germinating of a flower."[32] None of the critics mentioned the sculpture.

ALFRED'S SUMMER at Oaklawn, which would extend until October, followed an exhausting year. In an effort to shore up his tottering empire, he had become dangerously overextended.

The new journal, *291*, the dada-inspired avant-garde organ of young dissent, was losing money on every issue; the elegant, large-format magazine, with its distinctively modern design and four-color cover, would soon join *Camera Work*, doomed to expire in the next months, its three hundred fifty subscribers of 1905 down to thirty-seven. Alfred's one-third share in the rent of 291 and his monthly allowances to Marsden Hartley and Arthur Dove (to be repaid in paintings that, along with his Marin holdings, eventually added hundreds of works by American modernists to his collection of European artists) had required bank loans whose interest in the 1915–1916 season came to eleven hundred dollars.

Then, in the middle of the season, Alfred had decided to withdraw his support from the Modern Gallery. In this case the reason was not financial—Agnes Meyer was paying the bills—but emotional. The Young Turks, he was convinced, were using his name and prestige, the "spirit of 291," to hustle art. In a certain spirit of spite, Alfred lent his support to another collaborative venture in the sponsorship of abstract art, called the "Forum Exhibition of Modern American Painting."

Organized by Willard Huntington Wright,[33] critic, art theorist, and brother of artist Stanton Macdonald Wright, the Forum Exhibit, featuring two hundred works by thirty-three Americans, opened at the Anderson Galleries, on Park Avenue at 59th Street, in March 1916. Promoted by Stieglitz and Wright as America's answer to the Armory Show, the Forum Exhibit purported "to divert public opinion from European modernism," but in fact the high-minded "noncommercial" slant of its sponsors was a direct slap at art dealers, like Montross, Daniel, and the Washington Square Gallery, who were beginning to establish New York's preeminence as a market for modern art. For Alfred, the Forum Exhibit was the perfect revenge on the Modern Gallery and his rebellious children.

"Lofty claims about the non-commercial 'cause' of American modernism" as exemplified by the Forum Exhibit were belied by the low methods of its organizers, one historian has noted.[34] Using Wright as the first in a series of hit men, Stieglitz, acting for the Forum's selection committee, dispatched him to persuade his artist acquaintances not to exhibit at any gallery that showed European art. Reporting on the success of his mission, Wright noted: "This ought to teach Montross a lesson." Others might have felt the need to justify such an abrupt about-face: from ardently promoting European modernism to waging guerrilla warfare on galleries who exhibited the same artists. Stieglitz disdained any explanation; the most obvious would scarcely have occurred to him.

Aggression—whether by means of hired guns or his own open vendettas—was required to boost Alfred's morale and rally his supporters. If he could feel hated, misunderstood, and betrayed, he still counted as a force to be reckoned with. But this time, his exhilaration in the role of the Godfather of American modernism was short-lived; in the face of America's certain entry into the war, the public's interest in art—abstract or representational—along with the discretionary dollars of collectors had evaporated. By early summer, it was clear to Alfred that his struggle had been swept to the margins of history. Writing sadly to Georgia in June 1916, he noted: "The streets are full of soldiers—soldiers to be—and they do not strike me with any pleasure. And yet I feel if I were young I'd join them rather than be so apart from the world as I am these days."[35]

By the end of August, Georgia's miasma had begun to lift. Her emergence from depression was due, in large measure, to Stieglitz's constant presence in letters to her: several times a week she found in her mailbox thick envelopes addressed in his beautiful calligraphic hand; inside, swirling lines of black ink formed words so large that several sheets of paper were needed for even a brief note.

Alfred's own sense of mourning, his feelings of sadness and anger that a money-mad, war-crazed world had left him behind, and his annual departure from a gallery that had never seemed emptier intensified his empathy with Georgia's state of mind: her overwhelming depression on confronting the dissolution of her family. In encouraging her to think about her art, her state of mind, and her plans, he was at the same time exhorting himself to believe in a future. It was just what Georgia needed to hear. His letters, she wrote to Anita, were "like fine cold water when you are terribly thirsty."[36]

Promising to send him the results, she got to work again.

Buoyed by renewed productivity, braced by Stieglitz's passionate concern for her art, her state of mind, and her future, Georgia felt a burst of high spirits at the end of August intensified also by her relief at leaving the house on Wertland Street forever. There is a manic rush of excitement to her description of departing Charlottesville for Canyon, Texas: everything was plenitude and fullness. The two weeks between her two lives, she wrote to Anita from Texas, were "so very full . . . I have been living so hard—It has been so fine—that I haven't wanted to tell you till tonight—There has been so much that there was little room to want."[37]

Georgia's journey to Texas from Virginia became a voyage out. With friends, the Scotts, she drove from Charlottesville to Knoxville, Tennessee, sleeping nights in a tent—something she would always love with the intensity of a child: "Just did as we pleased," she wrote exuberantly. The billowing flap of the watercolor *Tent Door at Night* has the lyrical surge of a spinnaker filled with wind. Although a resting place, for Georgia the tent would always convey the buoyancy of the vagabond. Unlike the previous summer's outing with Arthur Macmahon when, dabbling her feet in a stream, she cautiously kept her stockings on, she now went barefoot in the rain. Parting from the Scotts, she detoured to Asheville, North Carolina, where she had planned a day's visit with a friend, Katherine Lumpkin, a social worker. Letting Katherine map local hikes, Georgia was amazed to find herself in the same place in the Smoky Mountains where she and Arthur had planned to stay the past spring—a visit that never took place. Then, changing plans again, she decided not to meet the Scotts in Atlanta, where they were to climb Stone Mountain. Instead, she stayed on with Katherine, chiefly, she told Anita, because her friend was very tired "and I knew she wouldn't rest unless I stayed and watched her do it." But her liberation into nature kept her still longer: much as she was looking forward to Texas, she wrote to Anita from Canyon, "I got up there in those mountains

and I simply couldn't leave till the last train that could get me here on time."[38]

THE LAST TRAIN arrived in Canyon, Texas, on a Saturday at midnight. The speck in the plains, where one could count all the houses in half an hour, would have been barely visible in the darkness. Only its windmills, silhouetted against the pale sky, showed where the sidewalks ended and the vastness of unpeopled land began.

Georgia's first impression of her colleagues made her want to head for the surrounding emptiness. "It is a shame," she reported sourly, "to disfigure anything as wonderful as these plains with anything as little as some of these darned educators."[39]

Within twenty-four hours she had yielded slightly; she wasn't feeling quite so "wrathy" toward the provincial pedagogues who were her new associates. Her mood was softened by the "finest" letter she had ever received from Stieglitz; to describe it, Georgia unconsciously adopted Alfred's chosen superlative: "it was a wonder," she wrote to Anita, scolding her at the same time for her much thinner communiqué. "His was so big—and I so much needed a big one that morning."[40]

She apologized for sounding grumpy; anyone would be in a "devil of a humor" who had wakened on Sunday morning to find "pink roses in squares hitting you from all over the walls—pale grey ground—dark green square lines—tails gold—roses *pink*." To convey the full horror of everything coming down roses (with more in the centers of two rugs), she added a diagram. "I moved next day," Georgia added.[41]

Like the rose-patterned paper and the petty-minded educators, Canyon itself felt too small for Georgia. The poky town of "ugly little buildings," windmills, and identical houses on identical streets had none of the raw glamour of Amarillo; in the cattle town, cowboys and roustabouts with dust-caked faces, gargantuan appetites, and boozy social habits brought the frontier to the Magnolia Hotel. The favorite Sunday diversions of Canyon's twenty-five hundred souls were clubbing jackrabbits to death or shooting, and then barbecuing, those buffalo unwise enough to wander too close to town. After the Texas of her memories, "it seems . . . queer to be here," Georgia wrote, "—it doesn't seem far away from the world like it used to."[42]

Canyon's confined scale made another escape into nature urgent. Georgia looked up at the sky constantly; there was always something thrilling to see. On her first night, she gazed in rapture from the window of the rose-papered room, elated by "wonderful white fleecy clouds." In

the next days, she walked into the sunset to mail some letters, "the whole sky . . . just blazing—and grey blue clouds were riding all through the holiness of it." Suddenly, an electrical storm lit up the sky, "first in one place—then in another with flashes of lightning."[43] The flashes of sheet lightning with a sharp, bright zigzag across it became a painting in which the bolt of light appears to have slashed a valley from the flatness. As with many of O'Keeffe's forms, the zigzag would reappear, transformed from part of nature to become an element in the artist's abstract vocabulary. She was never more inventive; in *Starry Sky* (1916), she used the blank paper to punch holes in the blue, creating a rhythm of twinkling constellations.

"It is absurd the way I love this country," she wrote.[44] Palo Duro Canyon, twenty miles east of town, became her favorite destination. A Grand Canyon in miniature, Palo Duro was a slit in the plains, only a mile wide but at some places a thousand feet deep. In keeping with its astonishing existence, like Alice's rabbit hole, the canyon's steep drop hid another world: from the brown tableland at the top, Georgia inched perilously down the only way, "narrow winding cow paths, hidden in the golden sandstone walls by banked earth whose edges rose so steeply you couldn't see the bottom,"[45] she recalled. When Claudia joined her in January, the two sisters explored pathless climbs for better views. Each held the end of a long stick to keep the other from falling. The only other regular visitors to the canyon were the cattle belonging to people in town; they came to seek shelter from the wind and snow blowing across the mouth of the canyon far above. Eden awaited on the canyon floor: an oasis of juniper and cedar trees, wild plums, and grapes watered by a small creek that splashed into a waterfall.

Suppressed during the dangerous climb, Georgia's fears emerged in nightmare form: "the fright of the day was still with me in the night," she remembered, "and I would often dream that the foot of the bed rose straight up into the air—then just as it was about to fall I would wake up."[46]

"Many drawings and later oil paintings came from days like that," O'Keeffe noted more than half a century later.[47] She compulsively reworked one composition, suggesting another dream of terror, in both color and black and white. In *Painting No. 21 (Palo Duro Canyon)* (1916), the fissured earth opens to reveal bubbling volcanic matter below, with flaming reds and oranges that seem to rise from an opening of hell; on the verge of spilling over the picture frame, the molten stream rushes toward the viewer, precariously perched on the cauldron's rim.

Slowly, Georgia found friends who were larger in spirit—or even body—than the shrunken pedagogues she had first encountered. She

watched a lightning storm with the "biggest [old man] I ever saw . . . tremendous . . . distinctly a working man . . . in his shirt sleeves."[48] Georgia's image of her new landlord (as he turned out to be) with his beautiful white head, picketing his horse calmly the morning after they had watched the storm together from her porch, has a flavor of John Steuart Curry's *John Brown*, suggestive of the regionalist "primitive" Georgia might have become.

LETTERS FROM Lake George multiplied in volume and intensity; with Emmeline banished to her tour of New England hotels, there was only Kitty—grateful for the most occasional of fatherly attention—to remind Alfred of his marriage.

Georgia's own reserves of deepest feeling were not easily expressed. Georgia was physically overwhelmed by Alfred's compulsion to bare his soul—and to a woman he scarcely knew. She was ambivalent (and always would be) about the burden self-revelation inevitably placed on the confidant. "Anita—he is great . . . Still—Im glad I cant see him," she wrote to her friend. His letters were "wonderful," yet "sometimes he gets so much of himself into them that I can hardly stand it." They were like the loud discordances of some contemporary music she had recently listened to: "you would lose your mind if you heard it twice— or like too much light—you shut your eyes and put one hand over them — then feel round with the other for something to steady yourself by."[49]

Deafness and blindness—Georgia's images for the way Alfred affected her, even on paper—did not bode well. What he was trying to tell her about himself was lost in a blaring cacophony of words, a dizzying confusion of ideas. There was something terrifying about this Ancient Mariner of 291: his need to talk, to tell, to unburden himself, seemingly, of his entire life. In one week—her second in Canyon—she received five letters from Stieglitz: "Everyday I was scared when I looked for the mail—afraid Id get another," she wrote to Anita.[50]

Her fear of Stieglitz's torrential verbiage, of caring too much about a married man—or any one man—made her hang on to Arthur Macmahon. She asked Anita to mail to Arthur *Man of Promise* by Willard Wright, which Stieglitz had sent her. Clucking maternally about the younger man, she noted, "He wants to read it but wont unless it's stuck right under his nose."[51] She wrote to Arthur, telling him of Stieglitz's letters and what they were coming to mean to her. News of competition did not stir Arthur to action. Before she left Virginia, he had promised to visit her in Canyon "soon," but she was doubtful that he would materialize.

Exchanges of letters, books, and journals with Macmahon, Stieglitz, and Anita provided all the intellectual stimulation Georgia needed. She had no nostalgia for the city whatever: "I am not even having the smallest wish for N.Y.," she wrote. Her rapture was constantly renewed in the miracle of light and space.

With a friend, a woman rancher, she walked way out on the plains where "there is no wind—so still and so light." Two women could just keep on walking alone at night, with "nothing to be afraid of—because there is nothing out there," she told Anita.[52]

More surprising, after her first encounter with fellow educators, Georgia was delighted with her job. Even the ugliness of the town was forgotten: "everything is so ridiculously new," she noted about the school.

Dominating the little county seat of Canyon, the imposing yellow brick building that housed West Texas State Normal College and all its activities had just been dedicated the previous spring. There was no art library, no supplies, not even chairs when Georgia arrived; her students sat on packing cases. An administrator as well as teacher, Georgia now had a budget of five or six hundred dollars a year. In a state of wild excitement, she commissioned Anita to buy books on textiles, carpets, and furniture, to send photographs of Greek pottery and Persian plates, and to look into the kind of display cases used by Teachers College. Meanwhile, accustomed to stretching every dollar, she covered the blackboard with burlap to make a screen for critiques of student work.

She taught first-year design, interior decoration, and costume to home economics majors in the two-year college. Her students would have been mystified by Alfred Stieglitz's image of O'Keeffe: the great primitive child/woman, an intuitive sprung from the American soil. At least one recalled her teacher as an aesthete of the most refined, cultivated taste. She introduced the students to cultural fare as varied as the Russian novelists and the art theory of Clive Bell. She taught her own fashion preference for straight lines over the corseted curves still favored by daughters of the frontier and insisted on the equal aesthetic importance of the cut of a sleeve, the addressing of an envelope, and (remembering perhaps her father's eccentric fenestration) the placement of a window.

Georgia's enthusiasm for the school was largely due to her students. She loved the raw-boned young men and women from farm hamlets or nearby ranches, almost all the first in their families to go beyond high school. Perhaps they reminded her of another serious and ambitious Wisconsin farm girl. Like their teacher, many had had to alternate work and study.

Ted Reid was a local football hero with a grin as wide as his strapping frame. The same age as Georgia, he had worked since he was fifteen, driving his father's cattle alone on the roads from Texas to Kansas. His ambition was to be a pilot; he hoped the war would last long enough for him to be trained and sent overseas. As president of the drama club, Reid was thrown together with O'Keeffe, the faculty adviser on sets and costumes. They shared a passion for the wilder manifestations of nature—thunderstorms or, perhaps, as in the favored movie cliché, those extremes of weather that expressed a smoldering sexual attraction. According to Anita Pollitzer, Georgia rebuffed Ted's manly arm placed around her shoulders as she stood watching from a window while the tropical rain poured down in sheets. She shortly forgave him, however. Soon, in Ted's brother's car, they were driving in the evenings into the sunset-drenched plains. She invited him up to her room to show him the photographs Stieglitz had taken of her work at 291. She was apparently ignorant of—or perhaps uninterested in—the college rule prohibiting faculty from dating students. But she could not have been unaware of a universal sanction of small-town life: respectable women did not receive men in their rooms. As an outsider, an artist who wore green smocks, who was rumored to have asked to paint her bedroom black, who hiked in the canyon like a man, the redoubtable Miss O'Keeffe might live by her own rules, but Ted Reid could not afford to flout community opinion. When a delegation of local matrons informed the model student that he was jeopardizing his career in aviation, he apparently capitulated. Too frightened or ashamed to tell Georgia of his decision, he simply disappeared from her life. Fifty years later, she still remembered him, "dropping me like a hot cake."[53] Her feelings for Ted may be measured by a gift she made to him. More than twenty-five O'Keeffe watercolors were recently discovered by Reid's granddaughter in the family garage. Georgia rarely gave her work away.

Other gentlemen callers gave rise to more gossip, but Georgia continued inviting men to her room. Receiving the Yale-educated county prosecutor might not fall into the category of corrupting local youth, but her landlady objected; Georgia and the romantically inclined lawyer drove in his car out into the prairie. Whatever he may have inferred from her invitation, he was rapidly proved wrong. Her only interest in him was as a guinea pig: an intelligent professional male, yet one uninterested in art, to try out her ideas for a forthcoming lecture to the Faculty Club on cubism.

They drove out to a canyon draw that Georgia planned to paint, and they parked facing the hills. "It was a wonderful lavender sort of moon-

light night," she recalled. But her companion wasn't "the kind you enjoy out doors with—he spoils it," she noted coldly.

They returned to the car, where they talked for a long while. Georgia leaned forward to get a better view of the hills. When she sat back, she found, with a mixture of outrage and amusement, the young attorney's arm around her. "I almost died laughing," she wrote to Anita. Understandably, he was perplexed by Georgia's hilarity: mystified as to why a woman nearing thirty, who invited him to her room and then drove with him out into the prairie moonlight, found his romantic impulse so risible. To Georgia, "that well fed piece of human meat wanting to put his arms round me" was merely an obscene contrast to the barren beauty of the landscape: "I wonder that the car didn't scream with laughter," she noted.[54]

As a local sample of educated philistine, the amorous prosecutor made a perfect trial audience for Georgia's lecture. Her talk on cubism was such a success that the allotted three-quarters of an hour proved too brief: in the question period that followed, her audience got so excited, she reported, that the staid event turned into a real circus. But she had left little to chance conversation. For three months, she had been "slaving" on her lecture, doing homework in aesthetics, she reported to Anita. She reread Kandinsky's *On the Spiritual in Art*, finding it even more stimulating the second time; and she read Clive Bell and Willard Wright, *Cubists and Post Impressionism* by Arthur Jerome Eddy, along with writings by *Camera Work* contributors Marius de Zayas and Charles H. Caffin.[55]

Besides her readings in art, Georgia devoured the "scarce" books found on local shelves: she read Longfellow's translation of *The Divine Comedy* all in one night; the poem seemed part of the "tearing storm" raging outside. Goethe's *Faust*, which "He" had sent her, "still has me bad—I read on it almost everyday," she reported.[56] The great drama of the infernal bargain was Stieglitz's favorite work, so he claimed; its grip on Georgia surely had much to do with the donor. She read, in order to discuss with Anita, novels and plays with feminist themes: Susan Glaspell, Ibsen's *A Doll's House*, and essays by Charlotte Perkins Gilman as they appeared in her short-lived journal *The Forerunner*.

Georgia's energies—physical, intellectual, and creative—expanded to Texan proportions. Along with teaching and advising student plays at the college, she taught a first and second grade class in town, just because she enjoyed young children. And she could outlast any man, Georgia told Anita proudly, on hikes and excursions. When her sister Claudia, seventeen, arrived in Canyon in the late fall (where Georgia had already enrolled her at the college), they added tennis to their

activities. A little Annie Oakley, Claudie loved shooting; she hunted duck and quail. The two sisters, slender and wiry, both dressed in mannish attire, complete with men's shoes, must have seemed to the locals a mirror image of each other.

SINCE HER arrival in September, Georgia had been drawing and painting in watercolor. As soon as she emerged from her depression in Charlottesville, she had continued her explorations of the color blue begun in South Carolina. Soon she was once again using the entire palette, producing watercolors that are arguably the most authoritative, original, and haunting work of her long career.

Like the *Blue Lines* series (1915–1916) other abstract forms first conceived in black and white were reworked in blue wash of varied intensities. From Canyon, at the end of September, Georgia mailed a number of these compositions to Anita. Another series—variations whose principal motif is a crook or comma form—included almost a dozen versions.

In the increasingly down-to-earth manner that reflected her feminist writing and organizing, Anita Pollitzer unblinkingly addressed the sexual content of Georgia's new work. While male critics—then and now still—talked about "the masculine and feminine principle" or gingerly invoked "a young girl's unfolding," Anita described one work as "the pod of stuff standing quite erect & without assistance . . . the one I called cucumber," noting briskly that "the cucumber is just truth—Its a fact—thats all . . . Its rather self evident in meaning—I've known it always—but as art . . . its O.K. very good."[57]

O'Keeffe was never able to acknowledge the erotic element in her art. By calling her first sculpture "a Lady" or "Weeping Lady," she denied the sexual by drawing on a classic Edwardian syllogism: A lady is never sexual; therefore, the plasticene form could not be a phallus. Now, in reply to Anita's letter, Georgia noted vaguely that she recognized the composition described as the erect pod (sketched by Anita in the margin of her letter to refresh the artist's memory). She couldn't, however, recall the cucumber. "Someday when Im least expecting it I'll probably remember," she conceded.[58]

Overwhelmed by the sexual intensity of the imagery, Anita asked: "Where did you keep the rest of yourself while you were doing it?"[59]

"I think I just stored it all away," Georgia answered, "and got it out one night this week and put it all into a little bunch of plasticene." She had sat up almost the entire night of its creation and "made the most infernally ugly little shape you ever saw." When it was finished, she

had wanted to smash the new work; but looking at the piece the following afternoon, she decided that it "amused" her. "Its so ugly—and still some ways it's quite beautiful," she wrote.[60]

Ugly, beautiful, laughable—this sculpture Georgia left untitled. We do not know whether the "Weeping Lady" or the later work made in Canyon is the piece exhibited in O'Keeffe's first one-woman exhibition at 291 the following spring, where it was photographed by Stieglitz; the inclined head and curved shaft could be read as a mournful female figure. In the photographic portrait of O'Keeffe that Stieglitz began as soon as they became lovers, she is shown in several prints fondling and stroking the plasticene form with her hands and feet. More than a prop, the sculpture was now a surrogate sexual presence of the photographer.

BY THE END of October, Georgia's beloved plains had taken on final fall colors: "green gold and yellow gold and red gold—in patches—and the distance blue and pink and lavender strips and spots," she reported to Anita; then, joking about their old teacher Dow's timid postimpressionist studies of the West, she added, "May sound like a Dow canyon but really its wonderful."[61]

Snow was flying. In December, it was bitter cold in Palo Duro Canyon: her last visit in a "tearing norther . . . was terrible." She had to decide whether to return to Virginia to teach summer school—having recommended Anita to take her place—or to remain in Canyon for the summer session. Unlike her well-off friend, who worried most about the Charlottesville climate, money was Georgia's principal concern: she would love to design the University of Virginia's annual pageant, but it was uncertain that even this "extra" job, combined with her two classes, could match Canyon's salary of three hundred fifty dollars or more.[62]

Before going home to Charleston for the Christmas holidays, Anita visited 291. Almost a year had gone by since she had climbed the dark stairs on that first day of 1916 with Georgia's drawings under her arm. Now confident of her own judgment and her acknowledged role of mediator, she appeared with the three blue watercolors chosen from her friend's recent mailing under her arm.

"He was wonderful—more than ever," she reported to Georgia, "but so much older."[63]

Alfred had indeed aged dramatically over the past eleven months: his hair, no longer pepper-and-salt but white, reflected real—not invented—battles that he was losing on every front. All at once, the end of everything that had defined Alfred Stieglitz for twenty-five years was

at hand: *Camera Work, 291,* his own photography, his leadership of a movement. With the certainty of America's entering the war, Alfred's German-flavored internationalism, once a source of pride, was now an embarrassment.

At home, Kitty's applications to college for the following fall reminded him that he would be losing the buffer state in his marital hostilities; returning uptown at the end of the day, he would face an ever lonelier and more depressed Emmeline. Prohibition, now being ratified state by state, would dramatically reduce Emmy's income; with the new expense of Kitty's tuition and the continued upkeep of 1111 Madison, discretionary dollars would be scarce. Alfred's funds were sufficient for him to play patron of the arts downtown in the modest setting of his one-room office at 291, *if* he did not have to contribute to his uptown household. He tried to convince Emmy of the advantages of the scaled-down, servantless life. She was not persuaded, clinging stubbornly to her girlhood notions of the way things ought to be done. Her household rituals, the dinner parties given and returned, the annual cleaning, painting, papering of closets and drawers—were the only source of her fragile sense of worth, the sole activities over which she maintained control. Without their consoling ceremonies, she was nothing.

For Alfred, however, retrenchment promised more than a leap forward. Anita's visit to 291 in late December revealed the rebirth about to come. The exhibit Stieglitz had just taken down was a group show. Featuring paintings and drawings by Hartley, Marin, Walkowitz; the synchromist abstractions of Stanton Macdonald Wright (which O'Keeffe would admire and emulate); and O'Keeffe herself, the exhibit consisted, significantly, solely of Americans. The show even had a mascot: ten-year-old Georgia Engelhard, Alfred's sassy, yellow-haired niece.

In dismantling the exhibit, Alfred left one work hanging. Georgia's *Blue Lines* stayed on the wall nearest his back room. Delicate and powerful, the two strokes of sure calligraphy described, Anita wrote to Georgia, forces that were "dependent on each other, yet perfectly separate."[64]

AT THE END of January, snow fell on the Panhandle for three days. Georgia and Claudia's canyon excursions were curtailed, but not the exuberant younger girl's hunting. Georgia's affectionate accounts of her little sister's boundless energy led Anita to wonder whether the state of Texas was big enough for her.

Georgia herself felt snowed under: she was too busy for books; the

only reading she had time for, aside from texts on art, were two other Ibsen plays—*An Enemy of the People* and *The Wild Duck*. It was the second that made an indelible impression on her: "tremendous," she called it, insisting that Anita read Ibsen's masterpiece immediately.[65]

In the somber drama that struck a deep chord in O'Keeffe, Gregers, the frustrated misfit son of a powerful industrialist, completes the destruction of a family begun by his father. Moving in with his victims, Gregers insists that they live by truth alone and drives a young daughter to suicide, her mother and grandfather to madness. Only the father of this doomed household escapes: Hjalmar the photographer, whose life of sentimental idealism, lies, and self-deception has been sustained by his adoring family, goes off to persuade other gullible souls to believe in his genius.

From a fallow autumn of "thinking more than . . . doing," by November Georgia felt a new "fever for painting and drawing." Her burst of creative energy was fueled by news from Stieglitz; he was planning to devote a special issue of *Camera Work* to her, along with a one-woman show of her paintings and drawings at 291—both to take place in late spring. She was finally becoming accustomed to the frequency of his letters (sometimes five a day) and their pitch of emotional intensity. "They knock me down, but I get up again," she wrote to Anita.[66]

Early in 1917, Georgia had begun to explore in watercolor the drama of Texan landscape and sky. With its arc of heaven emerging from bare paper, the series *Light Coming on the Plains* joins the transcendental tradition of American landscape painting. Whether or not O'Keeffe read Emerson, as one critic has argued,[67] these ecstatic meditations are suffused with a sense of the artist's pantheistic oneness with nature. Behind veils of blue wash, the first light of day appears, intermittently at first: a gradual revelation of the sublime.

Seen high in the sunset sky, while daylight lingered, "the evening star," O'Keeffe recalled, "fascinated me."[68] In the late afternoons the two sisters would walk away from town and into the plains. Claudia took her gun and, as they walked, she would toss bottles into the air and see how many she could shoot before they hit the ground. Echoes of shattering sound seem to resonate in *Evening Star*, a series of ten watercolors O'Keeffe made of this "walk into nowhere." In these variations, she reworked her favored crook shape, now turned horizontal to become the fiery nimbus of a tailed comet in whose center the yellow star glows like a bull's-eye.

Among the smallest works that O'Keeffe would ever paint, the Texas watercolors propose an infinity that defies their modest scale. Congenial

to the speed with which she always painted, this difficult medium yielded its every possibility to her: the white of naked paper, its surface rippling when soaked with water; color areas spanning high-intensity reds and blues to translucent sweeps of barely tinted washes. In these watercolors, vision and technique become one: they stake their coloristic claim with daring and confidence. O'Keeffe may have read Kandinsky twice, but she looked harder at Matisse.

Whether because of bigger Texan dollars or reluctance to return to Charlottesville, by February Georgia had decided against teaching summer school in Virginia; she passed the job along to Anita Pollitzer. She had found new friends in Canyon—uncomplicated young people who liked to laugh and have a good time; they shared her outdoor pursuits, inviting her to Amarillo and San Antonio on overnight and weekend visits.

MEANWHILE, 291 limped through its last season; Stieglitz's drumbeating for young American artists was turning into the gallery's death rattle. One-man shows of recent work by Walkowitz, Hartley, and Marin excited little interest from critics or collectors. The only sales—ironically—were generated by the one European to be shown: the Italian futurist Gino Severini. Shortly after the exhibition closed on March 17, John Quinn, an Irish-American lawyer, collector, and patron of James Joyce, gave Stieglitz a down payment of $400 on his purchase of $1175—a sum suggesting that Quinn may have been "allowed to buy" (as Alfred would have said) all twenty-five of the Severini paintings on exhibit.

Severini's success was symbolic of the end of American neutrality. By the beginning of 1917, war hysteria was approaching fever pitch. Allied propaganda focusing on German atrocities appeared confirmed by the ruthless submarine campaign that followed the sinking of the *Lusitania*. American public opinion, however, was most inflamed by a revelation closer to home: the publication on March 1, 1917, of the Zimmerman telegram. This intercepted note, bearing the signature of the German foreign minister, offered to Mexico the territories of Texas, New Mexico, and Arizona if it would join Germany in the event the United States entered the war on the Allies' side.

The specter of becoming German prisoners seems to have aroused Texans to a militaristic fervor that left the rest of America behind. No pacifist, Georgia was nonetheless distressed by the mindless enthusiasm with which her students, innocent farm boys, were rushing to offer themselves as cannon fodder. She proposed to the West Texas administration that the school should at least offer a course on the issues of

the war. Her suggestion does not appear to have gone far. Local adult response was more dishearteningly ignorant. Anti-Hun sentiment took the form of denouncing Nietzsche from the local pulpit. Challenged publicly by Georgia, the pastor was forced to admit he had never read a line of the philosopher. She could not even manage to dissuade Ted Reid from enlisting before he graduated and entered aviation training.

In contrast to Georgia's felt sense of responsibility for the young people who were her students, Alfred's reaction to the war was entirely subjective: as with all external events, it remained at the level of metaphor, an "equivalent" to his emotional state. The war, he told a friend, was like background music, played under the battles he waged against his own failings—battles he had lost.[69]

For Georgia, even Canyon's closed minds and perfervid patriotism could be forgotten with the latest news from New York: her first one-woman show would open at 291 on April 3. As the exhibit came in the last busy weeks of the semester, her schedule made it impossible for her to leave Texas. As soon as he had hung the paintings and drawings, Stieglitz rushed photographs of the show to Georgia in Canyon. But her pleasure in unpacking this most eagerly awaited of Alfred's beautifully wrapped parcels was dimmed by another event: on April 6, three days after the opening of Georgia's exhibit, Congress voted to declare war on Germany—the first American intervention to "make the world safe for democracy." Ignoring her pleas to finish school, Ted Reid had already enlisted; her favorite brother, Alexius, would shortly be called up; her sense of imminent loss made her feel still more isolated from the manic militarism she saw all around her.

In June, the historic final issue of *Camera Work* summarized the exhibitions of the 1916–1917 season. The selection of Georgia O'Keeffe's new work, on view until May 14, consisting of "water-colors, drawings in charcoal, oils and a piece of statuary," occupied both rooms of 291— the last works ever to be hung on the historic walls.

Critical coverage was sparse—hardly surprising, in light of the week's dramatic events. Such reporting as there was, moreover, had a distracted note. As one bemused critic pointed out, there were no labels, titles, numbers, or catalogue, and the works were all unsigned. Besides *Blue Lines*, other pictures from O'Keeffe's three-person show in the spring of 1916 were once again exhibited: the charcoals called *Specials*, including one of the bubbling lavalike studies inspired by Palo Duro Canyon, along with several of the numbered series, called simply *Blue*, variations in watercolor of her favorite crook or comma form, underlined with a left to right slash.

Writing for *Camera Work*, William Murrell Fisher waxed lyrical

about the "unheard melodies," "cosmic grandeur," and "exquisite tenderness" of O'Keeffe's art. In the only independent review, the critic of the *Christian Science Monitor* picked up the refrain of the year before, nervously alluding to the artist's "delicately veiled symbolism for 'what every woman knows.' " More perceptively, however, the anonymous critic seized on a quality that few writers would ever notice: the "loneliness and privation" emanating from O'Keeffe's art, which "put their impress on everything she does."[70]

No one, apparently, saw the single sculpture, exhibited once again.

The happiest portent of her first one-woman show was economic. One of the Canyon watercolors, *Train Coming into the Station*, depicted a tiny locomotive dwarfed by its billows of smoke in the Texan immensity of sky and plain. It was purchased by Jacob Dewald, a friend of Stieglitz, for four hundred dollars—the equivalent today of almost five thousand. This astonishing price for a watercolor by a young unknown artist pointed to the promise that Stieglitz would honor throughout his life: from the first, he established the highest market value for O'Keeffe's art. Whatever he needed to do to keep her there, he would do it.

AT THE END of May, classes ended in Canyon, with a ten-day break between the spring semester and summer session. Impulsively, Georgia decided to go to New York. She must have left Canyon on May 20, as she claimed to have persuaded the president of the local bank to let her withdraw almost all of her savings on the Sabbath.[71]

Sixty years later, Georgia insisted that her sudden notion to go to New York was the desire to see her pictures on the walls of 291. But she would surely have known that by May 23 her exhibition had been down for more than a week. The real reason for her spur-of-the-moment trip North she confessed only to Anita on her return to Canyon in June: "Stieglitz—Well—it was him I went to see—Just had to go Anita— There wasnt any way out of it—and Im so glad I went."[72]

In the same letter, she also reported to Anita, now teaching in the summer session in Charlottesville, the sad news that 291 was closing. Supreme irony—a picture rental library would be occupying the space. Stieglitz had arranged to have one small room measuring eight by eleven feet on a lower floor to the right of the elevator—"Just a place to sit he says—I dont know Its all queer," Georgia wrote, adding, "But Anita Everything is queer."[73]

She never alerted Stieglitz about her arrival; she just appeared at 291. Perhaps he was astonished to see her; or it may be that he was not surprised at all. How often have we seen, on the periphery of our

vision, the one we love, a mirage summoned by longing. In later years, Alfred loved to recall this moment—so different from her angry descent the year before—when Georgia reappeared miraculously before him.

His tribute to her visit—unexpected or expected—took the form of the impresario's own virtuoso performance for an audience of one: he rehung the show for her alone.

In the course of her ten days in New York, Georgia visited Stieglitz at the gallery several times again. She saw new work by Walkowitz and two recent paintings by Stanton Macdonald Wright. She was excited by the way the latter's synchromist research resulted in work that united "theory plus feeling," she told Anita. Marin's recently exhibited watercolors of Pennsylvania were like "bunches of wonderful flowers," she exulted.[74]

During these visits, Stieglitz took his first photographs of O'Keeffe, "my face twice—my hands several times," she would recall.[75]

They ate meals together at Stieglitz's favorite haunts: Holland House or Mouquin's or, with his allowance from Emmeline now reduced, a new, much cheaper favorite called the Automat.

Cramming more activity into ten days than she usually managed in a year, Georgia saw Dorothy True, "looking better than last year—Her work . . . really wonderful," she reported to Anita. She caught up with her old teacher Alon Bement, now married to an actress, who was also successful in selling his paintings. Late one rainy night, she walked in Central Park with Aline Pollitzer for several hours; she had no time to see her again. Reluctantly, it seems, and only at Dorothy's urging, she saw Arthur Macmahon. "He improves and he doesnt" was her measured verdict.[76] She had moved beyond him.

Then, on Memorial Day, May 30, Alfred invited Georgia and Dorothy to celebrate the holiday with an excursion to Coney Island. Their host would be Henry Gaisman, a friend of Stieglitz. A successful inventor and manufacturer, Gaisman had devised and marketed a lethal-sounding shaving device, the Auto-Strop Safety Razor. His fortune was made, however, with another invention: a process that allowed script to be projected on motion picture film and that he sold to Eastman for three hundred thousand dollars. Gaisman lived in Sea Gate, a prosperous Jewish enclave at the western end of Coney Island, whose Victorian mansions were separated from the daytripping masses by guards and iron gates. Dorothy declined the invitation.

On a Wednesday that was unseasonably cold for the next to last day in May, Georgia, Alfred, and Alfred's newest protégé, the brilliant young photographer Paul Strand, climbed on an open trolley car at the Man-

hattan end of the Brooklyn Bridge for the hour-long ten-cent trip to Coney Island.

The biggest, brassiest seaside playground in America, Coney Island had just opened for the season nine days earlier, an event celebrated by a Saturday night crowd of more than one hundred thousand.

"Coney Opens in War Dress" was the *New York Times* headline, noting the flags and bunting that, along with red, white, and blue lights, enlivened the annual parades held in both Luna and Steeplechase parks. While patriotic lighting celebrated the War Department's special ruling that Coney Island could stay lit all season long, bands played the national anthems of the Allied nations as two thousand marched in Luna's procession, including Pawnee Bill's animals and Wild West men. Continuing the war theme, there were new zeppelins on merry-go-rounds for visitors to ride and ominous-looking submarines floating just below the surface in the ponds of Luna Park.

Georgia seems never to have visited this popular tourist attraction in her earlier New York years; perhaps it was too tawdry and vulgar an amusement for art students in an era before the exaltation of kitsch and pop culture. More likely, ten cents a ride for all the chills and thrills would have been beyond the budget of most.

On this cold Wednesday morning, O'Keeffe, Stieglitz, Strand, and Gaisman began the day with their host's tour of staid and sedate Sea Gate. Leaving its guarded precincts, the four walked east along Surf Avenue. Six years before the construction of a boardwalk, visitors had to look hard to see the ocean; the space between this mile-long main artery and the beach was occupied by the two amusement parks, along with hotels and bathing establishments. As they walked along the beach, their view of the water was further obstructed by ramshackle piers and rookeries whose official designation of bathing houses was open to question.

For Georgia, the only non–New Yorker of the quartet, the size of everything—from the crowds to the entertainments designed to contain them—must have been a wonder. Indeed, Coney Island dealt in superlatives. Midway along Surf Avenue was a network of narrow intersecting alleyways and arcades whose principal strip, called the Bowery, boasted more games of chance, fortune-tellers, girlie and freak shows, shooting galleries, shills, carneys, and refreshment stands than all the other circuses, carnivals, and fairs she would ever have seen, combined.

At the very end of the Bowery was Steeplechase Park, whose swimming pool, so the proprietors insisted, was the largest in the world; its five thousand bathhouses would support their claim. Threading their

way back to Surf Avenue, the foursome would have passed Feltman's, a gargantuan restaurant with an open-air "motion picture garden" seating two thousand.

If the four hadn't tamed salt-air appetites with snacks from the stands, there were restaurants for every taste and purse. The Cadillac Hotel featured the cheapest, appealing to the thrifty Alfred; it offered a shore dinner for seventy-five cents. If the German background of both Stieglitz and Gaisman prevailed and—still likelier—Alfred wanted the outing to be a celebratory occasion, they would have repaired for lunch either to the elegant Kaiserhof Hotel or Feldner's Deutscher Garten, where a Shore Dinner De Luxe was offered for a dollar and a half.

Whatever the menu, Georgia had a glorious time. "It was a great party and a great day," she wrote euphorically.[77]

By the time they returned to Manhattan, it was bone-chillingly cold in the open trolley car. Stieglitz removed the black loden cape that was his signature and wrapped it around Georgia's shoulders. Even while warmed by his claim to possession, her mind was on another member of their group. Earlier that week, Georgia had met Paul Strand for the first time.

"He showed me lots and lots of prints—photographs," she wrote to Anita, "and I almost lost my mind over them—Photographs that are as queer in shapes as Picasso drawings."[78] Strand was to have the next issue of *Camera Work*—the last, as it happened—devoted to his work.

So often equivocal in her feelings toward men, Georgia plainly told Anita how she felt about Strand: she just "fell for him," she said.[79]

"The Finest Girl in Texas"

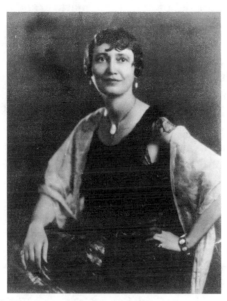

Leah Harris. A teacher of home economics, Harris was
O'Keeffe's companion during Georgia's last year in Texas,
1917–18.

WHEN STIEGLITZ had introduced his two most gifted "youngsters"
at 291 the week before, he could not have foreseen the consequences.
The first look exchanged by Georgia and Paul Strand ignited a passionate
mutual attraction. A few days later, Georgia reappeared at the gallery.
Strand was there alone, minding the shop while Stieglitz was out. By
then, Paul, as Alfred's trusted protégé, had the run of the place; he
showed Georgia Walkowitz's new paintings along with his own recent
photographs.

Returning to Canyon in the second week of June, Georgia found
waiting for her a package from Strand containing those of his prints she
had most admired.

She was swept away by the man and the artist; she was in love with
both, Georgia wrote to Paul on June 12. And she recalled their second
meeting, alone in the gallery, when she recognized the unmistakable
look in his eyes—a look she had come to fear and to flee, she told him.

There was more reason now to be afraid. Introduced by Stieglitz, they were both his "children." Most probably, Alfred and Georgia had become lovers only days before she and Strand met, in the last week of May. From the moment Georgia and Paul saw each other at 291, their mutual attraction was marked by a shared sense of betrayal and guilt complicated by symbolic incest. Less mature and experienced than O'Keeffe, Strand reacted with confusion to his conflicting loyalties. Practiced in the strategies of keeping several men on the string, Georgia, on the other hand, took a realistic view of the conduct of their affair. Secrecy and stealth were required if Alfred was not to find out.

Small (barely more than five feet six) and intense, Strand could have been Alfred's double, his biological as well as spiritual son. Twenty-six years Stieglitz's junior and three years younger than O'Keeffe, Paul Strand was born and raised in New York City, the only child of Jacob and Matilda Arnstein Strand.

Shortly before Paul's birth in 1890, his father had changed the family name of Stransky. The Strand family fortunes had changed, too: from rags to riches to hard times—if not rags—once again. Paul's grandfather Arnstein had prospered as a lace importer, only to lose his money in the stock market just before his death. His son-in-law Nathanael Meyer, a successful lawyer, bought a brownstone on West 83rd Street, near Riverside Drive, for his widowed mother-in-law, Catherine Arnstein, Paul's grandmother. Here Paul Strand grew up, in circumstances of comfort that would have been beyond the reach of his own father, Jacob "Jack" Strand, who earned a precarious living as a salesman of imported housewares. Paul would have been aware from childhood that his father, although loving and supportive, was the poor relation of the family: they lived in his maternal grandmother's house where, given the elder Strand's chancy earnings, the salary of Paul's maternal aunt Weentie, a kindergarten teacher, was needed to help support them. Luxuries, such as an expensive camera, were provided by a cash legacy from Uncle Nat Meyer. Thus, while Strand appears an exception to Stieglitz's fatherless artist-children, he fit the pattern all too well. Lacking a powerful protective male presence in his early years, he would seek paternal authority figures well into middle age.

Despite the wealth of the Stieglitz family and the Strands' limited means, the early circumstances of the two men were dramatically similar. Both were New Yorkers and Jews whose highly assimilated, secularized families seemed determined that their young should have no awareness of being Jewish.

Alfred was the adored oldest son, the favorite of both parents, the genius who could do no wrong. With no competition from brothers,

Strand was even more privileged; he was the "little Adam" described by Jean-Paul Sartre in his autobiography: the man-child worshipped by a household dominated by women, for whom growing up was the expulsion from Eden. Both Stieglitz and Strand would experience the same difficulty in leaving home.

The protectiveness of Paul's parents, however, led to the chance encounter that made of Strand, along with Stieglitz and Edward Weston, one of the trinity of great American photographers. Worried by the threat posed to their pint-sized son in his local public school by tough kids from Hell's Kitchen, the Strands, through a combination of scrimping and scholarships, enrolled Paul in the Ethical Culture School in 1904.

Founded in 1876 by Felix Adler, the Society for Ethical Culture took as its motto "Deed, Not Creed." Adler's father had been summoned from the Rhineland to become the rabbi of Temple Emanu-el; the young Adler had studied for the rabbinate himself, before going on to establish Ethical Culture as a humanist religion, a sort of Judaism without God. In an America that was both anti-Semitic and xenophobic, the society was a way of escaping the stigma of the *shtetl* in particular or of foreignness in general. Adler's secular temple provided an alternative to a troubling choice for the assimilated children of immigrants: proclaiming their Jewishness or converting to Christianity. More positively, Ethical Culture offered a sense of community, of shared moral and social values—the most central being the importance of education. From the Workingman's School, established by Adler on the settlement house model, the society turned to educating its members' children in a system that took them from kindergarten to college.

Socially, the Ethical Culture School on Central Park West embodied a peculiar irony: Aline Pollitzer, Georgia O'Keeffe's younger friend and Anita's cousin, recalled with shame that she had no idea she was Jewish until long after she graduated from the society's high school in 1913.[1] Educationally, Ethical Culture did better by its homogeneous student body. Putting into practice Dewey's theories that children learn most from applying knowledge to the world's real work, the school required courses in craft skills—carpentry, printing, and mold making—as well as traditional academic fare. But it was the moral climate of the school that students recalled long after they had forgotten how to turn a lathe: Ethical Culture insisted on the worth, dignity, and creative potential of the individual along with the expectation that as citizens its students would contribute to the betterment of society.[2]

At the end of his high school years, Strand, with typically adolescent disaffection, insisted that the school was no more "ethical" than any

other institution. Like a dormant seed, however, its philosophy took root, to flower when Strand, the heir of Stieglitz's aesthetic perfectionism, became in the 1930s an engaged filmmaker on the left. One teacher, in particular, sowed the seeds of social commitment.

In 1901, three years before Strand started high school, the new principal invited a young midwestern sociologist to come East and teach classes in nature and geography. Shortly after his arrival at Ethical Culture, Lewis W. Hine was given a camera and asked to record school activities. A swift and ardent convert, Hine started an extracurricular camera club for students and soon convinced school authorities to let him establish an accredited course in photography—probably the first in any New York City school.

When he encountered Lewis Hine and the camera, Paul Strand found the passion that would engage him for life. An indifferent scholar and unenthusiastic athlete, Paul was among the six or so high school students who signed up for Hine's class; there he learned the basic methods of camera and darkroom along with the technique of using an open-flash pan of magnesium powder for indoor photography.[3]

Besides his emphasis on the discipline of the darkroom and the organization of vision and experience, Hine's belief in the educational benefits of the camera embraced his own growing concerns: the photographer as both artist and reformer. His field trips brought seventeen-year-old Paul Strand on his first fateful visit, in 1907, to 291. Strand listened in fascination as Stieglitz held forth on photography as art, looking with still greater astonishment at the prints the master showed his young visitors: works by David Octavius Hill, Robert Adamson, Julia Margaret Cameron, and Clarence White and photographs by Alfred Stieglitz himself. Strand dated his desire to become an "artist in photography"[4] from that day.

Hine does not seem to have exposed his middle-class students to the settings that would appear in his own photographs. But he may have described to them Ellis Island, immigrant neighborhoods, and the construction sites where many recent arrivals found perilous employ. Hine himself would go farther to find those "behind the scenes," as he called America's laboring men and women. He soon gave up "polishing brains at the Ethical Informary"[5] to immortalize the accusing faces of working children, images that would help establish the first child labor laws and change factory conditions in every part of America.

After that first visit with Hine's class, the seventeen-year-old Strand returned to 291 regularly to talk with Stieglitz, showing the older man his work and getting criticism, advice, and encouragement. Following his graduation from high school in 1909, with no interest in college, he

worked at a series of dreary jobs to support his photography. He joined the Camera Club of New York, taking full advantage of its library and darkroom facilities to experiment with gum, carbon, and platinum prints as well as to make enlargements from negatives.

"The atmosphere was stupid, right in the heart of amateurism," noted the eighteen-year-old photographer.[6] Paul Strand had not yet sold a picture but he already thought of himself as an artist and a professional.

In 1911, he withdrew all his savings—six hundred dollars—spending the money on a tour of Europe, "doing" all the countries, museums, and monuments he could squeeze into four months of travel, much of it on foot. Perhaps this intense exposure to art encouraged him to risk more; he returned to New York and after a few months' work with an insurance company decided that whatever he had to photograph, he would earn a living with his camera.

Enterprising and eager, Strand scratched energetically for every kind of assignment. For the next fifteen years, he did portraits; covered sports events (ranging from professional boxing matches to the Harvard-Yale game); immortalized fraternity revels and commencement weekends at colleges around the country—all hand-tinted by young women specializing in this labor; and took pictures of anything that advertising agencies would pay him to photograph.

Weekends he devoted to his "real work." Walking the city with his 3¼-inch Ensign reflex camera, bought with a small legacy from his uncle Nat, he revealed a New York as harsh and pitiless as Stieglitz's had been melancholy and romantic, a city of face-to-face confrontations in the form of close-ups of grimy, angry "street people";* in his lens, the blind, yawning windows of the Morgan Bank became a sinister maw, devouring the innocent.

The photographs of Strand's early period—the eight years between 1907 and 1914—show him working through every style, as though the young photographer had swallowed an anthology of *Camera Work*. There are neo-Steichens and Stieglitz look-alikes, knockoffs of Käsebier and White. Then, sometime in 1915, "suddenly, there came that strange leap into greater knowledge and sureness," he recalled.[7] In April 1915, he brought a portfolio of his new work to show Stieglitz. In a scene that prefigures Alfred's astonishment on seeing O'Keeffe's drawings a few months later, his mentor first seemed "surprised," Strand recalled.

By curious coincidence, Steichen happened to be visiting 291 that day. His relations with Stieglitz had soured in the months since his

* Strand's encounters were mediated, however, by a false lens attached to his camera that made it appear to his subjects that he was shooting in another direction.

return to America at the outbreak of the war. After a decade in Vou-langis, Steichen had taken the French cause as his own; he was impatient for America to enter the war on the Allied side and did not disguise his disapproval of Alfred's pro-German sentiments combined with hopes for neutrality. When the disciple turned critic, it was time for a replacement: Alfred called Steichen from the back room to meet his successor and admire the younger man's dazzling prints.

"I'd like to show these," Stieglitz announced to the overjoyed twenty-five-year-old photographer, adding that from then on, Strand should think of 291 as home and come there whenever he wished.[8]

Paul took Stieglitz at his word, spending all his free time at the gallery. From his earlier visits, Strand had absorbed the lessons of Cézanne, Picasso, and Braque, reshaping their aesthetic to the possibilities of camera and darkroom and trying to solve problems "in a way that was abstract and controlled." From the cropped close-up of *Bowls*, with its ambiguous repetitions of curves and hollows, and from a study of slanted shadows on a front porch, Strand learned "how you build a picture, . . . how shapes are related to each other, how spaces are filled, how the whole must have a kind of unity."[9]

Stieglitz's surprise on that April day in 1915 proved that Strand had done more than learn his lessons well. In the way he saw and in the way he organized his vision, Paul Strand was the first twentieth-century American photographer.

On March 13, 1916 (two months before O'Keeffe's debut at 291), Stieglitz opened a one-man exhibition of work by his new protégé. Among Strand's platinum prints were a number of his New York views, including *Wall Street* and *City Hall Park*, along with earlier pictorial images from his grand tour and scenes from his college assignments around the country.

Reviewers were enthusiastic, seizing on the special qualities that would stamp Strand's work for sixty years: his insistence on objectivity, the respect for the innate character of his subjects, and the taste and craftsmanship with which he composed his prints. All critics, moreover, noted that Strand's work combined the new aesthetic of "straight" photography—the undoctored, unmanipulated print that did not strive to imitate painting or engraving—while exemplifying the vision, technique, and expressive qualities of art. Of all the tributes to the meteoric new talent, the most moving came from Stieglitz himself: perhaps because his own impulse in the direction of "straight" photography was validated by the fresh vision of his disciple, he was generous—almost humble—in his praise. Writing to the British pictorialist R. Child Bayley, Stieglitz described Strand with all the pride of a father in his more

talented son: "He is without doubt the only important photographer developed in this country since [Alvin Langdon] Coburn," Stieglitz declared categorically. "He has actually added some original vision to photography. There is no guming [*sic*]—no trickery. Straight all the way through, in vision, in work and in feeling. And original," he repeated.[10] But the master's most profound tribute to his disciple was the evidence of the younger man's influence: beginning in 1915, Stieglitz's own photographs became sharper in focus, more hard-edged. *From the Back-Window, 291, Building in Construction* (1916) plays off the solid geometry of brickwork structures pierced by a counterpoint of windows against the open forms of girders in a composition that moves toward a new objectivity. His recent work, Alfred happily noted, was "just the straight goods . . . everything simplified in spite of endless detail."[11]

In June 1917, a double issue of *Camera Work* appeared featuring eleven of Strand's prints, including *Abstraction, Bowls* and *Abstraction, Porch Shadows*, along with his essay "Photography." Stieglitz had planned a special O'Keeffe issue to follow, but in the event the Strand tribute proved—with a certain Oedipal symbolism—to be the magazine's last breath of life.

Meanwhile, in the two years since his momentous visit to 291 in 1915, Strand had been absorbed into Stieglitz's downtown family. Thrust into the real world by his commercial assignments, he seemed to retreat—even regress—in his emotional life, ever more dependent on his surrogate father. While at the gallery, he began taking out Marie Rapp, the lovely young voice student who was Stieglitz's secretary; she recalled her first impression of Strand as "very immature, very much tied to Stieglitz's apron strings." Paul seemed to derive little reassurance from the growing recognition of his serious photography and his increasing ability to earn a living at commercial work; he craved Stieglitz's constant approval, Rapp noted, following him around "like a child." Completely uninterested in Strand romantically, the perceptive young woman (soon to marry the son of her voice teacher, George Boursault) noted how essential Alfred's endorsement was to Paul's courtship, however casual, of her. "Because Stieglitz thought highly of me, Strand decided it was all right to ask me out," she recalled.[12]

A more obscure impulse hovered behind Paul's attentions: the son's need to usurp the father. With Marie, as with Georgia, this sexual agenda was further complicated by the particular "family romance" of 291. Describing herself as a "substitute for Kitty," Marie as surrogate daughter was cast doubly in the sexually forbidden role of sister.

For his part, Stieglitz's sense of Strand as a "satellite," in Marie's word, anxiously waiting on his approbation and love, was reassuring on

several levels. Professionally, Alfred felt safe exalting Strand's talent. More royalist than the king, the younger man's intransigent views on the separation of "pure" photography from what he did to earn a living made it clear that, unlike Steichen, who had recently compounded his Francophilia by turning out celebrity portraits for Condé Nast, Strand would never traduce Alfred's principles to sell his soul to the "slicks." Personally, Paul's sexual immaturity, his childlike dependence on Stieglitz, along with his "scout's honor" earnestness, would allay any suspicions of rivalry.

As the victim of boundless trust, Strand experienced mounting guilt and anxiety in the next twenty-four months, as his obsession with Georgia grew more intense. Writing to O'Keeffe from 291, his father's temple, under the unsuspecting paternal gaze, he must have felt that he and Georgia were on the verge of violating every taboo: sexual, moral, and ethical. Danger, however, also sustained the heat and excitement in their long-distance affair.

Georgia's letter to Strand from Canyon on June 12, 1917—the beginning of what would be a passionate exchange over the next year—made clear her sense of betraying Alfred along with her fear of being found out. Two earlier letters to Strand sat on her bureau, she wrote, sealed but not posted; she was afraid of sending mail to him in care of 291, where it could be intercepted by the sycophantic Zoler, Alfred's man-of-all-work (whom Georgia would always despise). *

Fiercely independent, honest to the point of cruelty, and quick to disabuse any man of the notion that he had any "rights" to her fidelity or commitment, Georgia was now obsessed with the need for stealth and secrecy. This uncharacteristic concern suggests guilt and confirms the likelihood that she and Alfred had become lovers during her brief visit in May 1917. Now her distance from both men was a blessing; she could express her passion for each on paper.

As she had done with Arthur Macmahon, Georgia took the initiative with Paul, boldly declaring her sexual yearning for him. He had found his way deep inside her, she wrote. From their first meeting, she had felt so overpowered by desire she was afraid to be alone with him.

Once again, Georgia honored the artist and man she loved with her own work. Her tribute to Stieglitz's photograph *The Hand of Man* (1902) was *Train Coming into the Station* (1916). O'Keeffe's homage to Strand's *The White Fence* (1916) was a watercolor of the same subject (*Trees and Picket Fence*, 1918).

* After the first letter to 291, the remaining thirty-five that O'Keeffe addressed to Strand in New York were sent to 314 West 83rd Street.

Seeing the world now through Paul's eyes, Georgia composed Strand photographs in her mind, she wrote him; his vision had become hers. For an artist, this was the ultimate infidelity to Alfred.

She had loved Arthur Macmahon for his "cleanness"; she now exalted Paul's "fineness." Both words point to a kind of moral scrupulousness in these sheltered, middle-class young men that would first attract and then irritate her.

Despite her coyly expressed fear of being alone with Paul, she closed her first love letter to him with a demand that was unequivocal: one night, she wanted him to take her to Riverside Drive, a favorite summer escape (in a safer era) for lovemaking couples.

At the end of June, Georgia went to Chicago to see her younger brother, Alexius, soon to leave for Fort Sheridan, the training camp for the Officer Corps of Engineers; from there, he hoped to be among the first to leave for France and the front.

Writing to Paul on a Western Union form during the train trip back to Texas, Georgia sounded despairing, as she looked out at the endless green of Kansas. Visiting her brother had evoked all of her ambivalence about the war. A huge, open-hearted bear of a boy, Alexius had treated Georgia, five years his junior, like a little sister; he was the only member of her family, she told Paul, who ever hugged and kissed her.

She was horrified to see what war fever had done to him. Impelled by a grim sense of sacrifice, he had no expectation of returning from Paris alive. She felt torn between revulsion and reverence, sensing both the waste and the nobility of her brother's determination to die for his country. Georgia's ambivalence extended to Paul's pacifism. On the one hand, she sympathized with Paul's refusal of active combat, his principled rejection of the folly of slaughter (enlisting the help of both Stieglitz and, through him, Steichen, Strand was trying to obtain a commission in a photography unit). At the same time, Georgia, the all-American girl from a town not fifty years removed from the frontier wars, distrusted the reflective agonies of conscience, the rationalizations of ideology that were typical of Strand, the Jewish urban intellectual. She might admire his "fineness," but why couldn't he also be the kind of instinctual red-blooded male who grabbed a gun to defend his country—or claim his woman?

Seductive, even erotic, Georgia's letters to Paul sound the same impatient challenge whether she writes of love or war: in a verbal striptease, she described a sultry June night on which her skin felt so hot that she couldn't bear the feel of clothing. She wrote to him naked.

In aggressiveness, Stieglitz clearly benefited by comparison to the

anxious and passive Strand. Georgia and Alfred were already lovers; as a married man, still nominally living with his wife, Alfred plainly was not inhibited by moral scruples about sex. As far as military service was concerned, Alfred's age exempted him from any question of active combat; he risked nothing by uttering a few war whoops. And they were sincere. At fifty-three, Alfred was in many ways still the boy whose favorite reading was biographies of Revolutionary War heroes and who, as a student in Berlin, had draped his mother's portrait with the American flag. Now he would repeat the wistful remark he had written to Georgia earlier in the year: had he only been younger, he would have eagerly enlisted.

His patriotism, paternalism, and sexual experience notwithstanding, Stieglitz seemed to be losing ground to the younger man. In the same continuous letter to Paul of mid-June, Georgia sounded offhand about Alfred's twice-a-day communiqués; she had time only for a cursory reading of his morning letter and nothing to say in reply—a consequence, perhaps, of feelings of guilt and disloyalty. Once again, she asked Paul for an address other than the gallery where she could write to him. (Perhaps she had lost his home address.)

Meanwhile, Strand now joined Stieglitz and Macmahon as one of O'Keeffe's intellectual mentors. Like his photographs, the books Paul sent her became extensions of the man; their material presence was transformed into sexual metaphor. She longed to curl up inside his *Life of Nietzsche*, feeling it envelop her, closing her off from whatever wasn't Paul. But she shouldn't be telling him these things, she added, repeating the dual role she played for Macmahon: bold seductress and modest maiden.

She was relieved to see that Paul was capable of making "big" prints, as well as the little ones he had sent her earlier; she wouldn't know him as the man she loves, wouldn't hear his particular music, she told him, if she hadn't seen these large photographs. The small ones, she noted flatteringly (if confusingly) only made her conscious of her frailty next to his powerful manliness. She hoped Paul would find in her fragility a sense of his own power. There is more than a little wish fulfillment in Georgia's cliché'd image from western stock footage—me-little-woman-you-big-man—as applied to the diminutive, dependent, and sheltered photographer.

Her attempts to brace him—taking Strand's "big" prints as a measure of the man he could be—were a response to Paul's confession to Georgia of his sense of unworthiness. She herself had no time, she told him briskly, for such paralyzing reflections; when she wanted something, she went after it. But this tough declaration was followed by an aside

more terrible for its casualness: other people would never feel they deserved anything, she wrote Paul, if they had to face in themselves the kind of person she knew herself to be.

Shame was how Georgia explained her burst of self-hatred; shame was also the reason for her earlier reluctance to touch Paul as she had yearned to do. If he knew what she was really like, he would despise her. She had let too many men kiss her in a very short time, she said. They hadn't forced their attentions on her; she had encouraged them. And here she was, leading him on, too. Her reminder that she had a perfect right to do as she pleased strikes a hollow note—the "party line" of the newly emancipated woman.

Georgia's use of the word "kissing" suggests a euphemism. Just as Stieglitz used the genteel circumlocution "touching" to mean sexual relations, kissing seems to have been Georgia's self-censored way of telling Strand that she had had many casual lovers.

Arthur Macmahon had been the last to kiss her, she told Paul. During her visit to New York, they had had a long and wonderful talk that confirmed for Georgia, at least, that it was time to part. When Arthur kissed her good-bye, she had felt nothing at all, she wrote Strand.

She seemed not to want what other women typically wanted from men: security, fidelity. In her pursuit of sexual variety, her avoidance of commitment, she felt more like a man in her desires. She disappointed men in the way that men usually disappointed women: by holding back. She saw her reluctance to give herself completely to another as masculine—the antithesis of a woman's sacrifice of self, whose highest expression is motherhood, the giving of life. What little she was able to give was worse than nothing; it only made those she loved unhappy. She could see into the future, she wrote Strand. She knew it would always be that way for her.

In her letters to Strand, O'Keeffe's self-knowledge, her "merciless" honesty—as she called it—is both painful and protective. By painting herself in the darkest colors, she avoided future liability. Paul had received fair warning.

Her sister Claudia had left Canyon for a student-teaching assignment in Spur, Texas. Before she went, Georgia heard her mother speaking to her in a dream. But it was Claudia, waking her up. She was alone, but not lonely, certain in the knowledge that solitude was her lot. Still, she felt abandoned, she told Paul. Like him, she was a wanderer in a world without signposts. Would he prove man enough to take her on, as she really was, in all her inconsistency and need? In her heart, she knew the answer; Strand would disappoint her just as Macmahon had done, and in the same way. Neither man could be for her what she

needed: loving and protective, strong and decisive, indulgent and for-giving—the ideal father. Only Stieglitz, she told Paul cruelly, seemed able to understand her.

THROUGH THE DISMAL SUMMER of 1917, Alfred, with the spo-radic help of 291 regulars, irregulars, and hangers-out, all supervised by the efficient Marie, cleaned out the gallery. For Stieglitz, the solution of where to store the work of half a lifetime meant destroying most of it: out went unsold runs of *Camera Work*, early Stieglitz prints and glass negatives, financial records. He claimed lack of storage space, but the real reason for his scorched-earth policy seems to have been low morale and too little energy to decide what was worth saving. Strand was among the regular helpers, and he was the only one Stieglitz immortalized at this task. His photograph of Paul captures all the younger man's con-tradictions: the shirt, tie, and proper suit vest visible underneath the work apron; the hammer in one hand, the pipe clenched in teeth; the receding hairline offset by baby fat around the chin. With his solemn, slightly disapproving gaze, Paul could still be a senior at Ethical Culture, deciding that his school wasn't ethical enough.

Indeed, after Georgia had daringly asked Stieglitz to send her a copy of this print, she used Strand's portrait to tell him everything she was coming to dislike—and fear—about him: the harsh, critical look in his eyes, an impotent anger that he expressed only in words. She loathed his recent letter, she told him; instead of going off by himself and whining about his feelings, why couldn't he *act?* she asked. Then, going straight for the jugular, Georgia acutely noted that Strand's anger lay deeper than any particular cause: if he wasn't outraged by the war, he'd find some other target for his wrath, she told him.

If anyone seemed to be suffering from generalized anger, it was Georgia. In a rage of frustration, she fixed on her room as on a hated black and white photograph; everything in it roused her to fury: the white wallpaper and molding; the white cloths stacked on the chair and her black patent leather pumps under the chair; her black pile of books on the table; and the blackness of the night sky outside the windows. The only object she could bear to look at, she wrote to Strand, was a square of black cloth she had framed, also in black, and hung on the wall. O'Keeffe's "black picture" did not, apparently, survive the artist's anger.

Then, coming back from a late-night walk to the canyon, she re-gretted the cruelty of her recent letter and told Paul so. If they were

together now, she would throw her arms around him and he would be healed of her wounding words.

STIEGLITZ's black summer was far from over.

In July, while Marie took a brief holiday from overseeing her cleaning squad, Steichen reappeared at the gallery. The sight of his former disciple, resplendent in officer's uniform, amid the ruins of 291 did not cheer Alfred. Writing to Marie, he noted that Steichen "looks well— impressed the ladies—much. Pity I'm not young enough—I'm sure I would have made a pretty good looking officer when I was 35—Gosh!— Now I have to be on the outside of Everything—Just *OLD*," he concluded sadly.[14]

Diminishment and decay seemed to describe Stieglitz's present life— uptown and downtown. His new headquarters, one room of 293, was so tiny that he baptized it the Tomb or the Vault. With sour humor, he wrote Marie that he could accommodate nine visitors at once. Incredulous, she asked, "How? Two on the window sill—one on the bookcase, three on the shelves, two on the white stool and one— yourself—in the chair?"[15] Alfred's communications with Marie by mail underlined another loss: he had had to let his surrogate daughter go— soon to retire, in any case, to marriage and motherhood. On his own domestic front, "all is quiet," he reported to Marie. "The tension is released—occasional visitors—But the basis is as rotten as ever—It will have to be tackled—like a rotting tooth—beyond filling. Only the situation isn't as simple as the dentist," he conceded.[16]

Some relief from gloom came with news of the happy month Kitty was having at Camp Kehonka, a fashionable girls' camp with an impeccable Bostonian constituency on Lake Winnipesaukee in New Hampshire. But glad as he was for Kitty's few weeks away from the parental battleground, he had a sense of foreboding. "Heaven knows what's in store for her," he wrote. "For all of us."[17]

His greatest source of cheer, though, was memories of Georgia's visit, kept alive by letters from Canyon.

Licking his wounds at Lake George in August, Alfred was moving at the same time toward a new resolve. Although he would soon swear to friends and relatives alike that "Miss O'Keeffe" had *nothing* to do with the end of his marriage—miserable for nearly twenty-five years— his passive, depressed state obviously required being in love to "think the unthinkable." Accepting Marie's sympathy for a spring and summer that had been "worse than murder," Alfred said that "through that

bleeding I was enabled to see the Truth more clearly—Myself—& all others."[18]

Like every lover, Alfred assumed that anyone who shared his confidence would thrill to every detail of Georgia's doings. As it happened, Marie was no fan of Miss O'Keeffe; on her visits to the gallery, Georgia had either judged the secretary too insignificant to merit her notice or, given Stieglitz's fondness for the lovely young woman, had seen her as a rival. From the first, she had treated Marie with icy indifference—and always would. Oblivious to O'Keeffe's behavior and Marie's feelings, Alfred passed on recent news from Texas: Georgia and Claudia had just returned from a holiday trip to Colorado; the two sisters "seemed to walk on an average of 20 miles a day in the mining district—came into contact with workers—a real healthy existence," Alfred reported happily.[19]

Georgia's concern that her exchange of letters with Paul remain secret was not shared by Strand. By early August, he seems to have made some sort of confession of his feelings to Alfred. With the naive egotism of the young, Strand may well have found it unthinkable, given the difference in ages, that his mentor's affection for Georgia was anything more than paternal. In all likelihood, Alfred decided that his own interests were best served by letting Paul believe just that, at least for the time being. By never revealing himself as a rival, he would save face should he lose Georgia to the younger man. Equally important, he would learn much more through discretion; his guileless protégé would tell him everything, allowing Alfred to monitor Georgia's actions and feelings through Paul.

In the middle of August, Stieglitz, then at Lake George, received an anguished letter from Strand, who was staying with his family at Twin Lakes, Connecticut: "As I wrote to Canyon [their code name for O'Keeffe], I sat here for nearly three weeks, looking at the hills and the Lake—doing nothing—reading nothing—feeling nothing. . . . the feeling of dissatisfaction with myself became intolerable."[20]

The principal cause of Strand's depression was that he had not heard from Georgia since he left New York a month earlier, "tho I have written right along." He blamed himself for her silence. He had failed to give her what she needed. "I suppose there is something that makes it impossible—something perhaps that I said or left unsaid—I don't know—perhaps I have nothing more to give."[21]

Stieglitz's reply was all consolation and sympathy: As for "Canyon," he himself had received only a few brief letters, Alfred wrote, with an elegant touch of sadism.

O'Keeffe's silence wasn't Paul's fault, Alfred reassured the younger

man. She had just returned from an extraordinary trip to Colorado; she had great hopes of important pictures emerging from all she had seen. Furthermore, Stieglitz explained to Strand, Georgia was exhausted. Writing letters from a sense of obligation was not her style, Alfred pointed out, leaving Paul to ponder the distinction between duty and pleasure where Georgia's correspondents were concerned. And he concluded on a note of fatherly sympathy. He knew how deeply Paul suffered. But surely he would prefer the truth of Georgia's silence to the falseness of unfelt words.

A few days later, Strand was released from his misery. A letter from Georgia arrived from Colorado, ecstatically describing the place where she was writing to him: a mining office clinging to the mountainside, furnished only with an empty oil can and her own watercolors, where she had taken refuge from a thunderstorm. Tough climbs in Ward and Estes Park had lifted her spirits. Her perspective regained with her escape from small towns and small minds, she described the scenery with burst of lyricism: the violet mountains frosted with snow; a moonlit lake, its surface covered with water lilies. She felt released by solitude into the first real peace she had known in years. She closed with a coy riddle for Paul: If she were to want someone with her now, who would that someone be?

Even Georgia's dissatisfaction with the painting she had done on the trip, a sense that she had lost her bearings, didn't seriously depress her. The journey served a function other than to move her art in new directions. She was distancing herself from the myopia of the everyday, surveying her life from an aerial perspective—very different from greeting the dawn on the peak of Mount Elliott in Virginia.

Dangerous flooding in Colorado forced Georgia and Claudia to make a large detour through Albuquerque and Santa Fe. Georgia was entranced by the pink adobe architecture and the "funny" blanket Indians. Aside from the great ceremonies and ritual objects such as kachina dolls, her interest in the lives of the Native American and Hispanic peoples would never move much beyond the level of her first observation. It was the landscape that made her feel, she later said, that the rest of her life was finding a way back to New Mexico.

From Albuquerque, she wrote to Strand to say that she hadn't felt like writing. She had not written to Stieglitz either, she claimed. To Paul, she could explain the reason for her silence.

There was another man in her life, a Texan. She had gone to New York more to escape him than to see Alfred. With her fear of feeling too much, Georgia had been terrified by how badly she wanted him, how much she longed to walk off the edge of the world with him; she

had never felt such yearning before. He wanted her just as much; he insisted that he was going to marry her; he didn't care that their lives had been utterly different, that all they had in common was their need to be together. He had gone away for a month and expected an answer on his return. Georgia was frightened that she cared more than he did; that he was the first man she wanted to live with; that she would feel tied down if she agreed; that she might say yes.

Georgia spared Paul nothing about her feelings for the irresistible frontiersman, probably her former student Ted Reid. This time, however, her brutal honesty to Strand about her passion for another man did not suggest either deliberate cruelty or the desire to fan flames of jealousy; rather, she appeared oblivious to the knife thrust that every sentence in this letter would inflict on a man who cared for her. She apologized for her cruelty in criticizing Strand personally; relations with other men, however, were her right. As a measure of her respect for him, she assumed he would prefer the truth.

Significantly, Georgia's compulsion for honesty didn't seem to extend to Stieglitz. Contrary to what she told Paul, she had, of course, written to Alfred; to the older man she alluded only vaguely to changes in her emotional state. Reporting to Marie in September on Georgia's return from her trip, Stieglitz quoted from a recent letter of Georgia's from which he learned that "Canyon has virtually wiped the slate clean of New York—The past."

Clearly worried—and with good cause—Alfred tried casting this remark in the best light possible: "Of course, I know what she means," he wrote to Marie. "She is always real. And it is a warm realness—not one devoid of heart—just built up on reason."[22]

As it happened, reason prevailed. Her Texas passion ended, Georgia felt restored to herself, free of the sense of bondage she always equated with love. The men in her life were like glasses on a table; in one gesture, she had sent them all crashing to the floor, she told Paul. The image—suggestive of a cowboy in a saloon brawl—points to an annihilating anger, the rage of the slave she felt herself to be whenever she loved a man.

Now that the others had been swept away, Georgia's letters to Paul were once again full of love and longing. The war had exacerbated her sense of confusion and isolation. She had no desire to paint: there was nothing she wanted to say. Primary evidence of depression—difficulty working—creates a secondary symptom: despondency caused by the inability to work. The entire world seemed to be spinning around; she felt as though she were dangling over a void, about to fall, she wrote to Strand. She related similar terrifying feelings of vertigo to her Char-

lottesville friend Anna Barringer, thanking her at the same time for her patience during the terrible last summer at home.[23] The war had made life a nightmare; she loathed the hatred in the faces and in the minds of everyone she saw. Still, she chided Strand for his pacifism: wouldn't he rather fight than read, ponder, and argue? Even if he was against war in principle, she insisted, it was a fact of life; immersion in the actuality of combat would be better than the numbing contagion of words, printed or spoken.

But what she really wanted was to be with him, she wrote, to take both his hands in hers and look into his very soul.

BY THE END of November, war hysteria had intensified. Ted Reid had been accepted for training as a fighter pilot. Georgia saw him off at the station. Once more, she was completely open with Strand, declaring her love for the strapping young rancher.

Now, for the first time, her letters from Texas mentioned a woman who was to play an important role in her life and art.

Leah Harris lived on the family farm in Waring, a community settled largely by German immigrants in the lush country just south of San Antonio. Before moving to Texas, Leah's father had published one of the few Republican newspapers in Arkansas. That he was a Jew did not diminish people's suspicion of her father's politics. Mose Harris seemed to fear for his family's safety; Leah, the youngest of three daughters and two sons, was taught to shoot at an early age. Moving to San Antonio, Mose Harris became editor and publisher of the *Texas Republic* and a respected community leader. Shortly after the move, when Leah was in her teens, her mother was committed to the state mental asylum in San Antonio. Although she was the youngest daughter, Leah seems to have managed the household on the Waring farm, where the family now lived.

Small, dark, and sturdy, Leah exhibited exceptional competence that was remarked by everyone who knew her—even in a region where women's self-reliance was taken for granted. Instead of rebelling against her assigned maternal role, Leah professionalized her domestic skills, training as a home economist. In early 1917, when she met Georgia, Leah was employed by the extension program of the county agricultural department, teaching canning and food preservation to Panhandle housewives.

By early spring 1917, Leah and Georgia had become intimate friends. Both nearly thirty, unmarried, and working, the oldest daughter of Ida O'Keeffe and the youngest child of Catherine Harris also had in common

the scars of maternal deprivation. In their relationship, Georgia acted out the needy, abandoned child, while Leah played her accustomed maternal role: nurturing, protective, and reliable. Georgia was staying with Leah at the Harris family farm when she made her impulsive trip to New York in May 1917.

The sense of security Georgia enjoyed with Leah was unaffected by the fact that the two friends rarely saw each other because of Leah's constant traveling. The time they did spend together meant that much more. Describing Leah to Strand as "the finest girl" she had met in Texas, Georgia detailed the precious occasions they had spent time together (one overnight visit, a hurried few minutes in Canyon). Leah's base of work was Amarillo, but her teaching demonstrations kept her on the road most of the time. (In 1917, she logged 12,155 miles of travel.) Leah's sister Annette had married a doctor, Robert McMean; the young family, now including a small son, lived in Amarillo, where Georgia visited with Leah in early December 1917. As their sister's close friend, Georgia was made to feel as welcome at Dr. Mac's house as she was at the Waring farm downstate.

Adoption by the Harris family created a retreat of warmth and solicitude in an atmosphere Georgia felt was becoming increasingly cold and hostile. Her own confusion played out with ever more contradictory feelings about the war. In November she gave a talk to the Faculty Club of the college, which was overwhelmingly patriotic; her message could not have been more pacifist. Indeed, she had astonished herself, Georgia reported to Paul, by tearing into her audience. She attacked the narrowness of their vision and the deadness of their teaching. When it came to telling her colleagues what they should be doing—for both children and their future teachers—Georgia used the word *conservation*, the substance and method of Leah Harris's lessons. She concluded her remarks with a savage denunciation of the war: every soldier was killing his moral self unless he had learned earlier the lessons of "livingness"— Stieglitz's favorite word—in which case he could no longer be useful as cannon fodder.

Instead of lynching her, Georgia's fellow teachers came up afterward to pat her shoulder and shake her hand, she reported. But her sense of triumph was short-lived. The Faculty Club was not the administration of West Texas State. The latter urged all instructors to establish a "war project" on campus; to encourage student enlistment, the college would grant early diplomas to young men who had not completed their course requirements. Georgia did not know how long she could continue to speak out against the war and keep her job. An unpleasant incident reinforced her uncertainty: when she protested against Christmas cards

whose message in a season of peace was "Kill the Huns," Georgia was made to feel more than a seasonal chill in the air. War was wrong, she wrote to Strand, but active combat must be one of life's great experiences. If she were a man, she'd join right up. Strand could not have missed her message: if he were a man, so would he.

In her isolation, art meant more to her than ever before, she wrote to Paul. But she still wasn't working. Neither Stieglitz's gift of a paint box—a response, perhaps, to Georgia's despairing reports of paralysis—nor his niece Elizabeth's warmly bracing letters helped. Surrounded by deadness and philistinism, military fervor and hostility from neighbors, she could not control her deepening depression, soon to take the form of physical illness.

A severe sore throat was the beginning. Writing to Strand in pencil on the train to Fort Worth, she mentioned having spent a few days in Amarillo. Later, she would admit that her visit included an examination, long overdue, by Leah's brother-in-law, Dr. Mac. Georgia's refusal to take care of herself was a source of concern to Strand and Stieglitz, both fussy and hypochondriacal.

Feeling low, emotionally and physically, she reached out to Paul with greater openness and intensity than she had allowed herself to express earlier. He had sent her a poem, "Invocation." Reading it on the train, she longed to touch the poet. She could not be feeling all that she felt for him if her yearning was not a response to his need for her. She wanted him there, his arms around her, giving her strength, protection, and peace as she dropped off to sleep.

Georgia's letters began to take on a pleading tone—very different from the needling sexual challenge to Paul's pacifism, which she saw as passivity.

Strand sent her more poems. Reading them released cries of love and pain; for once, she could not control her feelings, the maelstrom inside. Her defensive system, so elaborately constructed, was breaking down; the mechanism that allowed her always to conserve resources, to amortize her emotional investment, had stopped working. She was terrified, she told Paul, of exhausting her emotional capital. Her nerves were so taut that she was unable to sleep. Her throat was worsening; she had not been able to talk for more than a week; she was always on the verge of tears.

By mid-December, she was angry with Strand again. But she no longer conflated his passivity with the refusal to fight. She taunted him on the real issue: was he just Man, a frozen abstraction, or was he flesh and blood man able to love a woman? She compared herself to the small white plasticene figure (female, not phallic, in Georgia's description)

that she had made and given to Stieglitz. Could Paul's caress quicken the clay woman into life? Georgia asked. There seems to have been no question of the sculpture's owner taking on this challenge; Georgia's only mention of Alfred as Paul's rival remained in the realm of words: she wished she could talk to Strand as easily as she could to Stieglitz, she told him.

Georgia spent Christmas 1917 babysitting for her landlords. Douglas Shirley, a physics professor at the college, and his wife, Willena, celebrated by going to a picture show. She read three letters received the day before: from Paul, Stieglitz, and Elizabeth. It was a queer holiday, she reflected, to be loved by many yet to be alone. She had planned to visit her soldier brother, now stationed in Waco, but Alexius had written not to come; his unit would be overseas by Christmas. Instead, Claudia, still teaching in Spur, Texas, came "home" for a four-day stay. Significantly, "home" was now where Georgia happened to be.

In November, Georgia had turned thirty, an age at which most women were the maternal center of real homes. Indeed, her amused pride in Claudia was Georgia at her most motherly. But she also experienced the fear that is part of being a parent: when Claudia had to have her tonsils removed, Georgia, sitting in the doctor's office, was so full of terror "I nearly died," she wrote to Anita. She wished that Paul could meet the exuberant eighteen-year-old; her sheer energy captured everyone and everything. Claudia's Christmas haul had ranged from a new rifle to a paper goat. She had also appropriated Georgia's only suit— in a rare state of being freshly cleaned. On her next visit, she was going to walk the twenty miles to Amarillo and promised to go hunting with the college physical education instructor one hundred fifty miles into the country.

Just before the new year, Georgia sent Paul a packet of letters she had written to him and never mailed; she had been too cruel in some of her remarks, she admitted. When he read them now, he must imagine her standing there, contrite and small, like her little white statue, ready to be taken in his arms; together they would forgive each other for the pain they had caused. Their suffering was a measure of their love. She thanked him for his Christmas present: Dostoyevsky's *The Idiot*, with its beautiful inscription. Innocent and idealistic, Strand could well have seen his double in Prince Mishkin, the Holy Fool.

Georgia was sick again: stomachache and headache this time, symptoms she attributed to overexcitement. If Paul were there, she would be soothed. She pleaded with him to kiss her. But when she went up to touch his photograph—the one she had asked Stieglitz to send her— she felt the look on his face to be icy, disapproving, even cruel, capable

of smashing his hammer down on her. His righteous wrath about the war, about the greed and materialism that isolated the artist, was becoming self-righteousness. Analyzing, criticizing, judging, he had developed a brittleness that was choking all that she loved in him, repelling her at the same time.

Again, she begged him to forgive her. She turned to him as to no one else. Only he could give her what she had to have—which was not what most women required. An urgency of desire, not domesticity, is what she challenged Paul to fulfill.

On the day before the new year, she sat down to write him a letter. The first sentence that came into her head was a plea and a command: he must love her with a limitless love. Instead of beginning her letter, though, she cleared the table, resting her head in her arms. On looking up, she made three drawings. Not for the first time, her erotic impulse had been sublimated into art.

In the middle of January, Georgia felt so sick—her throat again—that she paid another visit to Amarillo to see Dr. Mac. After an injection in her arm and lights and metal instruments probing her throat, she left feeling worse. The war frenzy in the city made her realize the relative benevolence of Canyon's small-town patriotism: in Amarillo, soldiers were everywhere. She saw herself as an object of prey, stalked through the streets until she was cornered. Feeling too ill to teach on her return, she canceled her classes for two weeks (duly reported by the Canyon newspaper a month later). Her condition wasn't helped by the weather: below zero temperatures accompanied by blasts of icy wind. She stuffed paper in the front of her dress for extra warmth on the freezing walk between her room and the college. Then, on February 12, Georgia wrote to Paul, she was planning to visit Amarillo. Dr. Mac wanted to see her again.

On this next visit, Leah made a confession that shocked Georgia. Her friend's secret, too damaging to be committed to paper, was clearly the acknowledgment of her homosexuality. As soon as Leah revealed the truth about herself—a revelation triggered, most probably, by her feelings for O'Keeffe—Georgia grasped the meaning of incidents, hints, and behavior that had earlier eluded her.

Leah went south to her family's farm shortly thereafter. Then, at the beginning of March, O'Keeffe, now on indefinite sick leave from the college, joined her. Writing to Strand from San Antonio on March 3, she informed him coolly that she had changed. She was no longer the woman he knew. "I don't seem to be me—I seem to be someone else—or something else," she wrote.

Meditating, perhaps, on the meaning of these troubling remarks,

the reflective Strand did not reply at once. Georgia wrote to him on March 13, noting his silence and asking, somewhat anxiously, for news. Too agitated to stay put, she had been living in three separate places, her belongings scattered among them. Moving suddenly from one location to another, she could not keep track of anything; it was all muddled. To Paul, she explained fear as the cause of her strangely nomadic existence: if she stopped moving, she would have to confront her turbulent feelings. Georgia's movements, however, were neither random, impulsive, nor confusing; they followed the itinerant teacher Leah Harris in her triangular swing from Canyon to Amarillo to San Antonio.

By the end of April, Georgia was staying with Leah at the Harris farm in Waring. She had wanted to ask Paul to come down and work, but something had stopped her. She felt severed from everyone who was not part of her present surroundings—with the possible exception of 291. Even there, the thread seemed to have broken. Her present life was so strange.

Waring, she announced to Paul, was now her address.

ON APRIL 22, she wrote to Strand describing, in painterly terms, an idyll of intimacy. Together, she and Leah were delighting in the *Life of Strindberg*; with darkness, they ended their reading. Leah was lying down; her small head, with its black cropped hair, contrasted with the red quilted pillow and the other red of the army shirt she wore. Georgia sat beside her on the bed, watching. If it were Paul, instead, who was lying beside her, Georgia wondered, would his closeness be able to warm her? Because she and Leah, she wrote, were two of a kind: they were both cold women.

This would be the last letter that O'Keeffe would write to Strand from Texas. Less than two weeks after it was mailed, Paul Strand arrived in San Antonio, dispatched by Stieglitz on an extraordinary mission.

EIGHT

Mission Impossible

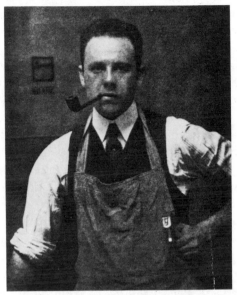

ALFRED STIEGLITZ, *Paul Strand* (1917). The photographer
Paul Strand succeeded Steichen as Alfred's disciple.
Stieglitz photographed Strand while the younger man was
helping to clear out 291 following the gallery's final exhi-
bition, of the works of Georgia O'Keeffe.

IN THE WARM spring sun of Waring, Texas, pecan trees blossomed
by the Guadalupe River. Neither the balmy weather nor a regime of
rest in Leah's care had brought Georgia back to health. Stieglitz, ob-
sessed with illness generally, was suffering acute anxiety over her con-
dition. His fears were not groundless. A terrible influenza epidemic*
would strike twenty million Americans, claiming five hundred thousand
lives in the first months following the Armistice, among them Mac-
mahon's brilliant friend Randolph Bourne.

Aware of Ida O'Keeffe's recent death from tuberculosis, Alfred
dreaded the hereditary threat of the disease (still popularly accepted, if
medically disproved) along with the more plausible possibility of Geor-
gia's infection while in Charlottesville. Finally, with his fleet of Stieglitz

* It has been suggested that O'Keeffe was suffering from flu during this period of intermittent
sickness; neither her symptoms nor the difficulty of diagnosing them support this view.

medical specialists on call (including his brother Lee, the doctor) Alfred had little confidence in medicine as practiced in the Texas Panhandle.

His concern, exacerbated by separation and Georgia's now sporadic letters and disconnected tone, took the form of repeated suggestions (echoed by a surrogate, his niece Elizabeth) that O'Keeffe come to New York to be examined. Whatever Georgia's reply to Alfred, it was not reassuring. O'Keeffe herself admitted to writing an angry letter to Elizabeth. To Georgia, in a run-down, depressed state, with a growing dependence on Leah and the convalescent care she provided at the farm, Stieglitz's letter writing campaign with its equivocal message—Please come, but at your own risk—was unsuccessful.

Finally, at the beginning of May, in reply to a particularly insistent letter from Elizabeth urging her to come, Georgia telegraphed back the bleak news of her physical condition: she was too ill to contemplate travel anywhere. Western Union's urgent style rekindled Alfred's fears: Georgia's message required immediate action. But it would be action demanding careful thought. O'Keeffe's volatility, Alfred's fear of rejection (fueled by his awareness of the intense exchange of letters between Georgia and Paul), and his still greater dread of assuming responsibility for a woman (should O'Keeffe suddenly agree to come), especially a sick and penniless woman, required a fail-safe strategy. In short order, Stieglitz devised a plan, the more foolproof as it appeared to be collaborative: Strand would travel to Texas as his emissary. That Paul was infatuated with Georgia made him a perfect stalking horse; Alfred would use his disciple to see whether O'Keeffe's feelings for him had changed.

Sincere, honorable, trustworthy, Strand was the perfect choice to play John Alden to Alfred's Miles Standish. And Stieglitz had an advantage that his Puritan prototype never enjoyed: the artless Strand remained unaware—at least consciously—that he was acting as Alfred's advance man. To Paul, the issue was O'Keeffe's health. In Strand's eyes, Stieglitz was still, to paraphrase Gertrude Stein, the Father of Us All.

ON MAY 5, Strand was dispatched to San Antonio.

"I advised him to go" was the way Stieglitz presented Paul's role to Elizabeth. Describing to his niece—also the object of Strand's intermittent attentions—the eleven-hour conversation that had preceded Paul's departure, Alfred noted that Strand had been planning to call on her at her parents' home in Mamaroneck, had he not set off for Texas instead.

Stieglitz further advised that nothing be said to O'Keeffe about Paul's imminent arrival, using Georgia's need to remain calm as his excuse for keeping Strand's visit a surprise.[1]

Thanking Paul for his letter en route from St. Louis, Stieglitz sounded euphoric: "It seems like a dream to think that you are in Texas—seeing and hearing for yourself," adding, "Of course, I hope to hear as soon as possible what O's actual physical condition is."[2] Alfred meanwhile had received a letter from Georgia that same day—May 12—which he described as "very quiet—very white."*

Finding himself in San Antonio, Paul felt indeed as though he were dreaming. His description of his first day—beginning with his failure to recognize Georgia's voice on the telephone—suggested the foreignness with which dreams envelop the most everyday transaction.

They arranged to meet in a small park near Strand's hotel. Arriving early, Paul struck up a conversation with an elderly man on the bench beside him, when he looked up to see a figure in black coming toward him. She wore the same black hat she had worn in New York, he wrote Stieglitz (the one Marie Rapp had called Georgia's "funny little pot of a hat").[3]

Expecting to see a wasted Camille, Paul was happily surprised by how blooming Georgia looked: "fuller than last year," he reported.[4] She was staying in town for a few days to recover from a frightening experience at the farm: a late-night visit from armed intruders. The intrepid Leah had rushed out in her nightgown, rifle in hand, and scared them off. But Georgia was still jumpy over the incident.

In any case, there were many friends and a busy social life in San Antonio, but, as the tactful Strand hastened to reassure Alfred, "No one sees her as you do—No equivalent of 291."[5] By using Alfred's "sign-off," Paul affirmed that his older friend's understanding of Georgia made him irreplaceable.

O'Keeffe's real attachment, however, was to place, not to people—as it always would be. Paul was quick to notice how much she thrived on the "holiday atmosphere" of San Antonio, the river and canals flowing through the town, the tropical flowers and exotic trees that bloomed everywhere. The small city had a Latin vitality without the "brutal aliveness of New York," Strand observed with the acute eye of the photographer.[6]

* "White" was Stieglitz's favorite term of approval. In his usage, the word embraced conventional meanings of purity and innocence but also denoted generosity, distinction, or even more vaguely, a specialness in anyone he happened to like.

They talked all day, with Georgia doing most of the talking. Paul was encouraged by her volubility: whatever was said about coming East would come from her, he wrote to Alfred. Shrewdness mingled with relief in his observation; Strand knew he was engaged in Mission Impossible. Alfred's only charge to him was in the form of mixed signals: he was to say nothing, do nothing to influence Georgia one way or another. His task was to see that she made up her mind—independently—to come to New York.

Walking together in the Alamo gardens, they admired the "wonderful roses and a gorgeous pomegranate tree with orange red blossoms." Charmed by Georgia, the "darky gardener," Paul reported, allowed her to pick one; she pinned the brilliant flower to her dress, where the petals glowed against the blackness.

At a little Mexican café, they sat at a green table eating frijoles and enchiladas. Just below them, the river flowed by. When Strand mentioned Stieglitz's name, Georgia said suddenly: "Oh, I would like to talk to him."[7] Her remark didn't mean that she was close to a decision, Paul warned Alfred. When he told Georgia that he had arrived in San Antonio without being certain that she hadn't started North, Georgia told Paul that she still hadn't made up her mind about teaching the summer session in Canyon. More important, she "somehow couldn't see herself in New York, yet," she said.[8]

Describing O'Keeffe's reaction to his unannounced visit—after a year's exchange of passionate love letters—Strand seemed to be groping for words that denied the highly charged intensity of their encounter: "She was very surprised that I came and she was glad," he said flatly.[9]

On less dangerous ground, Strand was delighted by Georgia's optimistic state of mind about her health: "I never mean to be sick again," she told him. She seemed well on the way to keeping that promise, Paul told Alfred, "if there is no germ," he added cautiously.[10]

Stieglitz found Paul's first letter from San Antonio just as he was leaving 291 at 9:00 A.M. for jury duty. Although he claimed to have sensed the happy news before reading Strand's report, Alfred admitted: "Of course, I'm human & I suffer terribly at moments—the night was Hell as I lay there."[11]

At least now, he could toss and fret openly; in these months, Alfred had moved from the conjugal bed at 1111 Madison to a cot in his small study at 291.

His fears for Georgia went beyond the dread of loss created by love, need, distance, even her illness. She had become both muse and creative force, sustaining the mystical state that Stieglitz would forever invoke by the numbers 291.

Life—Death—?
—I want her to live—
I never wanted anything
as much as that—
She is the spirit of 291
— —Not—I— —

"That's something I never told you before," Alfred confessed to Paul. "That's why I have been fighting so madly for her."[12]

Allowing for Alfred's histrionic style, he was expressing a profound—and dangerous—truth: the boundaries of his ego were blurring; O'Keeffe, the artist and woman, had become his reborn self, redeeming exhaustion, confusion, and failure. Through her, the spirit of 291—Alfred's identity and signature—was lifted from the page and given new life.

Writing exaltedly of his sense of fusion with O'Keeffe, his belief that she was his soul's immortality, Alfred admitted that his oceanic emotions were projected on a woman as yet unaware and unconscious of what he was feeling.

"She really doesn't know me," he said.

Ambivalent himself about the city, Stieglitz seconded Georgia's doubts about living in New York. "Just now I feel she'd suffocate here," he wrote Strand. "Her health—just plainly *She*—These are the prime considerations—All else must be secondary."

Paul clearly required some paternal reassurance: "You ought to know that you too mean a great deal to me," Alfred concluded.[13]

A few days later, Strand reported Georgia was seriously contemplating another visit to New York. She had all but decided to return to Canyon for the summer session on June 10; a trip East would necessarily—like the one last year—be brief.

Paul found her thinking "mixed up" and in need of firmer male guidance than he could offer. "You can always decide for her, if it becomes necessary," he wrote to Alfred. "I feel she should come up and talk to you."[14]

Talking to Paul in the park until late at night, Georgia had reported the opinion of the Canyon doctor: she was as near to having TB as anyone he had seen who was not yet stricken with the disease. Whether this diagnosis was based on Georgia's symptoms, her family history, or X-rays, she was severely frightened; even the news that her infection was restricted to the larynx did not assuage her anxiety.

Money, it finally dawned on Strand, was, along with health, a key element in O'Keeffe's decision about where to go. He had not yet

broached the subject with her, he confided to Stieglitz. Unafflicted with middle-class gentility, Georgia had been frank with Paul about her lack of money; she had "spoken several times of how necessary it is to have it," he admitted to Alfred.

"She certainly doesn't need very much," he qualified, lest he seem to portray Georgia as calculating, "that isn't what she means. But I fancy she hasn't anything left to speak of. I must find out when the time comes to ask."[15] Paul added that it would be easier to discuss such awkward matters when they arrived in New York.

Despite his own need to earn a living from the time he graduated from high school, Strand took a curiously Olympian view of O'Keeffe's poverty. Reporting to Stieglitz that Georgia would probably return to her job in Canyon because she had no money, he struck the amazed note of one making a major discovery: her financial plight, he concluded, "is no doubt one very definite reason for teaching again."[16]

Meanwhile, Georgia showed Paul San Antonio; together they explored the Mexican quarter, near the market. Strand was enchanted by everything he saw: the flowers in the windows of the tiny houses, the grave dignity of the men and women, the spontaneous gaiety of the children. His black box terrified the residents, but they loved Georgia and her box of colors. She had painted there once before; whether the youngsters remembered her or felt a kinship with her childlike wonder at all she saw—as described by Strand—they crowded around Georgia. One lad rushed to show her his own amusing drawings. In spite of the suspicion aroused by his camera, Paul managed to get more than two dozen plates, including "quite a few of [Georgia] against adobe walls and one picture of a Mexican toilet."*

On the evening of May 14, Leah Harris arrived in San Antonio. Meeting her the next morning, Strand reported that his first impression was of a "tall thin girl, a Jewess, very nice, but not at all good looking— but nice—yes I think she will be very nice," he noted, with evident relief. Leah struck him further as "very sensible and keen."[17] The encounter had clearly been a source of considerable trepidation.

Five days later, Stieglitz received a bulging envelope from Waring, Texas. The twenty-eight pages, designated "Letter X" by Strand (the title, he explained with boyish solemnity, would make the document easy to refer to in future correspondence), was a journal of Paul's mission. In those thirteen days, the ingenuous young photographer

* None of Strand's plates from his San Antonio visit seem to have survived; his memories of the quarter, however, would reappear in his great photographs of Mexico taken in the 1930s.

would, as he said sadly, learn much about himself and about Georgia, Leah, and Stieglitz. The end of his innocence had begun.

Paul had expected to leave San Antonio with Georgia for Waring several days earlier; instead, Strand wrote to Stieglitz, Leah had come to town for unspecified medical treatments extending over several days.

During her stay, Paul and Leah talked in the Alamo gardens. Their conversation, lasting many hours, concerned only Georgia, but inevitably Georgia's two friends learned something about each other at the same time. In his missive to Stieglitz, Strand now began to wax worshipful about Leah.

"She is a wonder," he wrote Alfred, "honest, fearless and she sees as clearly I think in great part as you do. She certainly sees Georgia clearly." Leah's clarity did make her exceptional among this quartet. Georgia was waffling on every front, while the convoluted language of Strand and Stieglitz reveals only the muddled state of the writers.

What Leah saw confirmed Stieglitz's fears; Georgia was certainly "at risk" of tuberculosis. The opinion of Dr. Mac, Leah's brother-in-law, moreover, was seconded by her own experience as a patient; Leah herself had "battled consumption" for almost ten years, Paul reported. Although cured, she was still watchful of any recurring symptoms of the disease.

As to Georgia's visit to New York, Leah was prepared to negotiate; she wanted the best possible terms before endorsing a move that risked her own happiness as well as Georgia's health. She saw no harm in Georgia's going, Leah told Paul, *provided* that Georgia would be returned to her should her health fail.

"I can't go and get her," she explained to Paul, "and if the throat gets worse she must come [back]—I will have the farm for her to come to." Speaking for Alfred, Paul took it upon himself to reassure Leah: "So I said that you would certainly take care of that part—not let G. stay any longer than was good for her and bring her back if necessary."[18]

Paul Strand would never make a promise less likely to be kept.

Any doubts Paul may have entertained about Alfred's relinquishing Georgia were overshadowed by other troubling intimations. Along with his own growing attraction to Leah and his admiration for her strength of character, he had to confront the complex relationship of the two women. The generosity of Leah's love made Georgia's neediness all the more naked. Leah, he wrote to Stieglitz, was "most extraordinary with a stability that G. hasn't got." One of the first things she had told Paul was that Georgia needed someone to take care of her. She was suspicious of airy summonses from New York, saying "Come." Leah

then confessed to Paul: it was she who had made Georgia send her telegram to Stieglitz's niece Elizabeth with the news that she was too ill to travel.

The cruel irony could not have been lost—not even on Strand: Georgia's telegram reporting her weakened health, sent at Leah's behest and setting in motion Paul's visit, was the instrument of Leah's loss.

Strand's equivocal role was made easier by Leah's frankness. Among the questions he felt obliged to ask (whether at Stieglitz's prompting or his own) was whether Georgia would be able to have a child and, if so, what effect pregnancy and childbearing might have on her health. Citing doctors' opinions, Leah reported that having a child would probably improve Georgia's condition. Her own general health, she believed, would have been helped by having a baby; tuberculosis decided her against it. "You can see how straight she talks," Paul wrote.

Other questions relating to Leah's decision to remain unmarried and childless, however, went unasked and unanswered. "I didn't go any deeper than the physical," Strand wrote.[19]

"A child and yet a woman," Strand described O'Keeffe, seeing her through Stieglitz's Victorian lens.[20] But Paul—Georgia's contemporary—was also a twentieth-century man who perceived the problems created by a thirty-year-old woman with still infantile needs. Georgia's hunger, uncertainty, and fear were more than could be assuaged by any man—or woman. As Leah told Paul, she "didn't think anyone could satisfy [Georgia]—she can't stand anyone for long and . . . he would have to be a millionaire."[21]

"Georgia needs money" was a refrain echoed by Leah, Paul, and Stieglitz himself. All three were agreed, however, that it was security and freedom she required, not money itself. Unlike the middle-class young people flocking to Chicago or Greenwich Village, prepared to starve for art and love, O'Keeffe was no bohemian. She was too well acquainted with poverty and its sufferings. She needed "stability of living," Paul said, to match her "stability of fineness and spirit." With her present unsettled life, "its really a wonder that she paints at all," he observed. Still, the frugal Strand was worried by evidence of how freely Georgia spent the little money she had. "If we weren't going out to Waring tomorrow I'd soon be broke," he wrote feelingly.[22]

Another "if" troubled Paul more deeply. "If I had some money I might be able to help her—I know I wouldn't be afraid despite all the difficulties of living with such a person," he confided to Alfred. "But I haven't—so it is all very clear that I am not the one. Besides it is very clear to me that you mean more to her than anyone else—so it seems

that you and she ought to have the chance of finding out what can be done—one for the other."[23]

Letter X marked a coming of age for Strand. His Texas mission was forcing him to grapple with the darker recesses of human complexity; the frequency of the word *clear* in this soul-baring document is a reminder of just how unclear everything was turning out to be—starting with his own role in this four-character drama.

With a certain disenchantment, he had taken note of Georgia's tendency to engage in gamesmanship; her agonies of indecision about remaining in Texas, he decided, had been an act. As for her dramatic announcement to Paul that she had just written to the Canyon administration of her decision not to return, "Well, she knew that long ago," he told Alfred, "but she plays around with the 'whether or not.'

"I'm sure she has made up her mind to come to New York—all it needs is for me to say at the right moment—let's go. Of course, if you wrote to come, that would settle it at once—But it isn't necessary unless you want to do it," he wrote soothingly.[24]

Georgia's face-saving indecision, Alfred's dodgeball avoidance of responsibility, Strand's role as advance man—the only one who wasn't playing games was Leah Harris.

Confronted with the depth of Leah's love for Georgia, the dignity of her suffering, and his own role as agent of her pain, Strand felt his burden as emissary growing heavier.

" 'I've been looking for Georgia all my life,' " Leah had told Paul. But having found her, she wanted her talented friend "to have every chance," she said, even if that meant giving her up. Moved by Leah's unselfishness and stoicism, Strand wanted to be sure that Stieglitz appreciated all that losing Georgia would cost her: "She means a very great deal to Leah—a great deal," Paul wrote soberly.[25]

Georgia's feelings for Leah, on the other hand, left Paul confused. He recognized the large part played by dependence and need on O'Keeffe's side. After three weeks in San Antonio, however, Strand's deepening involvement with both women forced him to see their relationship in a new light: they were a couple. He was not ready to articulate his sense that Georgia's sexual attachments embraced women as well as men, but he tried to signal the unsayable: "I think before she could go with you," he told Stieglitz, "there would be many things to be given up—very many.

"This letter sounds rather brutal, but you will understand," Strand ended Letter X.

"I love her very much. You know my feelings for you."[26]

Stieglitz penciled two drafts of his reply on the back of Letter X. In the final version*—probably telegraphed to Strand—he wrote:

Letter X received.
Wired to O yesterday
Letter changes nothing
This is the time to
come, if O feels the actual need of coming North.[27]

A longer communiqué followed immediately. "Letter X nearly knocked me out," Stieglitz wrote. While nothing that Paul said was unknown to him, taken together the facts pointed to "a question—a vital one—to be answered by me."[28]

Should Georgia come to New York, she would be a dependent. How could he be for her what she needed? He, who had never supported a woman—financially or emotionally—still less a family. The moment was soon approaching when he might have to assume responsibilities that until now—at age fifty-four—he had managed to avoid. No wonder that reading Letter X, with its echoing refrain of Georgia's needs, provoked Alfred's deepest fears: "I was simply paralyzed," he wrote to Strand. In his reply, he repeated, "The coming or not coming is entirely in her hands—there must be no suggestion or interference one way or another."

Acknowledging that Paul's position was a "nearly impossible one," he commended Paul's handling of the most sensitive element in the complex web of relationships. "You have brought about a very essential thing & that is Georgia's becoming conscious of her actual meaning to Lea," he wrote to Paul (using O'Keeffe's misspelling of her friend's name). "That is really important."

Alfred concluded his letter with another disclaimer: "From this end, nothing can be decided."[29]

In a limbo of indecision and expectation, Stieglitz found solace in the spectacle of a Red Cross parade: "75,000 people marched—mostly women," with President Wilson at the head, he reported. Neither the marching women nor the nation's leader prepared him for the transcendent state he would experience: "I'll never forget the thousands of girl children—between 8 & 11," he wrote, "all white and red—no hats—white dresses & shoes & stockings—a ribbon of white, small red cross on it tied around the head." Watching this march of the innocents,

* In the first draft, every line contains a negative. Where sensitive issues were at stake, Stieglitz often wrote several drafts of letters, even those whose final version suggested an impulsive burst of spontaneous emotion, set down at breakneck speed.

Stieglitz experienced a state of ecstasy, expressed as *Liebestod*: sex, children, woman, and art all merged in a moment of beauty so perfect it could only end in death.[30]

Whether as a result of Stieglitz's telegram, placing all responsibility for a visit to New York on Georgia alone, or for other reasons, Paul wrote Alfred that Georgia had become "nervous and hysterical."[31]

The week after posting Letter X to Alfred, Strand had moved with the two women to Leah's farm in Waring. Once more, he was feeling inadequate to everyone's expectations—starting with his own. "Everybody seems to be wanting something they can't have," he wrote. "What is it?—Life? rest? completion in some degree? I don't know," he faltered. "Everything seems unspeakably twisted—like the live oaks down here that have been eaten by the muzzy worms."[32]

Responding to Alfred's confession that Georgia, not he, was the spirit of 291, Strand was doubtful: if O'Keeffe could ever play that role, it would only be "*thru* [sic] you," he told Stieglitz.

Paul ended his unhappy note with a curious little prose poem:

She a woman
 hysterical
Cruel—and yet
So lovely—so
pure—so
like you fundamentally.[33]

After days of worrisome silence from Waring, Stieglitz received, first from Georgia and then from Paul, the account of yet another crisis.

As soon as O'Keeffe and Strand had arrived at the farm, Leah gave them unpleasant news: a German down the road had been slandering Georgia to the entire neighborhood. Not one to take this outrage passively, Leah was filing a complaint against the farmer for trespassing on her property when drunk. Having done her part in defending Georgia, she made it clear to Strand that manly action was now required of him.

"You know this southern attitude which expects somebody to go and beat up the offender," Paul wrote to Alfred. All very well, Strand allowed, but this was a German community, "absolutely vicious and unscrupulous,"[34] he insisted, with a little Hun-baiting of his own.

Strand knew that he was supposed to march over to the offender's house, gun in hand, to demand an apology. Instead, he looked for reasons not to go: carrying a gun in Texas was punishable by a one-hundred-dollar fine, while threatening a fellow citizen could mean a year in jail, he informed Alfred. In desperation, Paul had tried to enlist a few

"leading citizens" in Waring to accompany him in a vigilante posse; there were no takers.

Poor Strand! Torn between his desire to appear a Galahad in Georgia's eyes and his terror of violence at the hands of local rednecks, he lost on every front. Made miserable by his own cowardice, he had also "riled Georgia terribly." Still smarting, perhaps, from Paul's earlier failure to come down and carry her off, Tarzan-style, Georgia took this occasion of indecision to administer a merciless dressing-down, not forgetting past sins and other character flaws—and all in front of Leah.

Further fueling Georgia's anger was her realization that Stieglitz was behind Paul's visit, as he was behind his niece's invitation. What had appeared to be independent gestures of friendship was revealed as a puppet show, with Alfred pulling the strings. It was easier to blame Paul for her feelings of betrayal. "First Elizabeth and now you," Paul reported she said.[35]

Georgia's contempt, his loss of face in Leah's eyes, and the probability of having failed Alfred plunged Paul into despairing self-hatred. "It just drove me nearly mad to think I had made such a mess," he wrote to Stieglitz.[36]

Within another week—Georgia's last in Texas—matters had righted themselves. In a happy opera buffa finale, Paul, carrying a six-foot whip and pretending to have a gun in his jacket, paid a call on the offender. The tough, vicious farmer turned out to be just a timid gossip; terrified, he presented himself that same day at the sheriff's office to tender his official apology. A trial was averted.

Meanwhile, it was Stieglitz's turn to castigate himself for passivity and cowardice. "Sometimes I feel I'm going out of my mind," he wrote to Paul, "because I see so damnably straight—I don't know how to ACT—act so that I can give others what I know they need."

Where Georgia was concerned, Alfred knew what was required: "Rest—a simple home—peace of mind—Whoever can give her that will give her what she needs above all things," he said.[37]

He still wasn't sure who that would be.

IN WARING, Paul, Georgia, and Leah bowed to the inevitable. By May 26, it was decided that, following a few days in San Antonio, Georgia would be ready for the trip to New York. Concerned about the effect on Georgia's health of several days traveling in the heat of the southern summer, Paul planned to break the trip with a short stay in New Orleans. After assuring Stieglitz of O'Keeffe's improved condition, Strand took on a more delicate task: allaying the fears he knew Alfred

would still have about relations between him and Georgia, while remaining absolutely honest. "The best way I can tell you how things are at the moment is that she lets me touch her—wants me to," Paul began, in a sentence not exactly calculated to assuage the sexual jealousy of a man twenty-five years his senior. "But with me at least—no both—" he amended, "no passion—except in a far off—very far off potential. I never thought she would again—I don't think she did either—It was all a nightmare," he concluded, adding in a vague postscript, "I think besides she was unwell."[38]

Meanwhile, Georgia had sent Stieglitz a night letter, Strand told Alfred, explaining all; she and Paul had "talked it out and things are better. . . . This is a crazy letter—if ever there was one. . . . What happened was very bad—it mustn't happen again," Paul ended meekly.[39]

A telegram followed, asking Stieglitz to wire one hundred dollars to San Antonio.

On the last days before Georgia and Paul left Waring, the tense situation at the farm was transformed. Liberated by imminent separation, the "difficult three cornered arrangement," as Paul described living with the two women, eased into idyllic hours of creation and love.

"This has been the first quiet day since we have been here," Paul wrote to Alfred on May 30, "very free—a great day—photographing Leah."[40]

His wonder and delight at what took place was expressed in staccato stream-of-consciousness lyricism, reaching a crescendo of erotic excitement: "This afternoon—finally nude—very wonderful—you can imagine how free things must be for anything like that to have happened . . . [Leah had to have] no fear for that. So tomorrow I'm hoping to go on—she is long and slender very beautiful white skin."[41]

The next day, they did go on.

"Pardon the scrawl but I am in a state—photographing Leah—nude—body wet shining in the sunlight . . . Georgia painting Leah now—all my plates gone," Strand reported.[42]

O'Keeffe's paintings of Leah Harris, done at the same time that Paul was photographing her, were probably the last in a series of twelve watercolors of a female nude. The series was begun in late 1917, the period when she was traveling with Leah between Amarillo, San Antonio, and Canyon. The earlier studies were most likely among the "new works" mentioned by Strand as being safe at the farm. He was planning to pack them properly for shipment to 291. Among the new works were trees, people on streets, and "things she saw looking out," Strand reported to Stieglitz, as well as "nudes of a girl friend."[43]

At first glance, the model in the watercolor series seems fuller-

breasted and fleshier than the slender woman described by Strand—until we realize that the subject is always shown seated. The short dark hair, moreover, conforms to O'Keeffe's description of Leah's sleeping head against the red pillow. A considerable degree of safety, intimacy, and freedom is suggested by the act of posing nude, even when the sitter and artist are both women.

Fluid and free, the twelve nudes pay homage to O'Keeffe's memories of the Rodin watercolors exhibited at 291 a decade earlier. Unlike the great French master, however, she dispensed with preliminary drawing. Applied directly, her wet brush floods the paper with shifting stains of color that propose both abstract shapes and anatomical elements, such as the areolae around the model's nipples. The white paper of the background and lighter areas of skin on the back of the sitter's shoulder and arm in *Seated Nude X*, together with the large patches of blue wash behind the model in *Seated Nude XI*, suggest that both paintings—like Strand's photographs—were made out of doors, probably in the privacy of the Harris farm.

As far as is known, the twelve watercolors are the only nudes and are among the last figurative treatments of human subjects O'Keeffe would ever paint.[44]

Bravely, Leah told Paul that she wanted to see Georgia go to New York, convinced that one day she would return. For Georgia, Leah was already part of her past; her friend's need had begun to weigh on her. Living alone with Leah, Georgia confessed to Strand, was sapping her vitality. Conflating Leah's emotional devastation with her earlier tuberculosis, Georgia suddenly claimed to be concerned with a possible recurrence of her friend's illness.

Strand immediately recognized the symbolic nature of O'Keeffe's fear of infection: "Of course, she realizes Leah's dependence on her," he wrote to Stieglitz. With Georgia's acute sensitivity, he added, she feared absorbing the weakness of anyone around her.[45] What Paul could not know was that the debility of a consumptive woman would hold particular terrors for Georgia. Leah Harris, withdrawing from her maternal role to become dependent on Georgia, would become the accusing ghost of Ida O'Keeffe.

Buoyed by his triumph over the local villain, Paul finally presented his case to Georgia. "I offered—or rather told her—simply because I thought it—felt it and meant it—that if she wanted it—I would take care of her as long as she liked and wanted it—a job anywhere she wanted to be—without expecting anything in return—except the joy of doing it," he told Stieglitz. "Perhaps naive? But I could do it," he added

manfully, "if it were to be—But it won't—which I knew long ago."[46]

The offer was not so much naive as made in the certainty of rejection. In any case, Georgia had made up her mind. Her decision was indeed her own, independent of Stieglitz's letters "discouraging the trip" (as Paul described them) and of Strand's own halfhearted suit.

"You know, I don't think you want me to go to New York," she had told Paul on the eve of their departure from the farm. "But I have to go."[47]

A wan celebration took place before Paul and Georgia left San Antonio for the long trip North: "Last night we danced a little before taking the train," Strand wrote to Stieglitz from the Hotel Monteleone in New Orleans. "It was a little something to cheer Leah up—She felt pretty bad. But it would have been worse in the long run if she had stayed with her—wanting to come to New York. She realized that—Leah did."[48]

ON SUNDAY, June 9, 1918, at a little before 7:30 in the morning, the two weary travelers staggered from the train into a nearly deserted Pennsylvania Station. Strand delivered Georgia O'Keeffe over to an anxiously waiting Alfred Stieglitz. His impossible mission had been successfully completed.

NINE

"Woman Supreme"

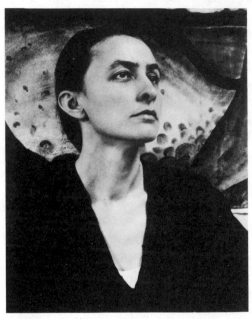

ALFRED STIEGLITZ, *Georgia O'Keeffe* (1917–18). O'Keeffe's
charcoal *Special No. 15* (1916) or a painting based on the
same motif is clearly visible behind O'Keeffe's head—a fu-
sion of woman and artist that Stieglitz would often portray.

EXHAUSTED BY the twenty-four-hour trip from New Orleans, Geor-
gia emerged from the train haggard and feverish, with a nagging cough.
Letting Strand disappear tactfully, Alfred bundled the wan voyager and
her few belongings into a taxi heading north on Lexington Avenue.
They got out at 114 East 59th Street and climbed to the top floor of a
brownstone, where Georgia was put to bed.

The studio had been rented by Alfred's brother Lee as a place where
his daughter Elizabeth could dabble at painting and photography a safe
walk from home—the family townhouse on 65th Street. Consisting of
a large skylighted space and a tiny bedroom, with a bathroom down the
hall, the studio was a luxury for an art student. As living quarters,
however, it provided only minimal amenities. From Alfred's point of
view, the Spartan quarters were ideal. Their provisional character of-
fered the perfect "cover" for O'Keeffe's officially single occupancy. Shut-
tling between unofficial cohabitation with Georgia in the studio, the

Tomb at 291, and his lodgings at Emmy's, Alfred could dramatize his preferred state of homelessness. Still more important, the studio, paid for by his brother and loaned by his niece, enabled Stieglitz to be provided for while playing the part of the provider, as he had been all his married life. In these two rooms, Georgia, soon to be joined by Alfred, was to live and work for the next year and a half.

Elizabeth's role of go-between in her uncle's affair with O'Keeffe, was a reciprocal one. For many months, Alfred had aided and abetted his twenty-one-year-old niece's clandestine romance with the Oaklawn handyman and gardener Donald Davidson, who was forty and divorced, with a grown son. In tribute to her "Mr. Flower," whom she would marry within the year, Elizabeth had decorated her rooms in chrysanthemum colors.

Fifty years later, O'Keeffe remembered the studio as joyful, "bright with a north skylight and two south windows. Elizabeth had painted the walls a pale lemon yellow. The floor was orange—not a very good place for painting, but it was exciting. It made me feel good and I liked it."[1]

Now that she was in New York, Alfred bundled her up and took her the six blocks to his brother Lee's consulting room where, to his relief, she was pronounced germ-free and in need only of rest and care. A stranger to kitchens for fifty-four years, Alfred undertook a crash course in basic convalescent cuisine. With the best raw materials— fresh eggs from Arthur Dove's Westport chicken farm (one of the artist's many valiant efforts to support his painting and his two families)— Alfred sought help from a bachelor friend.

A Harvard graduate and classmate of Paul Strand at the Ethical Culture School, Herbert J. Seligmann had just enough money from his family to resent not having more. He aspired to poetry and photography, but a combination of lassitude and lack of talent restricted him to "working up"—in his phrase—book reviews and short articles "on spec" and then badgering editors of newspapers and magazines like *The New Republic* to take them. Sometimes they did. The energy he lacked in pursuing his own literary and artistic ambitions was deflected into a fanatical devotion to Stieglitz.* Alfred lost no time in finding chores— as editor and publicist along with cooking instructor—to fill Herbert's many free hours, otherwise spent brooding. A late-marrying bachelor condemned to frequent solitary meals, Seligmann had more than one

* Seligmann was Stieglitz's male Boswell (the feminine recorder role being claimed by Dorothy Norman). He gathered oft-told stories, memoirs, and aphorisms into a collection titled, aptly, *Alfred Stieglitz Talking.*

egg recipe in his repertoire. After a single lesson, Alfred reported proudly to Strand, he was able to make a dish he *thought* was called coddled eggs.

As Georgia's strength returned, Alfred became as protective of her hours for painting as he had been of her need for rest and proper diet. His daily visits to the studio were scheduled so as not to interfere with her preferred work time. Since there was little reason to visit 291 these days, other than to collect his mail and to await the visitors who, he noted sourly, rarely appeared, he spent long hours walking the streets. Summoning the companionship of Strand (now billeted at Lee's Westchester estate while awaiting his draft notice), Walkowitz, or the ever available Zoler, Stieglitz tramped the city, trying to kill the time he had once captured with his camera.

Georgia still tired easily; after an early dinner with her, Alfred had long hours to pass before he could creep back to 1111 Madison with the certainty that Emmy would be asleep. He wrote letters to friends on the tables of modest restaurants where he stopped to rest, a small satchel containing his good suit on a chair nearby.

If he was himself a vagrant, Stieglitz was satisfied that he had solved the problems of Georgia's housing and health. He had also arranged for O'Keeffe's living expenses to be paid by an anonymous donor. As Stieglitz later described his role, he had approached a friend "who sometimes helped painters," explaining that "I was already an old man [he was then fifty-four] and that I couldn't take care of a woman and a family."[2] After sternly demanding of Alfred whether he loved "this woman" and lecturing him on the foolishness of ending his marriage for so frivolous a cause, the friend agreed to a subsidy of one thousand dollars—more than ten times that sum in today's dollars.

The most likely candidate among several possible patrons was Stieglitz's old friend Jacob Dewald. An investor who played the market as his only form of livelihood, Dewald was an enthusiastic collector of Stieglitz's artists when his stocks were doing well: he had been the first to buy an O'Keeffe drawing from her earliest show at 291 and would become the first purchaser of an O'Keeffe oil, paying six hundred dollars for a painting done at Lake George a few months after her arrival North. Dewald also bought several Marins and a Wright.

Another possible benefactor was Eugene Meyer. Although relations had cooled between Stieglitz and the Meyers, the banker and philanthropist is known to have helped many artists, insisting on anonymity as a condition of his gifts. If he admired O'Keeffe's work, the magnanimous financier may well have overlooked Alfred's spiteful behavior. It would also have been in character for the straitlaced Meyer—happily

married himself to the dazzling Agnes—to lecture Alfred on the error of his ways before writing a check. (The Meyers had also remained friends with Emmy; when they were installed in their summer house on the Jersey shore, they regularly rescued her from long lonely evenings at her hotel.)

Finally, Alfred may have invented the friend altogether, asking his brother Lee to add cash support to his indirect housing subsidy. The thousand-dollar annual allowance Lee was to give Alfred shortly thereafter, paid in quarterly installments, could well have begun as a "one-time gift" to O'Keeffe.

Unless Alfred told her, it is unlikely that O'Keeffe knew who the source of her support was. She was not one to ask questions, he noted to Strand a few months later, adding that Georgia disliked answering them even more.

Secure, cared for, and with no need to worry about earning a living, O'Keeffe had every reason to anticipate the most productive year of her life. Indeed, she signaled her optimism, her confidence in her talent and energy—in the future itself—by literally trashing the past. When the rest of her possessions arrived from Texas in a barrel, among them, she recalled "were all my old drawings and paintings. I put them in with the wastepaper trash to throw away and that night when Stieglitz and I came home after dark the paintings and drawings were blowing all over the street. We left them there and went in."

Half a century later, she still hadn't forgotten the sight of a "large watercolor of many hollyhocks sticking out of a big wastecan."[3]

Consigning her past to the junk heap—"turning the page," as she would later say—and enjoying new stability, freedom, and love did not lead to the expected surge of creativity. The most arid months in her career as a painter, O'Keeffe's first year in New York would immortalize her in another role: she became, after Garbo, the most photographed woman of the twentieth century.

Stieglitz had begun his symphonic portrait of O'Keeffe on Georgia's first visit in the spring of 1917. He took his last photographs of her in 1937; he was seventy-three and the heavy camera had become too burdensome for the frail old man. In those twenty years, he made nearly five hundred prints;[4] two hundred alone date from the first two years of their life together.

The photographs of O'Keeffe taken in those first twenty-four months document the most intense, passionate, and complex transaction between a man and a woman ever recorded by a camera. Stieglitz's portrait embraces the most public and private extremes of O'Keeffe's being: icons of a remote, enigmatic woman that merged with her paintings to create

her identity as artist together with sexual explorations of her body so intimate that they have yet to be published or exhibited.

Taken on June 4, 1917, at 291, the first five photographs (the only ones ever to be dated precisely) were sent by Stieglitz to O'Keeffe in Canyon. Her sense of self-discovery was immediate. As much as she hated to show her paintings to others, she felt an urgent need to display her own image: "two portraits of my face against one of my large watercolors and three photographs of hands," she recalled years later. "In my excitement at such pictures of myself I took them to school and held them up for my class to see."[5]

A few weeks after her arrival in New York in 1918, Stieglitz began photographing her again. They worked during his daily visits to her studio, where he now kept his equipment: the big box camera standing on its unsteady tripod, the lens covered by a large square of worn black broadcloth. Next to the camera leaned the folded white umbrella, grimy now but still ready, when opened, to cast reflected light into the shadow. "At a certain time of day," Georgia recalled, "the light was best for photographing, so at that time we usually tried to be in Elizabeth's studio."[6]

For Stieglitz, the studio was an enchanted aerie. "It all seems like a fairy tale," he wrote to his niece in a rapturous letter of thanks. The days there, he told her, "have been the most wonderful I have ever experienced." Without those two rooms, private and unknown to all but their intimates, "these days that are could not have been—not the perfection of them." As for O'Keeffe, "Why I can't believe she is at all. . . . I never realized that what she is could actually exist—absolute Truth—Clarity of Vision to the Highest Degree and a fineness which [is] uncannily balanced."[7]

Beginning with the first exposures, Stieglitz's portrait is an effort to dispel his sense of disbelief. From O'Keeffe's self-portrait in black and white—a "woman on paper"—he would try to fix on his glass plates the elusive reality of the woman who brought him back to life.

He was aware that such a record would summon all his skill, experience, and understanding as a man and an artist. "She is much more extraordinary than even I had believed," he wrote to Arthur Dove only a week after Georgia's arrival in New York. "In fact I don't believe there ever has been anything like her—mind & feeling very clear—spontaneous and uncannily beautiful—absolutely living every pulse beat."[8]

Stieglitz was conscious from the outset that his portrait of O'Keeffe was also a voyage of discovery, their daily photographing sessions a log of his own sexual rebirth, of a second life in complete ecstatic union

with another. He was in the throes of a "sane madness—so damn sane," he wrote to Dove, "that it sometimes frightens me. O'Keeffe is truly magnificent. And a child at that. We are at least 90% alike—She a purer form of myself."⁹

In his state of childlike joy, he became Adam in his innocence, seeing woman for the first time, dazzled by her perfection. "O'Keeffe is a constant source of wonder to me—like Nature itself," he wrote to Dove.¹⁰

Like nature, O'Keeffe's face and body seemed protean in their constant change. And, like the first man to behold a woman, Stieglitz's camera described what had never before been seen: Georgia's long, straight black hair and heavy eyebrows, the dark eyes* with their remote inward gaze, the mouth as exquisitely molded as Nefertiti's. Admired since she was a child, her hands, arranged and rearranged by Alfred, were engaged in their own choreography.

She was photographed, Georgia later said (sounding bemused, or trying to) with a "heat and excitement" that made her "wonder what it was all about."¹¹ Wild with the encyclopedic desire of passion to know and to possess, Alfred would try to capture Georgia's every feature and member, each physical and psychological state. Both his genius and the technique perfected for a quarter-century had been awaiting their subject.

Transcending the poor quality of postwar paper, Alfred's virtuoso printing rendered a richly varied palette of tonalities and textures never seen before, conveying the sense of touch that was his special pride: the dazzling white of starched collars and the translucent gauziness of Georgia's peignoir; the gleam of fingernails and tears; the wetness of hands and face, suggesting sexual fluids.

By infinite gradations of matte tonalities, Alfred translated the pale flesh of Georgia's belly and breasts, the brown areola circling the darker nipple, the dusting of pores and moles, the feather of down that moves from navel to pubes. Dense and luminous at the same time, Stieglitz's "unspeakable blacks,"¹² in the shrewd phrase of his friend the art critic Jerome Mellquist, achieved the "equivalent" he sought in all his pictures—the bridge from deepest feeling to objective form.

Blackness was the erotic leitmotif of his Song of Songs, his canticle to woman's sexual mystery. Black traces a single hair coiled at the join of pelvis and thigh. Stroked with the velvety brown of palladium-toned

* O'Keeffe's eyes have been described as gray-green; none of Stieglitz's prints, however, suggests the translucency of the light eyes he captured so memorably in his portraits of Hartley, Dove, and Sherwood Anderson or the luminous gaze of Katharine Rhoades.

paper, black pulls the viewer's fascinated gaze below that juncture, creating in the depth of a tabernacle a glow that stops just short of articulation. He could focus his lens with all the care and intuition born of experience, calculate to the minutest second the duration of his shutter's opening. Changing his angle slightly, he could squeeze the bulb a thousand times. He would come no closer to the source of so much dread and desire, of life and death.

TWENTY YEARS earlier, Stieglitz had begun another serial portrait using his daughter, Kitty, as the model. Projected as the diary of a human life, it was planned to record his child's growth from infancy to adulthood. According to Alfred, Emmy's objections caused him to abandon the project; she claimed that following the little girl around with a camera was interrupting her activities and making her self-conscious.

O'Keeffe's age—thirty-one in 1918 when she returned to New York*—and Stieglitz's relationship with her altered his vision of what such a portrait should be. Still, his view of Georgia as a "Great Child" whose "learning" and "growth" he supervised links the two projects more closely than the succession from forbidden daughter to eroticized child mistress.

The official description—a "composite portrait" whose goal was to document the "physical and psychological evolution of O'Keeffe's many Selves"[13]—is a partial one at best. With the exception of a very few prints taken in late summer 1918 and thereafter at Lake George,† the portrait does not record O'Keeffe engaged in any quotidian activities, however intimate. Unlike Degas's renderings of women, for example, O'Keeffe's portrait does not show her bathing, drying herself, or combing her hair. She does not eat or drink in front of her lover's camera. She is never photographed writing a letter, as Alfred immortalized Paula, his Berlin lover.

In one of many prints of Georgia's beautiful, strange hands, a thimble glows on one jointless finger. Like the waxy members themselves, this functional accessory has been frozen into abstraction. O'Keeffe always sewed, but these are not fingers that have ever stitched. Arranged with great care by Stieglitz, as she tells us, her hands appear in the stylized and artificial gestures of the Kabuki dancer.

* Despite the precise date of the earliest prints—1917—O'Keeffe, writing of the portrait many years later, gave her age as twenty-three at the time Stieglitz first photographed her.

† These images include one of O'Keeffe paring apples, two of her painting, and another (later) shot of her eating an ear of corn.

Although she painted daily "for many hours" in the big, bright room, naked under the skylight in the intense June heat, there is not a single image of O'Keeffe at work in the studio.

Nude or clothed, Stieglitz's O'Keeffe is a double sexual portrait. Whether the model appears remote and mysterious or completely absorbed in her own body, the tropism of her gaze, the position of her limbs and torso, or the angle from which we see her buttocks or pubic hair discloses the photographer's presence. She looks toward Stieglitz as she prepares to undo her cloak or shirtwaist. In a gesture of offering, she holds her breasts toward the camera; hands cupping the areolae, one finger points toward the navel or pubic hair, just visible at the bottom edge of the print. Coming closer, Stieglitz's camera crops the picture to show only her fingers squeezing or twisting her nipples.

A "collaborative performance" is the way the portrait has been described, but the neutral term says little about the nature of the drama itself: its function, script, theater, or intended audience. Nor is the notion of collaboration instructive of the complex, equivocal, interchangeable roles of the two artists who were also lovers, the seesaw of subject and object, performer and director, onstage and offstage personae.

In the images purporting to isolate and reveal the truth of her "many selves," O'Keeffe is never alone. Emerging from sleep or sexual pleasure, she looks off to one side toward the camera or upward with the supplicating, swoony gaze of Bernini's sculpture of St. Theresa. In other prints, O'Keeffe's sculpture of the erect phallus becomes a prop: in prints entitled *Feet* and *Hands*, she caresses the plasticene form with her big toe or, holding the base in one hand, strokes the shaft with the finger of the other. Her gift to Alfred, the piece now appears to function as his sexual surrogate.

Her paintings too serve only as erotic backdrop; on the canvas behind the artist's tousled head, lifted from the pillow, rise familiar stalklike forms, their bulbous tips shooting upward. In another print, O'Keeffe has disappeared altogether; the same erect penis has been placed before *Music, Pink and Blue, II*, framed by the labial opening to the tunnel of membranes within. At the lake, her hands caress horse chestnuts or crab apples in the unmistakable form of paired balls.

Both strongly androgynous, Stieglitz and O'Keeffe engaged in a dynamic interchange of sexual identities and appetites in the process of the portrait's making. The feminine O'Keeffe is nude, headless, and often limbless as well, reduced to a torso. The masculine O'Keeffe, full-length, is nearly always clothed: indoors, she is severe in tailored black with a touch of white, her hair slicked back or concealed under mannish

hats; at the lake, in late summer or early fall, she is wrapped in a loden cloak identical to Alfred's. In one pose Stieglitz, crouching, shot her from below. Against the low misty hills in the distance, she appears huge (despite her mere five foot four height), imperious, dominating.[14]

Only one print of O'Keeffe nude, as chaste and boyish as a Greek athlete but for the pendulous breasts, shows her beautiful neat head together with her body. Stieglitz posed her on the radiator, profiled against the window, the harsh light diffused by gauzy Japanese kimono sleeves hanging like panels from her outstretched arms.

We can only guess at the division of labor in the collaboration between photographer and model and at what Georgia thought of her role or how she viewed the result. Stieglitz noted her narcissistic pleasure in the portrait: "Whenever she looks at the proofs," he wrote to Paul Strand in late fall 1918, "[Georgia] falls in love with herself.—Or rather her Selves—There are very many."[15]

Among these many selves was O'Keeffe, lover of another woman, an artist who looked at that woman's body with a gaze—like Stieglitz's—informed by erotic experience of the model. From her double perspective, she could see Stieglitz's proofs from the point of view of subject and object: the possessive, consuming male gaze and the ambivalent female regard toward the self, an object to be displayed and admired, desired but also defended.

Props of cross-dressing become, in the prints, elements of sexual armor. In one, Georgia, wearing a man's black bowler, holds a frilly nightgown over the lower part of one breast; her long hair and nipple—secondary sexual characteristics both—are covered by those articles of dress most symbolically "masculine" and "feminine."

O'Keeffe spoke easily and personally of the work involved in posing for the photographs of her extremities: "I was asked to move my hands in many different ways—also my head and I had to turn this way and that," she recalled.[16]

She distanced herself from the more intimate views, writing about her naked body as though it belonged to another and reaching for strained, folksy humor. "There were nudes that might have been of several different people," she noted, "—sitting—standing—even standing upon the radiator against the window—that was difficult—radiators don't intend you to stand on top of them."[17]

About other images she does not speak at all. Never published or exhibited, these prints play out darker chapters in the relation between the photographer and his subject: the slide from collaboration to collusion; the power of the male behind the camera and the woman before

his lens; the interplay between the photographer as fetishist and the fetishized object.

Stieglitz was no stranger to surrealistic photographic scenarios. He certainly knew his former disciple Man Ray's symbolic amputations of women's bodies: breasts, buttocks, pudenda were severed from their bodily attachments. Inspired by Strand, Stieglitz had already played with cubist effects, shattering and slicing planes of geometric form. Through cropping, framing, or disorienting camera angles, photography was ideally suited to rearranging recorded reality.

New techniques and ways of seeing were also perfectly adapted to the fetishizing of women's bodies; where once the male gaze alone could isolate, or reproduce through memory, the erotic icon—foot, hand, breast, genital—the camera now fixed that regard, creating a surrogate fetish object, the photograph.[18]

Seen in sequence, the prints Stieglitz made in the studio during the first two years eliminate O'Keeffe in her totality; gradually, the human being, the artist, the woman disappear. In place of the idealized nude seen from a distance—the goddess Diana or the Gibson Girl unclothed, with arched back and small behind, flat belly, the merest tuft of hair visible above the line of the thigh, delicately etched collarbone and rib cage—Stieglitz's sexual obsession turned its object into the Venus of Willendorf, the prehistoric fertility figure: squat and heavy, with spreading buttocks and pendulous breasts, an opaque growth of pubic hair climbing nearly to her navel.

Stieglitz's gaze was no longer the lover's "downward look," in Robert Lowell's phrase. From his crouch below his model, his camera tracks the gynecologist's clinical view. In one series of almost identical prints, O'Keeffe's nude torso is cropped below the collarbone and at mid-thigh. Like a patient on an examining table, she has pulled her robe aside to reveal breasts, belly, and labia. Instead of lying down, however, she is seated; her foreshortened form assumes massive proportions, the slender body seems swollen in volumes and folds of flesh. Between her spread thighs, a black triangle of pubic hair draws the viewer's gaze to a vanishing point that flows into the darkness below, genital detail lost in a dark void.

No coy blackout or arty pictorialist device, devouring darkness defined the essence of Alfred's yearning and dread: the dark source of all mystery and terror, of life and death.

Going back to Alfred's childhood, the Stieglitz "family romance" was the classic drama of an adored oldest son's negotiations between the powerless mother and despotic father. From listening to Hedwig's abject

pleading and humiliation at Edward's hands, her "Hamlet"—as she called her favorite son—resolved his conflict by clinging to childhood. Defecting to his father in purely symbolic manly pursuits, such as billiards and horses, he remained his mother's loyal son by refusing the roles of male authority. Never, he acknowledged, would he be able to provide for a woman and a family. Even as he exalted Georgia's sexuality with his camera, he "unnamed" her as a woman; she was always to him "yet a child."

In her article "The Dread of Women," Karen Horney observes that "men have never tired of fashioning expressions for the violent force by which man feels himself drawn to the woman, and side by side with his longing, the dread that through her, he might die and be undone."[19] At the heart of men's glorification of women, in the impulse to exalt the emblems of her sexuality, lies the desire to conceal their dread.

Stieglitz had made many earlier fetishized images of women. His famous portrait of Dorothy True, in which the model's lace-stockinged leg and high-heeled shoe are superimposed on her face, is one of a number in which female subjects are represented by shoes and feet or by buttocks (often partially submerged in water) or are shown offering both breasts to the lens.

Glorious and terrifying in its intimacy and sense of union, his passion for O'Keeffe thrust Alfred into another realm. As he worked with her daily in the studio in those first months, his camera became an instrument of exorcism, demystifying even as it exalted the depths of what could be seen, touched, photographed, but never, finally, known.

In a print evasively entitled *Feet* (1918) Stieglitz plunged to the heart of the forbidden. With her heels braced at the table's edge, O'Keeffe's feet, cropped at the ankle, dangle from the top of the composition; bits of lacy undergarment indicate that, above the lens and out of sight, she is squatting. Gnarled and misshapen toes frame the vertical gash of her vagina. Long soft folds of drapery fall from the table and fill the lower two-thirds of the composition, emphasizing the shock of what appears above.

Stieglitz had long been interested in erotic art and photography. In the 1880s, while a student in Berlin, then a center for the production and dissemination of popular pornography, he had amassed ninety thousand photographs, "mostly of actresses," he later recalled.[20] His description of the subjects was a standard euphemism for the prostitutes who doubled as models to satisfy the vast market for cheap erotica created by the camera.

Both his own youthful collection and what he saw elsewhere reappear in the portrait of O'Keeffe, whose poses and props pay homage to

the conventions of pornography—from the naughty postcards that show a woman's upper thighs emerging from a frothy halo of underdrawers to the erotic tradition of female nakedness set off by articles of men's dress.

Then, in 1911, on Stieglitz's last trip abroad, Steichen brought him to Rodin's studio in Meudon. The master was away, but he had told his young American friend to let Stieglitz see anything he wanted. Steichen showed him a sampling of Rodin's famous erotic drawings, a fraction of thousands the French sculptor made of women—from duchesses to dressmakers—who flocked to his studio to be immortalized in the anonymity of sexual pleasure. Rodin captured his models caressing one another or masturbating, spread-eagled or squatting, on all fours, buttocks in the air, lying exhausted, or caught in the spasm of sexual release. Often without glancing at his paper, he seized in a few pencil lines and a stain of watercolor a representation of the entire range of female sexuality possible without the participation of men.[21]

Stieglitz was ecstatic. A fervent admirer of the sculptor, he had exhibited Rodin's more circumspect drawings at 291 in 1908; in 1910 he showed forty-one drawings and watercolors, and he consecrated a special issue of *Camera Work* to Rodin in 1911, the summer of his visit abroad.

As he pored over the sheets of drawings in the studio at Meudon, Stieglitz discovered a more profound affinity with Rodin: both the photographer and the sculptor were votaries of a cult that can only be described as cunt worship. Indeed, friends of the aging Rodin, such as the novelist Anatole France, worried about the master's obsessional focus on female pudenda in his art, along with his verbal outpourings, veritable hymns to the "arch of triumph of life," "bridge of truth," "circle of grace," "Eternal Tunnel."[22]

Learning of Stieglitz's intense sympathy for the work he shared with only a few, Rodin sent, by way of Steichen, the drawing Alfred had most admired during his visit. Overwhelmed by surprise and delight, Alfred promptly christened the untitled drawing "Woman Supreme," recording his reaction on a sheet of paper that he glued to the verso of the work. On his memorable Sunday visit to Meudon, Alfred noted in large diagonal script running across the page, "I saw hundreds of amazing drawings amongst other things/and this one I fell in love with— Never thinking it could become 'mine.' "[23]

Stieglitz looked often at his beloved "Woman Supreme." Crouched below Georgia's spread thighs, exploring daring angles of foreshortening, printing the velvety blackness that exalts what it envelops, Alfred paid homage to the sculptor as well as to the woman.

Although they were united by their fascination with woman's sexual mystery, a crucial difference of vision—more than of medium—divided the two artists. Rodin's gaze and pencil almost always embraced the whole woman, even if her extremities were rendered in the most minimal shorthand. Unlike Stieglitz, he did not need to guillotine the object of his desire.

ONE DAY early in July, Stieglitz picked up O'Keeffe at the studio and, lugging his heavy photographic equipment down the stairs, he hailed a cab, directing the driver to 1111 Madison Avenue, where he and Emmy had lived for the twenty years of their marriage. Once inside, Alfred set up his camera and began photographing Georgia. His excuse for moving uptown that day was Emmeline's announcement, probably the same morning, that she planned a day of shopping downtown.

Alfred's motives in bringing Georgia to Emmy's home are murky. With its light, space, and privacy, the studio was the ideal setting for the portrait in progress. Madison Avenue's overstuffed decor, with Alfred's quarters now confined (by his own choice) to one small study, does not suggest a change of scene based on improved working conditions.

Their experiment was short-lived; Emmeline came home unexpectedly. In whatever room or state of dress she found Alfred and Georgia, a terrible scene took place, followed by the flight of photographer and model. Reserved, dignified, with an almost morbid concern for privacy, O'Keeffe can only have felt humiliated by their expulsion. The inevitable question then arises: Why had she exposed herself to this treatment by invading another woman's home?

Reporting the incident to Dove, Alfred adopted an outraged tone: How could Emmy have indulged such hysterical suspicion? "We weren't doing anything," he claimed. At least he had managed to get three pictures of Georgia before his wife's untimely return.

"I was virtually 'kicked out' of home, like I was kicked out of the Camera Club ten years ago," Alfred complained to Dove. "The Club wishes me back—Home already 'regrets.' "[24]

Emmeline had not just "kicked him out"; she had apparently issued an ultimatum: either Alfred must stop seeing O'Keeffe or he must leave immediately and take his possessions with him. His passive aggression honed to a fine art, Alfred had manipulated Emmy—with Georgia's help—into making the decision for him.

He returned only to pack his belongings. Thanks to a new friend, the auctioneer, art dealer, and sometime publisher Mitchell Kennerley,

Stieglitz was able to store some of his books, pictures, plates, and prints in the basement of the Anderson Galleries at 489 Park Avenue. The rest accompanied him to the 59th Street studio, just around the corner from the galleries, where Alfred now joined Georgia.

His decision required that he be seen as the wronged party. Hanging a blanket on a clothesline to divide the studio's tiny bedroom, Stieglitz continued to insist that he and O'Keeffe were only friends; Marie Rapp and other young people might find such hypocrisies quaintly Victorian. In fact, this symbolic cover-up was essential to Alfred's need for martyrdom.

Hearing that his old friend and brother-in-law Joe Obermeyer had, first, dared to suggest that Stieglitz had underwritten Strand's mission to Texas and, second, believed Emmy's "suspicions" that he and Georgia were lovers, Alfred lashed out in a letter to Obermeyer that was a frenzy of denial and counteraccusation. After noting craftily that Paul "went with his own money" (thereby avoiding the inconvenient fact that his stay in San Antonio and his return—with Georgia—were subsidized by Alfred), Stieglitz moved on to new heights of indignation. "Emmy charged me with something which was absolutely untrue," he raged to Joe. "She slandered an innocent woman—girl. It seems you can't understand any fine or decent relationship between man and woman," he ended his letter.[25]

On August 1, only days after he had vacated the study at 1111 Madison Avenue, Alfred and Georgia, summoned by Hedwig, set off on the long train trip, via Boston and Albany, to Lake George.

Not even Alfred's joy in Georgia, his belief in the perfection of the beloved, prepared him for the warmth of Hedwig's welcome. Indeed, his mother's embrace of Georgia seems to have been decided before her arrival. Now that Alfred had found the woman he loved and who made him happy, Hedwig could demonstrate to the family, but most important to herself, that it had not been her favorite son's wife, the daughter-in-law as rival, that she hated, but the "wrong" daughter-in-law. Emmy's ostracism and banishment would be vindicated by Hedwig's loving acceptance of Georgia into the family circle. Georgia's place there, moreover, was officially privileged; seating Georgia at her right at the large dining room table, the matriarch took the choicest servings and placed them herself on Georgia's plate.

Unused to maternal favor, basking in the pride and passion of the man she loved, Georgia could overlook, on this first, "honeymoon" visit, less congenial aspects of the Stieglitz compound: the tedium of the

endless bland meals, Oaklawn's gloomy Victorian decor, the overdressed operatic self-absorption of Alfred's sister Sel, interrupted only by the occasional visits of her lover Enrico Caruso.

If anything could have added to Alfred's measure of happiness, it was the sight of Georgia thriving in the place he loved more than any other, his source of repose, renewal, and inspiration. Writing to Dove a few weeks after their arrival, Stieglitz captured his mystical sense of union with the elements, of which O'Keeffe was now a part. "The day is one of great deep blue clarity—a gentle Northwester, invigorating, embracing—the greens never fuller, deeper—more sensuous—the Lake always the Lake. . . . O'Keeffe is a constant source of wonder to me— like Nature itself," Stieglitz rhapsodized to Dove once again.[26] Of all his artists, the stolid, meticulous painter of passionate meditations on the natural world would sympathize most; Dove had left his wife to live with another artist and Westport neighbor, Helen "Reds" Torr. To him Stieglitz could confide, confident of perfect understanding. "O'Keeffe and I are One in a real sense," he wrote.[27]

Alfred, his brothers, and his sisters quarreled endlessly with one another; astonishingly, they all agreed in liking Georgia immensely, Stieglitz reported to Strand. Free, happy, uninhibited in the way they couldn't help touching each other, the lovers were granted immunity from the reigning rules of proper behavior: liberated from the lunch table, they rushed upstairs, Georgia unbuttoning her blouse as she went, in full view of the assembled family. "We'd say we were going to have a nap," O'Keeffe recalled. "Then we'd make love. Afterwards he would take photographs of me."[28]

Everyone, Alfred noted, seemed to feel a part of the lovers' joy in each other, which Alfred attributed to their unself-conscious behavior. His own blissful sense of well-being, calm, and intensely felt love at the same time was reflected in Georgia's changed physical state. He wished Strand could see how glorious Georgia looked, he told Paul with the unconscious cruelty of self-absorbed love. She herself could hardly believe her lusty good health and happiness. Snapshots of Georgia taken by Alfred during that summer show O'Keeffe looking a decade younger than her thirty-one years. Concentrated on the moment, she radiates the beauty of self-forgetfulness. Sitting on the grass, brush in hand, she looks up from her watercolor of wild roses growing near the porch trellis. Wearing a floppy hat and billowing smock and holding a saw, she watches Donald Davidson pruning trees. She pares apples and picks grapes; framed by a Dutch door, she smiles—the rarest of O'Keeffe images—the famous hands holding a bunch of wildflowers.

Alfred could feel fortunate that all was perfect harmony at the lake.

A few weeks before their arrival, he had received a series of anguished letters from Kitty, who had been enjoying a month's respite from family problems at her New Hampshire camp. Her mother was about to descend on her in a state of hysteria. Kitty's dread was compounded by confusion; she did not know what to believe. Caught between Emmeline's despairing hope that if she promised to "change," Alfred would come back; her father's latest protestations that he and Miss O'Keeffe were "just friends"; and other accounts she had heard that contradicted Alfred's version, she was desperate to know the truth. She tried persuading Alfred to be straight with her by asking directly how matters stood between him and Miss O'Keeffe. She was not prying, she wanted him to know; the unhappiness of both her father and her mother affected her intimately.

Torn apart by her parents' conflicting demands, Kitty was overwhelmed. With her mother's arrival on July 23, it was frighteningly clear that Emmeline, distraught and feeling abandoned and humiliated, required consolation and support. At the same time, Alfred had made it clear in June that he expected Kitty to be a friend to Miss O'Keeffe; Kitty's planned visit to the lake in early September would be the perfect time for them to get to know each other.

One day with her mother made clear the impossibility of such a visit. She tried to explain to Alfred that Emmeline did not deserve the pain she had already suffered. First she had been abandoned and then humiliated as she was publicly replaced by another woman. Kitty could do nothing to hurt her mother further; surely Alfred would understand.

Apparently Alfred could not understand. Kitty wrote to him again to explain her feelings of betrayal should she act as a junior welcoming committee to Georgia in the very place, moreover, where her mother had been made so unwelcome. She could not be his accomplice, she told her father, and inflict a still worse wound on Emmeline: hurting her pride. She would be happy to meet "Miss O." anywhere else, she said, but as for coming to the lake on September 1 with Georgia there, she simply couldn't do it, she repeated.

Stung by her father's accusation that she had broken her promise to him, Kitty defended her decision with heartbreaking dignity: she was not changing her mind from caprice but because she could see that in Emmeline's vulnerable state she could bear no further blows. What Alfred did was his affair; she would not be used as a weapon to wound her mother yet again.

A few days later, Emmy was so out of control that the camp director, Miss Mattoon, moved the distraught woman into her house; Kitty could no longer manage her mother alone, especially not in her thankless role

as bearer of unwelcome news to a terrified woman. Emmy still believed she could change and all would be well with their marriage. Kitty had tried, without success, to gently disabuse her mother of this fantasy. The twenty-year-old girl had come to the end of her resources. She begged her father for help.

More than two weeks later, on August 9, following an SOS wire from Kitty, Alfred made the trip from Oaklawn to Camp Kehonka, on Lake Winnipesaukee.

Learning from Elizabeth of Stieglitz's visit to New Hampshire, Strand expressed concern that problems with Emmy had worsened. He praised Kitty for the "extraordinary fineness and understanding she has already shown in an impossible situation."[29]

On his arrival, Alfred found Kitty in a hysterical state. Father and daughter spent the entire afternoon alone. Their five-hour talk resolved nothing. Despite his pessimism, Alfred watched sunset over the lake with a deep sense of peace. He admired his tentmate, a handsome young physical culture instructor. "I wish for O'Keeffe's sake that I had a little of his physique and self-confidence which comes from strong muscles," he wrote to his niece.[30]

During the night, a tremendous storm blew up. Illuminated by lightning accompanied by drum rolls of thunder, the skies opened and the lake was curtained by torrential rain. With his German romantic temperament, Alfred was delighted that nature's rage so obligingly reflected the human Sturm und Drang around him.

When Kitty appeared at six in the morning, she looked to her father "a different person. Calm & ready. I felt when I saw her that the day would be won," Alfred told Elizabeth.[31] Emmy arrived shortly from the farmhouse where she was staying. The three were rowed to a small deserted cottage by the edge of the lake. In the next hours, they each spoke calmly but frankly of what was in their hearts and minds.

Alfred left the lake ecstatic. At this "first true meeting" of mother, father, and daughter, "a miracle had happened," he claimed, translated by Alfred as the "essence of 291 in the heart of my own family."[32] He never seems to have asked himself why the fusion of his two lives had not taken place earlier. However late, the feelings of understanding, reconciliation, and simple kindness were both real and deeply felt by all three.

"The Truth," Alfred announced, "stood there in Sunlight".[33]

At the end of their meeting, Alfred promised that Georgia would not be at the lake when Kitty and her cousin Edward, Julius's son and her new romantic interest, arrived on September 1. Kitty's gratitude was overwhelming. She wrote to Alfred, back at Oaklawn, to thank him

for helping her to help her mother. Emmy now seemed to accept the fact that the marriage was over; she was standing on her own feet—or at least proving to herself that she could do it. The morning that the three of them spent together, the moment when they finally seemed to understand one another, was the first time Kitty felt she had a home, she told her father.

Emmeline confirmed her acknowledgment that the marriage was ended by her efforts to rent their apartment. Matter-of-factly, she discussed the practical issues of furnishings and tenants, noting sadly that she nonetheless felt stunned. Her life seemed unreal. She watched herself go through the motions of eating, talking, sleeping as though observing someone else.

Walking with her beloved Kitsie on the cliffs at Ogunquit, Maine, Emmy recalled that morning at camp. For her, too, their talk had been momentous. For the first time, she had seen how much meaning life could have, she wrote to Alfred. She had been unable to sleep lately; the long nights gave her time to think about the past. Many things were now clear that had earlier eluded her. She apologized for expressing herself so badly; she hoped that Alfred, who felt much more keenly than other people, would understand what she was trying to say.

BY THE TIME he returned to Lake George, Alfred had forgotten his promise. Kitty arrived at Oaklawn on September 1 to find Georgia still happily in residence. Her sense of outrage and betrayal exploded in a scene that swept her father and O'Keeffe onto the train for New York. This was the second time in two months that Georgia had had to beat a humiliating interloper's retreat, the unwitting accomplice of a scenario Stieglitz would enact again and again: reconciling the women in his life, if not voluntarily, then by ruse. Clearly, no one at Oaklawn was aware of Alfred's promise to Kitty; perhaps he never intended to keep it. If his daughter and his mistress failed to fall into one another's arms, united by their love for him, at least he would have succeeded in punishing Kitty for her defection to her cousin Edward. Despite the prevailing sanctions against first cousins marrying, the Stieglitzes seem to have encouraged the romance between Kitty and Edward. All the more reason for Alfred to retaliate in the bosom of the family.

Reporting on the horrible scene to Strand, now at basic training camp in Georgia, Alfred lamented the circumstances of their departure. It had all been so unnecessary and cruel. He and Georgia were bearing up bravely, he assured Paul. Especially Georgia. For the first time, however, Alfred sounded a note of criticism—or fear—in his description

of O'Keeffe: He could now see how she had played with Paul and others. Understanding her as well as he did, he hoped, would spare him similar treatment.

More unpleasantness followed. Responding to a final plea from Kitty, Alfred left Georgia at the studio and returned to Oaklawn for two days. No miracles happened this time; Kitty left for college without seeing her father again.

At the end of September, Georgia and Alfred returned to Oaklawn for a few weeks; with Kitty, Edward, and most of the others gone, there was peace in the crisp autumn days that energized both of them. Alfred worked furiously printing the images of O'Keeffe that he had made earlier in the summer. Georgia, he reported, "felt full of paint."[34]

Tranquil productivity didn't long survive the move back to the city. The Round Table of 291 regulars had moved to new, cheaper headquarters: the Far East China Gardens, on the second floor of a building on Columbus Circle, where the house specialty, pineapple chow mein, cost a dollar fifty. There, Stieglitz and "the men"—Alfred's appellation for his acolytes—would examine theories of art and life, while Georgia, bored and fatigued, would withdraw to her own thoughts. After dinner, strolling eastward along Central Park South, they would return to the studio, where talk continued. Gradually the two rooms had become the center of an informal salon and gallery, where Stieglitz showed his photographs and O'Keeffe's few new paintings late into the night.

Then, shortly before Thanksgiving, Georgia received word that her father had been killed. On November 6, Francis O'Keeffe had fallen from the roof of a barracks in Camp Lee, Virginia, where he was employed as a carpenter. Cause of death was listed as cerebral hemorrhage and a fractured skull, with the circumstances given as accidental. The hour of his fall—7:30 P.M. on a late fall evening—makes it unlikely that he was working at the time of his death, raising the question of what he was doing on a roof in the dark of a chilly November night.

Once again, Georgia refused to physically confront a parent's death. Ida O'Keeffe, now a student nurse at Mount Sinai Hospital in New York, went to Virginia to identify their father's body and to sign, for the second time, a death certificate as next of kin. Whether the decision was Ida's or was based on the dead man's wishes, Francis O'Keeffe was not laid to rest next to his wife in the Episcopal cemetery in Madison; he was buried in the Catholic graveyard in Sun Prairie, joining his parents and three brothers.

Georgia had neither seen nor communicated with her father in years. She was nonetheless so affected by the news that Alfred hesitated to

leave her alone in the studio, even when he went to 291 for mail. She had not told Stieglitz any of the facts surrounding Francis O'Keeffe's death, nor did he press her for details. Despite her unwillingness to express her feelings, he was aware that Kitty's behavior toward him added to Georgia's grief, he told Strand. He had not heard from his daughter since their stormy encounter in September.

Alfred warned Paul to say nothing to Georgia—or to anyone else— about her loss. And no condolence letter, please. On the subject of death, she wanted only silence.

Adding to the strains of these months—her father's death, Alfred's slowly dissolving marriage, late nights at the studio—were other problems created by Alfred in residence. His work took over every available space: developing solution filled the bathtub; clotheslines hung with prints crisscrossed the two rooms. More important, cohabitation made Georgia's availability as model unlimited. Alfred could indulge his obsessiveness—his passion for work and for her—without the restriction of visiting hours.

For Alfred, this expanded time together to observe and record at will every pore, follicle, and fold of Georgia's face and body enhanced his life and raised his art to new powers of expression. A year later, he was still in a transcendent state of discovery. Writing to Anne Brigman on Christmas Eve 1919, he exulted: "I'm photographing—I wish you could see—I know you would greatly enjoy.—No tricks.—No fuzzyism.—No diffusion.—No enlargements.—Clean cut sharp heartfelt mentally digested bits of universality in the shape of Woman—head—torso—feet—hands."[35]

In many prints of 1919, O'Keeffe looks haggard and exhausted. Dark smudges form half-moons beneath her eyes; deep furrows incise tracks between her heavy brows. Two admiring critics, writing of the portrait, pointed to "resignation" and "anguish" as her characteristic expression.[36]

Living together did not lead to images of tender intimacy. Moving closer at close quarters, Alfred's lens pitilessly magnified—or exaggerated—Georgia's physical flaws: one breast seems swollen, sagging far below the other; a nipple looms like a discolored bull's-eye. Lines strangely resembling stretch marks bisect the belly of a childless woman.

In a sequence of prints beginning in 1919, the camera frames O'Keeffe's hands and breasts as she twists both nipples between thumb and forefinger. These gestures may be part of a spectrum of erotic exploration in which both lovers willingly engaged; they are still painful to look at—especially if the viewer is a woman.

One of O'Keeffe's few surviving works of that year is a painting of

the place where she and Stieglitz first lived together. In *Fifty-Ninth Street Studio* (1919), she transformed the gaiety of orange walls and lemon floor into a narrowing, oppressive vista: from the glare of the larger area, painted in cold gray-white and icy blues, the viewer peers through a doorway, uneasily tilted, into a small dark room beyond. The bedroom has become a black box; beyond the barred panes of a prisonlike slit of a window glowers a dirty purplish light.

TEN

Show and Tell

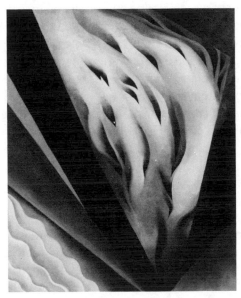

GEORGIA O'KEEFE, *Blue and Green Music* (1919),
oil on canvas.

THE NOVEMBER 1918 Armistice and its accompanying delirium
drove Stieglitz into a despairing mood of isolation punctuated by proph-
ecies of doom. He had harbored an apocalyptic fantasy: a great moral
cleansing would follow the bloodbath of the Great War. Instead, he
could see America beginning a retreat from the larger vision of the
Progressive era into a provincialism at once complacent and paranoid;
with the end of the war, voices of dissent were no longer to be heard.
The reforming spirit that had animated muckraking journalists, estab-
lished settlement houses, and made common cause with striking workers
and immigrant housewives had withdrawn into visions of individual
fulfillment, often followed by the flight from urban life.

Stieglitz's old friend Hutchins Hapgood had forsaken his walks
around the Lower East Side for a patroonship on the banks of the
Hudson, where he and his wife, novelist Neith Boyce, raised their
growing family with the help of a large staff imported from Italy. Mabel

Dodge had given up her lower Fifth Avenue salon to try the simple life and another marriage in Westchester, before pursuing the primitive in Taos, New Mexico. The prewar avant-garde, sparked by emigré brilliance and talent, had scattered: Picabia and de Zayas returned to Europe; the Arensbergs, claiming diminished income and exhausted energy, exchanged their glittering evenings off Central Park for reclusive retirement in Santa Barbara. In the view of Stieglitz and his friends, the departed movers and shakers were replaced by hustlers, hypocrites, and bigots. Alfred's contemporaries seemed ever more characterized by a narrowness of mind and spirit that took the form of an aggressive philistinism combined with a punitive zeal to regulate the morals of others. The spirit now abroad in the land was a mindless puritanism, defined by H. L. Mencken as "the fear that somewhere, someone might be happy."

Hun hysteria would soon be replaced by Red scares. There was a new virulence to old hatreds—of foreigners, Jews, Catholics, and, of course, artists and intellectuals. For the majority of his fellow citizens, Stieglitz felt, ideals had disappeared; the decline in quality of Kodak's photographic paper—Alfred's favorite jeremiad—he read as yet another symptom of a spreading disease: pursuit of the dollar as an end, not a means. Meanwhile, the energy required for "getting on" would be protected from dissipation through drink and sex by the Volstead Act, in concert with the vigilance of the Watch and Ward Society.

Demoralized by the war and by the America of their elders, bright and talented young people sought escape, the lucky few in Paris where the dollar went wonderfully far. Others, less fortunate, took refuge in a homegrown hedonism of bootleg whiskey and casual sex. The Twenties had begun.

Starting with the false armistice of November 7, 1918, whose source was a launch filled with French sailors in Brest harbor yelling "Finie la guerre," peace celebrations released a frenzy of joy and relief. After 1,564 days, the worst slaughter in the history of humanity was ended, with American losses limited to a mere 126,000. Four days before the actual historic event—the signing of the armistice agreement in Marshal Foch's railway car in the forest of Compiègne on November 11—New Yorkers went wild.

"A dozen New Year's Eves in one" was the way one witness described the premature festivities. Starting in the early afternoon, when office workers were given a holiday, impromptu parades sprang up everywhere; marchers were all but buried by an avalanche of paper cascading from every office window. A rehearsal of the Metropolitan Opera's production of Verdi's *La Forza del Destino* was interrupted when diva Geraldine

Farrar appeared onstage trailing red, white, and blue streamers. At nightfall, the lights of Broadway blazed after four years of darkness; couples danced in the streets.

After this "loony celebration," as Stieglitz denounced the festivities of the false armistice, November 11 was something of an anticlimax. The city had run out of paper for the official ticker-tape parade; office workers threw bills and coins out of windows, applauding as both were scooped up and pocketed by returning men in uniform. Joining Mayor and Mrs. John Hylan in the march up Fifth Avenue and Broadway to Columbus Circle were ten thousand boy scouts and ten elephants from the Hippodrome; the latter were the only marchers who could clear a way through the mobs.

Near 291, on lower Fifth Avenue, crowds cheered and screamed in delighted terror as a dummy of Wilhelm II was tossed from the top floor of a building, held by a rope whose length was finely calculated to arrest the plummeting body just above the heads of happily shrieking women. The enthusiasm of the crowd forced the plunge to be repeated until the effigy fell apart.

Nauseated by the savagery of the celebrants, Stieglitz retreated. He still defended his belief in the exemplary German character. But he was less specific now as to what the world had to learn from the German example.

One afternoon between the joyful explosion of the false armistice and the official celebration, Alfred had gone with Georgia to 291. Shortly after they arrived, an old friend of Alfred's, Hippolyte Havel, dropped by. While the two men were chatting, deafening sounds rose from the street; Georgia rushed in from the tiny adjoining room and told them to look out the window. In the street below, thousands of shipbuilders marched, bareheaded and in work clothes, carrying crude hand-lettered banners and shouting until they were hoarse: "We did it to the Kaiser"; "To Hell with all Autocracy."

Watching from the window, Alfred was seized by a familiar conflict: he was both repelled and attracted by this show of brute strength, which left him, as always, with a sense of his own physical inadequacy. Georgia looked frightened.

Alfred was fearful too; the possibility of mob rule echoed clearly in the marching feet and shouts of the shipbuilders who had stopped work to join with the fashionable bourgeoisie crowding Fifth Avenue. Alfred predicted that victory would be followed by depression: most of the marchers would soon be on breadlines. He was appalled by the blindness of the masses.

What he foresaw came to pass all too soon. Within weeks, the

marchers, joined by ten thousand shipyard laborers at the Bethlehem works, in Quincy, Massachusetts, twenty-three thousand men and women producing war materiel at the General Electric plant in Schenectady, and hundreds of thousands of others, would be jobless. For these workers, as well as for many artists and writers, the Armistice would bring not liberation but increased hardship; an inflationary economy was building toward the economic downturn of 1921, a rehearsal for the Great Depression to come.

Prohibition, enacted into federal law in 1919, would drastically reduce Emmy's income from the family brewery; most likely, other sources of Obermeyer wealth—mortgages and rentals on Brooklyn real estate—were also affected. Edward Stieglitz's estate, which supported Hedwig and provided Alfred's allowance, shriveled as the value of his stocks declined.

With finances uncertain, New Year's 1919 found the guest list changed at Alfred and Georgia's studio on 59th Street. Beginning in January, the two rooms were no longer the setting of an informal salon where small groups of friends dropped by in the evenings to talk and see Alfred and Georgia's latest work. Visitors were now patrons, collectors, and opinion makers who came by invitation only, usually one at a time.

O'Keeffe had not exhibited since 1917; Alfred had shown no photographs for six years. Without a gallery, viewings at the studio were a way of sustaining interest in their art among those whose judgment counted, as well as providing their visitors a discreet opportunity to buy directly from the artists.

The private showings were an immense success, not in real but in psychic income—the gratification of Alfred's ego. Opinion was unanimous, Alfred reported triumphantly to Strand, finishing his military service in the Army Medical Corps in freezing Minnesota. Everyone who saw their work found it unlike any painting or photography ever done. Stieglitz himself poured forth superlatives: their recent efforts had attained a beauty and force that spoke directly to every viewer.

Among those who climbed the three flights of stairs that winter was Leo Stein, brother of Gertrude, who was credited in the opinion of most with acting as advance guard of family taste. Visiting America between expatriate residencies in Paris and Florence, Stein had posed for Stieglitz the previous summer on a day when the humidity obliged Alfred to periodically ice his sitter's forehead to reduce the glare caused by sweat.

In the spring, Walter Arensberg himself, patron of dada and surrealism and host of 291's competing center of influence, came—and stayed to marvel, according to Alfred. Generally indifferent to American

claims to modernism not inspired by Europe, the scholarly amateur's crossing of Central Park was seen by Alfred as something between a conversion experience and royal patronage.

Arensberg was accompanied by a young painter and photographer from Philadelphia, Charles Sheeler, and by Marius de Zayas. The brilliant Mexican caricaturist and critic had taken over the Modern Gallery, started by Stieglitz's Young Turks as a commercial offshoot of 291, giving it his own name. Agnes Meyer, the gallery's original backer, had recently retired to furnish her Mt. Kisco estate, but not before she had warned de Zayas, "Watch out for Stieglitz."[1] Ever since Alfred had withdrawn his fatherly support for the Modern Gallery, the Meyers never had a good word to say about Stieglitz.[2] The genial de Zayas, however, decided to forgive and forget; before he moved to Spain a few years later, relations between the two men resumed their old warmth.

Stieglitz's portrait of O'Keeffe electrified the visitors. Arensberg and de Zayas were stunned by the photographs and, according to Alfred, said that no painter could afford to ignore their existence. Among the artists excited by the photographs was Arthur B. Davies, one of the organizers of the Armory Show and himself a painter of mystical landscapes in which chaste nudes cavorted with unicorns.

For Sheeler, the portrait would prove the most influential of Stieglitz's work; with his first visit to 291 in 1911, when he was living in Philadelphia, he had become Alfred's disciple by correspondence, sending Alfred the photographs he was making, at first, to support his painting. Shortly thereafter, Sheeler became a regular visitor to New York, where he found new clients for his bread-and-butter work: photographing works of art. Soon he was busy documenting the collections of John Quinn, the Meyers, and the Arensbergs.

In 1917, Sheeler and Strand had become friends when their work was exhibited together at the De Zayas Gallery. The following year, Sheeler sent Stieglitz a group of photographs entirely different from anything he had done before: the subjects were architectural, but the walls, roofs, and windows of Bucks County outbuildings had been transformed into abstract studies of texture, form, and structure. Stieglitz reported admiringly to Strand: "Sheeler . . . has done some wonderful new things, Pennsylvania barns! Uses Bromide paper now—smooth. Has much quality."[3]

More mysterious and haunting was the series of interiors Sheeler made of the small eighteenth-century Doylestown house he had shared with a brilliant fellow artist, Morton L. Schamberg. Schamberg's dazzling virtuosity, revealed in work that included authoritative color compositions, dada-inspired "machine art," and pure abstraction, offers

tragic evidence that his death in the flu epidemic in August 1918, like that of Randolph Bourne, deprived America of one of the most promising talents of his generation. Sheeler was devastated by the loss of his friend, and his haunting, mysterious prints of the three-room house where they had lived and worked together on weekends—the austere lyricism of Shaker masonry, the glimpse of a chair seat, of a stairway seen through a half-open door—have the presence of a portrait. Although he kept the house, unused, for several years longer, Sheeler moved to New York in 1919 and worked as manager of de Zayas's gallery.

No photographer could see the portrait of O'Keeffe without accepting its challenge. Shortly after his May visit to the studio, Sheeler began a series of studies, first in still photographs and later on film, of the woman he would soon marry. Filling the frame with its ample form, Katherine Shaffer's body is seen as a series of curves, angles, and arcs whose vectors suggest, even as stills, the motion of film. With little of the sensual or romantic intensity of Stieglitz's portrait of O'Keeffe, Sheeler's abstract organization of the nude underlines, by contrast, the germinating force of Stieglitz's vision.

Meanwhile, Strand was unstinting in his admiration and praise of Sheeler. On declining an invitation to participate in an exhibit, "Pictorial Photographers of America," Strand explained loftily to the sponsors: "Photography . . . is either an expression of a cosmic vision, an embodiment of a life movement or it is nothing—to me. This quality I find only in the work of . . . Charles Sheeler and Alfred Stieglitz."[4]

On Strand's return to civilian life in August 1919, the two younger men became closer; they had in common their work in commercial photography and a passion for motion pictures; theirs was the first generation in America to be movie-struck. In the next months, they began collaboration on a film, a six-minute silent tour of the city's skyscrapers, with intertext from Walt Whitman's poems. They gave their film the Whitmanesque title *Manhatta.*

Both O'Keeffe and Stieglitz were especially welcoming to visitors who were members of the press. Alfred's show-and-tell sessions worked both as informal interviews and as illustrated lectures for editors, art critics, and publishers. Evenings at the studio offered an intimate glimpse of their life together.

Georgia's reserved—even prim—manner, her loose black clothes falling in straight lines from a white collar or shirtwaist, made Alfred's photographs of her appear all the more astonishing in their uninhibited eroticism. The voluble white-whiskered photographer provided a running commentary, explaining, analyzing, full of stories and anecdotes.

As a couple, they were great copy. Their contrast of styles and the disparity of their ages underlined the romance and glamour of "living in sin" in the appropriately makeshift garret studio.

Keenly aware of the dangers of obscurity when there was no gallery for their work and no public forum for his discourse, Alfred was especially elated by the visit of Frank Crowninshield to the studio in late 1919. Since 1914, when Condé Nast appointed the young journalist editor of *Vanity Fair*, Crowninshield had transformed a frumpy fashion magazine into a smart, slick reflection of his own interests in modern art, literature, culture, sports, and society.

A notable collector of contemporary painting (and one of the future founders of the Museum of Modern Art), Crownie was an elegant bachelor and man-about-town whose trademark was the fresh boutonniere that sprouted daily from his lapel. He was the favorite of leading hostesses, especially those whose guest lists reflected what was coming to be known as Café Society, and his role as king of the social lions enabled him to realize his editorial ambitions for the magazine. *Vanity Fair*'s contents "were the things people talk about at parties," he said. Contemporary art was in the forefront of topics he helped to make modish among his sophisticated readers. Almost every issue featured a reproduction of a modernist painting—usually school of Paris—accompanied by a few brief, breezy, and easy-to-recall remarks about the work. His magazine needed the peg of an exhibition before he could feature an American artist, but without a gallery, Stieglitz could make no plans for showing O'Keeffe's work. In the meantime, cultivating Crownie— collector, party-goer, and tastemaker—was an investment in Georgia's future.

REGULAR VISITORS to the studio in late 1918–early 1919, whether fellow artists or knowledgeable amateurs, would have been aware that Georgia's art, like her life, was in a period of transition.

Most problematic was a change in medium: the shift from watercolor and charcoal on paper of her Texas period to oil and canvas. As a prize-winning pupil of William Merritt Chase fourteen years earlier, O'Keeffe had had a thorough grounding in oil technique. Then she had repudiated the medium itself, along with her stiff representational student work, exploring abstraction, first in charcoal and then in brilliant watercolor. Mastery of watercolor's demands—speed, sureness of hand and eye— along with its high-risk, one-shot process had released an expressiveness of form and imagination that had been stifled by oil. Finally, she was

free to render what was in her own head and no one else's, to say, with a few swift lines, in stains of pigment on white paper what had not been said before.

O'Keeffe's early drawings and watercolors stood for both the woman and the artist Stieglitz had recognized; they were and would always remain his favorites: the works that had drawn her into his life.

Lightweight in both portability and significance, watercolor still suffered from a traditional image as a pastime of English ladies and other amateurs; geniuses like Constable and Winslow Homer were the exception in both gender and gifts. John Marin, seen as Homer's heir, was already a star in the Stieglitz firmament.* For O'Keeffe to fulfill her destined role as the first great American woman artist, she was obliged to return to painting in oil.

Stieglitz's first predictable raves about the results were followed by qualifications. Promising Strand that he would be overwhelmed by Georgia's new paintings, Alfred continued with his standard hymn: each of her recent works expressed a combination of power, beauty, honesty, and womanhood. His press release dispatched, Alfred could now dispense with hyperbole: he was relieved that Georgia's painting had improved. Her control of the medium had advanced and her work in oil was approaching the quality of her watercolors, pastels, and charcoals, he told Strand in late November 1918. Nervously, he qualified further: she was finally winning the battle with oil technique; the sense of effort was almost gone from her canvases.

Almost, but not quite. In her paintings of 1919, O'Keeffe tried to turn oil into watercolor. In a series of three nearly identical abstractions, each entitled *Black Spot*, instead of using white highlights to suggest volume, she thinned the pigment to the point of transparency. Watercolor's veils of wash and brilliant intensities, however, were lost in translation. Large areas of cold dead colors—bleached-out yellow, pale muddy green—lie inert and contiguous in the form of cropped oval and spheroid shapes. The black spot of the title† is, in fact, a flat elongated oblong attached, tablike, to a double cone-shaped form.

Accompanied by inevitable anxiety, Georgia's return to oil attached her to the work of another artist who had enjoyed Stieglitz's imprimatur. In structure and color, the Black Spot series reveals O'Keeffe's careful study of Stanton Macdonald Wright and synchromism.

Developed in Paris by Wright and fellow expatriate Morgan Russell about 1912, synchromism was based on elaborate color theories, illus-

* Marin's later shift to oil painting met with great resistance from Stieglitz.
† The title was also borrowed from a Kandinsky of 1911.

trated by Wright's abstractions, and characterized by transparent fac-
eted planes of thin color seeming to merge with one another. Much
admired by O'Keeffe since her first exposure to his work at 291 in 1914–
1915, Wright's painting, like Dove's work, also provided an important
model of abstract art that retained consistent references to the organic
world.

O'Keeffe's affinity with Wright and the synchromists was strength-
ened by the movement's conscious analogy of painting to music. Pon-
dering possible names for his theory, Russell had first thought of
"symphony," a borrowing he quickly discarded as one whose vibrations
were in the air everywhere, most recently put forward by Kandinsky in
his influential *Concerning the Spiritual in Art.** In "synchromy," Wright
managed to keep the musical associations of the three syllables while
creating at the same time a new word conveying the meaning "with
color."

Meeting Wright in 1917, when he exhibited more than twelve of
his new works at 291, Georgia described him to Anita as a small, sickly-
looking man, but his painting continued to impress her. With the closing
of Stieglitz's gallery that same year, Wright exhibited, as did some of
Alfred's other homeless children, at the Daniel Gallery; there Georgia
would have seen *Oriental Synchromy in Blue-Green* (1918).[5] Described
as Wright's "culminating work,"[6] this composition consists of scattered
segments of female anatomy rendered in muted tones, including breasts,
buttocks, and thighs; slightly off-center, the one dark element in the
work—an arched tubular form, suggesting the opening of a tunnel—
draws viewers' attention.

Georgia's slender output of 1919 contains three works that pay direct
homage to Wright: *Blue and Green Music* and at least two versions of
Music—Pink and Blue, (I and II). Both compositions of the latter title
are dominated by an arched tunnel of ropey forms, cropped at the bottom
and lower right. By changing Wright's dark entryway to pink and white,
O'Keeffe becomes more anatomically literal—and labial; in both her
paintings, the brilliant blue that lights the end of the passage fore-
shadows her Pelvis and Sky series of the mid-1940s, beginning a pro-
gression from membrane to bare bone.

Feminizing the synchromist palette (whose color, more subdued than
theory suggested, was indebted to analytic cubism) Georgia transformed
one of many elements in Wright's painting into the dominant form of
her compositions: in both versions of *Music—Pink and Blue*, her arch

* First published in English in 1914 but well known to the European avant-garde since its German
publication two years earlier.

fills almost the entire canvas. O'Keeffe's passageway holds no promise—or threat—of Stieglitz's dark mystery of "Woman Supreme," of Rodin's Circle of Life, or of Courbet's long-hidden canvas *Origins of the World*. Her shallow tunnel opens on a bright emptiness of infinite space.

ROMANTIC AND BOHEMIAN, the studio did not solve the problem of living and working space for two resident artists. The question of where Emmy and Kitty were to live was still unresolved as well in the winter of 1918–1919. Alfred's failure to settle the issue of housing reflected—like a hall of mirrors—his refusal to deal with related issues: the end of his twenty-five-year marriage and the subsidized life he had come to take for granted, along with the question of how he and Georgia would support themselves in the inflationary postwar economy, particularly hard on those with modest fixed incomes.

Emmy, too, was worried about finances. Her income was much reduced and she was unaccustomed to economizing. She needed Alfred's advice, she told him. Early in February 1919, he agreed to see her, after first arranging to discuss her situation alone with her brother Theodore, manager of the family brewery.

What was to have been a businesslike talk with Emmy about money turned into a ten-hour marathon (at least, in Alfred's account) of accusation, argument, confession, and contrition with the lonely, despairing woman.

In a letter following his visit, Alfred urged Emmy not to see the future in terms of unrelieved bleakness. He stood ready to help her "because of Kitty & because you are a human being & because if anyone understands you I do," he added, turning a warm gesture into an offer that managed to be both icy and patronizing.[7]

He was convinced, he wrote to Emmy, that "out of the chaos of the world & the chaos of our own particular circle something fine must evolve," even if it was not the reconciliation that Emmy still hoped for. "*Chaos*," he told her, "to me has always signified *Hope*. And Peace—Good Will."[8]

He had no particular plan in mind, Alfred conceded—hardly surprising, given his belief in the therapeutic powers of chaos. "I merely have an intense desire to minimise [*sic*] your suffering. And so minimise also Kitty's and mine—. And also Miss O'Keeffe's."

Communications between father and daughter, meanwhile, appear to have broken down. Alfred charged Emmy, about to visit Northampton where Kitty was now a sophomore at Smith College, with a message: "Please do not forget to tell Kitty about my readiness to see her & that

she is not to consider the expense. . . . I too need help," he ended.[9]

Shortly before his day-long discussion with Emmy, Alfred had made it known to the entire family that he would be leaving the studio for a room in his sister Sel's apartment. Whether this move was in response to their landlords' disapproval or to Georgia's need for working space and privacy is unclear. Most likely, both were considerations in Alfred's plans.

Emmy and Kitty proposed an alternative to Sel's spare room; if Alfred was willing to return to 1111 Madison, Emmy would move out, taking rooms elsewhere for herself and daughter. Alfred would be completely free to come and go as he pleased.

For both Kitty and Emmy, however, Alfred's move "back home" would be the first step in the reconciliation of the family. Indeed, in Emmy's reference to the plan as a "trial," she could not have been clearer—and more justified—in her assumption that by leaving the studio Alfred would be signaling that eight months of living with Georgia represented an infatuation from which he was about to recover.

Alfred's warnings as to how his move should be interpreted were predictably confusing. In a letter to Kitty that he delivered to Emmy for mailing,* he wrote that he had agreed to the "experiment" (as he rechristened the plan, using his favorite scientific term) only because she and her mother wished it; Emmy was to "look at the situation from the dark point of view instead of the most hopeful."[10]

Moving uptown, in his view, was merely exchanging one roof for another: "all else remaining as it is, that is, I retain my entire freedom as it exists today without question."[11] Presumably, his freedom also included the right to entertain any guests he wished.

"What has brought about this decision, I can explain at a more opportune moment. I do not care to in this letter," he wrote.[12]

The opportune moment never arrived. Unknown to Alfred, the version of his relationship with Georgia that he had given Kitty the previous June had been exposed as false. Shortly after Georgia was installed in the studio, Kitty, home from college for the summer, had asked her father whether Miss O'Keeffe was in town. Alfred's response to this artless question provoked angry words: about him, about his friends in general, and about O'Keeffe in particular. But only now—nearly a year later—did Alfred discover the reason behind Kitty's outburst and her subsequently infrequent and perfunctory communications.

While he had been denouncing the Obermeyers for their lies and

* Asking Emmy to post or deliver his letters to Kitty suggests Alfred's belief that an envelope bearing his handwriting would remain unopened.

calumnies, for slandering an innocent young woman, and while he assured his wife and daughter that his relations with Miss O'Keeffe were those of friendship, his niece Elizabeth had taken it upon herself to plead the lovers' cause to her cousin. In playing advocate for Georgia and Alfred, she had no idea she was exposing her beloved uncle as a liar and hypocrite to his daughter and revealing his friends, especially Strand and herself, as accessories in the sordid subterfuge. Romantic and certainly more sexually experienced than Kitty at this point, Elizabeth might well have assumed that her cousin, now twenty and a college sophomore, had guessed the truth—whatever she may have been told. Her naive hope was to persuade Kitty to rejoice in her father's happiness and to accept the woman responsible for transforming his life.

When Alfred found out who had enlightened Kitty, he was beside himself with wrath: "A gross injustice with a seemingly irreparable consequence has been done to both you and me by one who undoubtedly meant well by both of us," he wrote to Kitty in March. Still, Alfred was never wrong. "I have been an innocent party," he insisted.[13]

In her reply, Kitty sounded more despairing than ever. She begged her father to tell her the truth. She sensed when she was being lied to, even when she didn't know the substance of the lie. She felt completely abandoned by everyone, even her mother. When she had called her grandmother to wish her happy birthday, Hedwig told her that, after her disloyal behavior toward Alfred, Uncle Joe was her father now. How could her grandmother have said such a cruel thing to her? she asked Alfred.

With Emmy gone from the scene, Kitty had clearly inherited her mother's scapegoat role in the family.

Her loneliness was overwhelming, she wrote. Whatever she said or did seemed to create trouble or cause pain. Told that her behavior was the problem, Kitty believed it. Obviously, she was responsible for the anger and unhappiness around her. She implored Alfred to tell the family how sorry she was. Guilt poisoned her one source of satisfaction: academic achievement. She didn't deserve her high mid-semester grades, she told Alfred.

By early summer, Alfred's "experiment" had ended in disaster, leaving all concerned feeling more outraged and betrayed than before. Emmy now decided to close the apartment after all. Alfred having been told there was no hurry about his leaving or in removing his clothes, books, and pictures, he apparently arrived one night to find the doors barred. His response would be the last expression of intimate violent feelings to pass between him and Emmy. She had never made the slightest effort

to understand him, he insisted. In her eyes he had always been "guilty."

"What chance did you ever give me—or yourself—or our so-called 'home'—& Kitty," he demanded. "I still maintain I'm the only real friend you have. Time will prove it," he ended.[14]

Through it all, Georgia had been a real trump, Alfred reported proudly. Everyone who knew her well—her sister Ida, Dorothy True (passing through New York on her way to Paris)—observed how much she had grown. However deserved Alfred's praise, Georgia had no small experience with family breakups; with dislocations, physical and emotional; with uncertainty about next month's rent. She had known much worse. In the certainty that Alfred loved her, she could distance herself from the family dramas of hand-delivered letters, crisis meetings, "trials," and "experiments." With more space to herself, she could indulge Alfred's need for the lodger's freedom in the bosom of his family without questioning its implications.

Still in the studio, after the failed "experiment," Stieglitz invoked the tatters of his beloved Charlie Chaplin to describe himself and Georgia. They were, he observed, "like two pal tramps."

IN JULY 1919, Georgia and Alfred left the city for Lake George. At Oaklawn, along with the outdoor pleasures of swimming, boating, and hiking, Stieglitz continued the sessions begun in the studio. In the evenings, his niece Georgia Engelhard recalled, he would bring Georgia's work into the living room, where the entire family and guests gathered to discuss the paintings in animated fashion, Uncle Alfred exuberantly leading the general debate. In the course of these lively and instructive seminars in art appreciation, it sometimes happened that a member of the family would want to buy one of Georgia's paintings—fresh from the easel, "permission being given or dramatically withheld by Uncle Alfred."[15]

During these postprandial discussion/auctions, Georgia Engelhard remembered, O'Keeffe sat, silent and remote, "only speaking when she was spoken to . . . as detached as though she had had nothing to do with the paintings." She had, apparently, resigned herself to these sessions and her required presence. The summer before, on her first visit to the lake, Georgia had realized the futility of objecting: "As much as she would have liked to stop him, no one could have," Stieglitz's niece recalled, "although she suffered while her paintings were being discussed."[16]

Replacing the hollyhocks that she had stuffed in the garbage can, Georgia made at least three flower paintings that survive from 1919.

Probably painted that summer in Lake George, all three pictures are small in scale and depict red blossoms. Two are studies of canna lilies. Of these, one is an exquisitely rendered but conventional watercolor; the other predicts the later works using a lens-optic perspective—that of a bee looking upward from the pistil. The third, *Red Flower*, an oil, is the first of O'Keeffe's magnified close-ups of the subject with which she would be most closely identified. The flower's species is unnamed, and the scale and cropping of the outer fuchsia petals (and their blurriness) make it difficult to identify, although its brilliant scarlet color suggests a camellia. The concentric forms, with their contrasts of dark and light, recall Strand's famous bowls among the prints the photographer had sent to Georgia in Canyon two years earlier.

At the end of September, Strand visited O'Keeffe and Stieglitz at Lake George. Alfred's invitation assured Paul, who had returned to civilian life in August, that Georgia felt ready to see him again: she would feel no awkwardness. Georgia does not seem to have expressed herself directly on the subject of Strand's visit. His presence, though, clearly quickened old memories; she had loved the man who emerged from the bold modern photographs, thrilled by his daring variations on cubism, on structure based on abstract form and tonal contrasts. In her first efforts to make the viewer "stop and see a flower the way I did,"[17] she also pays tribute to the photographer, recalling the time in Texas when she made Strand photographs in her head.*

Strand's visit to Lake George came at a difficult period. Alfred was working in a frenzy, but his labors, he admitted, were more catch-up than creation: printing old negatives, some made as much as three years earlier. Whether to justify his own finicky reworking of past efforts, he was grumpier than ever about the shoddy new material and "lax" standards of workmanship he saw around him. Every photographer now considered himself an artist, he observed acidly.

Georgia was unable to work at all. She could not point to distraction from the family; they had all returned to town. Alfred was prompt to take the blame for her lack of productivity. His work—its method and results—was apparently undermining her confidence and there were other matters troubling both of them. Among the causes of distraction were his still unresolved marital status and housing situation, the latter worry exacerbated by the Stieglitz family's decision to put Oaklawn on the market. In future summers, the much smaller farmhouse would have to accommodate the entire clan. In Alfred's view, however, Geor-

* Strand's presence is overpowering when the painting (not coloristically very successful in any case) is seen in a black and white reproduction.

gia's work block had no effect on their love and happiness in each other, he assured Strand.

At loose ends since returning to New York and civilian life, Strand could sympathize with Georgia's difficulties in working. For Paul, the disorienting effects of demobilization had been compounded by tragedy. In late January 1919, he was stricken with influenza. After a relapse landed him back in the base hospital in Fort Snelling, his anxious parents took the first train to Minnesota. Barely had they arrived when his mother came down with pneumonia. Reassured by what seemed a good recovery, Jacob Strand returned to New York, only to learn that his wife had suffered a fatal heart attack. Adding to Paul's grief was an inevitable sense of guilt. Like Georgia, from then on he avoided any mention of his mother's death.

Paul's visit to the lake did not quicken the passion he and Georgia had felt for each other two years before. Instead, they were united by recent loss, unspoken and unresolved. Her father's fatal accident left Georgia an orphan, but her life with Stieglitz, the same age as Ida O'Keeffe, had provided her with a companion who combined qualities of both her father and her mother—down to the particular forms of helplessness of each.

For Paul, the loss of his mother (followed shortly by the death of the grandmother with whom his family had lived since his childhood) was the culmination of a series of abandonments by women: he had been rejected first by Georgia and then by Alfred's niece Elizabeth, who early that year had married her family's gardener, Donald Davidson. More than ever, Paul seemed lost without Alfred.

The haunting portrait Stieglitz made of Strand during his visit to the lake shows a very different person than the one in Alfred's photograph three years earlier; the young man in work apron holding a hammer and looking severely at the world has given way to a melancholy artist. Standing squarely against a blurred landscape seen through a window or Dutch door, Strand wears the bohemian/intellectual uniform of the period: coarse dark shirt, knitted tie, and tweed jacket.* Head tilted back slightly, holding a cigarette burnt down almost to the stub, he stares straight ahead with a somber inward gaze.

Both he and Georgia enjoyed Paul's visit, Alfred assured their guest a few days after his return to New York. His only regret was the gray weather—threatening in more ways than Paul could know, his host told

* Strand's attire in this photograph represents an extreme of informality among Stieglitz portraits of men. Dove and Marin, Duchamp and Picabia all wear dark suits, white shirts, and ties; even Sherwood Anderson balances a tweed jacket with a dress shirt.

him. Alfred did not elaborate. Whatever Georgia's feelings for Paul, his visit had clearly broken a logjam in her inability to work: no longer complaining of troubled eyesight as she had earlier in the summer, Georgia was now painting furiously. Her oils sang in the spirit of her watercolors. One in particular was a "Wonder." Alfred knew Paul would agree when he saw it.

For Alfred, the high point of the summer was not art but his own act of heroism. One evening in August, he and Georgia were setting out for their evening row on the lake when a treacherous northeaster blew up, its fierce winds tipping over a canoe in the middle of the lake. By the time Georgia could see what was happening, one of its two occupants—an eighteen-year-old boy—had already gone under. Quickly putting Georgia ashore to call for a rescue launch, Alfred rowed toward the panicky twelve-year-old still clinging to the capsized canoe—"calling out: 'I'm coming'—knowing I'd save one—also knowing the other was lost—not another soul in sight!"[18]

As in his confrontation with Emmy and Kitty at the camp, Alfred invested the drama with the entire palette of high romantic weather effects; the scene was illuminated by the sheet lightning of a northeaster, the rising moon, and the northern lights.

Alfred's pride over his part in the rescue—involving quick thinking and calm decisiveness, if not physical prowess—was enhanced by Georgia's role as witness and assistant. Always prone to feelings of inadequacy about his size, age, and uncertain health (while enjoying the attentions his hypochondria focused on the latter), he had performed heroically, saving the younger boy in full view of the woman he loved.

LATE IN DECEMBER Oaklawn was sold. Since Edward's death in 1909, his children had found the large house too formal, too dark, and too expensive to maintain. In the early spring of 1920, renovations began on the farmhouse and outbuildings, supervised by Agnes and her husband, George Herbert Engelhard, who gracefully and competently added general contractor to his unpaid chores of family lawyer, financial adviser, and de facto executor of the estate.

Throughout the late spring and early summer, plumbers, plasterers, and painters were already at work to shore up, expand, and modernize the farmhouse to accommodate the swelling ranks of the Stieglitz family—in-laws, children, and servants—along with the needs of an ailing Hedwig.

In April came the news that 114 East 59th Street was on the market; the likeliest buyers, Alfred had reason to fear, were developers planning

to raze the house and build a commercial property on the site. The brownstone era was over.

This time, brother Lee came to the rescue directly. Two spacious rooms in his large 65th Street house would be available in the fall; he and his wife, Lizzie, had decided to reclaim the space from the present occupant, Steichen's oldest daughter, Mary, who had boarded with them for several years while attending school in New York. Whether or not Lee's favor to the Steichens was terminated to make room for his brother, Alfred could only have been pleased that his new home would effectively end the family's patronage of the Steichens. Since returning in glory from the war, where he had been decorated for his work in the photographic division, Steichen had moved steadily to the top of Stieglitz's list of enemies. He was now embellishing the splendid Westchester palazzo of his close friends the Meyers—among his last works as a painter before his fashion photographs and celebrity portraits for Condé Nast made him the highest paid photographer in the world.[19]

Lee's offer to Alfred could not have been more gracious; where his helpless big brother Al was concerned, the choleric doctor was all loving and tactful generosity. It would be a favor to him and Lizzie, he wrote to Alfred in May, if he and Georgia could make use of their too large house. He proposed that the sunny back room on the floor formerly occupied by his ancient mother-in-law might do for Georgia. Alfred, he suggested, should take the large front room on the top floor; with an alcove for a darkroom, it would make an excellent studio. (There was no suggestion that Georgia might need studio space.)

So that both households could maintain the same privacy and independence as before, it was expected that Georgia and Alfred would make their own breakfast and plan on dinner out—just as they had done at the studio. Lee concluded by assuring his brother once again that there was no one with whom he would rather share his house than Alfred and his talented companion; then he would no longer have to climb three flights of stairs to see Georgia's colorful canvases, he said.

By July, Georgia felt suffocated by the city in general and by the crowded quarters of the studio in particular. Other than the Atlantic as glimpsed between rides at Coney Island, she had never seen the sea. She gladly accepted an invitation from her friends Marjorie ("Marnie") and Bennet Schauffler to visit York Beach, Maine.

New Yorkers in winter and Maine residents in summer, the Schauf-flers seem to have been the only Stieglitz family friends to be adopted by O'Keeffe for her own. They were an attractive couple, contemporaries of Georgia's. The family's interest in artists had been established by Marnie's mother, a well-known patron of the arts to whom Carl Sand-

burg had dedicated a poem. (Indeed, the Sandburg connection may account for the Stieglitz-Schauffler friendship; the Chicago poet was married to Steichen's sister Lilian, and in the days when the glamorous young painter-photographer made frequent visits to Oaklawn he had probably introduced the two families.)

Marnie Schauffler had spent childhood summers in the Southwest visiting her maternal (Roe) grandparents. Fervent supporters of missionary work among the Oklahoma Indians, the Roes had at the same time acquired an important collection of Native American artifacts, examples of which were displayed to memorable effect in the simplicity of the Schaufflers' Maine "cottage." Georgia's first visit to York Beach was also probably her introduction to the art of the Hopi and Navajo. Her paintings of kachina dolls may have been based on examples in the Roe-Schauffler collection.

Bennet Schauffler, a sometime school administrator who later worked for the National Labor Relations Board, was a tall, handsome man whose dashing appearance in navy uniform sent no less a lyricist than Edna St. Vincent Millay into raptures. With her keen appreciation of big masculine-looking men, there is no reason to suppose that Georgia was any less admiring of her host.

Along with the pleasure of the Schaufflers' company, the tact of her hosts, and the separate quarters made possible by a compound of main house and guest facilities, Georgia was able to enjoy long stretches of privacy unknown at Lake George. In solitude, she could discover affinities with the harsh, flinty Maine shore, where the tide deposited stones, shells, and seaweed, while the wind sculpted derelict branches into driftwood. Crossing a weathered narrow boardwalk at her doorstep, she was at the edge of the ocean, studying its swiftly changing tides and tempers.

Lake George was too small to give Georgia the freedom she needed and found in the sea, Stieglitz explained to friends, reaching for the rationalization he would always use to disguise his sadness when Georgia went away. It was to be the first of many leave-takings.

Fortress America

ALFRED STIEGLITZ, *The Hill, Lake George* (mid-1920s). After Oaklawn
was sold in 1922, the renovated farmhouse on the family property,
known as the Hill, became the Stieglitz summer retreat.

AFTER THE WILD expanse of sea and the tranquil order of the
Schauffler household, Georgia returned to New York in mid-July to help
Alfred pack up the studio, adding her few belongings to the Stieglitz
boxes, bales, and crates that were divided between Kennerley's Anderson
Galleries and the family's new Lake George headquarters.

Up the hill from Oaklawn, which had been sold during the winter,
the renovated Victorian farmhouse now boasted such amenities as a coal
stove, electricity, and a downstairs bathroom. For Georgia, however,
modern conveniences would never compensate for lack of privacy. When
she and Alfred arrived at the Hill—as the farmhouse would be known—
Georgia discovered that larger numbers of people were crowded into
much closer quarters.

With the exception of a second-floor sun porch–guest room, any
newly created space was for additional help. Hedwig's failing health

now required a live-in nurse along with her personal maid, brought from New York. There was a new kitchen maid to assist the aging local couple, Ella and Fred Varnum, who served as cook and coachman/ gardener. A dining room and veranda for the staff had been added to the new pantry. The legions of Stieglitz help awed even their well-off summer neighbors, including relatives. "They had so many servants," recalled a cousin, Hannah Small Ludins,[1] comparing the Stieglitz entourage with her own family's simple summer household on Tea Island in the middle of the lake.

With only token family in residence—Hedwig and the Engelhards (Agnes, George Herbert, and O'Keeffe's favorite, known variously as Georgia Minor or the Kid)—O'Keeffe still felt claustrophobic. The occasional overnight guest or neighbors dropping by encroached on her work or leisure as they hadn't seemed to do at the big house. She felt overwhelmed by the need to get away.

Her walks now took her ever farther from the manicured summer places that ringed the lake shore. Behind the farmhouse, as though moving back into her own rural childhood, she passed the outbuildings of the original property: the barns and chicken house, carriage house, and icehouse. She climbed higher meadows, overgrown with berries and wildflowers. A splintered wooden stile and rusted barbed-wire fence separated fields that had been cleared for planting when the area was farm country. Second-growth woods revealed an abandoned stone reservoir. As she returned toward the farmhouse, her eye fell on a tumbledown structure of weathered wood about sixty yards behind the barns. Known as the Shanty, the one-room structure had been built, years before, to serve as a dance hall for local young people working in the summer houses. Surveying the first meadow from its sagging front door, Georgia decided that the Shanty provided the promise of solitude; it would make an ideal studio.

Secure in the swirl of life around him—servants, family, visitors, neighbors, and children—Alfred wrote letters, kibitzed with the help, argued with his sister, and chatted with all comers. He hauled out the heavy camera to make snapshots and the occasional portrait, retiring for brief intervals into the old potting shed off the kitchen, whose cold running water made an adequate, if primitive, darkroom. Terrified of solitude and silence, Alfred was incomprehending of Georgia's need to be alone for painting or for peace.

Still, he wanted her to be happy; throughout July, mysterious physical symptoms pointed to pain that was emotional in origin. Without directly acknowledging responsibility, he confessed to feeling inadequate

to her needs. "Georgia's not being well is a source of constant worry," Alfred wrote to Herbert Seligmann in late July. "[I'm] feeling that I ought to be strong as a bull to be able to take care of her properly—and not seeing any way of bringing about that strength."[2]

Georgia pleaded with Alfred to convert the Shanty into a studio. Dutifully, Alfred summoned the two estate handymen for an estimate. The bad news from Mr. Bright and Mr. Blessing was that restoring the derelict structure would cost between four and five hundred dollars—an unaffordable sum in Alfred's view of their budget. But at least he had looked into the matter.

Georgia, however, persisted. In early August, she took up the Shanty question with Stieglitz's niece Elizabeth Davidson and her husband, who arrived at the Hill with their baby daughter. As former gardener and man-of-all-work at Oaklawn, Donald Davidson was undaunted by anything to be grown, made, or fixed—outdoors or in. Recycling usable material from mysterious places, Davidson directed the restoration of the Shanty as an affirming collective enterprise—like a barn raising—that would involve family and guests.

Peeling down to her bloomers and chemise to work in the August sun, Georgia was immortalized by Alfred in both letters and snapshots astraddle the peak of the roof, hammering away and tarring.

By asserting her claim to the Shanty, Georgia defined her needs as an artist and a woman, publicly and for the first time in their two years together, as different and separate from those of Alfred. Working side by side with Georgia, relatives, in-laws, friends, and, finally, even Alfred himself labored in a collective acknowledgment of Georgia O'Keeffe as more than Alfred's gifted companion. Stieglitzes might be a law unto themselves, but others could be granted favors under its rule.

Favors, however, are not rights. The restored Shanty was still family property. Situated on Stieglitz land, shored up with material that was part of the estate, Georgia's new studio was hers only by virtue of protection and patronage; she had the room of her own, but not Virginia Woolf's requisite guinea. Lacking five hundred dollars, Georgia knew she was lucky to be appointed artist-in-residence.

Just as the Shanty restoration was getting under way, Waldo Frank—critic, editor, novelist, and recent Stieglitz acolyte—arrived with his wife Margy. In the last years of the war, Frank had been founding editor of *The Seven Arts*, a short-lived but influential pacifist journal dedicated to the radical premise that America had first-rate artists, poets, photographers, and composers whose work would be published and discussed in its pages.

Small and dynamic, with dark eyes, curly black hair, and the "tooth-brush" mustache then in style, Waldo Frank had first visited 291 in about 1914, when he returned from a postgraduate stay in Europe to register as a pacifist. Steeped in avant-garde art and poetry and in the writings of Freud, Nietzsche, and Kierkegaard and fired with ambition to express his own version of cultural radicalism, he was a natural Stieglitz disciple. But there was one problem: Frank's ego was more than a match for Alfred's. The younger man's interest in power—sexual, personal, and political—made it inevitable that the follower would soon become the rival. Alfred harbored doubts about Frank from the begin-ning; too ambitious, too radical, too greedy for recognition, influence, and money, Frank was brilliant but not "reliable" (read "loyal"). Anxious and hysterical, a storm center of love affairs and divorces, prey to writing blocks and money problems, Frank loved, admired, needed, and resented Alfred. He was not a son to be controlled for long.

During Waldo's month-long visit to Lake George, he saw Alfred every day but kept his distance from the Hill; he and Margy stayed at a guest house close to the village where Waldo spent most of the day writing. Shingling a roof in the broiling sun would not have been his idea of recreation. Margy Frank, a Montessori-trained teacher and pro-gressive school principal, enthusiastically joined Alfred and Elizabeth in laying floors and oiling timbers.[3]

On August 25, they all celebrated Waldo's thirty-first birthday with a favorite Stieglitz outing: a hike up Prospect Mountain, a baby Adi-rondack, followed by a picnic at the summit. On the return, toward evening, Stieglitz made his first portrait of Frank.

By the end of the month, the Shanty was finished and Georgia was hard at work inside. Invited for a September visit, Strand was warned, nonetheless, to be prepared to swing a hammer: Georgia had other construction projects waiting for him. The Shanty was glazed but not screened, and the one room was suffocating. Georgia painted there in the nude, as she had done in the sweltering city studio. She was feeling confined, and her first private domain aroused a territorial imperative: she was meditating a series of huts, Alfred told Paul, though for what purpose he could not say.

Perfectionist as always, Stieglitz was dissatisfied with the results of most of his summer's work. In the painstaking process of spotting prints of earlier plates (removing flecks of dust or minute discolorations), he was discovering that mistakes showed up more, he told Strand. Images for which he had high hopes turned out to be marred by some tiny imperfection. There were too many "nearlys," he wrote to Seligmann. "I am getting to hate 'nearlys'—like an incomplete erection," he de-

scribed them, "a sort of ⅞—the ⅛ lacking is often due to too much 'intellectuality.' I know the difference!" he added.[4]

GEORGIA'S EXPANSIONIST plans came to an abrupt halt in late September, when she found Hedwig, alone, speechless and partially paralyzed—overcome by the unmistakable symptoms of a stroke. Doctors and nurses took over the Hill. Less than a week later, accompanied by her maid and nurse and a local doctor, Hedwig was taken by ambulance to Albany, where Lee met them with his own nurse and ambulance for the trip to New York.

The emergency had unexpected consequences. The Engelhards and Davidsons followed Hedwig and her caretakers by train. Alfred and Georgia were left alone at the Hill. Stieglitz readily acknowledged to Strand his fearfulness: it felt "queer" to be at the lake without his mother—and alone with Georgia.

In October, relief arrived with the visit of Paul Rosenfeld. Another new member of the Stieglitz circle, Rosenfeld at thirty enjoyed a distinguished reputation as a music critic of sophistication and knowledge, but he also wrote on art, architecture, literature, and photography for *The New Republic* and *The Dial*. Although he was oriented toward European culture, Rosenfeld's tenure as an editor of *Seven Arts*, along with Van Wyck Brooks, Randolph Bourne, and Waldo Frank, signaled his conversion to art made in America. As American artists who had absorbed the implications of European modernism, the Stieglitz core group—O'Keeffe, Marin, Dove, and Hartley—exemplified for Rosenfeld the best of both worlds.

Remarkably similar in background, Waldo Frank and Paul Rosenfeld were, like Stieglitz, both first-generation Americans born into prosperous German-Jewish families. City-bred, they had each enjoyed the advantages of private schools and early travel abroad before enrolling at Yale (Frank graduated in 1911, Rosenfeld in 1912). Although they knew each other only slightly at college, as Jews—members of a group too tiny to be called a minority—they kept the same critical weather eye on each other throughout their closely entwined careers. But if the two precocious young men were similar in social background as well as in their cultural interests and literary ambitions, they were, by almost every other measure, worlds apart.

Pale and plump, with wavy ginger hair and mustache and the drooping limpid brown eyes of a basset hound, "Pudge" or "Red" Rosenfeld saw his favored beginnings blighted before his childhood was over. His mother, a talented pianist, withdrew into hysteria and depression, which

ended with her death when Paul was ten. His father, a prosperous braid manufacturer, fell apart soon thereafter. Unable to function, his business soon collapsed. Paul and his sister were taken in by their maternal grandmother.

Sent to a military school near Poughkeepsie, Paul endured the sneers of fellow students and masters, the fate of a Jew who was also overweight, unathletic, and musical. He spent weekends and holidays searching for his father, who was prone to wander the city in a confused, incoherent state.

On graduation from Yale, followed by journalism school, he spent a brief period as a reporter—work he hated. But soon after, he inherited a substantial fortune from his mother's family. (His private income was a source of considerable envy to Waldo Frank, whose expected patrimony either dissolved or went to others.) Freed from the necessity to earn a living, Paul spent time abroad, absorbing the art and music of European capitals.

Sometime around 1914–1915, Waldo Frank brought Rosenfeld to 291. But this first encounter with Alfred was followed almost immediately by Paul's military service and further travels abroad; his friendship with Stieglitz developed only when Alfred and Georgia began living together.

From the first, Paul idolized Georgia even more than he did most women—all of whom he tended to worship from afar. As he did with Alfred, the man and the photographer, he enshrined Georgia as both woman and artist. Together, O'Keeffe and Stieglitz became for Rosenfeld an idealized couple; they represented a union of love and creativity that he witnessed with the grateful adoration of one forever excluded from such happiness.

With his beautiful, somewhat precious manners, expensive clothes, and speech liberally laced with French, Rosenfeld was a man of letters in what he himself would have described as the fin-de-siècle tradition. In his elegant apartment at 77 Irving Place, a short thoroughfare between Union Square and Gramercy Park, Paul presided over an informal salon where friends from the worlds of literature, music, and art happily gathered. A few months before his October visit to the Hill, he had just been appointed music critic of *The Dial*, relocated from Chicago to New York—just around the corner from his apartment. A fellow editor, Alyse Gregory, remembered Rosenfeld's rooms as "an interior that might have been lifted out of some European capital—Vienna, Paris, Florence . . . an interior both intimate and spacious, an interior for pleasures that were grave and thought that was gay, for conversation witty and civilized."[5] In the course of spirited but decorous evenings, musicians such

as Leo Ornstein might play for the pleasure of guests who included fellow musicians Darius Milhaud and Edgard Varèse; poets e. e. cummings, Hart Crane, and Marianne Moore; and the Stettheimer sisters— Florine the painter, Ettie the writer, and Carrie the majordomo of the sisters' exotic salon.

When they were in town, Stieglitz and O'Keeffe would usually be found at Rosenfeld's weekly "evenings." Besides the company of their host and fellow guests and the pleasures of impromptu music making or poetry reading, Rosenfeld's art collection would have been an added attraction. His walls were hung only with works by members of the Stieglitz circle: paintings by Hartley, Dove, Marin, a few choice Stieglitz photographs, with pride of place given to several O'Keeffe paintings.

Rosenfeld's worldly, sophisticated way of life served to keep at bay a profound sadness, but he never used the large cast of his acquaintances to shield him from intimacy with individual friends. He had nursed Randolph Bourne through his final illness and in 1919 invited a forty-year-old midwestern businessman-turned-writer and his wife to join him on a trip abroad; this was Sherwood Anderson's first visit to Europe. So generous and loving was Rosenfeld's pleasure in sharing the beauties of Paris that, seated on bench, gazing up at the spires of Notre-Dame, Anderson wept as he thought of all that Paul's friendship had given him.[6]

Claiming the press of deadlines, Rosenfeld had turned down an earlier invitation to the Hill in August, missing, to his great regret, the historic Shanty raising.

"How I wish I could have helped in the building," he wrote Alfred wistfully. "The thing sounded great. Tolstoy I'm sure would have gloated over it. And blessed Georgia's paintings," he added.[7]

But when Alfred reissued the invitation, Rosenfeld accepted only after much coaxing. With the family and its entourage returned to the city, he was reluctant to intrude on Alfred and Georgia's best working time alone on the Hill. His own summer had been miserably unproductive, with "nothing at all" to show for weeks spent at the typewriter in a rented house in Westport, Connecticut. "Sometimes I feel as though I were falling to pieces," he confessed to Alfred.[8]

Once he was persuaded to come, planning the trip lifted Rosenfeld's spirits. Jauntily, he wrote to both of them, offering his newly acquired domestic skills to the household: his ability to boil water and scramble eggs "may seem very little to the world, but it means much to me, for now I do not fear the revolution as much as I did in more pampered days," he wrote.[9]

Scrambled eggs at breakfast, eaten on the porch in the warmth of

a dazzling Indian summer, were the only test of Paul's culinary prowess. Georgia did the cooking, with the men in charge of cleanup.

Despite Alfred's bulletins about how hard Georgia was working, the Shanty had not proved conducive to productivity after all. The sum of three months' work was a few still lifes and timid and conventional renderings of local flowers—zinnias and the red canna she loved, plums and pears.

Typical of women threatened by feelings of professional failure, she turned to the more certain rewards of householding: gardening, canning, preserving, and cooking. Alfred was delighted, vaunting Georgia's culinary skills to friends and family. Her talents, he noted thriftily, certainly "beat" those of the local woman who had been paid the excessive salary of one hundred dollars for a summer's work preparing the family meals.

To Stieglitz, the month of October was an idyll that marked a turning point in his life. From the first "wonderful full-up" week, he felt transformed by every activity: printing, rowing, walking, even dishwashing and his newest skill, stoking the furnace—"all chores I should have learned long ago," he confessed to Seligmann.[10] He had never experienced this sense of peace and inner contentment, "such feeling of being actually alive. And so clean—" he wrote. His situation was much different from that in other years; everything felt simpler, quieter, more balanced. "Have worked much out of my system . . . am nearing freedom," he wrote.[11]

Stieglitz was still in a transcendent state when Rosenfeld arrived in the middle of the month. Then, on October 25, they were joined by Charles Duncan, the painter with whom O'Keeffe had shared her first three-artist show at 291 in 1916. Alfred brought out his camera for a snap of the three at lunch. Writing to Strand, he smacked his lips over the menu: Steers bouillon with Zwieback, olives, asparagus, bacon, fresh scrambled eggs, cherries (canned and re-boiled), ginger cake, lots of fresh water, and butter.

Rosenfeld's two-week stay turned out to be a happy, harmonious time for all. Their guest, Alfred reported to Strand, was perfectly attuned to the rhythms of both work and pleasure at the Hill.

His joy in being with Georgia and Alfred buoyed Rosenfeld weeks after his return to the city. "I am still in the happy daze of it," he wrote of his visit to the Hill. Resigned to his role of outsider, he was grateful for vicarious intimacy: he thanked Alfred and Georgia for having "given me the opportunity of observing you at close range and for such a length of time."

He would hoard his memories of the lake: Alfred in his old brown

sweater, the black cape thrown over one shoulder, sitting on the carpeted porch, Georgia jackknifing picture frames. He harbored great hopes that the Shanty—"her factory" he called it—"will be one of the most sanitary of places—good for the eye, the soul, the body." He could not forget the sound of Georgia's "little voice."

New York in autumn no longer enchanted him, Paul reported sadly. In his student days "it used to thrill and fill me with dreams . . . the women in their furs and the automobiles on Fifth Avenue and the lights against the night sky." Now he saw only "a great scab, a great pile of refuse." He wondered whether he or the once beloved had changed: "Have I, the Jew, in the new freedom of leisure, ceased being a city dweller? Or is life literally departing from New York?"[12]

T H E V I S I T S of the two young journalists Frank and Rosenfeld that summer and fall heralded a dramatic change in both the substance and what Alfred would always call the spirit of 291. In the next months, Stieglitz himself turned from European cosmopolitanism to American boosterism; from promoting European postimpressionism in all its forms—futurism, fauvism, cubism, expressionism—he now shifted the ground of his struggle to the cause of art made in America by a few native-born modernists.

Stieglitz's turnaround had, in fact, been germinating for some time. First had come the defection of his European-born artists who looked toward Paris and Vienna: Max Weber had broken with Alfred in 1911 at the time of the Buffalo pictorial exhibition. Now, nine years later, Walkowitz followed his friend's example of perfidy and betrayal (the particulars of which Alfred did not elaborate on when he informed Strand of the ingrate's behavior). In between, Steichen's allegiance to France and its artists helped taint all things French for Stieglitz.

In New York, the art scene had changed dramatically. Well before its closing in 1917, the singular role of 291 as a lonely outpost of the transatlantic avant-garde had ended. Dealers and galleries dedicated to furthering the cause and raising the prices of modern European masters proliferated. Stieglitz had a low tolerance for competition. His role in the Forum Exhibit of 1916—when he deputized Stanton Macdonald Wright to dissuade his fellow artists from showing at any gallery that exhibited European art—staked out Alfred's new battleground.

Matisse, Picasso, Kandinsky, and Brancusi didn't need him anymore. Alfred's American artists did, more than ever. Sophisticated amateurs and professionals—critics and museum administrators—accepted modernism as long as it was imported. Those of advanced taste, however,

now joined with diehard conservatives to deny that there was such a thing as native talent. "What do you mean by American art?" the president of the Metropolitan Museum was asked by a trustee. "Do you mean English or French or what? There is nothing American worth notice."[13]

Stieglitz had his struggle cut out for him. He needed a new kind of disciple—not another Steichen scouting far-off fellow artists abroad, but writers and publicists devoted to the promotion of Americans at home. Emotionally, Alfred also needed his followers to be available. Frank, Rosenfeld, and, of course, the devoted Seligmann were blocks from Alfred in New York and happy to take their typewriters to Lake George for a working holiday. His artists (including O'Keeffe) worked best away from New York or—in Hartley's case—away from America.

Marin remained both prolific and devoted, but from a distance (arguably the best place from which to maintain an untroubled friendship with Alfred). Along with his art, the painter of puckish humor and fey bangs was fully occupied with the responsibilities of a householder: he had just bought a house in Cliffside, New Jersey, where he spent winters with his retiring wife and young son until it was warm enough to put the easel and paints in the jalopy and set off for their Maine island.

Unlike Marin, whose dynamically fractured, explosively colored Manhattan skyscrapers and Maine fir trees had attracted a loyal coterie of collectors from the beginning, Dove remained the most difficult of Stieglitz's artists to sell. His vision of the natural world was too uncompromisingly tragic; even a witty portrait of a cow or a collage of found objects washed up on the beach whisper of decay and mortality. Besides being unprofitable, the backbreaking dawn-to-dusk labor on his Westport chicken farm had left him neither time nor energy to paint. To save rent, he and Reds Torr, his companion, were now living on a leaky secondhand houseboat moored in the North River. Fond as he was of Alfred, Dove struggled to survive as an artist and had little leisure left for socializing or for writing the book on American art that Stieglitz kept urging on him. Nor would he have been able to scrape up train fare for a visit to Lake George.

Finally, struggling to earn a living with his commercial assignments, Paul Strand, Alfred's disciple in photography, spent more time on the road with his camera than at home.

For Stieglitz, Paul Rosenfeld and Waldo Frank were the right men at the right time; in them, he found two apostles ready to spread the gospel of American art as well as two new sons to compete for his favor and love.[14]

Only the year before, Frank had published a critical study, *Our*

America (his first book, an autobiographical novel, *The Unwelcome Man*, appeared in 1917). Highly acclaimed, the new work was an outgrowth of the articles he had been contributing to *The Seven Arts*. Frank's theme was a call for national self-consciousness fused with a sense of cultural manifest destiny.

America, he declared, needed, "above all things, spiritual adventure. It needs to be absorbed in a vital and virile art. It needs to be lifted above the hurry of details, to be loosed from the fixity of results."[15] An impassioned critique of the schizophrenic character of American culture, *Our America* pointed to moral decay that coexisted with coarse vitality, a needless conflict between highbrow and lowbrow (terms that Van Wyck Brooks had coined a few years earlier in his influential analysis *America's Coming of Age*). Frank's study ended with a revivalist's exhortation: it was not too late to be saved and reborn. America could still become the beacon in social community, art, politics, and culture. The first step toward redemption was to heed those voices concerned with saving the soul of America from the money changers and pharisees: voices of prophets like Alfred Stieglitz.

To be celebrated as the hero of this spiritual adventure, the prophet of the new awakening, would generally have affirmed Alfred's view of himself and his lifework: But Frank's hymn to Stieglitz was accompanied by an alarming text: America's rebirth as the New Jerusalem would come about by turning to the Chosen Race; Alfred Stieglitz was the Messiah because he was, in Frank's plainspoken tribute,

> A True Jew. He takes up the ancient destiny where the degenerate Jew [the money changer whom Frank had excoriated] had let it fall. He is the prophet. And his ways are near to the old ways of his people. . . . His means was art. But art always as a means. Stieglitz is primarily the Jewish mystic. Suffering is his daily bread: sacrifice is his creed; failure is his beloved.[16]

Poor Alfred! With friends like Frank, who needed enemies? For Stieglitz, Jewishness was the demon with which each member of the family grappled as best—or worst—he could.

Alfred usually managed to avoid the issue altogether; his perfervid identification with all things German helped to deflect questions of ethnic identity. The depth of his discomfort with the "Jewish question" was deeper, however, for being rarely expressed. To Frank, he later explained: "I never much thought of myself as a Jew or any other particular thing. But I'm beginning to feel it must be the Jew in me that is after all the key to my impossible make up."[17]

What Georgia O'Keeffe—a half-Protestant, half-Catholic midwest-
erner of Irish-Hungarian and Dutch descent—made of the Jewish self-
hatred expressed by all Stieglitzes she never said. Her own feelings
about Jews were contradictory. Late in her life, she told an interviewer
that her break with her brother Francis, a rupture dating from the time
when she moved to New York, was due to his virulent anti-Semitism.
He had even refused to pick her up from the house of Jewish friends
(probably the Pollitzers). Yet to the same interviewer, O'Keeffe con-
fessed that she attributed everything she disliked about the Stieglitz
family to their being Jews.[18] She would certainly have understood the
shamed loathing they felt toward coreligionists who were "too Jewish."
She could also connect the internalizing of anti-Semitism by its victims
with the anti-Catholic prejudice, rife in the Midwest, that had led her
father to deny his religion for the more socially desirable Episcopalian
church.

O'Keeffe does not appear to have seized on a singular irony. Despite
his discomfort in being a Jew, Alfred Stieglitz now provided a sanctuary
from anti-Semitism to younger Jewish writers and intellectuals.

As a cultural entrepreneur with his own income, gallery, and pub-
lication, Alfred had been spared the common bruising encounters with
prejudice. Unchallenged, he had been accepted, admired, feared, or
hated—on his own terms. "I am an American," he stated. In a provincial
reactionary climate—anti-art, antimodern, antiforeign—291 had been
a temple, not a ghetto. Its congregants included refugees from estab-
lished privilege and wealth such as Mabel Dodge and Hutchins Hapgood.
For Jews like Rosenfeld and Frank, Stieglitz's denial of the issue was
reassuring; yet he was still one of them, providing safety and refuge
from an alien world.

No one but Alfred could doubt that it was alien. As pervasive among
the most progressive as among the most ignorant, anti-Semitism (along
with similar views of Catholics and, of course, blacks) was a fact of
American life. It would have been evident to Waldo Frank, Paul Ro-
senfeld, and Herbert Seligmann, all contributors to *The New Republic*,
for example, that there was room for only one Jew on the masthead:
Walter Lippmann was "their" Alfred Stieglitz, the token non-Jewish
German-Jew. Even at *Seven Arts*, Paul Rosenfeld had to be transformed
into Peter Minuit before he could write of a "gentlemen's" profession
such as architecture (as opposed to an acceptably emotional "Jewish"
pursuit, such as music). Nor was their patrician colleague Van Wyck
Brooks—however radical a critic of philistine America he might oth-
erwise be—free of the genteel social anti-Semitism and nativism of his
class and period. In *America's Coming of Age*, Brooks suggested sadly

that the second wave of immigrants from eastern and southern Europe had given new meaning to the allegory of Rip Van Winkle; while he slept, "plain, fresh, homely, essentially innocent old America" had disappeared. Hendrik Hudson and his men, playing at bowls, had been "changed into Jews, Lithuanians, Magyars and German Socialists."[19] When Rip awoke, there was no one to recognize him as a descendant of Dutch colonial patroons (significantly, like Van Wyck Brooks himself).

With their fellow radicals still uneasy about the mongrelization of Yankee and Dutch colonial stock, it's not surprising that Alfred's literary disciples felt the need for paternal protection. With Stieglitz "the true Jew" in the forefront of the struggle to Americanize the arts, no one could challenge the right of a Frank, Rosenfeld, Strand, or Seligmann to do the same.

At least one observer, however, saw in Alfred's sanctuary a prison. Recalling Paul Rosenfeld from their days when both were youthful contributors to *The New Republic* and *Vanity Fair*, Edmund Wilson took the view that Alfred's influence on his friend was liberating but crippling—and peculiarly Jewish!

"Paul's strongest tie was undoubtedly with Stieglitz, toward whom he stood in something like a filial relation; and the group around Stieglitz became for him both family and church," Wilson recalled. He went on to underline a cruel irony: the protection Rosenfeld needed and found under Alfred's black loden cape was felt by others as a barrier. "The only traditionally and specifically Jewish trait that ever came, in my intercourse with Paul, as something alien, that blocked understanding between us," Wilson recalled, "was the quality of his piety towards Stieglitz, whom he accepted and revered as a prophet, unquestioningly obedient to his guidance."[20]

S T I E G L I T Z M A D E portraits of his two friends and disciples Rosenfeld and Frank during their visits to the Hill in the summer and fall of 1920. Like all of Alfred's portraits, they reveal as much about the photographer as they do about his subjects.

Alfred's iconic image of Rosenfeld is a portrait of the man of letters, whose gentlemanly tradition is confirmed by Paul's beautiful hands, a seal ring glinting on one finger. Arranged on his desk are the attributes of the writer's trade, along with evidence of its anxieties: a typewriter, a set of galley proofs, an agenda, and a crumpled pack of cigarettes. Turning from his labors with a worried expression, Paul looks obliquely toward the camera. Within close reach of the sitter are four books whose

titles proclaim both the strong familial ties of the Stieglitz circle and its leading role in an apostolic succession of celebrants and critics of American culture. On the left, still in its dust jacket, is Waldo Frank's *Our America*, which had appeared the previous year; standing next to Frank's volume is Van Wyck Brooks's *The Ordeal of Mark Twain*. A ground-breaking study of a writer in its use of Freudian perspective, Brooks's portrait, published only months before Rosenfeld sat for Stieglitz, had created shock waves. America's most famous and beloved humorist was depicted as a man tormented by having sold his talent and his soul for success—Alfred's favorite morality tale. On the other side of Brooks's volume, with matching dark spine and gold letters, stands Rosenfeld's first book, *Musical Portraits*. Recalled as "absolutely dazzling" by none other than Edmund Wilson, the book also announced Rosenfeld's new role: music critic of *The Dial*.

Where *Seven Arts* had been pacifist and self-consciously American, its more influential successor was international and apolitical, devoted to furthering modernism in arts and letters; Van Wyck Brooks was editor, but the journal's real headquarters was Rosenfeld's apartment. Paul's rediscovery of America would now enjoy a wider audience. For Alfred, having a key man on the magazine's masthead would ensure greater recognition for his artists.

On Rosenfeld's desk in the photograph, Carl Sandburg's most recent collection of poetry, *Smoke and Steel* (including "Slabs of the Sunburnt West") is the final reminder of the sitter's role as apostle in Alfred's struggle to Americanize the arts. With poems entitled "Work Gang," "Honky Tonk in Cleveland, Ohio," "Corn Hut Talk," and "New Farm Tractor" at hand, Rosenfeld has interests, Stieglitz's portrait tells us, that go beyond those suggested by his patrician professorial appearance; turning to his typewriter, he is prepared to exalt the roots of American art.

If Paul Rosenfeld is the reliable intellectual guide to America's heartland, Waldo Frank is portrayed as an unreliable bohemian. He is seated pigeon-toed on the farmhouse porch, and the incongruousness of his citified attire—dark suit, white shirt, and tie—is underlined by the comically turned-up brim of his felt hat. From his costume alone, it is obvious why Waldo was not a participant in Georgia's Shanty raising.

Waldo's portrait is the picture of a schlemiel—the classic Jewish loser (perhaps Alfred's revenge for Frank's canonizing him as a "True Jew").

Frank is shown coring apples over a messy-looking manuscript on his lap, two cores lying on the rug beneath his chair. His gaze, as he

looks toward Alfred's camera, manages to be both beseeching and defiant.

Stieglitz called the portrait of Frank his "apple picture." Certainly, the Americanness of that most native of fruit (especially plentiful on the Hill) was symbolically linked to Waldo's mission: rediscovering a distinctly American culture that would speak for and to all its citizens.[21] Even the spooled chair on which Frank sits, along with the white clapboard wall behind him, affirm the strength and simplicity of American vernacular craft; they exemplify the "usable past" that, in Van Wyck Brooks's famous phrase, would help forge a vital modernism.

It is Frank himself whose presence on the porch of this classic nineteenth-century farmhouse seems intrusive: the slovenly son of immigrants, in his "wrong" city clothes, travesties the purity of his rural setting. Consumed by Waldo for his own ends, the fruit of knowledge is not returned to the soil to become sustenance for others but is tossed on the floor as garbage. Waldo Frank's America is not "ours," but his alone; its author is no sower of seeds, but the worm in the apple.

TO VARYING DEGREES, Georgia kept her distance from Alfred's fervent apostles. She does not seem to have shared Alfred's distrust of Frank, writing him admiring letters about his social and cultural criticism and exhorting him to keep the faith. It was to Waldo that O'Keeffe officially proclaimed her role of reborn primitive, telling him, "I am one of the intuitives."[22] And when Alfred furiously objected to Frank's portrayal of O'Keeffe as a peasant, Georgia wrote to him to say how much she liked his article, which had appeared in McCall's.[23]

Although Georgia was fond of Rosenfeld personally, Paul's effulgent hymns to female sexuality as expressed in her art established the text for an interpretation of O'Keeffe's work that—publicly, at least—she repudiated. Seligmann she actively detested, baiting him to the point where he refused Alfred's invitation to visit the Hill; once Georgia had humiliated him by slyly challenging his statement that he didn't care to go where he wasn't wanted. He clearly wasn't wanted by her; why, then, was he there?

Recognizing the importance of his disciples' drumbeating, especially in the absence of a gallery to exhibit his artists, Alfred expended much ink on soothing the egos and smoothing "misunderstandings" caused by O'Keeffe's cavalier treatment of his unpaid publicists. The purpose of Seligmann's disputed visit, after all, was to discuss Marsden Hartley's collection of essays Adventures in the Arts. Through the remainder of

the long hot summer of 1920, Seligmann would edit the manuscript, see it through the press, and attempt to publicize the book, all the while fighting with the publishers as aggressive representative of Alfred's interests. Since the volume, moreover, included essays of fulsome praise for both Stieglitz's photographs and O'Keeffe's painting, this was no time for Herbert to be alienated by Georgia's transparent hostility. As he would always do when people "misinterpreted" Georgia's behavior, Alfred reminded the offended party of O'Keeffe's highly strung nervous system, her frail physical state, and the difficulties she was having—at that particular moment—of working and assured all (particularly the hypersensitive Rosenfeld, who could feel slighted with no provocation at all) of their admiration, appreciation, and affection.

RETURNING TO the city in early December, Alfred and Georgia were plunged into the flurry of activity imposed by the move from the studio to Lee and Lizzie's house. Shortly after they settled in, Mitchell Kennerley persuaded Stieglitz that he should avail himself of the Anderson Galleries' exhibition space, not only the basement storage area, for his first exhibition since 1913. It was high time for New York to see Alfred's new work, of which Kennerley, a studio regular, had been offered electrifying previews.

For Stieglitz, the first weeks of the new year were swallowed by the rush of selecting and mounting prints for the new show. Along with the agonizing decisions about what would best represent eight years of work, his choice also involved the sensitive issue of the intimate prints of O'Keeffe. Family objections were heard but, apparently, overruled.

For both landlords and tenants at 65th Street, the fraternal agreement worked out well. Georgia and Alfred ate out nightly; a weekly visit to Hedwig and another evening at the Engelhards took care of two dinners. On other nights, a passer-by, peering through the windows of one of the many cheap Italian restaurants along Third Avenue—windows begrimed by the El clattering overhead—might have spotted an arresting couple. Emerging from identical black loden capes, Alfred and Georgia would be seated at a table for two eating silently amidst the chatter of other diners.

After the meal, it was a short walk back to 65th Street, where visitors might be lounging on the stoop awaiting their return. Besides the always welcome regulars—Seligmann, Strand, Frank, and Rosenfeld—there were new faces. With Lee's blessing, Alfred took advantage of their present lodgings to try to sell Georgia's work to his brother's rich patients.

Money had become a pressing problem. Emmy and her trust funds (now much diminished) were gone. They could hardly expect Lee to do more for them than he was doing. Even other relatives' help—Alfred's generous niece Flora, recently married to a member of the Straus retailing family, was a steady patron—did not constitute an income. For the first and last time, Alfred succumbed to Georgia's urging to accept a well-paid commission; for fifteen hundred dollars he photographed a notably plain Miss Wertheim. Otherwise, an old friend, such as Simie Hermann, might persuade Alfred to accept a check for a portrait of himself or his wife.

ON FEBRUARY 7, 1921, the first visitors arrived at the Anderson Galleries, where two rooms were devoted to one hundred forty-six photographs by Alfred Stieglitz. One hundred twenty-eight had never been exhibited before; of these, seventy-eight had been made between 1918 and 1920, including forty-five prints from his portrait of O'Keeffe.

Called "A Woman" in the catalogue, the exhibition detonated greater shock value and provoked more gossip by its official anonymity about the woman revealed in the images: from cloaked and haughty mystery to the mysterious promise of her naked body, the prints created the scandal expected—and orchestrated—by Stieglitz. Indeed, much of the shock was created by the disparity between the clothed and naked O'Keeffe. A young cousin of Alfred's, then an art student herself, recalled her difficulty in reconciling the austere—even old-maidishly dressed—woman she saw at Lake George with the nude torso, covered by an astounding luxuriance of pubic hair, on display at the Anderson Galleries.

Even before the prints were framed, Alfred primed his journalistic coterie. Frank Harris, anonymous author of *My Secret Life*, the bible of Edwardian erotomania, had an early viewing during his visit to New York in January so that he could himself write the article for *Pearson's* magazine, the London-based journal that he edited.

Herbert J. Seligmann's review, first rejected as "incomprehensible" by Walter Lippmann at *The New Republic*, was finally accepted by *The Nation*. Buried in his panegyric to Stieglitz as prophetic voice of the "real" America was an astonishing insight about the portrait: the misogyny that smolders beneath the photographer's exaltation of the feminine. "Do not Americans fear woman as they fear the plague?" Seligmann asked. "With reason, for woman is terrible, as terrible as life."[24]

Writing in *The Dial*, Paul Rosenfeld brilliantly conveyed the tactile

quality of the portrait, noting the way Stieglitz "brought the lens close to the epidermis in order to photograph, and show[ed] us the life of the pores, of the hair along the shin-bone, of the veining of the pulse and the liquid moisture on the upper lip." No one had caught the "dark wet quick" of man (or woman) as Stieglitz had done, he said. But Rosenfeld, too, saw more pain and despair than joyous sexuality in the model. O'Keeffe's eyes gazed out "sorrowful and knowing," her navel "the point of an anguish that eats away the life within"; her breasts "hang tired and sensitive, sore from too much pain. A tiny phallic statuette weeps; is bowed over itself in weeping."[25]

For the three thousand visitors who crowded the two rooms gazing at the prints hung on red velvet walls, the portrait was a visual Song of Songs, a tribute by the most famous photographer in America to his beautiful younger lover, an artist whose paintings could, tantalizingly, just be made out behind her raised arms and naked breasts.

"I was born in Hoboken. I am an American. Photography is my passion. The search for Truth my obsession," read Alfred's terse autobiographical statement in the catalogue.[26]

Those who came, attracted by the steamy aura of the exhibition— because it was the thing to do—stayed to marvel and be moved. Most would have agreed with Lewis Mumford, who saw in the portrait "the exact equivalent of the report of the lover's hand, exploring the body of his beloved."[27] One young woman was seen weeping as she left. "He loves her so," she said.[28]

O'Keeffe recalled several men who "after looking around awhile— asked Stieglitz if he would photograph their wives or girlfriends the way he photographed me. . . . If they had known what a close relationship he would have needed to have to photograph their wives or girlfriends the way he photographed me—I think they wouldn't have been interested."[29]

Just as it is hard to know her role in the collaboration itself, Georgia's part in the decision to exhibit the prints remains murky. The most private of women, she cannot have been unaware of the kind of publicity, curiosity, and speculation that would attend the public availability of her naked body. Nor is it likely that she failed to explore Alfred's motives. Others in their circle lost no time in doing so. An admirer of Stieglitz, art critic Henry McBride, wrote:

And then, all at once, someone ran down Fifth Avenue crying that Alfred Stieglitz had put a price of $5000 on one of the photographs, a nude, one that was a unique impression with the plate destroyed. Gracious Heavens!

$5000 for a mere photograph! And then everyone had to see the exhibition over again, the crowd about the nude being particularly dense.[30]

Mabel Dodge swiftly made the connection between Alfred's use of the portrait for purposes of publicity and the curiosity aroused by Georgia's later exhibitions of paintings—works whose sexually organic themes the artist denied. In harsh language, Dodge accused both O'Keeffe and Stieglitz of moving in a "cloud of unknowing," proclaiming their innocence and the dirty-mindedness of others while they gleefully counted the house and the shekels.[31]

Whether Stieglitz and O'Keeffe were knowing or unknowing, the publicity created by the succès de scandale at the Anderson Galleries made O'Keeffe famous. She became, as McBride pointed out, "a newspaper personality." The obscure young artist whose debut had been obliterated by America's entry into the war was now a celebrity by virtue—or vice—of her way of life, her name known to a public who had yet to see her work.

One new friend of O'Keeffe's was appalled by the way in which Alfred had provided a public peep show into his and Georgia's private life. Writing to her sister, the painter Florine Stettheimer mentioned meeting Georgia for the first time; accompanied by Alfred, she had come for tea just after the notorious exhibit of prints from the Stieglitz portrait of O'Keeffe.

"I told [Georgia] I was pleased to see her whole, as so far I only knew her in sections," Florine reported. Alfred "spouted all sorts of indiscretions."[32] Florine would continue to voice her dismay at the worst of these: the exploitation of his intimacy with Georgia for the "white glare" of publicity and the soiled coin of profit.

TWELVE

New Beginnings

Alfred snapped Georgia watching while Donald Davidson, husband of
Stieglitz's niece Elizabeth, pruned a tree at Lake George.

DISAPPROVAL NEVER DAUNTED Stieglitz; it affirmed him. Georgia was discomfited by the scandal following her exposure at the Anderson Galleries in February 1921. Alfred wasted no time in exploiting her sudden fame.

Invited by the distinguished Pennsylvania Academy of Fine Arts to mount an exhibition of contemporary painting, called "The Later Tendencies in Art," he made a condition of his agreement the inclusion of three works by O'Keeffe. Of the canvases that Alfred carried to Philadelphia on the train in early April, the most recent, *Black Spot* (1919), had been executed two years before. Since then, Georgia had done little painting that satisfied her.

One symptom of her work block was an obsessive concern with preparation. Writing to Dove, who was represented by two paintings in the show that Alfred was then hanging, O'Keeffe made it clear that most of her energy was focused on priming. "I've painted a little more—

about 12 × 16 I guess—on a canvas filled with white lead till it was really smooth," she reported. "It was about like I imagine learning to roller skate would be."[1] Preparing her canvas for a perfection of whiteness had begun to preoccupy O'Keeffe earlier: in her one known abstraction of 1920, *Series I, No. 12*, a billowing veil of diaphanous white fills almost the entire canvas before folding into gray at the left and right edges.

In Lee and Lizzie's house in town, she could not take refuge in domesticity. But the city in the company of Alfred and his friends provided constant diversion, social and cultural. The feast of musical offerings, in particular, was Georgia's delight. In the early 1920s, New York boasted more orchestras, opera companies, and performing artists—visiting and resident—than would ever be heard again. The importance of music to avant-garde artists in other disciplines reached a peak at this time, as reflected by Paul Rosenfeld's salon.[2]

For O'Keeffe, music would always be the highest form of human expression: she later claimed that she painted only because she couldn't sing. In Charlottesville, she had persisted in trying to teach herself to play the violin, before giving it up. Opera, symphony, the harsh dirges of the Penitentes, Sviatoslav Richter performing Beethoven sonatas— her taste would always be eclectic. Music was a passion she and Alfred shared. Conventionally Romantic and German in his preferences, Stieglitz embraced musical form as an entirely subjective experience. At about this time, he began to translate music as the expression of his emotional state in a new series of photographs, the first of his Equivalents: *Songs of the Sky*.

Some, like Hutchins Hapgood, were startled by Stieglitz's indifference to the formal qualities of a work of art. His unquestioning acceptance of the "pathetic fallacy" (the belief that every cloud existed only as a reflection of his own mood) struck others as adolescent, unsophisticated, and anti-intellectual. For Georgia, Alfred's perceptions, as they were brought to bear on the world of phenomena, were virtues; his deep personal engagement with music, painting, and nature led her to see and hear with new insight. In contrast to the analytic, argumentative theorizing she loathed among his disciples, Alfred's intensely felt engagement with all experience helped keep alive her own freshness of vision.

Still, they both enjoyed Rosenfeld's knowledgeable commentary (and possibly free tickets) for musical events they might otherwise have missed. Paul, too, delighted in Alfred's unabashed "oneness" with what he heard as well as Georgia's more reserved pleasure. Her restraint, he recalled with fond amusement, extended to postmusical refreshment.

Following a concert by the Detroit Symphony, the three had repaired to a 59th Street restaurant. While her two companions wolfed down chocolate éclairs, Georgia, Rosenfeld noted admiringly, "remained faithful to her grapefruit."[3]

AFTER FOUR YEARS of playing mascot to "the men"—alternately exalted as "Woman Supreme" and patronized as the "Great Child," O'Keeffe was drawn into the circle of an astonishing trio of women.

Georgia's first meeting with Florine Stettheimer had developed into a warm friendship, leading to a still closer relationship with Florine's sister Ettie. The Stettheimer sisters—Ettie, Florine, and Carrie—lived with their mother, dividing the year between Alwyn Court, a High French Gothic fantasy of an apartment building at 58th Street and 7th Avenue, with summers at Andree Brook, a rented estate in Westchester. It had been a matriarchal household since Stettheimer *père*, a German-Jewish banker, had disappeared when the children were very young and the family was living abroad. Happily, the money belonged to the mother, the former Rosetta Walter. At the beginning of the war, she returned to New York with her five children. Walter, the only son, escaped early into business. After being educated privately, Stella, the one daughter to marry, moved to Los Angeles.* Florine went on to study painting, first at the Art Students League and then with Robert Henri. Ettie returned to Europe to earn a doctorate in philosophy at Heidelberg before writing cerebral novels under the name of Henrie Waste. Carrie took on the management of the elaborate household, soon to become famous as a salon where wit, elegance, and a precious style of baroque fantasy—in menu, decor, and hostesses' costumes—reigned. Normally ephemeral, Carrie immortalized her housekeeping talents in the building and furnishing of a dollhouse, in which the panoply of Stettheimer guests (including Stieglitz and O'Keeffe) along with their works of art were lovingly re-created in miniature.†

Fantasy swathed the Stettheimer ménage, symbolized by the festoons of cellophane favored by Florine as hangings and omnipresent in the bouquets of fake flowers. Florine's bedroom, here and later, in the grand studio apartment she rented, was hung with miles of antique white lace. The same precious stuff, laid over velvet or brocade, covered the table where the famous Stettheimer cook brought out heavy silver tu-

* One of her three children was Walter Wanger, the movie producer.
† The dollhouse is now in the Museum of the City of New York.

reens filled with the house specialty, feather soup, followed by squab and a dazzle of mouth-watering confectionery.

Central to the shimmering white and gold of the decor were Florine's paintings, displayed on easels strategically placed around the vast salon. Like Georgia, but in a very different direction, Florine had turned her back on the lessons of academic oil technique and perspective, in favor of a sophisticated, fauxnaïf style, in which brilliant fauve colors, pink and orange predominating, were overlaid on a heavy impasto of Chinese white.

Florine used this unlikely technique to forge a witty, original genre of social satire: in *Sale Day at Henri Bendel*, rubber-waisted floorwalkers dip toward dizzy customers. The Stetties' own circle of friends and relatives, disporting themselves at country weekends and city soirées, were not spared her ambivalent gaze. In group portraits of the family, sibling rivalries and resentful servitude to an invalid parent simmer below the surface of exotic costumes and studied postures of the three sisters and their mother. Other subjects were individual portraits of friends (including a full-length, flatteringly youthful study of Stieglitz) mixed with enchanted still lifes adorned always with Florine's symbol, a mayfly.

In a style that suggests an encounter between Grandma Moses and the Belgian visionary James Ensor, Florine's most ambitious works were a series of baroque celebrations called Cathedrals. The main staircase of the Metropolitan Museum, embellished with chandeliers and gushing fountains, is transformed into a Folies Bergères–like setting for *The Cathedral of Art*. Portrayed as a cosseted infant, Art is cradled by the museum director while lesser figures in the art world lounge, lurk, or preen above and below.

Sexual ambiguity perfumed the air of the Stettheimer evenings. Marsden Hartley saw Florine as "ultrafeminine"; the sisters' biographer called them all "virgins by desire."[4] Yet their attachments to chosen men and women were the more intense for remaining, most probably, asexual.

Marcel Duchamp—or Duche, as he was known in the sisters' matey style—was Florine's special friend. She was venomous at the news of his defection by marriage to the heiress of a French automobile fortune. A "fat peasant" was only one of the insults heaped upon Duchamp's real-life bride.

Literary Ettie harbored tender feelings for Sherwood Anderson. Surrounded by effete regulars, such as art critic Henry McBride and the mannered bejeweled photographer and writer Carl Van Vechten, the

earthy womanizing midwesterner must have appeared a bull in a cellophane-draped china shop. For a time, Sherwood and Ettie exchanged letters. In 1926, Anderson acknowledged that something, briefly, had ignited between them; she had attracted him in the way of "some warm exotic plant," he wrote in his *Notebook*, published that year.[5] In his presence, Ettie confessed, she felt "a sense of life such as one feels when holding a bird in the palm of one's hand in the quiver of its beating heart."[6] But Anderson soon found the atmosphere at Alwyn Court too rarefied, too rich, too desexualized and un-American. Brutally and in print, he dismissed the sisters for being "born rich"[7] and Ettie's novels as devoid of life, soon drifting off to pursue more passionate friendships and many marriages—the apt title of one of Anderson's novels.

Like Gertrude Stein's evenings, the Stettheimer guest list was dominated by men; women were tolerated, for the most part, as consorts.

Georgia was the rare exception. Androgynous in sexuality and style, she was the perfect foil for her hostesses' high camp femininity. Her ladylike reserve and austere elegance of dress, moreover, set her apart from the Greenwich Village bohemianism of the "new woman" whose slovenly or "arty" attire suggested both promiscuity and lack of taste—qualities equally abhorrent to the fastidious Stettheimers.

Sixteen years older than Georgia, Florine at forty-nine was admiring, envious, and protective of her younger friend. As serious a painter as O'Keeffe, she hid an equally intense ambition behind the genteel style of inherited wealth. After an exhibition of her work in 1916 at Knoedler's had proved a failure with both critics and collectors, Florine retreated into a fluttery, deliberate amateurism, professing a horror of seeing her work sold, lest a painting should end up "in the bedroom of some man."[8] (Georgia had expressed similar revulsion at seeing her paintings, "like beautiful children," sullied by the vulgar gaze.)[9] The difference between the two artists—that Georgia managed to get over such unprofitable inhibitions and Florine could not—was probably due to O'Keeffe's early poverty and Stieglitz's adroit management of her career. In the measure that Alfred hustled for publicity, Georgia could plead for privacy.

Florine's attitude toward Alfred was complicated by her fondness for Georgia; on the one hand, the warm, friendly, and often frank letters exchanged by Stieglitz and Florine reveal an understanding of one another special to those who are close in age, interests, and social background. On the other hand, her affection for, or perhaps attraction to, O'Keeffe intensified her disapproval of Alfred's exhibitionism.

THROUGH THEIR friends William and Marguerite Zorach, painters and sometime set designers, the Stettheimers were part of a group of artists and intellectuals who contributed, according to their means, money, talent, or applause to the Provincetown Players.

Since 1916, when the Players had performed his friend Alfred Kreymborg's poetic fantasy *Lima Beans*, Stieglitz had been a supporter of this historic incubator of talent. Earlier in 1916 the group had performed the first play to be staged by the son of a famous tragedian: *Bound East for Cardiff* by Eugene O'Neill.

Amateur actors, directors, stage managers, and playwrights, the members of the Players were professionals in other fields. Besides Kreymborg, the freewheeling company was studded with Stieglitz friends. The group had begun with living room theatricals performed in the rented Provincetown summer house of Hutchins Hapgood and his wife, Neith Boyce. After one season, the band of journalists, painters, and poets who had transformed the Cape Cod fishing village into a summer artists' colony found a winter venue for their plays: an early Victorian house at 139 (later 133) MacDougal Street in Greenwich Village.

In the days of 291, a brisk walk down Fifth Avenue and across Washington Square Park would take Alfred to watch plays written and performed by other friends and admirers, including Theodore Dreiser and William Carlos Williams. Among the audience that crowded into the parlor floor of the brick house consecrated to the Playwrights Theater were still more familiar faces: Mabel Dodge was unlikely to miss any performance that featured her handsome lover John Reed or the ingenious minimal sets devised by her friend and protégé Robert Edmund Jones.

When Georgia moved to New York in 1918, she was already familiar with the writings of Susan Glaspell, who with her husband, George "Jig" Cram Cook, had been part of the Chicago Renaissance before becoming guiding spirits of the Players. Georgia and Anita Pollitzer had worried over the morality of Glaspell's novel *Fidelity*; neither young woman could wholly approve of a work that seemed to argue that sexual passion justified hurting others. In the three years since they had read the book together, Georgia would have reason to be more sympathetic to lovers who agonized over such choices. She would still, however, find alien the programmatic bohemianism, especially the openness about sex, that was taken for granted by Village denizens: the Hapgoods, writing and performing in *Enemies*, a two-character play about their marital troubles, would not have been to Georgia's taste. Then, in 1919, the

Players added the acting and writing talents of a beautiful young poet, Edna St. Vincent Millay; if she did not make specific literary capital of her many lovers, neither did Millay trouble to hide the particulars of the dramas attendant on her affairs with men who were usually married and usually were friends with one another. The Provincetown Players, like the Village scene generally, tended to be incestuous.

In late November 1920, O'Neill's play *The Emperor Jones*, opened, featuring the black actor Charles Gilpin. Both the production and the star caused a sensation; ecstatic notices sent hordes of uptowners down to the tiny box office, where they pleaded for seats. As a subscriber, Alfred would have been the envy of newcomers to the Provincetown's precincts.

When he returned to America between long stays abroad, Marsden Hartley too spent time at 133 MacDougal Street; in addition to the lively company, he was attracted by the restaurant operated on the second floor of the house by the earthy, red-haired Christine El, where meals were sixty cents.

That same season, another painter, a charter member of the theater from the first Provincetown summer, became a friend of Georgia's. Charles Demuth had been on the periphery of the Stieglitz inner circle since the days of 291; in 1914, his friend Marsden Hartley, then living in Berlin, had introduced him to Alfred by letter. The following fall, Stieglitz invited Demuth, just returned from a second European visit, to contribute to a solicited hymn of praise—"What Is 291?"—published in *Camera Work* in January 1915.

From the beginning, Demuth yearned to be one of Stieglitz's chosen few. Paradoxically, it was the artist's genius as watercolorist that would keep him from realizing this ambition until 1925. Alfred was said to be leery of taking on an artist who would be competition to Marin, the resident watercolor star; he also claimed to find Demuth's work too French in its refinement.[10]

Failure to be included among the inner circle did not affect Demuth's friendship with Stieglitz. By the spring of 1915, Alfred had made several photographs of the intriguing artist, portrayed as an elegant, somewhat disdainful dandy.

An only child, Demuth was born in 1883 to a prosperous merchant family whose roots in Lancaster, Pennsylvania, went back to the eighteenth century. At the time of the artist's birth, his father owned and operated the oldest continuing snuff factory and tobacco shop in America. The family's beautiful Federal period house and his mother's prize-winning garden would remain a lifelong refuge and source of inspiration to Demuth, along with other scenes of the Lancaster region. Demuth's

precisionist paintings of churches, mills, and factories, together with his haunting watercolors of fruit and flowers, bear witness to what he saw closest to home.

The economic and social security enjoyed by the artist, who never needed to earn a living, was offset by other burdens. Lamed from childhood by an undiagnosed tuberculosis of the hip, Demuth first began to show symptoms as a young adult of the diabetes that would kill him in 1935. Sometime between these two afflictions, he became aware of his homosexuality; doubly crippled by illness, Demuth was forced by his erotic attachments to become an underground man.

William Carlos Williams called Demuth a "wisp of a man." Yet despite his size, his physical disabilities (including a cast in one eye), he was vain about his swarthy matador's appearance: dark eyes and slicked-down patent leather hair. Writing to Stieglitz of the portrait Alfred had done in 1922 when the ravages of diabetes were horrifyingly apparent, Demuth told him: "I think the head is one of the most beautiful things that I have ever known in the world of art. A strange way,—to write of one's own portrait,—but, well, I'm a perhaps, frank person. I sent it this morning to my mother."[11]

Most friends would have agreed with Demuth about his looks; the elegance of his style—if not beauty—created an aura of immense glamour and allure. A dandy to the tips of his long, expressive fingers, he was addicted to expensive English clothes and accessories; everything he wore and owned had to be "the best of its kind," as he liked to say. He was equally famous for his wit: he tossed off bons mots and drolleries of all kinds in a squeaky voice with an unmistakable Lancaster accent.

No one but the painter himself, however, would have described Demuth as frank. Indeed, even his closest friends claimed no intimacy; they were the first to describe him as secretive, enigmatic, and mysterious. His remoteness must be explained, in part, by his underground life in the baths and private homosexual clubs in the Village and Harlem. His associates in this twilight world formed an existence apart—even from the tolerant community of artists. His sense of mortality created another dimension of distance from others: insulin had been discovered just in time to save his life, yet he refused to act responsibly about its regular use, continuing to enjoy forbidden pleasures such as alcohol and sweets.

Georgia took an immediate liking to Charlie and she and Alfred began to see him whenever he was in town. His bingeing on these visits occasionally turned their outings into medical emergencies; Alfred and Georgia would have to carry their friend for help when he collapsed from diabetic attacks.

Acquaintances observed that these "rescue operations" seemed to have drawn the three friends closer.[12] But O'Keeffe and Demuth soon established a special relationship that excluded Alfred and puzzled other friends. Her preference for the mannered, remote dandy went beyond her explanation that he was more fun than most of the solemn souls in the Stieglitz entourage. He was "a better friend with me than any of the other artists," she acknowledged.[13]

Early in 1923, Georgia began visiting Demuth in Lancaster—without Alfred. She stayed at a hotel near the Demuth house, taking meals with either Charles's mother, Augusta, or with his aunt Mrs. Christopher Demuth. O'Keeffe at the time was earning next to nothing. For her to travel out of town and especially to bear the cost of a hotel underlines her attachment to Demuth.

As Georgia drew closer to Charlie, she began exploring his preferred subject—flowers—even down to the particular species Demuth favored: zinnias, iris, and lilies. Georgia's blooms grew bigger and she jokingly suggested that, with their different view of flowers, they should collaborate on a large-scale work: Georgia would do giant blossoms high up on the canvas; Demuth could do his small, exquisitely observed renderings below.

O'Keeffe became Demuth's first subject in a series of "object portraits" in poster format that the painter made of friends and fellow artists. In his watercolor, Georgia is portrayed as a potted sansevieria, a desert bloom known to be indestructible; its sinuous, spiky leaves give it the common name snake plant. Demuth's choice of symbol suggests that he was aware of his friend's less endearing qualities. His graphic play on O'Keeffe's initials exploits both meanings of the slang phrase: Georgia was O.K.—a "good kid" and a real survivor at the same time.

Hints about a deeper bond between the two friends emerge even from earlier works by Demuth that were rarely exhibited in the artist's lifetime: watercolor series depicting erotic transactions among sailors, between men in Turkish baths, in intimate scenes at home, and in the interlaced bodies of female acrobats. At the same time that the artist explored these subjects, he executed, between 1914 and 1919, a series of watercolor illustrations of literary texts, including scenes from Zola's *Nana* and *L'Assommoir*, Wedekind's *Lulu* plays, Balzac's *Girl with the Golden Eyes*, and Henry James's *The Turn of the Screw*. A recurring theme in the fictions chosen by Demuth, according to one critic, "is the confusion of masculine and feminine roles—sexual identification, and the signs of gender seem always in the process of breaking apart."[14] If male homosexual relationships are not depicted directly, "female ho-

mosexuality is almost always present." This is the "dangerous and essential secret" shared by the men and women who suffer or inflict pain in the scenes Demuth illustrated.[15]

In his will, Demuth left O'Keeffe all of his unsold works in oil. Among these was his painting *Calla Lilies* (1926). In 1923, three years before Demuth chose this subject, Georgia had made the first of many versions of the flower.

Subtitled *Bert Savoy*, Demuth's lilies are a portrait of a famous female impersonator. In using the lily as an emblem of his subject's dual gender—onstage and off—Demuth, like O'Keeffe, alluded to the flower's articulation of male and female sexual organs. Echoing the sexually ambiguous theme of his portrait, Demuth's entwined lilies rise from an open fluted shell, symbol of female procreation. O'Keeffe painted the first of her shell series in 1926, the year of Demuth's portrait.

Until 1921, Georgia could have seen her friend's paintings at Charles Daniel's gallery. But that year, just before he sailed for Europe, Demuth's relations with the genial ex-publican turned art dealer soured; he no longer trusted Daniel in money matters. Subsequently, he tried once more to convince Stieglitz that he belonged in the magic circle of his artists. Alfred was not persuaded; he vetoed the watercolors, but grudgingly took a few oils for a group show at Anderson Galleries in 1922; year: they did not sell.

Stieglitz sympathized loudly and on paper with Demuth about his dealer's venality and ignorance.[16] But as long as Alfred had no gallery of his own, he needed Daniel; he made sure they remained on good terms, continuing to hang Hartley and the rest of his homeless artists in Daniel's shows.

OTHER GALLERIES devoted to contemporary art were on Alfred and Georgia's regular circuit: Montross, Macbeth, Weyhe, Washington Square. Stieglitz might rail to Rosenfeld about "that damned French influence," but he kept a weather eye on the competition—transatlantic and homegrown—to "his" Americans. High on his enemies list among American competitors was the Whitney Studio Club, brainchild of socialite sculptor Gertrude Vanderbilt Whitney and her dynamic managerial alter ego Juliana Force. The inclusive policy of the Whitney shows, in which artists of varied styles, schools, and levels of talent were welcomed, drew Stieglitz's sneers. But the real object of his venom was not the Whitney's democratic support of the many; it was his hatred and fear of rich women and the institutions they controlled. Whitney's

patronage of Charles Sheeler and Marius de Zayas, both of whom were having a hard time supporting themselves, intensified Alfred's ill will toward these artists who had once been his friends.

Alfred and Georgia's gallery visits seem to have been restricted to viewing contemporary art. Georgia never got over her distaste for Old Masters acquired in the gloomy Great Hall of the Chicago Art Institute. In any case, Stieglitz's promotion of O'Keeffe as all-American unfailingly emphasized her native purity, untainted by foreign or past influence. Georgia had sprung, fully formed, from the American soil. She needed no masters, old or new. His own youthful passion for Reubens, along with late-nineteenth-century romanticism, moreover, seems to have waned with his repudiation of pictorialism and a commitment to American modernists. Ever since 1911, when General Cesnola, the director of the Metropolitan Museum, had sneeringly turned down Alfred's offer to sell the Picassos exhibited at 291, the treasure palace on Fifth Avenue had become enemy territory.

Still included in each week's social calendar was the Round Table dinner at the Far East China Garden (with Alfred still picking up the check). But one change in these gatherings would have struck Georgia for the better; the din of intellectual discourse had muted. Marriage was thinning the ranks of the men.

In 1922, Herbert Seligmann married a dancer and teacher of modern dance, Lillias MacLane. The bride's artiness inspired more mirth than affection, at least among the clan at the Hill. After the newlyweds' visit there, Donald Davidson reduced family and guests to helpless laughter by donning his wife's corsets and prancing around "doing" poor Lillias as Isadora.

Paul Strand too had fallen in love. Rebecca Salsbury had been four classes behind him at the Ethical Culture School. If Paul remembered Beck at all, it would have been as the school's basketball star. Now, while living at home, fighting with her mother, and trying to decide what she wanted to do with her life, Beck worked part-time as alumni secretary of the school. She and Paul probably met through her pursuit of lost graduates.

Since her days of shooting baskets, the tall, gangly schoolgirl had become a dramatically beautiful young woman. Long-limbed, slender, and full-breasted, she had a mahogany mane of hair, already streaked with gray, framing wide-set, heavily lidded green eyes and a square jaw.

Beck's origins were as theatrical as her looks. Her father, Nathan Salsbury, began a successful career as singer, actor, producer, and showman early: as a fifteen-year-old runaway recruit to the Union army, he was said to have cheered General Sherman in the darkest hours of

the march through Georgia with his spirited singing of "Oh, Susannah." Turning to straight acting after the war, Nate (whose family name most probably began as Salzburg or Sulzberger) went on to form his own vaudeville troupe, the Salsbury Troubadours, before becoming Buffalo Bill Cody's partner and the business manager of his phenomenally successful Wild West Show.

As impresario and producer, Salsbury raised money and organized the show's sell-out tours of England, which began in 1887, the year of Queen Victoria's jubilee; the aged monarch herself paid a visit to Earl's Court, astounding her entourage by staying for the entire spectacle. After meeting Her Majesty, Salsbury went on to arrange the show's continental tours; he was also in charge of the partnership's other investment ventures, from dams to dude ranches, in the West.

In 1887, the dashing showman entrepreneur married Miss Ray (Rachel) Samuels of New York. Rebecca and her twin sister, Rachel, joining two older brothers, were born in London in 1891, where Pawnee war whoops, cowboy yells, and the bull's-eyes of Miss Annie Oakley still mingled with the loud acclaim of British audiences.

By 1894, Nate's health was failing; he could no longer take an active role in managing the strenuous tours. He returned with his family to New York, settling into the life of the well-off German-Jewish community: a brownstone in Manhattan's West 70s; summers at Long Branch, New Jersey; the children at Ethical Culture. Then, on Christmas Eve 1902, when his daughters were eleven, Nate Salsbury died at the family house on the Jersey shore.

When Paul met Beck, her brothers and sister had married; she was the only child left at home. Stormy relations with her widowed mother were exacerbated by the traditional maternal strategies to find a husband for the moody rebellious daughter; the two women battled it out in every luxury resort from Lake Louise to the dude ranches of Missoula, Montana.

Passionate, intelligent, full of artistic yearnings and a desperate desire to get away from home, Beck seems to have taken one look at Paul Strand and decided he was for her. For his part, Paul, anxious, passive, and overanalytical, was swept away by Beck's unself-conscious intensity as much as by her beauty and sensuality. Her dependence on him, moreover, evident in her earliest letters, gave him a feeling of masculine self-confidence that, until then, had been lacking in his relations with women.

Unequal to Georgia's challenge five years earlier, he had since gained in maturity and professional success. He felt ready to take care of another woman's needs. He may also have found Beck's traditionally feminine

lack of focus less daunting than Georgia's ferocious ambition. Being Paul, however, he still harbored doubts—about himself, but also about Beck. And with reason. Battered by her mother's constant criticism, she had little self-esteem and few inner resources. As she reminded him in feverish daily love letters, he was "everything" to her.

At least a year before he presented her to Stieglitz, Paul had described Beck to Alfred, keeping him informed of the courtship. In September 1920, Paul spent two days at the Salsbury house in Long Branch, visiting Beck, who was ill. After expressing hopes for her speedy recovery, Alfred raised what was to be the most troublesome issue for Beck herself and the most corrosive problem in her relations with Paul: What should she do? She was already bored and frustrated in her new job of medical secretary; yet her only skills were typing and shorthand.

Told by Paul that Beck had been deeply impressed by O'Keeffe's pictures, Alfred suggested that it might be helpful if the uncertain young woman could see more of Georgia's work on their return from the Hill. Georgia's paintings, he hoped, would point the way for Beck, liberating her own imperative to create.

Stieglitz had gone straight to the heart of the problem: there was no imperative for Beck, only a vague urge to express herself, and she was paralyzed by a sense of unworthiness so profound as to preclude sustained discipline or effort.

Georgia's work did, indeed, produce an effect, but not in the helpful way Alfred had proposed. With Paul's encouragement, Beck began to try her hand at painting and, less happily, to show her beginner's efforts to friends. Paul Rosenfeld was unsparing. Writing to Stieglitz of Seligmann's fiancée, he noted waspishly: "I only hope she isn't producing watercolors, like Miss Salisbury [sic]. That would make it terrible, and I am not as strong as I used to be."[17]

Beck was presented to Alfred shortly before the annual hegira to the Hill in July 1921. The momentous event obviously went well. The young woman's beauty, vitality, and readiness to worship him were bound to find favor with Stieglitz. Reassured by Alfred's approval of his beloved, Paul felt free to air his misgivings: writing to Stieglitz in August, Paul noted how happy he felt reading Alfred's remarks about Beck; he had showed her Alfred's letter. She was "fine and strong and yet amazingly naive in some things—inexperienced."[18] That Strand, thirty-one, shared the naiveté of his sheltered thirty-year-old fiancée was both an attraction and a source of trouble. Neither had outgrown the need for a mother and father; as to the latter, Paul had two, his own and Stieglitz. Beck felt she had no one but Paul. That was only one of their problems.

"But we are working it out together so far and what more can we ask?" Paul wrote.[19]

With the elder Strands away in Connecticut, he and Beck had spent three days together, quietly in his room at home, "beautiful days of untouched companionship, reading together *Lord Jim*," Paul told Alfred.[20] This same room would be their only home for the duration of their marriage. Like Stieglitz, Strand could not leave his father's house.

IN JUNE 1921, Kitty graduated with honors from Smith. By arrangement, Alfred did not attend commencement exercises in Northampton; the family cheering section was all Obermeyers. Her father's absence, however, was not a sign of deepening hostility. During her senior year, Kitty had managed to detach herself from both parents; for the first time, in letters to her father, she sounded like a young woman with her own life to lead; indeed, she herself noted a new-felt sense of independence. She did well in a tough nontraditional major for women: chemistry, with courses in biochemistry and theoretical physics. English had been her worst subject, she lamented to Alfred. She had come to mistrust language as a vehicle of lies.

Like her classmates, Kitty had used her senior year to explore job possibilities; despite the depressed economy, she was astonished by numerous offers, including one that seemed made to order for her interests and training: assistant in a bacteriology laboratory at Columbia University College of Physicians and Surgeons. But Uncle Lee vetoed the work as too dangerous, Kitty reported to Alfred. He feared infection from the handling of tuberculosis sputum. She hadn't argued with his decision, but she had stopped job hunting. Easily discouraged, Kitty decided on cooking classes and a few culturally improving courses at Columbia School of General Studies. Her old feelings of unworthiness resurfaced; with so many suffering financial hardship, she wrote to her father, did she have the right to a paying job? Two serious suitors made it clear that marriage was the next stage in her life; preparation for homemaking was the sensible course for a young woman who wanted to do what was expected of her.

Her most devoted admirer, Milton Sprague Stearns, had been in love with Kitty since her first summer at Camp Kehonka, when the young Bostonian, a graduate of Phillips Exeter and Harvard, introduced her to his passion: baseball. Now working as a salesman for an importer of hides, Milton, accompanied by his boss, visited Kitty in Ogunquit following her graduation from college. Meanwhile, Kitty particularly

wanted Alfred to meet another young man. George Stack was a strange and brilliant fellow; she thought Alfred would find him especially sympathetic, she wrote to her father. A young businessman who worked in Baltimore, George had visited Kitty at Smith, bringing the latest translations of Wedekind plays or the new James Branch Cabell novel for them to read together. When he was transferred to Atlanta the summer of her graduation, the enamored young man pawned his cello to finance a trip to Ogunquit. Kitty was disapproving; although she pointed to the imprudence of the act when writing to Alfred, she more likely felt unworthy of the sacrifice implied and frightened by the passion it declared. She had little reason to find irrational love reassuring. Still, in her next letter to her father, Kitty reported with great excitement that George would be in New York during the coming year; the young man's company promised a literary and musical education. He would be the mentor that Alfred had been to everyone but his daughter.

In June 1921, a month earlier than usual, Alfred and Georgia packed themselves off to the Hill. The extra weeks only provided more time for family tension, strains, and angry outbursts. Aggrieved by Alfred's avoidance of her throughout the winter in town, his sister Selma arrived, looking for trouble. Further explosions of temper were detonated by the descent of Lee and his entourage: children, nursemaids, chauffeur, and cook. Arriving on the stormy scene in July, Herbert Seligmann noted to Strand that the Stieglitz family's behavior, in his view, was typical of people terrorized by their servants. Georgia's role, Seligmann observed sympathetically, was to "soothe all the temperaments."[21]

With only a year to live, Hedwig, partially paralyzed and deeply depressed as a result of her stroke, needed more and got less from her children, especially Alfred. Her indulged eldest son and favorite child, Alfred, now nearing sixty, found himself cast in that most fearful of role reversals: the small boy who never grew up was now expected to assume the role of parent to his enfeebled mother. His reaction was an aggressive infantilism whose acting out took the form of angry punitive behavior toward Hedwig. As recalled by his grandniece Sue Davidson Lowe,

> If [Hedwig] asked him to fetch something for her, he reminded her that she had a maid. If she sought to talk to him about Georgia or Kitty, his work or his friends, he answered roughly that he was too busy to sit and chat. If she told him she knew she had become a nuisance and wished only to die, he yelled at her, claiming no patience with martyrdom.[22]

Alfred, forever the child anticipating abandonment, turned his terror into rage and competing illness. His usual hypochondria intensified:

every ache, pain, boil, rash, or attack of indigestion became a symptom of terminal illness. When he wasn't exhibiting stigmata, he complained of insomnia and lack of energy. His every thought was shadowed by sorrow: past accomplishments darkened by present inaction. Writing to Strand in July, Alfred mourned his poverty: lack of money had killed *Camera Work* along with the possibility of another 291. Both losses were especially frustrating now, when there was so much begging to be done for American artists. He did not say how much it rankled to play no part in what was presently being done—by others—in the expanding art scene.

Infected by his unhappiness or their own, everyone at the lake seemed tired, gray, and depressed, a symptom, too, of the humid, overcast weather. Alfred felt drained of all enthusiasm, with a dull fatigue that proved impervious to sleep. Well into August, he was still despondent, his emotional state expressed by illness and ill temper. Every day brought news of another loss and its accompanying sense of diminishment, he complained to Strand, along with new ailments afflicting him, Georgia, or both. Aware of his regression to infantile behavior, he tried defensively to see his childishness as a virtue. Would he ever really grow up, he asked rhetorically. Then, answering his own question, he decided that he shouldn't even try. Growing up would mean losing his childlike trust in the world; he compared the process to a business deal in which he would lose his purity. By equating the adult male with the corrupt activity of making money, Alfred could justify his dependent, childlike state as prelapsarian: he was Man before the Fall, trailing the clouds of immortality he would soon photograph.

Once again, he expressed his anger in visions of Armageddon; referring to Strand's friend Harold Greengaard's prediction of a worldwide financial crash,* Stieglitz waxed euphoric: the bigger the better, as far as he was concerned. He prayed for a disaster that would reverberate throughout the world; nothing else would be of any value, he told Strand. In Alfred's Last Judgment, no one would be spared. By way of concluding his bleak July letter from the Hill, he warned Strand against having children.

News from Rosenfeld, returned from Europe in mid-August, suggested that Alfred's hoped-for economic crisis was striking close to home. The market value of Rosenfeld's investments had shrunk by two-fifths, his income diminishing along with the capital. There was reason to fear

* Heeding Greengaard's astute forecasting, Jacob Strand sold his considerable investments in the stock market just before the 1929 crash. Paul Strand's patrimony, unlike Stieglitz's, was spared the losses experienced by most American investors.

that worse was to come. The writer's new financial worries, moreover, had brought home another unpleasant reality. He could no longer afford to tell off his (and Alfred's) enemies, such as *The New Republic*, in print; he might be dependent on them for assignments for articles and reviews. He knew Georgia would miss his polemics; she had liked the "biff in my stuff," Rosenfeld recalled proudly. A "bellicose deity" like Georgia should be appeased with blood.

For the moment, at least, he had a secure commission from "that insect" Crowninshield: six pieces for *Vanity Fair*. He planned to devote several to "the men." It was high time, he wrote to Alfred, that something was done on Dove. "He's the strongest thing we have," Rosenfeld declared.[23] Reading these lines at the Hill would not have raised Georgia's spirits.

From jollying Alfred back to pleasures like rowing and hiking, Georgia had managed to coax him into working again. Then, in late August, the mail brought Stieglitz word of his own financial troubles: "A knockout blow," he wrote to Waldo Frank. "Something I have foreseen. Have prepared myself to receive—Yet for the moment I was stunned." The family's securities appeared unaffected and his relatives remained in Alfred's bitter view "as blind as ever. Only Georgia seeing with me."[24] Stieglitz provided no further details on his financial blow. The fact that only his investments suffered in 1921 suggests that Alfred had been speculating on his own with disastrous results.

T H R E E M O N T H S of serving as peacemaker, cheerleader, nurse, and therapist were taking their toll on Georgia's state of mind and her work.

Writing to Strand in mid-August, Stieglitz noted that Georgia had completed only a few canvases. Instead of the litany of "Wonders" and "Real Articles" strung through his usual description of O'Keeffe's latest works, Alfred now hedged; her new palette was somber and he simply didn't know how good the pictures were.

He explained Georgia's sparse output to Waldo Frank: "There is not much to *inspire* her this summer . . . a decided grayness pervades both of us. Red seems to hurt," he noted of O'Keeffe's palette.[25]

That summer, O'Keeffe began a series of meditations on nature that are "inscapes"—in Gerard Manley Hopkins's term—as much as they are depictions of land and water. When they are not somber—gray, brown, black—O'Keeffe's colors ice to cold violet blues and acid green. Whether natural or artificial, her forms are encircling, closed, claustrophobic, the low skies threatening or stormy.

In *Lake George with Crows*, probably painted in late summer or early fall 1921, the water, seen from high above, has become an oval pond narrowing to a thin inlet. Low purple-brown hills contain the lake, filling the landscape but for a thin band of pale gray sky. On the right the composition is framed by what appears to be a dirty white flap of gauzy curtain, on the left by a bare outcropping of rock. At the lower left corner balloon treetops whose leaves have already turned scarlet. O'Keeffe did use red here and it does hurt. At the lower right, a birch tree stretches white branches to puffs of muddy yellow dead leaves. Above the lake, three crows, birds often suggestive of death, * circle the water.

There were other reasons why gray days were the only time Georgia had to paint out-of-doors. From late July until the end of August, she complained of eye trouble. She couldn't be out in bright sunlight, and the disability limited her freedom to paint.

September, as always, brought relief from the presence of family. Georgia's eyes stopped bothering her. She reemerged from the dark quiet of the Shanty to pose again for Alfred. "I have just made my first attempts this summer photographing O'Keeffe," Stieglitz wrote to Seligmann on September 5. Following his visit to the Hill earlier in the summer, Herbert was visiting friends in Great Barrington, Massachusetts. For Alfred, Great Barrington resonated with memories of Katharine Rhoades. "It's undoubtedly a beautiful place," he wrote to Herbert wistfully. "I have heard so much about it many years ago."[26] The following evening, Stieglitz was in still better spirits. Writing to Herbert again, he described "another more than marvelous day. Georgia put up 24 glasses of grape jelly, after which we went for a glorious row on the Lake—indescribable."[27]

Seligmann served not only as sounding board and agent for Alfred in his battles with publishers; a fanatic loyalist, Herbert kept a critical and disciplinary eye on other disciples whose unquestioning devotion he felt to be wavering. Envious of Alfred's more talented and successful children, Seligmann in his role of spy was able to show Daddy just who loved him most and at the same time to tell Stieglitz what he wanted to hear: his most talented disciple, Paul Strand, could never approach the master.

Starting first with Rosenfeld, Seligmann informed Alfred that on Paul's return from Europe, he had ignored hints that he write a piece on the forthcoming Hartley volume, *Adventures in the Arts*. Pressed by

* In his journals, Van Gogh recorded visions of crows before his attempted suicide.

assignments already overdue, Rosenfeld was not, in any case, sufficiently admiring of Hartley's art criticism to produce the expected "puff." His lack of enthusiasm was not received kindly.[28]

From his father, Alfred had learned how to control through ambiguity. Nothing feeds the victim's fear so effectively as uncertainty about the nature of his crime. Without specifying the cause of his displeasure, Alfred wrote Rosenfeld a note whose scolding tone said everything— and nothing.[29] Paul was distraught. After telling Alfred what "a shock" his letter had given him, he begged forgiveness for sins unspecified, unknown, and even uncommitted: "I accept the reprimand . . . quite as much for what I may have unwittingly done in the past and for what I might do in the future," he wrote abjectly.[30] Stieglitz's reply was not intended to enlighten. "I was amused that you should have so construed that letter as a reprimand," he wrote, assuring the despairing Rosenfeld that nothing could have been further from his intent.[31]

Whatever his intentions, Stieglitz's letter combined with Seligmann's urging produced the desired results. "Rosenfeld has seen light," Herbert reported to Alfred exultantly a few weeks later, adding that Paul had "called up to say he had decided to write about the book anyhow—and, in fact, had arranged with *The Bookman* for 1500 words. He asked if anyone had talked to the Dial & I encouraged his suggestion that the Dial be prodded to ask Strand."[32]

Despite the warm flow of letters to Strand from the Hill, Alfred's anxious envy of his disciple's dazzling photographic technique needed only Seligmann's encouragement to become denigration. Wallowing in self-hatred over some recent botched work, Stieglitz recalled bitterly a letter he had just written to Seligmann praising Strand's "Mastery of photography." Invidious comparisons with his own failures followed. "I never saw any one make as many blunders as I did," Alfred fumed. From bad fixing to the camera shutter not functioning to finally dropping the "few flawless films on the floor," he emerged with the "worst lot of might-have-been masterpieces in my whole career. Thus you see," he declared to Herbert, "I am *no* Master of Photography as yet."[33]

Quick to seize the opportunity to reassure Alfred while venting his own spleen, Herbert replied that Strand's apparent mastery was but the superficial skill of a talent with "no where to go."[34] Thus placated, Alfred could take a generous view of Strand's shallowness; Paul was just a young man in a hurry. "It isn't easy to find where to go, if one hasn't the patience to let Self find Self," he wrote to Herbert.[35]

Restored to grace, Rosenfeld was once again an October visitor to the Hill. In September, just before his "reprimand" from Alfred, Paul

had bought two O'Keeffe oils: "the lily with the purple sweep in the background," as he rapturously described his new acquisition (one of Georgia's first paintings of this flower) and another of two alligator pears. At the same time, he wrote a check to Alfred for two hundred twenty-five dollars for a print from the portrait of O'Keeffe, "Breasts and Hands," which he had bought in August, along with three Hartley paintings and an etching by the Maine artist, now living in France.

Rosenfeld was especially enamored of the Stieglitz photograph of Georgia. "I have been watching it much and find that it possesses remarkable 'pushing from within' and has a movement extremely powerful, especially noteworthy in so small a thing," he observed.[36] His loyalty both as publicist and as patron was now immutable: despite any reverses and at whatever sacrifice, "one of the last necessities I shall forbid myself is the investment in American art," Paul assured Alfred. "I shall try to save for that, and the things I acquire will be savings indeed."[37]

For the immediate future, Rosenfeld's steady support of Stieglitz artists entailed no hardship. With the new year 1922, the American economy began a dramatic recovery from the postwar depression. A biblical seven years of plenty was beginning that would end only with the stock market crash. Key to the "piping prosperity of the decade," as one historian described this period,[38] was the enormous increase in the efficiency of production: from the depression year of 1921 to the end of the decade, industry doubled its output. From less visible forms of prosperity—oil, chemicals, synthetics—to the most visible—the omnipresent automobile on brand-new federally funded highways—evidence of American wealth was everywhere. A host of new products rolled off new factory assembly lines: cigarette lighters, oil furnaces, wristwatches, antifreeze fluids, reinforced concrete, paint sprayers, book matches, dry ice. New materials were suddenly everywhere: panchromatic motion picture film, Pyrex cooking utensils, rayon and Bakelite, celluloid and Cellophane, whose glory would soon be celebrated by Cole Porter.

Stieglitz and his fellow artists and intellectuals might deplore American materialism, the worship of success and the dollar to the detriment of art—and even craft. Nonetheless, people like Alfred and Paul Rosenfeld, who lived on unearned income (and before capital gains tax), would profit from an expanding economy and a bull market to make art or support those who did. The chain store boom and smart advice to buy Woolworth stock turned Paul Strand's father, for instance, from an unsuccessful businessman to a prosperous investor. Jack Strand soon

bought two O'Keeffe paintings. (Stieglitz, who followed the stock market closely if not so profitably, wrote Paul to congratulate him and admitted his envy of this valuable tip.)

Soon to be reflected, first in O'Keeffe's painting and later in Alfred's photographs, was the most important element in the prosperity of the 1920s: the increase in construction. Skyscrapers rising behind brownstones, ferryboats, and fragile saplings had been a key metaphor since the teens for Stieglitz's love-hate relationship with the modern city. Turning to portraits and symbolic meditations on nature in the twenties, he took up new buildings again in the early thirties, now seeing them through the unromantic lens of straight photography and abstract forms.

As 1922 dawned, expansive with promise, optimism buoyed the Stieglitz circle in the form of a familiar impulse: let's start a magazine. With no gallery or print forum, Alfred was more than encouraging—and perhaps sowed the seed of the idea.

MSS, the new publication, launched its first issue in February of the new year. Another house organ for the homeless, it also reflected the style and experiences of a new generation of Stieglitz's aging youngsters. With Seligmann and Rosenfeld as editors (both of whom had met with many rejections and much cutting elsewhere), MSS was planned as a collective, cooperative venture. Contributors shared the costs of each issue. Once accepted, no article was edited.

The results were undistinguished. Despite its large tabloid format, copy (not helped by a painfully ugly typeface) appeared either cramped or lost in space. With the exception of one stylish cover by O'Keeffe, layout and design were astonishingly amateurish, given the talents of those involved. Contributions—even those by known writers such as Sherwood Anderson—suggested that they had been rejected from other magazines. Criteria for rejection by MSS are not easy to determine; certainly, its two editors were unlikely to return Alfred's poetry. In the second issue, Stieglitz was represented by a poem, "Portrait—1918" ("The Blue of the Heavens / Comes Down to those Lips," etc.).

Besides nostalgia, readers who remembered Camera Work would have experienced a jolt of déjà vu in the fourth issue of MSS. A special number edited by Paul Strand, "Can a Photograph Have the Significance of Art?" was an embarrassing rerun of Stieglitz's call for tributes in the June 1915 issue of the old journal, "What Is 291?"

Along with hymns to Alfred's genius by the faithful—Marin, Dove, O'Keeffe, even his niece Elizabeth Davidson—the editors also published some unflattering responses from the better known names bannered on

the cover. After burying photography as "the refuge of incapables," illustrator Joseph Pennell was represented by a second contribution: "I have seen, but not attempted to read *Manuscripts*; it is more inane, artless and vulgar in its appearance than I could have imagined."[39]

Also in February on another front, Stieglitz tried to keep his artists before the public and in the marketplace. With the help of the ever enterprising Mitchell Kennerley, Alfred took over the Anderson Galleries for an auction of former 291 artists. There was no question, now, for Stieglitz of refusing to sell art. With the exception of Marin, none of his artists was represented by a gallery; all of them—including O'Keeffe and himself—needed a place to be seen and sold, all the more important when the economy was looking up. Despite its racy title, "The Artists Derby," featuring forty-one entrants and all of Alfred's circle, proved no sweepstakes for any of those involved.

A Hartley auction, on the other hand, was a runaway success, suggesting that the focus on a single artist was a better marketing strategy. Almost five thousand dollars was netted for the impoverished expatriate—precisely the sum he had announced to Alfred was needed to keep him from suicide.

Paul Strand, in the meantime, was building up a steady clientele and secure income from his motion pictures of sweepstakes; stable owners like the Wideners and the Whitneys commissioned him to immortalize their thoroughbreds at tracks throughout the East. This income, combined with that from other commercial films and still photography and supplemented by Beck's salary, allowed him to save enough by living at home to satisfy his notions of what was required by a man before he assumed the responsibilities of a husband.

Paul and Rebecca were married in February 1922. Although few would have disagreed with Rosenfeld that Miss Salsbury's painting posed no threat to Miss O'Keeffe, all of their friends were struck by the physical resemblance between the two women—a likeness that Rebecca, apparently with Paul's encouragement, emphasized. She forswore makeup, slicked her hair back, and took to wearing black clothing severely cut. Primed by Paul to worship Stieglitz, Beck transformed her envy of O'Keeffe into possessive adoration: if she couldn't *be* Georgia, she could claim "Georginkha" for her own.

The Strands' attempt to appropriate the O'Keeffe/Stieglitz identity is recorded in the photographs Paul took of Rebecca. Pose for pose, his portrait of Beck, begun in 1921, imitated Stieglitz's O'Keeffe series. The dozen or so prints that survive reflect the self-consciousness of both sitter and photographer: on Beck, Georgia's still choreography looks merely stagey. Even in the closest close-up, moreover, Strand fails to

engage with his subject—a reflection of their relationship off-camera as well.[40]

IN APRIL, Kitty wrote to Alfred that she had been feeling so miserable that she had gone to Northampton to get away from everything. She never specified the cause of her despair, but there is no further mention of George Stack, her literary and musical suitor. A month later, still in low spirits, Kitty accompanied her mother to the Breakers in Palm Beach, followed by a stay at White Sulphur Springs in Virginia. In May, installed with Emmy at the Gedney Farm Hotel in White Plains, New York, Kitty reported to Alfred that she was taking cooking lessons, learning to make popovers, pancakes, oatmeal, and coffee. Casually, she noted that she and Milton Stearns were waiting for "good news from his boss," Ray Shackleton. They were clearly—if unofficially—engaged.

Others among their family and friends might have wondered why the young salesman's superior education had not fired him with higher professional aspirations. Besides his unwavering love for Kitty, Milton's future mother-in-law had other grounds for approval: "It's Stearns with an *a*," Emmeline would assure Stieglitz relatives, just in case they thought Milton was Jewish.[41]

On June 22, 1922, Milton Sprague Stearns and Katherine Stieglitz were married in Boston. No member of either the bride's or the groom's family was invited to the Unitarian service. Ray Shackleton was their only attendant. Following a honeymoon on Cape Cod, the newlyweds settled into a rented house in Allston, a middle-class suburb of Boston.

One week later, Georgia and Alfred set off for Lake George. Before their stay was over, Kitty would write to her father that she was pregnant. They hadn't planned on a baby quite so soon, she admitted, but as they both wanted a large family and loved each other so much, they welcomed the news.

In early summer, from the Hill, it seemed a time of joyful beginnings.

THIRTEEN

"The Simple Thing
Before Us"

Georgia O'Keeffe, painter Charles Duncan, and critic Paul Rosenfeld, a
regular fall guest at the Hill, lunch on the farmhouse porch, captured by
Alfred's camera in 1920.

IN LATE SPRING 1922, Alfred had embarked on a new series of
portraits. His energies recharged at the Hill, he worked feverishly on
printing the studies of the artists and writers of his circle taken earlier.
With this group of portraits, Stieglitz had probed deeper with his camera;
the new images of Demuth, Marin, Dove, Frank, and Rosenfeld were
stamped with a sense of inwardness that was, literally, stunning.

When Rosenfeld opened the package from Lake George containing
his photograph, he "felt a sort of blow," he wrote to Alfred in early
July. "I felt as you might feel if you were out walking draped in nothing
but a sheet, and someone came along and whisked the sheet off . . . as
though everybody who saw the pictures would know all about me, things
I wanted them not to know as well as others," he continued.[1]

Rosenfeld's concern about the secrets he saw stamped on his likeness
was assuaged by his realization of how little others noticed. Rosenfeld
the art critic, moreover, soon came to the fore: losing his self-conscious-

ness about the photograph as a confession, he could now "enjoy it for the magnificent thing it is, only now and then waking up to the fact that it is a portrait of myself."[2]

Ravaged by illness, Demuth asked waggishly: was there any point in getting better after Stieglitz had immortalized him as a death's head? "You have me in a fix," he wrote to Alfred.

Penetrating the hidden recesses of soul and psyche, Alfred's new portraits revealed all he had learned from studying O'Keeffe. Four years of photographing Georgia had refined his powers of observation, intensified his concentration, and deepened his vision. In contrast to the hundreds of prints of O'Keeffe nude, Stieglitz's male subjects are buttoned up in every sense of the word. And yet they are nakedly exposed: his camera seems to have caught these men at precisely the moment when their public carapace cracked open to reveal grief, betrayal, or, in Marin's image, a veiled look of flight. Alfred did not hypnotize his sitters, as Waldo Frank slyly suggested; if they were men, he seized their sufferings as his own.

RENEWED INTIMACY with Strand—the result of their close collaboration on *MSS*—caused Stieglitz's competitive juices to surge. Seligmann might soothe Alfred's anxiety by denigrating Paul's "mastery" as mere technique. Nonetheless, the younger man's energy and drive, fueled by new obligations of marriage, goaded Alfred to greater efforts and further challenges, whose technical triumphs he laid out to Strand in long, detailed letters.

Stieglitz's race with Strand for the perfect print resulted in Alfred's first professional facilities. Earlier, he had seemed to prefer taking over kitchen or bathtub—as though to underscore the supremacy of the artist over the mere professional. Now, at fifty-eight, Alfred succumbed to a real darkroom. Or war room. The former potting shed at the Hill was outfitted with blackout curtains and the required lights; the old sink was remodeled accordingly. Here, by mid-July, Alfred was printing the portraits he had made that spring. Using the new negative film packs he had earlier disdained, he made snapshots of his young nieces, along with other outdoor studies: he tried surprising leaves in a rare moment of stillness; he continued "battling with the barn," determined to capture in one exposure exterior sunlight and the darkness within. He was in pursuit of the impossible, he conceded.

Meanwhile, he encouraged Strand to go after all the commercial assignments he could get. (As Stieglitz would never have accepted such

work, even if he were starving, this was also a reminder to Paul that he was not yet in the master's league.)

Not that Strand needed encouragement. The newlyweds were spending the long, hot summer in the city while Paul scratched for jobs and Beck did whatever clerical chores were required by the slower summer schedule of the two neurologists for whom she worked. Evenings and weekends, she labored as unpaid secretary to Strand, the editor of *MSS*, answering letters and retyping contributions.

The quality, or lack of it, of the essays solicited for the December issue—"Can a Photograph Have the Significance of Art?"—summoned Beck's most wicked critical barbs. George Of's contribution, she wrote to Alfred of his devoted framer, didn't even sound " 'hatched'—the word is too suggestive of vigor and strength. I should say it was 'stillborn.' "3

Beck already felt close enough to Alfred and "Georginkha" to write of more personal matters in the letters that flew back and forth between West 70th Street and Lake George.

The Strands' first summer together was not a happy one. Expecting completeness from each other, Beck and Paul found instead new reasons to feel incomplete. Bored with her job, exhausted by the heat, confined by their top-floor quarters at her in-laws', she felt both claustrophobic and lonely; her only diversions were socializing with the family or watching courting couples on Riverside Drive. Whether Paul was reluctant to spend the time or the money on frivolities, they did not seem ever to indulge in a concert, play, or movie.

Beck's dependence on Paul was a burden to both of them. Moody under the best of circumstances, he was depressed by her irritability, adding guilt to her feelings of unworthiness. Especially when she was "cursy," she was impossible, Beck admitted. (Both Georgia's and Beck's severe premenstrual reactions were the subject of much commiseration between Strand and Stieglitz.) With Paul working all the time on *MSS*, on commercial assignments, or on his own photography, she should be helping, not distracting him with her discontent.

They had an open invitation from Alfred to visit the Hill, but the last-minute nature of Strand's assignments, their uncertain location, and tight deadlines made a holiday together hard to plan.

In early August, a weekend with Paul Rosenfeld in Westport offered the first respite of the summer. Beck was enchanted by their host's rented house, a classic Cape Cod shingled cottage, with views of woods, pond, and cornfields. Writing to Alfred and Georgia, she sounded happy and refreshed by two days of swimming and socializing with the writers and illustrators "strewn through the neighborhood," including Rosen-

feld's beloved, painter Florence Cane, a safely married woman with young twins. On Sunday, Paul had given a tea, "where there was much clash and clink of crockery, feminine voices and repartee—hee!"[4]

Rosenfeld's art collection provided Beck with the happiest memory of her visit: "Georgia O'Keeffe, I spent two nights and several periods of minutes with you!" she reported to the Hill. "All your paintings were in *my* room—the group of apples, the musical blue mountain, canna lilly [sic] and "black spot"—truly lovely things—you are a rare spirit."[5]

The Rosenfeld cottage also boasted Hartley and Marin Rooms (the living room being given to Stieglitz's photographs). Her host may have hoped that putting Beck in the O'Keeffe Room would have an inspirational effect on the occupant.

Beck's adoring letters to the Hill made it clear that she had already cast Alfred and Georgia in the role of an idealized, larger-than-life version of the Strands themselves, their virtues, including genius and style, to be emulated, their problems worthier of worry than Beck's own.

Underweight when she left the city, Georgia was determined this summer, Alfred announced to their friends, to gain ten pounds. She was relieved of housework, with a cook in residence (Hedwig's former maid), and was eating with great gusto and bid fair to make her quota, he reported.

Exhausted and run-down, with no one monitoring her health, Beck followed the progress of her friend's diet with the intense solicitude of displaced envy. Joining the chorus of concern, she recommended three cups of cream and a quart of milk a day to help Georginkha "bloom like a young bay tree."

When Beck first met Alfred, she was concerned by the way Paul judged himself and his work as "less" than his mentor. "Aren't you absorbing too much of Stieglitz," she had warned her fiancé a year earlier. "Don't envy him. You have enough personality of your own not to envy anybody."[6] As soon as she was accepted into the magic circle, however, Beck stopped urging Paul to stand on his own feet. She no longer discouraged his dependence on Stieglitz; she absorbed it. The best of Strand, she made clear to both men, was Stieglitz's creation.

"I know very well that you have communicated much of your spirit to him and I am therefore grateful to you," Beck wrote to Alfred in July, "for you see, he expresses it to me."

Paul's special quality of "fineness," on the other hand, exacerbated Beck's sharp tongue, as earlier it had irritated Georgia; she loved goading Paul into a "good fight," Beck confided to Alfred. There were many occasions to indulge that particular pleasure.[7]

The O'Keeffe Room had no immediate effect on Beck's sense of purpose. But the weekend in Westport seems to have eased tensions between husband and wife. She and Paul were "inaccountably happy," Beck wrote Alfred in early August. "I'm awfully proud of him & cherish so much his feelings for me—We grow closer daily—It seems unthinkable that life could hurt us in any way as long as we are together."[8]

They would not be together during Beck's vacation in September. While Paul worked, it was decided that Beck should spend her holiday at the Hill, where, the farmhouse being full, she would stay at the Pines, a boardinghouse nearby.

On September 7, Beck boarded the train for the long ride to Lake George. Writing to Paul while the Hudson flowed by, she found it "incredible that I am away from you"—the first separation since their marriage in February.[9]

Before she left, Beck had used her mother's gift check to buy Paul an expensive Ackley viewfinder camera. Since borrowing Sheeler's, Paul had yearned for this beautiful piece of photographic equipment. Countering his objections, Beck wrote that the camera "really belongs to both of us—everything we have is ours together."[10] Along with generosity, there was a strong element of guilt behind the gift. Because of their marriage, Paul was doing work he would rather not do; despite greater harmony between them, sending her on holiday alone still suggested that her presence made Paul's labors harder.

At the Hill, "S & G. are in great shape," Beck reported. The weight-gaining program had worked; Georgia was "quite plump." They were both "so kind" to her, she wrote to Paul a few days after her arrival; daily invitations to tea or dinner rescued her from her middle-aged fellow guests, rocking placidly on the boardinghouse porch.[11]

The farmhouse was indeed full to bursting. Besides Alfred, Georgia, Hedwig, and her two German nurses, those in residence when Beck arrived for meals included Julius, Lee's twin and a professor of chemistry at the University of Chicago, along with both Stieglitz sisters: Selma Schubart, unofficially separated from Alfred's friend Lou and operatically alone, and Agnes Engelhard, with husband George Herbert and daughter Georgia, a voluptuous yellow-haired fifteen-year-old.

Already great friends, the two Georgias welcomed Beck on their walks. "Georgia OK" showed her "two great paintings" she had just completed; Alfred produced four of his latest prints, including the result of his famous battle with the barn and a head of O'Keeffe.

Both of her hosts were fired by creative dynamism; everyone, including Beck herself, was waiting for a spark to catch; Paul had sent

her canvas and Whatman paper; as soon as she got some turpentine, she promised him, "I'll give the 'erts a whirl." When Beck horsed around or retreated to baby talk, she spoke the language of anxiety.

"I have tons of things to work with—everything but IDEAS", she confessed. With no inspired thoughts of her own, she would transcribe Alfred's. She asked Paul to include a steno pad in his next mailing. She had also forgotten needed articles of clothing at home. She had to borrow Alfred's tie to wear with her middy blouse. [12]

ALONG WITH her frenzy of painting, Georgia had been wrestling for weeks with her contribution to the special photography issue of *MSS*. When she finally completed it, she read it to Beck and Alfred. "Interesting, short & sensible," Beck pronounced Georgia's essay. In fact, her contribution was one of the longest; it was Georgia's new style, consisting of short staccato sentences that suggested brevity, especially when read aloud.

O'Keeffe's tribute to photography began with an imitation of Stieglitz's terse autobiography: "I have not been in Europe. I prefer to live in a room as bare as possible. I have been much photographed." Echoing Alfred's fixed belief that nothing worth learning can be taught, she continued with an ironic litany of her teachers and schools, ending with a confession of her old false consciousness: "I am guilty of having tried to teach art . . . but I don't know what Art is." What she did know was that "some of the photography" being done in America was "more vital than the painting." The force behind the camera's primacy, O'Keeffe reminded the reader, was Alfred Stieglitz.

Besides his faith in his own medium, Stieglitz, continued O'Keeffe (in a perfect pastiche of Alfred's style), "also has faith in the painters and the writers and the plumbers and all the other fools."

Georgia may have denied her education, but she remembered her reading. Echoing Roger Fry's famous definition of abstraction as "significant form," she found Stieglitz photographs "aesthetically, spiritually significant." They provided the inexhaustible nourishment offered only by art whose formal qualities had come to seem "inevitable"—her favorite term of praise: "the Chinese, the Egyptians, Negro Art, Picasso, Henri Rousseau, Seurat, etcetera, even including modern plumbing—or a fine piece of machinery." [13]

Alfred had been redefined as an abstract artist.

Georgia's literary labors were enthusiastically received. Proposed changes were minor. ("I made one suggestion that was very bright for me!" Beck noted to Paul with characteristic self-denigration). [14]

Unable to paint and feeling awkward at the prospect of trailing Alfred like a Boswell "with a pencil behind one ear," Beck soon found another role—or rather Stieglitz found it for her: she became his favorite model.

Earlier that summer, using his precociously well developed niece Georgia Engelhard as subject, Alfred had made his first out-of-door nude photographs. Cued probably by O'Keeffe, who was painting only apples, he posed the luscious Kid as Eve; in one of the silliest allegories committed by Stieglitz, the young temptress (looking suitably embarrassed) crouches on a window ledge, clutching several globes of the forbidden fruit to her far more tantalizing breasts.

Whether Georgia Minor or her parents said "Enough" or Alfred recognized that the feelings aroused by naked adolescent girls were too troubled to be coolly translated into art, the fifteen-year-old Kid was replaced by Rebecca Strand, at thirty-one, in the full splendor of her beauty.

On September 14, Beck wrote to Paul that "G.S. [Georgia Stieglitz] & I went to the lake and as it was very balmy and warm we went in with nothing on. It was perfectly great—I have never experienced it before—We will go again tomorrow." That same afternoon, Alfred photographed the two women together; the three then went for a row on the lake. Following tea at the farmhouse, Georgia and Alfred went off together. After the day's happiness, Beck felt suddenly abandoned. "I could not bear my loneliness any longer," she wrote to Paul.[15]

Reading his wife's description of swimming naked with another man as a pleasure "never before experienced," Paul must have felt troubled. To be sure, Stieglitz was scarcely any man; Paul's devotion to Alfred—mentor, friend, and father figure—was based on profound trust. Given Strand's continued dependence on Stieglitz, moreover, the older man's choice of Rebecca as model, object of admiration and perhaps of desire, provided Paul with the validation he still needed.

At the same time, the masculine ego of the new husband was surely stung by Beck's account of their Indian summer idyll; in symbolic violation of her virginity, Alfred had been first to see Beck, naked and immersed in water, the primal sexual element, before seizing her on film. As yet, Paul had done neither; yet, ignoring both provocation and plea in her letter, he turned his back on his wife's need, leaving her to the attentions of Alfred and Georgia.

In the days to follow, there was no further mention of loneliness. Beck had graduated from the status of guest; as model, she became part of both Alfred's and Georgia's working days. She was now at the farm "for the usual lunch–supper," she wrote briskly to Paul.

The day after the first swim and picture session with Georgia, Stieg-

litz photographed Beck alone—"a few things of me with the big camera."
He proofed one negative and developed others taken earlier. Beck was
delighted with the results. While they worked together, Georgia made
an exquisite painting—in about two hours, Beck marveled—an apple
on a black tray.

Both her hosts had been "lovely" to her, she reported. Along with
Alfred's tie (Paul still having failed to send hers) she was now wearing
Georgia's stockings and slippers.[16]

Alfred had good words about their guest, too. Everyone had taken
to Beck, he told Strand. Although she missed him, Alfred thought the
separation was good for both of them.

His new model was certainly good for Alfred. Already, he had taken
a "quintillion" pictures of her, Beck wrote to Paul. On September 25,
there was another "grand swim . . . some more snaps of me in the
nudelet," she reported, reaching for the guiltless diminutive. Alfred had
given Beck the proofs; "one of them—a nude in the water—is a
beauty."[17]

Like his other models, Beck too came to see herself as art object,
her beauty, sexuality, even pain (seized by Stieglitz in a portrait head)
detached from her persona. In a photograph, she could admire herself
as she imagined Alfred saw her. "He takes quite a different slant at me
from you, which is at it should be," she explained to Paul.[18]

Photographing Beck, Alfred experienced the same imperviousness
to time and fatigue that Georgia had induced earlier. "Stieglitz must be
dead—on his feet all day—then started developing," Beck reported. He
made, she calculated, about "6 big shots & 25 little ones. . . . A lovely
relationship has developed between us and we have lots of fun gamboling
about," Beck wrote ingenuously. Nonetheless, she implored Strand not
to tell her mother about the nude swimming, the photography sessions,
or even her vacation with Georgia and Alfred without him.[19]

Whether or not he felt uneasy reading Beck's bulletins from Eden,
an assignment to film the races at nearby Saratoga galvanized Paul into
plans to join her for a few days at the end of the month. Instead of
being enthusiastic, Beck responded to news of his impending visit with
a professional suggestion: if he was thinking of making portraits when
he came, she advised, "bring your own lenses and perhaps Stieglitz will
let you use his own apparatus. We could try some nudes out-of-doors
if you want to," she wrote.[20]

Before Paul could photograph Beck, however, the Strands were
arrested for nude swimming. Alfred took the entire blame for the in-
cident; he had told them to go in "au naturel," he coyly wrote to his

niece. "We had been watched for some days—I had been doing some nudes."[21] He left unspecified the identity of his model.

A plainclothes detective, accompanied by the local sheriff, escorted Beck and Paul to the courthouse, where they were charged with disorderly conduct. Alfred paid their fine, ten dollars each.

After Paul left, Alfred continued to photograph Beck, undisturbed by the local constabulary. Meanwhile, her letters to West 70th Street were largely shopping lists: groceries to be ordered for Georgia at Reeves; photographic materials for Alfred to be mailed or brought on his next visit. "Stieglitz wants four nitrogen bulbs—2 sixteen watts and 2 thirty two. . . . Sweeting, he wants some wax for his prints. Please bring him some."[22]

In reply to Paul's query about her painting, she confessed that she had done nothing since he left; she felt too discouraged when she saw what Georgia was doing. Painting every day, "Georginka . . . has done nothing but apples. Each one is better than the last—all colors, sizes and shapes & qualities," she reported. But if the weather on the following day was poor or Stieglitz did not happen to be in a mood to photograph, she promised to try again.[23]

Early in October, Paul made another visit to Lake George. As soon as he arrived, tensions surfaced. Alfred and Georgia were alone at the farmhouse; the family had returned to the city. With the extra room, Beck moved from the Pines to join Paul on the sleeping porch. Both Strand and Stieglitz photographed her there in bed.

The younger man's nonstop energy, his determination to photograph everything in sight, had a paralyzing effect on his host. "While Strand was here, I virtually did no photography," Stieglitz wrote to Rosenfeld. "He photographed like one possessed—shooting right and left—forward & backward—upward & downward & in directions not yet named. This morning I started and jabbed my finger," Alfred noted bitterly.

He did not share Beck's view of his recent productivity nor of its happy results. "I have about 50 snapshots to develop and about 10 large plates," he continued to Rosenfeld. "I'm in no hurry to count up the batch of failures. Somehow this summer, failures seem to be my lot."[24]

The evening before Strand left, smoldering undercurrents of resentment and jealousy, the residue of old passions and static from new ones, erupted. At Alfred's suggestion, Georgia had given a final reading of her MSS article to the group. Squeezed between her hymn to Stieglitz's seminal role and her encomium to Sheeler ("one of America's most distinguished young modern painters . . . his photographs are of equal importance. He is always an artist"), Georgia's paragraph on Strand was

less than lukewarm. Strand had merely "added to photography in that he has bewildered the observer into considering shapes, in an obvious manner, for their own inherent value."[25]

Stung by her perfunctory remarks, Paul voiced criticisms and made suggestions aimed at the style of that section of the article—by far the most labored and poorly written paragraph in the piece. Georgia simply ignored him. Outraged for Paul, Beck exploded, thereby becoming the target for everyone's anger.

Writing to Paul, who left early the next morning for town, Beck apologized. She had wanted the others to show him the same respect she gave him. Instead, her attempt to defend Paul's interests had been seen as hysteria.[26]

Like the nude swimming incident, Alfred confessed to stage-managing the critique of Georgia's article. He had insisted she read the piece aloud to the Strands, anticipating the listeners' hurt feelings. Writing to Strand the next day, Alfred told him that he hoped the pain Paul had felt on hearing Georgia's remarks about his photographs would soon be forgotten. The experience, he insisted, had been valuable for all of them—especially Beck, who would now truly feel herself to be part of his work. Knowing her to be anxious, irritable, and "cursy," Stieglitz was sorry to have scheduled his game of truth for that evening. It could not have been postponed, however. He reassured Paul that Beck was feeling better.

The timing of Beck's brightened spirits could not have been lost on Strand. With his departure, Stieglitz was king of the hill once more; his favored configuration—a triangle consisting of two women with Alfred at the apex—was restored. Life for the three resumed the busy peacefulness of before.

No longer paralyzed by Strand's devouring energy, Stieglitz was now "frantically photographing skies and landscapes," Beck wrote to Paul. Georgia had not yet exhausted the possibilities of apples. She was "at a huge blood red one now on a blue and white platter. Looks like the American flag, but is very powerful & daring.* . . . [It is] "a very strenuous time with these two people a-going like mad," Beck reported.[27] Her hosts pressed Beck to stay longer. Feeling happily involved in their activity, she put off her planned return to the city for twelve days. To her modeling work she now added stenography, sewing, and scouting still life subjects for Georgia to paint.

* From Beck's description, O'Keeffe's apple painting seems to be an early version of her famous "joke" picture—*Cow's Skull: Red, White and Blue*—which the artist claimed was her answer to the sententious talk she endured from (male) writers about the Great American Novel.

Using the farmhouse Corona, Beck transcribed Stieglitz's "first story," an anecdote about Steichen's portrait of J. P. Morgan. She repaired Alfred's undershirt (the owner judged the garment elegantly mended, he told Strand). With white flannel and black ribbon bought in town, Beck sewed a pair of bed slippers for Georgia—just like ones she had made for Paul. On a walk down the road she found some of Georgia's favorite red canna lilies, which became "a beautiful O'Keeffe pastel," Beck reported.

Stieglitz developed the photographs he and Strand had taken of Beck in bed on the sleeping porch. "I like yours better in every way," she assured Paul.[28]

"Sweetheart, I am coming coming back," she wrote a few days later in her little girl singsong voice, on the eve of her departure from the Hill. "I am ready to. You are my only only." It was the middle of October. Beck had been at Lake George for almost six weeks.[29]

But again she deferred her return, staying for another day.

On the train trip home, Beck's buoyancy collapsed. In accepting her help as a "good worker," Alfred and Georgia had allowed her the illusion of being an artist. Now she had to see her labors as typist, seamstress, and model for what they were: menial substitutes for talent.

"The paintings really are punk," she wrote to Paul from the train of the work she had done, "just smears. I am not an artist—even by temperament."[30]

Her thank-you note to the Hill was wistful. Being home was a fall from grace. Like Rosenfeld, she felt grateful to have been part of her friends' privileged lives: "It was fine to wander & romp with you for a brief interval along the clear deep strain of your kind of living—an experience to which I return again when things are hectic & the spirit tired."[31]

ALONE TOGETHER for their last weeks at the Hill, Alfred and Georgia were still fired by the clear skies and dazzling colors of their favorite season: the hazy languor of Indian summer was gone, replaced by bracing days and cold, glittery nights. Georgia was "painting and cooking. Both extra well," Stieglitz reported to Rosenfeld. He himself was working very hard, his spirits soaring. "I never felt life more extraordinary—more beautiful than now," he wrote. "Beethoven would go mad . . . were he here today. Music beyond music!"[32]

A few days later, one proof from Alfred's labors arrived in the mail at West 70th Street: a photograph of Beck, nude, taken when she was lying in bed on the sleeping porch.

Describing the print as "cute" in her thanks to Stieglitz, Beck sounded uneasy. "Paul and I had a good laugh over it," she wrote. When the print was framed, she planned to hang it on the wall beside their bed, "next to my ear," in the space just under O'Keeffe's paintings of apples.[33]

Stieglitz's gift was a small missile launched into the hostilities that already existed between the Strands. Their humorous take on the proof deflected troubled feelings on both sides—feelings that Beck's forced humor only emphasized. Indeed, she assured Alfred that the photograph would be used in just the way he intended: as a sexual weapon against her husband: "when Paul gets haughty or tries my affections," she promised, "I shall point to it and and say that if he is not careful he will never find himself in that delightful situation again. Whereupon he will probably say all right and go out into the night, like Nora in 'A Doll's House,' munching macaroons!"[34]

Beck anticipated the real danger in this scenario—and her deepest fear. Calling Paul's bluff would expose his indifference to her; she would be abandoned.

While developing the dozens of negatives of Beck, Alfred had discovered that he'd made a few extraordinary prints. He had looked at the pictures with joyful astonishment. Having been convinced that he had failed completely in his work with Beck, he was all the more delighted when he saw the palladium prints. He knew they would both share his pleasure, he wrote in the note accompanying the photographs.

Stieglitz's relief was in direct proportion to the self-hatred he always felt at any evidence of failure; now he compared his earlier fear of defeat, before seeing the prints, to the experience of disappointing a woman sexually: Beck had been such an enthusiastic model, he wrote to Strand, that he would have felt worse than inadequate had the results been unequal to her expectations.

On November 16, Alfred's autumnal high ended abruptly: in New York, Hedwig was paralyzed by the stroke that would end her life five days later. This time, Alfred did not leave his mother in the care of his siblings. On hearing the news, he and Georgia rushed to the city.

His mother's helplessness of the previous summer had already detached her neediest son. For her part, Hedwig understood and forgave Alfred his angry behavior. This year, even before her return to New York on October 1, Alfred had added his mother to his list of daily correspondents. Two weeks later, he made a flying visit to the city to celebrate Hedwig's seventy-eighth birthday. She spoke gratefully of this last summer at the Hill; if only she were twenty again and Alfred a baby.

Her death came as an anticlimax. Reading Alfred's letter, written on November 21, Paul Rosenfeld could not have guessed that Hedwig had died that same morning. After he apologized to Paul for declining an invitation to see his new house and to catch up with his friend's doings, Stieglitz explained: "But work must come first. It becomes more and more the essential thing to me—for all of us.

"The summer on the hill—my mother's death—they have clarified much for me. Very much," he wrote. In two years Alfred would be sixty; the last months had forced him to an awareness of his own mortality. "Time is an awful thief—a cold blooded one—if one permits it," he warned Rosenfeld.[35]

The Stieglitz of the summer and fall of 1922 soon became subject to a dark transformation. By early 1923, the ecstatic photographer of a few months before, oblivious to everything but the need to capture the beauty of a woman's body, the light streaming through a barn door, a scudding bank of clouds, was forgotten. In his place, Stieglitz recast a self isolated, impoverished, and mourning his dead. From his own sufferings, from the decay and death that confronted him everywhere at the Hill, he began to create his most transcendent work. "My mother was dying. Our place was going to pieces.* The old horse of 37 was being kept alive by the 70 year old coachman," Alfred recalled in a letter to R. Child Bayley, an English friend from Alfred's pictorial period and now editor of *The Amateur Photographer*. "I, full of the feeling of today: all about me disintegration—slow but sure: dying chestnut trees—all the chestnuts in this country have been dying for years: the pines doomed too: I, poor but at work: the world in a great mess."[36]

Stieglitz gazed skyward, taking up once again a challenge begun thirty years before in Murren, Switzerland. He would capture with his camera the most fugitive of natural forms: clouds. He pursued woolly dimpled cirrus, the enveloping cumulus, the gathering of storm clouds and explored the relation of these forms to sky and earth, to manmade shapes of dirigible and farmhouse. Then, back in the potting shed, he struggled to fix the evanescent.

Once he had established himself as hero in his personal drama of death and transfiguration, Stieglitz confessed to a more human impulse behind the new work: to prove he could beat anyone at his own game—himself included.

With *Songs of the Sky* (1923) Alfred would "show them." In particular, the new Cloud series would silence the innuendos of Waldo Frank,

* With the recent renovation of the farmhouse, other members of the Stieglitz family and their guests must have found Alfred's description puzzling.

who had explained the penetrating brilliance of Stieglitz's portraits by his ability to hypnotize his subjects.

Both the formal and expressive problems solved in the making of these pictures would reveal everything he had learned in forty years, Stieglitz wrote to Bayley. Fixing the most mutable of forms, he would at the same time "put down my philosophy of life—to show that my photographs were not due to subject matter—not to special trees, or faces, or interiors, to special privileges, clouds were there for everyone— no tax as yet on them—free."

Alfred's ambition for his new series reached higher. Its musical title referred to the symbolist theory of correspondences between all art forms and staked Alfred's claim to surpassing the symphonic masters. Along with others of the American avant-garde, he and Georgia were one in their belief that music—in its fusion of intuitive expressive content and abstract rational form—was the most perfect of the arts. Georgia had used musical titles for several abstractions of 1919. Now Alfred's *Songs of the Sky* would show that a great photograph could attain—even surpass—this condition of the absolute, reducing a great composer to abject envy.

> I had told Miss O'Keeffe I wanted a series of photographs which when seen by Ernest Bloch (the great composer) he would exclaim: "Music! Music! Man, why that is music! How did you ever do that?" And he would point to violins, and flutes, and oboes, and brass, full of enthusiasm, and would say he'd have to write a symphony called "Clouds." Not like Debussy's but *much, much more.*

According to Stieglitz, the fantasy became reality "when finally I had my series of ten photographs printed, and Bloch saw them—what I said I wanted to happen happened *verbatim*," he insisted. [37]

Unfortunately, there were no witnesses to Alfred's triumph. The meeting of the two men took place; Alfred wrote Bloch thanking the composer for the hour he had spent looking at his photographs. But for Bloch's reaction—the fantasy that became reality—we have Alfred's account alone.

GEORGIA'S FRENZY of painting and Alfred's autumnal burst of energy centered on plans known to only a few friends: O'Keeffe's first one-woman show since the historic closing exhibition of 291.

Just days after their arrival at the Hill the past June, Stieglitz had

begun quietly negotiating with Mitchell Kennerley for space in his splendid Anderson Galleries. Georgia's mature works would be unveiled in the same rooms where, a year earlier, crowds of the curious had ogled images of her naked body.

Once Kennerley's enthusiastic cooperation was secured and the dates of the exhibition set for January 1923, Stieglitz the impresario swung into high gear. The momentous event must be planned to the last detail, starting with publicity.

Georgia had been sickened by the reaction to Stieglitz's exhibition of her portrait in 1921. The hypocrisy and sensationalism of the yellow press, in particular, had revolted her. If she suspected that Alfred's professed indifference to philistine opinion masked a certain complicity, she kept her opinion to herself—or for their private discussions. Once again, she felt disgust at the thought of the same stares—of "greasy vulgar people" sullying her "beautiful children," she told Sherwood Anderson.[38] Yet from the very moment plans for the show were under way, she prepared to publicize herself and her art for the sake of sales.

On July 1, she wrote Doris McMurdo, a friend from Chatham Institute, about plans for the forthcoming exhibition. She anticipated little pleasure from the event, she said. She dreaded the vast amount of work ahead of her, the replay of "stupid" speculations that had hounded her in the wake of the exhibit of Stieglitz prints. But she was frank about the need to conquer her distaste for exposure in the interests of success.

"I don't like publicity. It embarises [sic] me," she told McMurdo, ". . . but as most people buy pictures more through their ears than their eyes—one must be written about and talked about or the people who buy through their ears will think your work is no good . . . and won't buy—and one must sell to live."[39]

For more than twenty years, Stieglitz had skillfully cultivated editors, critics, publicists and reporters of the cultural scene to ensure that his work, his gallery, and his artists received the attention they deserved. But it was Georgia who applied this skill to immediate and practical ends. As a woman who had suffered the blighting effects of poverty, she had no patience with "art for art's sake." To justify making pictures, the work had to sell. If people judged and bought through their ears, she would make sure that everyone would hear of Georgia O'Keeffe.

Orchestrated by Paul Rosenfeld, the drumbeating started quietly— but quickly. The July 1922 issue of *Vanity Fair* featured vignettes of five women artists. "The Female of the Species Achieves a New Deadliness" was the lead article—an unmistakable echo of Rosenfeld's tribute

to Georgia as a "bloodthirsty goddess." Leader of the pack, O'Keeffe at her toughest-looking, in black-brimmed hat and mannish jacket, squints obliquely from Stieglitz's photograph at the top of the page.*

Hailing her recent paintings as a "revelation of the very essence of woman as Life Giver," the legend replays the Pygmalion-Galatea motif—already, for Georgia, a form of Chinese water torture. Ignoring her early abstractions, the caption asserted that her successful "struggle out of the mediocrity imposed by conventional art schools to the new freedom of expression" was due entirely to the "inspiration of such men as Stieglitz."[40]

Alfred's courtship of Crowninshield and Rosenfeld's forbearance were paying off. In October, the same magazine featured Rosenfeld's long, lush overture to the forthcoming show: "The Paintings of Georgia O'Keeffe." The subhead to the article (probably from the pen of the caption writer) was both inelegant and inaccurate: "Work of the Young Artist Whose Canvases Are to be Exhibited in Bulk for the First Time This Winter."

At thirty-five, Georgia was hardly a wunderkind; the world *bulk* was more suggestive of a warehouse sale than of an exhibition of work by a promising artist. But keen to garner as much attention as possible for the first promotion in print of Georgia's forthcoming show, Rosenfeld did not apparently object to her image as a wholesale producer of art.

Analyzing O'Keeffe's use of color and line, the article avoided discussing specific works; those to be shown had probably not yet been selected. Rosenfeld's ecstatic tribute to the artist-as-woman, however, would certainly jog the memories of readers who recalled the severe face and glorious body of Stieglitz's portrait, exhibited a year and half earlier. "there is no stroke laid by her brush," Rosenfeld declared of O'Keeffe, "whatever it is she may paint, that is not curiously, arrestingly, female in quality. Essence of very womanhood permeates her pictures."

Unlike the others who chanted this hymn, Rosenfeld pointed to the duality of O'Keeffe's sexual imagery. In her art, he said, the female principle was defined by its opposite, by "rigid hard-edged forms [that] traverse her canvas like swords through cringing flesh. Great rectangular menhirs plow through veil-like textures."[41]

His ultimate homage, however, was to declare O'Keeffe a sexual prophet like D. H. Lawrence, the preeminent hero of the Stieglitz circle (as he was to the larger Anglo-American intelligentsia). Rosenfeld's comparison cast Georgia in the role of liberating life force, moralist as

* Stieglitz was represented by another photograph on the same page, a portrait of Rosenfeld's mistress, Florence Cane.

The Portrait. *Stieglitz's serial portrait of O'Keeffe consists of more than three hundred principal images selected by Stieglitz and two hundred informal poses or snapshots.*

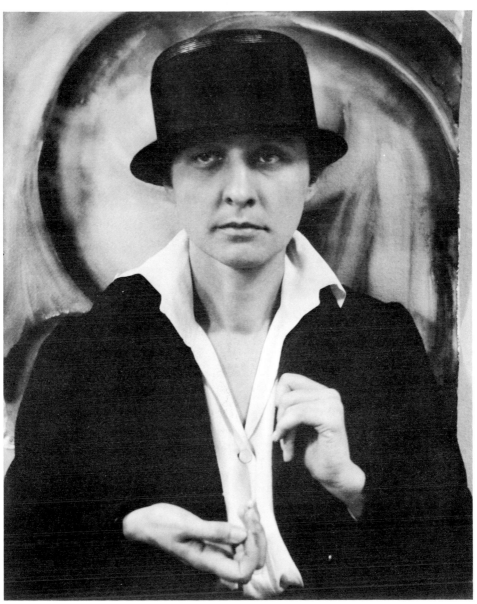

ALFRED STIEGLITZ, *Georgia O'Keeffe* (1918).
THE J. PAUL GETTY
MUSEUM, ALFRED
STIEGLITZ, 1918,
PALLADIUM PRINT, 9¹⁵⁄₁₆″ × 7¹⁵⁄₁₆″

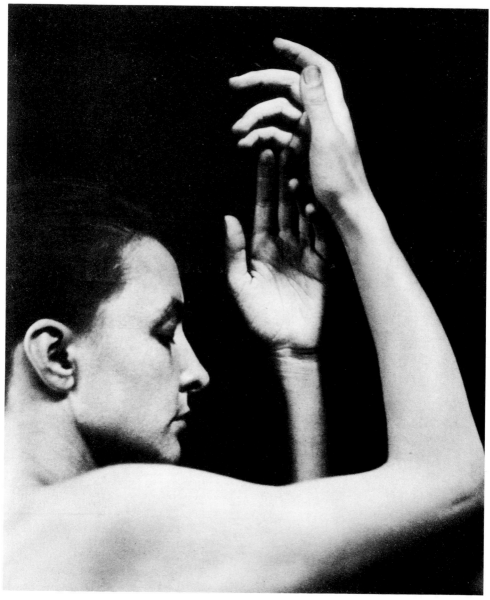

ALFRED STIEGLITZ, *Georgia O'Keeffe* (1918).
In one of the most choreographed images in *The Portrait*, O'Keeffe is arranged
in the attitude of an Asian dancer.
THE METROPOLITAN MUSEUM OF
ART, GIFT OF DAVID A. SCHULTE, 1928

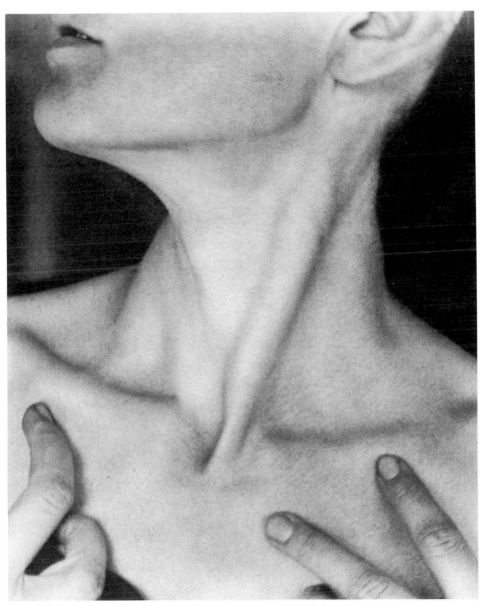

ALFRED STIEGLITZ, *Georgia O'Keeffe* (1921).
PRIVATE COLLECTION, NEW JERSEY

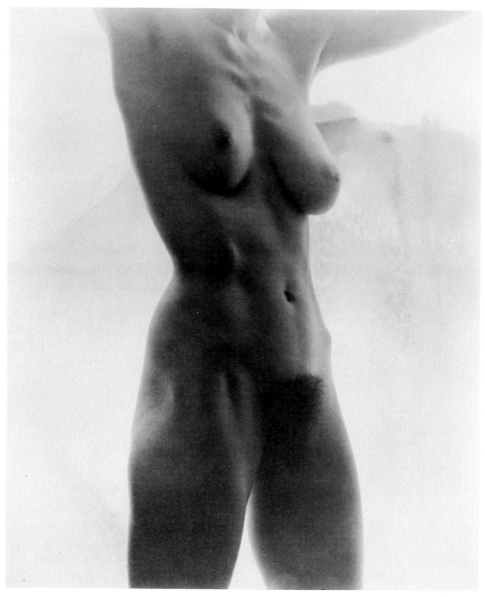

ALFRED STIEGLITZ, *Georgia O'Keeffe*, "Torso" (1919).
THE METROPOLITAN MUSEUM OF ART,
GIFT OF MRS. ALMA WERTHEIM, 1928

ALFRED STIEGLITZ, *Georgia O'Keeffe*, "Torso" (probably 1919).
GIFT OF ALFRED STIEGLITZ, COURTESY MUSEUM OF FINE ARTS, BOSTON

Alfred Stieglitz, *Georgia O'Keeffe*, "Thighs" (1918).
THE J. PAUL GETTY MUSEUM, ALFRED
STIEGLITZ, 1918, PALLADIUM PRINT, 9½″ × 7⁹⁄₁₆″

AUGUSTE RODIN, *Study of a Nude Female Figure*. Rodin gave this drawing to Stieglitz following the photographer's visit to the sculptor's studio in Meudon during the summer of 1911. Stieglitz baptized the pencil drawing "Woman Supreme." THE METROPOLITAN MUSEUM OF ART, GIFT OF GEORGIA O'KEEFFE, 1965

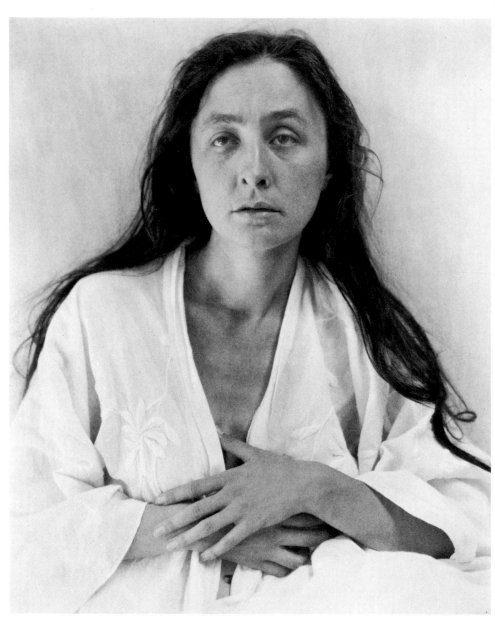

Alfred Stieglitz, *Georgia O'Keeffe* (1918).
GIFT OF ALFRED STIEGLITZ, COURTESY
MUSEUM OF FINE ARTS, BOSTON

ALFRED STIEGLITZ, *Georgia O'Keeffe*, "Breasts and Hand" (1918).
THE METROPOLITAN MUSEUM OF ART,
GIFT OF MRS. ALMA WERTHEIM, 1928

ALFRED STIEGLITZ, *Georgia O'Keeffe* (1919).
THE COLLECTION OF AMERICAN LITERATURE,
THE BEINECKE RARE BOOK
& MANUSCRIPT LIBRARY, YALE
UNIVERSITY

ALFRED STIEGLITZ, *Georgia O'Keeffe* (1919).
GIFT OF ALFRED STIEGLITZ,
COURTESY MUSEUM OF FINE ARTS,
BOSTON

ALFRED STIEGLITZ, *Georgia O'Keeffe*, "Hands IV" (1918).
PHILADELPHIA MUSEUM OF ART, GIVEN BY CARL ZIGROSSER

ALFRED STIEGLITZ, *Georgia O'Keeffe*.
THE COLLECTION OF AMERICAN LITERATURE,
THE BEINECKE RARE BOOK & MANUSCRIPT
LIBRARY, YALE UNIVERSITY

ALFRED STIEGLITZ, *Georgia O'Keeffe*, "Hands" (1920).
THE COLLECTION OF AMERICAN
LITERATURE, THE BEINECKE RARE BOOK
& MANUSCRIPT LIBRARY, YALE
UNIVERSITY

ALFRED STIEGLITZ, *Georgia O'Keeffe* (1927).
THE COLLECTION OF AMERICAN LITERATURE,
THE BEINECKE RARE BOOK & MANUSCRIPT
LIBRARY, YALE UNIVERSITY

ALFRED STIEGLITZ, *Georgia O'Keeffe, After Her Return from New Mexico* (1929).
PHILADELPHIA MUSEUM OF ART, THE ALFRED STIEGLITZ COLLECTION

well as artist. Like Lawrence, O'Keeffe was "one of those persons of the hour who . . . show an insight into the facts of life as an order wellnigh intenser than we have known. . . . Her conscious is akin to something that one feels stirring blindly and anguished in the newest men and women all through the land."[42]

Publicly, Georgia reacted to sexual readings of her work with anguished embarrassment or blazing anger. When she read Hartley's remarks on the erotic implications of her painting, published in 1920 in *Adventures in the Arts*, "I almost wept," she later said. "I thought I could never face the world again."[43] But of all the writers—men and women— who took for granted the sexual terms of her art, Rosenfeld's pulsating prose infuriated Georgia most. His first article, published in *The Dial* in 1921, seemed to move beyond discussion of the work. "Her art is gloriously female," he wrote. "Her great painful and ecstatic climaxes make us at last to know something the man has always wanted to know. . . . All is ecstasy here, ecstasy of pain as well as ecstasy of fulfillment."[44]

Hutchins Hapgood had dropped by 65th Street on the day the *Dial* piece appeared; he arrived to find Georgia in a rage. Hapgood himself was perplexed by the intensity of her reaction. Her sense of violation— of being "invaded," she would later say—was compounded by feelings of betrayal. Rosenfeld was not only a critic; he was a privileged visitor to the Hill, a friend of hers and a closer friend of Alfred's. Indeed, Rosenfeld's intimacy with Stieglitz cast O'Keeffe's anger in another light. How did the shy, gentlemanly Red come to write so authoritatively of Georgia's "ecstatic climaxes"? Alfred's confidences would certainly explain Rosenfeld's assured conflation of O'Keeffe's art and her sexual appetites.

O'Keeffe had told at least one friend that "every woman should have Stieglitz for a lover."[45] Whether or not revelations about Georgia's erotic behavior were a deliberate "plant" by Alfred or simply another instance of his "spouting indiscretions"—in Florine Stettheimer's words—we can assume that he was far more generous with specifics than O'Keeffe was. Neither should the propensity for sexual bragging be discounted.

Albert Barnes, great collector of modern art that he was, maintained puritanically that were he Stieglitz, he would feel obliged to defend Georgia's honor against her interpreters. Far from voicing the slightest objection, Alfred clearly approved of both Hartley's and Rosenfeld's readings.

Georgia's rage and humiliation suggest anger deflected. Neither text, she knew, could have come into being without Alfred's imprimatur, if not his collaboration. Her own role is still more equivocal.

During the summer of 1920, when Herbert Seligmann had had the

job of seeing Hartley's book through the press, Georgia had read her fellow artist's essay about her in manuscript. She had been so distressed by his remarks that, reading the only copy, "I wanted to lose [it] . . . so it couldn't be in the book," she told Mitchell Kennerley two years later.[46] If she had wept then or otherwise voiced her objections, changes surely would have been made. Unchanged, Hartley's text appeared in the next two exhibition catalogues of her work.

Then, using a different strategy of denial, O'Keeffe chose to misunderstand the substance of the offending Rosenfeld texts along with her own anger. In the fall of 1922, Kennerley sent Georgia a blue clothbound scrapbook in which, thinking to please her, the ill-advised donor pasted Rosenfeld's articles from *The Dial* and *Vanity Fair*. After thanking Kennerley for the gift, Georgia decided to enlighten him about why the clippings embarrassed her. The words Rosenfeld and others wrote about her "sound so strange and far removed from what I feel," she told him. "They make me seem like some strange unearthly sort of a creature floating in the air—breathing in clouds for nourishment— when the truth is that I like beef steak—and like it rare at that."[47]

Rosenfeld's articles scarcely suggested an ethereal O'Keeffe; his "bloodthirsty goddess" was clearly an eater of rare beefsteak. Paul, moreover, adored Georgia. Had she made known her unhappiness with his interpretation of her work, it seems unlikely that, even with Alfred as his "source," he would have published his remarks unrevised.

In early December 1922, nearly two months before the opening of the show, O'Keeffe gave the first interview of her career to a major mass-circulation newspaper. Although no byline appeared over the piece, its placement in the New York *Sun*'s regular feature "News of Women . . . Fashions . . . Domestic . . . in Public Places" makes it certain that the reporter Georgia invited to her studio at 65th Street was a woman.

Peering at the canvases arranged around the wall, her visitor agreed with Rosenfeld and quoted him: Georgia's paintings were the essence of womanhood. She further echoed Rosenfeld by declaring Georgia's art "more like music than any we have ever seen."[48] In musical analogies alone, O'Keeffe and Stieglitz inaugurated a new arena of competition: Whose art came closest to approximating the sublime order of harmonious sound?

The reporter had no difficulty with O'Keeffe's abstract works. Seen as pure subjectivity*—a sort of "mood music"—the dark spiral silhou-

* In this context, it is useful to recall that until the 1950s the term *nonobjective* was used interchangeably with *abstract* to describe modernist art of the period.

etted against a pale arch of space in *Cos Cob, Spring 1922* was "an expression of the artist's inner life."[49]

What puzzled Georgia's first interviewer was the recognizably realistic reduced to the structure of geometric form and idiosyncratic color; in *Lake George*, with its strong memories of early Kandinsky, her visitor was confused by "ripples of rainbow colors, curious balloon-like masses" that on further examination turned out to be trees and mountains doubled by their reflection in the water.

Perhaps in deference to the mass readership of the newspaper, O'Keeffe's explanation of the work made no reference to formal concerns; she explained the painting as an expression of her estrangement from both the natural and human environment at the Hill: "The people up there lead such pretty little lives and the scenery is such pretty little scenery," she said.[50]

FOURTEEN

Alfred Stieglitz Presents...

ALFRED STIEGLITZ, *Equivalent* (1924 or 1925).

ON JANUARY 1, 1923, Alfred celebrated his fifty-ninth birthday, along with an anniversary. Seven years ago this day, he had first seen a roll of drawings by an unknown art teacher from the South. Today, he posted a note of thanks to Mitchell Kennerley—one of many expressions of gratitude he conveyed to the auctioneer and publisher in these years. His friend's generosity would be rewarded, Stieglitz promised, when he saw Georgia's new paintings; greatness was about to descend on the Anderson Galleries.

On January 29, the exhibition was opened to the public. And in they flocked. More than five hundred people a day, according to one count, ascended in the elevator, with its carved brass fittings, to the top floor of 489 Park Ave at 59th Street, occupied entirely by the high-ceilinged rooms of Kennerley's auction house.

The decor of the Anderson Galleries—robber baron Renaissance—entirely suited Mitchell Kennerley, Georgia and Alfred's benefactor and

friend. Born in Staffordshire, England, in 1878, Kennerley had come to America at the age of eighteen to seek his fortune as a bookseller. In 1901, the dapper, elegantly dressed young man married an heiress from Cleveland and, with the help of her inheritance, launched himself into preeminence as an auctioneer of rare manuscripts, conducting some of the most famous sales of the century at his Anderson Galleries. At the same time, Kennerley started his own publishing house; the first American editions of D. H. Lawrence and the first volumes of Walter Lippmann, Vachel Lindsay, and Edna St. Vincent Millay appeared under his imprint. At his splendid estate in Westchester and large house in town, Kennerley entertained millionaire collectors and distinguished men of letters such as Mark Twain; in his private office, his callers were often glamorous, vividly made-up ladies. Men and women of every class were seduced by his charm. His friends, including Georgia and Alfred, were given frequent proof of his generosity and devotion—as witness, now, his second offer of rent-free gallery space for O'Keeffe's show. To Stieglitz, Kennerley was "whiteness itself."

Recalling the austere quarters of 291, art critic Henry McBride sounded a note of regret that the "inconsiderable grey paint" of that hallowed site on lower Fifth Avenue had been exchanged for the "considerable red plush" of the Anderson Galleries.[1] A setting in the grand style, however, was entirely in keeping with Alfred's comeback as impresario, while the tone of the announcement that gallery-goers picked up at the entrance to the exhibit mixed the flourish of P. T. Barnum with the flag waving of Bill Cody's Wild West Show:

<div align="center">

ALFRED STIEGLITZ

PRESENTS

ONE HUNDRED PICTURES

OILS, WATERCOLORS

PASTELS, DRAWINGS

BY

GEORGIA O'KEEFFE

AMERICAN

</div>

The brochure was *not* a catalogue, Alfred declared in testy Stieglitz style (catalogues suggested the museums Alfred loathed). The pictures had no titles;* they were listed only by number and date. Ninety of the works exhibited had never been shown publicly before.

* This appears to have been an ad hoc decision; O'Keeffe usually gave her paintings titles, even though she might—and often did—change them.

Several other significant firsts characterized this noncatalogue: none of Alfred's earlier exhibits of "native-born" 291 artists—Marin, Dove, Hartley, or Strand—had proclaimed the artists as American. Along with the new honorific promoting Georgia and her work, Alfred dispensed with his old soft sell: there was no further question of the "readiness" of the gallery-goer to own an O'Keeffe. As a "real American girl"— Alfred's favorite description—the artist, speaking through her manager, extended a democratic invitation to all comers:

ANYONE INTERESTED IN PURCHASING A
PICTURE MAY OBTAIN THE PRICES FROM
MR. W. GRANT OR MRS. M. H. SMITH.

Two short texts accompanied the list of pictures and sales information. The first was an excerpt from a Marsden Hartley essay that had reduced Georgia to tears of embarrassment two years earlier. O'Keeffe as constructed by Hartley was the romantic artist just returned from a season in hell. Taking her Texas motif of bubbling matter as an infernal sign, he warned: "With Georgia O'Keeffe, one takes a far jump into volcanic crateral ethers and sees the world of a woman turned inside out and gaping with deep open eyes and fixed mouth at the rather trivial world of living people."

To the tormented Hartley, Georgia's sexuality was no benevolent life-giving force; her paintings were "living and shameless documents . . . unqualified nakedness of statement," he wrote. "She has seen hell, one might say, and is the Sphynxian [sic] sniffer at the value of a secret." Yet her work "startles by its actual experience in life . . . life in all its huge abstraction of pain and misery."

As one who barely survived the hand life had dealt him—poverty, ill health, the double isolation of the artist and homosexual—Hartley admired and envied Georgia's toughness and implacable will, not just the will to endure but to conquer: "She looks as if she had ridden the millions of miles of her every known imaginary horizon, and has left all her horses lying dead in their tracks," he wrote.[2] (Hartley's exposure of a certain ruthlessless in O'Keeffe's character may have been another reason she disliked this essay.)

The second text in the catalogue was an autobiographical statement by the artist: her first to be published. In contrast to Hartley's image of O'Keeffe as a horsewoman of the Apocalypse, Georgia's two paragraphs about herself confirmed the public persona Stieglitz imagined for her: the shrewd, innocent, all-American girl.

Adopting the conversational tone and simple run-on sentences she

learned from Gertrude Stein, O'Keeffe traced her progress from oppression to liberation: "I grew up pretty much as everybody else grows up and one day seven years ago found myself saying to myself—I can't live where I want to—I can't go where I want to—I can't do what I want to—I can't even say what I want to—. School and things that painters have taught me even keep me from painting as I want to."[3]

Her life story was now part of the American myth of self-creation, and O'Keeffe did not need to explain just *who* or *what* prevented her from living, doing, saying, or painting what she wanted. Establishing her isolation and imprisonment, she had set the stage for her escape to freedom. "I decided I was a very stupid fool not to at least paint as I wanted to and say what I wanted to when I painted as that seemed to be the only thing I could do that didn't concern anybody but myself—that was nobody's business but my own," she wrote. Within the great frontier tradition of "minding one's own business," O'Keeffe staked her claim to the right to make art unlike anyone else's. By emphasizing the exile of her early years, she underlined her originality, the uniqueness of her struggle against the forces of darkness.

The work they saw on the walls, she told gallery visitors, was still controversial: "Some of the wise men say it is not painting, some of them say it is. Art or not Art—they disagree." Only one voice of assent mattered enough to be named: Alfred Stieglitz. "He is responsible for the present exhibition," she explained.

Then, taking the viewer into her confidence, O'Keeffe ingenuously made full confession: "I say that I do not want to have this exhibition . . . but I guess I'm lying. And I presume, if I must be honest, that I am also interested in what anybody else has to say about [my art] and also in what they don't say because that means something to me too."[4]

By the time the crowds read of the artist's ambivalence about exhibiting her work, Georgia was home in bed; since her mother's death seven years before, depression or severe anxiety triggered physical collapse. With the opening of every exhibition, Georgia retreated, leaving Alfred to expand in the heat of the publicity he had worked hard to create. (She could not stay away completely; while the show was still up, Sherwood Anderson recalled seeing her several times at the gallery.)

Stieglitz would never be happier and more exalted than in these two weeks. For six years since he had closed 291, he had been like a defrocked priest, banished from altar and pulpit. The studio or their apartment on Lee's top floor might do for intimate showings of Georgia's paintings, but to Alfred, receiving in the atmosphere of a bohemian salon underlined his exile from a public role to life on the margins.

The modest, muted, and austere 291 had embodied the spirit of

modernism. Grandiose, pretentious, and old-fashioned, the Anderson Galleries struck many as regressive. In fact, both settings accommodated Alfred's preference for a theatrical space, one sacred, the other profane.

Kennerley's crimson plush was a proscenium stage on which Alfred could entertain a larger audience. As soon as the gallery opened each morning, Alfred was there "explaining and enthusing over the O'Keeffe show," reported Helen Appleton Read in *The Brooklyn Eagle* two weeks after the opening. A painter-turned-journalist, Read had known Georgia during their Art Students League days when they had both made the trip downtown to visit 291. Even in this recent, fustian setting, "for a moment Stieglitz brings back a suggestion of that stimulating atmosphere if you will talk to him about the O'Keeffe show. His belief in the authority of her work and his unbounded enthusiasm is as contagious as was his cheering for Matisse in the old days." Read recalled nostalgically.[5]

Alfred's belief in Georgia provided him with a new theme and gave Georgia's old friend a lead quote: "Women can only create babies, say the scientists, but I say they can produce art, and Georgia O'Keeffe is the proof of it."[6] That Thomas Eakins, William Merritt Chase (teacher of both Read and O'Keeffe), Arthur Wesley Dow, and Alon Bement had believed fervently in the equal ability of women artists and had acted on their belief was conveniently forgotten by Alfred. He had always regarded himself and Georgia as Adam and Eve: in his view he was the first to express faith that women could create anything other than babies, just as Georgia was the first woman to do so.

Read's review proved, moreover, that male critics were not alone in their sexual reading of O'Keeffe's art. Taking Georgia at her word, Read seized on the artist's litany of the ways in which she had been thwarted, blocked, and silenced as the key to her meaning: a "clear case of Freudian suppressed desire in paint . . . the work is in the way of being an escape. She sublimates herself in her art," Read concluded.[7]

The reviews were gratifying; their writers quoted copiously from Hartley's volcanic prose, from O'Keeffe on O'Keeffe, and even from Stieglitz's running commentary to gallery visitors. The artist was not only "proof" that women could produce art; she "makes other women painters in America seem inconsequential," the *Sun* noted.[8]

Praise for the paintings was often couched in terms of the domestic virtues: O'Keeffe's "neatness"* was noted approvingly and often. One

* More recently, this same quality has been singled out by postfeminist detractors: a recent reviewer compared the artist's "neat and tidy" handling of pigment to the painting on china taught to young ladies in the schools O'Keeffe attended.

reviewer went further: "Her painting is, in fact, clean. It is the first adjective that occurs to the beholder. Had Georgia O'Keeffe taken up the customary duties of woman, had she married and kept house, there would have been no dust under the bed, no dishes in the sink and the main entrance would always be well-swept."[9]

The hundred works on view, executed in different media and over nearly a decade, revealed the artist's binary vision: some reviewers were puzzled by the way O'Keeffe moved back and forth between the worlds of closely observed phenomena and of expressive abstract form.

Alfred's principal function during Georgia's exhibits was to bridge the distance between these worlds with a web of words, sometimes accompanied by a hands-on demonstration. The critic for *American Art News* was ready to assume that a nonfigurative work had been conceived as pure abstraction. Not at all, Alfred explained, turning the picture around. His decision to hang a painting of Lake George "on end," he told the critic, had transformed the representational into the abstract. An O'Keeffe could be anything the viewer wanted it to be.[10]

A regular of the Stettheimer salon, Henry McBride, art critic of the *New York Herald*, had become a friend of Stieglitz and O'Keeffe through evenings at Alwyn Court, where Florine, Ettie, and Carrie received. Well traveled, witty, and sophisticated, McBride was immortalized by Florine in a portrait that placed on an attenuated body McBride's "long head with flat falling cheeks recalling a well-bred hunting dog," as artist Peggy Bacon described him.[11]

McBride knew his Old Masters as well as the work of young expatriates, keeping up with what was going on in Paris and Berlin through friends such as Gertrude Stein and Marsden Hartley. Fans of his reviews were rewarded by frequent nuggets of campy double entendre humor, private jokes, and sly digs at philistinism in all its forms.

Calling Georgia O'Keeffe a "B. F. (Before Freud)," he scrambled chronology by suggesting that her inhibitions had been removed long before Sigmund's influence had been felt on these shores. She had shed these inconveniences through the aid of another prophet: Alfred Stieglitz. Not only was Stieglitz responsible for the present exhibition, McBride informed his readers, but "it is reasonably sure that he is responsible for Miss O'Keeffe, the artist."[12]

After twitting Georgia about the "lie" in her brief autobiography—her claim to indifference toward opinion about her art—McBride got serious: the salient fact was not that she lied or was coy about it in print: "For a lady to admit she lied represents the topmost quality of freedom. . . . The outstanding fact is that she is unafraid."

Her lack of fear, McBride pointed out, accounted for the quality of

"calmness" in Georgia's painting. Younger critics liked to talk of the "punch" in an artist's work; he himself preferred "knockout." And seen in those terms, Georgia's first show* had been more of a "knockout" than the present exhibit; there, she had "burst the shackles" of convention. The outside world may not have been aware of the event, but insiders all "went, came away and whispered," McBride wrote.

Sensitive to the growing power of publicity, McBride knew the value of whispers. "To be whispered about in America is practically to be famous," he wrote. "A whisper travels farther and faster than a shout and eventually registers on every New York ear." (Reviewing the famous exhibit of Stieglitz photographs of Georgia in 1921, McBride was the only critic to accuse Alfred in print—albeit good-humoredly—of orchestrating the whispers to publicize Georgia and himself.)

O'Keeffe's real victory, McBride shrewdly perceived, had been to weld the expressively erotic to the cause of modernism in America. "It was one of the first great triumphs for abstract art since everybody got it," he wrote slyly. "In definitely unbosoming her soul, she not only finds her own release but advances the cause of art in her country."[13]

Georgia's attitude toward McBride was always a little wary. As with Demuth, his playful, campy wit was a relief after the high seriousness of the Stieglitz circle. McBride admired her work, but his approval was sheathed in irony, possibly in protest against the adoring dithyrambs of Rosenfeld and Company. A powerful presence in the art world, McBride managed to be a friend of many artists without being compromised or controlled. And he was more impervious to courtship from the Stieglitz camp than most other critics.

Georgia chose to thank McBride for his praise, telling him, "I was particularly pleased—that with three women to write about you put me first—My particular kind of vanity doesn't mind not being noticed at all . . . and I don't even mind being called names—but I don't like to be second or third or fourth—I like being first."[14]

She then confided a "secret" to McBride: "thats why I get on with Stieglitz—with him I feel first."[15]

If O'Keeffe could not transcend that lesser category of women artists, she was, from now on, first among unequals. Where she stood in the competition for Alfred's attention was more problematic.

As long as her paintings were on the wall, to explain and to sell, Alfred's focus was entirely on Georgia O'Keeffe, "his" artist. If he was fighting harder for her than for the others, he told Rosenfeld, it was

* Strangely, given that he credits Stieglitz with creating O'Keeffe, McBride places her first one-woman exhibit in 1917 at the Bourgeois Gallery instead of at 291.

because Georgia was "so American." By the end of the show, his labors were repaid; twenty works had been sold, amounting to a net of three thousand dollars (the equivalent of twenty-one thousand in 1990).* Together, the showman and his star had earned more than enough to see them through the next year.

LESS THAN eight weeks after Georgia's show closed, one hundred sixteen of Alfred's prints went up at the Anderson. One section consisted of his world at the Hill: tangled grasses and dying poplars, the barns and chicken house. Included among these was the series called *Music— A Sequence of Ten Cloud Photographs*, the prelude to the Equivalents, Stieglitz's extended meditations on the sky.

Of the portraits, sixty-four were of women. Among these were twenty-five of Georgia, two of her younger sister Claudia, now teaching school in New Jersey, and six of Rebecca Strand. Fourteen photographs of men included several new studies of Marin and one of Donald Davidson. There were also three portraits of a new friend of both Alfred and Georgia, Sherwood Anderson, whose image by Stieglitz would become familiar on book jackets the world over.

Anderson had become an acolyte of Alfred's with his first visit to New York and 291 in January 1917. Already forty at the time, Anderson was a heavyset, rumpled man with a broadly crooked smile and unruly forelock. Working for sixteen years at a job he loathed in a Chicago advertising agency, he had managed to publish two books; the first, *Windy McPherson's Son*, a classic young man's novel of escape from family, had appeared the year before, in 1916.

With only twelve years in age between them, Anderson had felt, besides admiration, an immediate rapport with Stieglitz, starting with a shared masculine interest in horses. They were both artists in midlife, "trying to keep alive the energy of experiment." Like Stieglitz, Anderson had recently left his first marriage to begin again with a new wife. Although he found Alfred more sheltered than the writers and artists he knew in Chicago, "a life lived in a generation where men haven't lived very much," he attributed his friend's unworldliness not to money—the assumption he had made in print about Ettie Stettheimer—but to Alfred's concern for others, his "infinite giving of himself."[16]

In 1919, during a longer stay in New York, Anderson had visited

* The largest number were purchased by friends and relatives, including the Strands and brother Lee.

the studio, where Georgia and Alfred showed him their latest work. Exalted, he wrote to Waldo Frank, who had discovered Anderson while an editor for *The Dial*, "I saw the O'Keeffe things and the Stieglitz things. I found out again the old lesson that one cannot muddy oneself and be clean."[17]

Hailed as the work of a ground-breaking voice in American letters by Gertrude Stein in Paris and the entire *Dial* crowd (Waldo Frank, Van Wyck Brooks, and Paul Rosenfeld), Anderson's poignant tales of small-town life, reread today, reveal a lyrical moralist more than a modernist inventor. It's not surprising that he felt at one with Alfred's essentially romantic vision of suffering humanity redeemed by transcendent nature.

By 1922, the restless midwesterner had become a good friend to both Alfred and Georgia, corresponding with each of them from sojourns in New Orleans, Reno, and his home in Chicago. He was the only friend that both Georgia and Alfred trusted enough to confide in individually—a role requiring considerable tact, since the suffering of one was usually caused by the other.

In the first year of their friendship, Anderson wrote to Georgia, reminding her (perhaps at a moment when she had lost patience with Alfred) of an earlier remark she had made about him: "The sweetness of the man is the thing to take hold of," she had told him.[18]

Sherwood Anderson, too, was seen as sweet and gentle. In Stieglitz's photographs, however, something of the sweetness dissolves in a soft fleshiness, causing the features of the man to blur. Like Stieglitz's, Anderson's sweetness had elements of sentimentality, self-pity, and fear. Avid for love and the security of a home, he nonetheless fled from the expectations of women. Having abandoned his first wife and three young children, he left the second almost as soon as they married; he would flee still a third marriage before his death. He also shared Alfred's obsessive concern with honesty, along with considerable confusion as to its meaning. Speaking of his "semi-autobiography" *A Story Teller's Story* (1924), which he dedicated to Stieglitz, Anderson confessed that he no longer knew which events described there had happened and which he had fabricated. To resolve this problem, he decided that "It is only by lying to the limit one can come at truth."

At heart, O'Keeffe was mistrustful of manipulators of words, but she felt an immediate sympathy for Anderson. Midwesterners, they had each escaped a poverty and isolation made worse by small-town life, where the mean expediencies of privation were known to every neighbor. Georgia probably revealed no more of her past to Anderson than she disclosed to others; the tragedies of her family would always remain a

secret. But in a guarded fan letter, she singled out the bleak settings of his stories, along with the character of the author's father, as "very familiar" to her.

Georgia would have instantly recognized Frank O'Keeffe in Anderson's recurring portrait of his father, Irwin, a feckless storytelling man whom drink and a fondness for playing the alto horn had reduced to occasional employment painting signs and houses.

Unable to support his family, Irwin Anderson was "a spectral figure at home," noted his son's biographer.[19] In one of Sherwood's stories, the father returns, drunk, after an absence of several days. Haranguing his terrified family seated at their sparse meal, he rails against the demands of manhood and of women: "I have tried being a man but I cannot make it," he cries. Their mother's bitter resignation was more frightening to the children than their father's rage. "When something happened she did not approve, she went about the house with a strange lost look in her eyes. . . . All became self-conscious, afraid. It was as though she had been struck a blow and when you looked at her you felt at once that your hand had delivered the blow."[20] Georgia could not have read this passage without thinking of Ida and Francis O'Keeffe. No wonder her letters to Anderson assume the unspoken understanding of those who have been friends from childhood.

An amateur painter of painstakingly realistic efforts, Anderson was slow to assimilate Georgia's early abstract work; he would come to appreciate her art only as she moved toward the figurative. A lingering misogyny, moreover, made it difficult for him to take a woman artist seriously. Although still lifes and landscapes were strongly represented among the hundred works in O'Keeffe's 1923 exhibit, Anderson's most vivid impression of his visit to the show was of Alfred Stieglitz talking. In the same letter to Alfred announcing the dedication of A Story Teller's Story to him, Anderson recalled the image that inspired his words: "There is just the picture of you as you will always stay so sharply in my mind, you in a room with paintings on the wall and facing the stupid, half-irritated people. You patiently explaining, over and over, trying to make all of the poor dears see the beauty you see."[21] Another fatherless son, Anderson in his dedication paid tribute "To Alfred Stieglitz, who has been more than a father to so many puzzled wistful children of the Arts in this big, noisy growing and groping America."

Knowing that Anderson considered him a far greater artist than O'Keeffe, Alfred felt free to vent his feelings of rivalry toward Georgia, starting with the disparagement of her recent success. His exhibition of prints, he wrote to Anderson in mid-April 1923, was quite a different kind of event than O'Keeffe's show. His photographs created an "ex-

citement of grimness" suggesting that the reverberations caused by Georgia's paintings were less profound, less significant—frivolous even—compared with the momentous triumph scored by his prints. Other artists and intellectuals, including earlier skeptics, experienced something like a religious conversion on seeing his new work, he reported. It was this spiritual quality that separated his vision from Georgia's. He could pitch her paintings, but there could be no question of selling *his* photographs, he told Anderson. The sordid exchange of money was the difference between sacred and profane art.

Given the divine order of creation in which Stieglitz placed his new prints, any reviewer found wanting in reverence was guilty of blasphemy.

Charles Sheeler, straightforward and unaware, strode right into Alfred's minefield. In April, the title page of the journal *The Arts* announced that in the following issue "Mr. Sheeler will discuss the art of Stieglitz with the sympathy of a friend and with the knowledge of a skilled photographer of the first order."

Studded with praise as promised, the review appearing on May 23 nonetheless summoned howls of protest from the Stieglitz camp. Waving the red cape of pictorialism, Sheeler had dared to compare the "material preciousness" of Stieglitz's platinum prints to the gold leaf on Italian painting; the photographer's cloud photographs to the landscapes of Mantegna; worse, he noted that Alfred's print of a hay wagon suggested the genre painting of the Munich school.

Alfred was outraged. After all his efforts to proclaim the independence of photography while repudiating pictorialism, this was the ultimate and unforgivable perfidy. There was no question of a respectful difference of opinion or the simple observation that, coming from Sheeler—a photographer who was also a painter—such comparisons were hardly invidious. Sheeler's attitude, Alfred wrote to Strand, was petty and spiteful; he had long suspected Sheeler of harboring a grudge against him and here was the proof.

The word went out: Sheeler must be brought down. With Seligmann appointed to coordinate the offensive, attacks on the artist written by Strand and Arthur Boughton, a rich amateur photographer and collector, appeared in the New York *Sun* and the New York *Globe*, accusing Sheeler of "errors and omissions" and general ignorance and hinting strongly of underlying malice.

Sheeler's reply to Strand was characteristically mild and gentlemanly: "Any exception that Stieglitz may have taken, through you, to my article in *The Arts* is quite all right," he wrote. "In fact, differences of opinion are more interesting than agreement."[22] Sheeler's assump-

tion—altogether accurate—that Strand was acting as Alfred's hit man provoked an enraged denial.

Well before the review appeared, Beck, Paul, and Alfred had been fanning flames of growing resentment toward Sheeler. From his role as Stieglitz's disciple and Strand's collaborator on the film *Manhatta*, Sheeler had been moving from success to success—without them. A favorite of Gertrude Vanderbilt Whitney and Juliana Force, Sheeler the painter was a star of the Whitney Studio Club shows. Favorable reviews of his photographs multiplied; his prints suddenly seemed to be shown everywhere: at Daniel's, the De Zayas Gallery, the Association of American Art. Brancusi chose him to photograph his sculpture.

Raves about Sheeler's work had started to rankle the Stieglitz inner circle, beginning, ironically, with Georgia's lavish praise of him as a painter *and* photographer in *MSS*. "He is always an artist," she had written.[23] The hard-to-please Henry McBride was ecstatic about Sheeler's talent in both painting and photography. Neither Stieglitz nor Strand, both preeminent photographers of the city, would have cheered on seeing McBride single out Sheeler's photographs of New York for special distinction. Nor, after laboring intensely (and competitively with one another) on studies of Lake George barns, would they have been thrilled to learn that McBride called Sheeler's photograph of a Pennsylvania barn "one of the most noteworthy productions in the history of photography," comparing its "passionate insistence on composition" with Cézanne's work.[24]

In the months between O'Keeffe's tribute to Sheeler in December 1922 and McBride's homage in the *Herald* of May 1923, both Sheeler and his wife were turned into objects of derision by the Stieglitz camp. Beck and Alfred's letters to one another now referred to the professorial, bespectacled artist as "The White Rabbit," and they exchanged lewd jokes about photographing Sheeler and his ample wife Katherine together in the nude. Although the Strands and the Sheelers continued to exchange visits, Paul was now convinced, Beck reported to Alfred, that Mrs. Sheeler called him a "dirty Jew" behind his back. By the time Sheeler's review of Stieglitz's exhibit appeared, his one-time friends had become enemies, impatient to strike.

WHILE THE SALVOS of Stieglitz's lieutenants were being aimed at Sheeler, Georgia and Alfred were preparing for an earlier than usual departure for the lake.

June 1923 marked five years that she and Alfred had been together. The success of her show signaled that one promise of the move to New

York had been kept: her talent was recognized. She was talked about and written about and, even more important, her work sold.

Relief as much as pride centered on her ability to earn a living by painting. More than anyone, Georgia had reason to be mystified by the confusion surrounding Stieglitz's finances. The austere elegance of 291; the twelve-room apartment on Madison Avenue; Oaklawn's rolling acres and armies of servants—she had no reason to doubt the public perception of Stieglitz as a rich man; and his brothers and sisters lived as grandly as their parents.

Until her move to New York, she could not have known of Alfred's refusal to sell his work and of his dependence on "allowances" and shelter from Emmeline and his family. Any fantasies she had harbored when ill and jobless in Texas of being supported and protected by a wealthy and powerful man soon yielded to reality. His fluctuating income required supplementary handouts from the family along with free housing. Independent and proud, Georgia had suffered too much from the pariah status of genteel poverty to become a poor relation once again. For the first time, it seemed possible that her earnings could support them both.

The easing of financial problems underlined another promise that remained to be kept. There had never been a time in her life when Georgia had not wanted to have—and assumed she would have—a child. Beyond the insistence of the culture that a normal woman was one who bore and nurtured children, she had grown up in a family of six in a farm community where large families were taken for granted. The cramped lives of her unmarried, childless aunts and uncles would not have argued for the freedom enjoyed by those who were not parents.

Wherever she lived after she left home, she had "adopted" little girls of friends or colleagues. Teaching normal school in Canyon, she had added a class of first graders to her busy schedule; she felt enriched by her engagement with young children. In her own art, she tried to retain the direct perception of the child. It was in Canyon, too, that Georgia had confided to a fellow teacher: "I'll die if I can't have a child of my own."[25]

A child represented the joyful actuality of love between a man and a woman—or its remembrance when sexual passion was ended. The transparency of her yearning had made her flee the small boy in her Horace Mann class; he was the child she had longed to have with Arthur Macmahon. The shame attendant on her fantasy suggests that Georgia had known that no issue would come of their love. In one of her last letters to Arthur, written from Canyon, she told him of her fear of leaning on a man, even though there must be a "little one" in her life

someday.[26] The dilemma of the woman made dependent by motherhood was starkly drawn by the tragedy of Ida O'Keeffe. The relation of child-bearing and childlessness, love and death was made more confusing by her sister Anita's abortion, followed by her elopement with the father of her unborn child, in the months while their mother was dying.

By the time Georgia arrived in New York in June 1918, Alfred had already broached the subject of divorce with Emmeline. Not that Georgia cared about the legalities of her union with Alfred. But she could feel reassured that Alfred saw their love as enduring, a public as well as a private fact of his life. Unlike her grandfather George Totto or her father, Francis O'Keeffe, unlike Ted Reid or George Dannenberg, her unreliable swain from the Art Students League, Alfred would not abandon a woman he professed to love.

During the first months of their life together, Alfred seemed receptive to having a child. His niece had turned the studio over to Georgia and Alfred on the eve of her marriage to Donald Davidson. Pregnant within a year, Elizabeth lost no time in vaunting the joys of child-bearing—and, shortly thereafter, of motherhood itself—to her uncle and his lover.

Aware that Georgia needed no persuading, Elizabeth directed her arguments toward dispelling whatever doubts Alfred harbored; flattering his genius, she pointed to the superior genetic endowment of any child he and Georgia would produce. Alfred might feel old, but Georgia was still young; it would be unfair to deprive her of a woman's most exalted experience. Should he die before her, Georgia would have more than memories of their life together.

As a final argument, Elizabeth offered herself as surrogate mother. She and Donald were struggling to raise chickens on a parcel of the parental Westchester estate. In this wholesome country setting, she would gladly board their baby, relieving them of the tedious, time-consuming, messy tasks of childrearing; Alfred and Georgia would be free to play whatever loftier parental roles their work and energies allowed. Georgia could have the pleasures and benefits of being a mother with no loss to her art.

Alfred's reply was guardedly positive. Not a day had passed since he and Georgia had been together when he had not weighed her offer, he wrote to Elizabeth during the summer of 1918. He considered it from every point of view: "G.'s reality—my reality—your reality.

"I do not lack courage—nor decision," he assured his niece. "But I know many things must be completed before new ones are begun." He promised that he and Georgia would visit Elizabeth soon, and then they could "go over the question very undisturbedly." His letter ended on a

note of optimism. "I'm beginning to see the possibility," he wrote.[27]

Eighteen months later, Alfred was advancing arguments against having a child. "Georgia is herself such a kid," he wrote to Elizabeth, although she was "developing beautifully." (O'Keeffe was then thirty-three.) "He may have been thinking of his sister Flora's death in childbirth when he alluded to unspecified fear: "Perhaps I lack courage," he conceded.[28]

But he had persuasive reasons for saying no: lack of money; the absence of a proper home; his earlier abdication as a father. Shrewdly, however, he always returned to the argument that found Georgia at her most vulnerable: the demands of motherhood would destroy her as an artist.

Early in 1922, Elizabeth repeated her offer; with a toddler and a new baby daughter, she could easily absorb a boarder in her homegrown nursery school. She noted feelingly that the urgent demands of young children strengthened discipline and will (qualities in which O'Keeffe was not notably deficient). She could not bear to think that both of the women Alfred loved—first Katharine Rhoades and now Georgia—should be deprived of experiencing the "pulse of life."

There was no more talk of possibilities. Alfred had either changed his mind or, never intending to have another child, he had preferred to appear undecided. In the heat of passion, to declare his adamant refusal to allow Georgia to have a baby would have seemed a failure of love; it was easier to equivocate with "perhaps" or "someday."

It's unlikely that Georgia tried to win him over. Persuasion was not her style; if she did succeed in changing anyone, she would be responsible for the consequences. Disengagement was her defense against disappointment. Five years of living together had revealed Alfred's lifelong dependence on his family—and, increasingly, on her. By orphaning him, Hedwig's death had cast Alfred back into the terrors of an abandoned child. He was afraid to stay in the farmhouse with her, Georgia reported worriedly to Elizabeth. Without his father or mother, Alfred felt alone. What could he be for a young child, except a jealous, resentful brother vying for Georgia's divided attention? In any case, a baby agreed to under duress would be her child, not his. In the end, Alfred's reluctance, his self-confessed "lack of courage," may have been his most persuasive argument.

A sense of profound crisis pervaded the decision—made final in 1922—to remain childless; the child Georgia would never have, bore the burden of other broken promises, of unmet needs, unspoken resentments, betrayals like internal injuries that weaken as they bleed unseen.

The issue was sealed the following year with unexpected and dreadful finality. At the end of May 1923, Kitty gave birth to a large, healthy son named for his father, Milton. On June 2 the day of Alfred and Georgia's early departure for the lake, they received the news: Kitty was stricken with a postpartum depression so severe she could not leave the hospital. As Alfred's past failures as a father rose up in accusation, he no longer needed to defend his present retreat.

FIFTEEN

The Long Summer of '23

PAUL STRAND, *Rebecca* (1922–23).

SHOCKED, STUNNED, DEVASTATED —the words echoed through the letters that now flew back and forth between Lake George and Mamaroneck, where Lee, Lizzie, Elizabeth, and Donald Davidson, within easy distance of the White Plains hospital, reported to Alfred on Kitty's condition.

The real subject of these letters, however, was not Kitty's pain but the suffering her illness inflicted on the writers. Without mentioning his daughter, Alfred wrote to Sherwood Anderson that the world was busy devising torments solely to martyr him.

Already suffering from an ear infection, Lee now complained of depression brought on by Kitty's sickness, Elizabeth wrote to Alfred. As a doctor, Lee was the relative kept most closely informed of his niece's condition. Yet Elizabeth did not dare ask her father for details. Silence was the response to any crisis that called for the expression of feelings, Elizabeth wrote to Alfred bitterly. Urging her parents to discuss

Kitty's illness was like stripping them naked, she said. Yet her own dependence on the family was symbolized in graphic form: her letters to Alfred were written on notepaper emblazoned with the crest her father had created for Elmcroft, his recently acquired estate.

Kitty's needs and feelings had always been ignored or disparaged by the whole family; now it was her symptoms that were veiled in secrecy or euphemism. In part, these evasions were typical of a class and period in which all mention of personality disorder was shrouded in shame. But adding to the defensiveness of middle-class gentility was the Stieglitz sense of specialness, of proud distinction. Once again, Kitty had proved herself unworthy.

Alfred had visited Kitty in the hospital on the eve of his departure for the Hill. Although he was "far from satisfied with her state of mind, then," he reported to his niece, he saw no need to change his travel plans.[1]

A few weeks later, Kitty's "angry outbursts" shattered the silence. Her depression, long preceding marriage and childbirth, had finally exploded into rage. Whether her anger included threats or acted-out episodes of violence is unclear. The spectacle of this docile young woman giving way to expressions of uncontrollable wrath was terrifying enough.

Blaming the Obermeyers was, predictably, the first Stieglitz line of defense. Emmy and her brother Joe, Alfred claimed, had been feeding Kitty the same lies—presumably about him. Emmeline had "doomed" Kitty to this illness, Elizabeth assured Alfred. Emmy's mother had succumbed to postpartum depression when Emmy, her sixth child and only daughter, was born. Emmy was obviously a carrier, infected with mental illness, which included a congenital inability to tell the truth.

The hysterical tone of the attacks on the Obermeyers intensified when it became clear that Kitty's outbursts were triggered by Alfred: his presence, image, even the mention of his name.

Nonetheless, the doctors were optimistic. Postpartum depression was a widespread and well-documented condition; the young mother almost always recovered completely. Milton Stearns was still more sanguine. He adored Kitty and their son. With his loving, attentive care, he was confident that she would soon get well.

Alfred made a brief visit to the city in mid-June, without Georgia. Then, accompanied by Beck Strand, he returned to the Hill on June 18. She found him exhausted, depressed, and "looking a thousand years old."[2] Whether from shame or guilt, Alfred withheld mention of Kitty's illness even from close friends. With Beck, Alfred was vague about the source of his distress, noting only the stock market and the deteriorating state of the Hill. His only allusion to Kitty's condition was to other "bad

news" he received just before leaving the city. In his second letter to Sherwood Anderson written from Lake George, Stieglitz alluded to his worry, noting archly that it was about a woman yet *not* a love story.

Beck's arrival at the Hill was a welcome distraction. She and Georgia enjoyed each other's company more each day. They did household chores together, working in a harmonious rhythm of alternating tasks. For one meal, they picked wild strawberries, made ice cream in the new "turnless" freezer, and cooked chicken, asparagus, and rhubarb. Beck boosted Georgia's natural energy, dampened by Alfred's depression. That same evening, after the dishes were done, the two women put on bathing suits. They first cleared and swept the kitchen and then, "each armed with brush, painted the floor and pantry a sweet & girlish grey," Beck reported to Paul.[3] They recovered with ten hours of sleep.

By the end of July, Kitty was improving steadily, Elizabeth wrote to Alfred. Agreeing with his niece's doctors, Lee felt that she was well ahead of the earlier prognosis of three to four months for full recovery. His optimism vindicated, Milton was ever more confident, hopeful and determined that he alone could help Kitty get well. In regular visits with the Davidsons, he persuaded them that his love would prevail over Kitty's past troubles. She wanted to begin her life over again with him and their son, she had told him.

At the Hill, Alfred was gladdened by the good news but still "too dazed" to take any photographs. Besides, he had left his camera in town. Georgia was doing only a little work: drawings and small watercolors of flowers. In the past, she had managed to distance herself from Alfred's tortuous machinations with Emmy and Kitty; unlike the rest of the noisome clan, they were not physical presences in her life. Out of sight, out of mind had always worked as a successful strategy for keeping troublesome people at bay.

But Georgia could not remain aloof from Kitty's illness. Alfred's sufferings as a father implicated her in his guilt. She could dismiss Emmy as foolish and self-deluded; Kitty was an innocent victim—a phrase Alfred kept repeating like a mantra. Georgia could not remain unaware, moreover, that she had replaced the daughter more than the wife. Infantilized by him as a "child/woman," as "just a kid," Georgia was conflated with Kitty; she was still the adoring child, not yet an accusing victim.

When Beck left the Hill in the last week of June, however, Georgia began to be seriously "affected" by his state of mind, Alfred wrote to Arthur Dove in early July. She had begun painting again, but he found her first large work "really tragic. . . . When I look at her, I feel like a criminal," he told Paul Rosenfeld.[4]

Tangled in the skein of his guilt toward Kitty/Georgia, Alfred found himself in a sexual double bind. By her desire to have a baby, Georgia repudiated the state of childhood. In refusing to allow her to abandon him for a child of her own, as Kitty had done, Alfred at the same time stood exposed as inadequate, less than a man. His sense of failure, he hinted, was reflected in sexual performance. "I with my rickety old carcass and my spirit being tired beyond words—There is something in me just lacking," Alfred confessed to Rosenfeld. "What it is I don't know. I suppose my physique has never been equal to the demands I made upon it."[5]

The demands may not have been his alone.

Georgia's gloom caused thoughts of Beck Strand—beautiful, vibrant, and admiring—to distract Alfred more each day. On her return to the city, Alfred bombarded Beck with letters, addressing her as "Beckalina Strandina Molta Bella Carissima Mia." He missed hearing her yodel in her special "yodeling bath." So did Fred Varnum, the coachman/handyman, who found it "much too quiet without Mrs. Strand."[6] Alfred pressed her to come for her long holiday in August. Her company would do Georgia good, too, he insisted.

In the meantime, there was the brief diversion of an overnight visit from Anita Pollitzer. She had spent the last few years as a full-time political organizer, lobbying for women's suffrage at every level, from local forums in Charleston to a White House audience with President Wilson. Despite her defection from art to politics, the tiny whirlwind of a woman continued to delight Alfred. Her belief in "the cause" and the way she gave herself completely to the struggle were for him "the true spirit of 291."

Georgia was glad to see Anita for other reasons: locked into the strain and tensions caused by Kitty's illness, Georgia finally had an old friend and ally to talk to. When Anita left for Chicago, however, O'Keeffe regretted her confidences as disloyal and indiscreet. Writing to thank Anita for coming, she begged: "Dont mention about Kitty . . . I shouldn't have said anything but you are nice to talk to—it accounted for conditions—better now."[7]

Now that things were better, Georgia could tell Sherwood Anderson how terrible the last weeks had been; Alfred's miseries—physical and emotional—had made her too wretched to write.

With the cheering news in July from White Plains and a breather between guests, Georgia's spirits improved. She was making small still life drawings and watercolors, but also gardening, cooking, doing things around the house that long needed to be done. The irony was not lost on Alfred that Georgia—competent, self-reliant, thrifty—"utilized" his

beloved Lake George more than he ever had. (She always liked to boast that she could do everything Fred Varnum was paid to do, better, faster, and cheaper.)

Her restoring solitude was short-lived. While anticipating Beck's return, Alfred invited Marie Rapp Boursault and her two-year-old daughter, Yvonne, for a ten-week visit to the Hill.

On the face of it, Alfred's offer of a two-month vacation to his former secretary was one of his most generous and sympathetic gestures. Gassed in the trenches of northern France, Marie's husband, George Boursault, had returned from the war with tuberculosis. Barely recovered, he was now looking for a job—without success. Money was scarce. Cooped up in a tiny apartment with a toddler and pregnant with their second child, Marie would have had no holiday without Alfred's invitation.

Still, the timing, length, and exceptional nature of Alfred's offer to Marie (in the history of the Hill, the only extended visit of any youngster who was not a family member) point to other motives: Georgia would get a thorough lesson in the realities of living with a young child.

Alfred's choice of teacher could not have been more diabolically apt. Little "Eonne" was in full throes of the terrible twos, exacerbated by unfamiliar surroundings and people. The little girl reacted still more predictably to the tensions of her overburdened mother. Anxious to make sure that her daughter was no trouble to their hosts, the gentle Marie tried to become a stern disciplinarian; there was much smacking of bottoms and banishment to bed. Yvonne expressed her sense of betrayal loud and clear.

Their young visitor, Alfred wrote Beck, "cried more than the contract specified." Even when cheerful, however, Yvonne's penetrating little voice was heard everywhere. Alfred christened her "21-cats-on-the-back-fence," but he enjoyed her company when she was good-humored and remained unfazed by tantrums or whining. Alfred was used to ladies loudly expressing their unhappiness. Still suffering the terrors of childhood himself, he was patient, sensitive, and attentive with children—especially female children. Yvonne was "a great source of entertainment . . . really a delightful little person," he wrote to Beck, who had just missed the small prima donna.[8] Her latest act was a war dance performed naked in front of the long mirror and accompanied by chanted words of her own invention. Attaching herself to Alfred—her most reliable source of affection and approval—Yvonne showed her fondness by eating his breakfast for him. In their favorite game, Yvonne stood next to Alfred and, aping his every word and gesture, announced, "Seed de monkey!" Stieglitz was delighted.

"I'm her teacher and she's receiving an unusual education, most unusual," he wrote to Beck.[9]

Yvonne's hardest lessons were posing for Alfred. Despite her frequently "evil" behavior toward him when he wanted to photograph her, he pursued the tempestuous little beauty around with his camera, cajoling her to remain still long enough for him to get his shot.

When Georgia saw Yvonne, it was hate at first sight—and sound. She could not bear the child's crying and frequent demands for her mother's attention. But she was equally irritated when she talked, sang, or banged the screen door. Alfred's fondness for his newest acolyte did not dispose O'Keeffe more kindly toward the little girl. After he had refused her a child, his enslavement to Yvonne could only seem a cruel betrayal.

On a rare evening when the grownups were sitting peacefully at dinner, it fell to Georgia to discover the reason for the exceptional calm: passing the upstairs bathroom by chance, she snatched the two-year-old from a tub filled with water where she was bathing herself and her doll. The irony of Georgia's rescuing Yvonne from the danger of drowning was not lost on Alfred.

Hostile toward Marie from their first meeting at 291, Georgia now added the daughter as another reason to dislike the mother. Chores were divided to require as little communication between the two women as possible. Georgia did the menu planning and cooking; Marie was in charge of cleanup. But one evening, when their guest was about to clear dishes with the remains of lamb stew and to pass clean plates for blueberry pie, Georgia lost her temper. "Alfred, you promised," she shrieked. Alfred cringed. He had forgotten their agreement: there was to be only one plate used for each meal. Once again, his broken promise to one woman intensified her feelings of rivalry, rage, and resentment toward another.[10]

Delegating Alfred to inform Marie of domestic arrangements made it clear that Georgia viewed the former secretary as his guest alone; she felt no obligations of hospitality or even civility toward the younger woman. Following dinner and the ascent to bed of any resident Stieglitz family member, Georgia, Alfred, and their guests usually repaired to the living room to talk and listen to records on the Victrola. Georgia made it plain to Marie that she was not included in their socializing. Neither Alfred nor Paul Strand, arriving from Saratoga at the end of July, dared brook Georgia's wrath by inviting Marie to join them—even once. "They were both terrified of her temper," Marie recalled.[11]

Strand joined Stieglitz in his passion for photographing Yvonne.

Strand was so entranced with his new model that he wanted to skip an excursion to the races with Alfred and Georgia. He was persuaded otherwise. Paul's cooking made up for his defection to "the brat," as Georgia called her nemesis. Perhaps as a sentimental reminder of their Texas idyll, Strand made "enchellados" (Alfred's spelling). Eating Paul's re-creation of the Mexican crepe filled with cheese, onions, corn, pepper, and tomatoes, Georgia "smacked her lips and assured Paul he was an artist," Alfred reported to Beck. Georgia's favorite ingredient effectively excluded Alfred from the feast. "As usual outside the Onion Circle," he noted.[12]

Although he found no more work in Saratoga, Strand stayed at the Hill into August. He missed Beck, feeling guilty at leaving her in the hot city. She had agreed with her doctor employer to take her vacation in September, and the trip to Lake George was too long for a weekend visit. For Georgia, who had to bargain for every hour alone, Beck's solitude seemed enviable bliss. A rest was very good for her, she assured Paul feelingly.

By early August, New York was unbearable. The Strands' top-floor bedroom was "so still & hot—even the usual night sounds of jazz and automobiles seem to have wilted under the terrific heat," Beck wrote to Alfred dispiritedly.[13]

Daily letters from both Paul and Alfred (including affectionate greetings from Georgia) allowed Beck vicarious participation in life at the Hill—every meal, walk, swim, and photographing session. She loved Georgia for making Paul "nicie icie cream"; she was sewing another undergarment for her. If it didn't fit, Georgia could donate the article to Ella Varnum.

Counting the days until she returned, Alfred wrote to Beck detailing his sexual fantasies, fueled by his developing nude prints of her: her belly, thighs, and sumptuous behind magnified by clear rippling water. "For an hour or more I have been tickling up your rear into most perfect condition of delight," he wrote.[14]

By mid-August, he playfully threatened her with being "in trim and too utterly dangerous." He was trying to keep his "higher mentality more than occupied. They say that's the only way to sublimate something good society thinks too naughty."[15] Far from inhibiting Alfred, Strand's presence seemed to multiply lustful thoughts of Beck; such scenarios were no sooner in his head than they were penned and posted to West 70th Street.

Georgia, too, had come to see Paul as a reflection of Beck's improving influence. Being Georgia, she saw no reason to spare Strand this insight.

"She told him that she appreciates you more and more daily seeing what you have made of him," Alfred reported to Beck.[16]

It was settled that for her long visit in September, Beck would stay at the farmhouse. "Georgia and I both want you to be with us, to eat sleep and yodel here," Alfred told her.[17] Symbolically, Beck had already joined them in bed, if only by proxy. The bed slippers she had sewed for her "O'Keefski" were now protecting Alfred's legs from the scratches and bruises caused by Georgia's long toenails. "I am a sight from the knee down," he wrote. Alfred wanted to know whether Beck wore bed slippers; or did she keep her toenails filed down? Or "was Paul's skin tough and properly prepared for scrapings & scratchings—unintentional & loving?"[18]

He could tell from the tone of her remarks that she had the "Curse," Alfred announced. He had queried Paul on the subject, but after some calculations Paul concluded it wasn't possible. He was wrong. "He didn't know. I knew," Alfred crowed to Beck.[19] Georgia wondered aloud whether Alfred kept such tabs on all the women of his acquaintance.

Just before Beck arrived, there was unhappy news from White Plains. Kitty had suffered a setback. Milton reported to Alfred (addressed always as "Mr. Stieglitz") that her symptoms now included hallucinations and delusions, among them the belief that her father was dead. Lee's visit and his diagnosis of a relapse shattered Milton's hopes of taking Kitty to Ogunquit in September. He was desolate. She had so looked forward to the trip.

Alfred professed to being unsurprised by the bleak bulletin. With Emmy and Joe filling her head with lies, how could Kitty hope to get well? But for the first time that summer, he complained of being unable to sleep.

WITH BECK's return in late August, Alfred enjoyed a happy diversion and Georgia found an ally in her loathing of Yvonne.

Like many infantile women, Beck, with her baby talk and sense of failure in the adult world, had a horror of young children. Their dependency, urgent needs, and legitimate claims to attention provoked in her a mixture of anxiety, envy, and resentment. The prospect of an afternoon at the beach with her sister's small children was more unbearable than the New York heat. In early July, Beck had replied to Alfred's amused description of life with Yvonne with hysterical disgust: "I am sure the child leaks at both ends and that the house is a chaos of diapers, sour milk, safety pins to run in the feet at night, Mennen's

powder (or is it Womens?) towels, washrags, dresses etc. I think the business of raising a kid is horrible. They all smell, spit, sleep, slobber, snort."[20]

Obsessed with the dread of getting pregnant, Beck suffered premenstrual misery exceeded only by the worry that she had skipped her period. At the same time, she felt guilty and defensive about not wanting a child. All her married friends were happily buying maternity clothes and layettes. Now that finances were brighter, Paul seemed to look forward to being a father. In her remarks to him on this troubling issue, Beck sounded both imploring and placating. One of these days, of course, they would have children, she assured him, but now, while they were still young, they should be having "adventures." Meanwhile, she begged Paul to "help her"—a plea that seemed to urge on him a more active role in contraception.[21]

Beck was spared the sight of Paul's conquest by Yvonne; in the Strands' pattern of alternating visits, he had returned to the city by the time she arrived at the Hill. Without suffering Georgia's sense of betrayal, watching Alfred delightedly pursue the blond sprite with his camera in hand, Beck nonetheless shared her friend's outrage. In the many snapshots Alfred was making of Yvonne, Beck noted nastily that the model "looks unhappy and sophisticated in all of them. Not a trace of wonder or the thing which makes a child look like a flower. . . . We will both be relieved when the kid goes," she wrote to Paul. "She has grown more and more unmanageable. Her voice penetrates into everything until the only refuge is a remote place away from the house."[22]

Escaping Yvonne drew the two women closer. On one long evening walk, they spoke of Paul and Alfred and the problems they shared. The men they lived with were remarkably similar: in moodiness, self-absorption, and a constant need for bolstering.

While rowing on the lake, Georgia told Beck about Paul's Texas mission. Although it was only six years ago, Georgia had "forgotten" much that happened, she said. On another daytime walk in the woods, they picked big clumpy pine boughs to cover the ample plaster bust of "Judith," a sculpture perpetrated by Moses Ezekiel, a distant Stieglitz relative, and profoundly loathed by the younger members of the family.

In early September, Katharine Rhoades arrived at the Hill for a brief visit. It was Georgia's first and only encounter with the beautiful, mysterious woman who had loved Alfred and been loved by him in return. Katharine had given up painting and New York to live in Washington, D.C., where she was helping Charles Freer amass his great collection of Oriental art. Stieglitz was relieved that the two women appeared to get on well, he wrote to Seligmann.[23] His doubts, however, about the

effect of Katharine's visit on Georgia raise questions, once again, about Alfred's motives. During this summer fraught with tension, inviting a former lover to the Hill was also an invitation to trouble.

Neither his attentions to Katharine nor the other woman's accomplishments seem to have inflamed Georgia's sense of competition. Stieglitz did not photograph Rhoades during her visit to Lake George; instead, he made her the subject of one of his most haunting symbolic portraits: a tall and majestic poplar bending, graceful and resilient, in the wind.

Then suddenly, on September 8, after hurriedly packing paints and clothes, Georgia boarded the train for York Beach, Maine. She had been wanting to go for a long time she told Beck, now charged with sending Georgia an "unexpurgated daily bulletin with all the details of Stieglitz' welfare."[24]

Grieved by her departure, Stieglitz tried to claim control over the decision: he had been in favor of Georgia's getting away for some time, he announced to Beck, the Davidsons, the Engelhards, who had just arrived, and Marie Boursault, who was departing.

While his sister Agnes was visiting, Stieglitz was dealt another blow: Agnes's husband, George Herbert Engelhard, acting as the family financial adviser, pointed out that Alfred was the only heir with any real attachment to the Hill; the others were unwilling to maintain the property for his use alone. A brief flurry of talks ensued with the Davidsons about the possibility of their living and farming there. The idea soon faded, and it became clear that if the Hill were to remain in the family, Alfred would have to pay for it.

From their intimate talks, Beck was aware that Georgia felt she was being "forced" to spend time at the Hill; she could not put up with conditions there indefinitely. Beck took a bleak view of what this would mean for Stieglitz. "He'll probably end up somewhere quite alone. . . . Its too terrible," she wrote to Paul.[25]

Every night, desolate and unable to sleep, he came into her room "like a haunted man pursued by his daemon. I wish I could take him to my broad bosom and comfort him," she wrote to Paul.[26] By September 9th, all the others, including Katharine Rhoades, had left. Beck and Alfred were alone.

A week later, on September 15, Georgia was "still away and painting," Beck wrote to Paul, who was filming the races in nearby Saratoga. "Stieglitz is fearful that she will come home too soon. We are both looking forward to being by ourselves." She did not mail this letter until the following day, when she added a postscript: "I can scarcely keep from coming to you . . . but it would only upset you."[27]

If she had returned then, Beck, with her compulsion to tell all, would have confessed to Paul that she and Alfred had become lovers— an affair as inevitable as it was brief. Beck was moved by pity, love, and gratitude for the high-intensity beam of Alfred's attention. Stirred by Beck's glorious beauty, Alfred needed her uncritical admiration even more. Both harbored resentments toward Georgia and Paul—a vastly underestimated aphrodisiac in adulterous passion.

On September 18, Paul Rosenfeld arrived. Georgia was still away. Beck felt sorrier than ever for Alfred and angry at his family for not helping him keep the Hill. But she admired and envied Georgia her independence and sense of entitlement; she had the *right* to leave and to work, even if it caused Alfred pain. Beck knew this tough-mindedness was the only way to produce anything worthwhile. The alternative was to be sucked into the quicksand of householding on the Hill. "She will make much of it," Beck noted of Georgia's flight to Maine. "I am the only one who seems to create nothing."[28]

On September 27, Stieglitz was in a "weird" mood, Beck reported to Paul. From the depths of despondency he had soared into his manic phase: "a terrific state," Beck described it. He followed her and Rosenfeld around, talking incessantly, trying to solve all the problems of his life "aloud."

The next morning, a telegram arrived from Georgia; she was on her way home; they should expect her later in the day. Stieglitz was "terribly upset" by news of O'Keeffe's imminent arrival, Beck wrote. Only the day before, he had received a letter saying that she had just begun to paint again; Alfred had wanted to cable Georgia to defer her return. But in a telling slip of the pen, when Beck reported this news to Paul she switched genders: "She was going to telegraph her to stay yesterday, but wrote a letter instead." The *She* has been crossed out and *He* is written above.[29]

Fueled by guilt, Alfred's sense of foreboding about Georgia's return had been building for days. He felt he had to be very careful about what he said to Georgia so as not to hurt her, Beck wrote to Paul disingenuously in her daily bulletin from the Hill. Alfred was still more fearful that Georgia would recognize the pain in his work—the prints of clouds and barns made while she was gone. He worried that his anguish would influence her painting.

Once again, Stieglitz had made an implacable judgment about his genius compared with O'Keeffe's talent. Suffering was an integral— indeed essential—element in his photography. Great art, like his own, was tragic. But any intimation of tragedy would "spoil" O'Keeffe's work.

Her painting should not even be sad; it must be bright and untroubling in its surface beauty.

In the hours before Georgia's return, Alfred worked himself into a frenzy of despair. Beck had never witnessed such naked human suffering, she said. But living through the crisis with him, captive to the ceaseless expression of his pain, she came to see how the crushing egotism of the man contributed to his agony: "Stieglitz wants his own way of living," she wrote to Paul, "and his passion for trying to make other people see it in the face of their own inherent qualities really gets things into such a state of pressure that you sometimes feel as though you were suffocating. Well, its all terrible."[30]

Another worshipper at the shrine of the ideal couple was shorn of his illusions. Paul Rosenfeld wept. Never had he been in such a hell, he told Beck. "He'll get used to it," she wrote to Strand coolly. It was good for Rosenfeld to see that the O'Keeffe-Stieglitz union was not "romantic or rosy," she wrote.[31]

Georgia appeared late in the day and in great form. A miraculous calm settled on the farmhouse. The sexual static between Beck and Alfred had dissipated. Beck had seen "the Little Feller" at his most pathetic—and terrifying. For his part, Alfred had become disenchanted with Beck; there was a "messiness" about her that repelled him, he wrote to Elizabeth. Perhaps it was too close to the "chaos" he acknowledged within himself. He needed Georgia's severity, her discipline, her sense of order—in life and in art. "She is the only woman that should be close to me. She is truly beautiful at the roots," he wrote.[32]

In the hours following her return, Alfred and Georgia talked as they never had before. Georgia "listened and heard.—And I was much clearer," he wrote to his niece. "The days of adolescence are over," he promised, "and the relationship reestablished clearly finely free."[33]

Beck's departure at the end of the month was celebrated by a huge row between her and Georgia. The ostensible issue was Beck's insistence on wearing trousers. Georgia disapproved of women who wore pants.

Earlier, Beck had been cowed by O'Keeffe; now, as both wearer of trousers and lover of Alfred, she discovered in herself a new sense of sexual power. She refused to "budge an inch," even answering Georgia in a "saucy way," Beck reported proudly to Paul.[34]

When Georgia capitulated on the trouser issue, Beck had another revelation: "O'Keeffe is reasonable if her opponent doesn't wither," she found. "Poor girl! She's much mixed up about many things & its not easy," she wrote with a new patronizing tone.[35]

Beck's thank-you note was addressed to Alfred alone. "There are no

words for my stay with you—there was infinite pleasure and real suf-
fering. I could not stand it again," she told him.[36]

Meanwhile, she was happy in her new job, secretary to one of New
York's most eminent neurologists, Dr. Frederick Tilney.

THE WEEK AFTER Beck left, Alfred received separate reports on
Kitty's progress from his brother Lee, his niece Elizabeth, and Eliza-
beth's husband, Donald Davidson. Alfred was grateful for the bulletins;
he had heard nothing from White Plains for some time. Whether be-
cause of more pressing worries or from fear of what he might learn,
Alfred never asked for news.

In a letter postmarked October 9, Elizabeth wrote that she had
heartening word from all sides. Kitty's first day without a private nurse
had been a great success. She loved the new baby nurse whom Elizabeth
had found. Miss Tillotson began by exhorting everyone—Emmy in-
cluded—that "faith" in Kitty was the key to her recovery. In this respect,
especially, Milton was marvelous, Elizabeth noted. The power of his
love for Kitty had already begun to strengthen her confidence—and his
own.

But four days later, Elizabeth wrote that Kitty had been moved from
home to a "semi-sanitorium" where she was also receiving treatment
for gynecological problems related to the birth. Physical symptoms, Eliz-
abeth felt, were a good sign; they suggested that Kitty's depression was
organic in origin and thus readily treatable. She had visited her cousin
while she was at home and was cheered by Kitty's enthusiastic welcome.

Enclosed in Elizabeth's letter, however, was a note from Donald.
That very morning, he told Alfred, Kitty had stared fixedly at a recent
photograph of Alfred, repeating "dear Father, dear Father,—over and
over again." But following his description of the incident, Donald
warned Alfred not to show his letter to anyone except O'Keeffe.

Davidson's anxious remark suggests that he had violated a family
agreement: there was to be no mention of any symptom of Kitty's that
implicated her father.

Indeed, Alfred reacted hysterically to Donald's note. Kitty's love had
always caused trouble. "If I had the power," Alfred wrote to Elizabeth,
"I'd pull up by the roots every bit of 'feeling' she has for either me, her
mother or uncle Joe."[37] Alfred described what was, in fact, a lobotomy
as the only cure for his daughter.

Lee's opinion after a recent visit was mixed: Kitty had improved
somewhat, but she was still far from recovered. Her uncle was une-
quivocally negative, however, about Milton; Lee was particularly in-

censed by the young man's stubborn insistence that he knew better than any doctor what was good for Kitty.

Only a few weeks earlier, Lee now told Alfred, he had sent Milton to none other than Dr. Frederick Tilney, one of the best neurologists in New York. Without seeing the patient, Tilney had agreed to take Kitty's case, but only on condition that he have complete control. To this end, Tilney had provided a day and night nurse of his choosing, along with orders that Milton was to report to him daily by telephone.

Both Tilney and Lee were infuriated by Milton's "criminally reckless" management of Kitty, Lee told his brother. He had failed to issue the reports and had fired both nurses. Predictably, Tilney threatened to withdraw from the case if his instructions were not obeyed. As soon as Lee realized that nothing would please Milton more than to see the eminent specialist carry out his threat, he flew into a rage, calling his nephew-in-law a pigheaded imbecile. Finally, as a special favor to his colleague, Tilney relented and agreed to see Milton and Kitty later the same morning that Lee was writing to Alfred—Saturday, October 13.

Beck Strand had never met Kitty or Milton. But at work on Saturday morning, she passed the doctor's reception room. The couple waiting there struck a strange chord of recognition: the young woman was impassive and motionless; something about her suggested to Beck that she had been or still was pregnant. Her companion's patience was still more poignant; he looked so young. A short while later, the young man came into Beck's office to ask where he could find a lavatory. Beck escorted them both in the elevator to the floor below. "The little lift was full of suffering," she wrote in a long letter addressed to both Alfred and Georgia.

When she opened the door for them to the unmarked bathroom and they both went in, she was suddenly aware of the man's "sweet nature," his lack of embarrassment in accompanying a young woman into a lavatory in the presence of a complete stranger. Most young men would have behaved very differently, she felt.

"She needs him and he's ready" was her impression of Kitty's husband. There was something so deep between them that hours later the empty chairs they had occupied while waiting to be called into Tilney's office still seemed to hold their bodies, Beck wrote.

As they emerged from the doctor's study, the young woman passed Beck's desk and, hesitating, looked at her "rather long." Beck reported that she wanted to "say something to her—to smile and make her smile— but they were gone—& she didn't smile."[38]

Although the letter was addressed to Georgia and Alfred, only Alfred answered. In his reply, he avoided any mention of Kitty's name or her

relationship to him. "I'm glad you felt you mustn't address the woman," he wrote. "It would have been the worst thing to do. . . . Its all too terrible. Only I know *how* terrible. Poor poor girl. Completely innocent."[39]

By most measures, Dr. Tilney was a curious choice of clinician to treat Kitty. A professor of neurology at Columbia and a founder of the Neurological Institute, he specialized in two fields: the development of the brain (*The Brain from Ape to Man* was his best-known work) and diseases of the central nervous system. His clinical practice—to judge from those cases cited in his many papers—was confined to patients suffering from neurological disorders: encephalitis, epilepsy, and Parkinson's disease. He does not seem to have had any prior interest in depression or schizophrenia (then known as dementia praecox).

Other eminent practitioners were noted precisely for their work in these areas: A. A. Brill, the brilliant therapist and translator of Freud, had treated many cultural luminaries known to Stieglitz, including Mabel Dodge. If the family viewed Brill as too bohemian or too Jewish, there was his distinguished pupil Ely Smith Jelliffe, the first Gentile American-born psychoanalyst and a Lake George neighbor.

Choosing Tilney as Kitty's doctor was a way of avoiding a psychoanalytic treatment of her condition. The "talking therapy" would inevitably deal with "unpleasantness" concerning Kitty's relations with her family—Alfred in particular. As his protective brother, Lee had every reason to avoid probing into Kitty's experiences with her father. Any psychiatrist—let alone psychoanalyst—would have wanted to explore the reasons why Alfred's presence, even in a photograph, provoked his daughter's hysterical rage and grief. It was in no one's interest—except her own—to have Kitty talk.

From the family's point of view, Tilney had other virtues. A third-generation Yale graduate who lived in Oyster Bay, Long Island, he had social credentials of the most reassuring kind. Even for a neurologist, he was excessively distant; he appears to have seen Kitty only once—in the visit she made to his office accompanied by Milton.

Tilney did possess one important area of specialization that, more than any other attribute, would explain Lee's choice. He was a frequent "expert witness" in commitment proceedings or trials involving the insanity defense. He traveled all over the country, his son has recalled, to testify on behalf of clients who needed a legal finding of insanity to institutionalize family members.[40] Tilney's most famous court appearance was in the Leopold and Loeb case in 1924, in which his testimony saved from the death penalty the two wealthy Chicago students who murdered a younger boy for thrills.

On the day after Kitty's visit with Dr. Tilney, she was admitted to Craig House, a private sanatorium in Beacon, New York, run by Dr. Jonathan Slocum. A series of adjoining estates, which the Slocums had acquired gradually, Craig House was ranked by a *Fortune* magazine survey a decade later as among "the most luxurious and expensive establishments as you will find in the country." It boasted splendid gardens and stables, two swimming pools, tennis courts, a nine-hole golf course, and Victorian-style cottages where Kitty, like her fellow patients, lived with private nurse/companions. Other amenities included a fleet of eight limousines waiting to take patients shopping in town or on excursions to New York. Rates ranged from a minimum of one hundred fifty dollars a week (about twelve hundred dollars today) to "four or five times that amount." The director and his wife owned ninety percent of the stock in the Craig House Corporation, which was "unrestricted as to profit," according to the *Fortune* report.

Of the six private facilities surveyed in the report—the others were the Payne Whitney Clinic in New York; Bloomingdale Hospital in Westchester; the Menninger Clinic in Topeka, Kansas; the Hartford Retreat and Austen Riggs Center in Stockbridge, Massachusetts—Craig House was the only one to provide no treatment other than baths (the nineteenth-century "water cure") and basket weaving.

"Dr. Slocum detests psychoanalysis and will have none of it," the *Fortune* report noted. His view of therapy "consists simply in getting on friendly terms with the patient, visiting him daily to talk over his problems and give him advice and encouragement."[41]

If Dr. Slocum's ministrations failed to cheer the patient, there were his wife's individualized Chinese-inspired decoration of each cottage and wine made from their own vineyard.

GEORGIA HAD barely returned from Maine—"still feeling like a visitor" at the Hill, she said—when Kitty, immediately following her first and only visit with Dr. Tilney, was dispatched to Dr. Slocum's care. O'Keeffe's departure had been a response to Alfred's refusal—or inability—to consider her needs or feelings. Reading Elizabeth's bulletins and Beck's letter and living with Alfred's assumption of guilt alternating with his accusations of others forced Georgia to consider the repetition of his failures: as a father, a husband, and a companion. A deeper symmetry would have been too painful to confront: like Francis O'Keeffe, Alfred could not be responsible for the welfare of a child or his child's mother.

Elizabeth made one last, untimely plea for Alfred to reconsider his

refusal to have another child. Alluding to her cousin's illness, she made the case that life, like art, must move beyond failure. "Photography does not end with a broken plate," she told Alfred. Georgia would have "few enough sunbeams in the years ahead."[42]

But the moment had passed. For Georgia, the summer had amply demonstrated the impossibility of having a child with Alfred. She put this loss behind her with the other sorrows of life, matter-of-factly sweeping it into the category of "things that can't be helped."

As though to confirm the closure of the issue, a letter arrived on October 29 from George Engelhard announcing the sale of Lee's house on 65th Street. Frightened by a mild heart attack the year before, Lee no longer cared to risk stairs.

"It means another great change for T.L.F.," Alfred wrote to Beck plaintively, using her nickname for him, The Little Feller. "Still I'm ready.—that is, I'm planning nothing," he said.[43]

They had until June 1 to find another place to live in the city. Alfred was running out of relatives with spare rooms.

By the middle of October, all family and friends were gone from the Hill. They had two weeks alone together—welcomed by Georgia and dreaded by Alfred. "To be alone in such a big house and the nights so dark and cold," he wrote to Beck.[44] He missed her, expecting to see her come downstairs at any minute. He missed "wonderful brilliant Yvonne" too, he wrote to Rosenfeld.[45] Then a visitor arrived whose presence delighted both of them: Ida O'Keeffe, Georgia's next younger sister, now a gynecological nurse at Mount Sinai Hospital in New York. When Ida had been studying nursing in New York, Claudia, Georgia's favorite and youngest sister, was teaching in nearby New Jersey. Now that Claudia had left the East, Ida took her place as family.

"Full of life to bursting," as Alfred described her, Ida was a plumper, taller, coarser-looking version of Georgia. She seemed to laugh or smile all the time, displaying to Alfred's camera with none of her sister's self-consciousness a mouthful of bad teeth. Ida did everything well—she gardened, cooked, cleaned; she was an excellent shot, bringing down a squirrel with one bullet; her unexpected arrangements of wildflowers, Georgia and Alfred agreed, were works of art. She told fortunes and did horoscopes—with eerie accuracy, Alfred reported. Most important, the two sisters got along famously. "The nicest girl I ever knew" was the way Georgia described Ida. She fit in perfectly without distracting Georgia from work as other guests did, even valued friends.

Georgia was painting every day. November frost made the unheated Shanty uninhabitable; she worked in the farmhouse's sunniest upstairs bedroom. Galvanized by her renewed energies, Alfred picked up mo-

mentum—almost equaling his July frenzy when, unstoppable, he worked for ten hours a day. "Have a bunch of fine sky pictures—new ones, all small," he wrote to Beck jubilantly on November 6. But he was also printing some large negatives, working into the night "gaslighting to beat Sheeler," he assured her.[46]

His competitive edge sharpened with another object of sexual fantasy in residence. Ida now replaced Beck as the focus of Alfred's erotic obsession. Everything about her fascinated him, starting with the ways she resembled Georgia—and the dramatic differences between them.

At thirty-two, Ida was a virgin; she was so completely innocent as to be unaware of her own sensual nature, Alfred rhapsodized to Sherwood Anderson. She even disapproved of her sister living in sin, he hooted. For twelve years she had been waiting for a sporadic suitor— a mining supervisor in Tennessee—to marry her. Alfred was not optimistic.

Meanwhile, he wanted to be the man to awaken her sexually. Hovering between fantasy, flirtation, and seduction, Alfred courted Ida openly during her visit. Following her return to the city, he bombarded her with letters, inventing for himself a split sexual persona: one part was a boyish suitor, "the very young blond man with eyes sky blue after rain"; Alfred himself was Old Crow Feather. Crow Feather was "no man," Alfred reassured Ida. But the image was a perfect metaphor for Alfred's anal reveries and his taste for being bitten, scratched, and clawed. "Ever jabbed into that reddest of round red apples" was a frequent sign-off by Old Crow Feather. Should Ida fail to get the point, he made a photograph of a ripe-to-bursting fruit, a quill plunged between its buttock-shaped halves. He urged—with stunning illogic—"Its good for little girls to eat Eggs & Butter—It will give them sharpest of teeth to clean bones and become perfect Idabiters."[47]

Georgia took an indulgent view of Alfred's new love object. Terrified of men, Ida—unlike Beck—was no sexual rival; Georgia's description of Alfred capering around her sister like a puppy dog makes it clear that she found his games a harmless outlet for the sexual anxieties of age.

An overnight visit from Paul Rosenfeld was the only intrusion in the intimacy of the three. Displeased by the draft of a piece Rosenfeld had written about him, Alfred summoned him to the Hill for revisions.[48]

"It was fine to see how promptly he came," he wrote to Elizabeth.[49] Arriving at eight o'clock at night, Rosenfeld rewrote from nine that night until two in the morning, leaving the next afternoon. The article, Alfred felt, had been "impossible as it stood," reflecting the "pressure of New York and the general mussiness everywhere." In his draft, Rosenfeld had called Stieglitz "the greatest artist in America." Feeling

that the statement presented an "unnecessary challenge," Alfred suggested instead that his friend describe him as "one of the leading spiritual forces in the country." Paul made all the changes Alfred urged and before leaving also ordered a series of Cloud prints for one thousand dollars, payable in installments.

Rosenfeld's unquestioning fealty was all the more reassuring as, earlier in the summer, Stieglitz had received a letter from Waldo Frank that was both a declaration of independence and an indictment. "You are incapable of a relationship of equality with anyone," Frank told him. "You demand that, in some way, the 'other person' accept your ascendancy, before you function in serving him, in understanding him, enlightening him, in helping him."[50]

Because his friends were artists, Frank explained, Alfred had been able to retain complete power over them: "spiritually, intellectually, aesthetically, socially, economically . . . most artists in America have been in a state of adolescence. In this state, you met and helped them marvelously," Frank wrote. As long as this "fixated adolescent" accepted Alfred—his work, his point of view—as the "tonality, as the fulcrum, as the determinant . . . through his own immaturity, you nourish him with your whole heart and your entire soul."

But this also explained why Alfred had a "series" of friends. Those who grew up, those who aspired to graduate from the role of disciple, could no longer live "in an atmosphere of your determining [that] served to arrest their own growth." Since Alfred was incapable of that "equilibrium of equality" that marked permanent friendship among adults, Frank had no choice but to withdraw, he explained.[51]

Frank's defection was easily explained away. Stieglitz pointed to his self-seeking, his ambition, and—the ultimate sin—his willingness to sell out spiritual values for success. Alfred had long suspected Waldo's weakness, knowing that he would be the Judas among his disciples. He had no time to worry about Frank when his core of true believers still needed him.

Then, on Sunday, November 25, while Alfred and Georgia were packing to leave the Hill, there was a great blizzard. Since he was a child, Stieglitz had dreamed of such a day. He and Georgia spent every hour of light out-of-doors in snow up to their knees. Alternating two cameras, Stieglitz "photographed like one possessed."

From the long Wisconsin winters of her childhood, the deep drifts would have been familiar to Georgia. But there, snow had blanketed flat farmland. Now she tramped the hilly woods, marveling at trees garlanded in white, or rushed down to the lake to watch flakes fall silently into dark water.

Together, they marched to the post office and back, the magic of Alfred's beloved whiteness everywhere. He felt a fierce primitive joy— like a child at play. Georgia had never been so beautiful and happy, he wrote to Sherwood Anderson. By nightfall, she went to bed, exhausted.

Drawn outside once more, Alfred was exalted by the vision of barns bathed in moonlight rising from the snow. "Maddeningly beautiful," the whiteness seemed a promise of redemption; the clamorous cares of the last months were silenced.

"The 'summer' certainly has had a perfect ending," Alfred wrote to Beck. "And now? New York?"[52]

SIXTEEN

City Lights

GEORGIA O'KEEFFE, *Radiator Building—Night, New York* (1927). In 1927, O'Keeffe painted this homage to Stieglitz, whose name appears in red neon at the left of the American Radiator Building.

IN DECEMBER 1923, New York shimmered with all the glamour of the Twenties. Bejeweled for the Christmas season, it was a night city, like the heady, dressed-up decade itself.

At dusk, the new skyscrapers thrust towers of twinkling lights heavenward, softening the blackness with their rosy glow. Below, street lamps and taillights of taxis, neon signs and theater marquees traced Manhattan's vertebrae of avenues: Park, Fifth, Broadway—the Great White Way.

Paul Rosenfeld knew he was middle-aged, he told Alfred, for the mysterious perfumed women wrapped in furs and emerging into the frosty night from the depths of luxurious automobiles had lost their power to enchant him. To recent college graduates like Scott Fitzgerald and his Princeton contemporary Edmund Wilson, these seductive creatures personified the glamour of the Twenties. Their rouged cheeks, scarlet lips, and sooty eyes proclaimed the sexual freedom of the Jazz

Age, when respectable women appropriated the harlot's mask. More ambiguously, however, the new fashions also suggested that painted ladies were still little girls; their hair bobbed or shingled, they wore dresses with dropped, unindented waists and knee-length hemlines (even in evening clothes) exposing naked legs under flesh-colored silk stockings.

In part, the period had caught up with O'Keeffe's special style: loose, long-waisted garments that, barely grazing the torso, fell to uncorseted hips. But her disdain of cosmetics, her refusal to bob her long hair, worn pinned up in a bun, or shorten her skirts gave Georgia the look of a provincial schoolmarm—a resemblance noted by every interviewer.

Suspended between the brothel and the playground in appearance, Georgia's fashionably dressed contemporaries answered to "Baby" and "Kid" while puffing cigarettes and drinking cocktails in public. Exchanges in baby talk between consenting adults emerged as the lingua franca of the times. Beck Strand's fondness for this idiom and Alfred's designation of thirty-six-year-old Georgia as "just a kid" were also symptoms of the period.

Men and women in evening dress always seemed to be "going on" to cocktails, dinner, theater, supper, dancing. New York had never boasted such an array of nocturnal diversions for the smart set—the bright young and not-so-young people with money to spend who read about themselves in the magazine of that name. Starting with late-afternoon tea dancing in fashionable hotels, weary celebrants greeted the dawn as they staggered from speakeasies now transformed into elegant nightclubs; for slumming, there were still raffish bars and bistros in Greenwich Village.

For both the rich and the intelligentsia, visits north on Park Avenue to Harlem were a required ritual separating New Yorkers of advanced taste from the burgers of Main Street and Gopher Prairie. The very alienation of "the Negro" from mainstream American life was held to be a virtue, allowing him—in the unself-consciously patronizing adjectives of the era—to retain the primitive, sensual, and expressive qualities of his African forebears.

Jazz—the sound of this legacy of suffering and release—baptized the Twenties. Its haunting syncopation was heard everywhere, accounting (in one form or another) for eighty percent of the rhythms broadcast on the new radios. Denunciations of "coon music" as a threat to public morals thundered from pulpits all over America, while American and European composers—Gershwin, Stravinsky, Bartók, and Milhaud—incorporated the blues into their compositions.

Boasting its own renaissance of writers, musicians, artists, and thea-

ter groups, Harlem promised both intellectual stimulus and sensual liberation. For their white counterparts, an evening spent listening to jazz, watching risqué revues, and hobnobbing with the gifted men and women who had come to Harlem from the rural South or the ghettos of the Midwest provided more than voyeuristic excitement. Charles Demuth, Waldo Frank, and Carl Van Vechten—all members of the larger Stieglitz circle—were among those who found subject matter in what they saw and heard in Harlem. Demuth painted black musicians and the racially mixed patrons of a noted homosexual club; Frank began pondering the social differences between Harlem and the Black Belt communities in the South; novelist and photographer Van Vechten was much more than a casual visitor: his novel *Nigger Heaven*, published in 1926, was the first widely read book on Harlem by a white writer.

O'Keeffe and Stieglitz never seem to have accompanied their friends uptown. Having come to young womanhood in a southern backwater, Georgia was still "afraid of niggers," she confessed to Sherwood Anderson.[1] Although Alfred was more open socially, he was a cultural conservative. A recent conversion to D. H. Lawrence was based on that writer's most academic critique—*Studies in Classic American Literature*—while his "enjoyment" (as he wrote to the poet) of Hart Crane's epic *The Bridge* derived more from his new friend's dedication of the work to Alfred than from any real interest in what Crane was trying to do in his poetry. The nineteenth-century Romantics and their descendants, such as Ernest Bloch, were the only composers whose music Alfred enjoyed. There is no evidence that Stieglitz saw black culture as playing even a marginal role in his definition of the new American art.

Far more exciting to Alfred than the prospect of listening to jazz in the heart of Harlem was the possibility of seeing Duse during her New York appearance that season—her first visit in twenty years. At sixty-four, with no makeup and untouched gray hair, she still electrified audiences as Ibsen's Lady from the Sea (in Italian). Writing to Beck from Lake George, Alfred asked her to buy two tickets; he was willing to pay as much as ten dollars each.

Thousands lined up before dawn on opening night, October 31, at the Metropolitan Opera House, where speculators easily found takers at two hundred dollars a seat. Many more were turned away. The glittering crowd of box holders included Belmonts, Astors, Morgans, and Rockefellers; among their guests were indefatigable first nighter Frank Crowninshield and Dr. Frederick Tilney. Weeks before the production moved to the Century Theater, every performance was sold out. Alfred's commission was unsuccessful.

In January, Stieglitz was awarded the annual prize of the Royal

Photographic Society. His newest laurels, however, rustled with mortality. Recognition from his most conservative English colleagues was a reminder that he was no longer a Young Turk but an elder statesman. In 1894, Alfred had been elected the first American member of the Brotherhood of the Linked Ring, a group of dissident British photographers who had joined forces in reaction to the conventional amateurism represented by the Royals. The American hell-raiser was now the Grand Old Man of photography.

Perhaps to reclaim some youth by association, Alfred decided that the 1924 exhibit at the Anderson Galleries would be a joint offering: sixty-one of his Cloud photographs in one room along with fifty-one paintings by O'Keeffe in the next. As pleased as he was with his recent work—the tiny prints that Georgia had said were "like a breath"—he was the more jubilant about their combined effort. The first public showing of Stieglitz and O'Keeffe together as artists, the exhibit would set a seal on their union.

Catalogues, however, were to be separate. Georgia cabled Sherwood Anderson, asking him for a short introduction to hers; if he was willing, he should wire his statement back. It was now February 10; there were only a few weeks left before the opening.

In her follow-up letter to the telegram, written the next day, Georgia sounded far less enthusiastic than Stieglitz about the exhibit. Indeed, her tone describing the forthcoming show was distinctly aggrieved.

For the first time, she had not dreaded an exhibit; indeed, she had been looking forward to a selective showing that would have allowed her to refine and clarify for herself the work she had done in the past year. Instead of getting what she wanted and needed, she grumbled, she was to have only two tiny rooms; Stieglitz had claimed the main exhibition space.* As she had planned to exhibit only a small number of pictures, however, the size of the rooms was obviously a symbolic issue. She had counted on "her" exhibit, not "theirs." Moreover, where Stieglitz the artist was concerned, there was no such thing as separate but equal: he always got the bigger half.

Her disappointment involved more than questions of space. She had planned her exhibit with a distinct programmatic goal: to escape the sexual associations that her abstract work seemed, inescapably, to inspire. There would be only two—or at most three—abstractions in the new show; the rest would be "objective," as objective as she could make it, she wrote to Anderson, adding that she had disliked the way critics

* As a consequence of her grumbling perhaps, when the exhibition was hung Georgia's work was shown in the larger space, with Stieglitz's prints on view in a small adjoining room.

had interpreted her other work. By keeping the subject matter of this year's paintings grounded in reality, she believed she could forestall Freudian parlor games about the meaning of the forms.

Showing their work together urged Georgia to an anxious distancing of her art from Alfred's. If her paintings were very much on the ground, his photographs had, marvelously, taken to the skies, she told Anderson.[2]

True to her word, O'Keeffe showed only two or three abstractions; with the exception of four prints of snow and barns, Alfred was represented entirely by abstract cloud studies. Their works, hung in adjoining rooms, were a reminder: two highly competitive artists living together risked constant collision, symbolically and even physically. Recently, at the lake, Georgia had wanted to paint a particular barn on a particular day. "But Stieglitz got there first," she said.[3]

One solution was role assignment: he was the rational intellectual artist, Georgia was the untutored primitive, the "homemade innocent."[4] "I am one of the intuitive ones," she would later tell Waldo Frank.[5]

What Alfred did with the sky, she explained to Anderson, was his response to what she had been doing earlier with color. In Stieglitz's clouds, he had done consciously something that she had done, for the most part, unconsciously; his photographs, she explained, "only proved her case."[6]

Georgia's analysis of their division of labor sounds suspiciously Stieglitzian in its clear-as-mud murkiness—a measure of her discomfort, surely, with her role of resident primitive.

Her long letter to Anderson expanded on her earlier cabled request for a catalogue essay. Stieglitz was already hard at work on his statement, she told the writer, popping off ideas in every direction. Still suffering from a cold, she could not seem to fix on a single thought. Of course, Anderson shouldn't feel disqualified by not seeing the show; she didn't want him to write about specific paintings. She was providing him with a description of the works only because she thought he would be interested. What she wanted from him was an overview of her art (suggesting that she might want to use his piece again, as often was the case with Stieglitz and O'Keeffe catalogue texts). He was so much better known than she was, Georgia wrote coyly. And a picture needed the printed word to get people to come and look at it.[7]

Replying by night letter, Anderson declined. "Down with the flu. Afraid it would be dull," he said.[8]

His real fear, though, was more likely related to the tensions between Georgia and Alfred generated by the exhibit and his reluctance to appear in print as Georgia's advocate. Although Georgia noted that it would do her good to have to write her own copy, Anderson's refusal rankled.

Their friendship began to chill shortly thereafter; by the end of the decade, they would lose touch completely.

When the exhibit opened on February 28, forty-eight of the fifty-one pictures chosen by O'Keeffe were reassuringly representational. Still lifes predominated, with about ten paintings of alligator pears, six calla lilies, and several "horrid" yellow sunflowers, as O'Keeffe described them to Anderson. There were several studies of white birches with yellow leaves, two new red cannas, and ten other oils of leaves, ranging from the intense green of Lake George midsummer to the darkest purple-black; their expanding size in relation to the canvas pointed to the large flower paintings to come. Lake George and the ocean at York Beach accounted for two and four paintings, respectively. O'Keeffe's seas are ominous, heavy with gathering gray waves, or lit by a zigzag of lightning that tears the canvas vertically at its center.

Reviews of the show suggest that Georgia had been uncharacteristically naive—or disingenuous—in expecting that a shift to recognizable subject matter would end the discovery of sexual symbolism in her work. "All Miss O'Keeffe's paintings are intimate, some of them almost unbearably so," Vergil Barker wrote in *The Arts*, adding that in her work, "fruit and leaves and sky and hills nestle to one another."[9] Georgia's friend Helen Appleton Read and the critic Forbes Watson both insisted on the "intensely personal" quality that, paradoxically, suffused the cool colors and neat, precise brushwork. Both reviewers took it for granted that all of O'Keeffe's paintings represented a self-portrait. "One has only to look at the artist, her clear-cut features and extreme simplicity of manner," Read concluded.[10]

Henry McBride found Georgia's sexuality more transparently revealed in her calla lilies than in the quivering rosy tunnels of her abstract forms. "The crux, so to speak, of the calla is the yellow rod at the base of which the real flowers occur, and it is this yellow that sounds Miss O'Keeffe's major note. . . . When one understands a calla lily, one understands everything," McBride declared significantly.[11]

To have been surprised at the interpretation of her still lifes, Georgia would have had to forget her self-portrait *Alligator Pears* of two years earlier—with its unmistakable allusion to Stieglitz's photograph of her breasts. The form of the fruit and its significance as a metaphor of fecundity reinforced one another. Her new work, however "objective" and "close to the ground," merely provided more fertile sexual readings for the less imaginative.

Shortly after the opening of the show, her sister Catherine gave birth to a baby daughter. Georgia's letter of congratulations struck a bitter note. "I like to feel that at least one member of the family lived

what might be called a normal life," she wrote to the new mother, living in Portage, Wisconsin. Her own barrenness was echoed by the sterility of the city: "No one in New York can even approach being a normal human being. . . . You can be glad that you live in a little town where you can look out and see a tree."[12]

The joint exhibit enjoyed only mixed success. The faithful came, but the smart set and its vanguard of tastemakers apparently stayed away: they had "done" O'Keeffe and Stieglitz last year.

"There's a funny mob here," Beck reported from the gallery to Paul, who was out of town on assignment, "old spinster gals, flappers—hawk-nosed student boys. . . . S.L.F. [Sweet Little Feller]—standing in the middle of the room roaring at a kid about brownstone houses & sky-scrapers and the kid is answering in low & frightened whispers—& can't get away poor child."[13]

As long as he had an audience, Alfred cared not whether it consisted of the fashionable, the brilliant, or merely terrified schoolboys. Writing to Anderson, he described the visitors to the show as twenty-five hundred to three thousand of superior quality. As far as he was concerned, their coupled showing had accomplished its task magnificently, especially in light of competition from a major exhibit of John Singer Sargent and other "foreign" shows, he added. After deducting expenses of more than twelve hundred dollars, he expected to clear several thousand dollars from sales, it being understood that such transactions involved only O'Keeffe paintings, not Stieglitz photographs.

"Mr. Stieglitz himself tends to grow more and more exalted," McBride noted, leaving it unclear whether he was referring to the celestial subject matter of the photographs or to the photographer ascending to his manic high in the last days of the show. Either way, the price for all the excitement was a severe attack of what Alfred described as kidney colic but that was, in fact, kidney stones. In addition to the physical pain that kept him bed, he was ever more anxious about the move from Lee's that loomed in a matter of months.

One diversion from Alfred's recurrent problem of homelessness was the work of showing and selling his other artists on borrowed premises. Just before the opening of his and Georgia's show in late February, Stieglitz had taken over the Montross Gallery as a favor to his friendly competitor, now ill. Presiding over the annual Marin exhibit, "farmed out" to Montross since the closing of 291, Stieglitz was delighted to report to Beck that he had sold a Marin watercolor for fifteen hundred dollars; two weeks earlier, Montross had been aghast when Stieglitz had suggested a price of three hundred dollars less. Here was proof, Alfred crowed, that an idealist could beat out a money-grubbing dealer

on his own turf.[14] In fact, Alfred's carefully burnished image of himself as an impractical head-in-the-clouds artist was a fictional persona designed to justify his dependence on others when it suited him. His letters to Eugene Meyer, his brother Lee, and his Engelhard brother-in-law are full of hardheaded discussions of his investments: stocks versus bonds; preferred versus common shares; the performance of mining versus retail stocks. Indeed, immediately after the joint show closed, Stieglitz asked Paul Strand's father to invest some of Georgia's earnings through his own account—O'Keeffe's first venture into what would come to be a substantial income based on capital gains.

With his and Georgia's needs, along with most of Marin's modest requirements ensured for the coming year, Alfred turned his entrepreneurial energies to Hartley: in mid-April, Alfred presided over an auction of paintings by the expatriate, returned from his wanderings in Germany and France. Before a "packed house" crowding the main rooms of the Anderson Galleries, Stieglitz reported to Rosenfeld, now in Paris, bidders, friends, and the "speechless artist" watched and listened as Stieglitz knocked down Hartley pictures for bids totaling nearly five thousand dollars. People were so excited, Alfred recalled, that they did not leave until the lights were turned off, when they continued their talk on the street. Hartley, who had earlier declared that five thousand dollars stood between him and suicide, finally felt himself "a free man," Alfred noted.[15]

The biggest surprise of the auction was Alfred's unabashed pleasure in its success. His pride in the coup he had pulled off and in himself as a hard-nosed businessman—a creature he loudly despised as "unclean"—suggests that he found relief in escaping the prison of his own idealism. "The perfection of every move—every moment," he wrote to Rosenfeld ecstatically. "If I ever did a piece of perfect work it was the Hartley Show and Sale."[16]

The triumph of the Hartley auction had other happy consequences. Newly impressed with his friend as a wheeler-dealer after his own measure, Mitchell Kennerley now offered Alfred a spacious room at the Anderson Galleries for a large group show of his artists next season. While negotiating location and scheduling with Kennerley, it emerged that a smaller space at the galleries—used for the sale of jewelry and bric-a-brac—might be available permanently the following year. The annual rent of two thousand dollars was not infeasible; in the dark days of the past summer, Elizabeth Davidson, Beck Strand, and Paul Rosenfeld had discussed a collective rent fund for a revived 291. And here it was; even the room number—303—sounded a worthy successor to the mystical numerals of the past. Excitedly, Alfred primed Strand,

Demuth (whom he had not showed before), and Hartley to start producing for the upcoming event—the first New York group showing of "his" artists in nine years!

The year had begun with a prize from his British colleagues; in the spring of 1924, Stieglitz received his first tribute from a major American museum. A recent admirer, Ananda K. Coomaraswamy, the brilliant, seductive Anglo-Indian curator of eastern art of the Boston Museum of Fine Arts, asked Alfred to donate a group of representative prints—making his institution the first major American museum to acquire permanent holdings in photography. Despite his official stance against selling his work, Alfred grumbled to intimates that the museum should have purchased the photographs. Nonetheless, he was sufficiently flattered by the request to provide twenty-seven of his finest prints, including *Songs of the Sky* (1923) and *New York Scenes and Portraits*. He spent four hundred dollars to have them mounted and matted, not even trusting Coomaraswamy to share his perfectionist standards. The prints went on exhibition in Boston in April. Earlier, Coomaraswamy had asked Alfred to lecture on the occasion of the show's opening, but he was obliged to rescind his invitation because of strong anti-Stieglitz or antiphotography feelings among his trustees; the diplomatic scholar declined to elaborate.[17]

IN EARLY June 1924, Alfred had been granted an interlocutory divorce decree from Emmeline, to become final four months later. After six years of acrimonious negotiations that seemed to involve all of the Stieglitzes and Obermeyers, he ought to have felt immense relief. Preferring chaos to clarity, however, Alfred found the finality unsettling. As the child in his own unhappy marriage, he still felt abandoned at its termination.

As soon as they opened the farmhouse on June 11, Alfred began pressing Georgia to legalize their union. Without parents or wife, his brother's house sold, who would take care of him? As for Georgia, she was so happy to be out of the "nightmare" of New York, she wrote to Anderson, that she could parry Alfred's arguments in favor of matrimony. Even his dread of being alone with Georgia in the absence of guests was allayed by her pleasure in these same circumstances.

"For the first time we are really masters of the house and so far we have managed wonderfully," Georgia told Anderson. Or rather, Georgia managed wonderfully. With Fred Varnum dead and his wife Ella retired, Stieglitz had wondered anxiously how they could get along, she told her fellow midwesterner with much amusement. Those who had

not grown up with servants had no such fears. In the six days since their arrival, and with only the help of a moonlighting handyman for a few hours daily, she had cleaned the house, plowed the ground, and planted a garden—everything was in but the potatoes. She was now "painting and praying for rain."[18]

In tribute to her own husbandry perhaps, Georgia began the Corn series of 1924. More American than Stieglitz's beloved apples, corn—when depicted at all—had been the province of the anonymous folk artist or decorator. O'Keeffe's series examines the form of the plant; each canvas is narrowly vertical, closely following the elongated shape of a single ear. No kernels are visible; instead, the viewer's vision plunges, as though from the height of a winged insect hovering overhead, to a tropical intensity of green fronds whose outer layers unfold beyond the confines of the frame. In the artist's later series, natural forms give way to abstraction, becoming simplified and stripped down in the process. The evolution of the Corn series reverses this movement; progressively, the outer leaves assume a fantastic baroque life of their own as they curl and peel beyond their assigned rectilinear space.

Georgia, too, exulted in her escape from the rigid verticality of the city: she had never been so happy to get to the country, to have a house where she knew she could eat, sleep, and have a hot bath every night. She particularly rejoiced in the knowledge that she wouldn't have to move again for a few months—maybe even five or six.

More than the frenzied pace of life in New York, the lack of privacy, space, and their own amenities at Lee's had worn her down. Stieglitz's anxiety about leaving his brother's house and finding somewhere to live, moreover, took the form of rehearsing the traumatic event obsessively before it took place. "It seems we have been moving all winter," she confided to Anderson wearily. "Stieglitz has to do everything in his mind so many times before he does it in reality that it keeps the process of anything like moving going on for a long time—It really isn't the moving with him. It is many things within himself that he focuses on the idea of moving—He has to go over and over them again and again—trying to understand what it is that he is and why—in relation to the world—and what the world is and where it is all going to and what it is all about—and the poor little thing is looking for a place in it—and doesn't see any place where he thinks he fits."[19] Assuming her cracker-barrel persona, she compared Georgia O'Keeffe the practical Wisconsin countrywoman and Stieglitz the helpless hysterical city intellectual: "Well—I dont know whether I fit or not but I do know that if I dont cook the dinner we wont have any," she noted.[20]

Brought up to do for herself and with no experience of men helping

around the house, she was humorously indulgent of Alfred's good intentions. He tried to help because he believed, in theory, that everyone ought to be self-sufficient. But it just wasn't worth her while to either teach or remind him how to do anything. Nothing got done and he simply got in her way. His photographic material hadn't arrived from town and he was roaming around like a little lost animal, she told Anderson.

At heart, though, Georgia knew that Alfred banked on her preference for getting the job done rather than wasting time on teaching him to forget how to do it right.

In fact, she always thrived on physical labor. Instead of the insomnia she suffered in the city, she now ached all over from exhaustion at the end of each day and slept soundly. And there were other compensating pleasures, felt more keenly this summer than ever before. But it was also the first summer that she was aware that Stieglitz was less able than his usual helpless self. In the same letter to Anderson, she referred to Alfred as "little," "a funny little soft grey creature" who "pokes around." She could have been describing a field mouse.

Like an aging parent, her once powerful protector had physically shrunk, becoming at the same time needier, more uncertain, and more demanding. For the first time, she was aware of the voracity of his need, of the danger that he would consume her if she let him. A conflict arose that had to be resolved anew with each decision she made: what was owed him and what she must withhold to survive: "I do what I can—but I have to keep some of myself or I wouldn't have anything left to give. . . . Living is so difficult—almost too difficult," Georgia, who rarely complained, told Anderson.[21]

There were positive consequences for her constant calculation of what to give and what to withhold. The very effort needed to conserve strength and creative energy for herself toughened O'Keeffe's sense of purpose—in art as in life. She scolded Anderson for his self-conscious and, in her view, paralyzing preoccupation with form, a concern that was the hallmark of modernism.

In a famous and oft-quoted credo, O'Keeffe insisted on one true process in the creation of art: making the unknown known. Underlining her own equally self-conscious role as the great intuitive, she had declared the previous fall:

I feel that a real living form is the natural result of the individuals effort to create the living thing out of the adventure of his spirit into the unknown—where it has experienced something—felt something—it has not understood—and from that experience comes the desire to make the un-

known—known. . . . Making the unknown—known—in terms of ones medium is all absorbing—if you stop to think of form—as form you are lost—The artists form must be inevitable."[22]

This is pure poetry. There is nothing "inevitable" about O'Keeffe's art—in form or subject matter. Her return from watercolor to oil, the shift from abstract to objective, and now the inflation of flowers to giant enveloping blooms—these were all considered choices, rational decisions, about whose process the artist herself kept her public well informed.

She, indeed, thought of form as form. And far from being lost, she found ever larger audiences. Few serious artists have considered the response to their work more thoughtfully or have been as honest about their primary quest: to compel the viewer's attention despite the competing visual bombardment of urban life. Describing the genesis of her large flowers, O'Keeffe's prose assumes the brisk tone of the market analyst. She had been looking at a small still life by Fantin-Latour, the great French painter of flowers, she said, only to realize that the psychological frame of the artist and the physical scale of the work mirrored the intimacy of nineteenth-century domestic life, irrelevant to the urban sensibility of twentieth-century America: "This was in the 1920s, and everything was going so fast. Nobody had time to reflect. . . . There was a cup and saucer, a spoon and flower. Well, the flower was perfectly beautiful. It was exquisite, but it was so small you really could not appreciate it for itself. . . . If I could paint that flower in a huge scale, then you could not ignore its beauty."[23]

O'Keeffe's photo-optic magnification of petals, pistil, and stamen was more than a way of arresting the rapid eye movement and shrinking attention span of the urban viewer. Her inspired enlargements translated into easel painting techniques already used in still photography, film, and graphic art, notably the giant billboards designed to seize the fast-moving consumer, pedestrian, or motorist.

Ballyhoo was a new word used in the 1920s to describe the extravagant hunger for bigness—in every form—that characterized the period. The impulse to exaggeration and hyperbole was everywhere: in America, bigger was already best. Every day set another world record: from the height of skyscrapers to batting averages to flagpole sitting; size determined prize heifers and champion hogs, apple pies and watermelons.

O'Keeffe's giant flowers were also hybrids of their era. The new obsession with size was linked to both celebrity and success. Georgia was not one to miss the message. "I realized that were I to paint the same flowers so small, no one would look at them because I was un-

known. So I thought I'll make them big like the huge buildings going up. People will be startled—they'll *have* to look at them—and they did."[24]

Conceptually, the enormous calla lilies, petunias, and sunflowers gave O'Keeffe freedom in another direction. Zooming in and out, like a camera lens, between blow-ups whose scale alone defined the composition as abstract and more conventional framing of her floral subjects, she could hedge her bets. *Flower Abstraction* (1924), the title she gave to one work of the summer, reveals the anxious desire to have it both ways.

Her uneasiness was justified. Although Stieglitz always resisted any change in the style or medium of "his" artists, he was more than usually dismissive of O'Keeffe's new floral explosions, calling them "silly, but lovely."[25] The addition of the second, "feminine" compliment only reinforced the verdict of frivolity.

Georgia's new gigantism could not have been further removed from Stieglitz's aesthetic: the cosmos contained in prints smaller than the palm of a hand. The enormous ripples, pleats, and billows of Georgia's insect-eye view of a flower, along with her modishly "fussy" colors—as Beck Strand called the new shades of orchid and mauve—struck Alfred and others as having more in common with a tearoom mural than with serious art.

"I wonder what you think you're going to do with that," she recalled Stieglitz asking when he first found her at work on one of the large canvases. "Oh, I'm just painting it," she told him.[26]

Undermined by Alfred's lack of enthusiasm for the new work, Georgia felt desperate at the prospect of the seasonal onslaught of guests— even friends she herself had invited, such as Arthur Schwab, a financial adviser to industry, and his wife, the novelist Edna "Teddy" Bryner, who were loyal collectors of her paintings. Unable to fight her way through the bleak inertia that descended, Georgia succumbed to one of her periodic nervous and physical revolts.

Following the July 4 weekend, which also brought the Strands for the holiday, she broke down completely, Alfred wrote to Paul on the latter's return to the city. Georgia was eating little and irregularly, spending twelve hours a day in bed and unable to work in the few daytime hours she was on her feet. In Georgia's present state, the brief hiatus between visitors reduced Alfred to near panic. They were both too unfit—in either city or country—to look after one another, he mourned to Strand. He was counting the days until the Davidsons' arrival a week hence. With a Swiss nurse to keep the children out of Georgia's sight and hearing, Elizabeth could devote herself to caring for her uncle and getting Georgia to eat—one of her many caretaking skills.

The Davidsons arrived with news not calculated to speed Georgia's recovery; Elizabeth's parents had so much enjoyed their visit of the previous summer that Lee now planned to reclaim his share of the Hill, building a cottage on the property that would become his summer headquarters.

The choleric Lee and the fearful, abject Lizzie were a dark mirror of everything Georgia loathed and dreaded about marriage—a caricature of the "big man" and "little woman." Poor, placating Lizzie, seen as a travesty of traditional wifely virtues, bore the brunt of Georgia's anxiety mixed with guilt. Joined by her sisters-in-law Selma and Agnes, Georgia made Lizzie, like the wounded barnyard hen, fair game for every form of persecution, from outright insult to jokes at her expense.

In the middle of July, Paul Strand returned to the Hill. His visit was brief and unhappy as he, too, became a victim of Georgia's fury. Suspecting what had happened between Beck and Alfred while she was in Maine the previous summer, Georgia seems to have blamed Paul (if unconsciously) for the behavior of his mate—and her own. Whatever the ostensible cause of her attack, Paul, certain that he had done nothing to deserve it, left deeply hurt.

Beck arrived at the beginning of August in high dudgeon over the way Georgia had treated Paul. Immediately, she poured out their grievances to Alfred. He did not even try to defend Georgia's ugly behavior, Beck reported. He just looked more miserable and alone than she had ever seen him.[27]

This time, Beck stayed at the Pines, where she also took her meals; Alfred had made the arrangement to free Georgia from cooking, he explained to Beck. With Catherine Colton, Hedwig's ex-maid, now helping in the kitchen, Beck's lodgings away from the farmhouse and its sleeping porch would seem to have other explanations. In the event, Alfred's belated efforts to keep the two women apart were unsuccessful. Immediately following Beck's arrival, she and Georgia had a fearful row by the lake. Georgia promptly retreated, barely emerging from her room each day, leaving Beck to keep Alfred company.

Beck's anger at Georgia tempered the slavish adoration and nervous excitement she usually felt in the other woman's presence. Unlike the previous summer when she "hopp'd" about after O'Keeffe, she now felt a chilly indifference—or so she claimed. She resolutely remained at the Pines for all meals, even turning down Georgia's laurel branch—an invitation to tea. "I wasn't going to start that again," she told Paul firmly.[28]

The two women went about their own business, carefully avoiding each other; indeed, Georgia avoided everyone. Stieglitz continued to

photograph Beck. The August heat was so fierce that her ability to remain for long periods naked in the icy water of the lake—long famous as a feat of endurance—now seemed common sense. Standing above her, Alfred photographed Beck floating on her back. In a print he called *Water Lilies*, her large round breasts, submerged to the nipples, are magnified by the clear water.

Normally, Alfred donned bathing trunks only to photograph others in the lake. Now, in the worst of the heat, he left his camera on the shore and went in for a swim, paddling about like a puppy dog, Beck reported, his pink bald spot wet and shiny. The arrival of Carl Zigrosser, an old friend of Alfred's and a founding partner of the Weyhe Gallery, provided Beck with a companion for serious swimming: together they circumnavigated the small island in the middle of the lake.

Georgia was quiet and friendly, leaving Beck feeling "hypocritical" in her efforts "to act naturally, just because of Stieglitz." Nervously, Beck wondered what was going on in Georgia's head. Strand's article on O'Keeffe, just published in *Playboy* (a cultural journal of the period) and soberly acclaiming Georgia as a great artist, arrived at the Hill. "It's much nicer than the lady it's about," Beck wrote to Paul waspishly. The subject of the article had no comment.[29]

Alfred's need to manipulate the women in his life into situations of intimacy was getting out of hand. First had been the disaster of Kitty and Georgia's forced encounter; then last summer's invitations to Marie Boursault and Katharine Rhoades had driven Georgia to Maine, leaving him to console himself in Beck's arms; now Alfred's efforts at damage control only shifted alliances. "It has been a very difficult week," he wrote to Elizabeth early in August. "But there has been some clearing up. . . . Nothing has been said except finally between G. and myself . . . I & my women folk seem to be on a working basis."[30]

Whatever was said between Georgia and Alfred healed no wounds as far as Georgia was concerned. In her despair, she turned, once again, to Beck, pouring out her troubles to the other woman in a long talk by the lake. Beck's anger melted, turning to sympathy. Georgia had been "beside herself . . . weeping uncontrollably." For Georgia to cry in front of anyone else, "you know how low she must be," Beck wrote to Paul. Georgia had been pushed to the limit—and by Stieglitz alone—"in all innocence," Beck was sure. Her own brief encounter with Alfred was not the issue; Georgia had recognized that the vulnerable Beck was a fellow victim. Her anger toward Paul, too, had been diversionary. "Don't return with any grievance,[31]" Beck warned him. He would realize when he arrived that Georgia was not to blame.

The heavy summer stillness outdoors made the suffering inside the house seem more intense. Georgia and Alfred cared for each other so deeply that every conflict caused excruciating pain, Beck told Paul. It was a critical time, Beck recognized. Matters had to be settled between her hosts that had nothing to do with others. With their clashing needs, how could they continue to live and work together?[32]

Beck left at the beginning of September, with Alfred waiting anxiously for the final notice of his divorce. Soon after her departure, Alfred wrote, "Beckalina, mia carissima. . . . You really had nothing to do with the, let's call it unrest—inner—of G.—as I see it. But we won't go into that. You have too much sense—there is today—& tomorrow—& we—you & I—& we & others—work & jobs."[33] The meaning of Alfred's mutterings: whatever had happened between them was over.

GEORGIA'S SISTER Ida arrived in late September, bringing an early cold spell. Calm and productivity returned to the Hill. On the chilly rainy day he'd been waiting for all summer, Alfred printed feverishly—80 snaps, he wrote to Rosenfeld. Georgia had painted two "extraordinary abstractions—on the old order," he noted approvingly. His favorite was "a real red" painting. Georgia was already worried that it wouldn't find a buyer. It was a big picture, but unlike the flowers Alfred found it "fine enough" for him to want to keep.[34]

Catherine Colton continued to do all the cooking; Ida took over the functions of chambermaid. Alfred especially admired the way she made beds. Suddenly, the atmosphere was "utopian." Never had he and Georgia enjoyed so much "ease and comfort," he told Rosenfeld.[35]

In October, Arnold Rönnebeck, a German emigré sculptor and friend of Coomaraswamy, Stieglitz's admirer at the Boston museum, arrived. While he was there, the Engelhards came for the weekend. On a crystalline Sunday afternoon, the Engelhards, Rönnebeck, Ida, and Alfred made the ritual ascent of Prospect Mountain, Georgia having begged off. Descending after the lavender sunset had darkened to fall twilight, the group briefly lost its way. For Alfred the safe uncertainty—the confusion of the familiar and the strange—brought on a mystical experience of dissolution: "it was all so beautiful that I couldn't believe that the moon was really the moon—the night not a dream—the people near me not my imaginings—& that I was anybody or anything or was anywhere—" he wrote to Rosenfeld.

Following the transitory loss of self, he was flooded by oceanic feelings of joy. He closed by sending Rosenfeld "Our deepest love—Georgia

is marvellous—So is Ida And Catherine. Everyone." Although Georgia had not been with them, she felt at one with Alfred's "untellable experience." She added a warm postscript to his letter: Paul had been part of it too because he was "part of us."[36]

A week later, Rosenfeld appeared in the substantial flesh. By way of affirming his new status as member of the family, he decided to fall in love with Ida. In symbolic anticipation of her literary suitor, the high-spirited, competent nurse had just added touch typing to her other skills and talents. To the surprise of all, Ida seemed to take the attentions of her improbable admirer seriously. Alfred was furious. He could never bear to see a woman's—any woman's—loving gaze directed toward another man. By virtue of his desire, Ida belonged to him. Her defection was a betrayal for which she would be punished.

The glory of October on the Hill was clouded by news from Milton. Kitty had been allowed to leave Craig House in June. During the quiet summer with her husband and one-year-old son in a rented cottage at Sagamore Beach, she had seemed to improve steadily. Then, with no warning, she had suffered a severe relapse. Milton's disappointment was almost more than he could bear, he wrote to his father-in-law.

Paradoxically, it was the blow of Kitty's reversal, after the last perfect weeks at Lake George, that seems to have persuaded Georgia to become Alfred's wife. On September 9, Alfred had received his final divorce decree from Emmeline, but his new status as a free man had failed to convince Georgia of the legal advantages of marriage. She had been unimpressed by the tax penalties, the added difficulty with leases, and the problems she would have in inheriting his share of the estate if they remained unmarried. He had not made his most eloquent case: Alfred was now sixty, Georgia thirty-seven. Without legal ties, he was afraid she would leave him.

Kitty was the reason they got married, Georgia told her sister Catherine. Less cryptically, Sherwood Anderson explained to a friend that medical opinion had advised O'Keeffe and Stieglitz that legalizing their union would dispel the confusions tormenting Kitty.[37] Alfred was grateful to have this professional advice secondhand. He was no more willing now than he had been earlier to confront his daughter's doctors.

Determined to show Georgia that he was ready to assume the responsibilities of a husband and householder, Alfred, with some reconnoitering from friends and relatives, set out to find a place to live. He settled on the top floor of a four-story brownstone at 35 East 58th Street. There was a spacious studio for Georgia, her first since Elizabeth's provisional quarters. The rent seemed very high to Alfred, who was unused to paying anything for housing; but even he admitted that, given

the cost of everything else in New York, it was cheap—and "perfect" for them.

On December 8, in a foggy drizzle, Alfred and Georgia boarded the Weehawken ferry—the same one that Alfred had photographed fourteen years earlier—for the trip across the Hudson to John Marin's house in Cliffside Park, New Jersey. On this first of two crossings needed for the New Jersey civil ceremony, Marin met his friends at the ferry slip and drove them to a hardware store, whose owner, the local justice of the peace, sold them a marriage license. The road was slippery and Marin—"stupidly," as Alfred recalled—turned to joke with Georgia in the back seat. The car skidded, crashing into an iron lamppost. The steering wheel was smashed and other parts of the car were bent, but miraculously none of the passengers was hurt. The license was obtained on foot, in the pouring rain. Of the incident, Georgia later said she felt as though she had lost a leg. Whether she referred to the accident or the crippling outcome of the trip is unclear.

On December 10, the night before their marriage, Ida invited Alfred to the theater. Despite lukewarm reviews describing the play as a "take it or leave it melodrama," High Stakes had been a popular success since its opening in September. The hero is a sixty-year-old man who has just married a much younger woman; fearful of losing his bride, he showers her with every object of her desire. The plot centers on the reappearance of his wife's former lover, a young adventurer who insinuates himself into the household as a friend of the family.

Alfred was so little engaged by the drama that he fell asleep. Having declined to join them, Georgia would not have passed the time as tranquilly. Asked many years later how she felt about getting married, she replied: "What does it matter? I just know I didn't want to."[38]

Much has been made of O'Keeffe's refusal to be known as "Mrs. Alfred Stieglitz," starting with Georgia's own view of her heroic radicalism. In fact, following the Lucy Stoners' belief that feminism began with the refusal to nominally disappear with marriage, most of O'Keeffe's women contemporaries who were writers or artists kept their maiden names: Neith Boyce, Ida Rauh, Susan Glaspell, Edna St. Vincent Millay, the precisionist painter Elsie Driggs.* Georgia had exhibited and been written and talked about as Georgia O'Keeffe. There was no reason to assume Alfred's name, nor is there any evidence that he expected her to do so: "Georgia O'Keeffe, American" was his creation; he continued to orchestrate her growing fame and higher prices. Her name was too valuable to be changed.

* Marguerite Zorach, painter, designer, and wife of William Zorach, was an exception.

. . .

ON THURSDAY, December 11, the couple returned to Cliffside Park accompanied by George Herbert Engelhard, who along with Marin acted as witness for the uneventful proceedings. Curiously, Georgia did not choose a woman—either friend or sister—to stand up for her.

No "funnier" marriage had ever taken place, Alfred assured Sherwood Anderson. At Georgia's insistence, only a few people were to be told. She would be keeping her maiden name, Stieglitz added neutrally.

On their return, Alfred took to his bed; the day's raw weather combined with the dirt and dust he had swallowed that morning while cleaning Room 303 at the Anderson Galleries had given him a savage cold.

SEVENTEEN

High Stakes

ALFRED STIEGLITZ, *Georgia O'Keeffe* (1924).
In the year of her marriage to Alfred, Georgia, with her drooping
eyelids and lined face, looks much older than her age—thirty-seven.

"SEVEN AMERICANS" opened at the Anderson Galleries on March
9, 1925. In tones that conjured the magician and carney barker, Alfred
Stieglitz presented "159 Paintings Photographs & Things Recent &
Never Before Publicly Shown."

For Alfred, it was 291 reborn with a New World birthright. Besides
O'Keeffe and himself, the seven included Dove, Hartley, Marin, Strand,
and Demuth. It was Dove's first show since 1912, Strand's first since
1916. The exhibit signaled Marin's homecoming after years of being
farmed out to Daniel and Montross. Stieglitz's catalogue was sure to
note that the Hartley paintings in the show were part of the brilliant
auction Alfred had conducted the year before, and he introduced a "new"
artist, Charles Demuth, admitted provisionally into the Stieglitz circle.

To celebrate the reunion of his artists, Alfred chose to describe the
event as an anniversary: it had been twenty years, according to his
calculations, since he had added paintings to the photographs at 291.

Thanks to Kennerley's largesse, Alfred's youngsters' work now filled the entire Anderson Galleries on the top floor of 489 Park Avenue.

Lamenting that Sherwood Anderson could not remain in town for the opening, Stieglitz described the show to him in terms of a religious revival: the apostate Waldo Frank returned; what he saw on the walls left him pale and shaken—purged, according to Alfred, of false consciousness. The spirit of 291 had never burned so brightly, Waldo had told him. Celebrities came in number, Alfred reported, and they stayed "to sing the praises of Life. . . . My own blood they really feel—the blood of the Seven."[*][1]

Contributors to the catalogue, none of them poets, were moved by the occasion to burst into verse. Sherwood Anderson's Whitmanesque effort might well have earned Georgia's gratitude that he had declined to write a preface for her last show: "The city is very tired / The men and women of the city are very tired," he began. Dove's offering should be spared quotation (this great artist tended to pop off bad poetry even without Alfred's instigation); sculptor Arnold Rönnebeck was represented by a prose poem on what made the seven artists typically American (they were all "explorers," he concluded). His portrait-bust of Hartley was also shown.[2]

Most dramatically, the exhibit gave new proof of the cross-fertilization—if not inbreeding—of the Stieglitz circle. The visitor entered to see Demuth's symbolic poster-portraits of his fellow artists, including Georgia as the spiky snake plant, tough and long-lived. Strand's ten close-ups of machine parts were echoed by O'Keeffe's magnified and cropped petunias; at the same time, the piercing off-center diagonal of her *Flagpole* rendered homage to Marin's thrusting convergence of skyscrapers. Hartley was the group's advance man in the Southwest; his brooding meditation on the Sacred Mountain of Taos struck a prophetic note. Within four years both Marin and O'Keeffe would be painting the same landscape. Now Hartley paid direct tribute to Georgia with his *Calla Lily*. Dove's *Storm Clouds in Silver*, their jagged saw-toothed outlines slashing the canvas vertically, recalled similar forms in his paintings of 1912 that O'Keeffe had freely borrowed in her early watercolors.

Throughout the show, American themes echoed as briskly as a Sousa march. Balancing the precision of the machine against the variety of nature were Strand's gears and wheels and three helpings of O'Keeffe's

[*] Stieglitz's choice of the number seven for his group seems an unmistakable allusion to Robert Henri's Eight; as the latter came to be synonymous with urban, socially resonant subjects, so Alfred clearly intended his artists to stand for an articulated American vision.

corn. Dove's first "assemblages" (the artist's term for his collages composed of found objects), *Miss Woolworth* and *The Five and Ten Cent Store*, evoked the poignant, cheap tinsel wares of that uniquely American institution. Marin was represented by the manmade rhythms of lower Manhattan and the flinty littoral of the Maine shore.

Critical reception of the exhibition was poor. The flatulent poetics of the catalogue backfired, irritating reviewers, who found Sherwood Anderson's puffery particularly offensive in its suggestion that the seven were more "alive" than other American artists. "Cutting out the ballyhoo," one critic suggested icily, the show "revealed that artists of the Stieglitz circle suffered the same unevenness of performance as any other group of painters."[3]

Unanimous judgment found O'Keeffe's work of the past year disappointing. She had been called "a great artist and a great poseuse; probably she was something of both," opined one reviewer.[4] This remark underscored an impression of indecision, of lack of direction and hedged bets in O'Keeffe's recent work that troubled all critics.

Inevitably, the first appearance of the outsized flowers drew strong reactions. Forbes Watson, critic and editor of *The Arts*, was the first to observe that magnifying a tiny petal into a form the size of an elephant's ear mercilessly exposed deficiencies in the artist's handling of paint. Whole areas of the canvas seemed to be filled in rather than articulated. "After the first gasp, one becomes aware," Watson wrote, "that several of Miss O'Keeffe's canvases appear to rely upon exaggerated sizes rather than upon intensive development of the spaces."[5]

Raves were accorded Stieglitz and Strand photographs, along with continuous praise for Marin's genius with watercolor. Dove's ironies, however, mystified many writers. Hartley and Demuth fared no better than O'Keeffe.

Alfred, instead of being "on deck" daily to educate critics and reviewers, was kept home in bed for much of the show, suffering from painful attacks of kidney stones. Whether or not his exegetical torrents would have swept away critical reservations, Georgia was depressed by the reception of her new work—a depression not eased by recalling the stormy distractions of the past year.

Shortly after the show closed, Georgia wrote to Mabel Dodge Luhan, who was well along in her mission to make Taos the spiritual and creative utopia of the New World. O'Keeffe was seeking a sympathetic understanding of her work that she was not receiving from New York critics, men and women alike. In a letter that managed to flatter Mabel the woman of mystery as well as Mabel the woman of intellect, Georgia told her, "About the only thing I know about you—from meeting you—

is that I don't know anything." Mabel was too profound to be known, Georgia assured her. Her fathomless depths yielded Georgia a single clue as to Mabel's being: she had never met "a more feminine person."[6] Most probably, Georgia was not aware of Mabel's opinion of the works exhibited in the 1925 show; in an unpublished article, she had denounced them as a shameless display of the artist's sexual juices.

Mabel had continued her involvement with art as she had begun—in the role of muse. From her white salon on Fifth Avenue, she had moved to Westchester, where she hoped to find happiness in a more peaceful setting with her third husband, Russian-Jewish artist Maurice Sterne. In a dream, it was revealed to Mabel that Sterne should give up painting to become a sculptor and that, for them both, New Mexico was the promised land. In 1923 they had settled in Taos, where Sterne obediently put away his paints and set about chiseling Indian maidens in marble. Then Mabel fell in love with Tony Luhan, a full-blooded Pueblo. Maurice departed and Tony left his Native American wife, moving with Mabel to Los Gallos, the property she had bought between Taos and the Indian land.

Despite the complicated dramas of her life, Mabel still found time to write on Indian problems and on the local Anglo art scene. On frequent trips East, she caught up with current cultural events in New York.

The previous summer Georgia had been impressed by an article Mabel had written on the acting genius of Katharine Cornell and she had told Stieglitz she wished Mabel had seen her work. Now she was hoping that Mabel "could write something about me that the men can't. What I want written—I do not know—I have no definite idea of what it should be—but a woman who has lived many things and who sees lines and colors as an expression of living—might say something that a man cant—I feel there is something unexplored about woman that only a woman can explore—Men have done all they can do about it."[7]

Among the "many things" Georgia probably knew about Mabel was her first and passionate love for another woman.* Known for her frankness in sexual matters, Mabel had primed her confessional impulse with extensive psychoanalysis. She may well have told Georgia about her youthful affair with "Violette." If not, gossip abounded about Mabel's varied love life, including her bisexuality. Whatever Georgia had heard—or sensed—about Mabel suggested profound affinities between the two: Mabel was the one woman who Georgia felt was equal to writing about her art.

* Detailed in the first volume of Luhan's four-volume memoir, *Intimate Memories* (1933).

Reviews of Georgia's paintings included in "Seven Americans" had suggested no special sympathy from other members of her own sex. The most dismissive judgments, in fact, came from female critics. "It is rather strange, considering how supposedly deep are the well springs of human emotion in which her ideas have their inception, how often she is deflected into mere prettiness," noted Helen Comstock in *Art News*.[8] Margaret Breuning in the *Evening Post* found O'Keeffe's colors, except in the calla lilies, "sickly," her choice of subjects "unpleasant" and "clinical," and her part of the show, in general, "a flop" in terms of both color and design.[9] Even Georgia's friend Helen Appleton Read damned with the faintest of praise: the dreaded laurels of the decorative. The works, "all painted in the artist's clean precise manner," worked well when the artist did not strive for significance. "The simple obvious arrangements are her best," Read noted, rather patronizingly, with the "petunia decorative panels, a new flower in her garden, . . . especially attractive."[10]

Besides leaving critics to their own unrevised reactions, Stieglitz's untimely illness forced Georgia into a new and unwelcome role. For the first time, she was obliged to sell her own paintings. Writing to Sherwood Anderson in early April, Alfred described the distaste Georgia felt in accepting money "*directly*" (his emphasis) for her work. Whether these transactions took place at the gallery after the show came down or in her studio in their new 58th Street apartment is unclear. In any case, the buyers, Alfred reported, were strangers as well as the friends and relatives of earlier years. She had come a long way from the horror she had confided to Anderson in seeing the "greasy vulgar people" merely look at her "beautiful children"; now she herself was selling these same progeny to anyone who had the money to buy.[11]

Alfred's tone in describing Georgia's feelings—and his own—about the sales is both sympathetic and smug. He clearly hoped the sufferings she experienced in placing her own pictures would make her more appreciative of his mediating role. She could afford to take to her bed only when Alfred was on his feet in the gallery, educating neophyte and philistine on the responsibilities of owning an O'Keeffe. But he also worried that Georgia felt demeaned by acting as her own salesperson and, worse, that the experience could affect her morale and her art. At the same time, Alfred was as susceptible to the current definition of success as any other American of his day; he could not but rejoice in the sales themselves.

Georgia now described herself as a little plant that Alfred had "watered and weeded and dug around."[12] Using the same imagery,

Stieglitz expressed his pleasure that every sale provided further proof: Georgia was "taking root."

ALONG WITH the strangers who stayed to buy paintings, Jean Toomer, a new friend, came to see the show.

Toomer's novel *Cane*, an impressionist collage about slave life, had been published two years earlier to great acclaim, making its twenty-nine-year-old author a star of the Harlem Renaissance and a downtown literary celebrity.

Tall, slender, and elegantly dressed, the writer arrived at the Anderson Galleries with his lover, Margy Frank. Margy and Waldo Frank had recently separated, but as Toomer was also a friend and protégé of Waldo, his affair with Margy had divided loyalties in the Stieglitz camp throughout the winter. Between his literary and sexual conquests, Toomer had become a fervent convert of the Russian mystic Gurdjieff. Toomer and Margy were joined at the exhibit by A. R. Orage, Gurdjieff's vicar in America, whose lectures spread the gospel and raised money for the Russian mystic's Institute for the Harmonious Development of Man in Fontainebleau. Stieglitz had been particularly keen to meet Orage, who spent a few "real" minutes contemplating his Cloud photographs, Alfred reported to Sherwood Anderson.

O'Keeffe had met Toomer a few months earlier when he had visited 65th Street, brought probably by Waldo Frank or Hart Crane. Initially reluctant to go to a restaurant in the company of a black man, Georgia had found the writer so fascinating that she had stayed up until two in the morning talking with him. Her earlier discomfort in the company of blacks evaporated in Toomer's presence—largely because he didn't look Negro. "People took him for an East Indian," a later lover noted, "that color—beautiful rich skin, gold shade, very fine features and bones . . . beautiful mouth, very sleek hair and fine hands. . . . I don't think he has been spoiled by white women—although all women are in love with him."[13]

Among the many rich women, besides Margy Frank, who fell under Toomer's spell was Mabel Dodge Luhan. Their meeting in New York in late November 1925 ignited an intense passion on Mabel's part; Toomer reciprocated sufficiently to visit her in Taos early in 1926, where she wrote him a fourteen-thousand-dollar check for Gurdjieff's center. Mabel was gracious when she learned that her loan had been pocketed by Orage. She was forgiving when, inevitably, Toomer's interest in her cooled. Like all of the writer's former lovers, she felt blessed—even if

briefly—by his spiritual illumination, his intuitive understanding, and his sexual stamina.

For Mabel, Toomer's Afro-American heritage was a gift, a direct current to the instinctual life repressed by white civilization. In contrast, Georgia was never drawn to the primitive. It was the writer's light skin, his "white" manners, and his animal magnetism combined with educated eloquence that dispelled O'Keeffe's prejudices. Toomer, moreover, was already distancing himself from the limitations implicit in the label "Negro writer." From accepting the endorsement of the Harlem Renaissance, he was soon moved to deny that he was black.

Deserted in childhood by his father and later by his mother, Toomer took as a surrogate male parent his maternal grandfather, A. S. A. Pinchback, who headed the household in Washington, D.C., where Toomer spent his childhood. Under Reconstruction, Pinchback had enjoyed brief glory as governor of Louisiana. But Toomer's pride in this illustrious forebear was contingent on his denial that Pinchback was Negro; he had claimed black blood only to secure the vote of freed slaves, his grandson said. Toomer himself refused to contribute to James Weldon Johnson's anthology of Negro literature, insisting that he was "simply an American."

Georgia waxed lyrical about Toomer's charms to two other new friends, Margery Latimer and Blanche Matthias. Latimer was an aspiring writer from Portage, Wisconsin, where Georgia's sister Catherine now lived. A ravishingly beautiful young woman, she was statuesque, with red-gold hair, flawless skin, and blue eyes, and her radiant presence dazzled everyone she met.

A descendant of the poet Anne Bradstreet, Margery had published stories in the local newspaper while still in high school. Her precocious talent attracted the notice of Portage's literary eminence, Zona Gale, whose phenomenally popular stories about Friendship Village chronicled real life in Portage. Before Gale's play *Miss Lulu Bett* won a Pulitzer Prize in 1921, she and Margery were bound in an intense fourteen-year relationship during which the younger woman moved restlessly back and forth between New York and Wisconsin.

Twenty-two and a university dropout, Margery had come East in the summer of 1921 to take a course in playwriting at Columbia. The class was disappointing, but one of her fellow students, Blanche Matthias, became her confidante, patron, and probably lover—a New York substitute for Gale.

At thirty-three, Blanche Coates Matthias was a glamorous, sophisticated woman with journalistic ambitions. Her childless marriage to a

Chicago lumber tycoon gave her few responsibilities and considerable freedom, which she used to make frequent trips to New York. On earlier visits East, she had made the pilgrimage to 291, where she had become friendly with Stieglitz. Then, early in 1921, a few months before she met Margery, she visited Alfred's exhibit at the Anderson Galleries, where she was electrified by his photographs of O'Keeffe. She had to meet Georgia, she told Alfred. He gladly arranged an introduction.

The first meeting was not a success; O'Keeffe seems to have been put off by the other woman's confident worldliness, stylish appearance, and the kind of easy culture that—especially in women—made her defensive. She may have also seen Blanche's dark romantic looks as a threat: she was just Alfred's type. But Blanche was interested only in Georgia. Refusing to be put off by the famous O'Keeffe frost, she invited Georgia to lunch in her suite at the Ambassador Hotel. Her admiration for O'Keeffe's art probably did more to win over the artist than any other overtures.

Given her wealth and her enthusiasm for Georgia's work, it seems odd that Matthias never bought a painting. Her resources, however, may have been strained; she was now helping Margery financially so that the younger woman could remain in New York to finish her novel. It was at this time that Blanche would have introduced O'Keeffe and Latimer. By 1925, the two Wisconsin-born women had become friends.

Her friendship with Matthias and Latimer set the pattern for O'Keeffe's intense involvement with women bound to each other. Whether she functioned as audience, player, or director in a drama of shifting alliances probably depended on the couple.

When Latimer was living in New York, she and O'Keeffe moved in the same circle. Both women were favorites of Carl Van Vechten and his actress wife, Fania Marinoff. Their all-night parties—where the host often made his appearance in drag—lured Georgia, without Alfred. This was not his scene.

Her social success in upper bohemia could not distract Latimer from more profound frustrations. After strong initial interest, the Knopfs had turned down her novel. Her passionate friendships with Zona Gale and Matthias notwithstanding, she was desperate to marry and have a child—a yearning that found sympathy in O'Keeffe. When none of her male lovers seemed inclined to marriage or paternity, Margery returned to Portage, where she wrote despairing letters to Georgia and resumed her relationship with Gale.

By late spring, Alfred decided that their perfect apartment, with its studio for Georgia, was uneconomical. They were now spending five months—almost half the year—at Lake George. It made no sense to pay

rent during that period for a place they weren't using. He made an offer to the landlord for a reduction based on the actual time spent there. The landlord did not reply. By now Georgia realized that money was not the issue. Stieglitz had only one home: Lake George. He would always find some excuse to justify his horror of householding on their own. As long as he clung to his need to be a transient everywhere but the Hill, they might as well rationalize his refusal to live independently and take rooms in a hotel.

Like many New Yorkers, Georgia and Alfred had watched with awe for the past two years as the Shelton Hotel rose from a deep hole in the ground between 48th and 49th streets on Lexington Avenue to become, in 1924, the first skyscraper hotel in the city.

Thirty-four stories high, Arthur Loomis Harmon's revolutionary building was the first skyscraper in New York to capitalize aesthetically on the new zoning resolution mandating setbacks of one foot of additional air space (and light) for every four feet of height. The attenuated effect caused one lyrical writer to observe that "the building seems not merely to have a tower, but to be a tower."[14]

For Alfred, the idea of transience combined with transcendence was especially appealing; if they could secure rooms on a high enough floor, he could ascend to a sense of oneness with his favorite subject, clouds, while returning to his childhood state in which basic needs were provided by invisible caretakers below stairs. Georgia was even more entranced by the prospect of an aerie loftily—and literally—removed from the pedestrian activities of marketing and housekeeping. She had always felt numbed and deadened by the street life of the city, by its frantic rhythms and frenzied human activity. Claude Bragdon, an architect/engineer who would become a Shelton neighbor and friend, described living at the Shelton as "the most successful escape from the dirt, ugliness, noise, promiscuity of the city."[15] Skyscraper living was the solution to being *of* the city but not *in* it.

From the outset, the Shelton's elegantly soaring form conflicted with its democratic function. It was planned as a men's residence, specifically for single male office workers, so its target market was those young men who could afford little more than the Y but who aspired to membership in an exclusive private club. To provide the illusion of the latter, amenities originally included a library, billiard and writing rooms, steam baths, squash courts, and a swimming pool. Dining facilities offered a grill room as well as a more formal restaurant.

The Shelton Hotel Club—its original name—was an instant flop. Its intended residents remained at the Y or in cheap boardinghouses— the traditional shelter for young people starting out in the city. Even

had they rushed to apply, the rates were too low to maintain the staff needed to service all the facilities.

One year after its opening, the Shelton advertised as a "mixed residence hotel," and Georgia and Alfred gave it a trial run for a few days in June 1925, just before setting off for Lake George. They were obviously not put off by the bleak, unwelcoming lobby, its glum air epitomized by the life-size wooden Indian standing to one side of the registration desk. Neither did they mind that the restaurant and grill room had now become a proletarian cafeteria; it still boasted a wood-burning fireplace for winter and a terrace with a splendid view for warm weather.

With firsthand evidence of the Shelton's unfilled rooms, Georgia and Alfred felt no need to reserve one of the hotel's two-room apartments for the fall and to once again pay rent for unoccupied space. Their winter housing problem solved, Alfred and Georgia set off for Lake George on June 11.

Before leaving town, Georgia had been vaccinated (against what contagion goes unrecorded). She and Alfred had just arrived at the Hill when her legs and feet swelled alarmingly, causing her such pain that she remained in bed.

Lee's appearance with family and servants for the first summer in their new bungalow Redtop meant there was no escaping his prescribed cure: he ordered Georgia's legs and feet bound, immobilizing her completely for more than four weeks. Miraculously, she survived her brother-in-law's care without permanently atrophied muscles or gangrene. To complete the summer's debilitating start, Alfred had passed several kidney stones at the same time that Georgia was sent to bed; weeks later, he was still weakened by days of excruciating pain.

Their concurrent illnesses allowed Alfred to indulge his hypochrondria à deux. They had not had a single day without sickness in their seven years together, he claimed. With this wild exaggeration Alfred reduced Georgia to his own frail, suffering state; instead of the strong, healthy woman he had married, twenty-three years his junior and in the prime of life, he recast a wife bound to him by her own dependence and debility. Lee's medieval cure assumed a grim symbolism.

By August, Georgia was ambulant just in time to endure the descent of additional family members: the small Davidson girls appeared without their parents, who were trying to work out marital troubles at home; Elizabeth's sister, Flora, and her husband, Hugh Straus, arrived with two young sons, followed by Selma Schubart, in chiffon gowns with vaporous comportment to match. By August 11, they were eleven at

table for every meal—and sometimes more, Alfred noted happily, in his element once again.

Fit but far from good-tempered, Georgia found it easier to vent her frustration and feelings of claustrophobia on the smallest Stieglitzes, whose very mannerliness was an irritant. When Sue Davidson, the pretty three-year-old, solemnly wished her "Good morning, Aunt Georgia," she received a swift slap in the face. "Don't ever call me 'Aunt,' " snapped O'Keeffe.[16] Just as she was *never* to be known as Mrs. Alfred Stieglitz, she rejected even the most nominal role of relative. No one was allowed to forget that she was not one of them.

By September, Georgia was once again free of the quarrels and croquet games, the sight of the entire family munching corn on the cob at table, the earnest discussions of Alfred's constipation. To compensate for her trials of the previous three months, Jean Toomer arrived for a working holiday of several weeks.

After the risks he had taken in *Cane*, Toomer was having difficulty finding both form and subject for his writing. His spiritual engagement in the Gurdjieff quest—to develop the individual's many selves—was adding further confusion to Toomer's already shaky identity and murky prose. Committed to spreading the master's word, he never again found a publisher for his writing. He ended his stay on the Hill that summer, however, in high spirits, grateful for both the bracing company of his hosts and the peaceful working conditions.

Another new friend, Frances Garfield O'Brien, visited for the first time. A young journalist and illustrator, O'Brien was a passionate fan of O'Keeffe's and had announced her plan to write about her art. Their guest's snapping Irish good looks reminded Alfred that he had lost his muse of summers past; Beck and Paul Strand were spending their holiday in Colorado, followed by a visit with Mabel Dodge Luhan in Taos. The several prints Stieglitz made of O'Brien portray a voluptuous nude clutching a large teakettle to her ample breasts.

Paul Rosenfeld had been in residence since July. Wisely, he remained all but invisible when Stieglitz siblings, children, and servants made tranquil talk impossible. His collected writings, *Port of New York*, had appeared during the previous winter, and Alfred had mixed views about the essays; they would have been improved by greater "leanness," he told Paul. Leanness was not Pudge Rosenfeld's style—in art or in life. Published offhandedly by Harcourt Brace, the book was advertised solely by its author (on Stieglitz's advice). It sank without much notice.*

* Today hardly an article can be found on the New York art scene at this period that doesn't quote from Rosenfeld's remarkable essays.

During the summer, while avoiding the family and working on a novel, Rosenfeld had a chance encounter with another old Stieglitz friend, the poet and playwright Alfred Kreymborg, who was staying with his wife in nearby Lake George Village. In a late-night conversation, the two writers lamented that outlets for young literary talent had, one by one, disappeared: *Seven Arts* and *Broom* (which Kreymborg had edited and Harold Loeb had financed with family money) had both disappeared. *The Dial* had become a little magazine for big literary names—preferably European or English. As always, the problem was cash. Then an angel appeared in the form of another Stieglitz neighbor, Samuel Ornitz, an executive of the Macaulay Publishing Company. With his offer of financial backing and rent-free offices, Rosenfeld and Kreymborg founded *American Caravan*, a yearbook of new writing edited by Lewis Mumford and Van Wyck Brooks. Jean Toomer and Margery Latimer were among those represented in its first issue.

One guest of the previous summer was conspicuous by her absence. Because of Rosenfeld's four-month residence, Alfred had refused to invite Ida O'Keeffe for a visit. In the spring, Paul and Ida had come dangerously close to marriage—despite Alfred's disapproval. Their union could only result in "ugliness" for both of them, he wrote to Ida. Until she learned not to make "mooing sounds and goo goo eyes at everything in trousers," she was better off where she was, he told his sister-in-law in answer to her hurt note about the missing invitation. Despite her pleasure in Ida's company, Georgia had not intervened. Keeping Ida away from the Hill was no sacrifice for him, Alfred wrote. Her behind had become too fat to photograph, he told her cruelly. Her "black spot" would have to be admired by her alone, in her bath—or by God.[17]

Alfred's need for revenge was not satisfied by deriding his sister-in-law's looks and her overage virginal state; he refused to divulge Rosenfeld's whereabouts, strongly hinting that he was about to marry someone else. In fact, Paul was at the Hill the whole time—which Alfred subsequently admitted. He had lied to protect Paul from being "disturbed" by Ida; Paul needed "to get clarity about himself—& he can get that only in working & keeping away from petticoats & all they signify," Alfred added in a triumphant burst of misogyny. He wanted Ida to know that sexual jealousy played no part in his efforts to end her romance with Paul. "Its none of my business if in the future at any time you want to lie down on your back," he assured her.[18] By way of a consolation prize, he sent Ida, who had begun putting her flower arrangements on canvas, a box of paints.

Georgia, however, couldn't seem to get started with her work, Alfred wrote to Strand. She had done less in these last months than in any

equivalent length of time since they had been together—now seven years. The reason was her deep yearning for larger space, Alfred conceded. Then, too, as his wife, she could not escape the traditional role of mediating everyone's conflicting needs; it was a great problem, he noted. The inclusive pronoun would not have fooled Strand: the conflict was between Alfred and Georgia.

On their return to the city, Georgia and Alfred had an unexpected blow. All set to move into the Shelton, they were curtly informed that it was full. Confronted by the full blast of Georgia's icy imperial wrath, management changed its mind. The Shelton may also have concluded that two "semi-transients" (in the words of the hotel's advertisement) were a safer bet and less bother than the larger population of transient guests. For the "semi-transients," the Shelton would be home for the next ten years.

Room 3003 was actually two small rooms with bath, located on the twenty-eighth floor of the hotel (the discrepancy in the numbering scheme was due to the unnumbered loggia floors that housed the cafeteria). The bedroom was so tiny that with their twin beds, a bureau, and Alfred's favorite deep armchair, there was barely "a path to the bathroom," Georgia wrote to Ida. As it faced northeast and south, however, "there was lots of sun and air," always essential to Georgia's sense of well-being. The sitting room was "large enough for our purposes," she noted. It faced north and south, and the light was good "so I can work if I want to."[19]

Georgia's laconic tone was decidedly one of making do. There was nothing to be done with the two poky rooms except to try to make them disappear, obliterated by the spectacular views. Georgia geared her decorating to this end: windows remained without shades or curtains; walls were painted her favorite palest gray; the few pieces of furniture were slipcovered in white. There was no distracting color anywhere.

Visitors found the place bleak, barren, and uncomfortably small—"like the reception room of an orphanage," one said. Only O'Keeffe's obsessive tidiness made it possible for the sitting room to function as her studio by day and a living room at dusk, when no traces of paint, brushes, or rags were to be seen, her easel shrouded with a clean white cloth.

When one looked out, the walls seemed to dissolve. Windows framed an ever-changing canvas of swirling snow or rain—often seen from above the storm. O'Keeffe delighted especially in the contrast between the views.

In the series of eleven small oils entitled *From the Shelton, Looking East* (1925), the same vista takes its stylistic cues from the weather.

On a clear morning, the view across the East River, punctuated by factory smokestacks, to the low-lying rooftops of Queens is rendered with bright postcard realism. Shrouded in mist, the same scene becomes an impressionist grisaille.

To the west and south, the artist immortalized New York as nocturne. Despite their hard-edged allure, O'Keeffe's skyscrapers owe more to a romantic than to a precisionist vision. Silver-sheathed towers and glittering geometries of lighted windows turn lyrical in the company of cloud-streaked skies and haloed moons. A valentine to Alfred, Georgia's painting of the American Radiator Building (1927) paid him the ultimate twentieth-century tribute: on a red sign to the left of the building, the name ALFRED STIEGLITZ appears in lights.

Frugal as always, Georgia was more excited by the low rent of their new quarters than by the view from its heights. The small apartment, she exulted to Ida, cost the same on a monthly basis as the single room they had taken by the day last June. She found the food in the cafeteria "excellent" and even cheaper than the Italian restaurants they had frequented when living at Lee's. "So, for the present we are very comfortable, as far as living goes, and that helps a lot," she told her sister.[20]

Their first few weeks allowed little time to enjoy the modest comforts of their new quarters. Every waking hour was spent at the Anderson Galleries, where Room 303 was being transformed into the Intimate Gallery, known to its real intimates as "the Room." Every sign and portent favored Alfred's new venture, starting with the room's numerological echo of their Shelton apartment; life and art were now joined by the holy significance of 3 and the mystical o, unbroken circle of the infinite.

Thanks to the generosity of both Strands (whose industry and thrift had allowed them to accumulate a sizable nest egg), the coordinated fund-raising efforts of Beck, and contributions by relatives and other friends, Alfred was ensured a rent fund for several seasons.

Like an avenging angel of light, Georgia tacked yards of unbleached white muslin over the dusty black velour walls that had darkened the room, from the top of the wainscoting to the ceiling. Natural light from the long north and west windows, boosted by the brightness of new electric ceiling fixtures, gave the room the feeling of Alfred's favored metaphor: a laboratory. To Georgia, free of Germanic scientism, it merely seemed light and free; its twenty by twelve feet of space felt much larger.

Among the canvases propped against the wall was a portrait of Georgia painted by Ida. "It is quite wonderful," the sitter told her sister.

Framed by Georgia herself, the painting held its own with the other works in the Room, she wrote Ida.[21]

O'Keeffe's reaction to her sisters' art—Catherine, too, had begun doing flower pieces—was subject to mercurial change. On paper, she was encouraging, especially to the young mother in Wisconsin, who appeared to be trying to earn pin money by painting. When Catherine later exhibited her flowers in New York, however, Georgia decided she was trying to exploit the O'Keeffe name with a look-alike style and subject matter; she turned venomous, threatening to "tear the paintings to pieces" if Catherine continued.[22]

Ida's portrait staked no claims to Georgia's turf; the warmth of Georgia's praise, moreover, can be read as an effort to compensate Ida for Alfred's coldly vindictive treatment and her own failure to stand up for her sister. Like Stieglitz's gift of a paint box, Georgia's inspiriting words about Ida's art suggest a sop; she wanted no responsibility for her sister's life—increasingly troubled, marginal, and isolated. "You must make your own decisions," she told her coldly in response to the needy Ida's plea for advice.[23]

Georgia's mounting anxieties about O'Keeffe knocking off O'Keeffe was the result of her new hardheadedness about the marketplace, especially the law of supply and demand. In the same letter to Ida in which Georgia warmly praised her sister's work, she voiced a new concern about her own: she was producing too much, she decided. Picking up her pictures from the framer, she had a sudden worrisome revelation: "There are so many paintings I feel quite horrified—when I think how hard it is to get rid of them."[24]

In eight years, she had changed profoundly. From a horror of having her work seen by the vulgar mob, she had become accustomed to selling her pictures directly to strangers. Now she could reflect on her paintings dispassionately: a product to be marketed, they were hard to get rid of in the best of times; she had to be careful not to glut the market.

Marin had no such worries. At his usual prodigious rate, he continued to produce watercolors of Deer Isle, the Ramapo Hills, the Berkshires, and an occasional foray into Manhattan, until he would leave the largest body of work by any American artist.

On December 7, 1925, the Intimate Gallery opened its doors with a Marin retrospective. By the time the exhibit closed on January 11, the Brooklyn Museum had acquired two of the works—the first purchase of a Stieglitz artist by a public institution.

Marin's sale and his fixed inaugural role in every Stieglitz season underlined his premier position among Alfred's artists. O'Keeffe trans-

lated this ranking as the privilege of gender, not talent. She didn't mind if Marin "comes first—because he is a man—its a different class," she told Henry McBride.[25] Others have invented tortured rationalizations for the simple fact stated simply by O'Keeffe: just as she accepted anything that couldn't be changed, she accepted second place to "the men" around Stieglitz. Similarly she accepted, with her keen critical judgment, that Dove was the one great artist of the group. The trade-off was being the only woman. Besides, she knew that she came first with Alfred in the most profound sense—not only as a woman but as a woman-artist; the two, for him, would always remain inseparable. "She is the real spirit of 291, not I," Stieglitz had confessed to Strand. "I've never told anyone that before."[26]

Four days after Dove's annual show came down, "Exhibition III: Fifty Recent Paintings by Georgia O'Keeffe" opened on February 11. A flyer accompanying the checklist proclaimed Alfred's credo: "The Intimate Gallery is an American Room," he began. The seven Americans of last year had now become a canonical number: the six—Marin, O'Keeffe, Dove, Hartley, Strand, and Stieglitz—fixed stars in Alfred's firmament plus a seventh, to be chosen. This season, the provisional artist was Charles Demuth.

A "Direct Point of Contact between Public and Artist," the gallery "is the Artist's Room," Alfred's flyer announced. "It is a Room with But One Standard. Alfred Stieglitz has volunteered his Services and is its directing Spirit."

Warning away the frivolous and venal, the directing spirit declared: "The Intimate Gallery is not a business nor is it a "Social" Function. The Intimate Gallery competes with no one nor with anything. *All but Time-killers are welcome*," Alfred concluded, in his favorite typeface: irate italics.

Demuth, Georgia's special favorite, contributed the statement to her catalogue—an anthem to O'Keeffe the colorist. Her pictures sang "the last mad throb of red just as it turns green, the ultimate shriek of orange calling upon all the blues of heaven for relief or for support. . . . In her canvases each color almost regains the fun it must have felt within itself, on forming the first rainbow." Georgia was so pleased with his remarks that she used the paragraph again the following season.

Buried in Demuth's spirited tribute was a quiet acknowledgment of O'Keeffe's limitations: in her flowers and flames there was only "colour as colour, not as volume or light."

Critical reception of Georgia's show echoed Demuth's praise for his fellow colorist. Other reviewers, including O'Keeffe's friend Helen Ap-

pleton Read, continued to beat the decorative drum: "What is the matter with our architects and interior decorators that they have not singled her out as THE person to design wall panels and decorations," Read wrote.[27]

Henry McBride was his eqivocal self: no critic ever managed to damn with faint praise in as many artless sentences. "As an artist, Georgia O'Keefe [*sic*] is always a success. By that I mean she is both liked and bought." McBride's ambivalence was fueled by the artist's vociferous women fans. "There were more feminine shrieks and screams in the vicinity of O'Keeffe's works this year than ever before," he noted. Speaking for himself, he backed and filled: "I like her stuff quite well. Very well." She was not in Marin's league, but nonetheless he commended O'Keeffe's "color, her imagination, her decorative sense."[28]

There is no evidence that Georgia was insulted by reviewers' emphasis on the decorative in her work. Trained by Dow in the canon of beauty, she later noted that she had no objection to the word *pretty* used to describe her art. And what critics disparaged, the public loved.

Although Georgia's friend Blanche Matthias hadn't seen the exhibit, she timed her debut as a reviewer to coincide with the event. Matthias's article on O'Keeffe in the Chicago *Evening Post* was an adoring hymn to the artist, with little said about the art: "She is like the flickering flame of a candle, steady, serene, softly brilliant. . . . This woman who lives fearlessly, reasons logically, who is modest, unassertive and spiritually beautiful."[29]

O'Keeffe was delighted by Matthias's first foray into art criticism. "I think it one of the best things that have been done on me—and want very much to thank you. . . . the spirit of it is really fine," Georgia wrote to Matthias. Stieglitz kept a stack of copies of the paper with Blanche's article in the Room to give to visitors, Georgia told her.

Describing the show to Matthias, O'Keeffe noted, "I have two new paintings of New York that I think are probably my best paintings. They seem to surprise everyone."[30] Stieglitz's dislike for the cityscapes, however, exceeded his distaste for the large flowers. Only one was exhibited. Henry McBride was the sole critic to remark on Georgia's first step in a new direction. Writing of *New York with Moon* before the label "precisionist" had been attached to O'Keeffe's skyscrapers, he seized upon the tension between the "literalness" of the precisely rendered structure and the lunar halo that "threw symbolic lights into the composition."[31]

The exhibit was extended for three weeks. But while it was still up, O'Keeffe left for Washington to address the annual dinner of the National Women's Party. Anita Pollitzer, a member of the party's ex-

ecutive board, had invited Georgia; knowing her friend's dread of public speaking, Anita had been so thrilled by her acceptance that she sent an ecstatic telegram with the good news to her colleagues.

Georgia had always yearned to see Washington in spring, and on the evening of February 25 Alfred put her on the train at Pennsylvania Station. Eight years before, on a rainy June morning, leaving Strand in the same station, he had swept Georgia into a taxi toward their new life together. This night, Alfred made his way home alone in the dark— something he had not done in years. Now, the "streets and the city became unreal and disappeared, and everything took on the aspect of O'Keeffe's whiteness," he said.[32]

In the meantime, Georgia rejoiced in the tender colors and promised luxuriance of the capital's early spring; the Washington that O'Keeffe saw on her visit was Williamsburg without decay and poverty disguised by crape myrtle. Her talk before an audience of nearly five hundred fellow members of the National Women's Party went well. She confined her remarks to general principles and goals of equality. With professionalism as the means, women should strive to end their economic dependence on men, she said. She did not address the obstacles to women's rights: the illegal status of contraception, the care of young children, the disparity in wages, or the social attitudes of America in the 1920s. O'Keeffe stood before them as an exception: a successful woman artist. But she would always deny her exceptional status, explaining the happy confluence of circumstance and helping presences, starting with Alfred Stieglitz, that shaped her career. She would always insist that individual effort, talent, and determination were all that were required. If she could do it, so could they.

In her absence, Alfred tried to conjure her presence in the Room. Surrounded by Georgia's enormous flowers, he told all comers about their predestined passion: the amazing coincidence that, years before their first meeting, they had stayed in the same room at a Lake George boardinghouse. He described the paintings O'Keeffe had made just for him and his pain when he had to sell them.

When he first "realized O'Keeffe couldn't stay with him," death became a presence in his photography, Stieglitz said.[33] Telling intimate anecdotes of their life together, he tried to assuage the terror he felt without her. He began to be consumed with dread that once she forgot him sexually, he would cease to exist.

"The cunt has no memory," Alfred told Lewis Mumford.[34]

EIGHTEEN

Enter Mrs. Norman

ALFRED STIEGLITZ, *Dorothy Norman* (about 1932). Alfred's new disciple and lover, Norman was twenty-seven when this photograph was taken. Rich, adoring, and capable, she took over the management of the Intimate Gallery and, subsequently, of An American Place.

GEORGIA'S LITTLE taste of freedom proved dangerous. Following her return from Washington, she sank into a depression whose physical symptoms were serious enough to warrant urgent help. Beck Strand had left Dr. Tilney to work for another socially prominent specialist. Trained as a gastroenterologist, Dr. Dudley Roberts was also noted for his success in treating illnesses of the intestinal tract whose origin was attributed to "nerves": severe cramps, diarrhea, ulcers. Together, Beck and Alfred persuaded Georgia to see Roberts. His first visit with his new patient went well and Georgia agreed to continue seeing him.

The intensity of Beck's concern about Georgia was colored by guilt. "I really feel responsible for whatever happens to her," she wrote to Paul.[1]

Beck had resigned her job as Roberts's secretary just before Georgia's visit. She felt emotionally prepared, finally, to have a baby; they were both ready, she told Paul, for another human being to come first in

their lives. In the months since they had made the decision, she had not managed to conceive. They were hoping that physical rest during the spring would help. Then, in the summer, they planned to combine a final childless holiday with their first trip abroad together, provided that tremors in the stock market didn't foil their plans for "love parties in the Vatican & maybe a baby conceived in the Tiergarten," Beck fantasized cheerily.[2]

Georgia was characteristically silent about her bleak emotional state: the only hint of her sufferings filtered through her letter to Blanche Matthias thanking her for the article she had written. Blanche, too, had been sick; her illness, like Georgia's, appeared to be psychological in origin. O'Keeffe was talking to herself as well as her friend, when she wrote: "I hope you are caring for yourself—giving yourself a chance—Something in you must quiet down so that you can get well— I wish I could help you."

For the moment, she needed all her energies for herself. "It must be so just now," she explained to Blanche. She was learning something important about Georgia O'Keeffe. "I don't know exactly what it is— but if I did—if I could put it clearly into form it would cure you," she promised.[3]

Whatever healing took place in the spring of 1926—with Dr. Roberts's help or by dint of Georgia's own efforts—was undone by summer at the Hill. Only days after their arrival, Alfred suffered one kidney stone attack after another. Probably with Lee's help, Georgia got him back to the city and into Mount Sinai Hospital. After two weeks, he passed the stones without surgery, and they returned to Lake George.

In compensation for last summer's banishment, Ida was at the farmhouse for an indefinite stay. Her good-humored presence failed to act as a buffer between Georgia and those members of Alfred's family who grated on her most: his sister Sel, whose normal histrionics had escalated into threats of a full-scale nervous breakdown, and the reasonably childish behavior of the little Davidson girls—"the brats" in Georgia's lexicon of tormentors.

As a measure of her desperation, O'Keeffe, who didn't believe art could be taught, took on a student: a young woman from Texas arrived who stayed at the Pines and repaired daily to the Shanty with Georgia. Neither the name nor any works of O'Keeffe's only known private pupil seem to have survived.

Then, to Georgia's fury, Alfred, egged on by Sel, decided that the Hill could enjoy new and "useful" existence as a summer art school. Georgia would be the star instructor, he wrote to Elizabeth, teaching

drawing and painting; Alfred and Paul Rosenfeld would assume the loftier roles of photographer and writer in residence, respectively.[4]

Like other Stieglitz plans, the art colony was just talk. But its implications enraged Georgia. She already felt herself to be a prisoner under house arrest at the Hill, her freedom and privacy at the mercy of every vacationing Stieglitz—children, servants, and guests included. Without even discussing the matter with her first, Alfred was ready to move from restricting her independence to exploiting her labor.

By the middle of August, Georgia was unable to sleep through the night and once again was losing weight dramatically. "Psychic conditions" was Alfred's explanation to Seligmann. "I'm hoping to have her build up. . . . Of course she has been exercising much and eating nothing."[5]

When Lee and Lizzie arrived at the end of August with their granddaughters, Georgia packed her bags hastily and left. "Georgia has gone to York Beach. She has suddenly decided," Alfred wrote to Seligmann. "She has lost 15 pounds and was terribly nervous. . . . Please don't mention it to anyone—either her going or her being run down. It's no one's business."[6]

Georgia's mood on leaving frightened Alfred even more than the prospect of travel, and he followed her to Maine. He had not made such a long and distant journey alone since his visit to Kitty at her New Hampshire camp in 1918. As the train chugged from Albany to Boston and then north, images of that earlier trip—its failed hopes of reconciling his wife and daughter to his new life—must have returned. For one brief moment, Emmeline and Kitty had been persuaded that his good faith and concern for their happiness would redeem past suffering.

Eloquent as he was now, his words failed to convince Georgia. Alfred returned to the Hill without her and with a "miserable cold. . . . But I don't regret the trip there," he reported to Seligmann, whose own marriage was dissolving. "I *had* to see Georgia for her own and my own sake. And miserable as I am in bed here now I was really more miserable before going. I feel much better—Georgia is certainly an extraordinary woman."[7]

Nine days later, Georgia was still gone. Alfred's spirits plummeted. "I've been alone—It's no secret—for weeks," he wrote to Seligmann on September 14. "So I've had a lot of time to ponder over much. . . . Getting much that had been tangled up straight within myself. Georgia returns tomorrow."[8]

On the next day, she did not return; instead, Alfred received a telegram announcing her decision to stay a while longer.

When she came back two weeks later, Georgia's calmed spirits were reflected in the canvases she brought with her. In long narrow panels like the wings of an altarpiece, she explored variations on the clamshell. Painted in cool tones of ivory, tan, and silver, each double oval fills the picture frame, neatly divided down the middle by the bivalve's opening. Taken as a series, the panels represent a progression from mystery to revelation: tightly closed, then slightly parted, finally the organism opens wide enough to reveal, bathed in a viscous light, a dark sphere within. The secretive host body, dead as a pair of white bones, is both reliquary and womb.

There was little time for Alfred to appreciate Georgia's restored serenity. Only days after her return, he dutifully accompanied Selma to New York for treatment of a large boil on her nose. When he reappeared at the farmhouse, it was the end of October: boxes and crates were waiting to be packed.

On November 1, they were back in the two small pale rooms on the twenty-eighth floor, dining in the cafeteria filled, mercifully for Georgia, with strangers.

The 1926–1927 season at the Intimate Gallery opened with the now traditional Marin exhibit. In the first days of the show, a new Stieglitz friend and client, Duncan Phillips, bought two small Marin watercolors not among those on view.

Heir to the Jones and Laughlin steel fortune, Phillips, not yet forty, had already formed an important collection of impressionist and post-impressionist painting, open to the public since 1918 in his Washington, D.C., house. Encouraged by his wife, Marjorie, an amateur painter of considerable talent and more adventurous taste, Phillips was now ready to be educated in the art of his American contemporaries. Among his first acquisitions, in the spring of 1926, had been an O'Keeffe oil, *The Shanty*, and two Dove watercolors from the artists' exhibits that season at the Room.

Now Phillips was cautiously considering the purchase of a major Marin. When McBride's review of the fall 1926 show appeared, pointing to *Back of Bear Mountain* as "one of the great ones," the Washington collector hurried back to New York. With McBride's imprimatur, he was ready to buy, he told Stieglitz, therein committing a strategic error he would never make again. The picture he wanted would now cost him six thousand dollars, three times the price of any other Marin in the show.

The next thing Phillips knew, the press announced "a record price for a Marin watercolor paid by a Washington collector." Phillips angrily denied that such a sale had taken place. In a letter published as an

editorial in *Art News*, Phillips pointed out that "Field Marshall Stieglitz manoeuvred operations so that I paid his record price for the Marin I liked best receiving as compensation two . . . [paintings] as gifts."[9]

The truth of this particular transaction has been obscured by the storm of letters and telegrams, public and private, between the two men—accusations, counteraccusations, denials, explanations, and, finally, reconciliation.[10] The facts seem to be that for seventy-five hundred dollars, the hard-bargaining collector acquired the painting in question along with several others, at a much reduced price, including one "gift" from Stieglitz in the artist's name. This type of arrangement—quoting a high, headline-grabbing sales figure for a major work, which actually represented the total of the publicized purchase plus several pictures quietly thrown in—was not uncommon. Alfred, however, had recently excoriated Montross for just such favoritism toward special clients. And his rival dealer had not planted stories in the press heralding a "record sale."

For Stieglitz and Phillips, however, their first deal established a pattern of mutually enjoyable manipulation of one another and of the art market for years to come. Both men had the voluptuous thrift of those born to wealth; they had a wonderful time haggling over every hundred dollars. Alfred's double-talk found its match in Phillips's poor mouthing. Begging for an extension of credit, the Scots millionaire's son bewailed the beating he had taken in the stock market. Bemoaning the materialism of the rich, the German-Jewish millionaire's son professed to make an "exception" for Phillips, adjusting prices and terms of payment to accommodate the "sacrifice" the collector was making for art. Psychologically and financially, dealer and client each believed that he had won every round—the definition of successful negotiation.

Alfred's leak to the press about setting a new Marin record was a trial balloon for sending Georgia's prices skyward. In the next months Stieglitz, probably with O'Keeffe's help, sold six of her paintings for a total of seventeen thousand dollars (the equivalent today of almost two hundred thousand). One picture went to a Mr. Henderson of New Orleans for the magical six thousand dollars—an astounding sum in the mid-1920s for a living American artist who was also a woman.

O'Keeffe's show in January 1927 was billed as "Georgia O'Keeffe, Paintings, 1927." For the first time, Alfred omitted the adjective *American* from his flyer. He had made his point; others now took up the cry.

Frances Garfield O'Brien, their friend and summer guest at the Hill (where Alfred had photographed her nude, holding a teakettle), now wrapped Georgia in the flag.

"Americans We Like," her interview with O'Keeffe, appeared in

The Nation in October 1927. Unprecedented for know-nothing jingoism—even in a period rife with such sentiments—O'Brien's article exalted the artist's ignorance and provincialism as the source of her talent. "O'Keeffe is America's," O'Brien wrote. "Its own exclusive product. It is refreshing to realize she has never been to Europe. More refreshing still that she has no ambition to go there."

With or without her subject's help, O'Brien fudged the facts to give Georgia's origins more frontier flavor and greater distance from the corrupting influence of civilization. "Born in Sun Prairie, Wisconsin, and with a childhood spent in Virginia and Texas, she absorbed an atmosphere untainted by theories, by cultural traditions," O'Brien informed readers.

Iconoclasm had inoculated the artist against the loss of her primitive purity or against infection by the ideas of a cultural elite. " 'If only people were trees,' " O'Keeffe had told O'Brien, " 'I might like them better.' "

Lest Georgia emerge as too deviant—even for an artist—from the gregarious American norm, O'Brien found "one potent bond uniting her with the world of humanity: If Georgia O'Keeffe has any passion other than her work it is her interest and faith in her own sex."

Warning the unwary never to address her as "Mrs. Stieglitz," O'Brien heralded O'Keeffe's ardent belief in "woman as an individual—an individual not merely with the rights and privileges of man, but what is to her more important, with the same responsibilities. And chief among them is the responsibility of self-realization."[11]

Feminism reinforced by nativism explained Georgia's uniquely American sense of obligation—to herself. In life as in art, O'Keeffe embodied "the scattered soul of America come into kingdom."

In time for O'Keeffe's second exhibit in the Room, Alfred tried to institutionalize the sacred feeling many had experienced on entering 291. Communion with the works of art was now scheduled. "Hours of silence: Mondays, Wednesdays, Fridays, 10–12 A.M.," the flyer announced. In place of 291's brass bowl filled with bright leaves, the Intimate Gallery displayed a crystal ball.

By now, Alfred had had time to get used to O'Keeffe's Manhattan pictures. Among the forty canvases on view at the Room on January 11, 1927, were four studies of their hotel; in one, *The Shelton with Sunspots*, the artist sends solarized disks in playful collision with the austere lines of the granite-sheathed structure. There were three scenes from their windows: under skies ranging from postcard blue to dreary gray, the East River, with toy-size tugs and barges, separates the flat roofs of their lower neighbors from the smokestacks of Queens.

In two oils, both entitled *Street, New York,* O'Keeffe made further use of photo-optic phenomena: when tall buildings were shot from below, the cameras of the period created the illusion of convergence. Empty of people and sealed off from the sky, one O'Keeffe street scene is a study in urban claustrophobia. Borrowing another peculiarity of the camera, O'Keeffe made expressive use of the solarized halo from a street lamp to cast the livid light of a bad dream on the melancholy thoroughfare.* Only O'Keeffe's contemporary Edward Hopper expressed the constricting solitude of city life with such restrained eloquence.

Hooting at the odor of sanctity wafted by Alfred's flyer ("A novel feature of the advertisement of Miss O'Keeffe's show announces that the hours from ten to twelve in the morning on certain days of the week are to be 'hours of silence' "), Henry McBride was not disposed to genuflection. Alone among critics, moreover, he seized a paradox at the heart of O'Keeffe's expanded vision of nature. Through the artist's suave handling of paint, the decorative became "cool" and "intellectual." As though contrasting O'Keeffe's invisibility with the gestural physicality of 1950s action painting, McBride noted with eerie prescience, "It is not emotional work because the processes are concealed. The tones melt smoothly into one another as though satin rather than rough canvas was the base. Emotion would not permit such plodding precision."[12]

O'Keeffe wrote a demure letter of thanks to McBride. As she couldn't understand a word of his review, she said, she was all the more amused that he should call her "intellectual." From his review, though, she could figure out that "intellectual" meant the opposite of "emotional," and she was mighty relieved to be rid of that label. Georgia went along with McBride, making sport of the women who visited her show. Where earlier the "ladies" had found pleasure or, perhaps, affirmation in her art, they would now preen themselves on being intellectuals, she told him.

ONE YOUNG WOMAN saw the exhibit without being much impressed. At twenty-one, shy, dark-haired Dorothy Norman, married for two years, still looked like a student. She had come to the Room to see the Marins again; disappointed to find them gone, she left, barely noticing the pictures now on the walls.

Norman had discovered the Room only a few weeks earlier. On that first visit, she had never heard of Alfred Stieglitz or John Marin, whose

* The image was already on its way to becoming a cliché of popular illustration, including stage design.

name suggested he might be French. Overwhelmed by his watercolors, she returned to study them again. There was one she longed to own. On her third visit, she seized her courage and asked the talkative man clearly in charge whether the picture was for sale. "It has been acquired," he answered distractedly, returning to his circle of rapt listeners.

When she returned again, she found it harder to concentrate on the paintings. She was mesmerized by the small man with bristling white hair and mustache. Peering from behind steel-rimmed glasses, his dark eyes fixed his listeners in their piercing gaze. More than anything else, it was "The voice . . . with its peculiar penetrating resonance [that] rivets my attention," she wrote.[13]

She listened intently while another, bolder young woman asked him the meaning of a painting. "You might as well ask what life means," Stieglitz told her. Young Mrs. Norman was electrified. No one had ever suggested the two were related.

"All my life I have been waiting for someone to answer my own questions," Norman wrote later. "Now a stranger, Mr. Stieglitz, in refusing to reply to the girl, makes the first satisfying statement I have heard about art. I bless him for it. Especially so because of the depth of his eyes, the quality of his voice, his uncompromising attitude."[14]

Falling in love is all timing; the *coup de foudre*, the thunderclap of passion, is heard only by the heart ready to listen. Alfred Stieglitz could have uttered any banality in answer to "What is art?" and he would have evoked the same response in the unfulfilled yearnings—spiritual, sexual, artistic—of romantic Dorothy Norman. "Within a split second, an inner music soars," Norman recalled of that moment.[15]

The only daughter of a German-Jewish clothing manufacturer, Dorothy Stecker enjoyed the stifling privilege of a sheltered childhood and adolescence, epitomized by the uniformed chauffeur who drove her to school and by her grandmother's warnings: "Never wear glasses and never marry anyone who isn't Jewish." With cultural and social aspirations that moved beyond those of Philadelphia's gilded ghetto, she secured her own admission to a New England girls' boarding school and then to Smith College. At the end of her first semester, a bout of flu gave her parents the excuse they wanted: she was better off at home where she could concentrate on making the right marriage.

She obliged them by falling ardently in love with tall, handsome Edward Norman. Son of the founder of the Sears, Roebuck mail-order empire, young Norman had changed the original family name, Nusbaum, at the start of World War I.

In the two years between her wedding and her first encounter with

Stieglitz, a disappointed bride had become a dutifully resigned wife. Edward Norman's sexual inadequacy was compounded by violent outbursts of temper followed by acute depressions. Before their marriage Dorothy had known that her husband had suffered severe emotional disorders since adolescence—the cause of his dropping out of Harvard. He had been under the care of psychiatrists since his undergraduate years.

The Normans' shared concern with social justice was the most positive element in their marriage. Dorothy threw herself into activities that seemed to complement her husband's interests. With no need to earn a living, he donated his time to the consumer cooperative movement; Dorothy worked as a full-time volunteer for the fledgling American Civil Liberties Union.

Like other unhappily married women, Dorothy hoped that a baby would transform two ill-mated young people into a family. As soon as she became pregnant, her doctor urged her to stop working, and thus she had the leisure to visit art galleries.

Silenced by shame—by her ignorance of art and her attraction to Stieglitz—she fled the Room without speaking to him on those first visits. Sometimes he seemed to address his remarks "directly, clearly" to her alone but, she was quite certain, "without having any idea who I am."[16]

Alfred had not failed to notice the young woman who couldn't stay away from the Room. Most probably, he knew exactly who she was. In two years, the Normans, young, rich, and attractive, had met "everyone" in New York; many of their new acquaintances, such as the Strands, were part of the Stieglitz circle. Most were charmed by young Mrs. Norman's eager, if unformed, intelligence, her intense desire to learn, and her generous impulse to help.

Appealing rather than beautiful, Dorothy's oval face—the broad, clear forehead framed by dark, wavy hair, the dramatically pale skin and large brown eyes under heavy brows—gave her a startling resemblance to Kitty, seven years her senior. In social background, too—even her choice of college—Dorothy was eerily close to the daughter who would never return to life as wife and mother. At the same time, the sheltered young matron, clinging to a genteel ignorance of everything to do with money, had more in common with Emmeline and the Stieglitz women of Alfred's generation than with a poor schoolteacher from Texas.

If Alfred could have revised the past, if he could have created an Emmeline who reciprocated his sexual ardor, who worshipped him and longed to learn from him, and who rejoiced in placing her social skills

and worldly goods at his disposal, she would have been Dorothy Norman.

One day in late spring, Dorothy came to the Room and for the first time she found Alfred there alone. He showed her his treasured issues of *Camera Work*. They were so beautiful that she was afraid to touch the pages or lift the tissue covering the plates. While she looked, he told her about the artists he had introduced to America before she was born.

Their conversation, in the little room that served as Alfred's office and storage space, was interrupted by the appearance of Louis Kalonyme, a member of the Stieglitz inner circle who occasionally reviewed for the *New York Times*. A devoted admirer of O'Keeffe, Kalonyme sensed trouble in Norman's shining eyes and worshipful gaze. He retreated into a chilly silence, broken only to make fun of the young woman's ignorance of photography.

Of her many endearing qualities, Dorothy Norman was never afraid to acknowledge what she didn't know. How else was one to learn? She was puzzled by Kalonyme's mockery, his attempt to belittle her in Alfred's eyes. He was misguided; Alfred was exalted by innocence in every form. Dorothy exemplified his ideal: a lovely young woman whose mind was undefiled by knowledge or received opinion.

Alfred went to a black box, Dorothy recalled, and placed before her, one at a time, several mounted photographs of clouds. She left the Room exultant, having seen "something extraordinary."[17]

By mid-April, the Room's season ended, Dorothy had no further excuse to visit 489 Park Avenue. In any case, she was busy preparing for her first child, expected in November, and for the household's summer move to Woods Hole on Cape Cod.

ARRIVING AT THE Hill on June 6, Alfred and Georgia took advantage of twelve days of uninterrupted sunshine to clean the farmhouse, painting and varnishing floors and porch chairs. Only on June 19, the first rainy day, did Georgia get to her painting.

She had always taken to physical labor with gusto; now it was even more welcome as the best homeopathic remedy for depression. Certainly the day-long chores that she assumed, with only token help from Alfred, did not fall in the category of labor lightened by love—of place or of people.

As soon as Lee and Lizzie arrived, just days later, Georgia was incapacitated by "rheumatism," as Alfred described her ailment. As though the multitude at every meal—family, guests, grandchildren— wasn't suffocating enough, a daily invasion of workmen now descended

each morning; with maximum noise, they transformed the dirt roads of the property and the floors of the carriage house into hardtop and cement to accommodate the new automobiles conveying family and visitors to the Hill. There was neither silence, privacy, nor peace to be found anywhere.

Alfred was in his element. "It's as if we hadn't left this place. Somehow neither the hotel nor the Room seems to be an actual part of our lives," he exulted to Marie Boursault.[18]

Now that he could use the former potting shed as a darkroom anytime day or night, he was printing nonstop. Seligmann had reported that Strand's new photographs from his visit to Georgetown, Maine, had attained a pinnacle of technical perfection (while remaining, of course, soulless imitations of Stieglitz's). Alfred was on his mettle. He wasted no time in writing to Strand that *his* latest efforts had taken him further than anything he had yet accomplished, giving his recent prints a beauty and completeness that transcended the limitations of inferior paper and other shoddy materials.

Then, at the end of July, Georgia discovered a lump on one breast. Lee ordered her to New York immediately, where the benign growth, to the relief of all, was removed at Mount Sinai Hospital.

A few years before, at home in bed with grippe, she had written to Henry McBride that when she was sick she saw marvelous paintings in her head—lilies and skyscrapers better than any he had yet seen— only to lose most of them when she was recovered and at her easel again. This time, one image from her hospital stay—at the last moment before the anesthetic took effect—remained available, to become *Black Abstraction* (1927):

> I was on a stretcher in a large room, two nurses hovering over me, a very large bright skylight above me. I had decided to be conscious as long as possible. I heard the doctor washing his hands. The skylight began to whirl and slowly became smaller and smaller in a black space. I lifted my right arm overhead and dropped it. As the skylight became a small white dot in a black room, I lifted my left arm over my head. As it started to drop and the white dot became very small, I was gone.[19]

Even if O'Keeffe's later version of the painting's genesis has been revised, her explanation is no less telling. In the choreography she describes taking place in the operating room, the role of will ("I had decided to be conscious as long as possible") is the crucial factor. The images do not wash over her, as typically happens in drug-induced sensations. She raises first one arm and then the other, noticing the dramatic differences

of scale that take place in the interval between one gesture and another: the large sphere of the operating room lamp has shrunk to the size of a pea, while the relationship of her arm (the only visible part of her anatomy) to the rest of her body remains the same.

Deferring to the intensity of her vision, she did not dilute the experience by serializing it. *Black Abstraction* (a misnomer, since it is altogether literal in its representation of what the artist saw) remains a uniquely powerful work. Borrowing the effect of a solarized negative to suggest the looming blackout, O'Keeffe's precise rendering of line and mass in this instance reinforces the hallucinatory clarity of a dream.

Two other works of 1927 qualify as pure abstraction. With their restricted palette and wide, slashing diagonals, both *Black and White Abstraction* and *Blue, Black and White* suggest that O'Keeffe was reaching backward to rework in oil the strong architectonic forms of her earliest watercolors.

Executed in her unhappiest period since coming to New York, these two paintings point to an attempt to recover her pre-Stieglitz self. Comparing these powerful abstractions of 1927, with their virile forms and somber palette, to the fluttery pastels of *Sweet Peas*, executed the same year, is a puzzling experience akin to observing a visual ventriloquist act. It's hard to think of another artist who, in the same months, produced such stark evidence of conflicting selves: of disparity to the point of fissure between past and present, masculine and feminine, decorative and violent.

Georgia's recuperation at the lake was slow, extended by Lee's Victorian views on the benefit of bed rest and the dangers of exercise to women. The only bright moments in her convalescence were inclusion in the high jinks of the young, who were looking for some excitement to brighten the tedium of endless meals and genteel amusements. Besides Georgia's sassy favorite, Georgia Engelhard, there was a new recruit to the Hill's band of young rebels. Dorothy Schubart, Selma's daughter-in-law, was a book designer who shared both Georgias' dim views of the family. With the Shanty functioning as a rural speakeasy, they tippled Canadian bootleg liquor, out of sight (and presumably smell) of their teetotaling elders.

Emboldened by firewater and boredom, one or both Georgias, accompanied by the young Mrs. Schubart, successfully carried out an expedition of bust snatching. Spiriting the plaster *Judith* from her parlor pedestal, they buried the militant heroine, with her endearing resemblance to Harpo Marx, in an unmarked grave.

October brought its relief of friends who were also fellow workers. A patrician Philadelphian and friend of Mary Cassatt, George Biddle

was the first to arrive. Biddle had given up the practice of law to paint neo-Gauguin scenes of Polynesia. Within a few years, he would move away from exotica in his art and from his hosts in his politics. Radicalized by the Depression, Biddle would give up easel painting for social realist murals, becoming at the same time a tireless and effective advocate of federal aid for artists. He was the only painter, a friend noted, who began his letters to the occupant of the White House "Dear Franklin," the President having been a Groton and Harvard classmate.

Their next visitor, C. Kay-Scott, had pursued careers in medicine and science before turning to painting in the mid-1920s. He had just founded a school of art in Santa Fe, and he was full of enthusiasm about New Mexico as a place for artists to live and work. Georgia would have been much interested in matching his glowing description of the region against her own still vivid memories from the brief detour she and Claudia had made there in 1917. Then, in the middle of October, Rosenfeld arrived, fresh from his first visit to Taos and Santa Fe. The eloquent Pudge added his impressions, feeding Georgia's hunger to see the West again. Somewhat milder in mood now, she managed to endure a two-week visit by Zoler, her bête noire among "the men" and Alfred's bumbling gallery factotum since 291 days. Deemed too insignificant to warrant remembering his given name, Georgia, with pitiless irony, referred to him always as "Zola."

Rejecting Alfred's suggestion that she remain in the country longer, she returned with him to the Shelton on November 2. In five months at the lake, they had spent only seventeen days alone; twelve of these had been devoted to June housecleaning. The bracing weeks of autumn, once sacred to living and working together without family or guests, had dwindled to five days.

Normally, Alfred resisted solitude in general and separation from Georgia in particular. Since he never felt at home at the Shelton, it was an unlikely time for him to urge Georgia to remain at the Hill. Within weeks of their return, he found himself unexpectedly alone. On December 30, O'Keeffe was in Mount Sinai again for the removal of another benign growth. This time, convalescence was slower; she remained hospitalized for ten days, and her 1928 exhibit opened on January 11 without her.

While Georgia was convalescing, Dorothy Norman reappeared at the Room. Her daughter Nancy had been born in November and in Alfred's eyes the child's birth added the ultimate experience of Woman to the charm of the ingenue. A radiant young mother, Dorothy represented the purity of the Madonna along with the most tangible proof of sexual wisdom. Most important, she was protected by another man; she

would never be Alfred's responsibility. He felt free to be intimate, seductive—even provocative—and he began testing the waters. Still self-protective, he wanted to make sure that the competition was, by every measure, inadequate.

Dorothy found Stieglitz alone, "looking far into space," she recalled. "He asks if I am married, if the marriage is emotionally satisfying." Startled, she gave the conventional loyal reply: "Yes, I'm in love with my husband and we have a new baby," she told him.

Then Stieglitz came to the point: "Is your sexual relationship good?" he asked. Her "inability to be totally honest," as Norman put it sweetly, told Alfred what he wanted to know.

" 'Do you have enough milk to nurse your child?' he continued.

"Gently, impersonally, he barely brushes my coat with the tip of one finger over one of my breasts, and as swiftly removes it.

" 'No.'

"Our eyes do not meet."[20]

Starved for intimacy, Dorothy found Alfred's intense interest irresistible. Although she was too ashamed of the truth to answer honestly, the "vital importance" of Stieglitz's questions exposed her isolation and loneliness.

"Why has no one ever asked me the questions Stieglitz does?" she wondered. "I know I can speak freely, openly to this man about anything, everything."

She became obsessed with him. "Try as I will not to go to the Room, I go. As I drive or walk down Park Avenue, I look dumbly at the windows of Room 303; by some magic they may tell me if Stieglitz is there."

At most, she could endure three days without seeing him. Artlessly, she wrote a letter of confession to Alfred: she couldn't keep away from the Room; she had no wish to interrupt his work; she wanted to become part of it. No chore was too menial. "I might park as a handyman to answer the phone, shut the door—hang the pictures—make order out of chaos among the what-not—or I might see whether long-hand might be possible as a means of taking the place of shorthand.

To her "relief and joy," Stieglitz answered her letter. Her visits were more than welcome. "Come whenever you feel the need," he wrote.

When she returned to the Room, Norman confided another ambition: she wanted to write about Stieglitz. As she had never published, this would surely strike him as presumptuous. Alfred was never one to discourage literary aspiration, however—especially if he was to be the subject. He applauded her plan to write about him, insisting that she was more than capable of the work. As soon as she allowed herself to be completely open with him, Alfred promised, all her feelings of in-

feriority would disappear. "With me people can be themselves, if they so choose. And if they choose otherwise, I know the consequences," he added ominously.

"The Room is ready to help," he said.[21]

Still weak, tired, and irritable, Georgia appeared at the gallery during the last days of her show. On one of these visits, she met Dorothy, who was radiantly happy and completely at home.

Gossip was already percolating about the charming new manager of the Room and its impresario. But O'Keeffe did not have to be told anything to recognize the threat. "I never did like her, from the very beginning," Georgia recalled later. "She struck me as a person with a mouthful of hot mush, and why didn't she either swallow it or spit it out? She was one of those people who adored Stieglitz and I'm sorry to say he was very foolish about her."[22]

Beyond Dorothy's adoration and Alfred's susceptibility, Norman embodied everything that O'Keeffe loathed, scorned—and feared—in other women.

Feminine in appearance, ladylike in manner, Norman disguised exceptional intelligence and original taste with a charming deference, especially to men. She had all the social graces of a young woman of her class and deployed them with consummate skill; at twenty-two, she was becoming known as a brilliant hostess with a gift for bringing together New Yorkers active in the arts and politics with their visiting European counterparts.

Her dedication to social justice—revolving around the rights of prisoners, of black Americans, of poor women deprived of contraception—was an impulse completely foreign to the women Alfred knew well; the Stieglitz ladies had no interest in the reform movements of the progressive era. Other than the art page, O'Keeffe never read a newspaper. Nor did she care to hear gloomy talk about the state of the world or the economy.

Georgia especially resented Norman's social activism; the younger woman's commitment to unfashionable causes as opposed to charities made it harder to patronize her as a frivolous society matron. Why didn't Norman work for the National Women's Party and drop all other "nonsense"? O'Keeffe demanded at their first meeting.

"Other causes interest me more," Dorothy replied sweetly, adding that the American Civil Liberties Union was concerned with equal rights for all citizens.

O'Keeffe never acknowledged the cruelest element in Alfred's attraction to the younger woman. He had denied Georgia a child, yet he made no secret of the fascination Dorothy's fecundity exerted on him—

from the erotic appeal of the nursing mother to the condition of pregnancy itself. Alfred photographed her when she was close to term with her second child.

Georgia decided to misunderstand the danger that Dorothy presented, portraying her simply—and simple-mindedly—as one of Yeats's "parish of rich women" who destroy the artist through flattery. "She had a lot of money. . . . I think if it hadn't been for the money, he would never have noticed her," O'Keeffe said.[23]

No one expects outraged jealousy to be fair toward the enemy, but O'Keeffe's unfairness about Norman suggests how little she understood about Stieglitz. Alfred never romanticized money. Since childhood, he had been surrounded by rich women; he had fallen in love with one, Katharine Rhoades, and had married another; in between he had ignored other suitable heiresses served up by his family. He particularly detested rich women as patrons of the arts. It wasn't Edward Norman's fortune that attracted Stieglitz, but Dorothy's yearning to give herself—along with every resource she possessed—to his every need.

Georgia's show, briskly billed as *"O'Keeffe Exhibition,"* closed on February 27. Recent works included a series of seven studies entitled *Clam and Old Shingle* and six panels of calla lilies executed in 1923. Two texts accompanied the checklist of forty-one pictures. The first was a reprint of Lewis Mumford's article "O'Keefe [sic] and Matisse," published the previous March in *The New Republic*.

Mumford's now familiar theme was precisely the view Georgia professed to find most abhorrent. "Miss O'Keeffe's world cannot be verbally formulated; for it touches on the experiences of love and passion," he declared. "She has beautified the sense of what it is to be a woman; she has revealed the intimacies of love's juncture with the purity and the absence of shame lovers feel in their meeting. . . . She has, in sum, found a language for experiences that are otherwise too intimate to be shared."[24]

Sharing the honors with Mumford was a letter to Georgia from C. Kay-Scott, an October guest at the Hill. Neither Stieglitz nor O'Keeffe, apparently, found anything unseemly about quoting an entire bread-and-butter note from a friend and houseguest as catalogue text. "You have dared, and loved, to paint what seems to me the organs of the spiritual universe," Kay-Scott wrote.

This year, McBride was unequivocal in his praise. Annual exhibits served most artists poorly, mercilessly exposing fallow or static phases, he noted. O'Keeffe was the exception. In her series, McBride pointed out, O'Keeffe worked through the themes that "haunted" her until they achieved a completeness of vision, which left nothing more to be said.

Singling out *The Shelton at Night*, McBride observed that "the searchlights cutting across the back of the building appeared to carry messages to other worlds," adding that the artist's "increased plasticity, increased mysticity and increased certainty in intention have enabled her this time to achieve one of the best skyscraper paintings that I have seen anywhere."[25]

O'Keeffe's convalescence from her second breast surgery was slow, not helped by a New York winter that froze out spring: winds howled around the twenty-eighth floor of the Shelton, piling up remains of dirty snow on curbs below. Meanwhile, Dorothy Norman continued to make herself indispensable.

In May O'Keeffe escaped to Maine, where it rained for two weeks. There, at least, the gray skies stretched over rocks and sea instead of oppressive buildings and streets filled with slush. Before she left New York, she had spent an evening with Henry McBride. In the course of their conversation he complained of the *Sun*'s meager salary; he wondered if he had made the wrong choice: drama critics were the real stars of cultural reporting and were rewarded accordingly.

Georgia's response was to send McBride two hundred dollars. A generous gesture from one friend to another (the equivalent today of fifteen hundred dollars), the money became a Trojan horse when the donor was an artist and the recipient New York's most powerful art critic. O'Keeffe genuinely liked and admired the witty, iconoclastic McBride; if he was the incorruptible spirit she believed him to be, he would not feel compromised by the gift or the giver.

McBride decided to accept the money in the spirit with which (he hoped) it was offered: "utter innocence," he told Georgia. But the arch convolutions of his thank-you note, with its negative references to the writer, revealed conflict still unresolved:

> A lady, right out of the blue, and therefore most indubitably an angel, drops manna to the value of two hundred dollars in my direction. . . . It was noble and beautiful of you to do it, my dear O'Keeffe, but I wasn't sure it was noble of me to accept—and I wanted to be noble too. . . . Also, I insist I'm not really hard-up and have about all that it is good for me to have. . . . I decided it was an action typical of your usual beautiful self (but innocent! you and Alfred are both a pair of innocents . . .).[26]

A marvel of grace and tact, O'Keeffe's reply does not suggest innocence as much as a sense of a favor owed to her friend. McBride's criticism had created the climate of acceptance for her art and for modernism in America. Modestly casting herself as the agent of repayment for a col-

lective debt, she tried to remove any onus of impropriety from her gift. She was happy that McBride had accepted her small expression of thanks.

Two years later, Georgia sent McBride, felled by a long bout of grippe, a more innocuous gift.

"Last night I got a great box of oranges, apples and Maan candy from the Ritz Fruiterer sur la part de Georgia O'Keefe [sic]," McBride reported to a friend. "The card said it was the only day of the year in which she could do such a thing, as my article on her show was already written (Friday) and since it hadn't appeared, the gift couldn't be called either graft or gratitude. In any case it wouldn't be called gratitude— for I don't think Georgia will like my review. . . . Of course I can't eat all those oranges and as they won't keep, I gave some to Grant and to that pest of a femme de chambre," McBride concluded peevishy.[27]

Georgia's card, with its conspiratorial joke about bribery, danced around a dangerous truth that implicated McBride as an accomplice. The threat was not lost on the prickly, self-protective critic. His earlier acceptance of the money had placed him in her power.

Although outwardly they remained on good terms, McBride's remarks about O'Keeffe to mutual friends, such as the Stettheimers, became ever more waspish and indiscreet; he retailed her troubles with Stieglitz and any falling off in her work with undisguised glee. Whatever Georgia's motives—and they were probably mixed—the two hundred dollars was a costly gift.

ON APRIL 16, the *New York Times* announced: ARTIST WHO PAINTS FOR LOVE GETS $25,000 FOR SIX PANELS. The article went on to report: "It was made public yesterday that six small panel paintings of lilies by Georgia O'Keeffe had been sold to an anonymous collector for $25,000 to hang in his own home."[28]

Less than a week later, *Art News* published a letter to the editor from Alfred Stieglitz: "My Dear Fulton: Six small O'Keeffe Calla Lily panels, painted in 1923, have been acquired to go to France. She is receiving—don't faint—$25,000 for them. I can hardly grasp it all."[29]

Basing its report on an interview with O'Keeffe and a "private viewing" of the pictures at the Room "before they left for France," the *Brooklyn Eagle* reported that the two largest panels had fetched twenty thousand dollars; another group of four, all white lilies, had brought the figure up to twenty-five thousand—"the largest sum ever paid for so small a group of modern paintings by a present day American."[30]

The anonymous collector was never identified, and for good reason—he didn't exist. There had been no buyer and no sale.

Mitchell Kennerley had taken the panels on consignment, in the hopes of selling them to his mistress, Margery Durant Daniel. Heiress to a General Motors fortune, Daniel was in Reno divorcing her husband, a New York banker. On obtaining her freedom, she was expected to marry Kennerley, who was in the process of being divorced by his wife.

Stieglitz's announcement was a fabrication designed to publicize O'Keeffe and raise her prices.[31] Because it was widely published, Alfred's press release has since been accepted as truth by every writer on O'Keeffe and Stieglitz.

In August 1928, Kennerley wrote to Stieglitz: "I have received a wonderful letter about the lilies which are in Reno . . . the others are at the Sherry Netherlands." Thus, five months after O'Keeffe's "record sale" to a "French collector," some of the panels were in Nevada, the others in Kennerley's New York apartment. Not a cent had been paid for any of the works.

Kennerley's hoped-for income from the sale of the O'Keeffe panels was a drop in the bucket of the bailout he needed from his mistress. He was dangerously overextended; both his publishing enterprise and his auction business had been built on a pyramid of borrowed money. He needed ever-larger sums to pay off the most pressing of his debts (which did not include royalties owed his authors). In 1927, he had been forced to sell the Anderson Galleries, becoming its salaried president. In less than a year, he had spent the four hundred seventeen thousand dollars he had realized from the sale. Now Kennerley was banking on Margery to buy back the Anderson, along with a bonus: the American Art Association, another auction house and art gallery across the street. With this wedding present, Kennerley would have become a major figure in the international market of rare books, manuscripts, and paintings.

Unfortunately, Daniel lost interest in Kennerley as well as in O'Keeffe—if, indeed, she was ever seriously committed to either. In May 1929, she did remarry; in a cruel reference to Kennerley, the tabloids described the bridegroom as a "younger and handsomer" man.[32]

The end of the Lily hoax was the beginning of Mitchell Kennerley's fall. In June 1930, the panels were still in his New York apartment. He wrote to Stieglitz asking for an extension on his debt to O'Keeffe, explaining evasively that Margery had not paid him "for all my O'Keeffe's. Had she done so, I would have been obliged to deliver the pictures to her long ago."[33]

Seven months later, in February 1931, the lilies were still at the Sherry Netherlands; Kennerley promised to send the pictures back to Stieglitz "one at a time." He appears to have returned several in the next days. But a week later he wrote to Alfred asking to have two of the panels sent back to his hotel. He had borrowed money using the contents of his apartment as collateral. He had to show the paintings to his creditor.[34] Eventually, Kennerley is believed to have returned all the panels to Stieglitz.

Georgia's complicity in the Lily hoax seems indisputable: Mitchell Kennerley's IOU's dated June 19, 1931, are made out to Georgia O'Keeffe. Hard evidence, though, doesn't answer the most troubling aspects of the transaction: how she saw and justified her public role in the affair; her many interviews about the "record price" paid for the pictures; and her insistence that she "only painted for love."

She had always dissociated herself from Stieglitz's manipulation of the truth—whether about sex or money; she couldn't answer for what Alfred said or did, she told friends. But this is the first known instance of her active collaboration in fraud for profit; for the first time they could be said to be "partners in crime."

In style, no less than substance, there is something debasing about the episode. The very subject of the panels—the public association of the severe, unworldly artist with the uncompromising purity of the flower—adds an exploitative edge to her role.

She had always found it hard to stand up to Stieglitz. He was the leader of the game or he didn't play. At the same time, his vulnerability was terrifying; he was "destroyed," O'Keeffe said, if one disagreed with him. That spring of 1928, she was not in a position of strength. Forty-one and physically weak and depressed, she confronted an entrenched rival in a lovely, adoring young woman of twenty-three. Tremors on Wall Street—preceding the crash—had severely affected the Room's sales. Although people had come in droves to the Marin show the previous November, not a single picture was sold. In contrast, she had done well; she had to retain her edge. Her most secure hold on Alfred— on her own future with or without him—was to be his most successful artist.

THEIR DEPARTURE FOR LAKE GEORGE on May 11 was fraught with greater tension than any summer had been since Kitty's collapse five years earlier.

Georgia was demoralized and depressed. When she agreed to go along with Alfred's Lily hoax, she could not have foreseen how com-

promising the consequences would be. First was the "private viewing" of the Lily panels before their putative loss to France. Next came the endless interviews, tiring and time-consuming, with reporters asking the same questions. Finally, she had to read her own pious statements in cold print, describing the twenty-five thousand dollars she had not received as a reward for "years of hard work." She had never been a liar or hypocrite: her Stieglitz in-laws and friends who had suffered the stings of Georgia's honesty could attest to that. Had she now become both?

Then, on the day before they left the city, Alfred slipped on the freshly washed floor of the Room, wrenching his back. He was in such pain that he could barely walk. That night, while pulling off his underdrawers, he tore the tendon on the middle finger of his right hand, and it was bandaged with a splint. He could only limp to the train with Georgia's support. When they arrived at the farmhouse, a bad cough joined his orthopedic ailments, sending him to bed.

Georgia was so exhausted that she felt "dazed" to the point of forgetting where she was, she wrote to McBride. She couldn't seem to remember how to do the routine tasks needed to open the house, like lighting the oil stove—a chore made more difficult by a first day of torrential rain.

They were alone. No family or friends intruded on their privacy. Lee and Lizzie's Redtop now included a kitchen and dining room. Margaret Prosser, a local woman who had helped at Oaklawn as a teenager, was in charge of farmhouse meals. Alfred was soon making a good recovery. The summer before them offered the promise of a long-held wish come true: freedom to work, to enjoy the outdoors, to be together and alone.

But they weren't alone. Dorothy Norman was an invisible presence between them. Probably while Georgia was visiting Maine in May, Alfred and his young acolyte had become lovers. Both were in that privileged state of passion—apart from the everyday world and its inhabitants. The young woman was ecstatic in the discovery of what sexual fulfillment could be: "To have a complete erotic experience again and again is breathtaking, almost frightening in its intensity. I am another person in another body," Norman wrote.[35]

Alfred was as obsessed with Dorothy as she was with him. They had to be in touch "by person, by letter, by phone at every possible moment," she recalled. Before they separated for the summer, Stieglitz assured her: " 'We are *one—Every day proves it more and more to be true.*' "[36]

From Lake George, he wrote pages of passionate yearning to Dorothy

at Woods Hole. He was "counting the days until they could be together again—look into each other's eyes—see each other's mouths—touch each other's hands—each glorified by the long inseparable separation."[37]

Memories of happier times make present pain harder to bear. For Georgia, trips into town for the mail had once been occasions of shared pleasure; they combined the brisk walk she loved and a few household errands, ending with the stop at the post office and the return along the Bolton Road, reading letters from mutual friends aloud to one another. Now if Georgia could bear to accompany Alfred for the mail, she was only too well aware that the letter he searched for feverishly each day was hastily pocketed, hoarded for private reading.

Both Alfred and Dorothy accepted their love for each other as something apart; they were both married to others for good. (Worried as always about assuming any responsibility for a woman, Alfred had made Dorothy promise she would never leave her husband.) He continued to deny to the world and to his family that they were lovers. "Not that anyone believed him," said a Stieglitz niece.[38]

Georgia least of all. The ignominy of her position, moreover, was made more cruel by its evident ironies. Ten years ago, their passion had been the subject of Alfred's same vehement lies, as he angrily insisted to Joe Obermeyer that he and "Miss O'Keeffe" were just good friends. Now the same sympathetic glances or patronizing smirks were directed toward her.

Warnings to Alfred from loving confidantes such as his niece Elizabeth that he not repeat with Dorothy the "stupidity" of his dalliance with Beck four years earlier missed the mark. (Elizabeth, however, loyally agreed to safeguard all incriminating letters.) Dorothy Norman was no dalliance. She had become essential to his work and to his life. If Elizabeth had not grasped the difference, Georgia had.

Absorbed in his new love, buoyed by the proof of renewed sexual powers, Alfred indulged his favorite fantasy. Joined by their love for him, the women in his life would love each other, thus re-creating for Alfred an Eden before the Fall. In this paradise, he would bathe in emotions without boundaries, an amniotic fluid in which the maternal and sexual, companionable and spiritual would flow endlessly, with Alfred as both source and object.

O'Keeffe was having none of it. Less than two weeks after their arrival at the lake, she took off again for Maine and the sanity of the Schauffler household. Undaunted by rain, she spent most of the days out-of-doors. "Am having a great time," she wrote to her sister Catherine. "I am quite a normal human being here—It is quiet—wonderful food—busy people who leave me alone—and the Ocean."[39]

For some time, Georgia had been considering a visit to Wisconsin. She had not been back in twenty-five years—since the family moved to Williamsburg in 1903. She had not returned for either parent's funeral. Her favorite aunt, Lola, was now ninety-eight. Aunt Ollie, with whom she had stayed in Chicago, was now retired in Madison. But the strongest motive for a visit was her unwillingness to go back to Lake George—and to Stieglitz. If she returned to the Hill before leaving for Wisconsin in late July, it was only to repack and make the necessary travel arrangements.

She was still away when Alfred wrote to Florine Stettheimer in early August. After thanking her for her portrait of him, which Florine had unveiled in New York, he noted the silence that enshrouded him in Georgia's absence. Exaggerating his mutism, he teasingly asked Florine whether she could imagine him silent for four weeks.

For Georgia, the Wisconsin visit, while peaceful and pleasant, was hardly a homecoming. The farmhouse of her Sun Prairie childhood had long since been sold; Madison, where her aged aunts lived, was now a large city. Significantly, when O'Keeffe decided she wanted to paint a barn, she and her sister Catherine, like tourists in search of the picturesque, set out for a day trip along country roads until they found what Georgia wanted. The perfect emblem of rural American life, the example she chose was painted classic barn red, with stone foundations and steeply pitched roof; with a silo on one side of the barn and a stable for horses on the other, the structures were unified by a white five-bar fence.

Executed from the back seat of her sister's automobile, O'Keeffe's painting *Wisconsin Barn* (1928) is astonishingly close to Andrew Wyeth, not only in subject but in sentiment and even facture.[40] Thinning her oil to the consistency of watercolor, the artist sends gray clouds scudding across the sky, emphasizing the strong red of the building. By painting the barn from the south end, she has made the structure resemble a church: the sharp angle of the roof grazes the frame like a steeple.

Generally, O'Keeffe showed little interest in textural contrast. Her Nova Scotia barns make their geometric point with flat areas of bright color, contrasted with black and white. In the Clam and Shingle series, there is no differentiation between the rough surface of the building material and the smooth striations of the mollusk. In *Wisconsin Barn*, however, the artist lavished uncharacteristic care on the rendering of the stone foundation, the wood pile, a weathered, unpainted door.

Seen from the automobile, the symbol of rootless urban modernity, O'Keeffe's barn is hallowed by the distance of time and space to become a social icon; its unchanging form pays homage to Americans' fruitful

partnership with nature and to the artist's own past. "The barn is a very healthy part of me—there should be more of it—It is something that I know too—it is my childhood," she wrote to Mitchell Kennerley.[41]

Nostalgia requires a highly selective memory. Like Wyeth's tributes to the purity of America's rural beginnings, O'Keeffe's barn exorcised the realities of life on the land. The hardship, suffering, and death that hung over her early years—the reasons for her family's flight from Wisconsin—have been painted out.

She said good-bye to her aunts knowing it would be for the last time and visited Catherine's home in Portage, where she also introduced her sister to Margery Latimer, Georgia's young writer friend. Before meeting Catherine O'Keeffe Klenert, Latimer had repeated rumors that the artist's sister had married a butcher and hung Georgia's paintings over the kitchen stove. On meeting Catherine, she found her too refined to be guilty of either sin. She was concerned lest Georgia discover that she had spread such calumnies.

Snobbish and small-minded, the provincial mentality offered no haven from the pain of living. Farmer Charlie Boylan's classic red barn notwithstanding, Georgia's return to the Midwest tempered any nostalgia she may have harbored about the sturdy, simple values of ordinary people. In any case, it was no place for an artist; if neither the Shelton nor Lake George was home, neither was Wisconsin.

In Georgia's absence, Alfred had been drawn back into the role of helpless uncle and brother; with Dorothy in Woods Hole, his existence as lover was confined to the epistolary. More than ever, his pleasure in Georgia's return was intensified by relief. When she would return was always uncertain; now, for the first time, there had been a real question of *if*.

Georgia had been away for more than a month. On her return she found that Alfred, sixty-four, seemed to have aged years. She had left with the dull, inward anger of depression. Now she felt overwhelmed with tenderness toward a frail old man. For both of them, Dorothy Norman moved, temporarily, to the margins of consciousness. Georgia's obdurate refusal to discuss her rival worked in her favor; no harsh, ugly words came back to haunt her reunion with Alfred.

Her sense that Stieglitz had aged suddenly was not an illusion caused by time spent apart. Two weeks after her return, Alfred clutched his chest in terror at the unmistakable squeeze of pain; he had suffered a heart attack or, possibly, the first evidence of an angina condition. Lee ordered him to bed, engaging two nurses for round-the-clock attendance. To Georgia, this invasion of foreign bodies was harder to bear than worry over Alfred's illness. With Lee's return to New York, she sent

for Ida, assuring her brother-in-law that the two strong O'Keeffe women could more than take care of the convalescent's needs. Together, she and the forgiving Ida indeed coped, but the sacrifice of time and energy took its toll on Georgia's patience. Feeling exploited in the prescribed wifely role of cheerful giver, Georgia was more vulnerable to reactivated anger and resentment at Alfred's affair with Dorothy Norman. Here he had been, tomcatting around with a woman more than forty years his junior, and now Georgia was relegated to the function of geriatric nurse. To Ettie Stettheimer, well acquainted with the servitude imposed by a resident invalid, Georgia felt free to sound as aggrieved as she felt. Her nursing duties left her "with not a thought in my head," she wrote Ettie,

> unless strained spinach, peas, beans, squash—ground lamb and beef—strained this—five drops of that—a teaspoon in a third of a glass of water—or is it half a glass—pulse this—heart that—grind the meat four times—two ounces—1 oz.—½ zweibach—will all those dabs of water make up two qts—is this too hot—that white stuff must be dissolved in cooler water—the liquid mixed with hot—castor oil every 15 minutes and so on—divide those 25—or is it 21 ounces into 5 meals—until the girl who helped me grind and measure and rub the stuff through the 2 sieves actually got hysterical laughing about it.[42]

She preserved her sanity only by standing outside the self that was reduced to mindless drudgery: "I almost feel as though I'm not doing all these wonderful things myself—but just looking on," she told Ettie.

Paintings from that autumn—usually Georgia's most productive period—were small and few. In *Yellow Leaves with Daisy*, the artist celebrated a victory over a creeping sense of entropy. Escaping from sickroom and kitchen, she walked far into the hills to find that "the thing I enjoy of the autumn is there no matter what is happening to me—no matter how gloomy I may be feeling . . . no matter what people do to me or anyone else."

The common leaves and field flower that came to stand for her epiphany were reassuring evidence of nature's reality: "To paint something that I know is," she wrote to Mitchell Kennerley, was a redeeming act. "I also enjoyed making it reach up by the way I made it reach out," she wrote of her humble bouquet.[43] To the viewer, the composition appears less dynamic than off-balance: enormous yellow leaves dwarf a small, dispirited-looking daisy. The colors of both leaf and flower suggest the deadness of winter rather than fall's promising brilliance.

Like a blade of grass bursting through a concrete sidewalk, the

picture became for O'Keeffe a sign: her fierce will to create could survive any obstacles.

By the middle of October, a month after Alfred's attack, Lee pronounced the patient "cured," Alfred reported to Strand, adding that he was still being crammed with beef to speed his recovery.

Four weeks later, he and Georgia returned to the city, with only a few days to hang the Marin exhibit, which opened the 1928–1929 season on November 14. Next came Hartley—this artist's first showing in the Room. As much as Stieglitz encouraged the dependence of his "children," Hartley the despairing wanderer was more than even he could handle. Perpetually broke, Hartley bombarded Alfred with pleas for money, exhibits, introductions, love—in tones that swung wildly between paranoid accusation and abject gratitude. Unenthusiastic critical reception of the one hundred works on view confirmed Alfred's warnings to Hartley: to renew his art at the source, the expatriate must return.

O'Keeffe's exhibit opened on February 4, 1929. People came in numbers but did not buy. Reviewers were barely more than polite. Predictably, Georgia's recent good deed—her two-hundred-dollar gift to McBride—did not go unpunished. Of the forty-five pictures in the show, Henry McBride found only four that he could "honorably mention"; of these, only one, a "free" version of the East River from the Shelton, deserved to be called "modern." After dismissing the art, the *Sun*'s redoubtable arbiter devoted the rest of his review to making sport of the swooning clubwomen from middle America who turned O'Keeffe's shows into "occult" happenings. The disappointment of one such delegation on discovering the absence of petunias in this year's offering at least reflected "the high grade of aesthetic sensibility in Davenport, Iowa," he sneered.[44]

If proof was needed of O'Keeffe's flight from modernism, it was found in the mass appeal of her pictures. McBride was the first critic—but not the last—to equate the mindlessness of the audience with the mediocrity of the art. The pictures that pulled them in from Davenport, Iowa—"calla lilies a yard wide," in McBride's words—undermined the artist's claim to serious consideration.

Georgia was well aware of the risks on both sides. On the one grinned the specter of poverty; on the other, the self-hatred engendered by selling out. Only months earlier, Dove, the uncompromising modernist, had been forced to give up the modest expense of a houseboat for the rent-free job of caretaker of a group of privately owned islands off Noroton, Connecticut. For Georgia, the prospect of being dependent on Stieglitz at the most troubled period in their life together was unthinkable.

Her conflict was expressed in contradictory attitudes about her paint-

ing. She defended the right of art to be "pretty" and, by implication, salable. But a year earlier, writing to Waldo Frank, she had confessed to a creeping sense of self-hatred accompanied by the desire to scandalize her swooning fans. Writing of her 1927 show, she told Frank, "It is too beautiful— . . . I hope the next one will not be beautiful . . . I would like the next one to be so magnificently vulgar that all the people who have liked what I have been doing would stop speaking to me— My feeling today is that if I could do that I would be a great success to myself."[45] But, like the Christian who prays to the Lord to make him chaste—but not too soon—Georgia set no date for alienating her fans. Her fantasy of returning to a modernist aesthetic that set a vigorous vulgarity above a beguiling beauty was indefinitely deferred.

Her current exhibit of forty-five paintings offered neither. She did not even try to defend the weak showing. For the first time since she began exhibiting, she had not produced enough work during the preceding year to qualify the paintings as recent. Her dismal feelings at the sight of her own efforts—diminished in size, quantity, and inspiration—weren't improved by the Strand photographs that replaced her paintings on the walls of the Room. His close-ups of Maine coastal vegetation communicated the life of organic form in a vision that fused the poet and scientist. Prints from his 1926 trip to Taos displayed Paul's growing technical skill to even greater advantage: he captured the working of light and space on the sculptural adobe structures.

Dove's exhibit followed: one hundred of the artist's most inspired and varied work in every medium, all executed in the last year under the most adverse conditions.

Writing to Henry McBride, Georgia expressed the hope that his nagging cold was better. She had some news she was sure would speed his recovery: "The encouraging note that I want to add is that I hope not to have an exhibition again for a long—long—long time."[46]

NINETEEN

Up in Mabel's Room

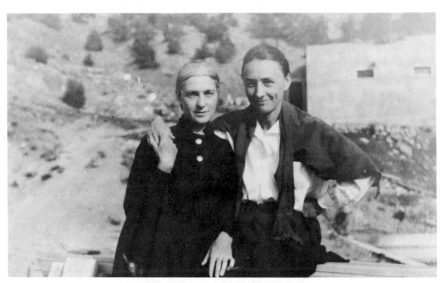

Georgia O'Keeffe and Beck Strand, Taos, New Mexico (Summer 1929). In the background is the Pink House, one of Mabel Dodge Luhan's guest facilities, where Georgia and Beck lived.

THE INTIMATE GALLERY ended its last season, 1928–1929, with a Demuth show: 489 Park Avenue was doomed to the wrecker's ball. Kennerley's final scheme to save the Anderson Galleries by turning part of the building into a moving picture theater had come to nothing. He left for England, trailing a wake of bad debts behind him.

Room 3003 at the Shelton could not contain the hostilities of its tenants. Alfred's angry outbursts, his sniping and sarcasm, Georgia's stoicism followed by weeping were the scenario.

Louise March, a former German exchange student at Smith College, had come to know Stieglitz and O'Keeffe from visits to the Room. Now living in New York, she was often invited to dinner at the Shelton; moments after her arrival, an argument would flare up. "A small thing would set it off," she recalled. "They would tell me to go ahead to the cafeteria, and say they'd be right there. They wouldn't come, and an hour later I'd go back, and she'd be in tears."[1]

Claude Bragdon, a retired architect, had moved from Rochester, New York, to the Shelton at the same time as Stieglitz and O'Keeffe. A courtly widower, Bragdon had, like Paul Rosenfeld, initially romanticized his new friends. He was a fervent admirer of Georgia's painting and Alfred's photography, and they had seemed briefly to Bragdon to represent the ideal artist couple. After witnessing similar scenes, however, Bragdon realized that things were going badly with his neighbors—and getting worse. "They are no longer beautifully together as of yore," he mourned.[2]

Bragdon was soon confiding his distress about Georgia and Alfred to a new friend of all three. In November, Lady Dorothy Eugenie Brett had dropped into—or, more accurately, up to—their life, establishing herself intermittently in a room on the twenty-seventh floor of the Shelton. Her arrival was preceded by impeccable references: she was an offspring of a peer of the realm and a friend of D. H. Lawrence, and she carried a letter of introduction from Mabel Dodge Luhan.

Daughter of the 2nd Viscount Esher, Brett, as she had been known since her student days at the Slade School of Art, had taken dancing classes with the royal children at Windsor Castle. She was presented at court during her London season, but from that point on her life was a long rebellion from the destiny of a daughter of the peerage.

The pretty child turned into a plain, plump young woman with a receding chin, the "small open mouth of a rabbit" (according to Lady Ottoline Morrell, hostess to the Bloomsbury circle), and the buck teeth that were the attribute of the aristocratic Briton. In her early twenties, Brett had succumbed to severe, if intermittent, deafness, at which point her tin ear trumpet, nicknamed Toby, was turned into a prop of her eccentric charm. Through fellow Slade students Mark Gertler and Dora Carrington, Brett found her place with the other privileged rebels of the Bloomsbury set: Lytton Strachey, Bertrand Russell, Ottoline Morrell, Aldous Huxley, and Katherine Mansfield.

Despite her own considerable talent as a painter, Brett was a groupie by vocation. She first attached herself to Katherine Mansfield. On the writer's untimely death in 1923 from tuberculosis, Brett had a brief liaison with the easily consoled widower, John Middleton Murry, before finding the genius worthy of her worship: D. H. Lawrence.

In 1925, Lawrence and his aristocratic German wife, the former Frieda von Richthofen, accompanied by Brett, embarked for America. This voyage was the novelist's second attempt to create in Taos his Rananim, a pre-industrial, pre-Christian community in which humans and nature would flourish, freed from civilization's deadening grip.

The Lawrences' first stay in New Mexico three years earlier had

been disappointing. Mabel Dodge Luhan had summoned Lawrence to become presiding genius of her utopia, where the writer would be restored to physical, moral, and spiritual health through the example of the Indian. But it soon became clear that the vast tableland of Taos was too small to accommodate two such gargantuan egos. With Frieda as a buffer (in her husband's own words), there was constant friction between Mabel and Lawrence, who also discovered, inconveniently, that he was repelled by the Indians who were to redeem them all.

Dealing with Mabel's ferocious will and exuberant sexual manipulation required backup. Lawrence returned to England to gather disciples for his second assault on "Mabeltown." Only Brett answered the call. Rananim proved no less elusive than before, but at least now Lawrence had three women fighting for possession of his soul and for credit as his muse. He and Frieda were installed in the Pink House, a two-story, porched adobe and wood building across the alfalfa field from Mabel's Big House. Brett was lodged in the studio next door, where, according to one observer, she spent most of her time spying on the Lawrences with binoculars.

Wearied by the feverish emotions, shifting alliances, and three-way quarrels that poisoned the pristine air, Lawrence accepted Mabel's generous offer of her son's ranch on the flank of Mount Lobo, seventeen miles above Taos. With Frieda and Brett, he moved there in the spring of 1926. The backbreaking work required to make habitable the primitive buildings, which were barely accessible by car even in summer, exhausted the frail writer, already showing symptoms of the tuberculosis that would kill him within a few years. Frieda and Lawrence returned to Europe, moving restlessly around Italy. Brett never saw him again.

Lawrence's legacy to his most devoted follower was a caretaker's cabin, rent-free, at the ranch. In winter, when the roads became impassable, Brett moved down to Taos and Mabel's fiefdom.

The two women alternated periods of calm friendship and venomous enmity. Mabel was unwavering, however, in her praise of Brett's talent, which found its focus in paintings of Pueblo life and ritual, called by the artist *Ceremonials*. The originality of the work stems from the unexpected encounter of subject matter and style: Brett used glowing primary colors, sweeping arabesques, and the flattened, arts-and-crafts manner redolent of her student years, circa 1910.

Aware of Stieglitz's enthusiasm for Lawrence's writing, Brett tried to interest him in showing her work by suggesting a joint exhibition of her *Ceremonials* and Lawrence's tepid nudes (then hanging in the old La Fonda Hotel in Taos).

Weeks before her first meeting with Stieglitz in New York in 1928,

she sent seven of her pictures to the Shelton; when she appeared at the hotel in early November, she brought several more. Spreading the large canvases around her tiny suite, she invited Georgia and Alfred down for a viewing. Georgia "appeared stunned" by what she saw; Alfred pronounced the work "very fine indeed," Brett reported happily to a Taos friend.[3]

Both reactions may have been mere politeness. Even if Stieglitz's enthusiasm and Georgia's amazement were sincere, there was room for only one woman artist in Alfred's stable. Brett was not offered the exhibit she had hoped for. Stieglitz's excuse was the Lawrence connection; with the banning of *Lady Chatterley's Lover*, he did not want to be accused of sensationalism, he told Brett. In any case, the Room's rent had been raised, making future plans uncertain. Finding new space and money was now in Dorothy Norman's capable hands.

Ever ready to be ravished, Brett became an ardent worshipper at the shrine of both Stieglitz and O'Keeffe. Following her return to Taos, she wrote letters to Georgia in the form of lyrical prose poems about her paintings and endeared herself to Alfred with eulogies to the Room. In her most impressive feat of diplomacy, she lost no time in becoming a close friend of Dorothy Norman; from their first conversation, in the elevator going down from the Room, Dorothy felt she had "known [Brett] always."[4]

For a brief period in December, Brett moved with Mabel into the latter's new pied-à-terre on Fifth Avenue. But a violent quarrel soon sent Brett back to the Shelton, where she joined Alfred, Georgia, and Claude Bragdon for meals in the cafeteria. On some days, Brett seems to have been invited to occupy Georgia and Alfred's bedroom while Georgia painted in the living room; on her return to Taos, she wrote Georgia fondly of her memories of watching her at her easel through the doorway.

Brett's most significant influence during that unhappy winter, was to conjure up for O'Keeffe, with her painter's eye, the feast of the senses that was northern New Mexico: the primeval wooded slope of the Lawrence ranch; horseback riding over the Indian land that bounded Mabel's property; the sun setting behind the Sacred Mountain of the Pueblos.

For nearly a decade, Mabel had tried, without success, to persuade Stieglitz to visit New Mexico. Among his circle, the number of converts to the region was growing: the painter Andrew Dasburg, Rosenfeld, the Strands; Marsden Hartley had spent several productive periods there between 1918 and 1920 before deciding that "Taos was another spelling for Chaos."[5] Untempted earlier, Alfred was now immovable; the altitude and his angina provided all the excuse he needed.

Georgia was becoming ever more determined to take a trip West. Both her art and her life felt stuck in the present, with its shrunken possibilities and failed promises. Memories of Texas and of the trip with Claudia through New Mexico and Colorado revived forgotten feelings of freedom and discovery. In March, with the threat of another summer at the Hill looming, she marshaled her reasons for going and presented them to a predictably unhappy Alfred. Neither eloquence nor bullying could break down her principal argument: she could no longer work within the confines—emotional and geographical—of their life together. Her own resources were depleted; she had exhausted Lake George, its low hills, narrow water, and excess of green, along with the city's unyielding architecture.

Her public position as a feminist, for all its insistence on independence, still conflicted with the emotional reality. She was not sure she would have the courage to leave, even for eight weeks, Georgia wrote to Blanche Matthias, without Alfred's permission.

Finally, an inspired idea settled the issue: Beck Strand would accompany Georgia. Stieglitz yielded. Beck's loyalty to him, Alfred reasonably believed, would make her the perfect traveling companion, nanny, and spy. He was further reassured by Beck's motherly promises to look after her friend, reporting faithfully to both Alfred and Paul. Strains in the Strand marriage were worsening; separate visits to Lake George in summer or fall underlined the difficulties of living together in close quarters on the top floor of the Strand house in New York. Beck was as delighted as Georgia at the prospect of relief from the role of wife.

On April 28, the two women boarded the Twentieth Century Limited for Chicago. Both were feeling depressed by the parting. Beck and Paul had quarreled furiously during their last night together. Georgia's low spirits took the form of physical discomfort: before she could settle down, she had to fix the elastic in her drawers and change her shirtwaist and shoes.

They were met in Chicago by O'Keeffe's favorite brother: the large, bearlike Alexius had recovered from the effects of being gassed in the trenches; he was now working as an engineer and was married and the father of a new baby. Armed with gifts for the sister-in-law and niece Georgia had never met, she and Beck visited the young family. Beck was sniffish about "the usual little apartment with radio and light blue toilet paper" and about Alexius's parvenu-in-laws, the Joneses, who invited them to lunch at their club, insisting on a tour of the facilities. Finally, the four younger people were liberated for a visit to the Art Institute.[6]

Back on the train, moving across the prairie toward Kansas City, they saw farmers plowing the earth with teams of oxen. The scene, as though from a Thomas Hart Benton canvas, inspired Beck with a sense of racial purification. "All my American and Western blood sings in me now," she wrote to Paul, "and all the Jewish blood dried up like a vapor under a sun so strong it cannot survive."[7]

Once on the Santa Fe Limited heading West, Georgia was strangely disappointed to find the scenery "even finer" than she had recalled. In the West, nature upstaged art and memory. She planted herself firmly on a suitcase in the middle of the observation car so as not to miss the sights on either side. At Lamy, the railhead for Santa Fe, a Harvey coach met passengers headed for town.

Since Georgia's visit ten years earlier, Santa Fe had grown, especially in self-conscious efforts to attract settlers and tourists: its Women's Board of Commerce, the newspaper *Santa Fean*, and a small but sophisticated group of emigré artists from the East were busy spreading word of regional treasures, including colonial architecture, the handcrafts of its Native American population, and the natural beauty of its setting; nestled in the foothills of the Sangre de Cristo Mountains, the town enjoyed the clear dry climate that had always attracted "lungers"— as they were called locally—to its Sunmount Sanatorium.

Both women felt exhilarated by the crystalline air, scented with piñon and sage. With unreal clarity, the light sculpted the mountains, which appeared deceptively near. After nearly three days of travel, neither felt tired; their appetites were ravenous. Beck had never before seen Georgia with red cheeks.

On their arrival at La Posada Hotel, three letters from Stieglitz were waiting for Georgia. There was no mail for Beck. The hotel was comfortable enough for the price: thirty-five dollars a week for a double room, or two dollars and fifty cents a night for each of them.

To their delight, they had arrived in time for the annual corn dance at nearby San Felipe Pueblo. They were alerted that Mabel and Brett would be there, too. By way of inducing them to stay with her in Taos, Mabel had already offered the Pink House (where the Lawrences, followed by Beck and Paul, had stayed earlier). They had planned to be in Taos for the Indian games and relay races at the pueblo, to be held a few days later, but were still undecided about Mabel's offer. Although Georgia could more than hold her own with the "Regent of New Mexico," as Mabel was known, both Strands had found her overpowering.

Already feeling possessive toward Georgia, Beck was reluctant even to watch the dances with the other women. "I feel sorry to make this

first break in our privacy," she wrote to Paul.[8] The excitement of the ceremonial was too absorbing for jealousy: the lines of male dancers, the intricate rhythms of feet, the low, throbbing drums and chanting voices—repetitive, then suddenly silenced before it all started again. Beck was moved to tears when a *santo*, under a white canopy, was carried into the center of the plaza; the women knelt to kiss the statue's carved wooden hand. It was the perfect experience, they both decided.

Staying until the end of the ceremonies, they had missed the Harvey car back to town. Although the story is always repeated that their overbearing hostess tricked them into staying with her by sending their luggage ahead to Taos, the truth seems to be that they were easily persuaded to leave with Mabel and Brett. It was Wednesday; as they planned to see the games and races on Friday at the Taos pueblo, it was much more sensible to make the arduous seventy-five-mile trip the next day in Mabel's luxurious car, arriving in time to spend a restful evening with her before further rigors of tourism.

The drama of the journey between Santa Fe and Taos still begins at the opening of the Embudo Canyon, where the Rio Grande, swift and green in early May, runs narrowly between the gorge of the mountains. The canyons are lined with black lava rock, whose cubist squares and slabs, scattered on the riverbanks, have been washed smooth and shiny by the water. From Embudo Junction, the road winds upward through almost twenty miles of barren hills. Then, rounding the corner of the highway, Beck and Georgia, like the traveler today, had their first glimpse of the panorama that unfolds "like the dawn of the world," as Mabel described it.[9]

Looking down, they saw the seven-thousand-foot-high plateau of the Rio Grande stretching vast russet flatlands toward the mountains that curve around Taos in a crescent: to the west lies the jagged hazy edge of the Jemez Mountains; to the north the silvery green of the Sangre de Cristo range rises another seven thousand feet from the valley floor. Cradled in the hollow below lies the "straggly vista of smoking adobe homes" that was Taos, with the Sacred Mountain looming behind.[10]

At the first sight of the plaza, the visitors understood why Santa Feans said there was nothing to Taos—a view that Georgia would soon come to share. Lined on three sides with long, low buildings housing shops, the square of dusty yellow grass, fenced with long wooden bars, boasted a few scraggly trees under which horses grazed.

Disappointingly scruffy, the town made Mabel's domain, one mile to the east, appear a magical oasis. Built on twelve acres of verdant meadow, orchard, and highland and bounded on two sides by Indian fields, Los Gallos, named for the vividly colored ceramic roosters that

preened on the roof, began as a three-bedroom adobe structure built by local Pueblo workers. In the decade since Mabel had bought the property, she had added fourteen rooms to the Big House and five guest buildings, along with servants' quarters for her staff of seventeen.

The core of the house was the Big Room, two large, rectangular spaces with fireplaces. The ceiling, like all those on the property, was built with the *viga* and *latiga* method of the Indians; cedar striplings were layered with sweet clover and sage on which was smeared wet mud. Bright pillows, scarlet and emerald, were spread on the large chairs, sofas, and benches, a mix of colonial and European styles. The whitewashed walls of the room were hung with striped Indian blankets, and Mexican *santos*, the religious figures made of carved and painted wood, stood on the mantelpieces.

Five round tiled steps led to the larger dining room below, whose ceiling, painted in striped earth colors, picked up the design of the Indian weavings on the adjoining walls. A long oak table was the gathering place at dinner for resident guests.

Mabel's apartment was just above; built in the room itself, her massive oak bed still cannot be moved; its huge twisted posts, made from the trunks of ancient pine trees, give the bed a Wagnerian, larger-than-life quality of a stage set, perfectly reflective of its owner. Above the sleeping quarters, with its adjoining room for Tony Luhan, her Pueblo husband, Mabel added a third-floor tower solarium; there, on serapes thrown on the floor, which was painted bright blue, Mabel sunbathed naked (much to Lawrence's disapproval) while looking at the Sacred Mountain to the north. When she glazed the room, the tower took on an international style "modern" look. Seen atop the traditional adobe structure, the tower still exudes the tension between the two cultures that expressed Mabel's central conflict: she wanted the luxury and freedom of the modern American woman along with the security and order of a primitive hierarchical community.

Looking directly down from the sun room, Mabel could survey her fiefdom: the flag-stoned *placita* shaded by the feathery leaves of a huge cottonwood tree in the center, its trunk circled by a wooden bench, and the dovecote city where Mabel's beloved pigeons cooed.

Now delphinium and plum blossoms greeted the travelers from Santa Fe; like all the flowers and fruit in their season, they were watered by the *acequia madre*, the wide irrigation ditch that circled the property, bordering the bright green alfalfa field. Across the field was the Pink House, where the new arrivals were to be installed eventually. For the moment, Mabel put Beck and Georgia in one of the guest rooms that extended from the Big House in a one-story wing facing the patio.

Surrounded by a roofed porch, the Pink House was dark for painting. To her original offer Mabel added the adjoining studio as a blandishment for Georgia; it boasted a "huge room, with marvelous light" from the big window looking north, Beck wrote to Paul. She was ecstatic about the "perfect" arrangement they were to enjoy: a place to live together and work apart. Since she and Paul had stayed in the Pink House, Mabel had converted an extra room into a kitchen; guests there were now expected to fend for themselves until dinner.[11]

The new facility seems to have delayed their departure from the Big House. Feeling lazy, Georgia and Beck enjoyed being waited on by Mabel's large staff, starting with the breakfast in bed preferred by women guests (men liked their bacon and eggs by the kitchen fire) and ending with Mabel's sumptuous dinners. At Los Gallos, all food except meat (butchered especially for Mabel) was grown, raised, baked, and preserved on the property.

Like all visitors, with the exception of Lawrence, Georgia and Beck were immediate converts of Tony Luhan. They were unprepared for the nobility of appearance that matched his character. Over six feet tall, he easily carried a certain portliness, while the domed bronze brow and impassive features lent to the Pueblo leader the head of a pharaoh.[12] When Tony made his entrance at dinner—his wrists and fingers covered with massive turquoise jewelry, a splendid colored Navajo blanket thrown over one shoulder, waist-length braids plaited with bright ribbons—an awed silence fell on the assembled guests. Those in residence were soon overwhelmed by his warmth and friendliness. His generous spirit took pleasure in acting as guide to visitors. Either at the wheel of Mabel's Cadillac or on horseback, he showed Beck and Georgia the pueblo, explaining those ceremonies they were allowed to see and introducing them later to his fellow councilmen. Tony was their guide on other excursions: joined by Mabel, Brett, and fellow guests, they soaked their bodies and washed their hair in Manby's Hot Springs, mineral baths owned by an English remittance man; inspected the Hispanic village of Arroyo Seco; and explored the waterfalls and caves fed by the holy Blue Lake at the summit of the Sacred Mountain and forbidden to the white man.

On May 2—only a few days after their arrival—both women felt transformed. Ingenuous as ever, Beck felt sure that Stieglitz would be pleased to hear how wonderfully well Georgia was doing—without him. "All the tensions gone & a real serenity reflecting it," Beck wrote to Paul. "Tell Stieglitz this and that she has not had a single ache or pain or physical distress since we arrived—in spite of new food and exciting vistas constantly opening up. She is a new woman."[13]

Borrowing Mabel's Ford, Beck began teaching Georgia to drive. She found her a slow student, hampered by overcaution and nervousness. Georgia feared damaging the car, which in fact she managed to do, albeit not seriously; she failed to shut the door, and the window glass shattered when the door swung open, catching the side of the garage. But progress was made and Georgia loved driving, reveling in her new sense of freedom in a vast new country. On their first excursion with Georgia at the wheel, they headed toward Glorieta on the road running through the pueblo, returning without mishap.

A young California photographer, Ansel Adams, joined Beck, Georgia, and Irish folklorist Ella Young at the long table. Trained as a concert pianist, Adams was still agonizing between the camera and the keyboard. On this first visit, he was captivated by the cubist purity of the Taos pueblo.

Besides their fellow guests, Beck and Georgia enjoyed the company of two other resident emigrés: Willard "Spud" Johnson, a midwesterner who had settled in Taos, where he founded and edited *Laughing Horse*, the local literary magazine, and his lover, Witter Bynner, a rich Harvard-educated aesthete, poet, and translator of Chinese. To a beguiling persona of gay literary cowboy Johnson added an extraordinary sweetness and charm. Mabel earned Bynner's enmity by stealthily hiring Spud as her secretary and ending his dependence on his friend's large private income.

Unlike the puritanical teetotaling atmosphere of Lake George, where the evening's festivities were confined to sitting around the gramophone, at Mabel's every night was a party; infused with wine, even homemade entertainments like mah-jongg or charades turned into hilariously memorable events. Other evenings, after dinner, guests would file along the wooden boardwalk across the alfalfa field to the studio. There, to the sound of drumming, Indian braves would appear. As arranged by Tony, they had left their clothes in the Big House; they wore only feathered headdresses and loincloths. In the firelight from the *kiva*, the visitors were thrilled by the "glistening bodies and rippling muscles" of the young Indian males as they danced, Beck reported. Those who had had enough wine to lose self-consciousness or loosen inhibitions joined the large circle.

Georgia continued to thrive. "She eats like a man & sleeps well and is gay and so interested in everything. Soon she will get tired, I know, of the company & when that happens, she will begin to work," Beck wrote.[14] There was still too much to absorb before she could start to distill observation and experience onto paper and canvas.

"Wonderful" was the word most often on Georgia's lips, Mabel

recalled. She would look around, saying again and again: "This is wonderful. Nobody ever told me how wonderful it is."[15]

Georgia's feeling of having all the time in the world was another of Taos's regenerative gifts. Stieglitz's manic tempo was too much for her, Georgia told Beck, especially when, as too often was the case, "she felt she couldn't keep up with him."[16]

At the end of the first week, Mabel was ill and in bed. A heart problem was the official version of their hostess's condition. In fact, Mabel was suffering from syphilis, apparently contracted twenty years earlier from her first husband, Karl Evans.* The painful treatment of the period consisted of alternating injections or "series" of arsphenamine, known as Salversan or 606, with shots of bismuth. Mabel regularly made the long, arduous trip to Albuquerque for treatment at the clinic there.

Meanwhile, Beck slipped into her familiar role of housekeeper. Georgia got down to work again, leaving Beck feeling ashamed and dissatisfied with her own initial efforts—a few pastels. Thus while Georgia painted in the cottonwood grove behind the pueblo, Beck, sitting beside her, "battled all morning to make up an expense account book for Mabel's cook." She had also taken on all of Mabel's telephoning and telegramming chores.[17]

Georgia's progress at the wheel was so encouraging that the two women decided to buy their own car; they would split the cost of a Model A Ford—six hundred seventy dollars—and sell it when they left. Tony was to take charge of order and delivery. They were beside themselves with anticipation.

Hostilities had broken out once again between Mabel and Brett; as the latter was unwelcome at the Big House, Beck and Georgia visited her by making the ascent up the dirt roads, twisting and turning, to Kiowa Ranch, the Indian name the Lawrences had revived during their residency. Chafing constantly in her dependence on others, Beck was admiring of the sturdy Englishwoman's ability to live and work in isolation. They were also delighted by her western garb: in her native habitat, Brett wore a large Stetson (a gift from Mabel), breeches tucked into her boots, along with a more surprising stiletto!

Two psychics appeared, staying long enough to tell Beck's and Georgia's fortune. Beck was thrilled to learn that her whole life was about to take on new significance, becoming "enriched and contented . . .

* Because of the prevalence of the disease among Native American populations, it was long supposed that Mabel contracted the illness from Tony Luhan; in fact, recent evidence suggests that it was Mabel who infected Tony.

through the love of several women who will also not serve me treacherously," she told Paul.[18]

One night Tony sang, accompanied only by a drum. The sound "runs into the blood like a poison," Beck wrote. "The beat is so insistent and deep, the voice high-pitched, broken and ecstatic."[19]

The happiest times for Beck were those evenings when she and Georgia retired to their room alone to sew before the fire "like two old-fashioned girls," play solitaire, or talk of their "personal problems." Beck was certainly privy to the recent strains between Georgia and Alfred; as Dorothy Norman became indispensable to Stieglitz, he had carried on the more violently over Georgia's need to get away. For her part, Georgia encouraged Beck to find her own sense of direction in art. Beck's world was "a beautiful and powerful one"; yet there were "holes and empty places," Georgia told her, that only Beck could fill; no one else's experience would be of any use to her.[20] Georgia made the practical suggestion that Beck put her drawings on the wall and study them before deciding about color.

The great day came when the Ford sedan, sleek and black, with a steel-blue interior, arrived. The proud new owners wanted to name the automobile "Tonybel," in honor of their favorite driver. He declined the honor. The car was large enough for both women to work in, should extremes of sun or the sudden local showers require shelter. Georgia was encouraging Beck to give up pastels for oil. But on their first working trip toward the hamlet of Glorieta, Beck returned with an empty canvas.

It was now the middle of May, and they had still not moved to the Pink House. Mabel was the reason for Georgia's reluctance to leave the Big House. Beck felt Georgia withdrawing from their privileged intimacy, moving closer to their hostess's magnetic orbit. Whenever she was with the other two, Beck felt crushed by the "power of them both." She was "not smart enough" or talented enough for either, she lamented to Paul.[21] Evenly matched in force of character and in their ability to impose their will on lesser mortals ("Mabel could paralyze a whole roomful of people with a look," Georgia would later say, with more admiration than censure),[22] Mabel and Georgia were engaged in a duel, a battle for power and dominance of others—and of each other—that completely excluded Beck.

On May 13, Tony went into Santa Fe; that night, Georgia moved into Mabel's apartment. One thinks of the Wagnerian bed and Rosenfeld's description of O'Keeffe as Brunhild. Beck was desolate. "I am quite alone in this big house," she wrote to Paul.

Finding her exclusion unbearable and with Tony still away, Beck moved into his bedroom next door to Mabel and Georgia. "Lying in

Tony's vast bed," she reported to Paul, "was like being out on the ocean in an enormous ship."[23]

LATE SPRING in Taos brought the lushness of paradise: Los Gallos was a Garden of Eden where no sin constituted a fall. Down from the Sacred Mountain, the water in the *acequia madre* flowed clear. Peach trees blossomed and the lilacs burst forth. Birds sang everywhere. The alfalfa field separating the Big House from the guest quarters became a carpet of bright green.

In May, Georgia and Mabel invited Marin to come to Taos "alone," as they made clear in their letter. He was undecided. His retiring wife was reluctant to be left behind with their young son. All three women at Los Gallos were outraged at such possessiveness.

Soon after, new worrisome symptoms sent Mabel to Albuquerque for a thorough examination. She left the whole household, including the staff of seventeen, in Beck's hands; Georgia told Beck that she was "crazy" to let their hostess exploit her.

As soon as Mabel was gone, Georgia and Beck's earlier intimacy was restored. Georgia gave Beck two silver buttons for a red skirt that she was making for herself. Beck wrote to Paul asking him to send her a green scarf that Georgia had given her. In her letter, she enclosed a small piece of red flannel; he was also to buy several yards of fabric to match the sample in color and weight. She was planning to make a wrapper for Georgia.[24]

Paul Strand saved every letter and postcard he ever received from Beck; the scrap of faded red flannel is the most poignant evidence of his love. Beck thanked him for the commission; she would remind Georgia to repay him for the yard goods. But she was apt to forget small debts, Beck warned.[25]

In the heat of the afternoons, Georgia and Beck would drive to the hot springs near Ranchos de Taos for another of the "magic baths"; after a dip in the dark pool, reached by ladder far below the surface of the earth, they emerged for a swim in the stream above, drying themselves naked in the sun afterward.

Paul was lonely and depressed; he felt the city closing in on him. He wanted very much to join them. Beck was discouraging. He should come only "if he really can't stand it," she told him ungraciously. She didn't see how they could accommodate his visit without upsetting everyone. Georgia would have to move into her studio (which, Beck failed to mention, had a large second-floor bedroom) or "be assigned another roommate or guest house IF Mabel even had free quarters available."[26]

The message could hardly have been clearer: his presence would be unwelcome and inconvenient.

At the end of May, Georgia was driving well enough to do without Beck's more experienced presence. She went off by herself to the Ranchos de Taos church. She took her paints but came back with only a drawing; she planned to return the next day to fill in the colors. O'Keeffe would do several paintings of the adobe mission, including studies of the buttresses whose sculptural volumes suggest a monumentality belied by the small scale of the actual structure.*

Feeling abandoned to her own uncertain efforts, Beck gave in to peevish envy of Georgia's work. "She had painted only three things— a fairly big one of trees, a lady santo & one of Mabel's porcelain roosters. I do much more than she does, both in work & outside things. I have taken hours in teaching her to drive," she complained to Paul.[27]

Despite the difficulties of working in Georgia's shadow, of needing her friend's approval for every pastel and drawing she made, of reacting to her greater accomplishments with childish spite or black self-negation, Beck managed to strike out on her own in terms of technique and subject matter. In the little local department store, she found white calico roses, intended to be placed beneath statues of the Virgin on feast days.

"I know that artificial flowers sound horrible to you," she wrote to Paul, "but they are really quite beautiful. Pure clear white & a nice shape." The painting she did on glass of these dime store offerings retained their meaning as religious folk art. She would use the same medium, with its luminous qualities, for a haunting depiction of the Penitente cross just behind Los Gallos near the *morada*, the hut that marked the Stations of the Cross used by the sect of flagellants in their reenactment of the Crucifixion.

Beck's calico flowers were appropriated by Georgia later that summer and mentioned in interviews thereafter as her own discovery; most likely, Beck was also the first to paint the black Penitente cross against the blazing sky. Questions of talent aside, the small scale of Beck's work and its restricted palette of purple, dark blue, black, and white—suggestive of folk art and even more specifically of nineteenth-century mourning pictures—made it inevitable that her work would be eclipsed by O'Keeffe's large-scale vision.

Georgia could encourage Beck only when the latter was floundering.

* When Paul Strand photographed the church two years later, he persuaded the padre to remove the basketball hoop, which, by providing too much "information" about actual scale, would have destroyed the illusion of monumentality he obtained in his print.

Now that Beck seemed to be finding direction of her own, Georgia turned patronizing and spiteful. She called Beck's paintings on glass "sweet"; shown a picture of the Sacred Mountain at sunset, she informed Beck, "I would have made something grand of that."[28]

Day after day, Georgia drove to the pueblo, paying the fee charged Anglo artists and photographers who worked there. None of the paintings she made of the site seem to have survived.

The last week in May, they began to move to the Pink House, stealthily and by degrees; both women seemed to be frightened of Mabel, even in her absence. The first evening, they took just toothbrushes and nightgowns, going to bed with only the light from the fire. "I shall remember that first night for a long time," Beck wrote to Paul.[29]

Early the next morning, they moved their possessions from the guest room on the patio; they wanted to be completely installed before their hostess's return. Mabel came back from Albuquerque still sick. On doctor's orders, she canceled her June guests.

One Sunday night, accompanied by the painter Andrew Dasburg and another friend, Bob Walker, they went to a movie, followed by a dance in the town hall. Dasburg didn't dance, so Walker took turns dancing with the women. Georgia always loved dancing—a pleasure she denied herself in her student days. When their male partner called it quits, she and Beck danced together until midnight.

"Can you imagine Georgia's emancipation?" Beck wrote. "Driving a car, dancing, even smoking a cigarette once in a while. Don't tell anyone." Beck did not mention the cocktails before dinner and generous quantities of wine that flowed during and after the evening meal. Georgia also ate "enormously" of Mabel's sumptuous food and "was even good natured most of the time."[30]

But not all of the time. When crossed, Georgia reverted to her imperial self. She was outraged when Beck failed to post a letter she had left for her to mail. As long as Beck had been "fool enough," in Georgia's words, to take on post office duties for the Big House, Georgia shouldn't even have to ask Beck to perform this favor for her. Beck was indignant at being treated like a servant and told Georgia so. As always, whenever she was "in the wrong," Georgia exploded in defensive anger. Beck sloshed back to town in the pouring rain to mail the forgotten letter.

Marin had arrived alone in early June and was promptly lionized by O'Keeffe, who took him off to paint at Valdez. Used to the crowding of forms in the East—boats, trees, rocks, houses, skyscrapers—he felt paralyzed by the vastness of land and space. At breakfast on his second day, he said: "None of us can do it—Its impossible."

But starting with the familiar jagged forms of the mountains and the light-washed atmosphere after the frequent rainstorms, the great watercolorist found his way. He became a "slave" of the Sacred Mountain. "Every day he set forth with paper, paint and pencils, vowing that this time he will escape, he will not be captured by the Taos mountain," his fellow guest Ella Young recalled. But he would return, to exhibit "somewhat shamefacedly" another study of the twin peaks, rounded by age, that rose suddenly to mark the end of the flat Indian lands.[31]

BY THE END of June, nearly two months after their arrival, Beck's letters to Paul became transparent with the wonder of passion. Her union with Georgia was "intact and happy and a miracle of surprise to me," she told him.[32]

A few days later, "the miracle continues," she wrote, "happy & naturally & will to the end." Georgia had assured Beck that she was "satisfied" with their relationship "and I believe her," Beck wrote.[33]

Frank, even abandoned—this is not the language of friendship. From this point on, Beck's daily letters to her husband suggest that, if he hadn't already guessed, he must now know: she and Georgia were lovers.[34]

Georgia gave Beck a beautiful silver necklace: almost two yards long, it had two hundred and eighty round small beads, "like a rosario," and eleven large beads. Beck was rapturous. "It means much to me to have it from her," she told Paul somewhat unnecessarily.[35]

At the beginning of July, Mabel's mysterious symptoms were finally diagnosed as a fibroid uterus. A hysterectomy was the standard treatment; Mabel decided to have the operation performed at the Buffalo hospital where her son John, now twenty-seven and helping to manage Los Gallos, had been delivered. She would be away for three or four weeks.

Beck and Georgia had become less guarded in their behavior. "Its too terrible how untamed and wild we are," Beck wrote gleefully to Paul. She reveled in the lovers' exhibitionism. In the event that Marin had not seen or heard about them, she made sure to tell him that they always sunbathed nude. "You WOULD," he told her sternly.[36]

They lay on blankets spread on the sagebrush behind the Big House; then, still naked, they strolled around enjoying the feeling of the dry, sun-warmed air on their moving bodies.

Marin's growing disapproval incited them to provocative playfulness. Acting one day on their threat to kiss him, both women jumped on the diminutive painter, who threw up his arms frantically to ward off the assault of the Amazons. "I'm going to put your little bit of a thing in

my pocket," Georgia taunted him. (Marin fled to the chaste passion he shared with Brett: fishing.)

They put on bathing suits to wash the car, using sanitary napkins for rags. Then they took their suits off and hosed each other down in the hot sun.

In Beck's descriptions, Georgia grows physically bigger, stronger, more masculine. Beck noted her friend's gain in pounds and constantly increasing energy. Georgia, in turn, urged Beck to look more feminine and "pretty. She says I can & I should," Beck told Paul.

Obediently, Beck put on a red silk blouse and her red skirt, fastened with Georgia's silver buttons, along with the silver chains Georgia had given her. She even curled her hair. "Very pretty," Beck purred to Paul of her new image. [37]

After encouraging Beck to give up her riding pants for red silk and curls, Georgia inevitably grew bored with her creation. Tony Luhan, bereft without Mabel, began to be included in their outings. Together, the three camped in Navajo country, going as far as Mesa Verde on one four-day trip. More than ten years of living with Mabel, observing the mixing and matching of lives and libidos that swirled around her, Tony was unfazed by changing sexual combinations. In Pueblo belief, moreover, gender and sexuality were not rigidly linked. "We are all birds in the same nest," said one chant. [38]

Strong, capable, intelligent, Tony emanated a quiet but powerful masculinity. He was a big man, the type Georgia always liked. His pantheistic love for humans, animals, and growing things was a further attraction. That he could not read or write English added to his sexual appeal: he was a force of nature.

At this point, Tony's inability to communicate with Mabel, far away in the hospital, was proving a hardship for both. As Mabel's intimate and Tony's friend, Georgia took on an indispensable, powerful, and ambiguous role: she became Tony's scribe. All mail to and from Buffalo passed through her hands. Tony dictated his thoughts and feelings to Georgia, and they were read by Mabel in Georgia's familiar wavy script. Mabel's replies to her husband—as she well knew—would have to be read aloud to him by Georgia.

Five years earlier, at the onset of menopause, Mabel had felt a mixture of despair and relief. Lawrence, then in residence, had helped her to see that change of life could mean a new beginning, the transcendence of sexual ego for a new, less vulnerable self. Now the finality of her operation, however, aroused all the old anxieties: biological loss was equated with loss of womanliness; the end of her sexual power threatened her ability to keep Tony's love.

Knowing Georgia's strong and varied sexual appetites, Mabel had good reason to fear Tony's new scribe. With Stieglitz's recent heart attack, Mabel could assume that Georgia had been missing a man's sexual presence in her life. The prospect of Georgia and Tony as lovers was too terrifying for Mabel to confront directly, however. Instead, she deflected her jealousy; in hysterical letters to Tony, she accused him of returning to the pueblo and to the bed of his beautiful ex-wife Candelaria, from whom he had separated six years earlier (with alimony paid by Mabel). Her anguish and humiliation fed by distance, Mabel now threatened Tony with divorce.

Georgia's own letters to Mabel, ostensibly attempting to allay the sick woman's fears and jealousies, were anything but reassuring: every remark about Tony seems intended to flay Mabel's wounds.

"Right now as I come fresh from six days mostly spent with your Tony—I want to tell you that next to my Stieglitz I have found nothing finer than your Tony. . . . I feel you have got to let him live and *be* his way—however much it might hurt you. . . . Even if he goes out and sleeps with someone else it is a little thing," Georgia wrote loftily. "If Tony happens to go out to women with his body, it is the same thing when one goes out for a spiritual debauch," Georgia added, with a dig at Mabel's fervent quest for the higher forms of communion.[39]

Every letter from Georgia to Mabel recites a rosary of Tony's limitless virtues: his strength and goodness, his innocence and wisdom—even his holiness. From her hospital bed in Buffalo, the sick woman could hardly fail to hear both the adoring passion and the smug intimacy that colored Georgia's words. With each sentence the secretary said: "I know your husband better than you do."

In his fashion, Tony loved Mabel deeply. On occasion, he was desolate without her, Georgia reported. On a recent night, she had come into Mabel's room to find his body lying "like a log" across the vast bed. He was weeping. Comforting as this evidence of Tony's grief might be, the question must also have occurred to Mabel: what was Georgia doing in her bedroom—conveniently adjacent to Tony's?

Hardest to bear was Georgia's warning—or threat: like Stieglitz, Tony was too great a man for one woman to keep for herself. Mabel should be willing to share his abundant attributes. If she refused, if she continued to "squeeze the life out of him" with her possessive jealousy, she would lose him—or come to hate what was left. Georgia's righteous bromides to Mabel on the joys of sharing a great man give no hint of the pain caused her by Alfred's passion for Dorothy Norman, of her flights of rage and humiliation to Maine, Wisconsin, and Taos. Indeed, O'Keeffe's high moral tone suggests that Mabel

should stop being a petty jealous bitch and—be more like Georgia!

Letters to Buffalo added a refined cruelty to certain betrayal; thanking Mabel for the restoring months at Los Gallos, Georgia twists the knife a little deeper.

"I owe you much—I owe you what Tony gives me," she told Mabel, following this thrust with a reminder of what she and Mabel had been to each other: "I feel like snuggling up close to you and crying about it all."[40]

Untangling the motives behind O'Keeffe's impulse to wound Mabel is not simple. That she was frequently and gratuitously cruel is documented by all those who knew her. Her reports from Taos, however, exude an unmistakable whiff of revenge. Georgia's appropriation of Tony, together with her insistence that Mabel be spared no agony of suspicion, was a way of asserting continued sexual power over the woman who was both her competitor and, briefly, her lover. By exacerbating Mabel's jealousy, Georgia paid her back for preferring Tony, for ultimately choosing, as most bisexual women do, a man. Finally, the glitter of sadism in the letters suggests O'Keeffe's determination that Mabel not be spared a single throb of the pain Alfred caused her; if she could not have Stieglitz to herself, Mabel was not going to enjoy exclusive rights to Tony.

Whatever the writer's motives, the letters produced the intended effect. If Mabel was suspicious before receiving Georgia's balm, she was now desperate.

As it happened, Stieglitz was still more wretched at Lake George. Alone for much of the time since his arrival at the Hill in May, he wrote to Mabel on July 4 to tell her that they had something in common; he concluded by describing himself as all but destroyed by his present sufferings.

Mabel took these remarks as confirmation of her worst fears: Alfred had heard gossip from Taos. The common source of their pain was their betrayal by those they loved most. From her hospital bed in Buffalo, Mabel wrote Alfred a series of despairing letters. Respecting his refusal to name names, she went beneath the immediate cause of their anguish to its origin. Architects of their own sufferings, she said, she and Alfred had in common "their damned ego." Blinded by ego, they both suffered dangerous delusions, the most harmful being that they were helping people when they were merely playing with them. "Suffocating the Self and usurping the whole creature, the ego is the cause of sickness and death," Mabel wrote.

At the moment, their pain was caused by injuries to that self: "You & I—Stieglitz—are suffering from drooping egos. Maybe we have had

blows to weaken the thing or maybe only age causes it to falter." In either case, Stieglitz was lucky: recognizing himself to be a broken man, he could be healed. "You *can* be born again," Mabel concluded with evangelical fervor, "[and] give a chance to that Self who loves all things without any thought at all of Stieglitz."[41]

Alfred was not moved by these inspirational words. Nor was he pleased to have been included in Mabel's diagnosis of ego sickness—especially its symptoms of deflation or drooping. His brokenness was merely loneliness, he assured her. Moreover, he had, literally, transcended his pain by chartering a small passenger plane (requiring him to pay the fare of the three absent passengers) and flying to New York. In the thrill of flight his anguish had turned to ecstasy. Coming down to earth, he had found Mabel's letter and four wonderful letters from Georgia confirming that, whatever separated them, at their hearts' core they were one. As for Mabel's conflict between self and ego, his troubles had always come from trying to reconcile the self that must mediate the world with his true "Self that was selfless and all giving. . . . In that we differ greatly," he informed Mabel. Then, with a dig at the frustrated muse's yearning to be an artist, he pointed out: "My photographs—the Equivalents—are what that Self is—as Georgia's paintings are what she is." Unlike Mabel, Georgia was "chaste."* She created, Mabel destroyed. Mabel's real problem was that she was too rich, he concluded.[42]

ON JUNE 19, Beck learned that her stay must end sooner than she had hoped. Her sister, Ray, had been their mother's companion for the early part of the summer; in August it would be Beck's turn to keep their difficult parent company in Atlantic City. Beck was "furious to have what should be a complete experience broken into this way. Georgia and I should really be allowed to finish as we started," she complained to Paul.

Until Beck's summons from her family, the eight weeks she and Georgia had planned to spend in New Mexico had been extended indefinitely. Now, they still had five weeks left, but already there was an elegiac tone in Beck's description of their idyll. "We have had a beautiful relationship together and feel the need of nobody else—in fact, we get

* By "chaste" Stieglitz seems to mean "pure" and to be describing his version of sublimation: O'Keeffe's libido was channeled into art; Mabel's sexual energy was corrupted in manipulating and destroying people. On one level, this remark is getting back at Mabel for her comment that Alfred played with people. But his use of "chaste" and "chastity" is even more interesting as it seems to confirm that he and Georgia had had no sexual relations for some time prior to her departure.

ugly if anybody joins us that we are not crazy about even for the shortest time. . . . Nobody can ever take this experience and mutual sharing away from us, no matter what happens—even if the relationship itself changed," she wrote to Paul. She was sure that Georgia cared as much for her as she did for Georgia. More hope than confidence, though, charges her recital of the plans they made. Georgia "speaks all the time of getting a large car next spring & our going off together again in it. We also have in mind trying to find a little house somewhere near New York where we can retire to."[43]

Not long ago, she and Paul had talked of finding just such a cottage. Like the child they would never have, the time for a house of their own had passed. Now she begged Paul to tell her whether she really had to come home: "Meantime, I have five more weeks of delight & maybe something will come up that will not break into this enchantment."

Paul proposed no alternative and a few days after receiving Beck's letter, he visited Stieglitz at Lake George, accompanied by a new friend. Harold Clurman was founder, producer, and director of the Group Theatre, and his vision of a theatrical community was closely related to Stieglitz's vision of 291. The principal difference between the two was political. The Stieglitz vision of art was unengaged and aristocratic. In founding the Group Theatre, Clurman was impelled by a left-wing populist ethos that aspired to dramatize the harsh social realities of American life. The Group and Clurman had appeared at a turning point in Strand's life: together they had begun to provide him with a new father figure and family allied with a changing political awareness.

Clurman and Stieglitz already knew each other slightly; along with Strand and Dorothy Norman, Alfred was an associate of the Group from its experimental beginnings. This trip to Lake George marked the transition in Paul Strand's life: he was about to present his new father to the old.

Driving from Connecticut, Strand and Clurman had planned only an afternoon stopover at Lake George. They found Stieglitz's state on their arrival so alarming, however, that they decided to stay the night.

In a hysterical filibuster, described by Clurman as "part lament, part harangue," he raved on for eighteen hours, nonstop. Sleep provided no escape.

"As we retired for the night," Clurman recalled, "the lights of the house still blazing . . . , Stieglitz came to our room with us and stood over our beds, continuing his monologue. . . . The immediate cause of this verbal flood was jealousy," Clurman immediately realized, "although Stieglitz would have been appalled to hear such a gross word applied to an emotion that was consuming him utterly."

Already dispirited and lonely in O'Keeffe's absence, Alfred had just received a letter from Georgia detailing Tony Luhan's charms and speaking of the "physical thrill she felt in the Indian's presence. This struck Stieglitz as tantamount to a confession of infidelity," Clurman recalled. His guests did not disagree.

Becoming ever more hysterical, Alfred read aloud to his by now exhausted visitors the most wounding sections of Georgia's recent letters to him, along with copies he had made of his letters to her. (On one day alone, O'Keeffe received fifteen despairing letters from Alfred, she told Mabel.)

Alfred rushed to the telephone to call Taos. "After hanging up he would then remember an inadvertent remark he had made and write her another letter about *that*." He wept uncontrollably.

Clurman was both horrified and fascinated by such shameless outpourings of grief and jealousy—in front of a virtual stranger. In the throes of a stormy love affair (and later marriage) with the actress Stella Adler, the glamorous young producer was a famous womanizer. Always a cool cat, he found "something absurd as well as poignant in the whirl of words that poured from Stieglitz. Yet I was elated that an old man* (I was less than half Stieglitz' age then) could get so wrought up about a woman!"[44]

Accustomed to Alfred's operatic despair, Strand would have been less shocked by the histrionics than by the act that preceded their visit.

A few weeks earlier, in a state of crisis brought on, he told friends, by the closing of the Room, O'Keeffe's abandonment, and the emptiness of the farmhouse, Stieglitz, aided by the hapless Zoler, had carried out an orgy of destruction. In an enormous bonfire whose flames lit the sky, he burned books, magazines, clippings, back issues of *Camera Work*, along with thousands of prints and negatives.

Destroying the past, the blaze promised to cauterize the wounds of the present. To Ettie Stettheimer and other friends, he described the material "cremated" in those seven hours variously as the "diapers of my children" and the "dreams of youth." There was nothing subtle about the connecting imagery.

BECK'S IMMINENT return East precipitated the summer's final crisis. Ever more tormented, Alfred continued his daily avalanche of letters to Georgia, and in the first weeks of July it began having its effect. Feeling guilty and seriously concerned about his state of mind,

* Stieglitz was then sixty-five.

Georgia almost decided to cut short her stay. Then, abruptly, she changed her mind. Her explanation named Beck as the culprit.

As intimate witness to the happy changes that had taken place in Georgia—her improved physical and emotional well-being and her pleasure in driving, horseback riding, and camping in the country she loved—Beck had raised the question: Should Georgia come back at all? As for returning to Alfred, Beck had apparently pointed to the restrictions he placed on her physical freedom (hadn't she been afraid to tell him about learning to drive?). But the clincher in her argument to persuade Georgia to remain in the West was a remark Stieglitz had made to Beck early that spring. He had never loved anyone, Alfred had told Beck.

Whether Georgia was as stunned and distressed as her letter to Alfred suggested or whether she used his confession, along with Beck's other arguments, to justify doing what she wanted to do, Beck became the scapegoat.

While acting as companion to her mother on the Jersey shore, Beck was bombarded with torrents of abuse and insult in Alfred's familiar hand. Moving from general accusations of her weakness, blindness, and stupidity, he detailed his own forbearance at her dishonesty, hypocrisy, and, now, disloyalty. As evidence of the three last vices, he did not fail to mention Beck's betrayal of Georgia with him. As to his never having loved anyone, couldn't Beck see that, on this occasion, he had been waiting for her to say "Not even Georgia?" Instead, her eyes had filled with tears and she had said nothing. Yet another proof of her obtuseness!*

Paul's daily bulletins from Taos, with Beck reporting on her idyll with Georgia, had not disposed Paul to defend his wife. Quite the reverse. His letters to Alfred were filled with abject apologies for the mess Beck had made, as one would apologize for the destructiveness of a very young child. He had not realized that Beck was so weak, so confused, so desperately unhappy. They must all three try to help her.

Beck was childish. Her infantile qualities were welcome as long as they were a foil for the others, feeding their needs. Her childishness allowed Paul to feel mature, Alfred to feel worshipped, and Georgia to dominate. Now, however, Beck had done the unforgivable. Like a child, she had blundered in and told the truth.

* The question remains: Did Alfred suspect that Beck and Georgia were lovers? Nothing in his letters to Beck suggests that he consciously entertained this possibility. Yet the intensity (even for Alfred) of his rage points to a level of jealousy and fear of Beck's "influence" (Alfred's word) hard to justify except as unconscious expressions of sexual rivalry.

Unable to stand the Hill any longer, Alfred flew to New York on August 2, staying at the Biltmore. There he received a telegram from O'Keeffe reassuring him of her love and announcing her plans to return. Overwhelmed by relief and joy, zooming toward his manic peak, he fired off a round of letters and telegrams to Beck. "Events" had exonerated her of any part in his troubles; realizing the terrible anxiety he had endured, she must forgive his unjust treatment and continue to confide in him; the "mess" had been essential for all of them to reach a new, higher level of understanding. *High* was certainly the operative word, in every sense.

Before leaving Taos, Georgia sent for her sister Ida to act as Mabel's private nurse. Ida was aghast at what she found when she arrived at the clinic in Albuquerque. Her patient was a drug addict, she reported to Georgia.

Georgia left for New York at the end of August without saying good-bye to Mabel, who remained at the clinic. She did not try to make logistical excuses for her failure to visit: in Mabel's present emotional state, Georgia wrote, safely back in Lake George, a brief visit would have been worse than none.

On August 19, Alfred flew to New York for the second time. He had no sooner arrived than a telegram from Georgia announcing her imminent return sent him scurrying back to Albany. Her train pulled in at 6:10 P.M. on August 25. Their reunion, according to Alfred, was more marvelous than he could have anticipated. Georgia was tanned and radiantly beautiful, Alfred reported; she was amused by his new passion for flying and indulgent of his attempt to keep up with her by learning to drive.

Writing to Mabel in the next weeks, Georgia elaborated on her joyous homecoming and renewed happiness with Alfred: it was marvelous to be back with her "funny little Stieglitz"—so marvelous that she wondered how she could have stayed away so long.

Thanking Mabel for all she had given her, Georgia described the greatest gift of her four months in Taos as self-knowledge. She was now able to love others because of—not in spite of—the failings that made them human. In those weeks of perfect happiness, she had come to see life's greatest pain and pleasures as one. Her gratitude for such revelation was nothing less than a state of grace.

She and Stieglitz felt reborn in their love for one another. Their new life together was about to begin.

TWENTY

A Cathedral and a
Laboratory

ANSEL ADAMS, *Alfred Stieglitz at An American Place,*
(early 1940s).

GEORGIA HAD BECOME a westerner and, impatiently, she awaited
the arrival of her beloved Ford on its way from Taos to Lake George.
The driver was Charles Collier, son of Mabel's great friend and ally
John Collier, the most effective commissioner for Indian affairs in the
history of that office. Young Collier, in his early twenties, was used to
being pressed into service by O'Keeffe. Before leaving Taos, she had
insisted, over his objections, that he drive her to the Grand Canyon.

More enthusiastic about an opportunity to see the East, Collier,
accompanied by a friend to share the driving, arrived from New Mexico
in high spirits, matching the mood of his hosts. Stieglitz had known
the senior Collier in the heyday of Mabel's Fifth Avenue salon. Like
Georgia, he was charmed by the son, so they promptly invited Charles
to join them on a motor trip to York Beach.

The celebratory excursion to Maine, beginning on September 18,

was the first—and only—time O'Keeffe and Stieglitz ever spent on holiday together away from Lake George. Even in the flush of a happy reunion, they significantly chose not to be alone. Collier was their companion on the road, and their hosts were the ever-hospitable Schaufflers, now keen to hear Georgia's experience of the Southwest and to meet a young man raised in the region they knew and loved.

Either before or after their few days in Maine, Stieglitz took out his camera and began photographing Georgia again. In these prints, the beauty and radiance that Alfred saw as she stepped from the train in late August seems to have faded. Owing perhaps to overexposure to the sun, her skin looks coarse and leathery; deep furrows curve from her nostrils to form parentheses of age around her mouth, which is set in a tense line. Even wearing a puckish expression (eyebrows raised, closed lips tilted upward in amusement), Georgia seems to have aged a decade in less than a year: there are bags under her eyes, whose lids and outer corners droop markedly. Standing in a doorway at the Hill, she has one hand on her hip in a gesture of defiance; the other arm and hand, fingers outspread, press against the door frame as though for support.

A barrel containing mementos of her four months in Taos arrived when they returned to the lake. She lovingly unwrapped her treasures of cattle skulls and bones from their protective layers of paper flowers. Ledges and shelves at the farmhouse became an ossuary of whitened skeletal remains and dark, empty eye sockets. Stieglitz did not find the new decor to his taste, and he was furthermore incensed by the sixteen-dollar freight charge on the barrel and its contents, which arrived C.O.D.

IN THE LAST week of October—starting on the afternoon that would come to be known as Black Thursday, the twenty-fourth—the stock market began to break. In that one day, three billion dollars disappeared by closing time. Two weeks later, twenty-six billion dollars—forty percent of the value of all stocks listed on the New York Stock Exchange—had evaporated into thin air, "like a conjuring trick," noted economist Caroline Bird.[1] Much worse was to come. Amid the shock, fear, and confusion of those first weeks, one message seeped through the national consciousness. The Twenties were over; their convulsive climax ushered in the longest depression in the nation's history, whose toll in human suffering has yet to be calculated.

Most of the losers during the first days of the crash were small investors and high fliers. Stieglitz's income from stocks, which hovered

around three thousand dollars annually,* diminished but did not disappear. Most probably, the losses he sustained in the market were compensated for by family members with more financial cushion. The majority of the solidly well-off, historians of the Depression now agree, got poorer only on paper, including collectors who continued through the decade to buy O'Keeffe paintings.

On November 7, Alfred and Georgia were back in the city. Moving from the unspoiled remoteness of Lake George to the twenty-eighth-floor fastness of the Shelton tower, they were insulated from evidence of spreading disaster. If either observed bread lines, soup kitchens, or friends from the financial world selling apples on street corners, their reactions are not recorded. One rare Stieglitz comment on the Depression took the form of a bad guess: he was sure that the election of Franklin Roosevelt in 1932 would lead to greater calamity to come.

Frugality—one of the few habits they shared—stood them in good stead. Their way of life was so modest that they could scarcely have cut back in any area, short of moving in with another Stieglitz relation. The Shelton was cheap. When they did not avail themselves of the cafeteria or dinner invitations from friends and family, they favored inexpensive restaurants like Childs', a chain featuring hearty fare combined with functional decor. Occasionally for Sunday lunch they went to Longchamps, a more expensive restaurant whose several branches in midtown Manhattan are still recalled nostalgically by New Yorkers for their alluring art deco interiors of red and black enamel traced with futuristic chrome. There, Brett remembered, she tucked into roast duckling while Georgia contented herself with a bowl of soup.

As to wardrobe, both Alfred and Georgia insisted on clothes of good quality, bought to last. Even in prosperous times, Alfred could hardly be induced to part with worn-out favorites: the pepper-and-salt tweed suit, cardigan sweater, porkpie hat, high-topped shoes with elastic sides—all had to be replaced with the identical article, including the loden cape that, more rarely, traveling friends were commissioned to buy in Germany. Two decades later, Georgia was still issuing orders from New Mexico for the cotton undershirts and drawers she had always worn—ever harder to find in the age of nylon.

Evidence that the Depression made little difference to the rich was soon forthcoming. In early November, the Museum of Modern Art

* Before the crash, it took surprisingly little money to be rich. In 1929, ninety-five percent of Americans had annual incomes under six thousand dollars. With no personal income tax and no dependents, Stieglitz's earnings from investments were more than respectable, explaining why he continued to "think rich."

opened its doors on the twelfth floor of the Heckscher Building at the corner of Fifth Avenue and 57th Street—the hub of the art world. The "founding mothers" of the first institution devoted to contemporary art in America—Mrs. John D. Rockefeller, Jr., Miss Lillie Bliss, and Mrs. Cornelius J. Sullivan—were "women of spirit, vigor, adventurousness, and, not unimportantly, of commanding wealth."[2]

From the beginning, Stieglitz saw the new museum as the enemy. First, "the ladies," as they were known, aroused the full force of Alfred's misogyny, exacerbated when the women in question were rich and disposed to spend money on art without his guidance. Stieglitz, observed Claude Bragdon, the Boswell of the Shelton, "is for keeping the Woman under, unless he himself lifts her up and creates her."[3] Reading the list of winners of the newly created John Simon Guggenheim Foundation fellowships a few years later, Alfred was outraged to learn that five out of eight grants to artists went to women; when you added to this gloomy statistic the number of new galleries being started by women, you had some idea of the "state" of American society, he wrote to Dove somberly.[4] As with all forms of bigotry, both men rationalized their misogyny by exceptionalism: like "white Jews" or "white niggers," the women they loved were seen as exceptions and, as such, exempt—supposedly—from their general hatred and fear of the female.

Alfred justified his hostility toward MoMA as an institution controlled by rich women with other, more legitimate-sounding criticisms: the internationalist bias of the new museum in general and its tropism toward the school of Paris in particular. The appointment of the brilliant young art historian Alfred H. Barr, Jr., as curator of painting was, for Stieglitz, a signal that American artists would be relegated to the status of provincials. Stieglitz's bluff was called, however, when plans for the second exhibition got under way. Scheduled for late November 1929, "Nineteeen Living Americans" invited Demuth, Marin, O'Keeffe, and Alfred's apostate disciple Max Weber to submit five paintings each.

Still critical, Alfred could soon add charges of favoritism to the museum's other sins. When he had discussed the show with trustee A. Conger Goodyear, Stieglitz had asked the Buffalo industrialist, "Do you want the best Marsden Hartleys?" Goodyear is said to have replied, "We only want the works of men owned by the trustees.* That's the only way we can run this museum."[5]

Alfred's anger over the exclusion of Hartley and Dove masked a

* Frank Crowninshield and Duncan Phillips, both trustees and O'Keeffe patrons, would have ensured her inclusion in the exhibit. But although Phillips already owned several paintings by Dove, his interest was not enough to persuade his fellow trustees of the importance of this artist.

deeper source of animus. Worse than neglect, the fledgling museum's efforts to do right by living Americans—including Stieglitz artists—constituted a threat to his control. Now that he had declared his small group to be a fixed canonical number, representing all that was "alive" in American art, co-option of his artists by a rich, powerful institution meant that he had outlived his usefulness. MoMA's imprimatur rendered him a dead letter in the struggle for American modernism.

He should have been cheered, then, by bulletins that plans were moving ahead for his new assault on the art scene. Beck's fund-raising letter had gone out in June. Throughout the summer, while Alfred was at the Hill, Paul had devoted himself, with the help of Dorothy Norman, to finding the space and financing for a new gallery, to be called An American Place. Of the sixteen thousand dollars guaranteed by fall, Paul and Beck provided the seed money with a donation of twelve hundred dollars each; Jacob Strand and other friends offered over four thousand more. Three thousand pledged by Dorothy and Edward Norman brought the guaranteed funds (covering a three-year period) to ten thousand. Six thousand more came from the Stieglitz family and old friends of Alfred's such as Jacob Dewald.

Paul Strand took on the job of finding space that was suitable and affordable: he got in touch with rental agents, looked at listings, and checked back with Alfred, giving descriptions of what he had seen. He apologized to Stieglitz for being such a "greenhorn"; he had never rented anything other than a hotel room for himself (a revealing form of virginity for a man of thirty-nine who had been married for seven years). By the end of the summer, Paul found what all agreed to be the perfect space: a seventeenth-floor corner suite of rooms in a brand-new office building at Madison Avenue and 53rd Street.

In early September, as soon as Alfred and Georgia returned from Maine, the Strands, triumphantly bearing floor plans, arrived at the Hill. Overflowing with enthusiasm and ideas for the new gallery, they were stunned by Alfred's reaction. He was no longer willing to do everything, he insisted grumpily. The "young ones" must now take their share of responsibility.

Beck and Paul were astounded by such ingratitude. After all they had given—in money, time, and energy over the last years, combined with recent efforts during the hot summer months to secure the new space—they could not believe what they heard. Furious outbursts of anger exploded, fueled by long-simmering resentments and rivalries on both sides.

Long overdue, the Oedipal shoot-out had begun. The Strands

stormed off precipitately, only to find on their return to the city a letter from Alfred. As ever, he had been misunderstood. Of course, he appreciated all they had done for the cause. Simply, he no longer wished to continue in an official role or to have An American Place known as "Stieglitz's Room." The struggle must be continued by the young.[6]

With Beck as mediator, the Strands decided to allow Alfred's version of the misunderstanding to prevail. But the quarrel was the beginning of Paul's enlightenment—and the end of his role as adoring disciple. The overage rebel had been looking for a cause to justify his revolt; Alfred's thanklessness had provided one. Another was Paul's growing discomfort with Stieglitz's apolitical view of art. Strand was ready to dissociate himself from the photographs that were the target of Henri Cartier-Bresson's accusation "The World is going to pieces and people like [Ansel] Adams and [Edward] Weston are photographing rocks!"[7] The miseries of the Depression were moving Strand away from Alfred's insistence on the privileged distance of the artist, removed from the concerns of ordinary men and women.

O'Keeffe recognized in Strand the son's need to rise up against the father. "He was one of Alfred's children," Georgia said, "and he grew up. It seems when this happens it's usually necessary to turn against the parents."[8] She did not acknowledge Alfred's increasingly destructive attitude toward Strand's career: it was too threatening to her. He no longer confined his venomous remarks to sycophants like Seligmann. Following the publication of an article Harold Clurman wrote praising Strand's photographs, Clurman was shocked to receive a note from Stieglitz saying, "You would not have written as you did about Strand, if you had seen my work first." Clurman warned Paul that he must sever relations with Stieglitz or be destroyed. "Your instinct to break away was again a right one," Clurman wrote to Strand. "Unless you can be close to Stieglitz without being absorbed by him—as Marin can— he is not healthy. And you could achieve that state only by breaking away first."[9]

O'Keeffe didn't need to read Clurman's letter; she could have written it.

With the stock market continuing to hemorrhage throughout the late fall and early winter, Alfred had given his backers the chance to withdraw their pledges. None did, a measure both of their loyalty and of the economic reality: for another year, the Depression would spare all but heavy speculators. The Strand and Norman "A" list was still solid.

An American Place was a bright, new beginning. Best of all to

Georgia and Alfred, the corner suite looked the part. No more white cheesecloth tacked over dusty black velour. They were free to exploit the bare-bones functionalism of a new office building by leaving the rooms virtually as they found them, adding only paint, lights, and window shades. Georgia chose the high-gloss industrial gray that covered the concrete floors (always hard on Alfred's feet); walls and ceilings were white; and in the largest room, which functioned as the main gallery, steel ceiling beams plastered in white articulated the space, further defined rhythmically by three large windows at one end. Light was controlled by shades rolling upward from the window base and, from above, by an early do-it-yourself version of track lighting: large blue reflector bulbs fixed at intervals along the length of a beam. On the other end wall, two ceiling-height doorways led to smaller spaces. The room at the left became Alfred's office, and the opening to the right led to additional exhibition space. Immediately to the left of the entrance to the main gallery, a modest cubicle provided the most dramatic addition to Stieglitz's new headquarters: his first real darkroom in the city. At the Hill he had used the refitted potting shed, but Alfred's galleries had never boasted facilities more sophisticated than a sink.

On December 15, two weeks before Alfred's sixty-sixth birthday, An American Place opened its frosted glass doors to the public. The name of the gallery was an inspired complement to its physical simplicity, invoking an art that was native in spirit, equally removed from the mannerist-inspired localism of the regionalists and the precisionists' worship of the machine.

Celebration for Alfred, however, was unthinkable without reminders that the enemy was at the gates. Still smarting from MoMA's co-option of both "modern" and "American," Alfred introduced "the Place"—as it was soon called—with a loud Bronx cheer for the competition. Engraved on an ivory card was the following warning:

> *No* formal press reviews
> *No* cocktail parties
> *No* special invitations
> *No* advertising
> *No* institutions
> *No* isms
> *No* theories
> *No* game being played
> *Nothing* being asked of anyone who comes
> *No anything* on the walls except what *you see there*
> *The doors of An American Place* are ever open to all

Undaunted, thousands of visitors streamed into the dazzling brightness of the galleries for the opening exhibition of fifty Marin watercolors. Many were obviously curious for a look at Stieglitz's latest avatar. Others, ironically, were attracted by the publicity that his artists had recently received, thanks to MoMA's fulsome coverage. Alfred would soon have cause to crow: the museum's "Nineteen Americans" got a critical drubbing. Henry McBride did nothing but complain about the painters who were left out, such as his great friend Florine Stettheimer. He said nothing about the five pictures exhibited by his other great friend Georgia O'Keeffe. Back at the Shelton, Alfred was no doubt unable to resist a few I-told-you-so's to Georgia, especially when his opening Marin exhibit got all the praise that reviewers had withheld from MoMA's group show.

Writing to Dove in early January, Stieglitz raved over the austere beauty of his new headquarters, with its atmosphere of lightness, freedom, and purpose. A cathedral and a laboratory was the way Dorothy Norman described the Place. Alfred's need for enemies, however, required bad fairies at every christening. "The usual envy is about trying to destroy but fortunately it does not worry me," he wrote. Jealous tongues said the Place reeked of money, proving that he had been a millionaire all along; in fact, his capital was shrinking with every drop in the market.[10]

When Dove wrote to sympathize with Alfred's paper losses, he could no longer buy paint; he didn't have the twenty-two dollars he already owed for art supplies. At the same time that the Depression struck, the artist's only source of income—magazine illustration—had disappeared, a victim, ironically, of photography. By the first months of the new year, he and his wife, Reds, were desperate. They had no money and they were running out of food. "Would be glad to take anything edible for paintings at any value," he wrote to Alfred.[11]

As the Depression deepened, Dove's situation became perilous. Once again he wrote Stieglitz: "do not want to worry you about all this when it is so hard for you there. . . . Can stick it out for another week and then if neither Phillips nor Paul R[osenfeld] can do anything, the food stops."[12]

Alfred's response to his friend's desperation is revealing. He personally advanced Dove money, taking as collateral the artist's paintings. His checks were usually accompanied by a sympathetic note expressing his outrage at Duncan Phillips's many ploys for delaying payment for pictures already hanging in his Washington collection. At the same time, Stieglitz wrote to Phillips and Lewis Mumford (who had bought a Dove drawing for seventeen and a half dollars) to assure them that

there was "no special hurry" in paying the artist: checks should be sent to Stieglitz in care of An American Place, "at your convenience."

By continuing to control Dove's cash flow with a tight hand, withholding money and then providing just enough to keep him alive, Stieglitz literally maintained life-and-death power over "his" artist. Significantly, the only quarrel between the two men took place as a result of Dove's artless request to meet with Phillips; perhaps explaining his circumstances directly to the collector would expedite payments, he told Alfred. Stieglitz made it plain he would view any meeting between Dove and his patron that took place without him as a withdrawal of trust and the end of their friendship.

O'KEEFFE'S EXHIBIT opened at the Place in the first days of February. Despite Alfred's inaugural proclamation—"*No* formal press reviews," "*No* special invitations"—Henry McBride's article announced that he had encountered the reclusive artist at "the private view" of her new work.[13]

Most critics agreed with McBride, who had found the "piercingly white walls" of the Place, which had shown the Marins to great advantage, "not so fortunate for the O'Keeffe's." (Before her next show, Georgia repainted the walls, mixing the pearly gray shade herself.)

Nineteen of the twenty-seven pictures exhibited were New Mexican subjects, including five paintings of the dark crosses that "covered the landscape like a veil," as O'Keeffe described them to McBride.

"Intellectually thrilling" was McBride's response to this work; he titled his review of her show "The Sign of the Cross." He was, nonetheless, unable to resist an opening in-joke about the artist's relationship with her hostess: "Georgia O'Keefe [*sic*] went to Taos, New Mexico, to visit Mabel Dodge and spent most of the summer down there. Naturally, something would come from such a contact as that. But not what you would think. Religion came of it. What Mabel Dodge got, I have not yet heard."

"Anyone who doesn't feel the crosses, doesn't get that country," Georgia told Henry during their encounter at the preview. McBride's favorite, *Black Cross, New Mexico*, he christened "the Parsifal Cross." Theatrical, even cinematic, the frontal composition crops out the arms, base, and top of the wide cruciform, as in a close-up. It might be the view of one about to be crucified, like the member of the outlawed Penitente sect chosen to reenact the Passion of Christ in the foothills of the Sangre de Cristo Mountains.

Instead of bringing back "the frivolities of the tourist colony at Taos,"

McBride commended O'Keeffe for adopting "so quickly the Spanish idea that where life manifests itself in greatest ebullience there too is death most formidable."[14]

Other critics, though, found suspect precisely the speed and facility with which the artist assimilated this alien culture. "An unpleasant hysteria," according to one writer, characterized the crosses.[15] Ralph Flint, a Stieglitz protégé, was troubled by O'Keeffe's decorative use of the most universal symbol of suffering. "She strives mightily for effects of a definite cosmic intent and while achieving patterns of undeniable appeal, she tempers her material to an often incongruous passivity by the mildness of her thrust," Flint wrote.[16]

Along with the other Stieglitz artists, O'Keeffe disdained the painting of regionalists Thomas Hart Benton, Grant Wood, and John Steuart Curry. (Just thinking about a Curry mural, she later said, "makes me tired.") As modernists, the Stieglitz artists found regionalists' social content and stylized treatment of subject matter banal and regressive: the Ashcan School gone rural. After hyping the uniquely American character of his artists, Alfred was particularly outraged to see the regionalists making off with his own brand of aesthetic boosterism.

Suddenly it was Stieglitz and his artists who began to seem out of sync with the times. Culturally, the Depression began a soul-searching scrutiny of American society; artists were rewarded who explored the lives of their fellow citizens. Modernists were reviled as decadent European imitators, a favorite diatribe of Thomas Hart Benton, who, after a youthful abstract period in Paris, became a born-again provincial philistine in Kansas City. An energetic polemicist, he sprayed attacks on modernism in every magazine of the coming decade. Stieglitz, unsurprisingly, was his favorite target.

For Alfred, the regionalists posed a double threat: they were stealing his "American soil" rhetoric with a realist vengeance, exalting farmers and folk heroes along with the land. Worse, these painters were capturing the market, commanding the highest prices ever paid for work by American artists.

Georgia especially was not insensitive to whatever it was they were doing right. As soon as she began working in the Southwest, O'Keeffe borrowed significantly from the regionalists' simplified treatment of nature as "stock footage." The appealing patterns noted by Flint aptly describe the landscape of *Black Cross*. Rows of identically spheroid hills, like the tops of hard-boiled eggs, colored gray, lavender, and purple, recede toward a horizon line of flame and yellow bands. What worried Flint and others was a disparity between this "passive" formula and the grand theme. Benton's farmer was not diminished by the stylized mean-

der of furrows dug by his plow; the tragedy of the empty cross, however, appeared trivialized by the visual clichés of flaming sky and lollipop mountains.

*Portrait of a Farmhouse** was one of the few paintings of Lake George to appear in the exhibit. Now that she was no longer captive on the Hill, Georgia could do justice to the spare elegance of the early Victorian dwelling. Her flat treatment of the Dutch door has the geometrical sobriety of an architectural rendering: Grant Wood's *American Gothic* without people. Cool tonalities of pale gray, blue, and green for the painted clapboard, carved cornice, and window glass contrast with the white lower half of the door and the wide black shutters. Blank and opaque, the window within the door is bisected by a black bar. If there is a room behind this facade, it stands empty; no one could look in or out.

LESS THAN a month before the opening of her show in early February, Georgia's brother Alexius, the only one she cared for, died suddenly in Chicago. He left a young daughter and a wife pregnant with their second child. Georgia's reply to her sister-in-law's news of loss and grief is a curious expression of condolence. "I was sorry to see Alexis [*sic*] marry— I felt it would make trouble for you," she told the widow.[17] As she had not known Betty O'Keeffe before she married Alexius, the remark suggests a belief in the damaging effect of marriage on women generally or a suspicion of a taint in the male line of the family.

Anita now replaced Ida as the sibling closest to Georgia. After dropping out of the University of Virginia, Anita's husband, Robert Young, had moved from success to success. In 1928, Young was assistant treasurer of General Motors and the president's protégé. When Young predicted that the market would collapse the following year, he and his boss quarreled. Young resigned to pursue his real vocation: stock speculator and manipulator. He went off on his own and, by selling stocks short, made a fortune in the 1929 crash.[18]

The Youngs moved to New York with their young daughter, Eleanor Jane, setting up a lavish household in a vast Park Avenue apartment whose decor was characterized as "acres of velvet." In 1931, Bob Young bought a seat on the New York Stock Exchange, followed by houses in Palm Beach and Newport.

Georgia never cared for her brother-in-law, but she benefited immensely from his shrewd management of her investments. At the same

* Now in the Museum of Modern Art, the work was later called *Lake George Window*.

time, the Youngs were loyal collectors of O'Keeffe paintings, especially favoring the flower pieces that looked so well in the tropical light of Florida or the sun room at Fairholme, their Newport estate. Anita's social life in New York expanded with her husband's new millions, especially in a period when most fortunes were declining. Just arrived from Detroit, she welcomed her sophisticated and well-known sister into her new social set.

Georgia began moving in more glittering circles—without Alfred. Henry McBride spotted her at the opera several times, seated in the Harriman box with a new friend, Sybil Walker, an artist and illustrator. Daughter of Greville Kane, a millionaire collector of rare books, Sybil was married to society architect Alexander Stewart Walker, whose firm designed the branch offices of the National City Bank, among other corporate clients.

By spring, the effects of the Depression began to be felt everywhere. Each week, thousands more banks closed their doors; slowdowns in industry began the spiral of unemployment that, in another eighteen months, would reach the terrifying figure of forty percent. Lobbying had quietly begun for federal aid to artists who, at the same time, would be encouraged to produce socially relevant work. Stieglitz was horrified by what he saw as a reward for mediocrity. In Stieglitz's view, art was aristocratic and antisocial; the artist served his fellow citizens by realizing his privileged vision, available only to those open to its transforming possibilities.

These opinions, expressed with Alfred's usual truculence, confirmed the suspicions of detractors that he was a rich, reactionary fossil, a beached relic from the era of "art for art's sake" ready to walk down Fifth Avenue, if not Piccadilly, with an O'Keeffe Lily in his hand.

In a loyal effort to show that a younger working artist could share Stieglitz's ideological stance, Georgia agreed in March to debate Mike Gold, editor of the radical New Masses. Probably organized by the New York World (the only newspaper to report it in detail), this event was held at the Brevoort Bar, a favorite meeting place for the more solvent Village intelligentsia. Accustomed to haranguing multitudes, Gold (born Irwin Granich in Brooklyn) was emotional and aggressive; Georgia was impersonal and ladylike. She countered his rhetoric about the artist's obligation to oppressed peoples by claiming that all women were oppressed; therefore, any woman who was an artist was striking a blow for oppressed groups everywhere. Gold didn't buy that argument. He insisted on the chasm between middle-class and working-class women.[19]

Gold's blustering attack on the evils of capitalism—never more evident than in the America of the early 1930s—was based on a classic

Marxist argument: the few rise at the expense of the many. As one of the fortunate few, Georgia never connected her parents' slide into poverty with the current desperation of many families like the O'Keeffes, whose failing mortgaged farms were turning them into Okies, a new population of Dustbowl vagrants. Nor was she likely to have raised moral questions about her brother-in-law's fortune, founded on the exploitation of collective disaster. An individualist to the end of her long life, O'Keeffe was an unquestioning social Darwinist: the smart, the strong, the talented, or the lucky make it. The others don't. She did not admit to structural obstacles, in her own life or anyone else's.

Rural poverty, in particular, was too close to her own past to be confronted; she repudiated any suggestion that the American landscape presently bore accusing evidence of hard times. Asked about the genesis of her famous *Cow's Skull—Red, White and Blue* (1931), O'Keeffe recalled that the idea came to her as a joke, a send-up of her contemporaries who depicted tumbledown houses, grim farmers, gaunt livestock: "I had gone across the country several times, and I knew that a horse didn't look like a skeleton. I knew that America was very rich, very lush. Their idea of the American scene struck me as ridiculous. I started painting my skulls around this time."[20]

Like O'Keeffe's flowers, the animal skulls and bones were examined for symbolic content. Taken together, they were seen as elements in a *vanitas*: the mortality of earthly desires—eros and thanatos, love and death, or the death of love.

In the matter of bones, O'Keeffe's demurrals have the ring of truth. Like the Penitente crosses, they were not so much a symbol as an analogue for her subjective feeling of the Southwest; in particular, the quotidian presence of death spoke to her need to demystify. "I don't think of their being bones," she said. "It is my way of saying something about this country which I feel I can say better that way than in trying to reproduce a piece of it. . . . It's a country that's very exciting." Then, borrowing Stieglitz's term, she asked: "How can you put down an equivalent of that kind of world?"*[21]

Because her own commitment to modernism wavered, O'Keeffe did not address the formal elements of skulls that would hold special appeal for the modernist aesthetic. Nonetheless, her treatment of skeletal remains plays with the paradox of abstract vision and realistic observation that engaged, in different ways, Hartley, Dove, and Demuth. In

* Here O'Keeffe anticipated the view of many critics on the failure of her Southwest landscapes as art. Popular as the paintings continue to be, her efforts to "reproduce a piece of this world" have a literalness that has caused them to be compared to tourist posters.

O'Keeffe's bones, random patterns of decay play asymmetry against symmetry. Gradations of white, ivory, gray, and tan, characteristic of calcified matter such as bones or clamshells, invited abstract experiment with color as composition.

Skulls and bones were also favored elements in surrealist iconography. Although she could have seen works by European surrealists at Julien Levy's gallery a few blocks from MoMA, O'Keeffe's interests were antithetical to the concerns of such artists, archeologists of the unconscious, of random playfulness and elaborate intellectual jokes. Other artist contemporaries shared O'Keeffe's respect for for the "spareness, purity and blatant honesty of the structure of bones." As a young disciple in the arts and crafts movement, British designer and sculptor Eric Gill headed his list of "approved objects" with "bones, beetles and railway arches."[22]

In April, Georgia went to Maine by herself. Then, in late May, she spent several weeks at the Hill, accompanied only by Georgia Engelhard. "The blonde young thing," as O'Keeffe called her favorite, had dropped out of Vassar in 1926, a year before she would have graduated as a junior Phi Beta Kappa. Her reasons for leaving college remain unclear.[23] Her parents had agreed to support her while she tried painting, but the crash forced them to end their subsidy of her studio and models. Life studies had not inspired her; she could not seem to break away from a slavish imitation of O'Keeffe's style and subject matter, the result of being allowed to paint alongside her famous relative in the Shanty. Remarks on the resemblance of her work to Georgia's apparently came as a shock to the younger woman. Confused about her life and choice of career, she was at loose ends.

Together, the two Georgias planted the garden and opened the farmhouse. In the marshy soil near the Shanty, O'Keeffe found a patch of jack-in-the-pulpits. The six versions she painted of this plant are widely held to be the artist's most sexually explicit work. In the first and smallest study of the series, the composition is dominated by the thrusting central shaft of the jack, its shiny purple head emerging from a pale green sheath veined in dark pink. One writer has described this erotic emblem as a "love note painting for Alfred."[24] Possibly. It is also possible that the series constitutes a self-portrait, homage to the artist's assumption of phallic sexuality.

O'Keeffe's intimacy with the younger Georgia followed her usual pattern. The adoration of the acolyte began to pall. "Little Georgia" grown up was dull and ordinary, she told a friend. Well before Engelhard married a British businessman in the late 1940s, O'Keeffe had dropped her completely.

Stieglitz's relationship with his young nieces is the most troubled chapter of his biography. His passion for photographing female children and pubescent girls nude did not set him apart from many of his Victorian contemporaries, whether amateur photographers like Lewis Carroll or professional purveyors of child pornography. Most of Alfred's activity, in any case, would have taken place out-of-doors, where other adults could be present. His behavior in private with his young relatives was more problematic. According to the memoir of his grandniece Sue Davidson Lowe, this included sexual interrogation of his teenage "love" of the moment and the loan of sexually explicit novels, such as Zola's *Nana*.

Lowe acknowledged that "the parents and grandparents of all Alfred's postpubescent friends were discomfited, at one time or another, by the long hours their little girls shared with him." She was disapproving of relatives who tried to protect their children, seeing their efforts as prudish and shortsighted: "Those few who prohibited *tête-à-têtes* unknowingly helped their daughters and granddaughters to become adepts at clandestine rendezvous."

Enlightened parents, presumably, accepted Alfred's attentions to their daughters as a benign introduction to adult sexuality. "The experience for the young participants, although skirting some hazardous shoals, was a generally salutary rite of passage," Lowe concluded. "An exhilarating and harmless catharsis was had by all."[25]

Denial by other family members is the first line of defense against the possibility of child molestation. Given what we know about the sexual exploitation of children by male relatives and the ways in which families collude to protect the offenders, Lowe's explanation leaves many questions unanswered.

There was "one possible exception," Alfred's grandniece conceded, to the "exhilarating and harmless catharsis" enjoyed by Uncle Al and his young relations. If there *was* only one, Georgia Engelhard is the likeliest candidate. Clearly, her mother did not view either Stieglitz's or O'Keeffe's relations with her daughter as harmless.

In 1942, Agnes Engelhard, Georgia's mother and Alfred's younger sister, was interviewed by Nancy Newhall, a historian of photography who was preparing an authorized biography of Stieglitz. Mrs. Engelhard was deeply distressed about her daughter, then thirty-six. She had given up imitating O'Keeffe for desultory efforts at making Stieglitz "equivalents." She had lost all interest in seeing men and informed her parents that she did not plan to marry. Mountain climbing was her only passion. The significance of this activity as escape was not lost on either Newhall or Georgia's mother. It was her daughter's relationship with O'Keeffe

and Stieglitz, Mrs. Engelhard suggested, that had blighted the young woman's chances for a normal life. They had both played with her, taking turns being "horrid" to her one summer and smothering her with loving attentions the next.

Looking once more at Stieglitz's portrait of Georgia Engelhard as Eve, holding three apples to her adolescent breasts, a viewer might see another meaning. Alfred cast his young niece as the primal temptress, seducer of Adam, handmaiden of the devil and cause of man's fall. This was the classic Victorian justification for sexually exploiting children. Irresistible to man's bestial instincts, their weakness, beauty, and innocence were a snare; they were not victims, but corrupters. Especially vulnerable to pedophilia are males who feel themselves powerless, those who fear the demands of women that they be men.

ALFRED SPENT a weekend with the two Georgias at the Hill. Following his visit, O'Keeffe returned to the city for another few weeks. Then, on June 17, she accompanied Stieglitz by train to Lake George. After depositing him there, she left immediately for Taos.

Through the late spring, she had been undecided about whether she would return to New Mexico. Alfred's distraught state the summer before had reverberated throughout their circle. She could have used Dorothy Norman as a perfect excuse to please herself, but that wasn't Georgia's way. She was not going to allow that insignificant young person to assume the importance of a large-scale weapon. She wanted Alfred's approval before she went West again. When he agreed, she felt as though he had made her the gift of herself, she told Brett.

She seemed equally undecided about where to stay in Taos. Following several rounds of negotiations with Mabel, it was agreed that Georgia would live and work at the studio but would take her meals in town. After one night, she changed her mind. "I smelled trouble," she declared later. With Mabel off on a trip, she moved to the Sagebrush Inn, a little way out of Taos. On her return, Mabel was furious, demanding that Georgia come back and stay with her, as she had agreed earlier. But Georgia stood firm, insisting that she couldn't work all day and then be with people in the evening. She promised that on a day when she wasn't painting, she would telephone and come that night. Now it was Mabel's turn to get huffy. One night when Georgia called, she was told: "You can't come. Tony's invited the peyote singers here and we have too many people."

Georgia had the last word, however. Tony had not been informed of Mabel's snub. He came by that evening to pick Georgia up. When

she told him what Mabel had said, he came into her room and sat down on the rocking chair in the corner. " 'I go to lot of trouble, get peyote singers,' he said. 'She no invite my friend. I not go.' He never did go," Georgia recalled. "He sat there all evening, rocking in the corner."[26]

Not that O'Keeffe claimed celibacy or even solitude as a requirement for her art. During the winter, she had written another of her fond yet needling letters to Mabel. Thanking her again for all she had gained during the previous summer, she mentioned, for the first time, an intimate and transforming relationship with another "little man" (clearly not Tony) she had met in Taos while Mabel was in the hospital. He had recently visited New York. Even Alfred had liked him. No such private relationship would be possible with her hostess in residence across the alfalfa field.

O'Keeffe acknowledged her compulsion to torture Mabel. "I enjoyed worrying her, I must admit," she said. "One of my favorite ways to worry her would be to leave her house after a party and pretend I'd forgotten to say good-bye to Tony, and then come back and say good-bye to Tony."[27]

At the beginning of September, she said good-bye to Tony, Mabel, and Taos. It was her last summer there. Physical separation from Los Gallos had not provided enough distance from the gossip, quarrels, and jealous backbiting endemic to an insular, incestuous community of second-rate artists and rich dilettantes. As Georgia discovered, "there were not that many interesting people" in that "funny crew,"[28] a fact that also explained why the brilliant, destructive Mabel reigned unchallenged since the Lawrences' departure.

On September 5, Georgia arrived at Lake George primed for the sweetness of the previous autumn's reunion. Instead, she found Stieglitz in agony over his usual alphabet of aches and pains—from arthritis to neuritis. Immersed in pills and potions, he expended whatever energy was left from his own ailments on worry over Dorothy Norman, awaiting the birth of her second child.

Alfred's erotic fascination with the process of pregnancy and the nursing mother was matched only by his fear of childbirth itself. The death of his favorite sister following days of labor, Emmeline's terror prior to Kitty's birth—nothing in his experience prepared him for the possibility of a normal event. Enacting the couvade of the tribal father-to-be, he promptly added severe stomach cramps to his other ills, in empathetic labor with his beloved. Following the safe delivery of Andrew Norman in November, Alfred's symptoms disappeared. Leaving Georgia at the Hill, he made a two-day trip to town, ostensibly to supervise repainting the Place but in fact to reassure himself of Dorothy's recovery.

By the time he returned to Lake George, there was only a week left to be alone with Georgia.

BEGINNING IN 1930, Alfred put his new darkroom to use. Shooting from the twenty-eighth floor of the Shelton and the seventeenth floor of 509 Madison Avenue, he produced a series of cityscapes. In a larger sense, the new sequence continued Alfred's ambivalent dialogue with the modern city that he had begun in 1915 with photographs taken from 291 and Agnes Meyer's Modern Gallery farther north on Fifth Avenue.

In the earlier series, shot from the fourth floor of a brownstone, the photographer found poignant metaphors for his conflict of old and new, permanence and change, progress and destruction. In the shadow of new commercial construction, evidence of human life and even of nature survive in Alfred's poetic rendering of lighted apartments, laundry lines, and the hardy luxuriance of a plane tree that grows in Manhattan.

With the new series, Stieglitz is, literally, above it all. Although these prints have also been described as "equivalents"—metaphors of the upheaval and loss he experienced with Georgia's increasing need to get away—the photographer's distance from his subject seems as much psychological as spatial. Alfred's age, his retreat into a small, fixed circle of friends, and his absorbing passion for Dorothy Norman severed him from the life of the city.

Symbols of conflict no longer visually balance the human against the forces of technology. Only the latter survive—at least as seen from the twenty-eighth floor of the Shelton: two steel cranes form ominous pincers against the dark shadow of a neighboring building; a fragment of facade with an oeil-de-boeuf window and Renaissance-style brickwork (themselves Beaux Arts imitations of the architecture of humanism) is overshadowed by the gleaming elegance of soaring skyscrapers. Alfred would have been apoplectic at the comparison, but the new sequence owed most to Sheeler's 1920s series of Park Row taken from the height of the Equitable Building. Only Stieglitz's patches of sky, occasionally textured with wisps of cloud, differentiate his New York of the thirties from Sheeler's cool precisionist studies of form, light, and volume of a decade earlier.

A great admirer of Stieglitz the photographer, if not the man, Harold Clurman found a political as well as emotional chasm between Alfred's New York pictures and Strand's. Paul's pessimism and hatred of the dehumanizing forces of society would lead him to radicalism and revolution, his friend observed. Strand saw the modern city as the enemy,

something apart from himself, to be destroyed. "In Stieglitz, there is no revolt: always a spontaneous acceptance—unquestioning—of what is there," Clurman said.[29] Strand agreed.

"The difference between my photos and Stieglitz' is that he has hope and I have none," Paul told him.[30]

The Powder Room War

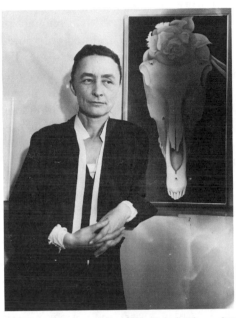

O'Keeffe with her painting *Animal Skull with Flower* (1931). By the
early 1930s, the austere painter, dressed always in black with a touch
of white, had come to be associated with her subject matter, the purity
of bleached desert bones.

IN THE SPRING of 1931, Alfred was, indeed, full of hope. His deepest
fear had proved unfounded; a second child had not curtailed Dorothy
Norman's involvement in his work or his life. Quite the reverse. Her
role in the Room had been largely confined to listening and learning.
With the Place, she entered into full partnership with Alfred. The
young matron who, by her own admission, knew nothing about money
a few years earlier now took over completely the financial and business
end of the gallery. She dealt with every problem of maintenance: water,
lights, paint, repairs. With her large acquaintanceship among the rich
and well connected, she extended fund-raising activities far beyond the
small circle of Stieglitz friends and family. When the time came to
renegotiate the gallery lease, she shrewdly insisted on much more fa-
vorable terms from a new owner than the naive Strand had accepted
from the previous management. The only areas outside her province
were sales, which Alfred alone was allowed to conduct, and hanging

the shows: that was O'Keeffe's domain. Otherwise, Georgia rarely appeared at the gallery.

Alone with Alfred, Dorothy was his new muse. "Whenever I photograph I make love," he had said. Once again, passion for a woman fueled the drive for work. He began a portrait series of Dorothy. Although Stieglitz had always insisted that photography could not be taught, he accepted Norman as his first and only pupil, lending her his Graflex camera. To his family gathered at the Hill and to Margaret Prosser in the kitchen he recited his new Song of Songs about the woman who was both mother and child. He sang her praises to Georgia, undeterred by her outbursts of rage. He couldn't help himself. Once again, he had found an intuitive feminine being whose many gifts—her beauty not least among them—inspired him to manic heights. Feelings, then words, overflowed.

In her dual role of student and subject, Norman lent herself, with passionate interest, to the photographic process, its art and craft. She learned as much from the hard work of posing for Alfred as from following his directions for exposure and developing. As presiding priestess of the Place, she welcomed every experiment with light and shade, patiently immobile or cheerfully changing position according to Stieglitz's exacting directions. As Alfred's lover, she gloried in the caress of his camera, the attentive eye of love that becomes art.

Rivalry, too, had to play a part in Norman's enthusiastic collaboration; Alfred's serial portrait of Georgia was already inscribed as canonical images in the history of photography, exalting his subject's face and body, along with the photographer's passion, for all time. As the only woman he had seriously loved since O'Keeffe, Norman would not have been human had she not hoped for equivalent immortality.

Inevitably, the photographs Alfred made of Norman must be compared with the O'Keeffe portrait. Two more disparate women could scarcely have been seen through any lens. The most memorable images of O'Keeffe fix an angular remoteness, a jealously guarded inner life, along with hints of a demanding, imperious sexuality. With Alfred's genius for conveying a sense of touch, his prints of Norman linger over the younger woman's yielding softness, her tender, open gaze. In compositions where her face fills the frame, Dorothy seems to consist entirely of curves: round cheeks, full lips, large, slightly popping eyes.

O'Keeffe clothed assumes a timeless and masculine severity. Dorothy dressed can appear almost a parody of 1930s femininity: in her snappy designer suit and stylish, elaborate hat, holding a telephone receiver to her ear, she could be auditioning for *His Girl Friday*.

In the famous photographs of O'Keeffe's hands, an erotically charged

choreography endows her double-jointed fingers with an animal life of their own. On seeing a print of Norman's hands, Charlie Chaplin is supposed to have exclaimed: "A prayer!" Thumbs together, fingers pointing downward, nails perfectly polished, Dorothy's hands become a folded water lily. (Suggestive of Steichen, this image is also the closest Alfred would ever come to the slickness of fashion photography.)

As art, any comparisons between the portraits of the two women will be invidious. In the spring of 1931, when he started photographing Dorothy, Stieglitz was sixty-seven. Thirteen years had passed since he had begun photographing Georgia. In that interval, Alfred had crossed the mysterious divide between the middle years and the beginning of old age. He could not have intended his record of Norman to parallel the encyclopedic ambition of the O'Keeffe portrait. But the disparity between the two is more than age, waning energy and time, or the differences between the models. The juncture of obsessive passion and genius at the height of its powers could not happen more than once in any artist's lifetime.

AFTER AGONIZING for most of the winter over her summer plans, Georgia decided to return to New Mexico, but for only half the summer. Between the indignity of giving up the Southwest to monitor Alfred's affair with Norman and leaving the field completely to her rival for months, her decision was a compromise. Just before she set off in late April, she wrote to Brett: "My feeling about life is a curious kind of triumphant feeling about—seeing it bleak—knowing it is so—and walking into it fearlessly because one has no choice—enjoying one's consciousness."[1]

Somehow, the declaration of stoicism and courage seems more *self*-consciousness than consciousness, more an attitude struck than feelings acted on. This was the Georgia she would like to be, not the woman who exploded in jealous rage at the very sight of Dorothy Norman.

That summer, she avoided Taos altogether, settling in Alcalde, a valley hamlet thirty miles to the south, toward Santa Fe. It was an area she knew from painting expeditions; she had always liked the pinkish sandy hills covered with clumps of piñon, like tufts on a bald pate. She rented a cottage from a friend, Marie Garland, whose H & M Ranch was another stop on the salon circuit between Santa Fe and Mabeltown. A rich, Radcliffe-educated Bostonian still handsome in her early sixties, Garland was a more benevolent, less ambitious version of Mabel. "A much married lady, statuesque and generous," a local chronicler described her, "Marie Tudor Garland Fiske Rodakiewicz writes a little

poetry, preserves a siren youth, and offers Delphic hospitality to artists, writers and mystics."[2] Her latest husband, Henwar Rodakiewicz, of mixed Polish and American parentage, was a glamorous filmmaker and photographer considerably her junior: most probably, the H & M brand was homage to Henwar and Marie. Earlier, Garland had called the ranch Swan Lake.

Georgia had made several excursions the previous summer with both Marie and Henwar. Like all women, she was susceptible to the seductive Henwar; she arranged for him to meet Alfred, who a few years later would show one of his films at the Place. And she found Marie's relaxed bohemianism inoffensive. Unlike Mabel's carefully orchestrated evenings with ethnic entertainment and clashing egos, Marie's parties followed a "go with the flow" order of merrymaking; they were bibulous, occasionally riotous, and only sometimes dangerous. Beck, too, returned to Taos that summer, staying at the ranch. At a party following the opening performance of Witter Bynner's play *Cake*, a wicked satire on Mabel, Beck, who had been drinking straight gin all evening, knocked into a male guest, starting a brawl that went on all night. When Georgia got up the next morning, she found the floor of the ranch living room carpeted in broken glass.

At the ranch, unlike Los Gallos, guests worked or played as they pleased. Georgia worked. She found that her Model A made a perfect mobile studio. She removed the front passenger seat, leaving it at the cottage; loosening the bolts, she could swivel the driver's seat and paint with her canvas propped on the back seat. The car's high roof allowed room for her largest canvases: thirty by forty inches. Light poured in the wide windows. After the confinement of the Shelton and her de facto banishment from the Place, the freedom and tranquility was balm and inspiration. She would never have two more productive months.

Early in July, just before Georgia's return, Alfred accepted Dorothy's invitation to visit Penzance, the Normans' large shingled house overlooking the harbor in the most fashionable part of Woods Hole. Whether Dorothy and Edward observed the same silence as Alfred and Georgia on the subject of "the affair" Dorothy, in her otherwise frank memoirs, does not say. She does discuss, however, Edward's uncontrollable outbursts of violence, which caused her to fear for the children's physical safety. Her invitation to Alfred would seem to have carried considerable risk, to say the least. While at Woods Hole, he photographed Dorothy nude in a field of daisies.

Back from New Mexico, Georgia continued busy and productive. Her only complaints to Beck concerned the family, not Alfred. Gathered in force, the clan was "at present a bit thick." She found laughing at

them to be the best weapon, she wrote to Beck.[3] Her sense of humor did not extend to the young; as always, Stieglitz children flayed every nerve raw, short-circuiting her self-control. One hot July day, the two small Davidson girls and two cousins, dressed as Indian scouts in fringed chintz leggings, braved the forbidden Shanty. Peering through the window, they were stunned to see O'Keeffe painting naked at her easel. More the "wild Indian" than her intruders, Georgia, still naked and screaming with rage, rushed out the door, whipping the air with her paintbrush to chase them away.[4]

A few days later, she was in the car headed for York Beach. Accompanying her was the genial Louis Kalonyme, one of the few Stieglitz loyalists, along with Rosenfeld, who managed to stay on good terms with both Alfred and Georgia—no mean feat of diplomacy in those days. Besides their shared affection for the art critic, Georgia and Alfred admired his talented wife, the monologist Angna Enters, and devotedly attended her performances. Kalonyme's official excuse for the trip was a visit to the Marins' place in Maine. In fact, he had been dispatched on this escort mission by Alfred, a move suggesting Alfred's anxiety and bad conscience about Georgia's state of mind.

Neither emotion caused Stieglitz to change his plans, however. Georgia had barely returned a week later when Alfred left for Woods Hole, followed by two days and a night spent with Dorothy in Boston. Among the pleasures of their trip was a visit to the Museum of Fine Arts to see Alfred's prints. His admirer Coomaraswamy had become a great friend of Dorothy, who was now beginning to embrace a passionate interest in Indian culture. If the charming scholar was still in town in the dead of summer, they would certainly have seen him. The days of discretion were over.

In October, Georgia returned to New York with Alfred for the ritual hanging of the Marin show. She then went back to the lake to paint. To take canvases to the framers, she made the four-hundred-mile drive a few times before the opening of her exhibit on December 23. She did not linger in the city. Alfred was now bringing Dorothy to the Shelton; the sharp-eyed Claude Bragdon had seen them leaving the hotel together on several occasions. On one of O'Keeffe's unannounced descents to the city, she had surprised them, in either the apartment or the Place. Master of the offensive strategy, Alfred flew into a rage; how dared she appear without warning? Effectively, she had been banished—first from the Place, next from the Shelton. By default, Lake George was now her only home. She was no longer a prisoner of the Hill, but a proprietor. Earlier she had ruffled family feathers by replacing a section of porch roof with a skylight; that had been for Alfred's work. Now she broke

through the wall of her bedroom, enlarging the space by the dimensions of a large adjoining closet. This was to please herself. She painted the floors of her room a green so dark it was almost black, laying down a blue and white Navajo rug; she tossed blankets over chairs, Mabel-style. Anyone who objected to the changes could—just object.

O'Keeffe's show opened at the Place two days before Christmas. Despite the sensation caused by the bleached animal skulls—especially in combination with the coquettish calico flowers—there were few sales, Alfred complained to Sherwood Anderson. Like a metastasized cancer, the Depression was spreading throughout the body of American life. Perhaps Georgia's new subject matter was, literally, too close to the bone. President Hoover had authorized federal subsidies to feed cattle; his free-market philosophy balked at doing the same for humans. Hunger was a grim fact of life, on city streets as well as farms. Bones showed through the skin of too many wan faces.

One hundred twenty-seven Stieglitz photographs went on exhibit at the Place in early February 1932—a forty-year retrospective of his work. Along with Alfred's new series of New York prints there were portraits of O'Keeffe spanning the decade since 1922 and recent portraits of Dorothy Norman. The speculation and scandal that had greeted intimate prints of Georgia in 1921 had focused on her as the adored lover; now, in cruel contrast to Dorothy's dewy youthfulness, Georgia, looking older than her forty-five years, was publicly displayed in the role of superseded wife. With portraits of only two women in the exhibit, Alfred made his point with brutal clarity. As reported by Claude Bragdon to Brett, Georgia had begged Alfred not to include his prints of her in the show; her objections were ignored. Other friends made known their distaste for the exhibitionism and cruelty manifest in displaying intimate photographs of O'Keeffe together with romantic close-ups of Norman. Florine Stettheimer had been so outspoken on the subject that Paul Rosenfeld had telephoned, "[taking] me to task for feeling the way I do," she wrote to Alfred in a cool note. She just wanted him to know she wasn't talking about him behind his back.[5]

At the Place, 1931–1932 was a season of couples. In March, Dove's new work was exhibited with nineteen watercolors by Reds Torr, his wife. Modest in scale, like the self-effacing artist, her personal organic abstractions were easily overshadowed. When Alfred declined to give her a one-woman show, her work was never exhibited again in her lifetime. The Doves were followed by the Strands, who were on the verge of separating. Both Paul's photographs and Beck's paintings on glass were done the previous summer in New Mexico, where they had been battling it out and finding consolation with others. Dorothy Nor-

man had never been fond of Paul and she found Rebecca vulgar and pretentious. She took particular exception to the way the Strands presented themselves as successors to Stieglitz and O'Keeffe: Beck slavishly imitated Georgia's style of dress, while Paul's photographs of his wife made embarrassing allusions to Alfred's portrait of Georgia. They were blissfully unaware, Norman later told Nancy Newhall, that their behavior made them a subject of scorn in sophisticated circles. Moreover, Alfred found Beck's work feeble; he had proposed the joint exhibit as a good joke on both of them. Paul may not have been aware that Alfred had conceived of the exhibit to ridicule them, but he certainly knew something was wrong.[6] "I hung the show myself, with Rebecca," he recalled later. "Stieglitz did not help hang it—not an iota, didn't say why. It was the strangest exhibition a person could have—no catalogue."[7]

The joint show was the definitive break between the Strands and the end of the twenty-five-year relationship that had bound Paul and Alfred. Years later, Strand recalled: "The day I walked into the Photo-Secession 291 in 1907 was a great moment in my life . . . but the day I walked out of An American Place in 1932 was not less good. It was fresh air and personal liberation from something that had become, for me at least, second-rate, corrupt, meaningless."[8]

WHILE COUPLES held sway at the Place, Georgia had welcome distraction from her own unresolved triangle. In March, the Museum of Modern Art invited her, along with sixty-four other painters and photographers, to submit a mural project for the inaugural exhibition in their new headquarters, the former Rockefeller house on 53rd Street. As the participants were aware, the exhibit was to function as a showcase to interest corporations and industry in the decorative potential of living American artists.

For several years, O'Keeffe had been keenly interested in obtaining a mural commission. The scale of a wall-sized painting was a natural outgrowth of her enormous flowers. Before setting out for Taos in the spring of 1929, she had written to Blanche Matthias in Chicago about her interest in doing a mural for the World's Fair, to take place there in 1933–1934. Georgia had already enlisted another friend, Ethel Tyrell, to lobby on her behalf. She suggested that Blanche and Ethel, who had never met, should combine forces to see what they could do. If their efforts proved successful, she would stop off and visit Blanche on the way to Taos; otherwise she wouldn't have time, she noted, with the famous O'Keeffe honesty. (As her friends made no headway with the

fair's art committee, Georgia and Beck saw only O'Keeffe's brother Alexius and his family when they visited Chicago.)

For the present exhibition at the new museum, the sixty-five artists were chosen by guest curator Lincoln Kirstein. The brilliant young arts impresario had just graduated from Harvard, where he had edited *Hound & Horn*, a distinguished literary periodical, and had organized, as president of the Harvard Arts Society, exhibits of contemporary work by artists well known on both sides of the Atlantic.

The idea behind the exhibition "Murals by American Painters and Photographers," according to Kirstein, was, in part to show that Americans could do as well in a genre now dominated by the great Mexican muralists Rivera and Orozco. More daringly, though, MoMA aimed to encourage American artists "to study the possibilities of this medium by inviting artists, few of whom had made their reputation as mural designers."[9] With barely six weeks to execute the projects, each artist was asked to submit a horizontal entry in three parts: a finished central panel to measure seven feet high by four feet wide accompanied by two smaller studies, approximately twenty-one inches high by forty-eight inches wide. The subject was to be "some aspect of the Post-War World." Unembarrassed about promoting the exhibit as a commercial showcase, the catalogue announced the hope that "architects and others responsible for the selection of mural designers will study these paintings and photographs with special reference to the possibilities of beautifying future American buildings through the greater use of mural decoration."[10]

This was just the opportunity Georgia had been waiting for: she was thrilled to be included. Predictably, Alfred was outraged. To begin with, he loathed murals—"that Mexican disease," he called them. But the real issue was betrayal; now it was his turn to be humiliated. *Creative Arts*, a journal that was read by the entire art world and that Alfred served as adviser, crowed at O'Keeffe's defection from the Place to MoMA. Furious, Alfred resigned from the board.

Georgia, meanwhile, was working at a ferocious pace to complete her submission in time for the May opening.

Titled *Manhattan*, her three panels are a curious anthology of influences, foreign and American, with elements foreshadowing her own work to come. In the small study for the left panel, O'Keeffe tried out Stuart Davis's style (an artist also represented in the exhibit), slicing her cityscape into layers of flat forms, dark against light. The right-hand section is a conventional precisionist view of recognizable landmarks such as the Chrysler Building. In the large center section, a pale windowless skyscraper, its dizzy tilt emphasized by two dark diagonals,

displays a significant debt to the Italian futurists. For the first time, however, O'Keeffe included a signature device that would loom large in her future work: two large camellias hover in the sky on either side of the towering structure, while a smaller blossom, its stem sticking out behind like the tail of an airplane, floats along the lower edge of the composition.

The muralists were mercilessly panned. "The exhibition is so bad as to give America something to think about for a long time," Edward Alden Jewell intoned in the *New York Times*.[11] Critical opprobrium was largely reserved for the radical subject matter of the social realists. One of their number, Hugo Gellert, an illustrator for *New Masses*, managed to send the trustees of the museum into a tailspin with a mural project entitled *Us Fellas Gotta Stick Together*, a quotation from Al Capone; the mural depicted J. P. Morgan, John D. Rockefeller, Sr. (the trustee whose former house was the museum's new home), President Hoover, and Henry Ford, together with Capone, who is holding a machine gun and is entrenched with the others behind a barricade of money bags. With "Commie-stuff"—as another outraged trustee called the work of social protest—creating scandal and grabbing publicity, contributions by apolitical modernists like O'Keeffe were ignored. One critic was quick to seize the schizophrenic nature of the exhibit. "The Show easily divides itself into two classes," Murdock Pemberton observed in *The New Yorker*: "a few serious artists, who really hoped that they would snare a contract, or at least interest the American architect in their potentialities, and [those] who saw only an opportunity to stick out their tongues and have a little prankish fun with their hosts."[12]

As one of the participating artists who had come to benefit from capitalism, not criticize it, Georgia realized her hopes. She did indeed "snare a contract"—for John D. Rockefeller's newest project.

Radio City Music Hall was the splendid art deco theater of Rockefeller Center, architect Wallace K. Harrison's complex of midtown skyscrapers that was to function as a "city of the future" in the heart of one mired in the ills of the present. The Music Hall's interior was entrusted to Donald Deskey, a leading industrial designer and decorator. Deskey's goal was to use the vast foyers and lounges, along with the audacious telescope-shaped auditorium, as a showcase of contemporary art and design. He planned to commission the best talent in fine and applied arts to create every visible element of the theater, from murals and sculpture to lamps and ashtrays. Deskey's only problem with this inspired patronage was the tight Rockefeller purse strings: fifteen hundred dollars was all he could offer each participating artist.

Despite the widening effects of the Depression in the spring of 1932,

a number of his first choices had to be wooed. As Deskey recalled, it required the mediating efforts of Edith Halpert of the Downtown Gallery to help him persuade O'Keeffe, William Zorach, and Stuart Davis* of the historic importance of the commission and its value as a showcase of their work. Halpert, whose husband, Samuel, was also a painter, had already been working quietly with Stieglitz, selling some pictures by his artists at her gallery. It would seem, however, that Alfred was not privy to her mediating efforts between Deskey and O'Keeffe.

O'Keeffe accepted Deskey's offer, under the terms of his standard arrangement with all artists, to decorate the walls of the second-floor powder room. No longer raw space, the eighteen-by-twenty-foot room had nine round mirrors, each six and a half feet in diameter, placed strategically around the walls, shrinking the space Georgia would have to fill while creating the illusion of greater size.

As soon as Alfred was told about the commission, he flew into a rage. This was worse than exhibiting at MoMA, whose imprimatur was undeniable. After all his years of effort to bring Georgia's prices to their present level, she had agreed to decorate—and for a pittance—the ladies' room of a theater! She had taken counsel with Edith Halpert, one of the upstart women gallery owners, and signed a contract with the hated Rockefellers—all without so much as consulting him!

A day or so after the contract was signed, Deskey recalled, Stieglitz appeared in his office. As O'Keeffe paintings sold for an average of five thousand dollars, he informed Deskey, Georgia's fee was "totally unacceptable." Deskey recalled: "I told him that the contract which had been executed was between O'Keeffe and the Rockefeller managers and was quite valid and that in my opinion, she was morally obligated to honor her commitment."

The next day, Stieglitz returned, to try another tack. O'Keeffe, he told Deskey, "was a child and not responsible for her actions." Since she had her heart set on being represented in the project, however, he, Stieglitz—as her business manager—agreed "to allow her to execute the murals *without fee* but her expenses for materials and other incidentals would amount to approximately $5000!"[14]

Alfred's attempt to save face in his defeat was no more successful than his earlier effort to bully Deskey. If Georgia had wavered before

* Stuart Davis's mural for the men's lounge of the Music Hall, *Men Without Women* (later removed to the Museum of Modern Art), has recently been shown to have had a crucial influence on a far more famous work of the twentieth century. Using a black and white newsprint photograph of the colorful Davis work, Picasso borrowed liberally from specific forms and general composition for his *Guernica*.[13]

accepting the commission, she now dug in, determined to honor her commitment. With this show of will, she had added humiliation of Alfred to her earlier defiance of his wishes; his rage knew no bounds. The violence of his attacks on Georgia shocked even friends who knew him well; he had never been heard to use obscenity as abuse before— still less to a woman.

The powder room decoration was a diversionary issue. Well before her participation in the museum's muralist show, Alfred knew that Georgia had been angling for just such a public commission. "She wanted a chance—and here it is," Stieglitz wrote Dove during the summer to explain Georgia's acceptance of the low fee for the Music Hall.[15]

Alfred's rage was a consequence of guilt. Following a pattern familiar from his first marriage, he began by denying any sexual impropriety with his lover and then turned on the betrayed wife. As soon as his affair with O'Keeffe had become public gossip, his letters to Emmeline were rife with savage accusations of the many ways she had wronged him. It was no coincidence, surely, that while Georgia was deciding to accept the Music Hall commission, Alfred's first exhibition at the Place included portraits of a dewy Norman side by side with an aging O'Keeffe.

In the middle of May, Georgia departed for the Hill, once again with the younger Georgia in tow, to work on the technical problems of the space she would begin painting in the fall. She planned to leave for the Southwest directly from Albany. Stieglitz arrived several weeks later for a farewell weekend. As soon as he returned to the city, he received a telegram from Georgia announcing a change of plans. She had decided not to go West that summer; the Music Hall project required visits to the site.

Disappointment added more fuel to Alfred's anger. His plans for a summer of freedom were suddenly foiled. He returned to the Hill, where his hectoring continued. Now he added another grievance to his diatribes against the vulgar, unworthy project that "prostituted" both of them. Georgia must stop snubbing Dorothy Norman. Using the same tactics he had tried with Emmeline and Kitty, when he insisted that their refusal of O'Keeffe's friendship was a rejection of him, he pressed Georgia to prove her love by sharing his (pure) affection for Dorothy. If she could not see that his happiness with the younger woman enhanced the lives of all who cared for him, perhaps she was no longer the same woman he had loved.

Alfred's alternating assaults on Georgia's obstinacy about the Music Hall and Norman needed backup. In July, reinforcements arrived at the farmhouse in the form of Paul Rosenfeld, critic Ralph Flint (who

had earlier weighed in as disdaining Georgia's decorative tendencies), and two new recruits to the Stieglitz inner circle: a forgettable and forgotten writer, Frederick Ringel, and Cary Ross.

A fair-haired Yale graduate from Tennessee, Ross was rich and intelligent, with taste and flair in matters of art. He was also too dysfunctional to do much of anything other than "odds and ends," recalled an associate at MoMA, where he had been working as a volunteer assistant to curator Alfred Barr. His behavior was so erratic that a number of his coworkers suggested he might be schizophrenic. He had tried several times to take his own life, including at least one suicide attempt at the museum.[16] His colleagues were more relieved than sorry when Ross shifted his allegiance from Barr and MoMA to Stieglitz and the Place.

Ross, Flint, and Ringel were dubbed the Sunshine Boys by Georgia Engelhard; they grimly dogged O'Keeffe's comings and goings, hammering away at the same arguments Stieglitz was continuing to make: her acceptance of the Music Hall commission and her unkind behavior to the sweet Dorothy Norman were both betrayals of Alfred's trust and love. When their eloquence failed to move O'Keeffe, they turned to "little Georgia," with equal lack of success. Only Rosenfeld, friend to both Alfred and Georgia, refused recruitment into the undignified carryings-on of Stieglitz's scrub team, who when they weren't trying to waylay the two Georgias followed Alfred about, addressing him as "Master."

O'Keeffe was matter-of-fact about the campaign against the Music Hall mural. "No one in my world wants me to do it, but I want to do it," she wrote to Brett.[17] She never alluded to the attack mounted on the other front: the situation with Norman was too humiliating for confidences. With one of Alfred's dismal trio apt to pop out from behind any tree, there was no freedom or peace of mind for work or pleasure. In late July, the two Georgias took off for the Gaspé, their first trip together.

Since seeing Strand's haunting photographs taken on a visit two years earlier, O'Keeffe had been longing to visit the French-Canadian peninsula of pristine villages untouched by modern civilization. Never a linguist, she rejoiced that her lack of French absolved her from having to be friendly with the natives. She refused to learn a word of Spanish for the same reason; all negotiations with the non-English-speaking population were handled through intermediaries.

Little Georgia was the perfect companion. Together they grumbled and giggled about the rough sheets and inedible food provided by local inns, where evil-smelling bearskins hung drying on porch rails. Like

Beck Strand, the adoring Georgia scouted subjects for O'Keeffe. According to Agnes Engelhard, it was her daughter who found the low whitewashed barn with its dark shingled roof. One of the artist's most beautiful paintings, *White Canadian Barn* (1932), with its crisp geometry and strong tonal contrasts of the simple rectangle against a flat blue sky, is also a tribute to Arthur Wesley Dow's foolproof design aesthetic.

They started for home with the American tourist's favorite Prohibition souvenir in their luggage: Canadian bootleg liquor. Unfortunately, border customs knew just what to look for. The bottles were confiscated and the two women fined.

Georgia's return to the Hill in early September was not an occasion of jubilant reunion. Resentments smoldered, waiting for a match. It came in the form of a notice from customs, addressed to O'Keeffe and acknowledging payment of the fine for attempted smuggling. Alfred, the teetotaler, was suddenly a rigid law-and-order advocate as well. He flew into a rage at this evidence of criminal behavior. Georgia exploded with wrath that he had dared open her mail.

On September 24, they returned to New York together, when Georgia made the first of several visits to the Music Hall to study the site. Apparently, she had decided to use the camellias from her winning Manhattan mural. Work on the building's interior was behind schedule, including the canvas that the Rambush Studios were to apply to the plaster walls of the powder room. Deskey was determined to keep the opening date of December 27. To escape tensions at the Shelton and its cramped working space, Georgia left for Lake George in October.

Months of argument by Stieglitz and the Sunshine Boys had taken their toll. Her confidence in her ability had been undermined, along with her enthusiasm for the project. Perhaps her flowers were too "tender" for the hard-edged art deco setting, she wrote Beck anxiously. She began worrying about the size of the area she had to fill, along with structural problems; the room's vaulted ceiling required that the wall decoration be continued above, involving shifts in both posture and perspective for artist and viewer.[18]

These were not real obstacles. If Georgia's emotional state hadn't been more fragile than her flowers, she would have viewed the problems as challenges. The Music Hall second-floor powder room was not, after all, the Capitol rotunda. It wasn't even the principal powder room! (Deskey had kept for himself the privilege of decorating the grander facility on the Promenade Lounge, which he turned into a mirrored art deco fantasy.)

Earlier, her anxieties had focused on the marketplace, on making art that would sell. Fear of failure as an absolute was a new and terrifying

experience. Her existential dread had nothing to do with the empty walls waiting for her camellia; Alfred's withdrawal of approval and love had undermined a vigorous confidence, a willingness to take risks, that she had taken for granted since her Texas years. Her stubborn defiance of Alfred had been, at least in part, repayment for his humiliation of her as a woman. His retaliation was worse: he had chipped away at her belief in herself as an artist. "I'll get Hell if I fail, won't I?" she wrote to Beck.[19]

On November 16, six weeks before the scheduled opening of the theater, the powder room was ready for painting. O'Keeffe, Deskey, and an assistant met at the site. As they stood inspecting the walls, a small section of canvas began to separate from the plaster, apparently from careless workmanship.

"O'Keeffe became hysterical and left in tears," Deskey recalled. "The next day, Stieglitz telephoned to say that she had had a nervous breakdown, was confined to a sanitorium and hence would be unable to fulfill her contract." As the failure to provide a timely working surface was the Music Hall's fault, Alfred threatened to sue if the management tried to hold Georgia to her agreement.[20]

Deskey immediately called Yasuo Kuniyoshi, a Japanese-American artist, who agreed to accept the assignment. His giant flowers still bloom, their stems twining graceful arabesques around the circular mirrors of the powder room, an unwitting tribute to Georgia's unexecuted work.

Alfred had lied; but this time, his lie was a self-fulfilling prophecy. Georgia had not been in a sanatorium when he spoke to Deskey; she had retreated to the Shelton bedroom. Her symptoms suggested either angina or severe anxiety; she was hyperventilating and complained of chest pains, and she had difficulty speaking. Rushed to the scene, Lee diagnosed Georgia's condition as "shock," prescribing the favorite Stieglitz cure of bed rest and bland diet. Within a few days, she had recovered sufficiently to travel to Lake George, where she threw herself into getting work ready for the season's exhibit at the Place. By December 10, she was back in New York with new and alarming symptoms, now commonly recognized as severe depression: insomnia coupled with chronic exhaustion, blinding headaches, and fits of uncontrollable weeping. Lee's backup of eminent specialists offered an entire medical encyclopedia of diagnoses: angina, kidneys, menopause.

"Heart," Alfred insisted to Seligmann, was the cause of Georgia's collapse. When she had recovered, Georgia described her symptoms to a reporter as "heart . . . and rashes."[21] Both these symptoms point to another possibility: venereal disease. With both Mabel and Tony suffering from syphilis, its transmission to O'Keeffe must be considered.

Stieglitz's photographs of the artists and writers in his circle became, in his own view, a collective portrait of the soul and conscience of American art.

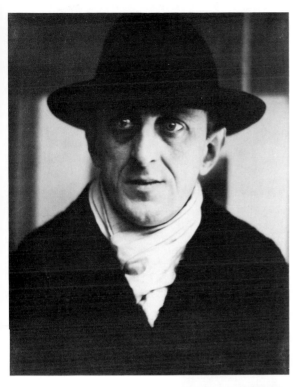

ALFRED STIEGLITZ, *Marsden Hartley* (1915–16). Alternating long periods abroad with efforts to find a home and subject matter in America, the Maine-born painter was the most clamorously unhappy of Stieglitz's "youngsters." THE METROPOLITAN MUSEUM OF ART, GIFT OF MARSDEN HARTLEY, 1938

ALFRED STIEGLITZ, *Arthur G. Dove* (1915). Dove's uncompromisingly tragic vision, expressed in organic abstraction or witty assemblages, made him the most difficult of Stieglitz's artists to sell. With the collector Duncan Phillips his only patron, Dove stoically accepted a subsistence living throughout his life in order to paint. COLLECTION OF WILLIAM C. DOVE

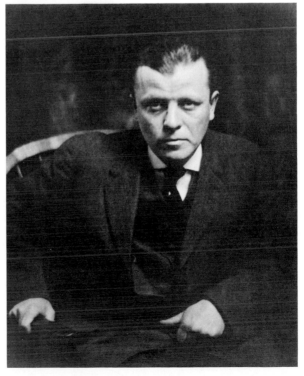

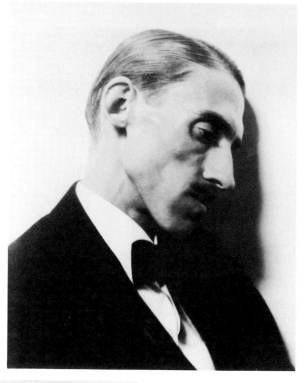

ALFRED STIEGLITZ, *Charles Demuth* (1922). Even ravaged by diabetes, Demuth remained the artist as dandy. A special friend of O'Keeffe's, the great still-life watercolorist would make forays from his home in Lancaster, Pennsylvania, to New York, where his binges would often require intervention by Alfred and Georgia. THE METROPOLITAN MUSEUM OF ART, THE ALFRED STIEGLITZ COLLECTION, 1928

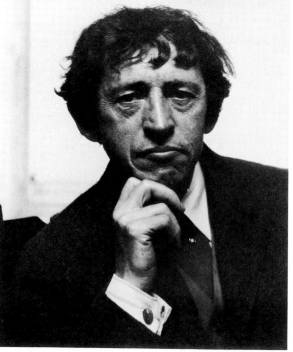

ALFRED STIEGLITZ, *John Marin* (1922). The fey leprechaun of Stieglitz's circle, Marin produced thousands of watercolors of the Maine coast and Manhattan skyscrapers. He owed his prodigious productivity to a tranquil domestic life in suburban New Jersey and on his Maine island, including only brief visits to New York and the intensity of the Stieglitz circle. THE METROPOLITAN MUSEUM OF ART, THE ALFRED STIEGLITZ COLLECTION, 1949

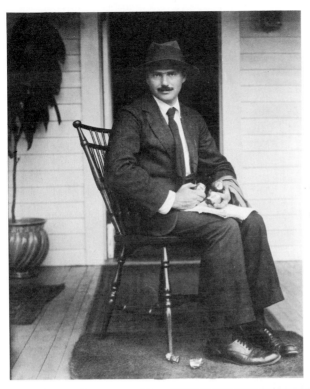

ALFRED STIEGLITZ, *Waldo Frank* (1920). Brilliant and egotistical, the critic and novelist had a stormy love-hate relationship with Alfred. Stieglitz's ambivalent feelings toward Frank are reflected in his portrait of the intellectual as urban Jewish misfit on the porch of a classical American farmhouse. THE METROPOLITAN MUSEUM OF ART, ANONYMOUS GIFT, 1928

ALFRED STIEGLITZ, *Sherwood Anderson* (1923). Another of Steiglitz's "fatherless sons," the novelist shared with Alfred a love of horses and women, along with the belief that American culture would be saved only when its artists mined native themes. PRIVATE COLLECTION

ALFRED STIEGLITZ, *Paul Rosenfeld* (1922). The melancholy critic idealized Alfred and Georgia as the perfect couple-as-artists. O'Keeffe claimed to object strongly to Rosenfeld's sexual interpretation of her work, but despite their friendship she seems never to have made known her displeasure to the writer himself.
THE COLLECTION OF AMERICAN LITERATURE, THE BEINECKE RARE BOOK & MANUSCRIPT LIBRARY, YALE UNIVERSITY

FLORINE STETTHEIMER, *Family Portrait II* (1933). The painter Florine Stettheimer and her sister Ettie, a writer, were friends of Alfred and Georgia, who were also regulars of the legendary Stettheimer salon. Florine's mannered rococo style of painting was reflected in the exotic atmosphere of the sisters' evenings, where the decor featured cellophane, gold lace, and a menu specialty called feather soup. COLLECTION, THE MUSEUM OF MODERN ART, NEW YORK, GIFT OF MISS ETTIE STETTHEIMER, OIL ON CANVAS, 46¼" × 64⅜"

EDWARD STEICHEN, *Katharine Rhoades*. This photograph of Alfred's earlier love as a wood nymph was probably taken shortly before 1920 at Seven Oaks, the Westchester estate of Eugene and Agnes Meyer. THE COLLECTION OF AMERICAN LITERATURE, THE BEINECKE RARE BOOK & MANUSCRIPT LIBRARY, YALE UNIVERSITY

ALFRED STIEGLITZ, *K.N.R.* (1923). Alfred's portrait of Katharine Rhoades, taken when she visited Lake George, transformed the tall stately beauty into a swaying poplar. VASSAR COLLEGE ART GALLERY, GIFT OF EDNA BRYNER SCHWAB

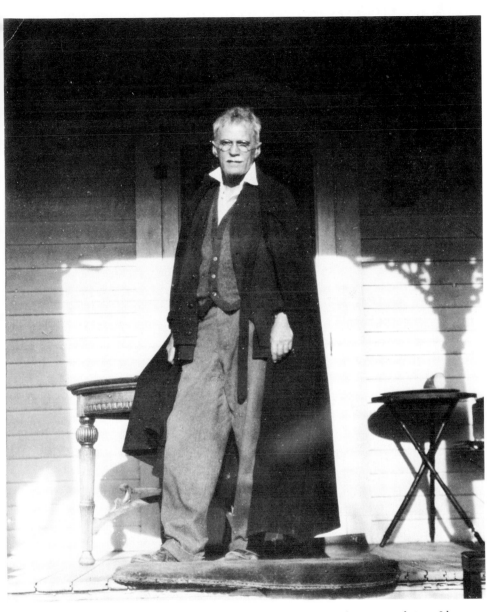

IDA O'KEEFFE, Alfred at Lake George (about 1924). Georgia's unmarried sister Ida was a favorite of Alfred's and the subject of sexual fantasies that he detailed to her in letters. When his sister-in-law became a serious romantic interest of Paul Rosenfeld's, Alfred turned on her with the wounded jealousy of a slighted lover.

ALFRED STIEGLITZ, *Rebecca Salsbury Strand* (1922–23). Alfred gave the title "Water-lilies" to photographs of Beck's breasts taken while she was swimming. GIFT OF MISS GEORGIA O'KEEFFE, COURTESY MUSEUM OF FINE ARTS, BOSTON

ALFRED STIEGLITZ, *Rebecca Salsbury Strand* (1922–23). About other poses of hers that he was developing at the Hill, Alfred wrote Beck: "Today I tickled up your rear with a perfect condition of delight." She bound this print, along with other intimate or informal shots, into a small book. THE COLLECTION OF AMERICAN LITERATURE, THE BEINECKE RARE BOOK & MANUSCRIPT LIBRARY, YALE UNIVERSITY

Soon after his marriage to Rebecca Salsbury in 1922, Paul Strand, using his wife as a model, began imitating Stieglitz's portrait of O'Keeffe. The project was ill suited to Strand's talents and remote from his real interests. The results appear posed and stagey—a measure, too, of the widening rift between the Strands.

ALFRED STIEGLITZ, *Georgia O'Keeffe*, "Hands" (1920). THE COLLECTION OF AMERICAN LITERATURE, THE BEINECKE RARE BOOK & MANUSCRIPT LIBRARY, YALE UNIVERSITY

PAUL STRAND, *Rebecca's Hands* (1923). SOPHIE FRIEDMAN FUND, COURTESY MUSEUM OF FINE ARTS, BOSTON

GEORGIA O'KEEFFE, *Black Abstraction* (1927). This painting represents
O'Keeffe's memory of her experience as a "patient etherized upon a table,"
in T. S. Eliot's words. Her black-and-white composition recalls Stieglitz's
print of the artist in profile with her arms raised. THE METROPOLITAN
MUSEUM OF ART, THE ALFRED STIEGLITZ COLLECTION, 1949

GEORGIA O'KEEFFE, *Slightly
Open Shell* (1926). In one
of O'Keeffe's most successful
series, executed in pastel on
paper, the vertical format
and pearly neutral tones used to
describe the mysterious hinged
organism suggest the gri-
saille panels of an altarpiece.
PRIVATE COLLECTION

ALFRED STIEGLITZ, *From My Window at the Shelton, West* (1931). In this series, taken from his and Georgia's twenty-eighth-floor suite at the Shelton and from An American Place, Stieglitz explored to the fullest the formal abstract possibilities of photography, devoid of the romanticism of his earlier photographs of New York. THE METROPOLITAN MUSEUM OF ART, THE ALFRED STIEGLITZ COLLECTION, 1949

GEORGIA O'KEEFFE, *East River from Shelton* (1927–28), oil on canvas. NEW JERSEY STATE MUSEUM COLLECTION. PURCHASED BY THE ASSOCIATION FOR THE ARTS OF THE NEW JERSEY STATE MUSEUM WITH A GIFT FROM MARY LEA JOHNSON, FA1972.229

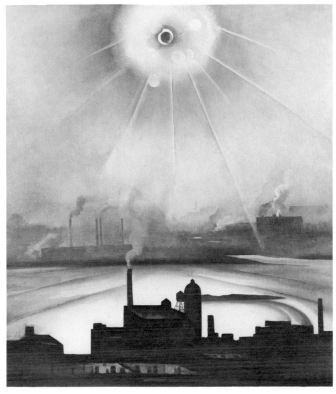

Mabel Dodge Luhan, Frieda Lawrence, and Dorothy Brett at the Lawrence ranch, Taos, New Mexico (1930s). The photograph appears to have been taken on the porch of Brett's cabin, which had been given to her by the writer. THE COLLECTION OF AMERICAN LITERATURE, THE BEINECKE RARE BOOK & MANUSCRIPT LIBRARY, YALE UNIVERSITY

Jean Toomer and Margery Latimer, his first wife who died in 1932. Following O'Keeffe's brief affair with Toomer, the black writer and author of *Cane* married Georgia's friend Marjorie Content.

ANSEL ADAMS, *Tony Luhan* (about 1930). With the impassive majesty of a pharaoh, Tony Luhan, a full-blooded Pueblo Indian and Mabel's husband, was too much of a man to belong to one woman, Georgia told Mabel.

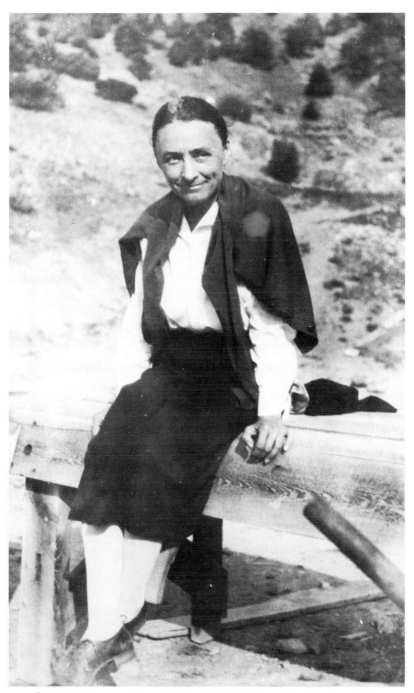

REBECCA STRAND, *Georgia O'Keeffe* (1929), Taos, New Mexico. This summer in Taos was the first time, Beck reported, that she had ever seen Georgia with pink cheeks and a hearty appetite. COURTESY OF MUSEUM OF NEW MEXICO, NEG. NO. 9763

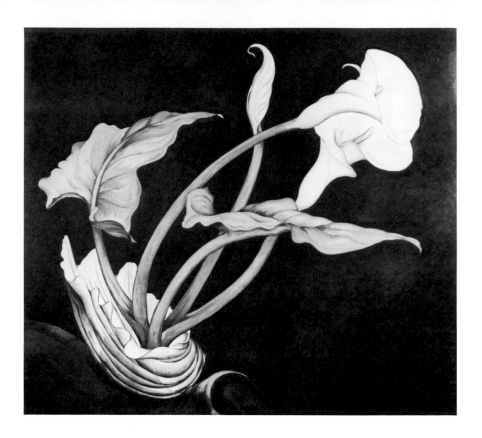

CHARLES DEMUTH, *Calla Lilies (Bert Savoy)*
(1926). THE ALFRED STIEGLITZ COLLECTION, THE
CARL VAN VECHTEN GALLERY OF FINE ARTS, FISK UNI-
VERSITY, NASHVILLE, PHOTO BY VANDO ROGERS, JR.

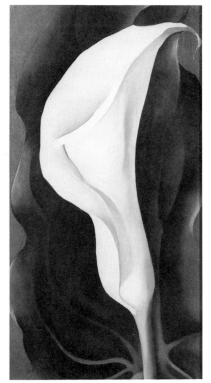

GEORGIA O'KEEFFE, *Single Lily with Red* (1928).
Demuth's choice of the calla lily to portray the
dual sexual identity of his subject, a well-known
female impersonator, seems related to O'Keeffe's
preference for this flower, which became in the
mind of the public and critics her emblem.
Beginning in the late 1920s, she executed many
versions of the lily, including the panel series, of
which this is an example. COLLECTION OF THE
WHITNEY MUSEUM OF AMERICAN ART, NEW YORK,
PURCHASE 33.29

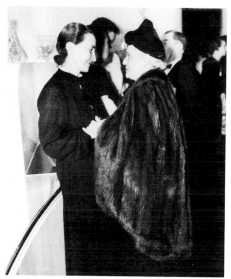

Georgia O'Keeffe and Mrs. Chester Dale at an opening (late 1930s). Her face wreathed in a rare smile, O'Keeffe posed with the wife of the collector and benefactor of the National Gallery of Art. UPI/BETTMANN NEWSPHOTOS

Gymnasium Moderne. In 1936, Elizabeth Arden commissioned O'Keeffe's painting *Miracle Flower* for her new exercise salon (shown here with sylphlike clients doing eurythmics). Although he disapproved of Georgia's commercializing her art, Stieglitz was proud of the price he negotiated for the work: ten thousand dollars. *TOWN & COUNTRY*, VOL. 92, APRIL 1937. PHOTOS BY CHARLES PETERSON

PHOTOS BY CHARLES PETERSON

Rhythm at Arden's, with O'Keeffe's "Miracle Flower" for background

BEAUTY IS FUN

These photographs can give you only a glimpse of the new Gymnasium Moderne at Elizabeth Arden's Fifth Avenue Salon. Georgia O'Keeffe's painting, "The Miracle Flower," dominates the yellow and white splendor reflected in the many mirrors of this latest in exercise floors. Here, in a day when the ponderous solidity of a Juno is as outmoded as a Model-T Ford, and a slim, lithe figure as necessary as a lovely face, Miss Arden has assembled the ways and means. For harmony of movement there is rhythmic dancing; for symmetry of form, exercises; for poise (which is balance), fencing; for youth (which is vitality and freshness), deck tennis, badminton, and ping-pong; for fun, all of them.

The painter and the patron at the tea which marked the opening of the new Gymnasium Moderne, when Miss Arden unveiled Miss O'Keeffe's flowery miracle

Alfred Stieglitz at An American Place (early 1940s). Now close to eighty, Alfred is
writing the title for the cover (a facsimile of his flowing script) of Dorothy Norman's
journal of politics and culture, *Twice-a-Year*.

Except for Lee's house calls twice daily, Georgia was alone all day in the two small white rooms. Alfred had returned to the Place and Dorothy. Georgia's depression worsened; she stopped eating and she cried for longer periods. On December 21, she moved from the Shelton to her sister Anita's apartment on Park Avenue. Alfred was forbidden to visit. The slightest noise disturbed her; she became phobic about water; she was afraid to go out in the street alone.

At 4:30 on February 1, 1933, she was admitted to Doctors Hospital, overlooking the East River on 85th Street. For almost two months, this would be Georgia's only window to the outside world. Closer to a private European clinic than an American medical center, Doctors Hospital, founded only a few years before, provided the rich and famous with complete privacy. With no house staff, patients could be seen only by their own physician. Favored for its casually luxurious maternity floors, where guests could quaff martinis at all hours with the new mother, Doctors soon became the retreat of choice for celebrities and socialites drying out from a bout of alcoholism, debutantes having illegal abortions, and psychiatric patients for whom rest, not restraint, was the prescribed treatment.

Dr. Edward B. Janks, Georgia's doctor, does not seem to have been a part of Lee's medical orbit. He is not listed in any professional directory of the period, nor was he licensed to practice medicine in New York State. His diagnosis, "psychoneurosis," does not suggest a sophisticated clinician. Janks's only treatment, apparently, was to continue to forbid Alfred's presence. Anita was the single visitor allowed.

This was the second time that Stieglitz had been denied the hospital room of a woman close to him and medically declared the destructive agent of her sanity: first Kitty, now Georgia. Describing Georgia's condition as a "living death," Alfred wrote to Dove: "I feel like a murderer."[22] Perhaps he forgot; he had said this before.

Georgia was installed in Room 293, with a private bath and a soothing river view. After four weeks, she slowly—very slowly—began to improve. Alfred was allowed one ten-minute visit a week. He brought her the photographs he had taken of her show—the first he had hung without her since they had been together.

"Paintings—New & Some Old," Alfred's flyer for the show announced in his sweeping calligraphy. Of the twenty-four pictures exhibited, only half had been done in 1932. Knowing of her illness and meager recent output, critics tactfully accentuated the positive; the solid forms of her Canadian barns, powerful and pure, were compared (favorably) to Picasso.

Alfred's decision to make the show a mini-retrospective had its mel-

ancholy consequences: some reviewers struck an elegiac note. "The year 1927 wears a nimbus of special lustre," recalled Edward Alden Jewell in the *Times*. "It was then that [O'Keeffe] painted some of her most beautiful abstractions."[23] If she was allowed newspapers, Georgia could not have been cheered by a sense of posthumous glory.

Scheduled to close on February 22, the show was extended until March 15—"By General Request," Alfred announced in a brochure that reprinted recent favorable notices along with encomiums past. In the last week of the show, he was able to bring Georgia from the hospital to the gallery twice. She was still weak and shaky. "Couldn't stay but a few moments—but I got there," she wrote to Beck with wan triumph. She had nothing to say about the exhibit. Still in the hospital, she now had visitors: "various people that I like and that I never seem to have time for when I am about."[24]

While Georgia was still in the hospital, An American Place became a publisher: *Dualities*, a volume of poems by Dorothy Norman, appeared in March with the gallery's imprint. For the last six months, Alfred had been trying to interest other publishers in Norman's first literary effort, free verse of a mystical nature. Writing to Ben Huebsch at Viking, Stieglitz compared his feelings on reading Norman to his sense of discovery in seeing, for the first time, the art of Marin and O'Keeffe. Shrewdly, he added that Viking would lose no money in this venture: Norman's "big personal following" would take care of the sale of a small edition. Huebsch regretfully declined, leaving the honors to Alfred and the Place.

ON MARCH 25, shortly after noon, Georgia left the hospital with a new friend, Marjorie Content, and her teenage daughter Sue. They headed straight for the North River pier and the Matson liner carrying them away from still wintry New York to Bermuda.

Familiar with the somnolent humidity of Virginia summers and the chill salt air of Maine, Georgia was unprepared for the semi-tropical island paradise of spring in Bermuda. Like every tourist, she was overwhelmed by the blue-green water, pink sands, and plantain and eucalyptus groves in startling juxtaposition with English Gothic revival churches built of cedar and gardens where retired British officers tended their roses in the soft twilight.

Once installed in their small hotel, she slept and slept, at night and lying in the brilliant sunshine in the garden. Her appetite returned. When she had the energy, she strolled the fine sandy beaches collecting

shells and admiring the coral formations, sculpted into abstract shapes by the winds and pounding ocean.

Marjorie Content was the perfect companion for O'Keeffe's convalescence. Cultured and cosmopolitan, she had many interests and knew everybody. At the same time, she was warm, even motherly—as her invitation to Georgia suggests—yet tactful and discreet. Daughter of a wealthy stockbroker, Marjorie had been married to Harold Loeb, an heir to the German-Jewish banking fortune. Loeb was cofounder, with Alfred Kreymborg, and publisher of *Broom*, one of the short-lived little magazines of the twenties. A companion of Hemingway and fellow aficionado of bullfighting, Loeb was widely assumed to have been the model for Jake Barnes in *The Sun Also Rises*. Marjorie followed her divorce from Loeb, father of her two children, with two other brief marriages. In between her ill-fated unions, she founded and managed the SunWise Turn Bookshop, with her friend the poet Lola Ridge. The bookstore became a gathering place for avant-garde writers, artists, and theater people, including those in the Stieglitz orbit. O'Keeffe may have met Content at the SunWise Turn or in Taos where Marjorie, a sometime photographer, had been documenting Pueblo life for the Bureau of Indian Affairs. Following her second divorce, Marjorie's father had bought her a charming house on 10th Street. There, dressed in vivid flowing skirts and Indian jewelry that complemented her dark, expressive features, she entertained friends from all areas of the arts, along with designing occasional sets and making props for "little theater" productions.

When Marjorie and Sue returned to New York, Georgia stayed on, moving to the Cambridge Cottages in Somerset. Without her friend to restrain her, she overdid it, climbing rocks and bicycling. She had to stay in bed for three days, a setback that decided her, suddenly, that she wanted to go home—wherever that was.

TWENTY-TWO

A Separate Peace

Stieglitz and O'Keeffe at the door of Georgia's beloved Model A Ford.

STILL EXHAUSTED when the boat docked, Georgia spent the next day and a half in bed at the Shelton. Then on May 21, Stieglitz put her on the train for Lake George. Once she was settled into her room at the Hill, confusion added to lassitude. Unable to anticipate what small effort would be too much for her, she gave up planning activity of any kind, she wrote to Beck, other than lying in the sun and eating Margaret Prosser's substantial if unexciting meals. Still, the solitude felt wonderful. A few weeks later, she weighed one hundred forty-two pounds, fifteen more than when she had left the hospital. Her under-drawers no longer fit; she had taken to wearing Alfred's. Despite what people might think, she assured Beck, she did not have a fat stomach.[1]

Mornings she stayed in bed until ten or eleven o'clock; then she drove the car very slowly to a level place, where she walked around a bit. She couldn't manage grades or stairs of any kind; the Hill had too much of both. The tranquil Kalonyme came for two weeks, followed by

a young woman she had met in Bermuda, who brought her a book on the Rio Grande. People—no matter who they were—proved too tiring. The doctor had forbidden her to travel West this summer. "Nothing too pleasant or exciting until September," she noted wryly.[2]

At the beginning of June, Georgia Engelhard arrived, followed in two weeks by Alfred. Since his illness five years earlier, he and O'Keeffe had had separate bedrooms at the farmhouse. But this was the first time they would be together under the same roof in more than a year. Stieglitz seemed both "very well and quiet. Maybe quiet because I cannot stand anything else," she wrote to Beck.[3] He was working very hard on his prints. One storm broke the unnatural calm: Georgia had an inseparable companion, Long Tail, a beautiful white kitten that had appeared at the farmhouse just after she arrived. Sel's dog, the fearful Rippy, gift of her admirer Caruso, had been the only pet allowed in the Stieglitz household. Alfred particularly detested cats. The animal must go, he announced. Georgia burst into tears. Shamed, Alfred relented. Her kitten stayed.

There was no point in trying to paint. She had no energy and nothing to say. Instead, she bought a new car: a Ford convertible coupe. As she could drive only very slowly, she kept the top down. She loved feeling the sun on her head.

Edward Stieglitz visited from Chicago. Julius's son was now a physician. Georgia took an immediate liking to him. "Big fat and good natured, he really laughs," she told Beck, astonished to find a Stieglitz with a gift for merriment. He had once been Kitty's beau.[4] That Georgia would mention Kitty, still in Craig House, as she herself was convalescing from her own breakdown suggested that she found a bond in their sickness. The name of Alfred's daughter, appearing in Georgia's hand for the first time, comes as a shock. She was no longer mentioned in family letters. Only Milton provided news of her and their son to his father-in-law. Stieglitz's only contacts with his daughter and grandson were small gifts on birthdays and at Christmas.

Lying in the meadow near the Shanty, Georgia was suddenly shocked to see the goldenrod in bloom. A year had gone by since she had last seen its yellow glory. She felt pained to recall how good she had felt then—"even tho' much harassed." Still, she could measure recent progress by the effect the family had on her nerves. When they first arrived, she had to take the maximum dose of the medicine prescribed for her heart in the hospital, when her symptoms were at their most severe. Now, a few weeks later, she had stopped taking the stuff altogether.

She had abandoned the idea of going to New Mexico in September. She had no desire to do anything yet. "I just sit in my effortless soup

and wait for myself. . . . The worst of my fatigue," she told Beck, "is a suffering in my nerves that is much worse than physical pain."

She asked Beck, installed in Taos for the summer, to send a replacement for her Mexican sandals, the kind one wets to make them fit properly; Georgia could not recall their name. She wanted her to tell Paul that the dress made from the red flannel he had bought for her the summer she and Beck were together had been "her best friend" since she was out of the hospital.[5] Not perhaps the most tactful reminder to either Strand.

In August, despite her evident progress, Alfred was still sunk in gloom over Georgia's condition. "I see no light for the autumn or winter as far as she is concerned," he wrote to Seligmann.[6] He echoed the feelings of inadequacy that always overwhelmed him when he was faced with women's needs: Katharine Rhoades, Kitty, Georgia: "I feel I have never been quite 'big enough' for my job—That's the truth."[7]

Beneath Alfred's normal pessimism in matters of health lurks an unmistakable *schadenfreude*: Georgia's illness was her punishment for having defied and betrayed him. Perhaps she did not deserve to recover.

Early in October, Ansel Adams wrote Alfred of his plans for a Stieglitz-O'Keeffe exhibition at his new gallery in San Francisco. Would Alfred agree to choose and lend a selection of his photographs and Georgia's paintings? Despite his desire to give sustenance to the "starved souls" of San Francisco, Alfred could not possibly agree to Adams's request. Georgia was not painting and might never paint again, he wrote to Adams. He could not take the risk of letting her work travel.

Georgia had been drawing since August. There was no reason to assume that, as her strength returned, she would not resume working at her easel.

Emotionally, she felt strong enough to offer both help and consolation to Beck; by fall, Taos tom-toms had reached New York with news of the Strands' separation. Paul was enamored of a young woman, Roberta "Bobbie" Hawkes, one of two beautiful sisters who lived on the Del Monte Ranch, just below the Lawrence property on Mount Lobo. Paul's affair with Bobbie, however, was a symptom, not a cause, of their troubles. Paul hated Taos, with its second-rate artists and silly rich women. He had visited Mexico several times, once driving with a woman friend, Susan Ramsdell, a bacteriologist and public health officer, and her teenage son. He was fired by the desire to participate in the cultural revolution taking place under the Cárdenas presidency. His friend the composer and conductor Carlos Chavez could arrange for him to become photographer and filmmaker of the new people's government, bringing art of the highest order to the most oppressed classes. Beck had no

interest in politics or social change or in following Paul around primitive villages while he filmed fishermen mending their nets. She made one trip to Mexico, when they apparently agreed to separate.

Hearing nothing of this directly, Georgia wrote, first to assure Beck that she had no desire to pry. She only wondered how Beck wanted her to respond to the inevitable queries: should she say nothing; snap off the heads of the "garbage collectors"; or was there any "official" statement Beck would like her to issue? Meanwhile, Georgia's advice to Beck was quintessential O'Keeffe: "Try not to take it too seriously—or maybe I mean take it more seriously—imagine it is years from now—and in the meantime don't do anything foolish— . . . Only time will make you feel better—and don't talk about it to people if you don't want to," she advised. "Why should you be expected to explain your personal life to anyone—It is rather difficult to even explain it to oneself." She prescribed a copy of the new best-seller *Anthony Adverse*: "It is so long, it ought to drug you for a few days."

She scarcely had to explain to Beck why her advice came straight from the heart—and her own present situation. "I think of you and think of you and wish I could think of something to say to you and I cannot—It just seems that what is going to hit us has hit you first."[8]

When she finally managed a trip to New York, she took a separate room for herself at the Shelton. Paul came to the hotel for lunch. She had been glad to see him, "but when he left I felt it had not been pleasant—that he has some odd notions about me—I don't even know what they are," she reported to Beck ingenuously.[9]

The "notions" that Paul harbored about Georgia were clear to others, Harold Clurman for one. While Paul was in Mexico, Beck had come to New York. After dinner and a concert with Clurman and Stella Adler, Beck had broken down. Weeping bitterly, she blamed the "tragic division" within herself, Harold reported to Paul, for the failure of their marriage.[10] There was no need for the two friends to probe Beck's meaning. Harold knew because Paul had told him: Beck and Georgia had been lovers.

Paul's unpleasantness during lunch with Georgia suggests that he blamed Georgia for the rift between him and Beck. Stiff and formal in manner under the best of circumstances, Strand was not the man to confront his wife's lover—least of all when the lover was the redoubtable O'Keeffe.

During this brief trip to the city, Georgia visited Florine Stettheimer and saw the Brancusi show at the Brummer Gallery. She measured her progress by the fact that she no longer feared she would go mad walking in the street, she wrote to Paul.

She also rediscovered another friend. After a hiatus of eight years, she saw Jean Toomer again. Since his peaceful working visit to the Hill in 1925, Toomer's life had been buffeted by extremes of joy and tragedy. While conducting Gurdjieff "awareness sessions" in Chicago, he had met a recent convert: Georgia's friend Margery Latimer. Amazingly, they had never encountered one another in New York. They fell instantly, rapturously in love. After a summer of trying unsuccessfully to establish a Gurdjieff center in Portage, Wisconsin, they were married there in October 1931 in a lavish Episcopal wedding. The bride, thirty-two, was ecstatic. "My stomach seems leaping with golden children, millions of them," she wrote to a friend, "and my head is all purged of darkness and struggle and misery."[11] After a blissful visit to Santa Fe as guests of the forgiving Mabel, the newlyweds had a less happy stay in Carmel, leaving hastily when the local newspaper accused them of coming to found a colony based on biracial free love. With Margery now pregnant, they returned to Chicago, settling in a large apartment on Division Street, with rooms for the nurse-midwife and Margery's mother, who arrived from Portage for her grandchild's birth. During labor, Margery began hemorrhaging. No doctor was called. Lapsing into a coma that night, she died early the next morning, either from loss of blood or septicemia. She had remained conscious long enough to see her healthy baby daughter.

Leaving the infant Margery, called Argy, with friends in Chicago, Toomer traveled East, ostensibly to gather Latimer's letters for a memorial collection, but probably to renew relations with his literary mentors: since publishing *Cane* in 1923, Toomer had severed his links with black-American writing. Accompanied by supporting letters from writer friends, his turgid essays on the Gurdjieff Way made the rounds of publishers, only to be rejected.

Toomer had written to Georgia from Chicago, asking whether she had kept letters from Margery; in reply, she told him that she would bring what she had, including a most wonderful one now in New York. Handing him the packet of Margery's vibrant letters—as vivid as her red-gold hair—was a symbolic act of connection. At this lowest ebb, both groping their way out of pain, loss, and lack of direction, Toomer and O'Keeffe found each other. Besides his sexual magnetism, Toomer had always reached women through a feminine willingness to articulate his—and their—deepest feelings. With this gift reinforced by his safe otherness as a black, he was able to release Georgia from her masculine horror of the expressive and emotional. Toomer was not likely to prescribe reading *Anthony Adverse* as a cure for grief and suffering.

When she left for the Hill, Georgia invited Jean to visit in December. He accepted gratefully and arrived in subfreezing temperature to find a world silenced by snow and glistening ice. It was the first time Georgia had seen the Hill magically transformed since December of 1923—the whiteness Stieglitz had waited for his whole life. Now the lake was frozen over; with the abandoned silliness of middle-aged passion, testing their ability to stay away from each other, Georgia and Jean did crazy kid stuff: when they tired of playing in the snow, they got in Georgia's car and skidded wildly over the deserted lake. Mornings and late afternoons, when it was too cold to be outside, Toomer wrote while Georgia caught up on the rest she still needed. They played with the cats; Georgia's beloved Long Tail had acquired a companion. In the evenings, Toomer read aloud the manuscript pages he had written. (With her low tolerance for abstract thought, was Georgia able to stay awake for "A New Force in Cooperation," the essay Toomer was working on during these months?). Happily, the primitive had not been stifled by Toomer's intellectual concerns: he picked up a tray and with his long fingers drummed an Indian rhythm on the bottom. "I got the shivers all over, through the roots of my hair," Georgia wrote to Marjorie Content.[12] Their intimate routine of work, rest, and pleasure was well established by December 11, when Stieglitz wrote to Toomer. He was glad that Jean was at the Hill, Alfred told him. But he took the opportunity to warn their guest of O'Keeffe's instability—however well she might appear to be—hinting of permanent mental illness. "Georgia has no idea of how much she worries me not only now, but has worried me all these years. It just cannot be helped," Alfred wrote.[13] As Stieglitz would be perfectly aware, Toomer was not looking for an emotionally disturbed dependent woman with no money of her own and the possibility of never working again.

Two days before Christmas, Alfred joined them. He and Georgia never observed gift-giving occasions: birthdays, anniversaries, Christmas. Georgia gave Jean a red scarf, the color of the vests she gave Alfred on other occasions to brighten his somber wardrobe. Alfred left the day after Christmas. On New Year's Day, he would be seventy years old. She wondered whether she shouldn't make an exception for this milestone birthday and go to New York to celebrate with him. Instead, she decided to stay on at the farmhouse with Toomer, who had deferred his return to Chicago for a few more days.

Several weeks earlier, a birthday tribute to Alfred had appeared in the form of a *Festschrift*, collected essays of disciples and peers. The result of months of work on the part of Dorothy Norman, Waldo Frank,

and Paul Rosenfeld, with editorial help from Lewis Mumford and educator Harold Rugg, *America and Alfred Stieglitz* was published by Doubleday and the Literary Guild. The longer pieces placed Stieglitz's contributions to photography, publishing, and modernism in their cultural and historical context. Brief encomiums to Alfred's genius produced the same embarrassing effect as that other solicited garland of praise, the special issue of *MSS* entitled "Can a Photograph Have the Significance of Art?," with its catechized response "Yes, and Alfred Stieglitz is its greatest artist." Conspicuous for her absence in either category of tribute was Georgia O'Keeffe.

The day before New Year's, Toomer left the Hill. He had planned a stopover in New York to see Stieglitz, but he changed his plans. He returned directly to Chicago, where another lover waited for him. "I miss you—We had duck for dinner today—Sunday—even the duck missed you," Georgia wrote to him. "It seems ages and ages—and it is just a week—so many things seem to have turned over in me that it seems a very long time."[14]

Through January and February, alone at the Hill, with snow swirling around the farmhouse, Georgia wrote fifteen letters to Toomer. In their passion and yearning, they recall the O'Keeffe of the Texas years writing to Strand. Now, however, she was telling a man what he had been for her, not what she wished he could be.

At forty-six, she had been roused by Toomer from the wintry deadness of illness and disappointment. "I seem to have come to life in such a quiet surprising fashion—as tho I am not sick any more—Everything in me begins to move," she wrote to Jean.[15]

His calm sense of his own power—emotional, spiritual, but above all sexual—had restored her to herself. "I like knowing the feel of your maleness," she told him. "I wish so hotly to feel you hold me very very tight and warm to you."[16] She loved to think of him wearing her red scarf; she wanted everyone who saw him to know that he wore her colors.[17]

To his credit, Toomer never spoke of permanence or vowed eternal love. He was looking for a woman to take care of him, one whose "womanness" at the same time would allow him to feel in control. In dreams, Georgia defended herself against inevitable loss. She dreamt about Toomer "just disappearing . . . someone came for you . . . seemed to be in my room upstairs—doors opening and closing in the hall . . . whispers—a womans slight laugh—a space of time—then I seemed to wake and realize that . . . the noises . . . undoubtedly meant that you had been in bed with her—and in my half sleep it seemed that she had

come for you as tho it was her right—I was neither surprised no[r] hurt that you were gone or that I heard you with her."[18]

In her waking thoughts, Georgia rationalized why their passion had to be finite, fugitive. They were too much alike and too different; their shared "relentlessness" drove a wedge between them. She was afraid of his "very large ego"; she had barely escaped destruction by another, even larger one.

She would rather remain "starkly empty" at the core, she told him, than allow anything to be planted that could not come to full growth. If her fragile center were to be damaged once again, she did not think she could keep on living, she said.[19]

Self-protective as she had to be, O'Keeffe paid tribute to a quality in Toomer that she herself lacked utterly: "a deep warm humanness that I think I can see and understand but *have not*."[20] Toomer could not disagree. He felt Georgia's absence of generosity, her "unconscious stinginess," he told her candidly. Her horror of taking anything from others, he pointed out, stemmed from the fear that she would be obligated to give something in return.[21] With Toomer, it was understood: there were no obligations on either side. Georgia was able to accept gratefully what he had given her. A week after he left, Georgia started painting for the first time in almost two years. At the end of January, she overcame an attack of anxiety—"panic" she called it—and went to New York. But after twelve days in the city, she couldn't remember how she ever got back to Lake George, "as tho I was smashed to bits so many times," she told Jean.[22]

Hardly surprising; from the white solitude of the lake, she had plunged into selecting and hanging pictures for her show, which opened on January 29. Another retrospective, "Georgia O'Keeffe at An American Place: 44 Selected Paintings, 1915–1927" dropped seven years out of her working life: Alfred had eliminated the flower paintings and Manhattan scenes—the one a reminder of the MoMA show, the other of the Music Hall debacle. But she brought down from the Hill a "tree portrait of Toomer," done at the time of Jean's first visit. She had never told him—or anyone else—of its subject, she wrote to Toomer. The seven years between the latest painting in the show and the present gave her an odd, disassociated feeling about the exhibit; it seemed the work of someone else. She didn't even like thinking of her show, she told an interviewer.

In March, while she was in Bermuda, the Metropolitan Museum purchased *Black Flower and Blue Iris* from the First Municipal Art Exhibition in Rockefeller Center, to which Stieglitz had lent the paint-

ing.* The irony of the show's venue was surely not lost on Georgia. Neither the exhibition nor the purchase—a milestone in any artist's career—seems to have been noted in her correspondence.

A revenant from madness, she was a survivor. Her long illness was a tempering. Claude Bragdon had always found Georgia a "fundamentally cold person," but there was a new hardness about her. "She glitters like steel," he wrote to Brett.[23]

She had yielded in other ways. Her idyll with the handsome, virile Toomer allowed her to see Alfred in a more compassionate light. Whatever the nature of his involvement with Dorothy Norman, despite the pain he could still inflict upon her, Alfred at seventy was an old man. Like all aged men and women, he had his good days and bad days. Irreversibly now, he looked his age: a white halo of hair framed the deathly pallor of his face. Only the coal-dark eyes blazed undimmed. Georgia had never been a wife in the traditional sense; no longer a lover, she could be a close friend and caretaker. From their new respectful distance, they had no need to lacerate each other. They could say the unsayable. "There were talks that seemed almost to kill me—and surprisingly strong sweet beautiful things seemed to come from them," she wrote to Toomer.[24]

She felt torn by Alfred's pain when she returned to the Hill. February alone at the lake depressed her: the raw cold, low gray skies, and piercing winds made her long "to lie in hot sun and be loved—and laugh—and not think . . . be just a woman," she wrote to Jean. "It is this dull business of being a person that gets one all out of shape."[25]

At the end of the month she left for Bermuda. On the boat, she wrote to Toomer, alluding again to her conflict: it was a woman he needed, not her—however much she might long to play that role. She was moving away from him, away from needing a man, "more and more toward a kind of aloneness—not because I wish it so, but because there seems no other way."[26] She was also moving backward, to the time before her illness. "When I felt well . . . I had a sense of power, I always had it," she told a reporter at the time of her show. "But a sense of power isn't the word. You walk down the street, I mean, and you feel so much better than anyone else you see."[27] She wanted that feeling back again. To be better than anyone else. To be first.

She stayed at Marie Garland's house in Somerset, Bermuda, sharing the beautiful old villa with sons of Garland's friends. She enjoyed the

* In May, O'Keeffe's painting was joined by four hundred eighteen Stieglitz prints that he had earmarked for the garbage. "Rescued" by friends, this collection, representing work done between 1894 and 1911, was donated to the museum.

young men's exuberant holiday spirits and she was pleased to have the nicest room, with a fireplace and a high four-poster bed. She had a view of the sea and the lush gardens below; she did not feel up to painting, but she copied, in highly finished charcoal drawings, the twisted trunks of banyan trees, palms, and banana flowers.

When she returned from Bermuda in May, Jean Toomer was in New York. In the months since they had seen each other, he had taken her advice and found another woman: Georgia's friend Marjorie Content. Lola Ridge had introduced them early that spring; they had become lovers almost immediately. For Toomer, his new Marjorie represented a fantasy come true. Rich, well connected, and generous, she had no ambitions of her own; she longed only to nurture his. Georgia's dream was prophetic but not, ultimately, protective. When he told her the news, she was clearly shocked and hurt. She couldn't see him again while she was in town. By the time she was back at the Hill in mid-May, she managed the conventional sentiments required by the occasion: she was truly happy that he and Marjorie were together. "I like it for both of you because I feel deeply fond of both of you," she wrote to Toomer. Regrets leaked from her pen: "I thought—it would be pleasant to ride with you in the spring instead of the cold winter." Then, reminded of what she was supposed to feel, she concluded gamely, "For both of us it is very right as it is."[28]

Georgia drew closer to Marjorie. She still wasn't up to facing the Southwest—either its distances or denizens—alone. Marjorie knew and loved the region. In June, the two women met in Chicago. Piling their luggage in Marjorie's old touring Packard, they set off for Alcalde, where Toomer, now in Wisconsin, was to join them in a month.

The trip was glorious and hilarious. They were both crazy for the sun, the scenery, and driving long distances. Once arrived at the H & M Ranch, they moved into their host's cottage. Henwar and Marie's marriage was over: the glamorous photographer was in Mexico working on a shooting script for Paul Strand's film *The Wave*.

Marjorie wrote Toomer daily letters. To provision the house, they had gone on a grand shopping spree, spending all their money. One entire afternoon they sunbathed naked on the patio. "With Georgia's keen eye and analyses of forms, I should get to know my body pretty well 'er long," she wrote to Jean. To her chagrin, Georgia still became upset when she talked about Stieglitz; at dinner the night before, Georgia began to describe their emotional conflicts. Her eyes filled with tears and she stopped eating. Marjorie vowed not to let this topic come up at mealtimes again.[29]

Georgia made no attempt to emulate her friend's tact. On a recent

visit to the Place, Marjorie had told Alfred that she and Georgia under-
stood each other so well because they were alike in many ways. She
was puzzled, she told Georgia, by Stieglitz's evident annoyance. He
hadn't been annoyed, Georgia corrected her, he had been "disgusted"
by the comparison.

Remarks like this were not repeated to wound, Marjorie realized.
Nor did Georgia say hurtful things in a spirit of tell-all frankness. There
was something missing in O'Keeffe—an "uninterest" in people that made
her oblivious to their feelings, Marjorie wrote to Toomer.[30] Georgia
lacked that human connectedness that allows most people to imagine
themselves in another's skin.

In July, Toomer arrived. Although there was ample room for the
three of them, Georgia felt superfluous, to say the least. Her young
friend Charles Collier had been telling her of a place he thought she
would like. After a little prodding from O'Keeffe, they set out together.
Ghost Ranch, a dude ranch, was forty miles from Alcalde on the road
from Espanola. The halfway point was the tiny Hispano-Indian village
of Abiquiu, perched on a crest overlooking the Rio Chama and the flat-
topped Pedernales. Beyond Abiquiu they got lost, driving around the
mesas until it was too dark to look further. O'Keeffe had heard from
stylish friends in New York that Ghost Ranch was the most beautiful
place in America—nothing like the usual dude ranch.

She set off by herself in her new black Ford roadster. With her
sense of predestination, O'Keeffe recalled spotting a truck with the
initials GR parked by a roadside grocery. The driver gave her the missing
directions: she would see a cow's skull nailed to a post just off the
Espagnola Road—if it hadn't been stolen. The skull was there, a re-
minder of the fratricidal legacy of the ranch. Part of the fifty-five thou-
sand acres of the Piedra Lumbre land grant from the Spanish Crown,
the area was first settled by two Archuleta brothers. One murdered the
other; the dead man's terrified widow and baby daughter were said to
haunt the settlement.

The sharp turn to the right was easy to miss. But she found it and
eased the car across a log bridge, continuing downhill along a dirt road
until, at the base of a mesa, she came to a group of low bungalows.

The astonishment produced by the landscape around Ghost Ranch
is the shock created by extreme contrasts. After the flatness of the Rio
Chama valley, with long, low mesas rising in the far distance, arriving
at the bottomland of the ranch site is like being dropped into a crater
of the moon. Invisible from the road, towering cliffs thrust up as though
out of nowhere. Formed by the wind and by the water of a vast pre-
historic lake, the immensity of sheer exposed surface would be fearful

enough. Striated in wild clashes of color, the cliffs rise like a hallucination, a garish spectrum of the earth's history: narrow top layers of sandstone, gray shale and coal, and white gypsum descend into purple and viridian green mudstone; runoffs from the pink sandstone cliffs look like the webbed feet of an enormous prehistoric creature; elsewhere towering mounds of siltstone have been dyed violet red, cobalt, and sulfurous yellow by the dense iron oxide. After the pale sandy colors of Alcalde and the Rio Chama basin—silvery cottonwood, olive piñon, brown-gray juniper—and the misty blue of the Taos valley floor, the brilliant lunar outcroppings around Ghost Ranch spoke to Georgia as no other place had ever done. The landscape gave her the "wonderful emptiness" of Texas along with a new vocabulary of form and color. "This is my world," she said.

It was August and the height of the tourist season; there was room at the ranch only for that night, she was told. While Georgia slept, a child of other guests was rushed to Santa Fe with a ruptured appendix. The family would not be returning; the cabin was hers.

Ecstatic, she returned to Alcalde long enough to pack her things and move. She did not say her farewells then to Jean and Marjorie. On September 1, she went to Taos to serve as witness at their marriage, performed by a drunken justice of the peace. The newlyweds left for the East, stopping in Chicago to collect Jean's two-year-old daughter. Georgia happily drove the sixty miles back to Ghost Ranch—and home.

The social world of the ranch was as much to O'Keeffe's liking as the desolate beauty of its setting. The owner, Arthur Newton Pack, was the son of Charles Lathrop Pack, who had made a fortune in timberland and lumber. Having pillaged the woods of the Carolinas, the senior Pack retired to devote himself to the cause of reforestation. Following his father's later interest in conservation, Arthur founded and edited *Nature* magazine. He was photographing mountain lions for a story when he discovered the abandoned Ghost Ranch in 1928. A summer on the San Gabriel ranch in Alcalde had proved so beneficial to one of his children, who was suffering from asthma, that he and his wife decided to settle in the region and try a dude ranch of their own. They bought the twenty-one-thousand-acre property and built a spacious adobe compound for the family and staff, along with some half dozen guest bungalows.

By the time Georgia found her way there, the Packs had turned Ghost Ranch into a millionaires' club. Charging eighty dollars a week in the depths of the Depression eliminated the kinds of dudes that Georgia once said were a "lower form of human life."[31] Pack's guests were his friends from New Jersey's horsier precincts or from Wall Street

suburbs such as Princeton. The allure of the setting and the facilities—roughing it luxuriously among peers—attracted more guests by word-of-mouth than the twenty-bed capacity of the ranch could ever handle. Accommodations were prep-school Spartan: there was no electricity in the cabins, and the nearest telephone and telegraph office was in Española, a forty-mile drive. (As one guest recalled, the absence of telephones was a real lure to captains of industry and finance, allowing them to be out of reach of the office for a few weeks). Meals were sumptuous, prepared with homegrown fruit and vegetables and meat from the ranch's own livestock, along with wild duck and quail. There were saddle horses enough for all guests and a staff of cowboys to serve as guides to the many wild, inaccessible splendors of the area. Pack soon built an airstrip to accommodate his new light green Fairchild and any small planes his guests might prefer to the rigors of train and automobile.

With her host, Georgia developed a friendship based on mutual interests rather than affection. She enjoyed talking with Pack, a cultivated man of wide-ranging interests, about religion, art, photography, and the West. O'Keeffe's imperious style—rudely snubbing some of her fellow guests while cultivating others—offended Pack's well-bred civility, however, and was out of place in the ranch's atmosphere of a small upper-class family.

Over the next few summers, the chosen among Georgia's fellow guests became close friends. A grandnephew of John D. Rockefeller, David H. McAlpin (Princeton '20), a handsome financier, had been a collector of photography since he was an undergraduate, buying his first Stieglitz photograph during those years. A fervent outdoorsman, he shortly became a patron of Ansel Adams, supporting both his photography and his efforts to preserve Yosemite through the work of the Sierra Club. With Georgia, McAlpin shared a passion for saddling up the horses at dawn and riding to see sunrise on the brilliant cliffs.

As happened with other of her Ghost Ranch favorites, Georgia's friendship with McAlpin continued on their return to New York. Recently divorced, McAlpin was pleased to serve as O'Keeffe's escort when Alfred was unwell or unavailable. One evening she asked him to accompany her to a new Soviet film. Over supper afterward, Georgia told McAlpin that she wanted a favor from him. "I want you to introduce me to some of your friends," she said. Later McAlpin explained what O'Keeffe was really asking: "She wanted to meet my *rich* friends," he said.[32]

McAlpin admired the famous O'Keeffe candor, and he had long

revered Stieglitz as an artist. He brought the woman he was in love with to dinner with them at the Shelton.

To the fair hair and classical features of a Gainsborough portrait Margaret Bok, thirty-one, added a charm and wit that mesmerized everyone who met her. No man could ever forget her tinkling laugh, David McAlpin said. Divorced from Edward Bok, heir to Curtis Publications, Peggy was lukewarm toward McAlpin's attentions, but she was immediately adopted by her hosts. As he did with all young women who attracted him, Alfred invited her confidences in long letters, mixing queries and advice about her love life with assurances that no man was good enough for her. Georgia promptly invited "Peggie" (Georgia's eccentric spelling of names was always a sign of her special affection) and her three children to stay with her at Ghost Ranch. Her first visit, the following summer, proved ideal for the four Boks, and they returned almost every year thereafter. The Bok children, a daughter and two sons, seem to have been among the few youngsters for whom O'Keeffe ever developed any real fondness. Her favorite was the youngest, serious little Derek, who would become president of Harvard. They went camping together, sometimes including local friends. One of them, Georgia's former landlord Henwar Rodakiewicz, fell in love with the beautiful divorcée. McAlpin was gently dismissed; Peggy and Henwar were married in 1935. (Ghost Ranch was also the scene of other, more disruptive romances. The previous summer, Mrs. Pack had decamped with the children's tutor.)

The network of Princeton dudes soon came to include local gentry with no ties to the university. Robert Wood Johnson, the chairman of the pharmaceutical empire that bears his name, and his wife, Maggie, finding the cabins too austere, built their own house on the property, shipping in fancy furnishings and a Steinway grand piano. Georgia and Maggie Johnson, who had dabbled in photography as one of Steichen's assistants, became friends. Georgia invited Maggie to accompany her on her day-long painting expeditions, another mark of special favor and one reserved for women. Through Maggie, Georgia met and became closer friends with her new sister-in-law Esther Underwood Johnson, second wife of Robert's eccentric brother J. Seward. One of three beautiful Underwood sisters of Boston, Essie was a small, elegant woman; like Georgia, she dressed austerely, favoring soft flat shoes and eschewing makeup. The Seward Johnsons' model farm in Oldwick, New Jersey, must have reminded Georgia, who soon became a frequent guest, of Sun Prairie in her happiest memories.

Ghost Ranch soon attracted the famous, along with the merely rich.

Charles Lindbergh, whose wife, Anne Morrow, belonged to the New Jersey gentry, appreciated the privacy assured guests, as did refugees from Mabeltown such as the conductor Leopold Stokowski and his wife.

Late in September, Spud Johnson drove Georgia back to New York; his friendship and financial help from Witter Bynner had ended; the literary cowboy needed to earn money. In an unlikely assignment, he began contributing to the "Talk of the Town" column in *The New Yorker*. Georgia departed almost immediately for Lake George. After four months of absence, her reunion with Alfred lasted a few days only: on October 3, he went to New York, leaving Georgia at the Hill until December.

Since Georgia's illness, Alfred had acquired two photographer protégés to replace the departed Strand. Ansel Adams, whom Georgia had met when they were fellow guests of Mabel's (and who was soon to reappear at Ghost Ranch in McAlpin's entourage), had brought his prints of Yosemite to the Place in the spring of 1933. Then a recent graduate of Harvard Medical School had shown up at the gallery with his portfolio. Eliot Porter had dutifully pursued the study of medicine to please his rich, conservative family. His older brother, Fairfield, had defied their parents to become a painter; the younger son hesitated to deal another blow to paternal expectations. Stieglitz validated the young man's decision to leave medicine for photography. Porter's prints of the natural world almost conquered Alfred's objection to the principle of color photography. His sensitive close-ups of plant life must also have reminded Stieglitz of Paul Strand the prodigal son.

At the end of December, Stieglitz mounted his own exhibit at the Place. It was his last picture show. For the occasion, he had made new prints of negatives—some half a century old—that he had found in the farmhouse attic the previous summer. Of later vintage was a series of his New York scenes and some recent prints of Lake George and of O'Keeffe. There were no photographs of Dorothy.

New prints of Dorothy Norman were not lacking. Alfred seems to have learned something from Georgia's reaction, seconded by others, about the difference between exhibition and exhibitionism. He had good reason, moreover, for greater caution. Georgia had returned from Ghost Ranch restored to health—emotional and physical. She talked of nothing but the wonders of the country—the mix of privacy provided by her cottage along with the pleasures of good food and company when she wanted either. Already, she was planning next spring's departure. She did not have to tell Alfred: that will be my home from now on. He could hear it in her voice, with every sentence.

If the hypochondriac lives long enough, his fears will be justified; his imaginary ailments will become real. At seventy-one, Alfred was frail and weak; he tired easily. Colds, aching joints, bad stomachs hung on longer. Claude Bragdon was shocked at how, suddenly, Alfred had seemed to age. Alfred needed care. He would make sure that nothing would justify Georgia's abandoning him for good.

Together, they hung her show in January. There were just nine new pictures, six done in New Mexico; of these, only three were landscapes, of red and pink hills. That first summer at the ranch she had done more looking and absorbing than painting. The technicolor slashes of cliffs against bright blue sky was harder to capture just because so much was given.

For the first time, Georgia was heard to complain about the claustrophobic Shelton rooms, where work was constantly interrupted by the chambermaid. In his new placating mood, Alfred wrote to the management of the Place, informing them that Georgia O'Keeffe, the greatest "woman painter," just recovered from severe illness, needed a room to paint. Free studio space in the building would confer honor on their enterprise. They declined the distinction.

In March 1935, An American Place exhibited the first European artist Stieglitz had shown in seven years: a refugee from Nazi Germany, George Grosz painted caricatures of the world he had fled, giving frightening human form to the "banality of evil." Alfred's uncharacteristic welcome of Grosz's savage portraits of his swinish, leering countrymen was one measure of Stieglitz's ambivalence on the subject of Germany; the other was his invitation to Marsden Hartley to write the catalogue essay. The rise of nazism and the Anschluss had reminded other assimilated friends that they were Jews. Florine Stettheimer had stopped speaking to Marsden Hartley: his continued exaltation of the Prussian military as an ideal type was no longer an amusing homosexual foible. She was appalled by Hartley as a guide to the work of Grosz. Stieglitz was distressed by Florine's provincialism. And Henry McBride applauded Alfred's distress. Unlike all of his other Jewish friends, he noted, Stieglitz was completely free of "hysteria" about what was happening in Germany. A rabid anti-Communist, McBride himself could not entirely disapprove of the Nazis; they were, after all, trying to rid Europe of the Red menace, he liked to point out.

Georgia's usual indifference to politics sharpened to impatience at the obsessive interest now focused on events abroad. From Lake George, she complained to a friend that Stieglitz had invited recently arrived Dutch-Jewish refugees, visiting in the neighborhood, to the farmhouse.

Alfred wanted to hear firsthand what was happening in Europe. Georgia dreaded the evening's "gloomy" talk about world affairs that couldn't be helped anyway.

WHILE HER SHOW was still up, Georgia visited friends in Washington: it was late February, her favorite time in that tropical city. She was planning an early return to Ghost Ranch in April, but she was hospitalized again, this time for acute appendicitis. It was June before she was well enough to go West.

Her third return to the ranch was now a homecoming. Beginning this year—1935—she would stay until November: half the year. Her time in New Mexico was no longer a summertime escape, with "real" life elsewhere. More than New York or Lake George had ever been, this was her life.

Besides new guests and regulars, she maintained connections with Taos friends: the Colliers; Miriam Hapgood, daughter of Hutchins and Neith Boyce, who had come out for her health and never left; Spud Johnson, soon to return West. She enjoyed occasional visits with Rebecca Strand, now remarried to a wealthy gentleman cattle rancher, Bill James. Beck found in her new husband, a fourth-generation westerner, her all-American cowboy ideal. Loved and appreciated, she still painted, exhibiting locally. Besides her work on glass, she had revived a Hispano-Indian form of needlework, the *colcha* stitch, which she used to create rich sampler-like canvases. Free of the Stieglitz circle, with its premise that one was a genius or one was nothing, she could assume other, more congenial roles: hostess and patroness of Indian crafts. Still wearing pants (now adopted by Georgia), a black sombrero atop her silver pageboy, Rebecca was a much-admired local attraction.

Georgia drew closer to two other Taos artists: Russell Vernon Hunter, a painter recently turned bureaucrat, who headed the local Federal Arts Project for the Bureau of Indian Affairs, and Cady Wells, a rich Bostonian who specialized in pleasing pictures of pueblos and their picturesque inhabitants. Neither man was threatening; both were devoted friends and admirers.

She kept up with Brett and grew even fonder of Brett's archrival Frieda Lawrence, recently returned to Taos with her new husband, ex-chauffeur Angelo Ravagli. Kept East by her illness, Georgia had missed the dust-up between the two women over ownership of Lawrence's ashes. In an opera bouffa postscript to the writer's life, his widow won a Pyrrhic victory. Claiming to have mixed Lawrence's ashes with wet

cement, Frieda used this immortal mortar to build on a hill near the main ranch house at Kiowa a mausoleum of aggressive ugliness.

Mabel was the only friend who was dropped—forever—from O'Keeffe's local orbit. When Georgia was recovering from her break-down, Mabel had proffered several gracious invitations to return to Los Gallos. Georgia declined with a sneering letter: it was Mabel's intelligence that made her "horrid" behavior so grotesque, Georgia told her. When anyone as smart as Mabel was "wrong," the effect was laughable. She would always remain fond of Mabel—as long as she never had to see her, Georgia asserted.[33] For her part, Mabel could not understand such an unforgiving attitude; fights with friends were like lovers' quarrels. She and Georgia never spoke again.

During her stay in Alcalde, O'Keeffe had met another emigré from Boston. Classified as one of a breed of "Mighty Maidens" by her Beacon Hill cousin and friend Mark DeWolfe Howe, Mary Cabot Wheelright was a large foursquare woman with a trumpeting voice and strongly held views on all subjects. In her New England youth, she was already renowned as a great sailor, navigating her schooner *Lyria* along the Maine coast.

Liberated by her parents' death, Wheelright threw off the shackles of the dutiful Victorian daughter. She sold the house in Boston and the cottage at Northeast Harbor and with an "endlessly deep pocketbook filled with dollars,"[34] set out to become her own woman. She explored Greek islands, traveled through the interior of China on a packhorse, and bought a palace in Majorca.

Early in the century, she had gone camping in northern New Mexico with her governess. Like Georgia, she had vowed to return. In 1928, following several visits in the region, she bought a vast ranch in Alcalde, Los Luceros, another early Spanish land grant, spending lavish sums on restoring the crumbling colonial hacienda and outbuildings.

Along with her love of the land and passion for exploring the wilderness on horseback, Wheelright was drawn to the area by her interest in Indian culture. She learned everything she could about the ritual and ceremonial of "her" Navajos. Then, with the help of her friend the famous medicine man Klah Hosteen, she transcribed legends and songs, writing learned articles on the symbolism of sand paintings and tribal dances.

The Southwest held another attraction for Wheelright and other refugees from civilization. Remote regions like Alcalde offered escape precisely from such genteel euphemisms as "Mighty Maiden" and "Boston marriage." As the pioneer settler, Wheelright, or MCW as she

announced herself, became the doyenne of a growing colony of lesbian women. Throughout the 1920s and 1930s, they flocked to the Santa Fe area. Professionally, anthropologists and archeologists were drawn by the research and fieldwork opportunities; photographers such as Laura Gilpin came to photograph Indians in their cultural context and natural setting—both understood as endangered. Personally, however, these women came for the psychological space and sexual freedom democratically provided by the West to all genders. It came with the territory, where a belief in the sanctity of private property and minding one's own business were articles of faith. As long as it didn't frighten the horses, as the cliché went, whatever took place between consenting adults was no one else's affair. In matters of style, it was easy for lesbian women to disappear. Cross-dressing was the only sensible way to dress. Women in boots, pants, buckskin jackets, or the Indian moccasins favored by Wheelright caused no raised eyebrows. In wintertime at the post office in Taos, Mabel Luhan recalled, it was impossible to tell men and women apart; both were bundled in identical sheepskin outerwear. Especially for lesbian women of independent means, New Mexico, like Paris in the 1920s, was utopia: an escape from repression and convention. Social gatherings, even at the houses of proper Episcopalians, Republicans, and pillars of the community, were likely to include women couples, recalled a native Santa Fean.

At Los Luceros, with its large staff, Wheelright maintained an active social life. She hosted luncheons and dinners, at which O'Keeffe was a frequent guest. "Wherever she was living," her cousin noted of MCW, "there was usually a dependent female companion in her train."[35] At the ranch, these long-staying visitors were young women who helped with horses, with overseeing physical improvements on the ranch, or with her transcriptions from the Navajo.

O'Keeffe's relationship with Wheelright was described by mutual acquaintances as "friendly rivalry." Georgia admired MCW's combination of patrician privilege, competence, and grit. She spoke admiringly of her travels through China, along with her Western need to eat fiery chili with every meal. Like Georgia, she had an artist's eye: when Wheelright went for a walk, on a Maine island or in the Alcalde hills, she returned caressing one perfect stone in her long hands. The beautifully restored hacienda at Los Luceros was a showcase of the best Indian crafts and colonial furniture. Like Mabel, MCW was a discerning collector of Navajo weavings, *santos*, splendid jewelry,* and

* Her holdings formed the nucleus of the Museum of Navajo Ceremonial Art, which she founded in Santa Fe, renamed the Wheelright Museum after her death in 1958.

seventeenth-century chests. The only work she is known to have bought by a contemporary Anglo artist was two paintings by Georgia O'Keeffe.

Wheelright was also threatening. Rich, domineering, and influential, like Mabel, she loomed for Georgia as a competing sphere of influence. To a bisexual woman, her open lesbianism was too challenging. O'Keeffe's move to Ghost Ranch was also a decision that Alcalde was not big enough for both of them.

Georgia did not return East until November. During the months without her, Stieglitz seemed to fade away. A "Hebrew Prophet of Despair" Bragdon called Alfred, listening patiently to his lament of feeling "lonely and deserted."[36] Death was tightening the circle of old friends. Fifteen years of diabetes had finally caught up with Demuth; the elegant, witty dandy had died in his mother's home in Lancaster in October. He left his paintings in oil and tempera to O'Keeffe.

Over the last two years, seeing Georgia and Alfred together at the Shelton, Bragdon had been struck by the change in their relationship: Alfred had become "too 'soft'—she is too 'hard': in them the sexes are, in a manner, reversed," he noted sharply. "Sex surely is the 'siege perilous,' the seat that always has a tack in it," he concluded.[37]

Six months at Ghost Ranch had allowed O'Keeffe to assimilate nature's excesses. Without transforming, she transcribed its strangeness: gray hills like a herd of elephants, the geological "accidents and incidents" of gypsum and coal that created white places and black places. She came back with nearly all of the seventeen new works completed that were exhibited at the Place in early January.

There were many more in her head, and now she needed a real studio. Stieglitz might have liked to see both of them as starving artists; Georgia found the truth more to her liking. She was a success. She had enough money to pay her bills for the next few years, she told Henry McBride. In the middle of the Depression, there weren't many artists—men or women—who could make that claim.

Confirming her need for space, Georgia accepted another large-scale commission. She agreed to decorate the new exercise room at the Elizabeth Arden salon on Fifth Avenue.

She was waiting for a chance to redeem the Music Hall debacle. So was Alfred. MoMA's mural project was betrayal; the Music Hall powder room was prostitution; the Arden exercise salon was Georgia's apotheosis. Alfred not only applauded the commission from the very beginning, he also claimed to have conducted the tough negotiations that resulted in O'Keeffe's high fee: ten thousand dollars. By way of conferring his benediction, Alfred even made an appearance at a soirée given by Arden in her Fifth Avenue apartment, an art deco shimmer

of satin sofas and smoked glass mirrors, where he could admire the prominent place given to O'Keeffe's large petunias.

Called *Miracle Flower*,* the six-by-seven-foot painting of four gigantic white morning glories was the "unique selling principle" of Arden's new "gymnasium moderne." Its title clearly suggested the transformations to be wrought beyond the Red Door. The April 1937 issue of *Town and Country* featured the exercise salon and its star decorator. Accompanied by an illustration of three sylphlike young women clad in chiffon and swaying in concert, an article called "Beauty Is Fun" noted that "Georgia O'Keeffe's painting 'The Miracle Flower' dominates the yellow and white splendor reflected in the many mirrors of this latest in exercise floors." Besides "rhythmic dancing," the salon offered fencing, deck tennis, badminton, and Ping-Pong.

There was also a photograph of O'Keeffe, an exceptionally broad smile lighting her face, chatting with an elegantly hatted Elizabeth Arden at the tea marking the "unveiling" of the picture.

All of O'Keeffe's and Stieglitz's friends were asked to the gala occasion. Claude Bragdon was one of those who declined. "G. invited me to the opening of the new Fencing Room where her decoration will be on display, but I don't think I could go to a thing like that," he wrote to Brett.

Bragdon took an equally dim view of the sudden intense friendship that had developed between artist and patron: "Georgia's evidently much in the good graces of Elizabeth Arden, Beautician to the American Aristocracy of Dollars and she takes Georgia about with her and sends her flowers etc. etc."[38]

By the mid-1930s, Elizabeth Arden had become America's richest woman entrepreneur. Of O'Keeffe's many wealthy women friends, she was also the only one who, like Georgia herself, was a self-made success. She was born Florence Graham in rural Ontario to tenant farmers who were too poor to allow their five children to finish high school. She took over an associate's first name along with the business when their partnership in a beauty parlor dissolved; her new surname, she claimed, was chosen from the Tennyson poem "Enoch Arden." Cosmetics sales soon became the basis of her salon empire; the exercises and facials were frills, good for publicity.

When she and O'Keeffe met, Arden had recently divorced her first husband; by most accounts, he had never been more than a business associate. By the same period, the mid-thirties, the glamorous executive

* Like many of O'Keeffe's original titles, *Miracle Flower* was later changed to *Jimson Flower*; such a rebaptism always signaled a shift from the silly or sentimental to the straightforward.

had successfully parlayed her fortune into "a place just within the magic circle of New York society largely by cultivating Elisabeth Marbury, member of a prominent old New York family, an influential literary agent and housemate of Elsie de Wolfe,"[39] interior decorator to the fashionable on both continents.

The Arden–Marbury–de Wolfe configuration has definite analogies to O'Keeffe's triangular relationships: with Matthias and Latimer and with Mabel and Beck Strand. Arden's niece soon became her aunt's "constant companion," another parallel to the intimacy between the two Georgias.

In April or October 1936—accounts differ—O'Keeffe moved Stieglitz from the Shelton into the apartment she had begun using as a studio to work on the large Arden commission.

Known as the Arno Penthouse after its former tenant, the cartoonist and man-about-town, 405 East 54th Street, near fashionable Sutton Place, was O'Keeffe's domain: the lease and the telephone were in her name. To his credit, Alfred never tried to fudge the issue; she had a penthouse studio, he wrote Ansel Adams. For the first time, they no longer lived as Stieglitz dependents or as semitransients.

A small duplex, it had a bedroom for each of them besides a living room and separate studio; its wraparound terrace, whose railing was camouflaged by a privet, preserved Georgia's familiar East River view. Like the Shelton, the rooms were painted white, with curtainless windows. Here, in her own apartment, Georgia could stain the floors dark brown. She hung a changing display of her work on the walls, once including an example of her household arts: a beautifully darned sock. The most important facility of their new home had nothing to do with art or views: there was room in the penthouse for a live-in housekeeper— or nurse. Georgia's insistence on moving was also primed by the realization that Alfred would soon need caretakers during her months of absence. He was too frail for anonymous hotel living.

From the beginning, Alfred had only complaints about the penthouse. It was too noisy, too grand, too drafty, too far from the Place; its very airiness afflicted him. "So grandly spacious and light that I feel queer," he told Ansel Adams.[40] When Arthur Dove and his son Bill, an art student, came to visit months after the move, Alfred marched them into his bedroom where, like a sulking child, he showed them his steamer trunk—still unpacked![41] His symbolic resistance pointed to the new reality: O'Keeffe now made the decisions for both of them.

She did her best to accommodate the habits and tastes of half a century. With the help of a Norwegian cook-housekeeper, Saturday nights were sacred to Alfred's social life. Survivors of the old loyalists

or new disciples came for dinner and stayed, talking into the small hours of the morning. Georgia's friends, now often curators and collectors, were asked for lunch, which consisted of cold meat, cheese, and fruit laid out on an improvised sawhorse table, or to dinner on other evenings. When it was "her" evening, Alfred's behavior could be appalling: the gentlemanly Bragdon was shocked on one occasion when Alfred—irritated by a "Miss Parkhurst"—simply rose from the table and stalked from the room.

With more space for their separate lives, larger quarters seemed to exacerbate conflict. Alfred acted out his resentment at O'Keeffe's control of his life and the independence of her own; he was so rude and insulting to her that Bragdon and other friends wondered how she could stand it.

One reminder of Alfred's dependence on Georgia was the widening gap in their finances, and Alfred resented it. Georgia's brother-in-law Robert Young had invested her ten-thousand-dollar fee from the Arden commission and had done so well for her that she owed two thousand dollars in taxes on the profits. Stieglitz's entire income, he told Bragdon, came to eight hundred dollars.

Alfred's brother Julius, Lee's twin, died in January 1937. They had not been close, but the death of a younger sibling is a double blow—a painful whiff of mortality.

In May, just before they left New York for Lake George, O'Keeffe and a friend went to the movies; Alfred stayed home to watch from the terrace as the great zeppelin *Hindenburg* passed overhead. He turned on the radio just in time to hear the news of the horrifying disaster: as it approached its landing site in New Jersey, the airship burst into flames, killing all aboard. Alfred felt himself touched by the fingers of death, he told Bragdon. When Georgia returned, he was still listening to the news, in a state of shock.

"Has that radio got to be on?" she asked him crossly. Hadn't she heard about the *Hindenburg* tragedy? he wanted to know. "Oh, yes, we heard about it hours ago," she said airily. She sounded as though he were talking about the baseball scores or who won the derby, Alfred told Bragdon bitterly.

Their old friend and neighbor felt sorry for both of them. To be sure, Georgia had seemed oddly unmoved by the tragedy, the horrible death of so many. Still, Alfred had behaved as though her very presence in a movie theater was a sign of her heartlessness.

Angry and bitter when she was in residence, Stieglitz was desolate and lonely when Georgia was gone. His feelings of abandonment were not helped by the rules O'Keeffe imposed in her absence. The house-

keeper was given a list of approved visitors along with the name of one never to be admitted to the apartment: Dorothy Norman. He felt like a prisoner under house arrest, he told Bragdon.

Not that there were many begging to call. Dorothy herself had less and less time these days. With Alfred's blessing and his design as a cover, Norman was about to launch a periodical of politics and the arts: *Twice-a-Year*. The chores of editor/publisher along with her full schedule as hostess had much diminished her presence in Alfred's life. His increased frailty and querulousness did not, moreover, make him an ideal companion. A melancholy symbol of their changed relationship was the folding cot Dorothy had given Stieglitz so that he could receive visitors more comfortably at the Place.

Fewer and fewer came. Whenever Bragdon called at the gallery or the apartment, he found Stieglitz alone, sunk in misery.

"He wanted so to die," Bragdon said.[42]

TWENTY-THREE

The Empress of Abiquiu

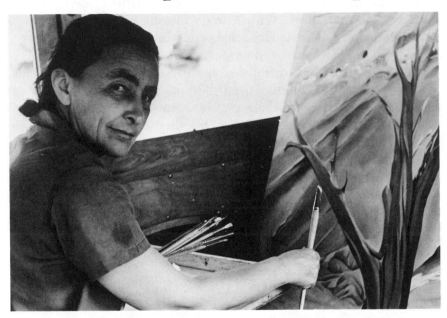

ANSEL ADAMS, *Georgia O'Keeffe Painting in Her Car, Ghost Ranch, New Mexico* (1937). By removing the back seat of her Ford coupe, O'Keeffe was able to use the car as a mobile studio. In the desert and rocky country near Ghost Ranch, her first home in the region, the car kept the artist protected from sun and torrential rains.

"You sound a bit lonely up there on the hill—" Georgia wrote to Alfred in late August 1937 from Ghost Ranch. "It makes me wish that I could be beside you for a little while—I suppose the part of me that is anything to you is there—even if I am here." With the safety of several thousand miles between them, a "part" of her could remain his "for a little while."[1] Rarely has so much equivocation been compressed into so few lines.

In June, the Cleveland Museum of Art had mounted a one-man exhibit of his photographs, distracting Alfred from the bleak reality that his camera was now too heavy for him to manage: he could take no more photographs. Then the Hill had thronged with guests. Besides the faithful Sunshine Boys, more glamorous visitors were brought by Harold Clurman: Elia Kazan, a director-protégé from the Group Theatre, an exquisite young actress, Frances Farmer, and a stalwart leading man, Leif Erickson. Elizabeth and Donald Davidson had become converts to

Hinduism. Swami Nikhilananda, whose Manhattan religious center they were financing, was guru-in-residence for the entire summer.

For Alfred, the early part of the summer had felt like a reprieve. Most important, he had found a new passion. Two weeks after Georgia's departure for the Southwest, Alfred had fallen in love with his fourteen-year-old grandniece Ann Straus. From the little girl he barely remembered, he wrote a friend, had emerged a beautiful child/woman, the archetype Alfred found irresistible. Only Georgia later noticed the teen-ager's resemblance to a younger Dorothy. Ann gave him a sense of rebirth, he told intimates. Her elders applauded the young girl's "precocious maturity . . . in extricating herself" four years later from Alfred's obsessive attentions.[2]

O'Keeffe left for New Mexico in mid-July and would not return until December. She was no longer a tourist. This was her country. She had made no reservations at Ghost Ranch, arriving to find every cottage taken. The fair-minded Arthur Pack couldn't agree to Georgia's suggestion that he evict other guests. Instead, he showed her Ranchos de los Burros, the U-shaped adobe structure he had originally built for his family but had not used since his wife's departure. Pack had been living in the main house. He gave Georgia a tour of the whitewashed rooms surrounding a patio, with a master bedroom whose enormous window overlooked color-drenched cliffs. "As soon as I saw it, I knew I must have it," Georgia recalled. "I can't understand people who want something badly and don't grab for it. I grabbed."[3] Three miles from the guest facilities, the house had what O'Keeffe treasured most—privacy. Even the view from her "front yard"—as she titled a painting of that summer—she felt to be hers alone. The slanting plane of mesa, called the Pedernales, like the Texas river, became as fixed as the horizon line in O'Keeffe landscapes: "that perfect blue mountain," she called it—as blue as the Jemez mountains just beyond.

She got rid of the rose garden—an attempt by the first Mrs. Pack to re-create the East—and let the patio return to nature. Wild sage bushes grew; she found an enormous stump of tree for a seat; she spread her collection of skulls and bones around the patio to whiten in the sun; her most essential piece of outdoor furniture, a ladder propped against the adobe wall, allowed her to enjoy with her guests the panoramic view, transformed by sunset and moonrise, from the flat roof. This would be her house, her mountain, her views for the next fifty years.

Settling in centered her. From July on, she wrote Alfred tender, newsy letters. Her young Hispanic housekeeper, LaVerna, was such a good cook that, unless she was out all day painting, Georgia had lunch at home. One night on the porch after supper, the Pack children and

guests' youngsters performed a play, with help from the Pack governess. Georgia found the adults' involvement with their offspring's performance somehow surprising. "It was amusing to see the way parents are effected [*sic*] by their children's capers," she noted. Her favorite was a ten-year-old boy with a bad stutter. Georgia sat out the dancing that followed with Pete, a handsome ranch hand who had worked for Mabel—"half Indian and half a very good French line," she reported.[4]

Peggy Bok arrived with her family, which now included Henwar, her husband of two years. Georgia was approving when they called on his former wife, Marie Garland, in Alcalde. Ansel Adams came. They went camping with a new friend of Georgia's, Anglo-Irish writer Gerald Heard, who with Aldous Huxley and his wife was visiting Frieda Lawrence Ravagli. That same night, they all celebrated the Rodakiewicz anniversary by opening the Johnson house with its Steinway grand; Ansel played the piano while the others drank beer. It had been a perfect day. "You would have liked it too and been a nice part of it," Georgia wrote to Alfred.[5]

IN SEPTEMBER, Georgia's absence made the airy Arno Penthouse seem vast and empty. That month, Alfred moved back to the Shelton. Besides the comfort of loyal Claude Bragdon, he had a new protégé-helper. A distant relative, William Einstein was a painter of imperceptible talent and substantial private means. The Vichy government had ended his happy expatriate years in France, and he now had all the time in the world to devote himself to Stieglitz and the Place. As his reward, in October 1936 Einstein had been given a one-man show in the small room at the same time as Ansel Adams's first exhibition of photographs hung in the main gallery. Georgia appreciated Einstein's faithful volunteer services and invited him to Ghost Ranch for a visit. His intelligent, cosmopolitan discourse could never compensate, in her eyes, for a white sluglike appearance and lack of charm. Behind his back, she referred to him as "that envious goat."[6]

At the beginning of December, O'Keeffe returned to reinstall Alfred and herself in the penthouse and to hang her show, which opened two days after Christmas.

Her first New Mexican landscapes had suffered from literalness of vision, her need to render faithfully what she saw. She had succumbed to the dangers of a region whose clarity of atmosphere offered shapes and colors that defied the artist to do better than copy. In one of her letters from the summer that Stieglitz, touchingly, used as catalogue

text for the show, she had described her effort to paint exactly as she saw: "I think I am through with my tree—Its the first thing I have done that when I stand it by the window and look at it—then look out the window—it looks like what I see out the window, tho it was painted a mile away, I think it really looks like here."[7]

In an attempt to free herself from the slavish imitation imposed by the landscape, she painted during her second stay at Ghost Ranch the first of her fantasy landscapes. *Summer Days* features a cow skull floating above the Pedernales and resting uneasily above a bouquet of flowers. The picture and her 1937 exhibition made *Time* magazine. When interviewed by a reporter about his reaction to the painting, Stieglitz could not even summon a minimally selling response. "I hate it," he said.

Others welcomed the free rein O'Keeffe now appeared to give to her imagination along with an opportunity to discuss the Christian symbolism of animal remains ascendant. In the summer of 1937 O'Keeffe had produced a variation on the earlier work *From the Faraway, Nearby*, eliminating the flowers and changing the cow skull into a more dramatically horned ram. The simplified version exposed problems of scale that even the catchy title could not resolve: there is missing middle ground between the faraway and the nearby.

The source of O'Keeffe's imagery is neither Christian symbolism nor her own imagination. A ram's head appearing to the blessed in the sky above the Sacred Mountain is the subject of a Navajo legend, retold by Ernest Seton Thompson, a writer and folklorist.[8] O'Keeffe could have heard the story at Los Luceros from Thompson himself, who was a friend of Wheelright's, or from the learned MCW.

Famous, popular, and successful, O'Keeffe now drew fire from a new direction. Earlier, her detractors had been among the aggressively hickish regionalists, busy shooting down all forms of modernism as a decadent hoax perpetrated on the unwary by "that Hoboken Jew" Alfred Stieglitz. At fifty, Georgia was now established enough to have critics among a younger avant-garde. Following her 1937–1938 exhibit, the abstract painter George L. K. Morris offered a devastating overview of the O'Keeffe career. Using the form of an "open letter" in *Partisan Review*, a new political and cultural journal of the left, he wrote:

> The subject matter in your first pictures—the gigantic flowers—was arresting to begin with; but from the start your limitations were plain. You could ingratiate with an image, but the art of painting itself, the necessary technical equipment, did not come naturally to your fingers. This could have been overcome, as many great artists have overcome it, had you only

understood. But you had been deluded. You felt that everything you touched was sensational and "artistic," whereas in reality, there was only the sign painter's slimy technique.

She had soon exhausted her repertoire, Morris declared. Her flower pictures had become "tiresome; even the sexual overmeanings became sticky and dull," he said. With every addition to her subject matter—skyscrapers, bones, barns, scenery in the West—her "lack of technical equipment" and "lack of taste lay naked and raw."

Focusing on the present exhibit, he noted that O'Keeffe had tried in the year past to loosen her technique. "But only a sure foundation can permit flexibility," he warned. She had ignored the aesthetic structure itself while fiddling around with the decoration.

Morris concluded with a withering look at O'Keeffe's cheering section. Their conservatism explained the exaltation of O'Keeffe: she was a renegade modernist. "Only the academic critics can now applaud you, and the columnists who write for housewives; they believe correctly that they have found a celebrated modern painter who has joined their ranks at last," he sneered.[9]

Laurels from *Life* magazine either compensated for or confirmed Morris's views. A month before her fellow artist's attack, the new Luce publication featured O'Keeffe—"America's most famous and successful woman artist"—with approving mention of the prices of pictures (average five thousand dollars) illustrated with three of twelve color reproductions just published as a portfolio and selling for fifty dollars. An addendum to the feature on Georgia was a brief article "Alfred Stieglitz Made Georgia O'Keeffe Famous." Below the title, looking ancient and glum, Alfred peered at the reader. His claim to fame: "He helped her to become the country's most prosperous and talked-of woman painter."[10]

In April, Dove fell ill with a long siege of pneumonia; the blow came just weeks after he and Reds moved to their first real house—a small converted post office in Centerport, Long Island. Only days afterward, Alfred was stricken with a coronary that nearly killed him; two weeks later he succumbed to double pneumonia. In his aged, frail state, without antibiotics, it hung on for six months.

This time, a live-in nurse was in charge of the slow recovery: five weeks in bed, over a month more before he could resume the activity that, for Alfred, came closest to breathing: letter writing.

His heart attack in 1938 was the first of six over the next eight years; until his death, he would alternate coronary and angina attacks. For Georgia, 1938 marked the first of those official laurels of fame that

consecrate established success: in May, with Alfred still housebound, she returned to Williamsburg to receive an honorary degree from the College of William and Mary. When she came back to New York, he had been taken to Lake George with his nurse. She managed two and a half weeks with Alfred at the Hill before her departure for Ghost Ranch on August 7.

Another new pattern was established. Not only did Georgia make the decisions for both of them, but increasingly they would be made and carried out long distance.

For Georgia, the summer's pleasures reached their height with a memorable excursion: a camping trip to Yosemite organized in grand style by David McAlpin and his cousin Godfrey Rockefeller. With Ansel Adams as wilderness Virgil, their travel was eased by cook, packer, guide, and other supernumeraries. The chuck wagon produced not only piping hot coffee at dawn but cold martinis at sundown. Georgia had never looked so beautiful and happy, Adams reported to Stieglitz—a view verified by an album of marvelous snapshots he sent members of the group as a memento. Georgia's reaction was startling. She excoriated Adams for giving away pictures to a millionaire like McAlpin. Her anger toward the gentle, generous photographer had other explanations: Adams was poaching on her turf. She also made waspish remarks to McAlpin and his new wife suggesting that Adams wouldn't be wasting his time with them if Dave was a dry-goods salesman and not a Rockefeller.

She returned from New Mexico in November—in time for the first issue of Dorothy Norman's *Twice-a-Year*. Published by An American Place, the journal reflected how far the editor had come in her education and how much she had learned that did not derive from Stieglitz. Her new house on 71st Street, designed by William Lescaze, was now a center for refugee artists and intellectuals from Nazi-occupied Europe. Besides regular contributions from antifascist writers such as Ignazio Silone and Arthur Koestler informing readers of the horrific developments abroad, country by country, there was a regular feature on civil liberties in America, with analyses of racism and anti-Semitism by David Riesman and Felix Frankfurter. With the exception of frequent tributes to Stieglitz (the only artist covered regularly), the issues addressed by the journal's table of contents, as far as Alfred was concerned, might have been taking place on Mars!

In February of the new year, Georgia accepted a commission from the Dole company. In exchange for an all-expense-paid stay in Hawaii, she was to produce illustrations of tropical fruit or flowers suitable for use in the company's advertising. As O'Keeffe understood the arrange-

ment, she need not even consider its best-known product: the pineapple. Remaining in the islands until April, Georgia had a glorious time. She eluded the clutches of Dole executives and explored tropical rain forests and volcanoes. The results, however, met with intense unhappiness, especially her rendering of a papaya, whose products were processed by a competitor. Hoping she would view the pineapple more positively, Dole shipped a perfect specimen of the fruit to the penthouse. She relented, but not without a curious replay of the symptoms leading to her earlier breakdown: for the next two months, she was ill with the same blinding headaches and loss of appetite triggered by the powder room fiasco. (Her next exhibit, in February 1940, consisting mostly of Hawaiian pictures, was easily the weakest showing of O'Keeffe's career: the tropical flora look copied from a calendar.)

As soon as she returned from Hawaii in April, she was rewarded by another honor: the World's Fair Commission named O'Keeffe one of the twelve most accomplished American women of the past fifty years. For the first time, she was honored outside the realm of art, included in the ranks of physicists and social workers.

Nonetheless, her recent transactions with Mammon once again exacted a painful toll in conflict and depression. This time, a severe crisis was avoided, forestalled perhaps by eight weeks in bed followed by two weeks more, in early July, spent at Dr. Janks's private rest home in the country.

At the beginning of August, Georgia and Alfred went to the lake— together this year, a touching reminder of the old days. Two weeks later, Alfred suffered an angina attack. It was apparent that he was not making a complete recovery from the successions of cardiovascular traumas: each one left him weaker, more vulnerable to other illnesses. In May he had agreed—after considerable arm-twisting by MoMA's first curator of photography, Beaumont Newhall, a brilliant young Harvard-educated art historian—to prepare a show of his work for the opening of the museum's Photography Department. Whether because of physical frailty or depression, he was unable to complete the task. Sifting through the past was not inspiriting work.

With both of them barely recovered by early fall, Georgia stayed East—the last year that either of their ailments would keep her from home.

A week after her Hawaiian exhibit opened in early February 1940, Georgia left for Nassau and a month of visiting Lyford Cay and cruising the Caribbean waters with Maggie and Robert Johnson. She did one painting based on her experience on board the Johnson sloop: a static precisionist study of billowing sails. Unlike Demuth and Hartley, who

were as productive on holidays in Bermuda or Provincetown as they were at home, Georgia on vacation devoted herself to being a guest. Even visiting her sister in Newport or Palm Beach, O'Keeffe did not mine the local scenery for subject matter.

Early in June, after an absence of almost two years, she was back at Ghost Ranch. When she found "her" house occupied on arrival, she made up her mind. Almost fifty-three, O'Keeffe had never had a home of her own: at the end of the summer, she signed the deed for the Ranchos de los Burros, reputedly paying six thousand dollars for the house and about eight acres of land. Immediately, she set about making improvements. She knocked down interior walls to make a large studio, glazing the two outer walls of her bedroom for uninterrupted views to the north and west. She painted the *viga* and *latiga* ceilings white, building high narrow fireplaces in each room. Years before, Georgia had told Herbert Seligmann that her dream was a house with only kitchen furniture. Starting with the penthouse, wooden tables and wall seating were a fixture in her surroundings (even when, later, these would be joined by Mies chairs and Calder mobiles).

Middle age and money in the bank awakened Georgia's territorial imperative. For several years, she had had her eye on derelict property in a tiny village between Ghost Ranch and Alcalde. A farming pueblo in the precolonial period, Abiquiu in the 1930s was an impoverished Hispano-Indian hamlet whose population of fewer than five hundred souls eked out a miserable living as subsistence farmers and shepherds. Once a center of the outlawed Penitente sect, the town itself consisted of several abandoned *moradas*, a run-down church dedicated to St. Tomás, two bars, and the ramshackle adobe dwellings of the inhabitants.[11] Like the remains of a feudal castle, the ruined hacienda (most recently a pigsty) that attracted O'Keeffe was located at the highest point of the village, a promontory of land directly above the Espanola Road, with views across the Rio Chama valley to the mountains beyond.

On the hilltop, O'Keeffe found the shell of a house with a collapsing *viga* roof and crumbling adobe walls, the remains of a seventeenth-century hand-hewn wooden door lintel, and a patio with a well. Extending the enclosure, a long wall punctured by a door proposed a series of interlocking rectangles whose geometry fascinated her.

Initial negotiations for the property came to nothing. The heirs were asking the same price as Pack wanted for the Ghost Ranch house; she couldn't afford both. Then the church bought the land. Using the roofed part of the structure to house livestock, they were reluctant to sell.

For the time being, O'Keeffe let the matter drop. With America's entry into the war clearly imminent, materials and manpower to build

a livable house in Abiquiu would be in short supply. Especially for an owner who spoke not a word of Spanish, constructing a second home from a ruined pigsty seventeen miles from Ghost Ranch seemed infeasible, if not fantastic.

That same summer of 1940, O'Keeffe met the young woman who transformed fantasy into reality. A stocky, athletic thirty-one-year-old Texan, Maria Chabot had grown up on a ranch near San Antonio. On her father's side, her family traced its arrival in America to a diplomat with the first French legation to the new state. Her mother's people were pioneer ranchers. With the Depression they had become one of the millions of land-poor Americans. Intelligent, quick, and cultured, Chabot seems to have acquired a formal education piecemeal, between jobs and travels in Europe, Mexico, and elsewhere. To survive on her own, she mastered every practical skill. She could handle horses and cars. She could build or fix almost anything. With the open, classless friendliness that seems the birthright of many westerners, she was equally at ease with Hispanic ranch hands, blanket Indians, and Boston Cabots.

In 1935, she was working as a photographer for the state Department of Vocational Education in Santa Fe, documenting Spanish colonial objects for the Federal Arts Project. She visited Los Luceros to photograph Wheelright's collection, sending her some prints along with a thank-you note, signed Mary Chabot.

When O'Keeffe met Chabot at Los Luceros in 1940, Chabot was living in one of Wheelright's guest houses. Either later that summer or the following one, she moved into O'Keeffe's house at Ghost Ranch.

Chabot had unfocused literary aspirations. Along with room and board, O'Keeffe promised her time to write in exchange for managing the simple household. Chabot knew O'Keeffe's painting, but she had never been close to a professional artist. She was drawn to the example of a discipline and a devotion to work whose importance—to everyone in Georgia's life—was taken for granted. O'Keeffe knew her women. She knew that Chabot, like Beck Strand, would fall into her predestined role: facilitating Georgia's work as a way of avoiding the terror of being tested by her own. "I was the second of O'Keeffe's slaves," Chabot recalled. "Beck Strand was the first."[12]

Freeing Georgia to paint became Chabot's full-time vocation; she took over the management of the household, hiring the Hispanic help, tuning up the car, taking care of the recently acquired horses, and getting the new electric generator to work.

Their ménage had echoes of that of Gertrude Stein and Alice B. Toklas, with a crucial difference: the division of labor was deliberately

left unclear. It was important to O'Keeffe to maintain an image of competence as a householder. In fact, she couldn't do anything, Chabot claimed. (Perhaps Georgia preferred to appear inept or helpless, knowing her companion would do the work.) Even the bread that Georgia told reverent visitors she made herself was usually baked by Maria or the kitchen help.

Chabot received no salary. O'Keeffe gave her fifty dollars a month to buy provisions in Santa Fe; whatever was left over was hers to spend on toothpaste or Kotex. She took care of all the preparation for camping trips in the remote hill country where Georgia liked to paint: loading the station wagon with bacon, venison, stew, coffee, along with water, rope, easel, paints, and blankets; a rug so that Georgia could paint standing on the hard-packed frozen earth; books to read aloud at night by the light of the campfire; and one time even the cat. Chabot knew and loved the country. She navigated the packed car through flooded arroyos and sandy roadless canyons, watching while O'Keeffe used every daylight hour to paint. She created not the work of art, but its conditions, its possibility.

In September, Stieglitz had a mild angina attack, followed by a severe attack the next month. Georgia did not return East; in October, she was concluding the purchase of the Ghost Ranch house. She came back to New York on November 11.

Whether or not Alfred could manage to creep there to his cot, the Place had become a backwater; the best work of his holy trinity—Marin, O'Keeffe, and Dove—could be seen elsewhere. Marin's 1940–1941 exhibit at the Place, featuring a new medium—oil—and new painted frames, attracted little attention; instead, New Yorkers flocked to see Picasso's *Guernica*, on view at the Museum of Modern Art. With tragic timeliness, the exhibition of the work marked a fresh occasion of mourning: that June—1941—Finland fell to the Nazis.

Following the fall of France in 1939, through the grim spring and winter of 1940, Hitler had invaded Norway, Denmark, the Netherlands, Belgium, and Luxembourg; the mythic Maginot line had crumbled at the first Panzer assault. Horrifying firsthand accounts of Hitler's deportation of Jews, Communists, gypsies, and homosexuals arrived with those lucky enough to reach American shores. Alfred's continued defense of the German people as superior to their Führer became an embarrassment to intimates. Lee might shrink at the thought of Jews as Lake George neighbors; he fulminated, nonetheless, at Roosevelt's reluctance to enter the war.

In the months preceding Pearl Harbor, there were consolations: reconciliation with Strand was one, followed by an unannounced visit

to Lake George from the apostate himself, Edward Steichen. An O'Keeffe pastel was sold for three thousand dollars—a staggering price for a work in that medium—proving to Stieglitz that his artists were still record breakers.

Between Georgia and Alfred there was a new rapport based on their happiest and most enduring bond: work. Time was running out; the unspoken realization was present for both of them. In the early spring of 1941, they spent evenings alone together, the first in several years without Alfred's "yes men" (as Bragdon called them) or Georgia's flossy new friends who compared sloops and racing stables.

Separately first and then in collaboration, they took up the task of making a selection of the best work of both. Georgia's paintings of the past twenty-three years that were still in their possession were sifted in view of a coherent retrospective of her evolution as a painter. In May, just before Georgia left for New Mexico, they plunged into thirty-six cartons of Alfred's best prints.

Once again, in September, Alfred suffered a severe angina attack; this time an injection by Lee averted major damage to his heart. Back in New York two weeks later, he succumbed to another series of attacks and required a full-time nurse.

Coming eight weeks after Pearl Harbor, O'Keeffe's 1942 exhibit hung in a Place empty of visitors. With America mobilizing for war, lives everywhere were in a state of upheaval: the draft, rationing, the transformation of industry and agriculture to meet the needs of wartime production, the relocation of women and families in the wake of departing husbands and fathers.

With priority transportation in effect, O'Keeffe still managed a trip to Wisconsin in May to collect an honorary degree from the university in Madison. Then she was off in June to Ghost Ranch. Now the joys of inaccessibility were proving to have drawbacks. Especially in wartime, with gas rationed, the forty-mile trip to Espagnola for telephone and canned goods was a hardship; flash floods often made roads impassable. Otherwise, the dry soil made gardening a lost cause; the closest supply of fresh produce was in Santa Fe, more than a hundred and fifty miles away. Socially, Ghost Ranch was less appealing; the glamorous Princetonians and their friends were officers or were contributing their executive skills to the war effort. Pallid, nosy men appeared from the FBI to grill the Packs and their guests to determine whether the ranch would make a suitable resort for the rest and rehabilitation of scientists engaged in "top security" work at nearby Los Alamos.

Accompanied by Maria Chabot, O'Keeffe explored the Abiquiu site again; now she was as delighted by the discovery of the water rights

that came with the property as she had been with the patio door and the view. With assurances from Chabot that, if supplies could be gotten, she could build the house of Georgia's dreams, O'Keeffe kept after the local church hierarchy.

Alfred was alone in New York, feeling ever more forgotten. Grateful for attention, he finally succumbed to MoMA's blandishments: the museum's summer show featured "Alfred Stieglitz: His Collection," a sampling of Alfred's vast holdings in early photography. When O'Keeffe returned in October, she decided that the penthouse was too big and too expensive for Alfred and a caretaker. With gas rationing, taxis were scarce, and the apartment was too far from the Place, where Alfred still spent part of each day. She swiftly moved him into smaller quarters at 59 East 54th Street, a block from the gallery. Family and friends were unhappy; the new rooms were poky, dark, and even more sparsely furnished than Georgia's usual decor. The setting spoke starkly of abandonment.

Despite the war, the Art Institute of Chicago proposed an O'Keeffe retrospective, becoming the first major museum to mount a one-woman show of her work. She had met the present director, Daniel Catton Rich, at Taos in the memorable summer of 1929. He had become a friend, a frequent visitor at Ghost Ranch, and a faithful admirer of her painting. Surprisingly, Alfred warmed to the idea of the retrospective. An important showing in the Midwest would gain Georgia a new audience and market. For the last time, he played business manager: the walls of the galleries must be painted white and the artist was to hang her own pictures, one of which the institute was committed to purchase. A few days before the exhibit opened on January 31, 1943, Maria Chabot traveled with Georgia to Chicago. At the Art Institute, O'Keeffe had her revenge on her unhappy Chicago years. While giving interviews to the press, she moved pictures around on the floor, making known her displeasure on various counts to the staff. She then retired with grippe to her rooms at the Blackstone Hotel, missing the opening festivities.

In February, Joe Obermeyer died. Alfred was too old now for the savage glee he once expressed at the obituaries of former friends turned enemies. For Stieglitz at seventy-nine, the death of every contemporary was a diminishment. Then in September, Hartley died, his perpetually needy, accusing voice stilled.

O'Keeffe's 1944 show at the Place introduced a new discovery of the previous summer: she had found, she wrote to a friend, a perfect animal pelvis. Seven of the nineteen paintings on exhibit were variations on the chalky curved form, suspended against a sky of flat blue. This particular section of skeleton seems in these works not so much mag-

nified as stretched: it has no gravity. It floats, like a giant version of a dog's rubber bone.

In the next years, the pelvis grew bigger until, edges cropped by the frame, the subject became the blue sky visible through large round openings. In her only reference to the war, O'Keeffe suggested a transcendent meaning to the heavenly perspective: "[The bones] were most wonderful against the Blue—that Blue that will always be there after all man's destruction is finished."[13] One young critic, Clement Greenberg, challenged the universal significance of these images. O'Keeffe's work, he found, "has less to do with art than with private worship and the embellishment of private fetishes with secret and arbitrary meanings."[14]

NEITHER THE celebrations nor the sorrows of V-J Day, September 2, 1945, were permitted Stieglitz. He hadn't the physical strength or the heart to watch parades—not even to echo his jeremiads against the 1911 Armistice, seen from the windows of 291. News of two grand-nephews' deaths in action was to be rigorously kept from him. O'Keeffe was not one to feign sympathy for what she could not feel; a month after the news of Bill Schubart's death in the Pacific, Georgia had dinner with his twin sister, Diana. She was puzzled to find the young woman still grieving.

"How can you still be in mourning after all this time?" she asked.[15]

At the end of the year, the Museum of Modern Art proposed a retrospective to Georgia—the first offered a woman artist. Like a dormant volcano, Alfred's wrath erupted. The same old arguments were trotted out, masking the same fears: betrayal, abandonment, loss of control. Unlike Chicago, no artist—or dealer—dictated terms to the museum. If Georgia listened at all, she was merely humoring Alfred. A MoMA show was the ultimate accolade. She was charmed by the curator in charge, as indeed was everyone who met James Johnson Sweeney, collegiate athlete, polymath of immense culture, great host, collector of taste and originality. Sweeney, however, was forever overextended. (He was to have done a catalogue for the exhibit, which never materialized.) The day-to-day preparations for the show were taken over by a young assistant curator, Dorothy Miller. Initially, O'Keeffe was outraged at having to deal with such a lowly member of the staff. But when she realized that the talented, knowledgeable Smith graduate was the museum's fair-haired girl, she cultivated her assiduously, Miller recalled, inviting her to lunch at the apartment often and, shortly afterward, to stay with her in New Mexico.

The preview opening in May 1946 was a glittering event; the small private dinner beforehand included among the guests Le Corbusier, the McAlpins, and the dean of art critics, Georgia's friend Henry McBride. Stieglitz had long ceased going out at night. Still, Georgia knew that seeing her sail off for this occasion would be particularly depressing, so she arranged for Anita Pollitzer and her engaging husband, Elie Edson, a publicist for French performing artists, to have dinner with Alfred. The fifty-seven paintings, which included works from 1915 on, were respectfully, if not enthusiastically, received. Several critics found it a skimpy offering, noting the five-year hiatus of the early thirties. Reviewers dutifully trudged through the artist's "periods," without finding that the thirty-three-year career added up to what might be expected of the "great American artist" all agreed Georgia O'Keeffe to be.

But it was the unbuyable McBride who had delivered the ultimate verdict two years before: reviewing her pictures of bones at the Place, he noted O'Keeffe's "urgent, inner leaning towards the abstract; a leaning to which, being a 100 per cent American, she has never dared yield. Were she abstract she'd lose her public, and as she has a considerable public, naturally she hates to do that."[16]

On June 6, Georgia left for Albuquerque—her first nonstop flight to New Mexico. As always, Alfred wrote well before her departure so that she would find his letters when she arrived. "I greet you on your coming once more to your own country," he wrote on June 3. "I hope it will be very good to you. You have earned that. A kiss. I'm with you wherever you are. And you ever with me I know."[17]

The following day, she had taken him through her exhibit at the museum. "Incredible Georgia—and how beautiful your pictures are at the Modern—I'm glad. I'm glad we were there this morning. . . . Oh Georgia—we are a team—yes a team. Can't believe that you are to leave and that you are reading this in your country," he wrote to Ghost Ranch.[18]

A note of panic crept in as Georgia's departure loomed. Writing from the Place, he told her: "It is very hard for me to realize that within a few hours you will have left. . . . But there is no choice. You need what 'Your Place' will give you. Yes you need that sorely. And I'll be with you, Cape and all. And you'll be with me here and at 59 [East 54th Street]. . . . goodnight with much love."[19]

She hid messages for Alfred to discover in sequence. "Found your letters and notes gradually," he wrote. "Ever surprised. And ever delighted. Ever so you."[20]

He felt weary. Even with the help of the housekeeper, he had trouble getting off for Lake George, delaying his departure each week.

On July 6, Nancy and Beaumont Newhall visited Stieglitz at the Place. On their way to Long Island for a weekend, they brought Alfred his favorite chocolate ice cream cone, a bon voyage treat, for his scheduled departure for the Hill two days hence. They found Alfred alone, lying on his cot; a sharp pain in his chest had left him unable to move all morning. But he had already called the doctor himself. If they would only help him home, he would be fine. Before they left, he asked them to read aloud James Thrall Soby's review of Georgia's show. A MoMA trustee, Soby had never been a fan of Georgia's; the present exhibit had changed his mind. Stieglitz listened, exultant. He had always loved a convert.

Delivering Alfred to the housekeeper, the Newhalls left. After lunch, Nancy returned to find him weaker. The doctor had already been there. After tending to the patient, he had reached O'Keeffe in New Mexico; the prognosis was not good. He urged her to return.

In the last eight years, Alfred had suffered seven coronary or angina attacks—most of these when Georgia was away. He had always recovered. She decided to stay where she was. Donald Davidson was engaged to spend nights with Alfred.

He rallied enough to send her a reassuring note on June 8: "Nearly all right. Nothing for you to worry about. Lucky that I had decided not to go to the Lake today."[21]

The next morning, he was well enough to write Georgia again, the flowing letters still firm and black: "I am sitting in your room. At your desk. . . . Your letter one of 3 letters. Read it first. As I always read your letters first. Kiss—another kiss. Tomorrow I'll go to the Place for a while."[22]

He never got to the Place. Davidson had to leave the apartment early. Andrew Droth, his helper at the Place, arrived at 54th Street about noon. He found Alfred sprawled on the floor, unconscious in the little hall between Georgia's bedroom and the living room; the pen he was holding in his hand had rolled a few feet away from his body. Rushed to Doctors Hospital, Alfred was diagnosed as having suffered a massive stroke. He never regained consciousness.

Dorothy Norman arrived from Woods Hole to find Henwar Rodakiewicz and Mary Callery, the sculptor and friend of O'Keeffe, at Alfred's bedside. The news of his stroke had reached O'Keeffe, shopping in Santa Fe. Without returning to the ranch, she took the next flight from Albuquerque. Shortly before her arrival at the hospital, two and a half days after Alfred was admitted, Norman withdrew from his room. O'Keeffe was with him when he died, in the dawn hours of July 13.

Through the blistering heat of a summer Saturday, she finally located

the plain cloth-covered coffin she wanted, in a Jewish funeral home. The story has been told and retold of Georgia, sewing through the night, to replace the pleated pink satin of the original lining with plain white linen. Late in her life, she relented with the unembroidered truth: in fact, she had ordered a plain white sheet delivered along with the unlined coffin to the funeral home.[23]

On July 14, at Frank Campbell's on Madison Avenue and 80th Street, only twenty mourners filed past the closed coffin. At Stieglitz's request, there were no eulogies, music, or flowers. Only Steichen broke ranks, placing on top of the casket a branch of evergreen from the tree he and Alfred had planted together on the Hill almost half a century before. Distant and impersonal, O'Keeffe accepted condolences; then, alone, she disappeared into the limousine for the trip to the crematorium in Queens. As it was a Sunday, Alfred's body remained in a private room with a view until the crematorium opened for business the next day.

Friends, including the Newhalls and Dave McAlpin, were told by a nurse that O'Keeffe did not wish to see anyone; she had a lot to do and Steichen was helping her. This choice must have appeared as the ultimate revenge on the dead man, but it merely showed O'Keeffe's political sensitivity to a shift in power. Almost as soon as he was out of his naval officer's uniform, Steichen had ousted Beaumont Newhall from the Photography Department of the museum, taking over his job.

A few days later, Georgia telephoned Dave McAlpin, asking him to drive her to Lake George with Alfred's ashes. Leaving him in the car by the side of the road, Georgia and Elizabeth Davidson buried his remains in the earth under the roots of a tree near the lake. "I put him where he could hear the water," she said.[24]

Emmeline Obermeyer Stieglitz died in 1953 at age eighty.

Moved from Craig House to Bloomingdale's Hospital (now a part of the New York State psychiatric facility) Katherine Stieglitz Stearns died in 1971.

WITH ALFRED'S DEATH, Georgia's public facade of stoicism toward Dorothy—maintained through pride or fear—shattered. She tore into Norman, calling her relationship with Alfred "disgusting." Dorothy could leave her things at the Place until she, Georgia, returned from New Mexico in the fall. Then Georgia wanted her OUT; she would be running the gallery from then on. Stieglitz had allowed Norman to take care of the lease only "because he and all his family liked making things difficult," she informed the younger woman.[25] Alfred had been

planning to hand over control of the Place to Georgia shortly before his death.

Those diplomatic souls who were friends of Norman, Stieglitz and O'Keeffe tried to be understanding of Georgia's "malignant" behavior. Their sympathy was strained, however, by O'Keeffe's lack of control in Norman's presence. On May 1, the Newhalls had given a party to celebrate Beaumont's resignation from the museum and his new position, director of Eastman House in Rochester. Arriving with Dave McAlpin, Georgia had seen Dorothy through the doorway and had screamed and fled. They had feared then that she might be having another breakdown. Ansel Adams was still more specific. "I am convinced O'Keeffe is psychopathic," he wrote to Nancy Newhall. He was particularly appalled when he heard to whom Georgia had turned in her bereavement. "I despair at the thought of Steichen getting his claws in on the kill," he wrote, adding, "It's all lousy, stinko, cheap & dreadful."[26]

WORK, AS ALWAYS, was O'Keeffe's salvation. Administering Alfred's estate was a monumental task that would absorb her for the next three years. His will, made out in 1937 and probated in September 1946, appointed O'Keeffe as sole heir and executor. She was left $148,000 in cash and stocks and charged with the distribution of his collection to such institutions as she would designate: more than eight hundred fifty works of art, plus photographs and fifty thousand pieces of correspondence. O'Keeffe entrusted the task of appraising the paintings, sculpture drawings, and works of graphic art to Edith Halpert, owner of the Downtown Gallery.* Over the years, Stieglitz had quietly amassed staggering holdings in twentieth-century art. To the Rodin drawings he had acquired with such excitement in Paris in 1911 he had added a Kandinsky purchased from the Armory Show in 1913, followed by African sculpture; prints and posters by Toulouse-Lautrec; bronzes and drawings by Brancusi and Matisse; and paintings, drawings, and etchings by Picasso.

Alfred's arrangement with his own artists, taking work in lieu of deducting gallery expenses from sales, had given him three hundred thirty-seven works by Marin along with substantial holdings of Dove

* Halpert's estimated value of the entire Stieglitz collection, $64,425, was clearly indexed to the lowest possible tax assessment on the estate; even so, the figure dramatically illustrates the values separating the postwar art market from that of the 1990s.

and Hartley. In O'Keeffe's inventory, the most poignant items are not the work of a professional artist: two watercolors by Kitty Stieglitz.

Major paintings, works on paper, and photographs were divided among the Metropolitan Museum, the Museum of Modern Art; the Art Institute of Chicago; the Philadelphia Museum of Art, and the San Francisco Museum; photographs were given to the National Gallery of Art and the Library of Congress. Through her friendship with Jean Toomer and Carl Van Vechten, who had made Fisk University a beneficiary of his own collections, O'Keeffe decided on the preeminent black school in Nashville as repository for other works. Charmed by a young bibliographer at Yale, Donald Gallup, who had acquired Gertrude Stein's papers while serving in France during the war, she decided to give Alfred's correspondence and other photographs to the Yale Library.

Before distributing the works of art, O'Keeffe decided on another mammoth project: two exhibitions of Alfred's photographs and art collection were held concurrently at the Museum of Modern Art in 1947.

What to exhibit, keep, sell, give away—and where? The decisions, not to speak of the paperwork involved, threatened to consume her. To help with the vast labors ahead, she engaged a young woman, Doris Bry, who was at the time doing related work for another employer: Dorothy Norman.

For a short time Bry was in the delicate position of working for both widow and former mistress. A choice had to be made, and O'Keeffe was the winner. Hiring Doris Bry away from Norman was, for Georgia, an important credential. But Bry had other attributes that made her perfectly suited to the undertaking ahead. A Wellesley graduate, she had come to know and admire Stieglitz's photographs in the Museum of Fine Arts when she was living in Cambridge. She had applied to Norman for the job because of her interest in Alfred and the Place. She had the needed secretarial skills; she was meticulous, hardworking, and reliable; she had an excellent eye; most important, she was tough enough to represent her employer's interests in New York while O'Keeffe was in Abiquiu.

I N 1945, the summer before Stieglitz's death, the hilltop property in Abiquiu had become available. O'Keeffe became its new owner—the first Anglo landlord in the two-hundred-year life of the village.

Maria Chabot was entrusted with the mission of transforming a patio surrounded by a crumbling pigsty into a small, self-sufficient estate:

studio and living area for O'Keeffe; servant and guest quarters; and a garden oasis supplying fresh fruit, vegetables, and flowers in the middle of the desert. To her function as majordomo, Chabot now added the titles of architect, designer, and construction superintendent. She commandeered building materials unseen since the construction of Los Alamos—copper wiring, plumbing, electrical fixtures, even hard-to-find nails. She supervised the fabrication of adobe bricks on site, along with the handwork of the women who traditionally smoothed the sand-and-water mixture into facing, covering perpendicular corners with the famed curves of reddish pink. She saw to the traditional interior features of the two main buildings: the wooden *viga* and *latiga* ceilings and the long, narrow fireplaces, both painted white. To these, O'Keeffe contributed her preference for minimal furnishings: built-in cushioned benches around the walls, low shelves for books and phonographs, shells and bones, and a country kitchen that could have belonged to a Wisconsin farm.

Only Georgia's insistence on views reveals that the adobe structure is a conceit. The ancient building method was the solution to keeping out light and heat. Like all attempts to replicate vernacular architecture, the Abiquiu compound bears the stamp of its period. Perched high above the road, O'Keeffe's studio/bedroom, with its horizontal slash of "picture windows," suggests a model ranch house of the early 1950s.

By the late 1940s, the balance of power between the two women had shifted. In the war years at Ghost Ranch, there had been only occasional visitors. On the inaccessible, isolated ranch, with few amenities, Georgia had been more dependent on Chabot's survival skills—camping or householding—and grateful for the younger woman's companionship. Leaving Maria at the Albuquerque airport in November 1941, she had written to her from the plane heading East. There in the sky was "our beautiful star." She wished Maria good night, adding, "I want to thank you for the many, many things you thought of for me—your real kindness—and freshness—you made so many things so easy for me."[27] In those long summers, she had been the possessive one, imperiously sending away a young man who had come a long distance to call on her companion.

After the Abiquiu headquarters were completed in 1949, the provider became the prisoner. Dorothy Miller, now a full curator at MoMA, and her husband, Holger Cahill, were among the first guests. Miller was shocked to hear O'Keeffe refer to Chabot as "my slave" in front of other visitors. The significance of the term was not lost on those present.

For her part, Chabot resented her demotion to the unambiguous

status of servant. Now that O'Keeffe had a second home, she would invite guests; when she felt oversocialized and underworked, she would ship them, along with Maria, to Ghost Ranch while she stayed to paint in the Abiquiu studio. Chabot would end up taking charge of the teenage Bok boys, along with managing two residences. Maria became angry; she made claims. As soon as O'Keeffe's control was threatened, the end was imminent. Chabot sensed what was coming as soon as O'Keeffe had the porous adobe of the houses covered with hard gray weather-resistant surface. Georgia would no longer be dependent on Maria's seasonal supervision of local women to do the work.

A house is the possession most readily conflated with the inhabitant. O'Keeffe accepted no claims on either. "Maria, who really built this house, became attached to me as a result, and was very jealous," O'Keeffe said later in her flat way. "I told her eventually that she'd have to leave and not come back."[28]

Earlier, O'Keeffe had made a will, leaving the Abiquiu house to Chabot. Not only had she changed the will, she changed the locks; Maria was forbidden to set foot in the house she had built.

O'Keeffe no longer divided her year between New York and New Mexico; her life at home became predictable, an orderly movement between Ghost Ranch and Abiquiu, largely dictated by the seasons. With her advancing age, the ranch was too cold and damp beginning with the heavy rains of late fall. Arthur Pack had promised her "first option" on his property, which she counted on adding to her own Ghost Ranch acreage. Changing his mind, he sold it to the Presbyterian church for use as a retreat and conference center. O'Keeffe's relationship with her new neighbors was chilly.

WITH BRY'S HELP, the jumble of photographs and pictures was catalogued and distributed; a Stieglitz Archive was established at Yale for the voluminous correspondence, sales catalogues, and photographs Georgia had rescued from Alfred's perfectionist weedings-out. "The Wastebasket Collection," she called it. The remainder of the estate— far from negligible—was under Bry's stewardship in New York. Only she had the key to the storage area.

By the summer of 1949, the task was completed; Georgia was free to leave New York and the poky last apartment she had shared with Alfred. The friends they had in common were gone. One week after Stieglitz's death, Paul Rosenfeld, diabetic and reduced to near-poverty, died of a heart attack at fifty-six. After a two-year battle with cancer,

Florine Stettheimer died in 1944, followed by Ettie in 1955. In 1950, Mitchell Kennerley, destitute, rented Room 1828 at the Shelton Hotel and hung himself with his belt from the bathroom light fixture.

Always devoted to Georgia, Margaret Prosser, the Lake George housekeeper, had made it clear that she would like to work for her in her new home. The idea horrified O'Keeffe; Prosser talked about the past all the time and Georgia didn't want to hear about it, she said.

In Abiquiu, a staff of local help provided for O'Keeffe and a growing stream of visitors. Old friends passed through briefly: Honi Pollitzer Weiss and her husband; from Chicago, Dan Rich and his children; Peggy Bok, now remarried to a Los Angeles surgeon named Kiskadden.

When Peggy drove off after her visit in 1953, Georgia wept. She felt that Stieglitz was leaving her all over again, she wrote to Peggy. The ranch always made her think of Alfred; she was writing her from the same table where, so many times, she had written to him. Peggy, like Alfred, represented a part of herself—a capacity to feel tenderness, love, pain—that was gone. Her visit, she told Peggy, made her feel that she had come home again, in a sense that was not part of her present life. Tears fell on the page as she wrote.

She wept for all the losses she had ever endured.

Other old friends were dropped, especially if they claimed repayment of past favors. Marjorie Toomer asked whether Jean's daughter, Argy, could spend a few weeks with Georgia. Toomer was drinking heavily; he was ugly and abusive, and life at home was bleak for an adolescent. Sorry, O'Keeffe replied. She was tired and couldn't accommodate a "problem child." It was easy to forget the problem friend that Marjorie and her daughter had swept off to Bermuda twenty years before.

Henwar Rodakiewicz, devoted to both Alfred and Georgia, was banished for the same sin: presuming upon friendship. Shooting a film for the State Department about local artists and their world, he and his crew had taken up too much of Georgia's time. Soon, the witty and loyal Spud Johnson was savagely dismissed: he had declined an O'Keeffe dinner party to visit his aging parents in the Midwest.

More often now, the famous O'Keeffe candor turned into naked cruelty. On the occasion of her election to the National Institute of Arts and Letters in 1949, she saw an old friend, Katherine Kuh, who as Dan Rich's assistant had worked on O'Keeffe's Chicago show. Kuh had recently given up smoking, with predictable consequences. "You've gotten so fat and old-looking. You used to be such a pretty girl," O'Keeffe announced to the stunned woman and her fellow guests. Then she sailed off.[29]

Everyone had a theory to account for Georgia's uncontrolled sav-

agery—like a sawed-off shotgun. Peggy Bok Kiskadden attributed it to a sudden surge of her Hungarian blood. She seemed to be getting even with everybody, with every woman who had ever been young and pretty, for every slight she had ever suffered.

She was easier on men whom she felt to be real men—especially if they were handsome and helpful. William Howard Schubart was even forgiven for being Sel's son and a Stieglitz. A successful investment banker and a Kuhn, Loeb partner, Schubart was married to another Obermeyer cousin. Beginning in the late 1940s and until his death in 1953, he gradually took over Robert Young's role as manager of O'Keeffe's portfolio. Within those few years, he increased her capital by one hundred thousand dollars. Besides his prudent advice about money (he insisted that Georgia was spending too much on her simple life), he was shrewd about art, counseling her against showing her work in 1950, the last year of the Place. There were too few important pictures, he said. Georgia did not take his advice, and the show was charitably ignored.

Georgia's letters to Schubart, five years her junior, are intimate and confiding, with bursts of elephantine flirtatiousness." I was surprised that your eyes were so blue," she told him, adding that she would love to visit the Irish Sea with him.[30]

She was frank about her relationship with Bry and its limitations. "Why dont you go in and call on Doris at the Place and see the kind of slave I have," she suggested. Howard could ask Bry anything he wanted—"only dont let her worm anything about my finances out of you," she warned.[31]

At the same time that women intimates were publicly designated slaves, O'Keeffe was open about her own helpless attraction to a type of young male tough, preferably one with a record. In 1953, before their friendship ended, Marjorie Toomer had visited Ghost Ranch. She was worried, she wrote to Jean, about Georgia's involvement with an Abiquiu boy who was in jail for assault, battery, and rape. O'Keeffe was rushing back and forth to Albuquerque to try to get him out of prison, where he clearly belonged, in Marjorie's view. O'Keeffe wrote Anita Pollitzer a fond description of her weakness for "Jackie" (Suazo), whose criminal behavior was clearly the source of his allure. "I call him my darling and tell him my idea of a darling is someone who is a nuisance," she explained. "—he has been the horror of the community—I hope he doesn't become a jailbird—at 20 he has been in jail 3 times," she added proudly.[32]

Starting in the early fifties, O'Keeffe made up for her unadventurous early life and, later, Stieglitz's ban on travel. In 1951 she went to

Mexico, part of an uneasy convoy that included Spud Johnson, Eliot Porter, and his wife Aline. On the road, the Empress of Abiquiu refused to alter her preferred nursery-hour dinnertime: her companions' insistence on dining later than six o'clock was taken very badly. Tempers frayed.

In 1953, she made her first trip to Europe, guided about Paris by her friend Mary Callery. An expatriate since the twenties, Callery had become a friend to O'Keeffe when the handsome blond sculptor returned to New York during the war years. Daughter of a Westinghouse president, she had first married patrician New York lawyer Frederic Coudert. Subsequently, she had become notable for her witty, brightly colored, tubular metal sculpture, her splendid emeralds, and her many lovers. (Picasso was one of the few geniuses of the period whom she skipped; he frightened her, she told a friend. Her feelings were communicated to O'Keeffe, who demurred at the offer of an introduction.)

In 1954, Georgia went abroad again, accompanied by a young woman, Betty Pilkington, daughter of the local garage owner at Abiquiu. Besides France, they visited Spain, Germany, and North Africa. Two years later, O'Keeffe and Pilkington, who also acted as secretary, spent two months traveling in Peru. In 1959, O'Keeffe, seventy-two, went around the world with a small group of well-heeled art lovers. Then in 1961, she visited Cambodia via Japan, Hong Kong, and Bangkok, returning by way of Fiji and Tahiti. She kept fit for these strenuous hegiras by frequent sessions of rolfing, the system of violent massage of nerves and muscles designed to relax and prevent stiffness of limbs. Ida Rolf herself came to Abiquiu for the series of painful three-hour sessions extending for days. Georgia tried to arrest the beginnings of macular degeneration with the Bates method of eye exercises. She counseled sprouts, wheat germ, and yogurt to friends and family.

Troubles had descended on two of the O'Keeffe sisters. Since the death of Anita and Robert Young's only daughter in an airplane crash in 1940, Robert had suffered severe bouts of depression. In 1958, under attack as president for the bankruptcy of the New York Central Railroad, Young got into his car in the garage in Palm Beach and turned on the gas. Beset by lawsuits, Anita had become even less generous than usual, Georgia told Claudia.

Anita's stinginess was an issue because the three solvent sisters—Georgia, Anita, and Claudia—were contributing to the support of the indigent Ida. After abandoning nursing, Ida had tried painting; she had even exhibited her work at the Opportunity Gallery in 1933. Georgia had not attacked her painting, as she had Catherine's competing still lifes; but Ida became discouraged. She worked in an airplane factory

during the war, but then the once ebullient, capable young woman fell apart. Georgia was responsible, but not generous. She informed Ida, through Claudia, that any outlay of money over the amount of five thousand dollars would have to be used to mortgage Ida's house; she could not afford to give away funds with no security, Georgia said. Of course, Ida should be reassured; she wouldn't be put out on the street. For tax purposes, however, Ida was to describe these sums as a gift, not a loan. Claudia should watch Ida very carefully to see that she made no errors in this regard to the IRS. (There is a shaky column of figures on one of Georgia's letters to Claudia: listing the sums received by "I. O'K." At one point, Georgia obviously felt ashamed of the mortgage ploy; it had been Anita's idea, not hers, she told Claudia.

While not as well-off as Robert Young's widow or Georgia (soon to be one of the richest self-made women in America), Claudia, the youngest O'Keeffe sister, had done well in California real estate and other investments. She and her companion of thirty years, Hildah Hohane, had started a Montessori kindergarten in Beverly Hills "for particular parents." Georgia's populism had been unexpectedly aroused; she found their brochure "snooty." But she eagerly awaited Claudia and her friend's visits: the two women, accompanied by their dogs, would arrive in a chauffeured limousine from Los Angeles. Once installed, Claudia would get to work in the garden; the peach trees she tended were Georgia's special pride.

In a decade of constant travel, the tranquility of Abiquiu inspired O'Keeffe's most serene works. The series called *In the Patio* began, predictably, in the late 1940s with a realistic rendering of the enclosed space, complete with ladder. The horizontal paintings that followed moved directly to simplified geometric forms, stopping just short of abstraction: with the black patio door as a constant, each version varies only in the color relationships of the rectangles within rectangles.

Seen in the context of O'Keeffe's life and work, the Patio series looks backward and forward. There is an echo of Dow's teachings and of her Texas years, in which she asked her pupils to put a door in a wall—"anything to get them to think about dividing space." Her own sophisticated thinking about the division of space and the rhythmic possibilities of pigment anticipated the color field painters of the decade to come.

In 1965, Bry became O'Keeffe's exclusive dealer and agent, adding her own interests to the elaborate system of controls, restrictions, and copyrights that governed the purchase, exhibition, and reproduction of the artist's works. Although she now denies this, negotiations with Bry—subject to unexpected delays and silences—were widely held to

inflict permanent damage on the central nervous system of curators and museum directors. Anyone familiar with Stieglitz stratagems—keeping prices high by limiting access to the work—would recognize the winning psychology involved. Since O'Keeffe had always overproduced (except in her years of illness), conditions of scarcity had to be artificially created: the difficulties, obstacles, and frustrations, the pleading letters and phone calls as deadlines loomed became a form of value-added tax.

The crowning effort of Bry's twenty-five years of work came in 1970, with the Whitney Museum's O'Keeffe retrospective, the artist's first since 1946. Bry and the museum's director, Lloyd Goodrich, shared equal billing as coauthors of the catalogue. The most important feature of the Whitney show was its historical timing: at eighty-three, O'Keeffe now reached a new receptive audience of women who saw in America's most successful independent woman artist a triumph of feminism. A new generation of critics and journalists found her life and art exemplary. Her early membership in the National Women's Party was dusted off along with her letter to Eleanor Roosevelt, written in the 1940s, in support of an Equal Rights Amendment. O'Keeffe's art—the denials of the artist notwithstanding—was once again exalted as a unique expression of an intensely feminine erotic energy. Biology had, indeed, become destiny: O'Keeffe had attained the apotheosis Stieglitz had, from the moment he saw her drawings, envisioned: she was the first great American woman artist.

O'Keeffe never disguised her disdain for the new generation of feminists. She didn't need them. Women had no power in museums, and younger women were rarely to be found among the ranks of collectors. She was dismayed by the "jumping up and down" of demonstrators and even more dismissive of writers who focused on female artists. "Write about women. Or write about artists. I don't see how they're connected," she told one journalist.[33] The movement's star, Gloria Steinem, came to Abiquiu bearing a large bouquet of red roses, only to be turned away. In the phrase of the period, O'Keeffe was a "queen bee"; the drones were beneath her interest, and emerging talent was a potential threat. Certainly, she had nothing to gain from collective advances of women in the arts. Occasionally, she appears to have encouraged individual women of modest ambition and abilities. Work, not activism, was the way to overcome any obstacles to achievement, she said.

Her own achievements, she had long agreed, justified a biography. Anita Pollitzer had written a vivid memoir of her early days in New York—"That's Georgia!," published in the *Saturday Review* in 1950. O'Keeffe had liked it and authorized her friend to expand the article to book length, providing her with correspondence and other documents.

When Pollitzer submitted her draft version in 1967, O'Keeffe professed not to recognize the romantic, rosy version of herself that she read. Doris Bry was appointed professional arbiter to deliver the bad news: Anita's manuscript was unacceptable in its present form. Although at least one publisher offered Pollitzer a contract, O'Keeffe threatened to sue if she proceeded with publication.

Before O'Keeffe saw Pollitzer's work, she was already discussing with James Johnson Sweeney the possibility of his writing the canonical text on her life and art. A fan and friend of Georgia's, Sweeney, with an international reputation as curator, scholar, and collector, would obviously have made an ideal choice. (Ultimately he agreed to take on the project. Like his catalogue for the O'Keeffe show at MoMA, the biography was never written.) Pollitzer was destroyed by O'Keeffe's treatment, according to her nephew. This shock, followed by the loss of her husband, led to a swift decline in her mental powers that preceded her death in 1975.

Along with the choice of official biographer, O'Keeffe's advancing age made the disposition of her work a pressing matter. Prompted by the appointment of Derek Bok, her friend Peggy's son, to the presidency of Harvard, O'Keeffe decided in 1972 to leave all her works to that university for the benefit of students. In the "Harvard Agreement," Bry was appointed O'Keeffe's sole agent and executor of her estate, with lifetime tenure. In 1977, O'Keeffe changed her mind, both about Harvard and Bry's role as agent; the agreement was invalidated by the court.

On the Thursday before Labor Day 1973, a young man appeared at the back door of Ghost Ranch looking for work. Born the year of Stieglitz's death, the twenty-seven-year-old, with his dark mustache and flashing eyes, bore an astonishing resemblance to photographs of a debonair Alfred on the grand tour. John Bruce Hamilton, called Juan, was not touring so much as drifting around the country. Like many young men of his generation, he knew better what he sought to flee than what he hoped to find. A potter, he escaped the expectations of Presbyterian missionary parents and a former wife for antiwar activism and a belief in the healing capacity of the handmade. Driving around Lake George, he had apparently told friends of his fantasy of becoming close to Georgia O'Keeffe. Persistent in the face of O'Keeffe's initial coolness, Hamilton soon rose from heavy work around the ranch to secretary and assistant. He loved cars and enjoyed tooling around in O'Keeffe's succession of streamlined models: a Lincoln Continental followed by a succession of Mercedeses, black and white. O'Keeffe's eyesight was failing; Juan became indispensable. More to the point, she loved him. Every visitor described the tropism that turned the eighty-six-year-old woman's

blurred gaze toward the handsome young man. "Her face lit up when he entered a room," one woman recalled. In 1974, Hamilton moved into Ghost Ranch and the two went off on a trip to Morocco, the first of several journeys they made together.

Hamilton's motives and behavior and his influence on O'Keeffe are a continuing subject of debate. To some, their relationship is a sinister drama of the old and rich victimized by the young and greedy. His ascendant role in her personal and professional life alienated other helpers. Her increasing isolation worried many who had always kept in close touch with her. Certain friends were no longer welcome; telephone messages, letters, and in some cases Christmas cards, it was believed, never reached O'Keeffe. Whenever there was a showdown or ultimatum, O'Keeffe rendered unquestioning judgment: Juan won. O'Keeffe's eyesight may have failed, but her hardheaded choice could not have been clearer. Juan's presence extended her life, with its pleasures of travel and work, with television programs and publishing projects. The alternative—being warehoused in a fancy nursing home where she would be sure and get her Christmas cards—did not make for a tough decision.

Gradually, Juan took over the protective role of censor that Bry had exercised from New York. By 1976, it was made clear to art dealers that Bry was no longer exclusive agent; her commission of twenty-five percent was split with Hamilton. (Bry continues to deny exercising any censorship function or fee-splitting arrangement with Hamilton.)

On at least one occasion, Bry produced a frail and barely sighted O'Keeffe for lunch with a New York art dealer to show that she was still in control. Her hosts were amused by Georgia's professed awe at their grand apartment and splendid examples of twentieth-century art. She was unaware that both were familiars of her sister's lavish establishments and of Mary Callery's collection of school of Paris masterpieces. At almost ninety, Georgia was still playing the little girl from Little Rock.

She always knew the advantages of innocence. Her New York hosts made two visits to Abiquiu. The first invitation was the result of a telephone call in the course of which the dealer reassured O'Keeffe that he did not care about the "few good things" that she told him were all that were left in her possession: he only wanted the junk, he said. He was willing to sit on it for twenty years. He bought six or seven pictures on that trip. Fifteen months later, in the spring of 1976, he and his wife returned. They spent four days of unvarying routine. At 8:30 each morning, they appeared at Abiquiu, where O'Keeffe received them dressed in a long, loose black dress by Balenciaga. In the course of the morning, pictures were brought out by Juan and arrayed around the

walls of the large white studio; some would be replaced by others or would disappear altogether. Shortly after noon, luncheon was served. Her guests would return to Santa Fe to await the next morning's negotiations. On the fourth day, they had agreed on the purchase of forty-three pictures. There was some discussion of the commission, to be split between Juan and Bry. The larger pictures, some half dozen, would be shipped; the others would be taken back with the new owners. Although O'Keeffe said she needed cash badly, a three-year payout was proposed and accepted. "That way you know you have to live to collect it," the new owner explained, a realist after O'Keeffe's own heart. As his wife began packing up the pictures, O'Keeffe looked down at her, crouched on the floor. "That's just how *they* like to see us," she said, motioning with her chin toward her husband and Juan, "on our knees."

A few days later, O'Keeffe telephoned New York. She had decided that the price they had agreed on was too low. She wanted twenty thousand dollars more before she would ship the larger paintings. Since the earlier agreement was in writing, she would make one concession: she would add one more picture of her choosing to those held hostage. By every measure, recalled the art dealer's widow, it was the worst of the lot.

By 1977, Bry was banished. She had allegedly aroused the artist's wrath by selling several paintings without O'Keeffe's knowledge. But most likely, Georgia had been looking for an excuse. There followed eight years of lawsuits. O'Keeffe sued Bry for the return of works in her possession; Bry responded with lawsuits against both O'Keeffe and Hamilton, charging Juan with "malicious interference" and claiming thirteen million dollars in damages. Both lawsuits were settled before coming to trial, but Bry lost her claim to having been wrongfully deprived of her rights as O'Keeffe's agent. In 1985, she received a substantial out-of-court settlement on the condition that all documents and lips remain sealed. Friends who had filed depositions on Bry's behalf were swiftly dispatched from O'Keeffe's life. Peggy Kiskadden, who had described Hamilton as a bird of prey circling over carrion, received a savage note from Georgia announcing that their friendship of almost half a century was over. The handwriting was shaky but the message was delivered with stinging clarity.

By now, Hamilton had been given power of attorney along with his other responsibilities. O'Keeffe's deteriorating physical condition meant that other caretakers assumed charge. Rumors emerged from Sol y Sombra, the large house in Santa Fe in which O'Keeffe, Hamilton, and his family lived together.

Reports described a "wedding" in which O'Keeffe signed not a mar-

riage certificate but a final codicil to her will, further benefiting Hamilton.[34] There were alleged threats of abandonment; witnesses cited evidence of maltreatment and neglect.

Then, in early March 1986, Hamilton went to Mexico with his family. While he was there, O'Keeffe's housekeeper telephoned with the news that Georgia was failing fast.

If life copies art, it chooses kitsch. O'Keeffe had ignored the urgent plea of Stieglitz's doctor that she return when he was dying. Hamilton is said to have responded in kind to the same news: they should let him know if things got worse, he apparently told the housekeeper.[35] The same night, O'Keeffe was taken to St. Francis Hospital in Sante Fe, where she died. As she requested, her ashes were scattered over Ghost Ranch; instead of the lapping waters of Lake George, she wanted to hear the wind.

GEORGIA O'KEEFFE survived Alfred Stieglitz by forty years. No more compelling evidence exists of the changes in the art world that took place in that time than in the claims filed by litigants in the lawsuits that erupted over O'Keeffe's estate. As her sole heir and executor, Hamilton stood to inherit seventy million dollars on her death. Perhaps Alfred's shock at this figure would have been dulled by the sale of one O'Keeffe painting, *Black Hollyhock with Blue Larkspur*, for nearly two million dollars in 1985.

This time, it was O'Keeffe's family—the children of her only surviving sister, Catherine—who sued Juan. Once again, an out-of-court settlement was reached whose terms were to remain secret; paintings, money, and other properties were to be divided among the claimants. Juan remained primary heir, and the remainder of the estate went to the artist's descendants and provided for the establishment of the Georgia O'Keeffe Foundation, now housed in the Abiquiu compound. In the 1970s, there had been lively talk of establishing a museum in the area devoted to her art, but the project foundered. Perhaps Alfred's hatred of museums cast its spell.

By many measures, O'Keeffe seems to have become Stieglitz's creature more completely after his death; without him, there was nothing to resist. She had learned his lessons well.

Americans of the twentieth century, historian Christopher Lasch observed, differ from their forebears in their ability to exploit the media. At Alfred's death, the term didn't exist; the small marginal coterie of cultural critics and publicists whom he and Georgia cultivated, befriended, and adopted as family had become part of a vast mass-market

industry. But the strategies of image making were the same. Stieglitz had assigned Georgia her role: the austere, remote priestess of art, "whiteness itself." That role played even better in the desert, where the whiteness of bones, the blackness of Balenciaga, and the unforgettable face whose skin lined but never sagged were as compelling to *People* magazine (where O'Keeffe was among the first artists to be featured) as they had been to *Life* and the old *Vanity Fair*. Just as sympathetic critics found themselves invited to Lake George, there was a well-worn path to Abiquiu.

COUCHED IN THE romance of conflict and reconciliation, the real drama of O'Keeffe and Stieglitz, as with most couples, was collusion. Especially for men and women whose careers are intertwined, fueled by one another's success, there is a private union and its professional, public face. He has his assigned role, she has hers. A bargain is struck.

The "unwritten contract," a friend once called it, collusion is a system of deals and trade-offs, tacitly agreed to and carried out, for the most part, without the exchange of a word. Preferring avoidance to confrontation on most issues, O'Keeffe was the principal agent of collusion in their union.

For the researcher, evidence of collusion must be teased out, lying as it does literally between the lines, in what is *not* said. In one dramatic instance, however—the Lily hoax (significantly concerning money)—the collusion between O'Keeffe and Stieglitz surfaces as conspiracy.

But collusion also answers the questions we ask of their relationship, along with those of friends and public figures alike: how could she or he stay, put up with, stand for, suffer the indignities that the other inflicted. Friends asked this question about O'Keeffe and Stieglitz throughout their life together. Love—as friendship—played a part in keeping their union nominally intact even when they lived apart.

"I grew very fond of Stieglitz," O'Keeffe said coolly later in her life. He made good on the promise he had held out to the innocent, ambitious Texas schoolteacher studying Picasso and Kandinsky in issues of *Camera Work* in the emptiness of the Panhandle. She would never forget all she owed him: his efforts on behalf of her career, the constant example of his genius as an artist, his humility in the exercise of work. For these gifts, she had forgiven much.

In O'Keeffe's bequest to the Beinecke Library at Yale was one folder, sealed in 1953 at the artist's request "until 1 January 1968 or five years after the death of O'Keeffe, whichever is later."

Tied with string and placed in a manila envelope sealed with wax,

the package was unsealed at the request of the author on September 12, 1989.

O'Keeffe had found the folder after Stieglitz's death, shoved in the back of a shelf in his closet. In it, he had placed drafts of the letters he had written to Joe Obermeyer, to Emmeline, and to Kitty in 1918–1919, O'Keeffe's first year in New York.[36] To the brother-in-law who had once been his friend and to his estranged wife, he addressed page after page of angry accusation, contrasting his purity of motive, his unselfishness, with their egotism and meanness of spirit, his honesty with their lies.

To Kitty, her father's letters hold out the seductive promise that no adolescent daughter can ever keep and grow to become a sane woman. He will give her the love she has never received from him if she will repudiate her mother and accept Georgia as her friend.

On the outer envelope, in her familiar wavy hand O'Keeffe had written:

"ART IS A WICKED THING. IT IS WHAT WE ARE."

ACKNOWLEDGMENTS

IN FIVE YEARS of work on this book, I have sought and received help from hundreds of individuals and numerous institutions. It is a pleasure to acknowledge my debts.

Many of those who knew Georgia O'Keeffe and Alfred Stieglitz shared their memories with me. For their generosity of time, often accompanied by the warmest hospitality, I am grateful to Marie Rapp Boursault, Maria Chabot, Hester Diamond, William Dove, Diana Schubart Heller, Margaret Bok Kiskadden, Katherine Kuh, Hannah Small Ludins, Sally McAlpin and the late David McAlpin, Dorothy Miller, Dorothy Norman, Beaumont Newhall, William Pollitzer, Aline and Eliot Porter, Flora Stieglitz Straus, Aline Pollitzer Weiss, and others who wish to remain anonymous.

Scholars, museum professionals, and fellow writers were no less forthcoming with answers to my questions, along with many other favors and kindnesses. I would like to thank Clifford Ackley, Dennis Anderson,

Tom Armstrong, Peter Bunnell, Martha Charoudi, Francesca Consagra, Andrew Decker, Anita Duquette, Peter Galassi, William I. Homer, Janet Malcolm, Grace Mayer, Lisa Messinger, Linda Nochlin, William O'Reilly, Sue Reed, Timothy Rogers, Ronald Pisano, Lois Rudnick, Gert Schiff, Patterson Sims, Andrew Solomon, Robert A. M. Stern, Gail Stavitsky, Calvin Tompkins, H. Barbara Weinberg, Jonathan Weinberg, Bonnie Yochelson, and Judith Zilczer.

Frances Smyth and Gaillard Ravenal provided the happiest mix of help and distraction, as did Pierre and Susana Torruela-Leval.

My discussion with Theodore H. Stebbins, Jr., and Norman Keyes about the Sheeler-Stieglitz connection was especially enlightening. Naomi Rosenblum generously extended to me her knowledge of Paul Strand's life and career, along with her ideas about the Jewish issue in the Stieglitz circle.

Talks with Justin Kaplan and Anne Bernays helped me to think about the complicated relationship between biographer and subject; a conversation with Robert Caro braced me for the perils of truth-telling. Laurie Lisle, Barbara Kramer, and Suzan Campbell graciously plumbed their research into the lives of Georgia O'Keeffe, the Stettheimer sisters, and Rebecca Strand, respectively, to answer my questions. From his vast erudition and experience, Milton Horowitz considered with me the psychoanalytic dimensions of my subjects. Eva and Allan Leveton opened the Pink House in Taos and added to my understanding of local history and human motive. Every discussion with Frederick Brown about biography—or any other topic—provided pleasure and profit.

Invitations to talk about O'Keeffe's art at the Los Angeles County Museum and about Stieglitz and O'Keeffe at the Norfolk Society of Art helped me to clarify my thoughts on the dynamic between the lives and careers of my subjects. Similarly, my participation in Carole Klein's panel on the problems of biography allowed me to contemplate what I had just survived. As Aileen Ward's guest at several meetings of the Biography Seminar, New York University Institute for the Humanities, I benefited from hearing about members' work-in-progress.

The friendship of Donald Gallup, curator emeritus of the Yale Collection of American Literature, and of his successor, Patricia Willis, has been a lavish reward of my labor. The many months spent at the Beinecke Library were further brightened by the gracious help of the staff: Steven Jones, Rick Hart, Kate Sharp, and Laurie Misoura. For more than three years, the hospitality of Alison, Cameron, and the late Basil Duke Henning made New Haven my home for part of each week.

In Tuscon at the Center for Creative Photography, University of

Arizona, Amy Rule and Maryanne Reading made a series of visits to the Paul Strand Archives a pleasure eagerly anticipated.

Far more than a researcher, Anne Umland brought the imagination, intelligence, and industry of a first-rate scholar to the documentation of this book. Other specific research projects were conducted with perseverance and resourcefulness by the following: Jane Lloyd; in San Antonio, Sharon Crutchfield; in Charlottesville, Sharon Hamner and Anne Freudenberg; in Chicago, Peggy Sinco. In New Haven, Isabel Tang helped me sift through the Stieglitz Archive. Mark Piel, director of the New York Society Library, solved countless research problems. Max Marmor, reference librarian of the Institute of Fine Arts–New York University, pursued elusive bibliography.

Increasingly, lawyers play an essential role in the publishing of biography. However melancholy in its implications, I was constantly cheered by the counsel of Katherine Trager and Mary Luria.

In the final months and with the greatest patience and goodwill, Emma Hall took on remaining research needs, principally the painstaking work of tracking permissions, for which Steven Ratazzi created a database.

Like the teachers we recall with affection and gratitude, a gifted editor stretches the writer's capacity to do more and better. I am indebted to Nan A. Talese for her generous attentions to the author and the book. The care and knowledge that Barbara Flanagan lavished on copyediting the manuscript were humbling. Sabra Moore brought dedication along with an artist's eye to the pursuit and selection of illustrations. Alex Gotfryd and Marysarah Quinn contributed taste and skill to the book's appearance. With efficiency and good humor, Jesse Cohen coordinated the myriad stages required before a manuscript becomes a publication.

The telling of others' lives lays great strain on the biographer's own. For love—bracing, consoling, diverting—I am grateful to Rachel Eisler, Wendy Gimbel, Halcy Bohen, Celia Eisenberg, Sallie Bingham, Robert Petersson, Bruni Mayor, Phyllis LaFarge, Natalie Schwartzberg, and my friend and agent Gloria Loomis.

I first read about Alfred Stieglitz in an undergraduate thesis on the photographer written by my husband, Colin Eisler, more than thirty-five years ago. With only a fraction of the material available now in the vast holdings at Yale, he developed insights into the character and career of his subject that have been confirmed with time. Allowing me the use of his unpublished research is only the smallest measure of his constant and loving support.

PHOTO CREDITS

NOTES

ARCHIVES IN WHICH SOURCE MATERIAL IS LOCATED

Archives of American Art (AAA): Helen Torr Dove Papers

Center for Creative Photography, University of Arizona, Tucson (CCP): Paul Strand Archives (PSA), including Rebecca Salsbury Strand to Paul Strand; Harold Clurman Papers

The New York Public Library, Rare Book and Manuscript Division (NYPL): Mitchell Kennerley Papers

Newberry Library, Chicago, (NL): Sherwood Anderson Papers

Museum of Fine Arts, Museum of New Mexico, Santa Fe, New Mexico: Correspondence between Georgia O'Keeffe and Claudia O'Keeffe (the latter deposited in facsimile)

Collection of American Literature, Beinecke Rare Book and Manuscript Library, Yale University, New Haven (YCAL): Alfred Stieglitz Archive; Mabel Dodge Luhan Papers

Van Pelt Library, University of Pennsylvania (UP): Waldo Frank Papers

ABBREVIATIONS OF CORRESPONDENTS' NAMES CITED IN THE NOTES

Sherwood Anderson	SA
Marie Rapp Boursault	MRB
Elizabeth Stieglitz Davidson	ESD
Arthur Dove	AD
Mabel Dodge Luhan	MDL
Henry McBride	HMcB
Arthur Whittier Macmahon	AWM
Georgia O'Keeffe	GOK
Ida O'Keeffe	IOK
Anita Pollitzer	AP
Paul Rosenfeld	PR
Herbert J. Seligmann	HJS
Alfred Stieglitz	AS
Emmeline Obermeyer Stieglitz	EOS
Katherine Stieglitz (Stearns)	KSS
Paul Strand	PS
Rebecca Salsbury Strand	RSS

PROLOGUE

1. AP to GOK, November 1915, Monday night, in Giboire, *Lovingly, Georgia*, 84.
2. GOK to AP, October 1915, in ibid., 46.
3. Ibid.
4. GOK to AP, October 1915, Saturday night, in ibid., 40, 42.
5. O'Keeffe, *O'Keeffe*.
6. AP to GOK, January 1, 1916, in Giboire, *Lovingly, Georgia*, 115.
7. AS to Anne W. Brigman, December 25, 1918 (YCAL).
8. GOK to AS, January 1916, in Pollitzer, *Woman on Paper*, 123.
9. AS to GOK, mid-January 1916, in ibid., 124.
10. Pollitzer, *Woman on Paper*, 134.

ONE ❧ IN FLIGHT FROM EDEN

1. Wiebe, *Search for Order*, 4.
2. Pollitzer, *Woman on Paper*, 55.
3. Ibid., 77.
4. Lisle, *Portrait of an Artist*, 15.
5. Lesy, *Wisconsin Death Trip*, conclusion.
6. Pollitzer, Woman on Paper, 58.
7. Juan Hamilton, "In O'Keeffe's World," in Cowart, Hamilton, and Greenough, *Georgia O'Keeffe*, 10.
8. O'Keeffe, *O'Keeffe*.
9. Ibid.
10. Pollitzer, *Woman on Paper*, 60.
11. Winsten, "Georgia O'Keeffe Tries to Begin Again."
12. Lesy, *Wisconsin Death Trip*.
13. Quoted in Brooks, *Confident Years*, 182.
14. Wiebe, *Search for Order*, 16.
15. Lesy, *Wisconsin Death Trip*.
16. Lisle, *Portrait of an Artist*, 54.
17. Index to Circuit and Superior Court Matters by Plaintiffs, Dane County, Wisconsin, Civil Actions, p8, under "B." Film No. 241, drawer No. 851. Wisconsin State Historical Society.

18. Pollitzer, *Woman on Paper*, 71.
19. Stevens, *Old Williamsburg*, 261ff.
20. Hildegarde Hawthorne, *Williamsburg: Old and New* (New York: Appleton-Century, 1941), 121.
21. Stevens, *Old Williamsburg*, 265.
22. Lisle, *Portrait of an Artist*, 29.
23. Stevens, *Old Williamsburg*, 263.
24. Christine McRae Cocke, quoted in Lisle, *Portrait of an Artist*, 32.
25. Ibid.
26. For a discussion of women art students and social class at the turn of the century, I am indebted to H. Barbara Weinberg, "Class Struggles: American Women as Art Students, 1870–1930," paper delivered at the Whitney Museum, New York, January 27, 1987.

27. O'Keeffe, *O'Keeffe*.
28. Willa Cather, *The Song of the Lark* (Boston: Houghton Mifflin, 1943).
29. Brooks, *Confident Years*, 165.
30. Robinson, *Georgia O'Keeffe*, 73.
31. O'Keeffe, *O'Keeffe*.
32. Ibid.
33. GOK to Ronald Pisano, September 18, 1972, quoted in Pisano, *William Merritt Chase*, 38.
34. O'Keeffe, *O'Keeffe*.
35. Ibid.
36. Ibid.
37. Pisano, *William Merritt Chase*, 79.
38. O'Keeffe, *O'Keeffe*.
39. Ibid.
40. Ibid.
41. Ibid.
42. Ibid.

TWO ❧ THE SPELL OF THE CAMERA

1. All researchers exploring the early life of Alfred Stieglitz are indebted to Sue Davidson Lowe's *Stieglitz: A Memoir Biography*.
2. Hedwig Stieglitz to AS, September 28, 1898, quoted in Lowe, *Stieglitz*, 31.
3. Others were the sculptor Moses Ezekiel (1844–1917), a distant Stieglitz cousin, and Louis Maurer, an illustrator and the father of the far more talented painter Alfred Maurer. The latter's works were shown in a group exhibition by Stieglitz at 291 in 1910, and he was to have had a one-man show in the 1917–1918 season, but 291 closed its doors in the spring of 1917.
4. Diana Schubart Heller, interview with the author, June 24, 1987.
5. AS to Edward Stieglitz, December 8, 1877 (YCAL).
6. Lowe, *Stieglitz*, 15.
7. Paul Rosenfeld, "The Boy in the Darkroom," in Frank et al., *America and Alfred Stieglitz*, 64.

8. Lowe, *Stieglitz*, 49.
9. Ibid., 72.
10. Ibid.
11. Ibid., 74.
12. Rosenfeld, "The Boy in the Darkroom," 60.
13. Lowe, *Stieglitz*, 74.
14. Ibid., 80.
15. Norman, "Six Happenings."
16. All of Stieglitz's remarks about Paula are quoted in Newhall, "Notes," 37ff.
17. Norman, *Encounters*, 102.
18. See Dijkstra, *Idols of Perversity*, for a discussion of this subject of genre painting and the implicit analogies between the idle woman and domestic pet.
19. Newhall, "Notes," 37.
20. Freud, "On Fetishism," 198.
21. Newhall, "Notes," 49.
22. AS to John Marin, September 1914, in Seligmann, *Selected Letters of John Marin*.
23. Eisler, "Stieglitz Circle."
24. Ibid.
25. Newhall, "Notes," 37. Stieglitz sug-

gested to Newhall that his mother never got over the shock of her oldest daughter's death.

26. Lowe, *Stieglitz*, 94.
27. AS to Lenzel, undated (YCAL).

THREE ❧ ARTIST IN EXILE

1. Lisle, *Portrait of an Artist*, 50.
2. GOK to Florence Cooney, November 3, 1908, in Pollitzer, "Manuscript Notes."
3. Quoted in Brooks, *Confident Years*, 419.
4. Robinson, *Georgia O'Keeffe*, 77.
5. *The Code of the City of Charlottesville, Virginia*, 1909, Sects. 351, 352, 353, pp. 187–88; *Pollard's Supplement to the Code of Virginia*, 1910, Chap. 41 of Acts 1908: "An Act for the Prevention of Tuberculosis," pp. 725–26.
6. Philip Alexander Bruce, *History of the University of Virginia*, vol. 1 (New York: Macmillan, 1920), 88.
7. GOK to AP, August 25, 1915, in Giboire, *Lovingly, Georgia*, 14.
8. O'Keeffe, *O'Keeffe*.
9. Ibid.
10. Johnson, *Arthur Wesley Dow*, 58. Probably because he subordinated his art to spreading the Word, Dow's paintings have been largely forgotten. They would certainly have been recalled by his most famous pupil. In the fall of 1913, Dow exhibited seventeen large canvases of the Grand Canyon at the Montross Gallery in New York. Georgia O'Keeffe was not in New York at the time of the show, but she saw the paintings later. Although true to his Japanese aesthetic, Dow's vision turns Jupiter Terrace at Yellowstone into Mount Fuji. It was his sense of the West that would emerge in O'Keeffe's art. He had not, he noted, "attempted to paint particular places, nor any of the famous views of the Canyon but rather he had sought to abstract the Spirit of the Place" (p. 99).

Dow's explanation of the role of color in his western canvases could describe his student's later work: "first of all, burning bright or smouldering under ash grays. The line, for the colour lies in rhythmic ranges, pile on pile, a geologic Babylon" (p. 99).

Unlike O'Keeffe, for whom the American West would prove a regenerative force in life and work, Dow's Colorado journey led to his untimely death. Thrown from a mule on a canyon trail, he was terminally paralyzed by the resulting spinal injury.

11. Ibid., 99.
12. O'Keefe, *O'Keeffe*.
13. Ibid.
14. The Dow method, encouraging invention rather than proficiency in young children, was no longer revolutionary. Early in the century, European avant-garde circles exalted the direct, unmediated vision of the child, along with that of "primitive" peoples. In 1908, four years before Georgia's use of the method, Stieglitz had held an exhibition of children's art at 291, the artists ranging in age from two to nine years, followed by a one-child show of his eight-year-old niece Georgia Engelhard.
15. Tomkins, "Rose in the Eye."
16. Significantly, Stieglitz's first purchase from the Armory Show was a work by Picasso's friend the Spanish sculptor Manolo, which he bought three days after the opening of the exhibit. This was followed by the far more daring acquisition of Kandinsky's *Improvisation No. 27* for five hundred dollars, the only work by this artist to be exhibited.

17. Johnson, *Arthur Wesley Dow*, 61.
18. Robinson, *Georgia O'Keeffe*, 89.
19. The official family version of this troubled period has Ida at home caring for her mother. If this were the case, however, persuading the couple to remain at Wertland Street would not have been a crucial factor in Georgia's departure for New York. Robinson, *Georgia O'Keeffe*, for example, makes no mention of the boarding couple, who were noted in Lisle, *Portrait of an Artist*, and listed in tax rolls as residents of the house at the time.
20. O'Keeffe, *O'Keeffe*.
21. Pollitzer, *Woman on Paper*, 2.
22. Pollitzer, "That's Georgia."
23. Pollitzer, *Woman on Paper*, 1.
24. Quoted in Pollitzer, "That's Georgia."
25. GOK to AP, August 25, 1915, in Giboire, *Lovingly Georgia*, 14.
26. Quoted in Robinson, *Georgia O'Keeffe*, 136–37.
27. The term "lyrical left" was coined by historian Christopher Lasch in *The New Radicalism in America*. Alfred Stieglitz's place in this ideology is the subject of an important examination by Edward Abrahams, in *The Lyrical Left*.
28. GOK to AP, August 25, 1915, in Giboire, *Lovingly Georgia*, 15.
29. Ibid.
30. GOK to AWM, August 1915, quoted in Robinson, *Georgia O'Keeffe*, 114.
31. GOK to AWM, September 4, 1915, quoted in ibid., 114.
32. GOK to AWM, September 12, 1915, quoted in ibid.
33. GOK to AP, September 1915, in Giboire, *Lovingly, Georgia*, 24.
34. GOK to AP, August 25, 1915, in ibid., 15.
35. Ibid.

FOUR ❧ THE WILL TO ART AND THE WILL TO POWER

1. GOK to AP, September 1915, in Giboire, *Lovingly, Georgia*, 24.
2. Ibid., 25.
3. Savory, *Columbia College*.
4. AP to GOK, October 1915, in Giboire, *Lovingly, Georgia*, 39.
5. GOK to AP, September 1915, in ibid., 32.
6. Ibid.
7. GOK to AP, October 1915, in ibid., 52.
8. AP to GOK, September 1916, in ibid., 195.
9. GOK to AP, October 1915, in ibid., 47.
10. GOK to AP, October 1915, in ibid., 52–53.
11. GOK to AP, October 1915, in ibid., 47.
12. Ibid., 47–48.
13. Ibid., 48.
14. Ibid.
15. Ibid., 46, 48.
16. Ibid., 46.
17. GOK to AP, October 1915, Saturday night, in ibid., 40.
18. GOK to AP, October 1915, in ibid., 59–60.
19. GOK to AP, October 1915, in ibid., 66.
20. GOK to AWM, November 19, 1915, quoted in Robinson, *Georgia O'Keeffe*, 125.
21. GOK to AWM, November 30, 1915, quoted in ibid., 126.
22. GOK to AP, November 1915, in Ibid., 87.
23. GOK to AP, December 4, 1915, in Giboire, *Lovingly, Georgia*, 95.
24. GOK to AP, November 1915, in ibid., 92.
25. GOK to AP, December 1915, Monday night, in ibid., 103.

26. GOK to AWM, December 25, 1915, quoted in Robinson, *Georgia O'Keeffe*, 127.
27. GOK to AWM, January 6(?), 1916, quoted in ibid., 130.
28. Stieglitz made this remark about *Blue Lines* (1916), which he saw a few weeks after Anita showed him the first roll of drawings; an earlier version of *Blue Lines*, executed in charcoal or black watercolor, may have been included in the first mailing.
29. Fillin-Yeh, "Innovative Moderns."
30. AP to GOK, January 1, 1916, in Giboire, *Lovingly, Georgia*, 115.
31. GOK to AP, January 4, 1916, in ibid., 117–18.
32. AP to GOK, January 1, 1916, in ibid., 116.
33. GOK to AP, January 4, 1916, in ibid., 117.
34. GOK to AS, mid-January 1916, in Pollitzer, *Woman on Paper*, 123–24.
35. GOK to Dorothy Brett, October 12(?), 1930, in Cowart, Hamilton, and Greenough, *Georgia O'Keeffe*, 201.

36. AS to GOK, mid-January 1916, in Pollitzer, *Woman on Paper*, 124.
37. Ibid.
38. AS in *Amateur Photographer*, quoted in Eisler, "Stieglitz Circle," 59.
39. Newhall, "Notes," 38.
40. Ibid., 44.
41. Ibid., 43.
42. Ibid., 33.
43. Marie Rapp Boursault, interview with the author, March 10, 1986.
44. Paul Rosenfeld, "The Boy in the Darkroom," in Frank et al., *America and Alfred Stieglitz*, 39.
45. Miller, *Lewis Mumford*, 175.
46. Norman, "Six Happenings," 89.
47. "How *The Steerage* Happened," in ibid., 94.
48. Sekula, "On the Invention of Photographic Meaning."
49. Eisler, "Stieglitz Circle," 66.
50. Norman, *Encounters*, 43–45.
51. Norman, *Alfred Stieglitz: Introduction*, 43–45.
52. Eisler, "Stieglitz Circle," 66.

FIVE ᎒ GONE TO LOOK FOR AMERICA

1. Dorothy Norman, "From the Writings."
2. Jussim, "Stieglitz Mystique," 154.
3. Norman, *Alfred Stieglitz: Introduction*, 24.
4. Hapgood, *Victorian in the Modern World*, 337.
5. "The 'Photo-Secession' at the Arts Club," *Camera Notes*, vol. 6 (1902).
6. Quoted in Eisler, "Stieglitz Circle," 182.
7. "The 'Photo-Secession' at the Arts Club."
8. Ibid.
9. Sekula, "On the Invention."
10. Mabel Foote Weeks to Gertrude Stein, December 12, 1912, quoted in Gallup, *Flowers of Friendship*, 68.
11. *Camera Work*, no. 1 (January 1903).

12. "Photo-Secession Notes," *Camera Work*, no. 18 (April 1907).
13. Looney, "Georgia O'Keeffe."
14. Kreymbourg, *Troubadour*, 164.
15. Marie Rapp Boursault, interview with the author, March 10, 1986.
16. Flora Stieglitz Straus, interview with the author, May 4, 1987.
17. Lowe, *Stieglitz*, 137.
18. AS to KSS, undated (YCAL).
19. ES to AS, August 1913 (EES).
20. Hannah Small Ludins, interview with the author, July 27, 1987.
21. Marie Rapp Boursault, interview with the author, March 10, 1986.
22. O'Keeffe, "Stieglitz."
23. AS to ES, February 1913 (EES).
24. AP to GOK, November 1915, in Giboire, *Lovingly, Georgia*, 82.

25. AS to PS, September 1915, quoted in Stebbins and Keyes, *Charles Sheeler*, 82.

26. William Carlos Williams, *Autobiography*, 136–37.

27. Newhall, "Notes," 58.

28. Ibid.

29. Ibid.

30. Indeed, Rhoades's later life could have been a Wharton novel. Increasingly interested in Oriental art, she moved to Washington, D.C., where she helped industrialist Charles Freer establish the great collection that bears his name. Rhoades never married, playing the familiar nineteenth-century role of maiden aunt to numerous young relatives. She became ever more devout and devoted in her last years to the Library of St. Jude, a collection of texts related to the Episcopal Church that she acquired, housed, and made available to readers at her own expense.

SIX ❧ "A GREAT PARTY AND A GREAT DAY"

1. GOK to AWM, February 8, 1916, quoted in Robinson, *Georgia O'Keeffe*, 134.

2. GOK to AP, February 1916, in Giboire, *Lovingly, Georgia*, 143.

3. GOK to AP, January 28, 1916, in ibid., 128.

4. GOK to AP, January 14, 1916, in ibid., 123.

5. GOK to AP, February 1916, in ibid., 137.

6. GOK to AP, February 1916, in ibid., 152.

7. Robinson, *Georgia O'Keeffe*, 135.

8. GOK to AWM, December 28, 1916, quoted in Robinson, *Georgia O'Keeffe*, 135.

9. Only after she was a married woman with children, Aline (later known as Honi) Pollitzer Weiss recalled, did she realize that Georgia was bisexual. Her own attraction to O'Keeffe was certainly sexual; indeed, it was the strongly masculine component of Georgia's personality that she found so compelling. Honi Pollitzer Weiss, interview with the author, May 1987.

10. Marie Rapp Boursault, interview with the author, March 10, 1986. The faculty child's comment was mentioned in GOK to AP, October 1915, in Giboire, *Lovingly, Georgia*, 66.

11. Honi Pollitzer Weiss, interview with the author, September 14, 1987.

12. The neighbor, Ethel Holsinger, is quoted by Lisle, *Portrait of an Artist*, 89.

13. Robinson, *Georgia O'Keeffe*, 153, has O'Keeffe returning to Charlottesville immediately on hearing of Ida's death and remaining there through the summer. On the evidence, this is not possible. Had she been in Virginia by May 3, O'Keeffe could not have visited 291 and seen works by "Virginia O'Keeffe," as this exhibit opened on May 27. Georgia's first letter to Anita Pollitzer from Charlottesville (Giboire, *Lovingly, Georgia*, 159), moreover, dated June 21, notes that she arrived the previous Thursday, or June 15.

14. Pollitzer, *Woman on Paper*, 133.

15. AP to GOK, January 1, 1916; GOK to AP, January 4, 1916, in Giboire, *Lovingly, Georgia*, 116, 117.

16. Pollitzer, *Woman on Paper*, 134.

17. Ibid. This same account was given, at various times and with variations, by Stieglitz and O'Keeffe.

18. AS to GOK, March 31, 1918, in Pollitzer, *Woman on Paper*, 159.

19. Newhall, "Notes," 21.

20. Dorothy Norman, interview with the author, May 1987.

21. AS to GOK, June 1916, in Pollitzer, *Woman on Paper*, 139–40.
22. GOK to AP, June 1916, in Giboire, *Lovingly, Georgia*, 159.
23. Ibid.
24. Ibid., 159–60.
25. GOK to AS, Summer 1916, in Pollitzer, *Woman on Paper*, 142.
26. AS to GOK, July 16, 1916, in ibid., 141.
27. GOK to AS, July 27, 1916, in Cowart, Hamilton, and Greenough, *Georgia O'Keeffe*, 154.
28. Ibid., 153.
29. The circumstances of the gift sculpture, its exhibition, and disappearance remain murky. In reply to her query, Georgia wrote to Anita from Charlottesville saying that, instead of delivering the work herself to 291 as planned, she had taken it to be cast. She also referred to another copy that was in the possession of the foundry. Both cast versions seem to have been lost or destroyed. Until the end of her life when she began making pots, O'Keeffe does not seem to have worked again with clay.
30. AS to GOK, July 31, 1916, in Pollitzer, *Woman on Paper*, 141.
31. AS to GOK, 1917, in ibid., 143. Pollitzer has dated this letter 1917, but on the basis of the author's research and a letter from AS to ESD, a date of the previous summer, 1916, is more probable.
32. "New York Art Exhibitions and Gallery News," *Christian Science Monitor*, June 2, 1916.
33. A man of parts, Wright was much admired by Stieglitz, O'Keeffe, and the young William Faulkner, among others, for his Nietzschean tract *Man of Power*. He also enjoyed considerable fame and much wealth as a writer of detective novels; under the pseudonym A. A. Van Dyne, he was the creator of Philo Vance.
34. For a complete discussion of Stieglitz's use of the Forum Exhibit, see Zilczer, "The Aesthetic Struggle in Amerca."
35. AS to GOK, June 1916, in Pollitzer, *Woman on Paper*, 139.
36. GOK to AP, July 1916, in Giboire, *Lovingly, Georgia*, 164.
37. GOK to AP, September 1916, in Giboire, *Lovingly, Georgia*, 179.
38. Ibid., 180.
39. Ibid.
40. Ibid., 180–81.
41. Ibid., 181.
42. GOK to AP, September 1916, in ibid., 182.
43. GOK to AP, September 11, 1916, in ibid., 183.
44. Ibid., 184.
45. O'Keeffe, *O'Keeffe*.
46. Ibid.
47. Ibid.
48. GOK to AP, September 1916, in Giboire, *Lovingly, Georgia*, 200.
49. Ibid., 201.
50. Ibid.
51. Ibid.
52. GOK to AP, October 1916, in Giboire, *Lovingly, Georgia*, 208.
53. Pollitzer, *Woman on Paper*, 153.
54. GOK to AP, January 1917, in Giboire, *Lovingly, Georgia*, 238–40.
55. Ibid., 239.
56. GOK to AP, November 1916, in ibid., 216.
57. AP to GOK, September 1916, in ibid., 195.
58. GOK to AP, September 1916, in ibid., 198.
59. AP to GOK, September 1916, in ibid., 195.
60. GOK to AP, September 1916, in ibid., 198.
61. GOK to AP, October 30, 1916, in ibid., 209.
62. GOK to AP, December 1916, in ibid., 227–28.
63. AP to GOK, December 1916, in ibid., 221.
64. AP to GOK, in Giboire, *Lovingly, Georgia*.

65. GOK to AP, February 19, 1917, in Giboire, *Lovingly, Georgia*, 248.
66. GOK to AP, October 1916, in ibid., 207.
67. Rose, *American Painting*, 18. In the detailed accounts of her reading, O'Keeffe never mentioned the Sage of Concord.
68. O'Keeffe, *O'Keeffe*.
69. AS to PS, November 1, 1916 (YCAL).
70. Tyrrell, "Esoteric Art at 291," *Christian Science* and Fisher, "O'Keeffe Drawings and Paintings."

71. Lisle, *Portrait of an Artist*, 106.
72. GOK to AP, June 20, 1917, in Giboire, *Lovingly, Georgia*, 255.
73. Ibid.
74. Ibid., 255–56.
75. O'Keeffe, *O'Keeffe*.
76. GOK to AP, June 20, 1917, in Giboire, *Lovingly, Georgia*, 255–56.
77. Ibid., 256.
78. Ibid.
79. Ibid.

SEVEN ❧ "THE FINEST GIRL IN TEXAS"

1. Honi Pollitzer Weiss, interview with the author, September 14, 1987.
2. Strand's early years and the influence of Ethical Culture are discussed in Rosenblum, "Paul Strand."
3. For Strand's encounter with Hine and photography, see ibid.
4. Tomkins, "Profile," 18.
5. Rosenblum, "Paul Strand."
6. *Paul Strand*, 142.
7. Tomkins, "Profile," 20.
8. Ibid.
9. Ibid., 19.
10. AS to R. Child Bayley, April 17, 1916 (YCAL).
11. Rosenblum, "Paul Strand," 53.
12. Marie Rapp Boursault, interview with the author, October 3, 1986.

13. AS to GOK, June 1916, in Pollitzer, *Woman on Paper*, 140.
14. AS to MRB, July 23, 1917 (YCAL).
15. MRB to AS, July 21, 1917 (YCAL).
16. AS to MRB, July 23, 1917 (YCAL).
17. Ibid.
18. AS to MRB, August 13, 1917 (YCAL).
19. AS to MRB, September 12, 1917 (YCAL).
20. PS to AS, August 1917(?) (YCAL).
21. Ibid.
22. AS to MRB, August 1917 (YCAL).
23. GOK to Anna Barringer, December 1917, quoted in Lisle, *Portrait of an Artist*, 110.

EIGHT ❧ MISSION IMPOSSIBLE

1. AS to ESD, May 1918 (YCAL).
2. AS to PS, May 12, 1918 (YCAL).
3. Marie Rapp Boursault, interview with the author, March 10, 1986.
4. PS to AS, May 13, 1918 (YCAL).
5. Ibid.
6. Ibid.
7. PS to AS, May 1918 (YCAL).
8. Ibid.
9. PS to AS, May 13, 1918 (YCAL).

10. Ibid.
11. AS to PS, May 17, 1918 (YCAL).
12. Ibid.
13. Ibid.
14. PS to AS, May 15, 1918 (YCAL).
15. Ibid.
16. Ibid.
17. Ibid.
18. PS to AS, May 18, 1918: Letter X (YCAL).

19. Ibid. In the late 1920s Leah Harris married Hampstead Bentley, an Englishman. In November 1931, as soon as their son, Brackenridge Harris Bentley, was born, Bentley, a bigamist with several families in Texas and Oklahoma, abandoned Leah and their child. Her struggle to support the two of them in Depression Texas is further tribute to Leah Harris's industry and grit, if not her choice of love objects.
20. Ibid.
21. Ibid.
22. Ibid.
23. Ibid.
24. Ibid.
25. Ibid.
26. Ibid.
27. AS to PS, written on the back of Letter X (YCAL).
28. AS to PS, May 23, 1918 (YCAL).
29. AS to PS, May 28, 1918 (YCAL).
30. AS to PS, May 23, 1918 (YCAL).
31. PS to AS, May 23, 1918 (YCAL).
32. Ibid.
33. Ibid.
34. PS to AS, May 26, 1918 (YCAL).
35. Ibid.
36. Ibid.
37. AS to PS, May 27, 1918 (YCAL).
38. PS to AS, May 26, 1918 (YCAL).
39. Ibid.
40. PS to AS, May 30, 1918 (YCAL).
41. Ibid.
42. PS to AS, May 31, 1918 (YCAL). During those two days, Strand used sixty plates photographing Leah Harris; despite the care with which he typically packed his work, all of the plates were lost or destroyed, either in shipment or later.
43. Ibid.
44. Earlier, O'Keeffe had done portraits of her family, neighbors, and friends. Very much "student work," these include studies of Anita Pollitzer and Dorothy True, the latter a monotype à la Bonnard. Other than symbolic portraits, either abstract or—following Stieglitz's lead—showing the sitters as trees, her only known likeness to survive is a stiff pencil drawing of the self-taught black artist Beauford Delaney.
45. PS to AS, May 29, 1918 (YCAL).
46. PS to AS, June 1, 1918 (YCAL).
47. PS to AS, June 1918 (YCAL).
48. Ibid.

NINE ❧ "WOMAN SUPREME"

1. O'Keeffe, O'Keeffe.
2. Newhall, "Notes," 38.
3. O'Keeffe, O'Keeffe.
4. Depending on how they are counted, the number of images varies. Stieglitz mounted 310 prints, now canonized as the "key series" at the National Gallery of Art. He made many more, however, that, like his other informal photographs, he called snapshots. Some he simply did not consider as having the same quality as the mounted prints.
5. O'Keeffe, O'Keeffe.
6. Ibid.
7. As to ESD, June 16, 1918 (YCAL).
8. As to AD, June 18, 1918, in Morgan, Dear Stieglitz, Dear Dove, 59.
9. Ibid.
10. Ibid.
11. O'Keeffe, O'Keeffe.
12. Mellquist, Emergence of an American Art, 354.
13. Sarah Greenough, Research Curator, Alfred Stieglitz Collection, National Gallery of Art, in Greenough and Hamilton, Alfred Stieglitz, 22.
14. The persuasive theory of the nude and clothed O'Keeffe as representing an androgynous portrait was

suggested to me by Dr. Bonnie Yochelson.

15. AS to PS, November 17, 1918, quoted in Lisle, *Portrait of an Artist*, 133.

16. Stieglitz, *Georgia O'Keeffe*.

17. Ibid.

18. Freud explains fetishism—the required condition or circumstances for sexual arousal—by linking the young child's castration anxiety to his observation of the mother's body, specifically to the mother's awareness of her absence of a penis. With the introduction of the omnipotent father into the small son's consciousness of power relations within the family, the mother's relative powerlessness, with which her young son identifies, is equated with her "missing" sexual organ. For the adult male, both the objects and angles of fetishism move from the ground upward, following the forbidden gaze of the young child. Thus women's feet, shoes, stockings, garter belts, pubic hair (or, by way of substitution, fur and velvet), and bodily smell function as the young child's "replacement" for the missing penis and become for the man necessary presences required to dispel sexual anxiety.

19. Karen Horney, "The Dread of Women," cited in Coward, *Female Desires*, 62.

20. Newhall, "Notes," 60.

21. The absence of male participation was not unique to Rodin. Every student of pornography has noted the rarity of depictions of heterosexual genital sex in visual—as opposed to literary—erotica.

22. Grunfeld, *Rodin*, 515.

23. Note on verso of Rodin drawing, Alfred Stieglitz Collection, Metropolitan Museum of Art, New York.

24. AS to AD, late July 1918, Friday, in Morgan, *Dear Stieglitz, Dear Dove*, 61.

25. AS to Joe Obermeyer, October 31, 1918 (YCAL).

26. AS to AD, August 15, 1918, in Morgan, *Dear Stieglitz, Dear Dove*, 62.

27. Ibid.

28. Interview taped for the Amarillo Art Center, 1987, quoted in Robinson, *Georgia O'Keeffe*, 246.

29. PS to AS, August 12, 1918 (YCAL).

30. AS to ESD, August 18, 1918 (YCAL).

31. Ibid.

32. AS to ESD, August 1918(?) (YCAL).

33. Ibid.

34. AS to PR, September 29, 1918 (YCAL).

35. AS to Anne W. Brigman, December 31, 1919 (YCAL).

36. Seligmann, "A Photographer Challenges," and Rosenfeld, *Port of New York*, 276.

TEN ❧ SHOW AND TELL

1. Agnes Meyer to Marius de Zayas, 1915, quoted in Stebbins and Keyes, *Charles Sheeler*, 12.

2. Telephone interview with Elizabeth Meyer Lorentz, March 1987.

3. AS to PS, November 17, 1918, quoted in Stebbins and Keyes, *Charles Sheeler*, 17.

4. PS to Susan Shreve, August 9, 1919, quoted in ibid., 17.

5. The painting was subsequently purchased by George F. Of, a painter and friend of Stieglitz who did all the framing for his artists. Besides seeing the work exhibited at the Daniel Gallery, Georgia would have had further opportunity to study Wright's composition at Of's shop, where she often accompanied Alfred.

6. Agee, *Synchromism*, 28.

7. AS to EOS, February 7, 1919 (YCAL)

8. Ibid.

9. Ibid. Both this letter and the accompanying stamped envelope, addressed to Emmeline in care of her brother Joe Obermeyer, were torn into small pieces that were then saved and carefully taped together later.
10. AS to KSS, February 1919(?) (YCAL).
11. Ibid.
12. AS to KSS, February 26, 1919 (YCAL).

13. AS to KSS, March 1919(?) (YCAL).
14. AS to EOS, June 1918(?) (YCAL).
15. Interview with Georgia Engelhard in Newhall, "Notes," 98.
16. Ibid.
17. O'Keeffe, *O'Keeffe*.
18. AS to MRB, August 19, 1919 (YCAL).
19. Longwell, *Steichen*, 21.

ELEVEN ᴠ⁄ FORTRESS AMERICA

1. Hannah Small Ludins, interview with the author, July 27, 1988.
2. AS to HJS, July 29, 1920 (YCAL).
3. Born into a wealthy German-Jewish family with a tradition of philanthropy, Margaret Naumburg Frank (1890–1983) held degrees from Barnard, Columbia, and the London School of Economics before becoming one of the first Americans to study with Maria Montessori. In 1915 she founded the Walden School, which began in one room on Manhattan's West Side with ten pupils.
4. AS to HJS, September 15, 1920 (YCAL).
5. Edmiston and Cirino, *Literary New York*, 156.
6. Townsend, *Sherwood Anderson*, 174–75.
7. PR to AS, August 30, 1920 (YCAL).
8. PR to AS, September 4, 1920 (YCAL).
9. Ibid.
10. AS to HJS, November 2, 1920 (YCAL).
11. AS to HJS, October 9, 1920 (YCAL).
12. PR to AS, October 29, 1920 (YCAL).
13. Quoted in Berman, *Rebels on Eighth Street*, 5.
14. For a valuable discussion of Rosenfeld's and Frank's role in Stieglitz's mission, see Corn, "Apostles of the New American Art."
15. Frank, *Our America*, 88.

16. Ibid., 186.
17. AS to Waldo Frank, April 3, 1925 (YCAL).
18. Tomkins, "Notes."
19. Brooks, *America's Coming of Age*, 40–41.
20. Mellquist, *Paul Rosenfeld*.
21. Sarah Greenough, in "From the American Earth: Alfred Stieglitz's Photographs of Apples," *Art Journal*, vol. 41, no. 1 (Spring 1981), provides a thorough discussion of apple symbolism in Stieglitz's photographs and in the writings of his disciples. Greenough does not see any negative references in Waldo Frank's portrait.
22. GOK to Waldo Frank, Summer 1926, in Cowart, Hamilton, and Greenough, *Georgia O'Keeffe*, 184.
23. Waldo Frank, "Art of the Month: Georgia O'Keeffe," *McCall's*, September 1927, 31, 80.
24. Seligmann, "A Photographer Challenges," 268.
25. Rosenfeld, *Port of New York*, 279.
26. Alfred Stieglitz, catalogue statement, February 7, 1921, Anderson Galleries.
27. Lewis Mumford, "The Metropolitan Milieu," in Frank et al., *America and Alfred Stieglitz*, 57.
28. Hapgood, *Victorian in the Modern World*, 339.
29. O'Keeffe, *O'Keeffe*.
30. McBride, "Modern Art."

31. Mabel Dodge Luhan, unpublished paper, n.d.

32. Florine Stettheimer to Ettie Stettheimer, December 9, 1922 (EFS).

TWELVE ❧ NEW BEGINNINGS

1. GOK to AD, April 6, 1921 (YCAL).
2. For a discussion of the importance of music in the New York art world of the 1920s, see Champa, *Over Here!*, 78ff.
3. PR to AS, August 23, 1921 (YCAL).
4. Tyler, *Florine Stettheimer*, 82.
5. Anderson, *Notebook*, 168.
6. Quoted in Townsend, *Sherwood Anderson*, 199.
7. Ibid.
8. Ibid.
9. Quoted by Sherwood Anderson in Jones, *Letters of Sherwood Anderson*.
10. Haskell, *Charles Demuth*, 133.
11. Charles Demuth to AS, August 1922, quoted in Haskell, *Charles Demuth*, 139.
12. I owe information about Stieglitz and O'Keeffe's help during Demuth's attacks, along with evidence of O'Keeffe's visits to Lancaster, to Dennis Anderson, who has generously allowed me to quote from his unpublished article "Charles Demuth's 'A Poster Portrait: Georgia O'Keeffe.' "
13. Haskell, *Charles Demuth*, 175.
14. Weinberg, "Some Unknown Thing."
15. Ibid.
16. AS to PR, September 5, 1923 (YCAL).
17. PR to AS, August 23, 1921 (YCAL).
18. PS to AS, August 5(?), 1921.
19. Ibid.
20. PS to AS, August 1921.
21. HJS to PS, August 1921 (YCAL).
22. Lowe, *Stieglitz*, 246.
23. PR to AS, August 23, 1921 (YCAL).
24. AS to Waldo Frank, August 25, 1921 (YCAL).
25. AS to Waldo Frank, August 25, 1921 (YCAL).
26. AS to HJS, September 5, 1921 (YCAL).
27. AS to HJS, September 6, 1921 (YCAL).
28. HJS to AS, October 11, 1921 (YCAL).
29. AS to PR, September 17, 1921 (YCAL).
30. PR to AS, September 27, 1921 (YCAL).
31. AS to PR, September 1921 (YCAL).
32. HJS to AS, October 11, 1921 (YCAL).
33. AS to HJS, October 2, 1921 (YCAL).
34. HJS to AS, September 27, 1921 (YCAL).
35. AS to HJS, October 1, 1921 (YCAL).
36. PR to AS, September 10, 1921 (YCAL).
37. PR to AS, August 23, 1921 (YCAL).
38. Leuchtenberg, *Perils of Prosperity*, quoted in Paul Carter, *The Twenties in America*, 2nd ed. (Arlington Heights, Ill., 1975), 2.
39. Joseph Pennell, quoted in *MSS*, December 1922.
40. For a useful discussion of the Strand portrait of Beck, see Rathbone, "Portrait of a Marriage."
41. Hannah Small Ludins, interview with the author, July 27, 1987.

THIRTEEN ❧ "THE SIMPLE THING BEFORE US"

1. PR to AS, July 6, 1922 (YCAL).
2. Ibid.
3. RSS to AS, July 10, 1922 (YCAL).
4. RSS to AS, August 1922 (YCAL).
5. Ibid.
6. RSS to PS, 1921 (ERSS).

7. RSS to AS, July 10, 1922 (YCAL).
8. RSS to AS, August 18, 1922 (YCAL).
9. RSS to PS, September 7, 1922 (ERSS).
10. RSS to PS, August 1922 (ERSS).
11. RSS to PS, September 9, 1922 (ERSS).
12. RSS to PS, September 12, 1922 (ERSS).
13. O'Keeffe, MSS, December 1923.
14. RSS to PS, September 12, 1922 (ERSS).
15. RSS to PS, September 14, 1922 (ERSS).
16. RSS to PS, September 15, 1922 (ERSS).
17. RSS to PS, September 25, 1922 (ERSS).
18. Ibid.
19. RSS to PS, September 30, 1922 (ERSS).
20. Ibid.
21. AS to ESD, October 1, 1922 (YCAL).
22. RSS to PS, September 30, 1922 (ERSS).
23. Ibid.
24. AS to PR, October 4, 1922 (YCAL).
25. O'Keeffe, MSS, December 1923.
26. RSS to PS, October 5, 1922 (ERSS).
27. RSS to PS, October 15, 1922 (ERSS).
28. Ibid.
29. RSS to PS, October 17, 1922 (ERSS).
30. RSS to PS, October 19, 1922 (ERSS).
31. RSS to AS and GOK, October 20, 1922 (YCAL).
32. AS to PR, October 18, 1922 (YCAL).
33. RSS to AS, October 23, 1922 (YCAL).
34. Ibid.
35. AS to PR, November 21, 1922 (YCAL).
36. AS to R. Child Bayley, editor of *The Amateur Photographer* (London), where the letter was published on September 19, 1923. Cited in Herbert J. Seligmann, "291: A Vision Through Photography," in Frank et al., *America and Alfred Stieglitz*, 119.
37. Ibid.
38. SA to AS, July 12, 1924, quoted in Modlin, *Selected Letters of Sherwood Anderson*, 127.
39. GOK to Doris McMurdo, July 1922, quoted in Lisle, *Portrait of an Artist*, 166.
40. Rosenfeld, "The Female of the Species."
41. Rosenfeld, "The Paintings of Georgia O'Keeffe."
42. Ibid.
43. Quoted in Glueck, "It's Just What's in My Head."
44. Rosenfeld, "American Painting."
45. Lisle, *Portrait of an Artist*, 128.
46. GOK to Mitchell Kennerley, Fall 1922, in Cowart, Hamilton, and Greenough, *Georgia O'Keeffe*, 170.
47. Ibid., 170–71.
48. O'Keeffe, "I Can't Sing So I Paint."
49. Ibid.
50. Ibid.

FOURTEEN 🍂 ALFRED STIEGLITZ PRESENTS . . .

1. McBride, "Photographs by Alfred Stieglitz."
2. Marsden Hartley, in *Alfred Stieglitz Presents One Hundred Pictures* (catalogue).
3. Georgia O'Keeffe, in ibid.
4. Ibid.
5. Read, "Freudian Complexes as Art."
6. Ibid.
7. Ibid.
8. Burroughs, "Studio and Gallery."
9. Watson, "Georgia O'Keeffe."
10. "Georgia O'Keefe [sic], Individualist."
11. Bacon, *Off with Their Heads*.
12. McBride, "Curious Responses."
13. Ibid.
14. GOK to HMcB, February 1923, quoted in Robinson, *Georgia O'Keeffe*, 256.
15. GOK to HMcB, February 1923, in

Cowart, Hamilton, and Greenough, *Georgia O'Keeffe*, 171.

16. Quoted in Townsend, *Sherwood Anderson*. I have drawn my discussion of Anderson's family and early years, along with his relationships with members of the Stieglitz circle, from Townsend's book.
17. Quoted in Jones, *Letters of Sherwood Anderson*, 51.
18. Georgia O'Keeffe, quoted by Sherwood Anderson in ibid., 88.
19. Townsend, *Sherwood Anderson*, 9.
20. Sherwood Anderson, "Tar."
21. SA to AS, Fall 1923 (ESA).
22. Charles Sheeler to PS, June 22, 1923, quoted in Stebbins and Keyes, *Charles Sheeler*, 55.
23. GOK, *MSS*, December 1922.
24. McBride, "Salons of America."
25. Lisle, *Portrait of an Artist*, 141.
26. GOK to AWM, December 28, 1916, quoted in Robinson, *Georgia O'Keeffe*, 168.
27. AS to ESD, June 13, 1918 (YCAL).
28. AS to ESD, November 14, 1920 (YCAL).

FIFTEEN ༔ THE LONG SUMMER OF '23

1. AS to ESD, June 26, 1923 (YCAL).
2. RSS to PS, June 20, 1923 (ERSS).
3. RSS to PS, June 22, 1923 (ERSS).
4. AS to PR, July 10, 1923 (YCAL).
5. Ibid.
6. AS to RSS, June 25, 1923 (YCAL).
7. GOK to AP, September 1927(?) (YCAL).
8. AS to RSS, July 28, 1923 (YCAL).
9. AS to RSS, August 20, 1923 (YCAL).
10. Marie Rapp Boursault, interview with the author, March 10, 1986.
11. Ibid.
12. AS to RSS, July 28, 1923 (YCAL).
13. RSS to AS, August 7, 1923 (YCAL).
14. AS to RSS, August 6, 1923 (YCAL).
15. AS to RSS, August 15, 1923 (YCAL).
16. AS to RSS, August 18, 1923 (YCAL).
17. AS to RSS, June 23, 1923 (YCAL).
18. AS to RSS, August 25, 1923 (YCAL).
19. AS to RSS, August 23, 1923 (YCAL).
20. RSS to AS, July 2, 1923 (YCAL).
21. RSS to PS, August 11, 1923 (ERSS).
22. RSS to PS, September 3, 1923 (ERSS).
23. AS to HJS, September 5, 1923 (YCAL).
24. RSS to PS, September 9, 1923 (ERSS).
25. RSS to PS, September 4, 1923 (ERSS).
26. Ibid.
27. RSS to PS, September 15, 1922 (ERSS).
28. RSS to PS, September 19, 1922 (ERSS).
29. RSS to PS, September 28, 1922 (ERSS).
30. Ibid.
31. Ibid.
32. AS to ESD, September 24, 1922 (YCAL).
33. AS to ESD, October 2, 1923 (YCAL).
34. RSS to PS, September 30, 1923 (ERSS).
35. Ibid.
36. RSS to AS, October 8, 1923 (YCAL).
37. AS to ESD, October 16, 1923 (YCAL).
38. RSS to AS, October 14, 1923 (YCAL).
39. AS to RSS, October 16, 1922 (YCAL).
40. John Tilney, interview with the author, March 21, 1987.
41. "The Sanitariums," *Fortune*, April 1935.
42. ESD to AS, October 12, 1920, quoted in Robinson, *Georgia O'Keeffe*, 235.
43. AS to RSS, November 2, 1923 (YCAL).
44. AS to RSS, October 16, 1923 (YCAL).
45. AS to PR, September 5, 1923 (YCAL).

46. AS to RSS, November 6, 1922 (YCAL).

47. AS to IOK, late November 1923 (YCAL).

48. AS to PR, November 12, 1923 (YCAL).

49. AS to ESD, November 14, 1923 (YCAL).

50. Waldo Frank to AS, July 13, 1923 (EW7).

51. Ibid.

52. AS to RSS, November 26, 1923 (YCAL).

SIXTEEN ✔ CITY LIGHTS

1. Georgia O'Keeffe, quoted by Sherwood Anderson in a letter to AS, November 11, 1923, in Modlin, *Selected Letters of Sherwood Anderson*, 111.

2. GOK to SA, February 11, 1928, in Cowart, Hamilton, and Greenough, *Georgia O'Keeffe*, 175–76.

3. Quoted in Dorothy Seiberling, "Horizons of a Pioneer," *Life*, March 1, 1968.

4. A phrase used by literary historian Herbert Leibowitz in *Fabricating Lives* to describe the voice adopted by Gertrude Stein; it perfectly conveys O'Keeffe's literary persona, which strove to imitate Stein.

5. GOK to Waldo Frank, Summer 1926, in Cowart, Hamilton, and Greenough, *Georgia O'Keeffe*, 184.

6. GOK to SA, February 11, 1924, in ibid., 176.

7. Ibid.

8. SA to GOK, February 1924 (Newberry Library).

9. Barker, "Notes on the Exhibitions."

10. Helen Appleton Read, *Brooklyn Daily Eagle*, March 9, 1924; and Forbes Watson, *The Arts*, vol. 5, 1924.

11. McBride, "Stieglitz-O'Keefe [sic] Show."

12. GOK to Catherine O'Keeffe, February 8, 1924, in Robinson, *Georgia O'Keeffe*, 263–64.

13. RSS to PS, March 13, 1924 (ERSS).

14. AS to RSS, February 18, 1924 (YCAL).

15. AS to PR, April 25, 1924 (YCAL).

16. Ibid.

17. Lipsey, *Coomaraswamy*, 143.

18. GOK to Sherwood Anderson, June 11, 1924, in Cowart, Hamilton, and Greenough, *Georgia O'Keeffe*, 177

19. Ibid.

20. Ibid.

21. Ibid., 177–78.

22. GOK to Sherwood Anderson, September 1923(?), in Cowart, Hamilton, and Greenough, *Georgia O'Keeffe*, 174.

23. Kotz, "A Day with Georgia O'Keeffe."

24. Kuh, *Artist's Voice*.

25. AS to RSS, June 18, 1924 (YCAL).

26. RSS to PS, August 2, 1924 (ERSS).

27. Ibid.

28. RSS to PS, August 8, 1924 (ERSS).

29. Ibid.

30. AS to ESD, August 3, 1924 (YCAL).

31. RSS to PS, August 8, 1924 (ERSS).

32. Ibid.

33. AS to RSS, October 3, 1924 (YCAL).

34. AS to PR, September 6, 1924 (YCAL).

35. Ibid.

36. AS to PR, October 14, 1924 (YCAL).

37. Anderson, *Letters to Bab*, 211.

38. Tomkins, "Notes."

SEVENTEEN ✔ HIGH STAKES

1. AS to SA, March 11, 1925, in Modlin, *Selected Letters of Sherwood Anderson*.

2. "Seven Americans" (catalogue).

3. Fulton, "Cabbages and Kings."

4. Ibid.
5. Watson, "Seven American Artists."
6. GOK to MDL, 1925, in Cowart, Hamilton, and Greenough, *Georgia O'Keeffe*, 180.
7. Ibid.
8. Comstock, "Stieglitz Group."
9. Breuning, "Seven Americans."
10. Read, "Alfred Stieglitz Presents."
11. Quoted in Lisle, *Portrait of an Artist*, 137.
12. GOK to Blanche Matthias, March 1926, in Cowart, Hamilton, and Greenough, *Georgia O'Keeffe*, 183.
13. Kerman and Eldridge, *Lives of Jean Toomer*, 89.
14. Fiske Kimball, quoted in Stern, Gilmartin and Mellins, *New York 1930*, 208.
15. Ibid., 211.
16. Lowe, *Stieglitz*,
17. AS to IOK, September 18, 1925 (YCAL).
18. AS to IOK, September 24, 1925 (YCAL).
19. GOK to IOK, November/December 1925 (YCAL).
20. Ibid.
21. Ibid.
22. Quoted in Robinson, *Georgia O'Keeffe*, 388.
23. GOK to IOK, November/December 1925 (YCAL).
24. Ibid.
25. GOK to HMcB, February 1923, quoted in Robinson, *Georgia O'Keeffe*, 256–57.
26. AS to PS, May 17, 1918 (YCAL).
27. Read, "Georgia O'Keeffe."
28. McBride, "Georgia O'Keeffe's Art."
29. Matthias, "Stieglitz Showing Seven Americans."
30. GOK to Blanche Matthias, March 1926 in Cowart, Hamilton, and Greenough, *Georgia O'Keeffe*, 183.
31. McBride, "Georgia O'Keeffe's Art."
32. Quoted in Seligmann, *Alfred Stieglitz Talking*, 63–64.
33. Newhall, "Notes."
34. Lewis Mumford to Henry A. Murray, January 31, 1965, quoted in Miller, *Lewis Mumford*, 340.

EIGHTEEN ❧ ENTER MRS. NORMAN

1. RSS to PS, March 18, 1926 (ERSS).
2. Ibid.
3. GOK to Blanche Matthias, March 1926, in Cowart, Hamilton, and Greenough, *Georgia O'Keeffe*, 183.
4. AS to ESD, June 5, 1926, quoted in Lowe, *Stieglitz*, 284.
5. AS to HJS, August 20, 1926 (YCAL).
6. AS to HJS, August 22, 1926 (YCAL).
7. AS to HJS, September 5, 1926 (YCAL).
8. AS to HJS, September 14, 1926 (YCAL).
9. Quoted in Rodgers, "Alfred Stieglitz, Duncan Phillips."
10. The most complete discussion of this Byzantine episode is Rodgers, "Alfred Stieglitz, Duncan Phillips." I am grateful to Mr. Rodgers for allowing me to read his paper.
11. O'Brien, "Americans We Like."
12. McBride, "Georgia O'Keeffe's Work Shown."
13. This and the following quotations are from Norman, *Encounters*.
14. Norman, *Encounters*, 54.
15. Ibid.
16. Ibid.
17. Ibid, 56–57.
18. AS to MRB, June 19, 1927 (YCAL).
19. O'Keeffe, *O'Keeffe*.
20. Norman, *Encounters*, 56.
21. Ibid., 59ff.
22. Tomkins, "Notes."
23. Ibid.

24. Mumford, "O'Keefe [sic] and Matisse."
25. McBride, "Georgia O'Keeffe's Recent Work."
26. HMcB to GOK, May 1928 (YCAL).
27. HMcB to Malcolm MacAdam, February 8, 1930 (YCAL).
28. *New York Times*, April 16, 1928.
29. *Art News*, April 1928.
30. Sabine, "Record Price."
31. This is the conclusion of Kennerley's biographer, Matthew Bruccoli, in *Fortunes of Mitchell Kennerley*, 198–99.
32. Ibid.
33. Ibid.
34. Ibid.
35. Norman, *Encounters*, 73.
36. Ibid., 71–72.
37. Ibid., 72.
38. Flora Stieglitz Straus, interview with the author, June 1987.
39. GOK to Catherine O'Keeffe Klenert, May 29, 1928, quoted in Robinson, *Georgia O'Keeffe*, 307.
40. The painting's resemblance to Wyeth is all the more startling as Wyeth was born in 1917, the year of O'Keeffe's first one-woman show at 291. Conversely, O'Keeffe's barns owe little to her own contemporaries Sheeler and Strand.
41. GOK to Mitchell Kennerley, January 20, 1929, quoted in Cowart, Hamilton, and Greenough, *Georgia O'Keeffe*, 187.
42. GOK to Ettie Stettheimer, September 21, 1928, quoted in ibid., 186.
43. GOK to Mitchell Kennerley, January 29, 1929, in ibid., 187.
44. Henry McBride, "Decorative Art That Is Also Occult at the Intimate Gallery," *The New York Sun*, February 9, 1929.
45. GOK to Waldo Frank, January 10, 1927, quoted in Cowart, Hamilton, and Greenough, *Georgia O'Keeffe*, 185.
46. GOK to HMcB, February 1929, in ibid., 188.

NINETEEN ℘ UP IN MABEL'S ROOM

1. Quoted in Robinson, *Georgia O'Keeffe*, 316.
2. Claude Bragdon to Dorothy Brett, July 24, 1931 (YCAL).
3. Dorothy Brett to Spud Johnson, November 1926, in Hignett, *Brett*, 201.
4. Norman, *Encounters*, 69.
5. Hartley to RSS, quoted in Haskell, *Marsden Hartley*, 142.
6. RSS to PS, April 29, 1929 (ERSS).
7. RSS to PS, April 30, 1929 (ERSS).
8. RSS to PS, May 2, 1929 (ERSS).
9. Rudnick, *Mabel Dodge Luhan*, 143.
10. Ibid.
11. RSS to PS, May 2, 1929 (ERSS).
12. Rudnick, *Mabel Dodge Luhan*, 152.
13. RSS to PS, May 2, 1929 (ERSS).
14. RSS to PS, May 4, 1929 (ERSS).
15. Luhan, "Georgia O'Keeffe in Taos."
16. RSS to PS, May 16, 1929 (ERSS).
17. RSS to PS, May 8, 1929 (ERSS).
18. RSS to PS, May 9, 1929 (ERSS).
19. RSS to PS, May 11, 1929 (ERSS).
20. RSS to PS, May 1929 (ERSS).
21. RSS to PS, May 10, 1929 (ERSS).
22. GOK to Calvin Tomkins, in Tomkins, "Notes."
23. RSS to PS, May 4, 1929 (ERSS).
24. RSS to PS, mid-May 1929 (ERSS).
25. RSS to PS, May 20, 1929 (ERSS).
26. RSS to PS, May 1929 (ERSS).
27. RSS to PS, May 23, 1929 (ERSS).
28. RSS to PS, May 25, 1929 (ERSS).
29. RSS to PS, May 22, 1929 (ERSS).
30. RSS to PS, May 20, 1929 (ERSS).
31. Rudnick, *Mabel Dodge Luhan*, 237.
32. RSS to PS, June 1929, Saturday (ERSS).
33. Ibid.
34. Interviewed by Calvin Tomkins in

1976, Strand suggested to Tomkins that he knew that Beck and Georgia were lovers. Tomkins, letter to the author, August 28, 1989.

35. RSS to PS, June 1929, Saturday (ERSS).
36. RSS to PS, June 16, 1929 (ERSS).
37. RSS to PS, June 1929, Saturday (ERSS).
38. Rudnick, *Mabel Dodge Luhan*, 151.
39. GOK to MDL, July 1929, quoted in ibid., 239.
40. Ibid.
41. MDL to AS, July 5, 1929 (YCAL).
42. AS to MDL, July 6, 1929 (YCAL).
43. RSS to PS, June 19, 1929 (ERSS).
44. Clurman, *All People Are Famous*, 58.

TWENTY ❧ A CATHEDRAL AND A LABORATORY

1. Bird, *Invisible Scar*, 23.
2. Lynes, *Good Old Modern*, 6.
3. Claude Bragdon to Dorothy Brett, July 16, 1936 (YCAL).
4. AS to AD, April 4, 1933 in Morgan, *Dear Stieglitz, Dear Dove*.
5. Lynes, *Good Old Modern*, 52.
6. AS to RSS, October 22, 1929 (YCAL).
7. Goldberg, *Margaret Bourke-White*, 152.
8. Calvin Tomkins, "Notes."
9. Harold Clurman to PS, November 21, 1932 (EHC).
10. AS to AD, January 8, 1930, in Morgan, *Dear Stieglitz, Dear Dove*, 186.
11. AD to AS, December 19, 1930, in Haskell, *Arthur Dove*, 39.
12. AD to AS, January 1933, in ibid., 203.
13. McBride, "Sign of the Cross."
14. Ibid.
15. Mann, "Exhibitions."
16. Flint, "Around the Galleries."
17. GOK to Betty O'Keeffe, January 24, 1930, quoted in Robinson, *Georgia O'Keeffe*, 348.
18. Robert Sobel, in *Dictionary of American Biography*, suppl. 6, 722.
19. Oaks, "Radical Writer and Woman Artist Clash on Propaganda and Its Uses," *New York World*, March 16, 1930.
20. Tomkins, "Notes."
21. McBride, "Skeletons on the Plain."
22. McCarthy, *Eric Gill*, 93.
23. Family chronicles, including Lowe's "memoir/biography," have Georgia graduating, but this does not coincide with Vassar College records.
24. Lowe, *Stieglitz*, 310.
25. Ibid. 230–31.
26. Tomkins, "Notes."
27. Ibid.
28. Ibid.
29. Harold Clurman to PS, Autumn 1934 (EHC).
30. PS to Harold Clurman, March 30, 1934, quoted in *Paul Strand*, 154.

TWENTY-ONE ❧ THE POWDER ROOM WAR

1. GOK to Dorothy Brett, October 12(?), 1930, quoted in Robinson, *Georgia O'Keeffe*, 358.
2. Weigle and Fiore, *Santa Fe & Taos*, 358.
3. GOK to RSS, September 14, 1931 (YCAL).
4. Lowe, *Stieglitz*, 316.
5. Florine Stettheimer to AS, February 14, 1932 (EFS).
6. Dorothy Norman, quoted in Newhall, "Notes," 779.
7. *Paul Strand*, 175.
8. PS to RSS, December 13, 1966 (PSA/CCP).
9. *Murals by American Painters and Pho-*

tographers, Museum of Modern Art catalogue, n.d.

10. Ibid.
11. Quoted in Lynes, *Good Old Modern*, 101.
12. Ibid.
13. K. Sullivan and D. McBroome, "Manhattan Masterpiece: Was Stuart Davis's Radio City Mural the American Blueprint for Picasso's *Guernica*?," *Art and Antiques*, December 1989, 43–44.
14. Donald Deskey to Laurie Lisle, November 7, 1978, quoted in Lisle, *Portrait of an Artist*, 256.
15. AS to AD, August 11, 1932, in Morgan, *Dear Stieglitz, Dear Dove*, 246.
16. Lynes, *Good Old Modern*, 51–52.

17. GOK to Dorothy Brett, quoted in Robinson, *Georgia O'Keeffe*, 438.
18. GOK to RSS, October 6(?), 1932 (YCAL).
19. GOK to RSS, October 6, 1932 (YCAL).
20. Donald Deskey to Laurie Lisle, November 7, 1978, quoted in Lisle, *Portrait of an Artist*, 257.
21. AS to HJS, December 10, 1932 (YCAL).
22. AS to AD, June 25, 1933, in Morgan, *Dear Stieglitz, Dear Dove*, 277.
23. Jewell, "Georgia O'Keeffe's Paintings."
24. GOK to RSS, March 1933 (YCAL).

TWENTY-TWO ✧ A SEPARATE PEACE

1. GOK to RSS, June 7, 1933 (YCAL).
2. Ibid.
3. GOK to RSS, August 1933 (YCAL).
4. Ibid.
5. Ibid.
6. AS to HJS, August 17, 1933 (YCAL).
7. Ibid.
8. GOK to RSS, November 25, 1933 (YCAL).
9. GOK to RSS, undated (YCAL).
10. Harold Clurman to PS, December 1933. (EHC).
11. Quoted in Kerman and Eldridge, *Lives of Jean Toomer*, 200. For the facts of Margery Latimer's life, I am indebted to Nancy Loughridge, "Afterword," in *Guardian Angel and Other Stories* by Margery Latimer (Old Westbury, NY: Feminist Press, 1984).
12. GOK to Marjorie Content, December 1933 (YCAL).
13. AS to Jean Toomer, December 11, 1933, quoted in Kerman and Eldridge, *Lives of Jean Toomer*, 213.
14. GOK to Jean Toomer, January 7, 1934, quoted in Lisle, *Portrait of an Artist*, 263.
15. Ibid.

16. Quoted in Lisle, *Portrait of an Artist*, 262.
17. GOK to Jean Toomer, January 10, 1934, in Cowart, Hamilton, and Greenough, *Georgia O'Keeffe*, 216.
18. GOK to Jean Toomer, January 1934, quoted in Robinson, *Georgia O'Keeffe*, 398.
19. GOK to Jean Toomer, January 10, 1934, quoted in Lisle, *Portrait of an Artist*, 265.
20. GOK to Jean Toomer, quoted in Robinson, *Georgia O'Keeffe*, 400.
21. Ibid.
22. GOK to Jean Toomer, February 8, 1934, quoted in Cowart, Hamilton, and Greenough, *Georgia O'Keeffe*, 218.
23. Claude Bragdon to Dorothy Brett, September 26, 1937 (YCAL).
24. GOK to Jean Toomer, February 8, 1934, in Cowart, Hamilton, and Greenough, *Georgia O'Keeffe*, 219.
25. GOK to Jean Toomer, February 14, 1934, quoted in Lisle, *Portrait of an Artist*, 267.
26. GOK to Jean Toomer, March 5, 1934, in ibid., 267.

27. Winsten, "Georgia O'Keeffe Tries to Begin Again."
28. GOK to Jean Toomer, May 11, 1934, quoted in Lisle, *Portrait of an Artist*, 268.
29. Marjorie Content Toomer to Jean Toomer, June 1934.
30. Ibid.
31. Tryk, "O'Keeffe."
32. David H. McAlpin, interview with the author, June 1987.
33. GOK to MDL, Winter 1933–1934, quoted in Robinson, *Georgia O'Keeffe*, 405.
34. Howe, *Gentle Americans*, 212. Howe gives an affectionate account of Wheelright's Boston years in pages 204–17.
35. Ibid., 211.
36. Claude Bragdon to Dorothy Brett, June 26, 1934 (YCAL).
37. Claude Bragdon to Dorothy Brett, July 17, 1933 (YCAL).
38. Claude Bragdon to Dorothy Brett, October 31, 1936 (YCAL).
39. Albro Martin, in *Notable American Women*, vol. 4, 33.
40. Adams, *Letters and Images*.
41. William C. Dove, interview with the author, March 1987.
42. Claude Bragdon to Dorothy Brett, July 22, 1946 (YCAL).

TWENTY-THREE ❧ THE EMPRESS OF ABIQUIU

1. GOK to AS, August 26, 1937. One of eight letters written between July 29, 1937, and September 30, 1937, published by An American Place as part of the catalogue for O'Keeffe's exhibit, December 1937–February 1938.
2. Lowe, *Stieglitz*, 360.
3. Janis, "Georgia O'Keeffe at 84."
4. GOK to AS, July 29, 1937, catalogue, 3.
5. GOK to AS, August 20, 1937, catalogue, 7.
6. GOK to AP, January 17, 1956, in Giboire, *Lovingly, Georgia*, 305.
7. GOK to AS, August 16, 1937, catalogue, 4.
8. Brooks, *America's Coming of Age*, 82.
9. George L. K. Morris, "Art Chronicle: Some Personal Letters to American Artists Recently Exhibiting in New York," *Partisan Review*, March 1938.
10. *Life*, February 15, 1938.
11. When the author first visited Abiquiu in 1986, the town appeared to have changed little since the 1930s: from the gaping window of an abandoned house, a torn mattress oozed stuffing into the tiny square. The only improvement was a hangarlike structure faced with aluminum siding. Used as a social hall by the local kids, it was contributed by O'Keeffe in the 1950s after considerable arm-twisting by the local priest. In 1989, when the O'Keeffe compound became the offices of the foundation bearing the artist's name, dramatic beautification of all visible parts of the village took place.
12. Maria Chabot, interview with the author, July 18, 1987.
13. McBride, "Miss O'Keeffe's Bones."
14. Clement Greenberg, *The Nation*, June 5, 1946.
15. Diana Schubart Heller, interview with the author, July 1987.
16. McBride, "Miss O'Keeffe's Bones."
17. AS to GOK, June 3, 1946, quoted In Pollitzer, *Woman on Paper*, 249–50.
18. AS to GOK, June 4, 1946, quoted in ibid., 250.
19. AS to GOK, June 5, 1946, quoted in ibid.
20. AS to GOK, June 6, 1946, quoted in ibid.
21. AS to GOK, July 8, 1946, quoted in ibid., 257.

22. AS to GOK, July 9, 1946, quoted in ibid., 251.
23. O'Keeffe decided to tell the unembellished version to Donald Gallup, quoted in *Pigeons on the Granite*.
24. Ibid.
25. Ansel Adams, *Letters and Images*, 175.
26. Ibid., 177.
27. GOK to Maria Chabot, November 1941, in Cowart, Hamilton, and Greenough, *Georgia O'Keeffe*, 232.
28. Tomkins, "Notes."
29. Katherine Kuh, interview with the author, August 1988.
30. GOK to William Howard Schubart, October 26, 1950, in Cowart, Hamilton, and Greenough, *Georgia O'Keeffe*, 256.
31. GOK to William Howard Schubart, July 28, 1950, and October 26, 1950, in ibid., 253 and 256.
32. GOK to AP, October 24, 1955, in Giboire, *Lovingly, Georgia*, 286.
33. Quoted in Robinson, *Georgia O'Keeffe*, 509.
34. Ibid., 556.
35. Robinson, *Georgia O'Keeffe*, 550. Another friend maintains that he returned on the first available flight.
36. These letters are discussed in context in Chapters Nine and Ten.

BIBLIOGRAPHY

BOOKS

ABRAHAMS, EDWARD. *The Lyrical Left: Randolph Bourne and Alfred Stieglitz*. Charlottesville: University Press of Virginia, 1986.

AGEE, WILLIAM C. *Synchromism and Color Principles in American Painting*. New York: Knoedler, 1965.

ALINDER, MARY STREET, and ANDREA GREY STILLMAN, eds. *Ansel Adams: Letters and Images, 1916–1984*. Boston: New York Graphic Society; Little, Brown, 1988.

ALLEN, FREDERICK L. *The Big Change: America Transforms Itself, 1900–1950*. New York: Harper & Row, 1952.

ALLEN, FREDERICK L. *Since Yesterday: The 1930s in America*. New York: Harper & Row, 1940.

ANDERSON, SHERWOOD. *Letters to Bab: Sherwood Anderson to Marietta D. Finley, 1916–1933*. Urbana: University of Illinois Press, 1985.

————. *Notebook*. New York: Boni & Liveright, 1926.

————. *A Story Teller's Story*. New York: Huebsch, 1924.

BACON, PEGGY. *Off with Their Heads*. New York: R. M. McBride, 1934.

BANTA, MARTHA. *Imaging American Women*. New York: Columbia University Press, 1987.

BERMAN, AVIS. *Rebels on Eighth Street: Juliana Force and the Whitney Museum of American Art*. New York: Atheneum, 1990.

BIRD, CAROLINE. *The Invisible Scar*. New York: McKay, 1966.

BRETT, DOROTHY. *Lawrence and Brett: A Friendship*. Philadelphia: Lippincott, 1933.

BROOKS, VAN WYCK. *America's Coming of Age*. New York: Farrar Straus & Giroux, 1975.

————. *The Confident Years: 1885–1915*. New York: Scribner's, 1952.

BRUCCOLI, MATTHEW J. *The Fortunes of Mitchell Kennerley, Bookman*. New York: Harcourt Brace Jovanovich, 1986.

CHAMPA, KERMIT. *Over Here! Modernism: The First Exile, 1914–1919*. Providence: Brown University Press, 1989.

CLAYTON, BRUCE. *Forgotten Prophet: The Life of Randolph Bourne*. Baton Rouge: Louisiana State University Press, 1984.

CLURMAN, HAROLD. *All People Are Famous (Instead of an Autobiography)*. New York: Harcourt Brace Jovanovich, 1974.

COWARD, ROSALIND. *Female Desires: How They Are Sought, Bought, and Packaged*. New York: Grove Press, 1985.

COWART, JACK, JUAN HAMILTON, and SARAH GREENOUGH. *Georgia O'Keeffe: Art and Letters*. Boston: Little, Brown & Company in association with the National Gallery of Art, Washington, D.C., 1987.

DEUTSCH, HELEN, and STELLA HANAU. *The Provincetown: A Story of the Theatre*. New York: Farrar and Rinehart, 1931.

DIJKSTRA, BRAM. *The Hieroglyphics of a New Speech: Cubism, Stieglitz, and the Early Poetry of William Carlos Williams*. Princeton: Princeton University Press, 1969.

————. *Idols of Perversity: Fantasies of Feminine Evil in Fin de Siècle Culture*. New York: Oxford University Press, 1986.

EDDY, ARTHUR JEROME. *Cubists and Post Impressionism*. Chicago: A. C. McClurg, 1914.

EDMISTON, SUSAN, and LINDA D. CIRINO. *Literary New York: A History and Guide*. Boston: Houghton Mifflin, 1976.

FRANK, WALDO. *Our America*. New York: Boni & Liveright, 1919.

————. *Time Exposures*. New York: Boni & Liveright, 1926.

FRANK, WALDO, ET AL. *America and Alfred Stieglitz: A Collective Portrait*. New York: Doubleday, Doran, 1934.

FREDERICKS, PIERCE G. *The Great Adventure: America in the First World War*. New York: Dutton, 1960.

FREUD, SIGMUND. "On Fetishism," in *Collected Papers*, vol. 5. New York: Basic Books, 1959.

GALLUP, DONALD C., ed. *The Flowers of Friendship*. New York: Knopf, 1953.

————. *Pigeons on the Granite*. New Haven: Beinecke Rare Book and Manuscript Library, Yale University, 1988.

GARLAND, HAMLIN. *Rose of Dutcher's Coolly*. Chicago: Stone & Kimball, 1895.

GIBOIRE, CLIVE, ed. *Lovingly, Georgia*. New York: Simon & Schuster, 1990.

GOLDBERG, VICKI. *Margaret Bourke-White: A Biography*. New York: Harper & Row, 1986.

GREEN, JONATHAN, ed., *Camera Work: A Critical Anthology*. Millerton, N.Y.: Aperture, 1973.

GREENOUGH, SARAH, and JUAN HAMILTON. *Alfred Stieglitz: Photographs and Writings*. Washington D.C.: National Gallery of Art, 1983.

GRUNFELD, FREDERICK. *Rodin*. New York: Henry Holt, 1987.

HAHN, EMILY. *Mabel: A Biography of Mabel Dodge Luhan*. Boston: Houghton Mifflin, 1977.

HANSEN, OLAF, ed. *The Radical Will: Selected Writings of Randolph Bourne, 1911–1918*, New York: Urizen, 1977.

HAPGOOD, HUTCHINS. *A Victorian in the Modern World*. New York: Harcourt Brace, 1939.

HARRIS, ANN SUTHERLAND, and LINDA NOCHLIN. *Women Artists, 1550–1950*. New York: Knopf, 1976.

HARTLEY, MARSDEN. *Adventures in the Arts*. New York: Boni & Liveright, 1921.

HASKELL, BARBARA. *Arthur Dove*. San Francisco: San Francisco Museum of Art, 1974.

————. *Charles Demuth*. New York: Whitney Museum of American Art in association with Harry N. Abrams, 1987.

————. *Marsden Hartley*. New York: Whitney Museum of American Art in association with New York University Press, 1980.

HELM, MACKINLEY. *John Marin*. Boston: Pellegrini and Cudahy in association with the Institute of Comtemporary Art, 1948.

HIGNETT, SEAN. *Brett: From Bloomsbury to New Mexico*. New York: Franklin Watts, 1985.

HOMER, WILLIAM INNES. *Alfred Stieglitz and the American Avant-Garde*. Boston: New York Graphic Society, 1977.

HOWE, HELEN. *The Gentle Americans, 1864–1969: Biography of a Breed*. New York: Harper & Row, 1965.

JOHNSON, ARTHUR W. *Arthur Wesley Dow: Historian, Artist, Teacher.* Ipswich, Mass.: Ipswich Historical Society, 1934.

JONES, HOWARD MUMFORD, ed. *Letters of Sherwood Anderson.* Boston: Little, Brown, 1953.

KANDINSKY, WASSILY. *Concerning the Spiritual in Art.* London: Constable, 1914.

KAPLAN, ANN E. *Women & Film: Both Sides of the Camera.* New York: Methuen, 1983.

KELLNER, BRUCE. *Carl Van Vechten and the Irrelevant Decades.* Norman: University of Oklahoma Press, 1968.

KERMAN, CYNTHIA EARL, and RICHARD ELDRIDGE. *The Lives of Jean Toomer.* Baton Rouge: Louisiana State University Press, 1987.

KREYMBOURG, ALFRED. *Troubador.* New York: Boni & Liveright, 1925.

KUH, KATHERINE. *The Artist's Voice.* New York: Harper & Row, 1962.

KUHN, ANNETTE. *The Power of the Image: Essays on Representation and Sexuality.* London: Routledge & Kegan Paul, 1985.

————. *Women's Pictures.* London: Routledge & Kegan Paul, 1982.

LASCH, CHRISTOPHER. *The New Radicalism in America, 1889–1963: The Intellectual as a Social Type.* New York: Knopf, 1965.

LEUCHTENBERG, WILLIAM E. *The Perils of Prosperity: 1914–1932.* University of Chicago Press, 1958.

LESEY, MICHAEL. *Wisconsin Death Trip.* New York: Random House, Inc., 1973 (unpaged).

LIEBOWITZ, HERBERT. *Fabricating Lives.* New York: Knopf, 1989.

LIPSEY, ROGER. *Coomaraswamy: His Life and Work.* Princeton: Princeton University Press, 1977.

LISLE, LAURIE. *Portrait of an Artist: A Biography of Georgia O'Keeffe.* New York: Washington Square Press, 1981.

LONGWELL, DENNIS. *Steichen: The Master Prints, 1895–1914, The Symbolist Period.* New York: Museum of Modern Art, 1978.

LOWE, SUE DAVIDSON. *Stieglitz: A Memoir/Biography.* New York: Farrar Straus Giroux, 1983.

LUHAN, MABEL DODGE. *Intimate Memoirs: Edge of the Taos Desert.* New York: Harcourt Brace, 1937.

————. *Lorenzo in Taos.* New York: Knopf, 1932.

————. *Winter in Taos.* New York: Harcourt Brace, 1935.

LYNES, RUSSELL. *Good Old Modern: An Intimate Portrait of the Museum of Modern Art.* New York: Atheneum, 1973.

MAY, HENRY J. *The End of American Innocence.* New York: Knopf, 1959.

McBride, Henry. *Florine Stettheimer*. New York: Museum of Modern Art, 1946.

McCarthy, Fiona. *Eric Gill: A Lover's Quest for Art and God*. New York: Dutton, 1989.

Mellow, James R. *Charmed Circle: Gertrude Stein & Co*. New York: Avon, 1975.

Mellquist, Jerome. *The Emergence of an American Art*. New York: Scribner's, 1942.

Mellquist, Jerome, and Lucie Wiese. *Paul Rosenfeld: Voyager in the Arts*. New York, 1984.

Miller, Donald C. *Lewis Mumford: A Life*. New York: Weidenfeld & Nicholson, 1989.

Modlin, Charles E. *Selected Letters of Sherwood Anderson*. Knoxville: University of Tennessee Press, 1984.

Morgan, Anne Lee, ed. *Dear Stieglitz, Dear Dove*. Newark: University of Delaware Press, 1988.

Newhall, Beaumont. *The History of Photography from 1839 to the Present Day*. Rev. ed. New York: Museum of Modern Art, 1964.

Nochlin, Linda, and Thomas Stern. *Woman as Sex Object: Studies in Erotic Art, 1730–1970*. New York: Newsweek, 1977.

Norman, Dorothy. *Alfred Stieglitz*. Millerton, N.Y.: Aperture, 1976.

———. *Alfred Stieglitz: Introduction to an American Seer*. Duell, Sloane & Pierce, 1960.

———. *Dualities*. New York: An American Place, 1933.

———. *Encounters: A Memoir*. New York: Harcourt Brace Jovanovich, 1987.

O'Keeffe, Georgia. *Georgia O'Keeffe*. New York: Viking, 1976 (unpaged).

Paul Strand: Sixty Years of Photographs. Millerton, N.Y.: Aperture, 1976.

Pisano, Ronald G. *William Merritt Chase*. New York: Watson-Guptill, 1986.

Pollitzer, Anita. *A Woman on Paper*. New York: Simon & Schuster, 1988.

Reich, Sheldon. *John Marin: A Stylistic Analysis and A Catalogue Raisonné*. Tucson: University of Arizona Press, 1970.

Robinson, Roxana. *Georgia O'Keeffe: A Life*. New York: Harper & Row, 1989.

Rose, Barbara. *American Painting: The Twentieth Century*. New York: Skira, Rizzoli, 1977.

Rosenfeld, Paul. *Port of New York: Essays on Fourteen American Moderns*. New York: Harcourt Brace, 1924.

Rudnick, Lois P. *Mabel Dodge Luhan: New Woman, New Worlds*. Albuquerque: University of New Mexico Press, 1984.

Russell, Don. *The Lives and Legends of Buffalo Bill*. Norman: University of Oklahoma Press, 1960.

SAVORY, JEROLD J. *Columbia College: The Ariail Era*. Columbia, S.C.: R. K. Bryan, 1979.

SELIGMANN, HERBERT J. *Alfred Stieglitz Talking*. New Haven: Yale University Library, 1966.

——. *Selected Letters of John Marin*. New York: An American Place, 1931.

SOLLERS, PHILIPPE, and ALAIN KIRILI. *Rodin: Dessins Érotiques*. Paris: Gallimard, 1987.

STEBBINS, T. E., JR., and NORMAN KEYES, JR. *Charles Sheeler: The Photographs*. Boston: Museum of Fine Arts, 1987.

STEICHEN, EDWARD. *A Life in Photography*. Garden City, N.Y.: Doubleday with the Museum of Modern Art, 1963.

STERN, ROBERT, GREGORY GILMARTIN, and THOMAS MELLINS, *Architecture and Americanism Between the Two World Wars*. New York: Rizzoli, 1987.

STEVENS, WILLIAM OLIVER. *Old Williamsburg and Her Neighbors*. New York: Dodd, Mead, 1938.

TOMLINSON, CHARLES. *Some Americans: A Personal Record*. Berkeley: University of California Press, 1951.

TOWNSEND, KIM. *Sherwood Anderson: A Life*. Boston: Houghton Mifflin, 1987.

TYLER, PARKER. *Florine Stettheimer: A Life in Art*. New York: Farrar Straus, 1963.

WEINSTRAUB, STANLEY. *A Stillness Heard Round the World: The End of the Great War, November 1918*. New York: Dutton, 1985.

WIEBE, ROBERT. *The Search for Order, 1877–1920*. New York: Hill and Wang, 1967.

WEIGLE, MARTA, and KYLE FIORE. *Santa Fe and Taos: The Writer's Era*. Santa Fe: Ancient City Press, 1982.

WILLIAMS, WILLIAM CARLOS. *Autobiography*. New York: 1951.

WILSON, EDMUND. *The American Earthquake*. New York: Farrar Straus and Giroux, 1979.

YOST, NELLIE SNYDER. *Buffalo Bill: His Family, Friends, Fame, Failures, and Fortunes*. Chicago: Sage Books, the Swallow Press, 1979.

ARTICLES

"Advertising Art Lures Brush of Miss O'Keeffe." *New York Herald Tribune*, January 31, 1940.

"Art from All U.S. to Be in Two Fairs: This State to Be Represented by Canvases of Georgia O'Keeffe and Burchfield." *New York Times*, May 9, 1940.

ASBURY, EDITH EVANS. "Georgia O'Keeffe Dead at 98; Shaper of Modern Art in U.S." *New York Times*, March 7, 1986.

BARKER, VERGIL. "Notes on the Exhibitions." *The Arts*, vol. 5, 1924.

BRAGGIOTTI, MARY. "Her Worlds Are Many." *New York Post*, May 16, 1946.

BREUNING, MARGARET. "Art in New York." *Parnassus*, December 1937.

————. "Current Exhibitions." *Parnassus*, March 1937.

————. "Georgia O'Keeffe." *New York Evening Post*, January 24, 1931.

————. "O'Keeffe's Best." *Art Digest*, March 1, 1944.

————. "Seven Americans." *New York Evening Post*, March 14, 1925.

BRIGHT, DEBORAH. "Georgia O'Keeffe, 1887–1986." *In These Times*, March 26–April 1, 1986.

BROOK, ALEXANDER. "February Exhibitions." *The Arts*, February 1923.

BRY, DORIS. "The Stieglitz Archive at Yale University." *The Yale University Library Gazette*, April 1951.

BURROUGHS, ALLAN. "Studio and Gallery." New York *Sun*, February 3, 1923.

BURROWS, CARLYLE. "Contemporary Types in Art: Some New Paintings of the West by Georgia O'Keeffe." *New York Herald Tribune*, February 2, 1941.

————. "Paintings by O'Keeffe in Large Review at the Modern Museum." *New York Herald Tribune*, May 19, 1946.

CANADAY, JOHN. "O'Keeffe Exhibition: An Optical Treat." *New York Times*, October 8, 1970.

COKE, VAN DEREN. "Why Artists Came to New Mexico: 'Nature Presents a New Face Each Moment.'" *Art News*, January 1974.

COMSTOCK, HELEN. "Stieglitz Group in Anniversary Show." *Art News*, March 14, 1925.

COOK, HOWARD. "Howard Cook's Record of His Wanderings: Recent Paintings by Georgia O'Keeffe." *New York Times*, February 4, 1937.

CORN, WANDA. "Apostles of the New American Art: Waldo Frank and Paul Rosenfeld." *Arts Magazine*, Special Issue, 1979.

CORTISSOZ, ROYAL. "Recent Work by American Painters." *New York Herald Tribune*, January 12, 1936.

————. "A Spring Interlude in the World of Art Shows: Mr. Alfred Stieglitz and His Services to Art." *New York Herald Tribune*, March 15, 1925.

DEVREE, HOWARD. "Alfred Stieglitz Opens Art Show." *New York Times*, October 18, 1941.

ELDREDGE, CHARLES. "The Arrival of European Modernism." *Art in America*, July–August 1973.

"Exhibitions in the New York Galleries." *Art News*, February 22, 1930.

FILLIN-YEH, SUSAN. "Innovative Moderns: Arthur G. Dove and Georgia O'Keeffe." *Arts Magazine*, Special Issue, June 1982.

FISHER, WILLIAM MURRELL. "The Georgia O'Keeffe Drawings and Paintings at 291." *Camera Work*, 49–50 (June 1917), 5.

FLINT. "Around the Galleries." *Creative Art*, March 6, 1930.

———. "Lily Lady Goes West." *Town & Country*, January 1943.

———. "What Is '291'?" Christian Science Monitor, November 17, 1937.

FULTON, DEOGH. "Cabbages and Kings." *International Studio*, May 1, 1925.

GALLUP, DONALD. "The Weaving of a Pattern: Marsden Hartley and Gertrude Stein." *Magazine of Art*, November 1948.

GENAUER, EMILY. "Delicate Brushwork by Georgia O'Keeffe." New York *World Telegram*, February 1, 1941.

———. "Two Schools Meet in Her Art." New York *World Telegram*, February 16, 1937.

"Georgia O'Keeffe Exhibits Skulls and Roses of 1931." *Springfield* (Mass.) *Sunday Union and Republican*, January 10, 1932.

"Georgia O'Keeffe Honored." *Equal Rights*, June 1942.

"Georgia O'Keefe [*sic*], Individualist." *American Art News*, February 3, 1923.

GLUECK, GRACE. "It's Just What's in My Head." *New York Times*, October 18, 1970.

HAINES, WILLIAM. "A Series of American Artists: In Color, No. 1 Georgia O'Keeffe." *Vanity Fair*, April 1932.

HUGHES, ROBERT. "A Vision of Steely Finesse." *Time*, March 17, 1986.

HURT, FRANCES HALLAM. "I Can't Sing so I Paint." New York *Sun*, December 5, 1922.

JANIS, LEO. "Georgia O'Keeffe at 84." *Atlantic Monthly*, December 1971.

JEWELL, EDWARD ALDEN. "Adventures in the Active Realm of Art: Lost Chord Retrieved." *New York Times*, February 24, 1929.

———. "Autumn Art Show At American Place." *New York Times*, October 18, 1940.

———. "An O'Keeffe Portfolio." *New York Times*, October 31, 1937.

———. "Exhibition Offers Work by O'Keeffe: Modern Art Museum Presents a Chronological Showing of Woman Artist's Paintings." *New York Times*, May 15, 1946.

———. "Georgia O'Keeffe Gives an Art Show." *New York Times*, January 7, 1936.

———. "Georgia O'Keeffe in an Art Review." *New York Times*, February 2, 1934.

———. "Georgia O'Keeffe, Mystic." *New York Times*, January 22, 1928.

———. "Georgia O'Keeffe Shows Work." *New York Times*, December 29, 1931.

———. "Georgia O'Keeffe Shows New Work: All but One Picture Exhibited at An American Place Was Painted Last Year." *New York Times*, February 6, 1937.

———. "Georgia O'Keeffe Shows Art Work." *New York Times*, January 29, 1941.

———. "Georgia O'Keefe's Paintings Offer Five-Year Retrospect at An American Place." *New York Times*, January 13, 1933.

———. "O'Keeffe: 30 Years." *New York Times*, May 19, 1946.

———. "Three One-Man Shows." *New York Times*, January 12, 1936.

JUSSIM, ESTELLE. "The Stieglitz Mystique." *History of Photography*, April–June 1984.

KALONYME, LOUIS. "Georgia O'Keeffe: A Woman in Painting." *Creative Art*, January 1928.

KELLER, ALLAN. "Animal Skulls Fascinate Georgia O'Keeffe, but She Can't Explain It—Not in Words." New York *World Telegram*, February 13, 1937.

KLEIN, JEROME. "The Critic Takes a Glance Around the Galleries." *New York Post*, February 20, 1937.

———. "O'Keeffe Works Highly Spirited." *New York Post*, January 11, 1936.

KOTZ, MARY LYNN. "A Day with Georgia O'Keeffe." *Art News*, December 1977.

KRAMER, HILTON. "Georgia O'Keeffe." *New York Times Book Review*, December 12, 1976.

KRAUSS, ROSALIND. "Alfred Stieglitz's 'Equivalents.' " *Arts* Magazine, February 1980.

LANE, JAMES W. "Current Exhibitions." *Parnassus*, March 1935.

———. "Notes from New York." *Apollo*, April 1938.

LIFSON, BEN. "O'Keeffe's Stieglitz, Stieglitz's O'Keeffe." *Village Voice*, December 11, 1978.

LOONEY, RALPH. "Georgia O'Keeffe." *Atlantic Monthly*, April 1965.

LUHAN, MABEL DODGE. "Georgia O'Keeffe in Taos." *Creative Art*, June 1931.

MALCOLM, JANET. "Two Photographers." *New Yorker*, November 18, 1974.

MANN, MARTY. "Exhibitions." *International Studio*, March 1930.

———. "Through the Galleries." *Town & Country*, March 1, 1930.

MANNES, MARYA. "Gallery Notes." *Creative Art*, February 1928.

MATTHIAS, BLANCHE. "Stieglitz Showing Seven Americans." Chicago *Evening Post*, March 2, 1926.

McBRIDE, HENRY. "Attractions in the Galleries." New York *Sun*, February 2, 1935.

———. "Curious Responses to Work of Miss O'Keefe [sic] on Others." *New York Herald*, February 4, 1923.

———. "Georgia O'Keeffe Accused of Misdemeanor." New York *Sun*, January 28, 1939.

———. "Georgia O'Keeffe's Art." New York *Sun*, February 13, 1926.

———. "Georgia O'Keeffe's Bones: Readings from Tea Leaves and the Sands of Time." New York *Sun*, February 6, 1942.

————. "Georgia O'Keeffe's Exhibition: Star of An American Place Shines in Undiminished Luster." New York *Sun*, January 14, 1933.

————. "Georgia O'Keeffe's Hawaii." New York *Sun*, February 10, 1940.

————. "Georgia O'Keeffe's Heaven: The Theory Is if You Got One You'd Better Hold on to It." New York *Sun*, February 1, 1941.

————. "Georgia O'Keeffe's Recent Work." New York *Sun*, January 14, 1928.

————. "Georgia O'Keeffe's Work Shown: Fellow Members of Little Group Become Fairly Lyrical over It." New York *Sun*, January 15, 1927.

————. "Miss O'Keeffe's Bones: An Artist of the Western Plains Just Misses Going Abstract." New York *Sun*, January 15, 1944.

————. "Modern Art." *The Dial*, May 1926.

————. "O'Keeffe at the Museum: An Exhibition That Confirms the Opinion Long Held by the Public." New York *Sun*, May 18, 1946.

————. "Paintings by Georgia O'Keefe [sic]: Decorative Art That Is Also Occult at the Intimate Gallery." New York *Sun*, February 9, 1929.

————. "Paintings by Georgia O'Keeffe: Her Symbols of Life in the Southwest Mysteriously Attract." New York *Sun*, January 11, 1936.

————. "The Palette Knife." *Creative Art*, February 1931.

————. "Photographs by Alfred Stieglitz." *New York Herald*, February 13, 1921.

————. "Salons of America Now Include Art Specimens of Entire World." *New York Herald*, May 27, 1923.

————. "The Sign of the Cross." New York *Sun*, February 8, 1930.

————. "Skeletons on the Plain: Miss O'Keeffe Returns from the West with Gruesome Trophies." New York *Sun*, January 2, 1932.

————. "Stieglitz–O'Keefe [sic] Show at Anderson Galleries." *New York Herald*, March 9, 1924.

McCausland, Elizabeth. "Exhibitions in New York." *Parnassus*, March 1940.

"The Modern Honors First Woman: O'Keeffe." *Art Digest*, June 1, 1946.

Morgan, Ann Lee. "Fires of Affection: The Paintings of Marsden Hartley." *New Art Examiner* (East Coast ed.), December 1980.

Moore, Dorothy Lefferts. "Exhibitions in New York." *The Arts*, March 1929.

————. "In the Galleries." *The Arts*, March 1930.

Morris, George L. K., "To Georgia O'Keeffe: An American Place." *Partisan Review*, March 1938.

Mumford, Lewis. "O'Keefe [sic] and Matisse." *New Republic*, March 2, 1927.

"New York Art Exhibitions and Gallery News." *Christian Science Monitor*, June 2, 1916.

NORMAN, DOROTHY. "From the Writings and Conversations of Alfred Stieglitz." *Twice-a-Year*, Fall—Winter 1938.

———. "Six Happenings." *Twice-a-Year*, no. 14–15 (1946–1947).

O'BRIEN, FRANCES GARFIELD. *"Americans We Like." The Nation*, October 12, 1927.

O'KEEFFE, GEORGIA. "Can a Photograph Have the Significance of Art?" *MSS*, December 1922.

———. "Stieglitz: His Pictures Collected Him." *New York Times Magazine*, December 11, 1949.

"Paintings by Women Artists Bought by the Metropolitan." *New York Herald Tribune*, March 26, 1934.

"The Passing Shows." *Art News*, February 1–14, 1944.

PEMBERTON, MURDOCH. "The Art Galleries: A Different American." *Art News*, February 22, 1930.

———. "The Galleries." *New Yorker*, January 22, 1927.

———. "The Galleries." *New Yorker*, January 21, 1928.

———. "Georgia O'Keeffe's Arresting Pictures." *New York Times*, January 16, 1927.

———. "Mostly American." *Creative Art*, March 1929.

PHILLIPS, DUNCAN. "Original American Painting of Today." *Formes*, January 1932.

"The Photo-Secession at the Arts Club." *Camera Notes*, 1902.

POLLITZER, ANITA. "Finally, a Woman on Paper." *American Review* (U.S. Office of War Information), vol. 2, no. 8, 1945.

———. "That's Georgia." *Saturday Review*, November 4, 1950.

RATHBONE, BELINDA. "Portrait of a Marriage: Paul Strand's Photographs of Rebecca." *J. Paul Getty Museum Journal*, vol. 17, no. 89.

RAYNOR, VIVIEN. "Art: Whitney Displays Its 10 Georgia O'Keeffes." *New York Times*, August 14, 1981.

READ, HELEN APPLETON. "Alfred Stieglitz Presents Seven Americans." *Brooklyn Daily Eagle*, March 15, 1925.

———. "Freudian Complexes as Art; Georgia O'Keeffe's Show an Emotional Escape." *Brooklyn Daily Eagle*, February 11, 1923.

———. "Georgia O'Keefe" [*sic*]. *Brooklyn Daily Eagle*, January 16, 1927.

———. "Georgia O'Keefe [*sic*] Again Introduced by Stieglitz at the Anderson Galleries."

———. "Georgia O'Keeffe." *Brooklyn Daily Eagle*, February 21, 1926.

———. "New York Exhibitions." *The Arts*, April 1925.

———. "The Feminine Viewpoint in Contemporary Art." *Vogue*, June 15, 1928.

"Reviews and Previews." *Art News*, June 1946.

ROSENFELD, PAUL. "American Painting." *The Dial*, December 1921.

——. "The Female of the Species Achieves a New Deadliness." *Vanity Fair*, July 1922.

——. "The Paintings of Georgia O'Keeffe." *Vanity Fair*, October 1922.

SABINE. "Record Price for Living Artist." *Brooklyn Daily Eagle*, May 27, 1928.

SCHAKENBERG, H. E. "Exhibitions." *The Arts*, March 1931.

SEKULA, ALLAN. "On the Invention of Photographic Meaning." *Artforum*, January 1975.

SELIGMANN, HERBERT J. "A Photographer Challenges." *The Nation*, February 16, 1921.

SHERBURNE, E. C. "G. O'Keeffe." *Christian Science Monitor*, January 14, 1936.

——. "Georgia O'Keeffe's Paintings." *Christian Science Monitor*, February 2, 1935.

SOBY, JAMES THRALL. "Fine Arts: To the Ladies." *Saturday Review*, July 6, 1946.

SPENCER, EDWINA. "Around the Galleries." *Creative Art*, April 1933.

STEVENS, MARK. "The Gift of Spiritual Intensity." *Newsweek*, March 17, 1986.

STIEGLITZ, ALFRED. "How I Came to Photograph Clouds." *Amateur Photographer and Photography*, September 19, 1923.

STRAWN, ARTHUR. "O'Keeffe." *Outlook*, January 22, 1930.

TAYLOR, CAROL. "Lady Dynamo." New York *World-Telegram*, March 31, 1945.

——. "Miss O'Keeffe, Noted Artist, Is a Feminist." New York *World-Telegram*, March 31, 1945.

TOMKINS, "PROFILE." In *Paul Strand: Sixty Years of Photographs*. Millerton, N.Y.: Aperture, 1976. 15–35.

——. "The Rose in the Eye Looked Pretty Fine." *New Yorker*, March 4, 1974.

TRYCK, SHEILA. "O'Keeffe." *New Mexico*, January–February 1973.

TYRRELL, HENRY. "Esoteric Art at 291." *Christian Science Monitor*, May 4, 1917.

——. "Exhibitions and Other Things," *World*, February 11, 1922.

——. "Two Women Painters Lure with Suave Abstractions." New York *World*, February 4, 1923.

WATSON, ERNEST W. "Georgia O'Keeffe." *American Artist*, June 1943.

WATSON, FORBES. "Georgia O'Keeffe." *The Arts*, February 1923.

——. "Seven American Artists Sponsored by Stieglitz." *World*, March 15, 1925.

——. "Stieglitz–O'Keeffe Joint Exhibition." *World*, March 9, 1924.

WEINBERG, JONATHAN. "Some Unknown Thing: The Illustrations of Charles Demuth." *Arts*, December 1986.

"White Flower by Georgia O'Keeffe." *Bulletin of the Cleveland Museum of Art*, April 1937.

WINSTEN, ARCHER. "Georgia O'Keeffe Tries to Begin Again in Bermuda." *New York Post*, March 19, 1934.

———. "Jazz Age Priestess Brings Forth Paintings." *New York Post*, April 3, 1934.

WOLF, BEN. "O'Keeffe Annual." *Art Digest*, March 1, 1946.

"Woman from Sun Prairie." *Time*, February 8, 1943.

ZAYAS, MARIUS DE. "On the Failure of Alfred Stieglitz to Win Public Acceptance of Modern Art." *291*, July–August 1915.

CATALOGUES

An American Place, Georgia O'Keeffe show, 1937.

Alfred Stieglitz Presents One Hundred Pictures, Oils, Water-Colors, Pastels, Drawings by Georgia O'Keeffe, American. Anderson Galleries, January 29–February 10, 1923.

Alfred Stieglitz Presents 'Seven Americans.' Anderson Galleries, March 9–March 28, 1925.

Anderson Galleries, February 7, 1921.

The Second Exhibition of Photography by Alfred Stieglitz. Anderson Galleries, beginning April 2, 1923.

GEORGIA O'KEEFFE

Fifty Recent Paintings by Georgia O'Keeffe. Intimate Gallery, February 11–March 11, 1926.

Georgia O'Keeffe Paintings. Intimate Gallery, January 11–February 27, 1927.

O'Keeffe Exhibition. Intimate Gallery, January–February 1928.

Georgia O'Keeffe Paintings, 1928. Intimate Gallery, February 4–March 18, 1929.

Georgia O'Keeffe Paintings: New & Some Old. An American Place, January 7–February 22, 1933.

Georgia O'Keeffe at An American Place: 44 Selected Paintings, 1915–1927. An American Place, January 29–March 17, 1934.

Georgia O'Keeffe: Exhibition of Paintings, 1919–1935. An American Place, January 27–March 11, 1935.

Georgia O'Keeffe: Exhibition of Recent Paintings, 1935. An American Place, January 7–February 27, 1936.

Georgia O'Keeffe: New Paintings. An American Place, February 5–March 17, 1937.

Georgia O'Keeffe: Exhibition of Oils and Pastels. An American Place, January 22–March 17, 1939.

21 New Paintings (Hawaii): Georgia O'Keeffe. An American Place, February 1–March 17, 1940.

Georgia O'Keeffe: New Paintings. An American Place, January 27–March 11, 1941.

Georgia O'Keeffe: Paintings, 1942–1943. An American Place, March 27–May 22, 1943.

UNPUBLISHED SOURCES

ANDERSON, DENNIS. "Charles Demuth's 'A Poster Portrait: Georgia O'Keeffe.' "

EISLER, COLIN. "The Stieglitz Circle." Scholar of the House paper, Yale College, 1952.

HAUBOLD, MARCIA ANN. "Mabel Dodge Luhan: An Historical Study of an Individual and Her Social Environment." M.A. thesis, University of Iowa, 1965.

LUHAN, MABEL DODGE. Unpublished paper, n.d., Mabel Dodge Luhan Papers (YCAL).

NEWHALL, NANCY. "Notes for a Biography of Alfred Stieglitz," unpublished manuscript.

POLLITZER, ANITA. "Manuscript Notes for a Biography of Georgia O'Keeffe."

RODGERS, TIMOTHY ROBERT. "Alfred Stieglitz, Duncan Phillips, and the $6,000 Marin," paper presented to the College Art Association, New York, 1990.

ROSENBLUM, NAOMI. "Paul Strand: The Early Years, 1910–1932," Ph.D. dissertation, City University of New York, 1978.

RUBENSTEIN, MERIDEL. "The Circles and the Symmetry: The Reciprocal Influence of Georgia O'Keeffe and Alfred Stieglitz." M.A. Thesis, University of New Mexico, Albuquerque, 1977.

TOMKINS, CALVIN. "Notes from an Interview with Georgia O'Keeffe."

WEINBERG, H. BARBARA. "Class Struggles: American Women as Art Students, 1870–1930."

ZILCZER, JUDITH KATY. "The Aesthetic Struggle in America, 1913–1918: Abstract Art and Theory in the Stieglitz Circle," Ph.D. dissertation, University of Delaware, 1975.

INDEX

FOR THE BEST IN PAPERBACKS, LOOK FOR THE

In every corner of the world, on every subject under the sun, Penguin represents quality and variety—the very best in publishing today.

For complete information about books available from Penguin—including Pelicans, Puffins, Peregrines, and Penguin Classics—and how to order them, write to us at the appropriate address below. Please note that for copyright reasons the selection of books varies from country to country.

In the United Kingdom: For a complete list of books available from Penguin in the U.K., please write to *Dept E.P., Penguin Books Ltd, Harmondsworth, Middlesex, UB7 0DA*.

In the United States: For a complete list of books available from Penguin in the U.S., please write to *Dept BA, Penguin*, Box 120, Bergenfield, New Jersey 07621-0120.

In Canada: For a complete list of books available from Penguin in Canada, please write to *Penguin Books Canada Ltd, 10 Alcorn Avenue, Suite 300, Toronto, Ontario, Canada M4V 3B2*.

In Australia: For a complete list of books available from Penguin in Australia, please write to the *Marketing Department, Penguin Books Ltd, P.O. Box 257, Ringwood, Victoria 3134*.

In New Zealand: For a complete list of books available from Penguin in New Zealand, please write to the *Marketing Department, Penguin Books (NZ) Ltd, Private Bag, Takapuna, Auckland 9*.

In India: For a complete list of books available from Penguin, please write to *Penguin Overseas Ltd, 706 Eros Apartments, 56 Nehru Place, New Delhi, 110019*.

In Holland: For a complete list of books available from Penguin in Holland, please write to *Penguin Books Nederland B.V., Postbus 195, NL-1380AD Weesp, Netherlands*.

In Germany: For a complete list of books available from Penguin, please write to *Penguin Books Ltd, Friedrichstrasse 10-12, D-6000 Frankfurt Main 1, Federal Republic of Germany*.

In Spain: For a complete list of books available from Penguin in Spain, please write to *Longman, Penguin España, Calle San Nicolas 15, E-28013 Madrid, Spain*.

In Japan: For a complete list of books available from Penguin in Japan, please write to *Longman Penguin Japan Co Ltd, Yamaguchi Building, 2-12-9 Kanda Jimbocho, Chiyoda-Ku, Tokyo 101, Japan*.